Bucks County Fraktur

Edited by
Cory M. Amsler

Contributors:
Joel D. Alderfer
Cory M. Amsler
Michael S. Bird
Corinne P. Earnest
Russell D. Earnest
Mary Jane Lederach Hershey
Henry C. Mercer
Terry A. McNealy
John L. Ruth
Don Yoder

The Bucks County Historical Society
Doylestown, Pennsylvania

———

The Pennsylvania German Society
Kutztown, Pennsylvania
Volume XXXIII
1999

Dust Jacket Illustration:
Birth and Baptismal Certificate for Isaac Weaver (detail)
School of Bernhard Misson, Tinicum Township, Bucks County, Pa., c. 1819
(Spruance Library/Bucks County Historical Society)

Edited by Cory M. Amsler, with the assistance of Willard Wetzel

Designed by Mary Ann Davis, Davis Graphic Design, Indianapolis, Indiana

Copyedited and indexed by Christina Palaia, Emerald Editorial Services, Pittsgrove, New Jersey

Printed and bound in the United States of America by Jostens Book Manufacturing, State College, Pennsylvania, 16803, under contract to Maury Boyd & Associates, Indianapolis, Indiana

Published for The Bucks County Historical Society, Doylestown, Pennsylvania 18901, by The Pennsylvania German Society, Kutztown, Pennsylvania 19530-0244. Distributed to members of The Pennsylvania German Society as a benefit of membership for the calendar year 1999 (Volume XXXIII).

Funded in part by donations and grants from Robert and Joyce Byers of Byers' Choice Ltd., Paul and Rita Flack, Victor and Joan Johnson, Christie's, CIGNA Foundation, The Pennsylvania Council on the Arts, and The American Folk Art Society

"The Survival of the Mediaeval Art of Illuminative Writing Among Pennsylvania Germans," by Henry C. Mercer, is reproduced here by permission of the American Philosophical Society, Philadelphia, Pennsylvania. Mercer's article was originally published in the *Proceedings of the American Philosophical Society* 36 (September 1897)

Library of Congress Control Number: 2001132658
ISBN 0-911122-01-X

To Helen Hartman Gemmill (1918-1998),
former Chair of the Bucks County Historical Society's Collections
Committee and passionate champion of Henry Mercer's
remarkable legacy, this book is affectionately dedicated.
Her enthusiasm inspires us still.

Contents

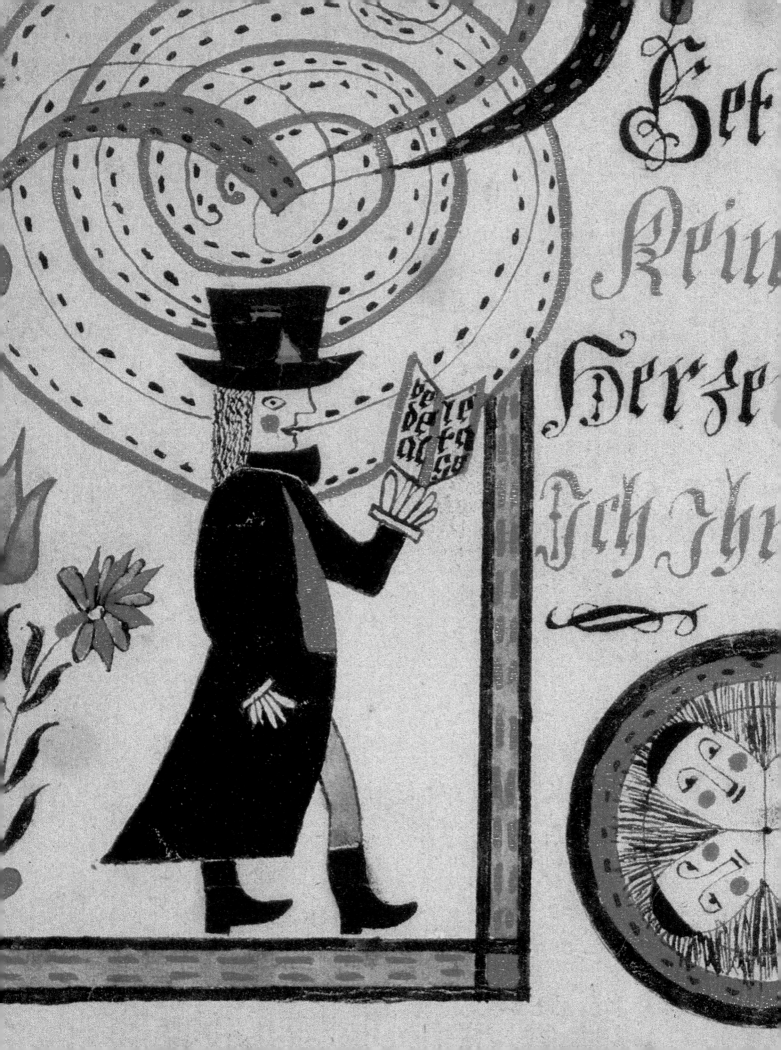

Acknowledgments

As coordinator of the 1997 *Discovering Bucks County Fraktur* exhibit project and editor of this volume, I realize that I have been something of an interloper in the world of fraktur scholarship. After all, this is just one of many projects which I have leapt into and out of during my tenure with the Bucks County Historical Society. Fortunately, in this endeavor I have benefitted from the expertise of a remarkable group of people for whom fraktur has been a lifelong passion and perennial research interest. Now, this is my opportunity to recognize them for their extraordinary contributions to this publication.

At the outset, I am extremely grateful to the authors who have contributed essays to the book. Not only have they presented new and intriguing scholarship, but they have also aided the project in other ways. Don Yoder, for example, translated most of the fraktur for the exhibit and this publication. By phone, fax, and in person, Corinne and Russell Earnest generously shared their vast knowledge of a whole host of Pennsylvania fraktur artists and scriveners. Joel Alderfer, Mary Jane Lederach Hershey and John Ruth, all associated with the Mennonite Heritage Center in Harleysville, Pennsylvania, did the same, specifically for Mennonite frakturers. Terry McNealy, the Historical Society's former librarian, catalogued the museum's fraktur collection and gathered a great deal of preliminary

Fig. 1. (facing page) **Religious Text for Elisabetha Schneider (detail).** Unidentified artist, probably Hilltown Township, Bucks County, 1812. Hand-drawn, lettered and colored on laid paper. 15 ¹/₂ x 12 ³/₄ in. (Private collection.)

information on several known and potential artists. Michael Bird, a relative latecomer to the project, has been an enthusiastic contributor who has helped us to broaden the appeal of this volume to our Canadian neighbors. My sincerest thanks go to all of these individuals for supporting and promoting this publication at every opportunity.

Too often bound by the tunnel vision that comes from constant worry over exhibit and other deadlines, I doubt that I would ever have considered the possibility of producing a major publication unless nudged. Happily, that was a key role of our project advisory committee. Those members who pushed and prodded the most were Historical Society trustee and collections committee chair Joan Johnson, trustee and longtime Society supporter Helen Gemmill (who with her husband Kenneth sadly passed away before the book could be published), and collectors David Miller and Paul Flack. Their passionate and constant pressure to develop this book simply left me with no other option. Thank you!

No major book or exhibit project sees daylight in this era without generous funding from a variety of public and private sources. Among the earliest and most munificent supporters of this publication were Robert and Joyce Byers of Byers' Choice Ltd., Chalfont, Bucks County. Other major private contributors have included Paul and Rita Flack, Victor and Joan Johnson, Christie's, CIGNA Foundation, and the American Folk Art Society. Funds to conserve fraktur in the Historical Society's collection were also provided by the Friends of the Bucks County Historical Society, King's Path

Questers, and the Featherbed Hill Questers. Their contributions enabled conservators Susan Duhl, Maria Pukownik, Franklin Shores, and Elizabeth Wendelin to perform their magic. Their work in turn helped to ensure that the Society's fraktur artwork would look its best in the book's illustrations. Among the major public contributors to the fraktur project were the Pennsylvania Historical and Museum Commission and the Pennsylvania Council on the Arts, the latter agency providing three grants during the course of the project.

Of course this book would not have been possible without the substantive support of the Pennsylvania German Society, the co-publisher. In addition to contributing to the cost of the volume, the Society also lent its considerable expertise. I am indebted to Pastor Willard Wetzel, former PGS editor, for helping to coordinate early work on the book, and to Dr. Robert M. Kline, Dr. David Valuska, Dr. Simon Bronner, Troy Boyer, and George Spotts for their encouragement at several points in the publication process.

Many institutions and private collectors loaned fraktur for the exhibit and provided illustrations for this publication. They include the Abby Aldrich Rockefeller Folk Art Center (Colonial Williamsburg, Williamsburg, Virginia), Blooming Glen Mennonite Congregation (Hilltown Township, Bucks County), Dietrich American Foundation/H. Richard Dietrich, Jr., Eastern Mennonite University (Harrisonburg, Virginia), Paul Flack, The Free Library of Philadelphia Rare Book Department, Jordan Historical Museum (Jordan, Ontario), Lehigh County Historical Society (Allentown, Pennsylvania), Mennonite Historians of Eastern Pennsylvania (Harleysville), Mennonite Historical Library at Goshen College (Goshen, Indiana), Historical Society of Pennsylvania, Philadelphia Museum of Art, Rothman Gallery at Franklin & Marshall College (Lancaster, Pennsylvania), Schwenkfelder Library and Museum

(Pennsburg, Pennsylvania), Dr. Donald A. Shelley, Winterthur Museum and Library, and, of course, the Bucks County Historical Society. This list should also include many private individuals who, for reasons of anonymity, are not listed by name but whose contributions are and have been significant.

Several other individuals also deserve special recognition here. At the top of the list is Pastor Frederick Weiser, probably America's foremost fraktur scholar, who has kindly provided important criticism and useful pointers as we have sought to put Bucks County fraktur in its proper historical and cultural contexts. Appropriately, he also urged us to take a conservative approach in attributing fraktur to specific artists, reminding us not to overreach the visual and documentary evidence.

Others who have provided key information and encouragement are Isaac Clarence Kulp, Dr. Donald Shelley, and Ronald Trauger. Former Curatorial Department secretary Carolyn Rubilla, current office assistant Jan Katz, and volunteer Pat Conard typed manuscripts onto computer disks for editing. Early on in the project, Society volunteers Leslie May and Pat Howe conducted useful local history research. Betsy Smith, Society librarian, provided assistance in accessing research materials and participated in the development of the exhibit and publication. She also helped proofread portions of the text, along with Historical Society Public Relations Coordinator Karen Benson and advisory committee member David Miller. Among the museum staff, I would also like to recognize Executive Director Douglas Dolan for providing the time and resources to work on the publication project, and Associate Director Molly Lowell for assisting with fund-raising.

Much of the photography for this book was done by Doylestown photographer John Hoenstine. Despite his incredulity that there was "any Bucks County fraktur left to photograph" after taking

dozens of pictures, he was always ready for another road trip to shoot yet another collection.

Special thanks is also due to those individuals who kindly purchased advance copies of this publication. You have been more than patient in awaiting a return on your investment these past three and a half years. The Historical Society and this editor appreciates the trust and faith you have placed in us. I hope that you will find the finished volume well worth the long wait.

Finally, I would like to thank my mother, Joyce Amsler Bonhoff, and stepfather, Howard Bonhoff, for providing a quiet place in which to write and edit during holidays and vacations. And, most important of all, my deepest thanks go to my wife (and colleague) Eileen Shapiro who has read portions of this manuscript, provided ongoing encouragement, and endured long periods of absence and late nights at the computer while I worked on the exhibit and publication. She gave me shots of confidence and reassurance when they were most needed.

If I have omitted anyone in this list please accept my apologies, and know that I have greatly appreciated everyone who, over the past five years, have provided timely access to fraktur collections, research materials, and family histories. This book is as much yours as it is mine, the contributing scholars', the Pennsylvania German Society's, or the Bucks County Historical Society's.

Cory M. Amsler, Editor
Autumn, 2000

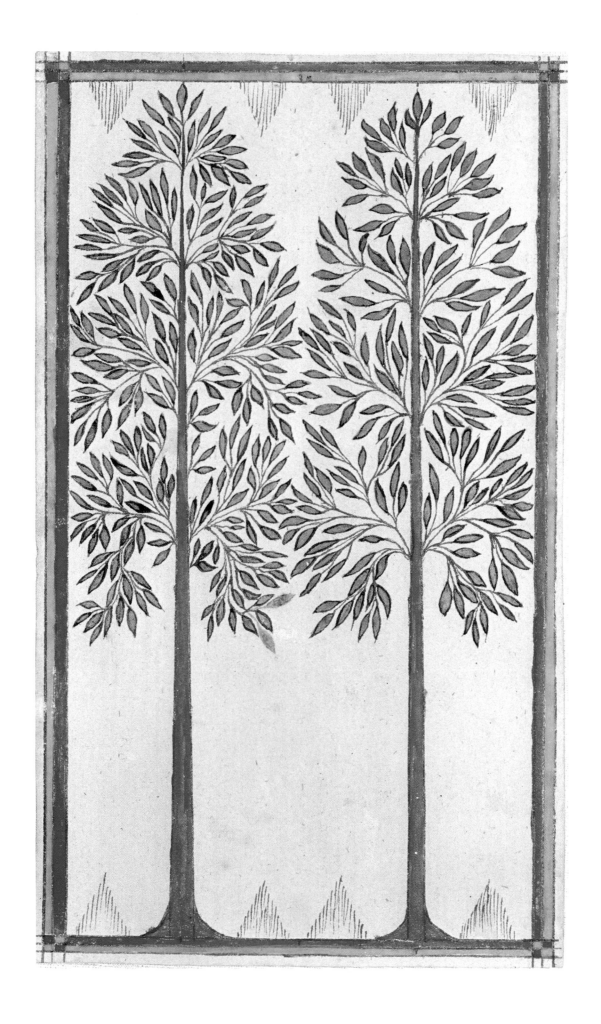

Introduction

Cory M. Amsler

This book represents the final step in a long-term fraktur documentation, exhibition, and publication project begun formally in 1993 under the auspices of the Mercer Museum of the Bucks County Historical Society. In a very real sense, however, the project actually began with Henry Chapman Mercer more than a century ago, in 1897. It was Mercer who first called the Society's attention to fraktur, and who ultimately mobilized several generations of scholars and folk art enthusiasts to root out thousands of these decorated manuscripts in garrets, family bibles, chests, and the myriad other places where they had come to rest, so that they might be preserved. To mark the centennial of Mercer's rediscovery of fraktur, the Historical Society's Mercer Museum mounted the 1997 exhibit, *From Heart to Hand: Discovering Bucks County Fraktur.*

To accompany the exhibition, the Historical Society presented a popular symposium in the fall of 1997, inviting several noted scholars and students of fraktur to participate. The essays that comprise the first half of this volume are an outgrowth of the papers originally presented at the symposium. However, in the succeeding three years, the speakers have performed additional research, and continued to refine

Fig. 2. (facing page) **Drawing**. Unidentified artist, probably Bedminster Township, Bucks County, c. 1830. Hand-drawn and colored on wove paper. 6³/₈ x 3⁷/₈ in. This was one of the earliest pieces of fraktur documented and collected by Henry Mercer. In 1897 it was owned by Henry K. Gross, son of Bucks County fraktur artist Isaac Gross (1807-1893). (Spruance Library/Bucks County Historical Society, SC-58. No. A-01.)

and amplify their thoughts, so as to convey much more information here than was possible at the conference.

A word must be said about the geographical parameters of this volume. Although its focus is on "Bucks County" fraktur (that is, Pennsylvania-German decorated manuscript material and related folk art produced within the confines of the historical county of Bucks), we recognize that the boundary lines that this implies are somewhat artificial. As is pointed out later in the book, the schoolmasters, scriveners, and artists who produced fraktur generally did not recognize the invisibly drawn borders of counties or even states. Frakturers—and the art that they created—clearly moved around. Thus, we may well be frustrated looking for a "Bucks County fraktur style" in the same way that we might search out the distinctive qualities of Philadelphia silver or Mahantango Valley decorated furniture. Rather, our concentration on Bucks County has been primarily an attempt to make the subject a manageable and logical one for the Bucks County Historical Society.

Nonetheless, regional studies such as this one do have merit. First, they provide for in-depth study on just a few fraktur artists in a narrowly defined context. From such studies, scholars may wish to compare and contrast the art form as is was practiced here with other counties or locales. Indeed, broader generalizations about fraktur production ought to be based on the particularities revealed in a specific area. Second, regional studies highlight what might be important local influences on the practice of fraktur, or even the origination of

certain motifs and forms. Clearly, an artist like Bucks County's Johann Adam Eyer had enormous influence on other frakturers—both through his own movements as well as the travels of the recipients of his fraktur. Likewise, aspects of the historical character of Bucks County—its split between German and English speakers, and the significant presence of a conservative Mennonite minority for example—may well have had an impact on the character and longevity of fraktur production.

The essays that follow consequently reflect both the broader view of fraktur as well as the narrower context of Bucks County and its immediate environs. The lead essay is Henry Mercer's, a reprint of his 1897 monograph on illuminated manuscripts. Appropriately, Mercer bridges the general and the specific, discussing fraktur in broad terms but using examples he found nearby in northern Bucks County to illustrate his points. The next two essays, belonging to folk culture scholar Don Yoder, also take a broad view. Dr. Yoder first considers the European origins of fraktur, presenting new and exciting research particularly on the development of the *Taufschein* and its European antecedents. Following that, he discusses the spiritual content of fraktur, reminding us that the text of these manuscripts was as important to their owners as the colorful embellishments that fascinate folk art collectors today.

Former Bucks County Historical Society librarian Terry McNealy then begins to narrow the focus. He first provides a geographical, political, and social overview of the German element in Bucks County. Then, along with co-author Cory Amsler, he explores the local educational milieu in which fraktur arose, flourished, and declined (or was transformed, depending on one's point of view). This latter essay makes extensive use of primary source material available in Bucks County—teachers' bills to the county for instructing poor children, schoolmasters' records, and other documents—to reveal more about the German schools (and schools generally) than has heretofore been published.

The significant influence of the Mennonite community on fraktur production, and its perpetuation, are the subject of the next two papers. Mennonite historian John L. Ruth considers the gradual migration of Mennonite fraktur from the area around Skippack, in present-day Montgomery County, to Deep Run and other settlements along Tohickon

Creek in Bucks. Ironically, much of this early fraktur was the product of non-Mennonites who apparently found stimulating and comfortable teaching positions among the plain sect. Dr. Ruth shows the manner in which the fraktur tradition traveled back and forth between distant Mennonite communities, and among the schoolmasters who served them.

Mary Jane Lederach Hershey then contributes an in-depth study of the *Notenbüchlein* (manuscript tune book). Her investigation, too, focuses on the extended Mennonite community in several southeastern Pennsylvania counties, but finds that the bulk of surviving fraktur-decorated tune books actually originated in Bucks. Although the form was not exclusive to Mennonite schools, the vast majority of tune books were prepared for Mennonite children. She concludes her essay with detailed and valuable descriptions of extant tune books, the teachers who produced them, and the students for whom they were made.

Mennonite Heritage Center curator/librarian Joel D. Alderfer next shows what can be learned through the study of an individual artist, especially when important documents survive that can illuminate the artist's personality as well has his work. The recently discovered copybooks of schoolmaster-artist David Kulp allowed Mr. Alderfer, and others at the Heritage Center, to finally identify the hand behind what may be the largest grouping of Bucks County fraktur by a single artist, that attributed previously to the so-called Brown Leaf Artist. Some of the material in Kulp's copybook hints at the pride he took in his penmanship, and reveals a rather worldly (though private) vanity in the personality of a nineteenth-century Mennonite schoolmaster.

Although not present at the 1997 symposium, Michael S. Bird of the University of Waterloo, Canada, was invited to contribute a paper on the Bucks County–Ontario fraktur connection. Dr. Bird writes from an art historical point of view, and is unique among all of the authors in deconstructing and analyzing the imagery found on fraktur. He looks specifically at fraktur from Lincoln County on the Niagara Peninsula—an area settled by Bucks County Mennonite emigrants during the post-Revolutionary period.

Finally, Russell and Corinne Earnest encourage us to look beyond purely hand-drawn fraktur, and consider the printed *Taufschein* forms and bible records that were completed by professional penmen

or scriveners. Although the focus of this volume is primarily on hand-decorated and hand-lettered fraktur, the Earnests help us again to push outward the boundaries of our subject matter. In keeping with our geographic focus, however, they concentrate on the scriveners who worked, at least part-time, within the borders of Bucks County.

The book's concluding segment provides an illustrated catalogue of Bucks County fraktur, organized by artist. Short biographical profiles of artists, both identified and anonymous, are accompanied by representative examples of their works. The catalogue is, in turn, followed by translations of all of the fraktur illustrated in the book.

Of course, this publication can make no claims to being definitive. It requires little prescience to predict that not long after publication, some new piece of information will come to light that will identify yet another artist, or perhaps even invalidate a tentative attribution made here. That is as it should be. The possibility of another discovery, of learning something more, is what keeps us going. I hope that the research presented here will provide a steppingstone to future scholarship, and will encourage others to add their voices and expertise. It is hard to imagine that Henry Mercer believed that his 1897 monograph would be the last word on fraktur. In fact, as a forceful advocate for the study of Pennsylvania-German material culture, he would probably see it as a hopeful sign that the outpouring of books and articles on the subject shows no signs of abating.

The Survival of the Mediaeval Art of Illuminative Writing Among Pennsylvania Germans

Henry C. Mercer

Editor's Introduction

It seems only appropriate that the lead essay in this volume should be contributed by Henry Mercer. Reprinted here for the first time since 1897, Mercer's article was the first serious treatment of fraktur as a folk art form and, in fact, one of the first forays into Pennsylvania-German material culture by a scholar not of German ancestry. Though much of his scholarship is now antiquated and should be read with caution, Mercer's monograph is nonetheless a fascinating document, especially when considering that those folk informants from whom he drew his information were so much closer to the origins of the manuscripts than we are today.

There are also small nuggets of information here that appear nowhere else, including, unfortunately, in the catalogue records of the Bucks County Historical Society. His attribution of several fraktur to Isaac Gross of Bedminster Township, based upon information from Isaac's son Henry, seems to ring true. His identification

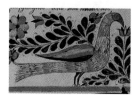

of at least two fraktur artists still living in 1897, Jacob Gross and John H. Detweiler, has provided a starting point for identifying their work. Similarly, his mention of schoolmasters Samuel Musselman and "Mr. Meyers" of Deep Run offers other leads for identifying potential fraktur artists. We are also fortunate that Mercer documented the thirty fraktur listed in his article in 1897, since some are now, apparently, lost to time.

Following his 1897 talk before the American Philosophical Society, that venerable organization chose to print Mercer's essay in its Proceedings *(volume 36, number 156). We are grateful to the Philosophical Society for permitting us to reprint the text, with updated color illustrations, in this volume.*

Indeed, Mercer's text is presented here as originally written and published. Only the illustration captions have been substantively altered, this so as to render them consistent with captions elsewhere in the book. Where this has been done, Mercer's original words have been entered as quoted passages.

The notion of a novel collection was suggested to me by a visit paid last April to the house of an individual who has long been in the habit of buying "penny lots" of so-called trash at country sales. There, scattered in confusion about the premises, rusting, warping and crumbling, lay a heterogeneous mass of objects of wood or iron, which by degrees I recognized as of historic value. Forgotten by the antiquary, overlooked by the historian, they were the superannuated and cast-away tools of the Pennsylvanian pioneer. Because they illustrated, with the

fidelity of visual facts, the felling of the forest, the building of the log cabin, cooking in the open fire and the disused arts and crafts, professions and amusements of colonial times, I gathered them together and, ransacking Bucks county for other specimens, stored them by the wagonload in the museum of the Bucks County Historical Society, at Doylestown, as a novel and hitherto unattempted illustration of the American beginning.

Among the manifold suggestions involved in the genealogy of such objects as the reaper's cradle, the American carpenter's hatchet and pitching axe, the Dutch scythe and the wooden plow, carrying

investigation from America to various parts of Europe, a rude, lidless paint-box, fastened with wooden pegs, long puzzled us (Fig. 3).

About a foot long by six inches broad, with several compartments containing little glass bottles, it was finally explained as one of the color-boxes of teachers of the German schools, super-seded in Bucks County fifty years ago. Using it as a receptacle for their home-made pens, brushes and colors, they had instructed scholars in the art of Fractur [*sic*] or illuminative handwriting until about the year 1840.

With great interest, we learned that the time-stained box found in one of the garrets of Bedminster had long ago in its longest compart-ment contained goose-quill pens, and brushes made of the hair of the domestic cat; that the caked colors in the small bottles had been the home-mixed inks and paints of the master once liquified in whisky, and that the varnish was composed of the gum of the cherry tree diluted in water.

Working with these primitive tools, often lit at his task, let us suppose, by the once familiar boat-shaped lard lamps suspended upon trammels of wood, the pioneer schoolmaster at the log school-houses produced in the latter part of the last century and the beginning of this, the beautiful illuminated hymns (Fig. 4) and ornate title-pages which when found in numbers among Mennonites in central Bucks county astonished and delighted us for the first time in August, 1897.[1]

These glowing relics of the venerable stone farmhouses of eastern Pennsylvania, sometimes falling to pieces through carelessness, sometimes preserved with veneration between the leaves of large Lutheran Bibles, revealed by degrees to our investigation the following facts:

First, that the art of Fractur was not confined to Bucks County or to the Mennonites, who had presented us with the first specimens seen, but that it had flourished throughout Pennsylvanian Germany, among the Dunkers, the Schwenkfelders and probably the Amish and Moravians.

Second, that it had been chiefly perpetuated by deliberate instruction in German schools by German schoolmasters, and that it had received its death blow at the disestablishment of the latter in Bucks County in 1854.

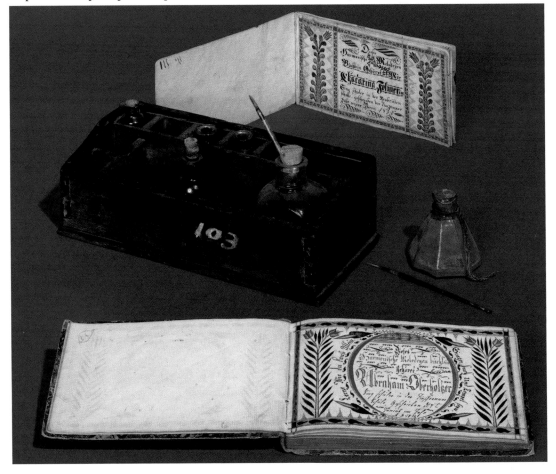

Fig. 3. **Fraktur Artist's Paint Box.** Bucks County, 1820–1850. Wood, glass, cork, iron, quill, bristles, pigment residues. 4^1/$_2$ x 4^1/$_2$ x 9^7/$_8$ in. Mercer: "Paint box used by German schoolmaster about 1820 in the execution of Fractur or illuminative German handwriting. Presented to the society by Tobias Nash of Wormansville." (Mercer Museum/Bucks County Historical Society, No. 00103.)

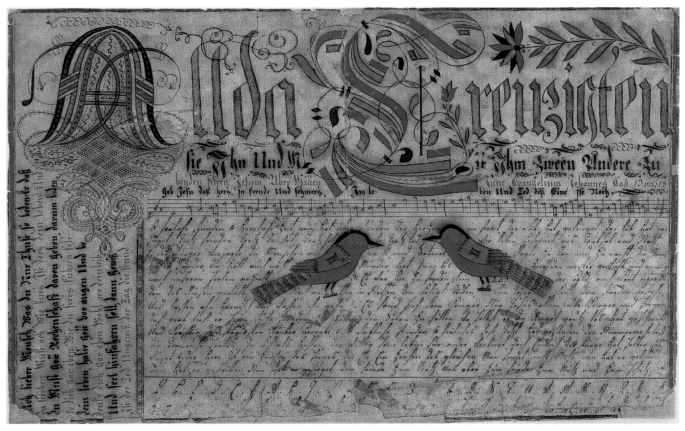

Fig. 4. **Penmanship Model.** School of Johann Adam Eyer, Bucks County, c. 1800. Hand-drawn, lettered and colored on laid paper. 13¼ x 8⅜ in. Mercer: "Illuminated leaflet in the possession of Henry W. Gross, of Doylestown. The floriated text is Luther's translation of John xix, 18. *Allda Kreuzigten sie Ihn*, etc., etc. Below it is a bar of music with red lines heading a hymn of six verses beginning *'O fröhliche Stunden O herrliche Zeit,'* and beneath an alphabet and numeral series. A pious rhyme beginning *'Ach lieber Mensch'* forms the lower, left border. Colors red, black, blue, yellow, brown and green." (Spruance Library/Bucks County Historical Society, SC-58. No. A-13).

Third, that the art, always religious, had not been used for the decoration of secular themes, such as songs, ballads or rhymes,* but had expressed itself in

A. Illuminated Song Books,

Such as the beautiful manuscript song books called *Zionitischer Rosen Garten,* and *Paradisisches Wunder-Spiel,* made by monks at Ephrata, and presented by Mr. Abram H. Cassell to the Pennsylvania Historical Society.

B. The Title-Pages to Small, Plain Manuscript Mennonite Song Books,

Often giving the owner's name, with the date and the writer's school, with illuminated borderings,

overhanging tulips or lotus, birds and angels blowing trumpets. For example:

1. Leaflet 8¼ inches long by 6¾ inches broad. Name. Words, *Dieses Vorschrifften Büchlein Gehöret Margretha Wismerin Schreib Schuler in der Birckenseher Schule* (now Blooming Glen). *Vorgeschrieben der October 4te, 1781.* Above a short prayer, surrounded with admonitions to diligence. In rectangle, formed of ornate foliated borders, are three feathered crowns and two angels holding tulips and blowing trumpets. Tulip stalks spring from hearts. Colors, blue, green, red, yellow and black. Probably made in the last century by Jacob Overholt, teacher in a log schoolhouse near Deep Run, Bucks County, Pa. Presented to the writer by his descendant, David Landis, of Plumsteadville. [Editor's note: although Mercer grouped this item with manuscript tune books, it is actually a student's

* As will be clear from several of the fraktur illustrated elsewhere in this volume, Mercer erred in claiming that the art form was never used to decorate secular manuscripts, or for secular purposes. Clearly, there were any number of pictures, personal greetings, love letters, poems, and other forms that were embellished in the same manner as that used to decorate the more overtly religious manuscripts.

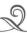
penmanship copybook. Also, it is now known not to have been created by Overholt, but instead by Johann Adam Eyer.]

2. Title-page to church song book *(Lieder Buch,* printed in Germantown, Michael Billmeyer, 1811). Name, Susanna Fretz, upon heart, from which springs a tree with the conventional tulips. Deep beaded bordering, 1814. Colors, red, yellow, brown and black, red predominant.

3. Title-page to manuscript song book. Name, Susanna Fretz (spelled *Fretzin* for feminine) in red circle, with date, 1810. Stalks, with black leaves and conventional tulip to right and left. Foliated border with red leaves on black and yellow ground.

4. Illuminated card on blank page of same hymn book. Above name, Susanna Fretzin, heart, from which rises conventional tulip. In possession of Henry W. Gross, Doylestown.

5. Title-page to manuscript hymn book. Name, Joseph Gross; illuminated letters, foliated capitals. Date, April 20, 1830. Double tulips in foliate border on yellow ground.

6. Title-page to manuscript hymn book. Name Sarah

Wismer. Foliated capitals, conventional flowers on heavy stalks. Date, 1827. Colors, yellow, red, brown and blue.

7. Title-page to ditto. Name Elizabeth Nesch, spelled *Neschin;* with words, *Dieses Sing-Noten Büchlein Gehöret Mir. Sing Schuler in der Bedminster Schule. Geschrieben, September 6ten, im Jahr, 1799.* Three tulips. In possession of Joseph N. Gross, Doylestown.

8. Title-page to similar book, with tulips floriated capitals, and name, Stauffer. In possession of Isaac J. Stover, of New Britain.

C. Rewards of Merit on Loose Leaflets.

About a foot Long by Eight Inches Broad.

First there is a text of Scripture, with elaborately illuminated characters, and done in many colored inks, under which a bar of music may set the tune to a German hymn, engrossed in many verses below. From this rich, floriated text, with its adorned and highly colored borderings, emerge birds, twining stalks growing from symbolic hearts bearing tulips, or angels blowing trumpets. Examples are:

Fig. 5. **Penmanship Model.** Possibly Isaac Gross, Bedminster Township, Bucks County, c. 1830–1840. Hand-drawn, lettered and colored on wove paper. 8¹/₈ x 13¹/₂ in. Mercer: "Illuminated leaflet with text in Philippians i, 23, and hymn. In possession of Henry K. Gross, of Plumsteadville." (Spruance Library/Bucks County Historical Society, SC-58. No. A-52).

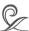

Fig. 6. **Religious Text.** Isaac Gross, Bedminster Township, Bucks County, 1830. Hand-drawn, lettered and colored on wove paper. 8¼ x 10½ in. Mercer: "Illuminated leaflet with hymn, and date, 1830. In possession of Henry K. Gross, of Plumsteadville." (Spruance Library/Bucks County Historical Society, SC-58. No. A-12).

1. Leaflet, 13¼ inches long by 8⅜ inches wide, with floriated text, *Allda Kreuzigten Sie Ihn*, etc., etc., nineteenth chapter of John, eighteenth verse, Luther's translation (Fig. 4). Above, single bar of music, with red lines heading hymn and six verses beginning, O *fröliche Stunden, O herrliche Zeit*. Under this the alphabet in common German handwriting, capitals and small letters, with Arabic numerals up to a hundred. Below, to the left, transverse rhymed admonition in red and black ink, beginning *Ach lieber Mensch*. Two birds are set upon the text of the hymn. The capital letters are elaborately illuminated and surrounded with scrolls. The bordering to the left is colored with a design. In the possession of Henry W. Gross, Doylestown. Date probably from 1760 to 1790.

2. Similar leaflet. Text, one hundred and third Psalm, verses nine and thirteen, in German. Hymn and six verses. Alphabets, numerals and admonition arranged as before. Elaborately illuminated capitals and colored borderings, birds, scrolls and tulips. Colors, red, brown, blue, green yellow and black. Name Christian Gross, in rectangle. Date probably about 1760. In possession of Isaac Gross, of Bedminster.

3,4. Two similar leaflets, closely resembling each other (Fig. 5). Text, Philippians i. 23. Hymn in five verses. Admonition, alphabets and numerals omitted. Capitals more elaborately floriated than before. Conventional leaves, flowers, tulips and birds. Colors, red, blue, green, yellow and black. Ornate borderings with heart pattern. Name, Isaac Gross, on corner of one specimen. Made by Isaac Gross, of Bedminster, related to the owner, born 1807, died 1895 *[sic]*. Date about 1840, or earlier. In the possession of Henry K. Gross, of Plumsteadville.

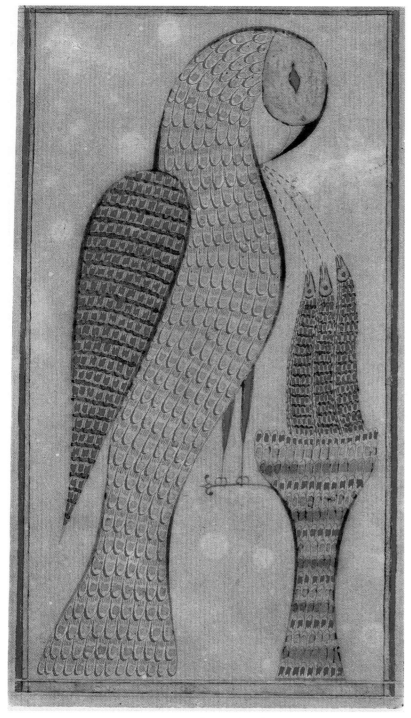

Fig. 7. **Drawing.** Attributed to Henry C. Mercer, Doylestown, Bucks County, c. 1897. Hand-drawn, lettered and colored on wove paper. 7¹/₄ x 4 in. [Editor's note: this drawing, seemingly identical to the one illustrated in Mercer's 1897 article, is attributed to Mercer's hand in early Bucks County Historical Society catalogue records. It may be a copy of the fraktur originally illustrated, which Mercer said was then in the possession of Henry K. Gross of Plumsteadville, Bucks County.] (Spruance Library/Bucks County Historical Society, SC-58. No. A-51).

5. Leaflet, slightly smaller (Fig. 6), with hymn or sacred verse in six rhymed lines, beginning *Jesus soll mein Jesus bleiben,* intertwined with numerous leaves bearing flowers. Elaborately scrolled capitals and four birds over the name of the maker, Isaac Gross, January 10, 1830. Colors, green, red, brown, blue and black. In possession of Henry K. Gross, of Plumsteadville.

6. Leaflet, 11³/₄ inches long by 7³/₄ inches broad. Text, Proverbs xiii. 7. Below this, a prayer on the theme of poverty. Capitals set in rectangles filled with pen hatchings. Colors, red and black, with a little green. Date about 1760 or earlier. In possession (1897) of Isaac Gross, of Bedminster.

7. Leaflet, 13 inches long by 8 inches wide. Pious rhyme of admonition to children, beginning *Die Kinder Lieb ist Wunderlich,* [*sic,* this word is actually *Sonderlich*] with elaborately illuminated capitals, scrolls, leaves, a bird and several tulips. A separate admonition in small ovate enclosure to the right, colored borders with alphabet below. Colors, blue, red, yellow, green, brown and black. In possession of John Walters, Chalfont.

D. Book Marks.

Sometimes consisting of such designs as tulips springing from hearts, conventionalized trees, or religious symbols. Examples are:

1. Leaflet, 6¹/₂ inches long by 3³/₄ inches wide. Two conventional trees with red stalks, and lanceolate green leaves. Border, yellow and red. No writing. In possession of Henry K. Gross, Plumsteadville. Date, about 1830.

2. Conventional bird, the pelican (a mediaeval church symbol emblematic of the Redemption), standing upon bracket protruding from urn-shaped nest, tears its breast with its beak (Fig. 7). Three dotted red lines lead from the wound to the outstretched mouths of three eel-shaped young birds uplifting their bodies from the nest. Colors, red, yellow, green and black. No writing. In possession of Henry K. Gross, of Plumsteadville. Date, about 1830.

4. Small leaflet, 4 inches long by 2 inches wide. Stalk bearing large tulip. Flower rises from centre of the heart. Name, Susanna Fretzin. Illuminated border. Colors, red, green, yellow, brown and black. Date probably about 1810. Property of Henry W. Gross, of Doylestown.

5. Unfinished leaflet, 7 inches long by 4⁵/₈ inches wide. Words, *Diese Bibel ist gekauft worden im Jahr unsers Herrn 1830, den 25th December und gehöret mier, Isaac*

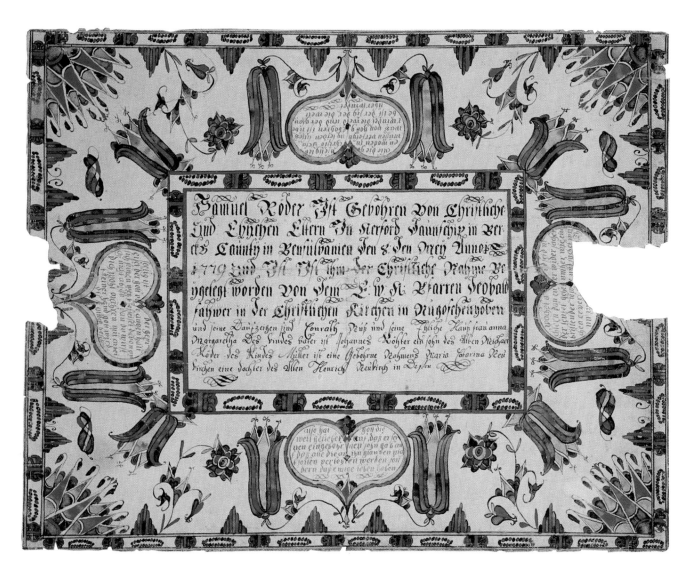

Gross, $10. Abundant leafage springing from a heart with flowers and tulips done in red outline. Brush work just begun. Ornamental borderings. Colors, blue, black, yellow, red and olive. In possession of Henry K. Gross, Plumsteadville.

6. Leaflet, about 9 inches long by 6¹/₂ inches broad, with angels and illuminated writing done by teacher of Pebble Hill German School about 1800. In possession of Mrs. Levi Garner, Doylestown.

E. *Taufscheine* or Baptismal Certificates with Marriage and Death Registers in Bibles.

The German custom of preserving baptismal certificates, though wanting the force of legal compulsion, after crossing the Atlantic, survived until recent years in parts of Pennsylvanian Germany. Not practiced by the Mennonites, owing to

their rejection of the doctrine of infant baptism, it prevailed extensively among Lutherans in northern Bucks and Lehigh counties, where however since about 1840 printed *Taufscheine*, gaudily colored, took the place of the old documents illuminated by hand.

Three of the printed certificates (giving the date of the individual's birth on a colored sheet adorned with hearts, wreaths, four birds, and angels blowing cornets, published by Johann Ritter, Reading, 1845, and in Allentown in 1848) were seen by the writer in October, 1897, in possession of Philip Flores, of Dillingersville, Lehigh county.

Examples of the old illuminated *Taufscheine* are:

1. Round leaflet, 7¹/₄ inches in diameter, surrounded by a round band, spotted in red, the latter fringed on both sides with yellow and red cross. Text, in black, *Anna Maria ist von christliche Lutherische Eltern im Jahr Unsers Herrn Jesu Christi 1782 den 30. Jenner in*

Fig. 8. **Birth and Baptismal Certificate for Samuel Röder (b. 1779).** School of Henrich Weiss, Hereford Township, Berks County, c. 1779. Hand-drawn, lettered and colored on laid paper. 13¹/₂ x 16¹/₄ in. Mercer: "Samuel Roeder's *Taufscheine [sic]*, 1779, showing the Heart and Tulip decoration. In possession of the Bucks County Historical Society. Deposited by Nathan C. Roeder, of Spinnerstown, Bucks County, Pennsylvania." (Spruance Library/Bucks County Historical Society, SC-58. No. B-05.)

Grosschwam Taunschip, Bocks Counti, Geboren, etc., giving name of minister, father, mother and witnesses. Presented by Mr. S.W. Boyer, of Spinnerstown, to the Bucks County Historical Society.

2. Leaflet, 15 inches long by 12¹/₂ broad. Text in scalloped circle inscribed with legend, *Wer da glaubt und getauft wird, der wird selig werden. Wer ihn nicht glaubt der wird verdamet werden.* The border is adorned with two large flower stalks, a singing bird and a swan, and two gaudy flying female figures with puffed hair and rosy cheeks, bearing flowers. Another singing bird adorns a small circlet, and upon a heart is inscribed the motto, *Dis Herz mein soll dir allein O lieber Jesu sein.* The baptismal inscription is in plain black Gothic text, *Diese beide Ehegatten als Johannes Erdman und Seine Ehefrau Sara, Eine Geborene Pitzin, Lutherische Religion, ist Einen Sohn Zur Welt Geboren als Heinrich, ist Geboren im Jahr Unseres Herrn Jesu Christi 1792 d. 29. Jany um 6 Uhr Abends in Saccon Taunschip Northhampton Counti im Staat Pensylvanien,* giving name of pastor and of witnesses. Colors red, brown, green and yellow. In possession of the Bucks County Historical Society. Given by Oliver H. Erdman, Steinsburg, Bucks County, Pennsylvania.

3, 4. Two leaflets in style like the above. Certificates of Peter Flores, 1792, and Elizabeth Wetzel, 1804. Flying woman, birds, swans and hearts, floridly executed as above. On one of the hearts is the legend, *Dis Herz mein soll dir allein O lieber Jesu sein.* In possession of Philip Flores, Dillingersville.

5. Leaflet about 15 inches long by 12 wide, containing text in an ornamented square, with heavy border adorned with conventional flowers and tulips, and four hearts containing legends (Fig. 8). Colors brown, red, yellow, green and blue. A certificate in black German Gothic text, translated, says that "Samuel Roeder was born of Christian and married parents in Hereford Township, Berks County, in Pennsylvania, on May 8, in the year 1779, and was given his Christian name by the minister, Theobald Sahwer [*sic*, should be Faber], in the Christian Church in *Nugoschenhoben* [New Goschenhoppen]," giving witnesses, etc. Deposited in the Museum of the Bucks County Historical Society by Nathan Roeder, of Spinnerstown, Bucks County, Pennsylvania.

The marriage and death registers in Bibles are plainly executed as compared with the other specimens, and it seems that the practice of engrossing these latter lasted much later than the other phases of the art, and still continues (1897) among German families in upper Bucks County. More than

two colors, red or purple and black, are rarely used. The elaborate scrolling, the leaves, hearts, birds and tulips, have disappeared. Examples are:

1. Register bound in Lutheran Bible of Mrs. Levi Garner, of Doylestown.
2. Similar register, in purple ink, made about 1890, in Bible of Mr. Elmer E. Funk, of Doylestown.
3. Loose register from Bible of the Hendricks family near Perkasie, showing late survival of the tulip design. Words, *Sarah Hendricks ist geboren den 1ten September im Jahr 1851.* Capitals decorated in inferior style with leaves and three tulips. Colors, very little red, blue and yellow. Probably made in Bedminster. In possession of J. Freeman Hendricks, Doylestown.

It appeared upon inquiry that the art of Fractur was easily traceable to Germany, where, according to information received from foreign-born citizens of the United States living in Philadelphia and Bucks County, it had been taught without religious significance (generally in black, rarely in colors, save to special scholars, and sometimes, if desired, in Nassau with the reed pen of the monks), until about the year 1850, at public schools in Saxony, Bavaria, Hanover, Hesse and Nassau.

If the existence of Fractur in Pennsylvania had been adequately noticed before, its evidences are so interesting that it might well be described again, but we learn that it has been little more than casually alluded to by any writer. Yet it illustrated the relation of Germany to the United States at one of its most interesting points. It recalls the fact that while the English reformation was hostile to artistic impulses, the German reformers were not always unfriendly to them. In this case, at least, they held fast to one of the most beautiful products of mediaeval fancy. Here is a contribution to American character at the beginning, for which we owe nothing to New England and the Puritans. Fractur did not come over in the *Mayflower,* nor did it flourish among the associates of those New England reformers who, at the siege of Louisburg, are said to have attacked the adornments of the captured cathedral with axes. As in the case of the Pennsylvanian earthenware of the last century, glazed in several colors and decorated with tulips or the lotus; as with the Durham stove plates of 1750, adorned by Germans with flaming hearts, tulips and designs of Adam and Eve, Potiphar's wife, and the Dance of Death, we see that we are dealing with a reflection of the artistic instinct of the Middle Ages, directed upon us from the valley of the Rhine. The fresher from Germany the better the work. But by degrees the iron

caster forgets his trans-Atlantic inheritance of taste. A lack of skill finally overtakes the potter after years spent under sterner and more material conditions. First, the German mottoes are abandoned upon the plate and jar. By degrees the colors grow less varied and the designs weaker. Then the toys and whistles in the shape of birds, fish and animals, are forgotten with recipes for glaze. At last only the yellow tints of the pie-dish remain. So, too, the hand of the master of Fractur loses its cunning and the fading art ceases to exist in the memory of a generation yet living.

The establishment of the English school system in Bucks county in 1854[2] necessarily resulted in the suppression of the previously existing German schools. Hence that date after which the latter, sustained by private subscription, lingered on for a time, reasonably marks the end of Fractur in a region where at least two aged masters of the craft still survive in the person of Jacob Gross, of New Britain, and John H. Detweiler, of Perkasie.

A study of these fugitive examples of a venerated handwriting leads the investigator by sure steps from the Germany of Pennsylvania to the valley of the Rhine, from the backwoods schoolhouse to the mediaeval cloister. In the fading leaflets we recognize prototypes of the glowing hand-made volumes that illuminated learning in the Middle Ages and still glorify the libraries of the Old World. From the paint-box of Bedminster to the priceless book which at Venice is shown to the delighted visitor as the handiwork of Hans Memling, we are led by a chain of intimately related facts. With strange sensations, we rescue from the Pennsylvanian garret evidence indisputable of the passing away in the New World of one of the fairest arts of the cloister, which, meeting its death-blow at the invention of printing, crossed the Atlantic to linger among the pious descendants of the German reformers until recent years.

Notes

1. The observation was made while my *Tools of the Nationmaker* was in press, on August 20, 1897. I called attention to the special discoveries made in Bucks County in *Science* (See "Survival of the Art of Illuminative Manuscripts among the Germans in Eastern Pennsylvania," September 17, 1897), at a special meeting of the Bucks County Historical Society at Doylestown, October 7, 1897, and in *Tools of the Nationmaker,* published by the Bucks County Historical Society, Alfred Paschall, Doylestown, 1897, under the numbers 103, 633, 689, 726.

2. A German school sustained by a private subscription was taught by the Mennonite Samuel Musselman, in Swartley's schoolhouse, at the lower end of Hilltown, Bucks County, Pa., about 1866. Information of Mr. J. F. Hendricks, Doylestown. Another, the last in Bucks County, existed, under the tuition of Mr. Meyers, of Deep Run, at the old Mennonite Schoolhouse near the meeting house at Deep Run, Bucks county, Pa., in the winters of 1895–96 and 1896–97. At the latter school, where a pair of the time-honored leathern spectacles (*Bocks-brille* or *Schulbrille*), now in possession of the Bucks County Historical Society, were used to punish children in 1897, the ceiling rafters are still inscribed with bars of music written in chalk.

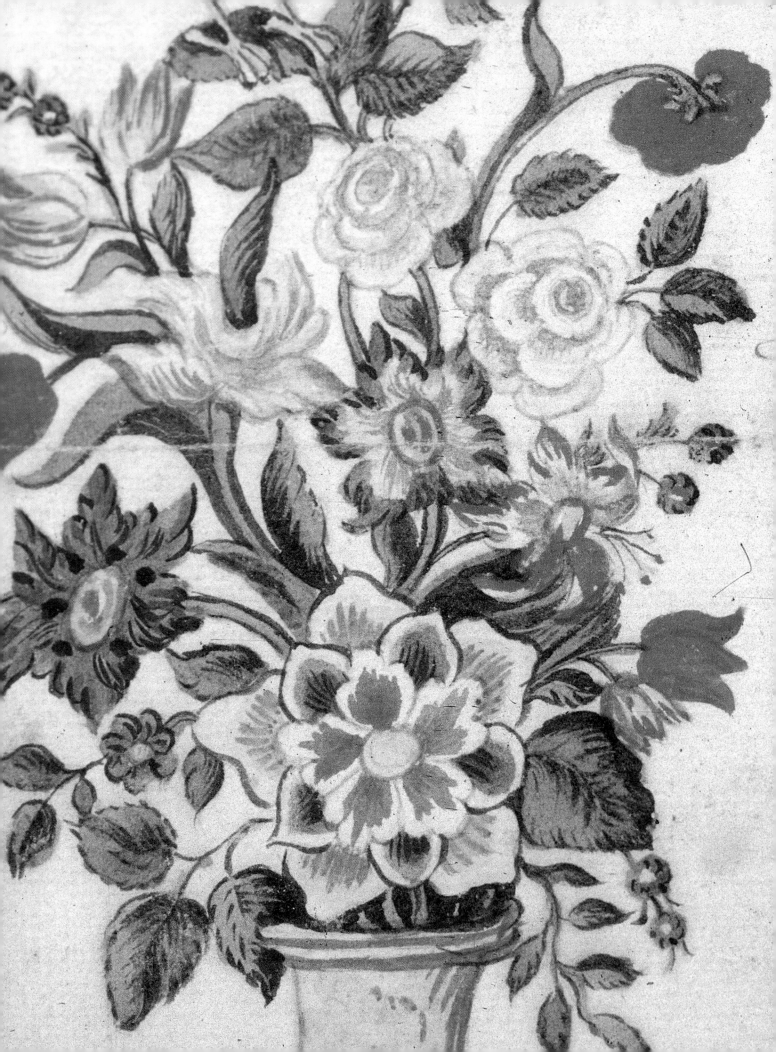

The European Background of Pennsylvania's Fraktur Art

Don Yoder

In the United States, *fraktur* has become the accepted term for the manuscript folk art of Pennsylvania-German culture: handwritten and hand-colored, containing on single sheets of paper religious texts and auxiliary designs framing the texts.[1] The term appears to be a shortening of the longer German term *Frakturschriften*—writings in Fraktur

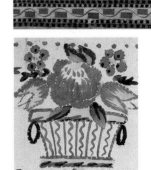

Fig. 9. The Fraktur Typeface. The example here is Friedrich Cunrad Hiller's hymnal, the title of which reads in English: *Memorial of the Knowledge, Love, and Praise of God in New Spiritual Songs* (Stuttgart, 1711). The texts are accompanied by emblematic engravings and musical typography. Hiller was a Pietist writer whose devotional books were widely read in Pennsylvania. (Roughwood Collection.)

script—which was used here in the nineteenth century, and reported from the Ephrata Cloister in the 1830s. The root word is, of course, *Fraktur*, which in standard German means an elaborate form of manuscript lettering and the printer's typeface derived from it. A related form is the *black-letter* script of England, also called Gothic or Old English. Fraktur developed during the Renaissance and flourished in the baroque era of the seventeenth century, immediately before the mass migration of the ancestors of the Pennsylvania-German people across the Atlantic.[2]

German speakers in Pennsylvania and in Germany, Switzerland, Austria, and adjoining areas of Europe were familiar with the baroque script that they came to use on fraktur documents here. In their homes, they had German devotional books—Bibles, hymnals, prayer books, and collections of sermons by weighty clergymen of the city churches of the Rhineland—printed in fraktur typeface. These were adorned with elaborately designed title pages in fraktur type, often printed in red and black (Fig. 9), with engraved frontispieces displaying the bewigged author rigged out in clerical robes.

In addition to baroque books in their households, the Pennsylvania Germans were also familiar with printed legal forms in fraktur type—German indentures or deeds, powers of attorney, broadsides, almanacs, and newspapers—all issued from the German presses of colonial and nineteenth-century Pennsylvania.

Many Pennsylvania-German children also learned to write in German cursive script (for

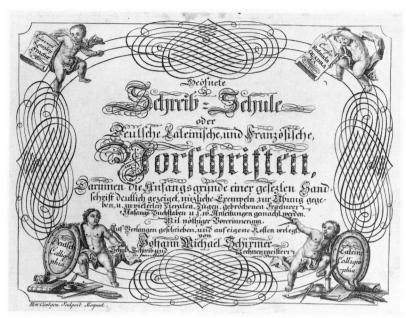

Fig. 10. **Title Page.** From Johann Michael Schirmer's *Geöfnete Schreib-Schule oder Deutsche, Lateinische, und Französische Vorschriften* (Frankfurt/Main, 1760). Schirmer was a writing and mathematics teacher in Frankfurt. The plates were engraved by Henrich Cöntgen of Mainz. (Courtesy, The Winterthur Library: Printed Book and Periodical Collection.)

at Philadelphia from 1727 to 1775, and who had to take the oaths swearing allegiance to the British and Pennsylvania governments, abjuring all European allegiances (including that of "popery"), signed their names to the lists.[3] Only a minority of the emigrants made *marks*; that is, they had never learned to write. This was a possible result of the disastrous wars of the eighteenth century which made school keeping and school attendance in some areas difficult.

In the Protestant schools of Europe and America, schoolmasters were sought out who possessed two talents. First, they were highly regarded if they could write a good hand and so serve as scriveners for the parish, filling out legal or ecclesiastical documents needed by the parishioners, and if they also were capable instructors of children in the art of writing. Second, a schoolmaster who not only knew music, but could sing well and teach children the rudiments of music, and who could also play the pipe organ for the church services, was highly desirable. Hence, in Protestant Europe as well as in the Pennsylvania Dutch Country and its Diaspora to settlements in other colonies, the combination of schoolmaster-organist was commonly found. Advertisements for teachers in eighteenth- and nineteenth-century newspapers make that clear.

As soon as possible after the founding of a Pennsylvania congregation, schools were established. In many cases, the eighteenth- and nineteenth-century Lutheran and Reformed churches, especially those in the country, were organized as union churches (*gemeinschaftliche Kirchen*). In such arrangements, one edifice housed both Lutheran and Reformed congregations, and church affairs were often managed by a joint council (*Kirchenrat*).

ordinary communication, such as letters and accounts), and at least a few of the more skilled pupils were taught fraktur script (for preparing documents, imitating models set for them by the schoolmaster). This was all a part of the Protestant school culture in Europe and America.

In Europe, the Protestant Reformation of the sixteenth century helped to inspire the public education of children in both town and country. Schools were mandated by state-church law in all the Lutheran and Reformed parishes in the Rhineland. In them children received training in the basic arts that could help them understand both their religion and the world in which they would live and work. Teachers taught the so-called Three R's—reading, writing, and reckoning, plus religion—as well as music (for hymn singing in the churches) and occasionally some natural science, geography, and history. The textbooks were either directly religious (Testament and Psalter were often used as readers) or heavily religious in content. Village schoolmasters, hired by the church community and responsible to the parish, often served as catechists to prepare their pupils for the rite of confirmation.

Hence, in Protestant German states as in Pennsylvania, literacy was widespread although not universal. As an illustration, the majority of the male emigrants over the age of sixteen who arrived

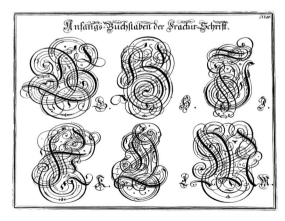

Fig. 11. **Initial Letters of Fraktur Script.** From Schirmer, 1760. (Courtesy, The Winterthur Library)

Hence, their schools were often union institutions as well. The church council hired the teachers and often provided housing for them in the school building, where one end was the dwelling part and the other the school room.[4] In other cases, separate school buildings were erected and used until the public school law of 1834 was accepted in the different districts. When that happened, some of the church school buildings were sold or leased to the new school districts erected under state law.

The congregational schools set up by Mennonite, Brethren, and other sectarian groups in this country likewise favored teachers skilled in writing and singing. And, as we know, they produced stellar fraktur in the eighteenth and nineteenth centuries. Finally, the Moravians who founded Bethlehem, Nazareth, Lititz, and other settlements, were renowned for their schools, including the first interracial school founded in the American colonies as well as the earliest schools specifically for educating women.

Calligraphy and Folk Art

Pennsylvania-German fraktur combined two elements brought from the Rhenish homeland: (1) calligraphy, an elaborate baroque script with flourished initial letters used to introduce a religious text, and (2) folk motifs, most of them ancient and widespread in Europe, used in the decoration of the fraktur document. If one accepts the theory of cultural levels, calligraphy operated on the elite level of European culture, while the folk motifs represented a long heritage of artistic hand-me-downs from antiquity and the Middle Ages.

Decorative writing or calligraphy (*Schönschrift* or *Zierschrift*) in the modern period traces to the Italian Renaissance, from whence it spread to France, Spain, England, Holland, Germany, Switzerland, and Austria. North of the Alps the principal centers for the development of calligraphy were the free imperial cities, particularly Augsburg and Nürnberg, where penmen, engravers, and printers produced seminal sixteenth and seventeenth-century ABC books filled with various alphabets and calligraphed drawings of animals, humans, and fabled beings—all created from fluent flourishings and extravagant arabesques. The first of these influential writing manuals (*Schreibmeister-bücher*) appeared in Augsburg in 1507, but the genre soon spread to other printing centers: Nürnberg, Frankfurt, Berlin, Zürich, Bern, Basel, Strassburg, and elsewhere.

Fig. 12. **Devotional Spiral.** Switzerland, early eighteenth century. The spiral or labyrinth format was used in Pennsylvania, especially for valentines. This printed piece features the opening verses of the Apocryphal book of Ecclesiasticus, or the Wisdom of Sirach. It is part of the Wisdom literature featuring proverbs and was favorite reading among the Pennsylvania Germans as well. The passage begins: "All wisdom is with God the Lord and is with him forever. For who hath considered beforehand how much sand there is in the sea, how many drops in the rain, and how many the days of the world shall be?" (Photo courtesy of the author.)

What these magnificent examples of baroque printing provided were models that could be copied or adapted by schoolmasters, town clerks, notaries, clergymen, and other educated members of the elite level of European culture. While the books themselves were examples of elite art, their materials made their way ("descended," as proponents of Naumann's theory of *gesunkenes Kulturgut* would put it) to the folk level of culture. Village schoolmasters emulated the urban calligraphists in executing work commissioned by the peasants and common folk of the villages, hence these printed ABC books strongly influenced the manuscript art of German folk culture in the eighteenth century (Figs. 10–14).[5]

Locating the European origins and tracing the backgrounds of fraktur artistry are complex research

Fig. 13. **Title Page.** From Johann Christoph Albrecht, *Fünfhundert auserlesene zur Schön-Schreib-Kunst unentbehrliche Züge* (Nürnberg, 1800). The book contains nothing but 500 elaborate flourishes (*Züge*) used to decorate any sort of fraktur document. The book was intended for "All learners and teachers, but especially for scriveners, chancery clerks, and officials." (Courtesy, The Winterthur Library: Printed Book and Periodical Collection.)

matters. In a sense, Henry Mercer, by highlighting the medieval background of fraktur in monastic book illumination, deflected scholarship from the immediate source of Pennsylvania's fraktur art—the baroque calligraphy of the seventeenth and eighteenth centuries and the contribution of folk motifs to frame and decorate the calligraphic texts. This is not to say, however, that Mercer's attribution to medieval sources was wrong. Certainly in the chain of historical development, the medieval art of illuminated manuscripts was an older, if remote, model for Pennsylvania fraktur. And, as for the

motifs, folk art scholarship had barely begun in the United States at the time of Mercer's pioneer article of 1897.

We are indebted to the "dean" of American fraktur scholarship, Donald A. Shelley, for the first incisive look at the art form's European counterparts, and its "immediate background," as he phrased it, in the baroque era. Sixty years ago, at the beginning of his twenty-year project of documenting the Pennsylvania fraktur tradition, he spent the summer of 1938 in the Rhineland, where he made a point of searching out European counterparts and models. His study became a Ph.D. dissertation at New York University and was published in 1961 under the title: *The Fraktur-Writings or Illuminated Manuscripts of the Pennsylvania Germans*. In this work, Dr. Shelley also developed the first usable classification of fraktur into the "schools" of its production and use. Out of all the many books that have been published on fraktur, I still consider it, and recommend it to my students, as the best single-volume introduction to the subject.

Dr. Shelley's examples of manuscript pieces found in European collections included eighteenth-century letters of apprenticeship (*Lehrbriefe*) in the Gewerbemuseum at Kaiserslautern (Nos. 12–14), three Swiss eighteenth-century *Probeschriften* and a *Glückwunsch* (Nos. 15-18); a *Christlicher Tauff-Wunsch*, 1737 (No. 19); two manuscript *Taufbriefe*, 1792 and 1828, in the Gewerbemuseum, Kaiserslautern (Nos. 20-21); and a manuscript Alsatian *Lettre de Baptême* (1814) from the Northrup Collection in New York City (No. 23 or Fig. 25 in this essay).

We turn now to calligraphers in Pennsylvania and their use of European writing manuals. In her

Fig. 14. **Wedding Contract of Philip Pfneissl and Catharina Rätz.** Haschendorff, Austria, 1731. Hand-drawn and lettered on laid paper. 8 x 12³/4 in. Note the *Vorschrift* format, beginning "In the Name of the Most Holy Trinity, God Father and Son and Holy Ghost, amen!" The groom was a widower of Haschendorff, and the bride the daughter of the late Stefanus and Susanna Rätz of Haschendorff. The couple were married August 12, 1731, hence it is both a wedding certificate and a wedding contract, since details of the dowry arrangements are given. (Roughwood Collection.)

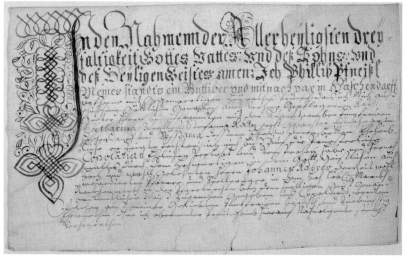

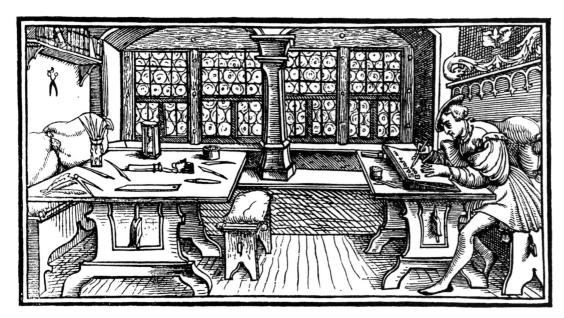

Fig. 15. **Calligrapher at Work in Well-lighted Chamber.** Note his tools on other table. From Wyss, *Libellus valde doctus* (Zürich, 1649). (Courtesy, The Winterthur Library: Printed Book and Periodical Collection.)

1954 article in *The Pennsylvania Dutchman*, Elizabeth C. Kieffer provided some useful information on Pennsylvania scriveners and their personal use of printed source materials from Europe and America.[6] She cites a "copperplate copybook" by Johann Jacob Brünner of Basel and engraved by C. G. Guttenberger of Bern in 1766, now in the Textbook Collection at Franklin and Marshall College. It was owned in 1820 by John P. Young of Easton and includes Fraktur, Chancery, Current, and French scripts.

In Lancaster, scrivener John Hoffman, "who taught the school of the Reformed Church for thirty-five years, wrote and taught a clear and elegant German current script in which (fortunately for later historians) he wrote many of the church records." One of his pupils, Caspar Schaffner (1767-1825), also became a professional scrivener. Along with teaching writing to private pupils, Schaffner wrote legal documents for Lancaster's lawyers, served as clerk of the County Commissioners, and acted as secretary to local organizations. Two of his manuscript books have survived, the first a music book in the Archives of the First Reformed Church, where he was organist from 1795 to 1806.[7] The second is a manuscript copybook dated 1809, with many full pages copied from Henry Dean's *Analytical Guide to the Art of Penmanship*, published in Salem, Massachusetts, in 1805. Other original designs are included as well.

Beginning in 1756, German instructional materials for learning writing appeared in Christopher Saur's *Hoch-Deutsche Americanische Kalender*. These were entitled "A Brief Instruction for Those Who Wish to Learn to Write and Have No Teacher.

For the use of those who can read printing and wish also to learn to read writing." Included were lines of script for the teacherless student to copy.

As pointed out previously, American as well as German and Swiss writing manuals were available in Pennsylvania and were used by local scriveners. Hence it was not until the nineteenth century that Pennsylvania printers produced their own volumes for sale. These were the manuals engraved by the 1802 emigrant Carl Friederich Egelmann (1782–1860) and published in Reading under the title: *Deutsche und Englische Vorschriften für die Jugend Aufgesetzt und gestochen von Carl Friederich Egelmann*. There were two editions, the original of 1821 and an enlarged version in 1831. The cover featured a German verse calling the art of writing the "Daughter of Heaven," and an English rhyme that read:

Hail Youth! Here use these copys right
They shew quite simply how to write.
Learn but the letters forme[d] by heart,
Then soon you'l gain this noble art,
And know how magic lines are drawn.
Come buy this book before 't is gone.

Egelmann carried on several trades during his eventful life: carriage and chairmaking, almanac calculator (his most widespread activity), German poet and author, parish schoolmaster, church organist and choir leader, engraver, and German newspaper editor and publisher in Reading. In the world of fraktur, he is well remembered for his

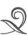
engraved and printed *Taufschein* forms.[8]

Finally we must look at Carroll Hopf's 1972 article, "Calligraphic Drawings and Pennsylvania German Fraktur."[9] Hopf traces calligraphy from the Middle Ages and baroque era into American practice, focusing on Pennsylvania fraktur art. He provides a balanced introduction to the European backgrounds, offering clearly reproduced examples of medieval manuscript calligraphy, sixteenth-century chancery cursive script, and the magnificently "snorkeled" title-page of Johann Christoph Albrecht's writing manual with the title: *Muster einer ganz neuen schönen und Regulmässigen Schreib-Art, durch das ganze Alphabet, in Fractur, Cantzley und Current, dann vielen veränderten Zügen bestehend mit Fleiss ausgefertiget* (Nürnberg, 1764).

Two Pennsylvania *Vorschriften*, or penmanship models, are included in the article. One is the 1769 piece by Huppert Cassel with the calligraphed swan, for which a possible model is presented in a plate from a Rotterdam writing manual of 1605. The article concludes with a discussion of the revival of calligraphy, especially the elaborate calligraphic drawings of Victorian America.

American trends in historic calligraphy have not been as thoroughly researched as has been done in Europe. An exhibit at the Peabody Institute Library in Baltimore, 1961–1962, produced a catalogue with the title *Calligraphy & Handwriting in America, 1710–1962* (Caledonia, New York: Italimuse, 1963). The introduction by P. W. Filby commented on the current revival of handwriting

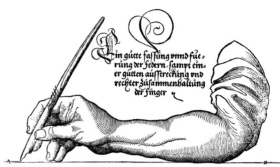

Fig. 16. **Arm and Pen Poised in Correct Position for Calligraphy.** Illustration from Wolfgang Fugger's *Schreibbüchlein* (Nürnberg, 1553). This how-to plate appeared in many writing manuals, including American ones. (Courtesy, The Winterthur Library: Printed Book and Periodical Collection.)

in England and America and defined calligraphy minimally as "handwriting considered as an art."

There is in this catalogue almost no emphasis on fraktur (three items). Only one example is pictured, a religious text by Maria Kriebel (1843). The brief introductory paragraphs on fraktur state that these pieces "may be remote descendants of medieval illuminated manuscripts" (à la Mercer), and "they may have derived some of their inspiration from such sources as the gaily decorated vellum bindings that found favor in eighteenth-century Germany." We are told, finally, that fraktur art flourished from the mid-eighteenth to the mid-nineteenth century, and, rather questionably, that it was responsible for "many a colorful wall decoration" in "snug" Pennsylvania farmhouses.

Most of the items displayed represented Anglo-America, using all the writing styles from seventeenth-century chancery script, through Spencerian flourishes of the nineteenth century, to the boring school hands that some of us will remember learning in our elementary school days. A few stunning examples of contemporary calligraphy conclude the volume.

Who Produced European Fraktur Art?

European examples of fraktur manuscript art were produced by a range of persons with professional handwriting skills—all of them officials in local or regional government. These included state, city, and town clerks and official scriveners; city, town, and village schoolmasters; and Protestant clergymen (Figs. 15–17).

Evidence of the preparation of personal and civic documents for pay, by the town clerks of the villages in Württemberg in the seventeenth century, has

Fig. 17. **Penmanship Model.** From Van der Velde, *Spieghel der Schryftkonste* (Rotterdam, 1605). The Holland Dutch verse is: "Every good and every perfect gift is from above, and cometh down from the Father of Lights, with whom is no variableness, neither shadow or turning" (James 1:17). (Courtesy, The Winterthur Library: Printed Book and Periodical Collection.)

Fig. 18. **Apprenticeship Certificate of Johann Philipp Odenwalt.** Heidelberg in the Palatinate, 1736. Hand-lettered on laid paper. Dimensions not available. This document, made out for Odenwalt, is signed and sealed by Ludwig Herbst, "Citizen and Master Butcher in the Electoral Palatine Capital and Residence City of Heidelberg," and Ana Barbara Bormann, widow. Odenwalt, who served his apprenticeship "in the honorable butcher trade," was from "Thüren" (Dühren) near Sinsheim, in the Kraichgau. He was to study with Herbst from Fastnacht 1736 to Fastnacht 1737. This is a good example of an official secular fraktur document brought to Pennsylvania by an eighteenth-century emigrant. (Historical Society of Pennsylvania, Pennsylvania Manuscripts and Printed Material.)

turned up in a recent history of the City of Künzelsau in the Kocher Valley northeast of Stuttgart.[10] In the seventeenth century, when Künzelsau was part of the county of Hohenlohe, it was administered by a *Schultheiss* (village mayor responsible to the count), and a town council (*Rat*) and court (*Gericht*), usually combined. Second in command after the *Schultheiss* was the *Gerichtsschreiber* (clerk of the court), later called *Ratsschreiber* (clerk of the council, or town clerk).

In the sixteenth century, the town schoolmaster filled this position, but later the *Gerichtsschreiberamt* (town clerk's office) was headed by one official appointed for the purpose, usually trained in record keeping, writing (calligraphy on occasion), and knowledge of affairs. This official received a salary plus emoluments (*Akzidenzien*), or perks, for preparing special documents for the town and its citizenry.

In the official schedule of documentary fees as posted in the year 1679, the town clerk received for preparing birth certificates (*Geburtsbriefe*), 1½ florins if on parchment, 1 florin on paper. These were roughly equivalent to our *Taufscheine*, but were official records necessary in applying for citizenship or residence in another community. For certificates of apprenticeship (*Lehrbriefe*) (Figs. 18, 19), property deeds (*Kaufbriefe*), or discharges

Fig. 19. **Odenwalt Certificate (Detail).** Note that while this is a secular document, it features the Christian symbol of the Agnus Dei, the Lamb with the Conquering Banner, frequently used by Pennsylvania Moravians as a symbol of their faith in *Gottes Lämmlein* (Christ, the Lamb of God). Note also the carnations and olives flanking the Agnus Dei. (Historical Society of Pennsylvania.)

(*Abschiede*), the same prices held. For marriage certificates (*Heiratsbriefe*), in duplicate, on paper, the cost was 1¹/₂ florins. These could, of course, be wedding contracts, outlining the dowry arrangements agreed to before marriage. For wills (*Testamente*), on parchment, prices varied according to length and complexity. For codicils (*Codicillen*), or additions or changes to a will, it was 2 florins. In addition, the town clerk might be called upon to prepare bonds or promissory notes (*Obligationen*), petitions (*Supplicationen*), guardianship accounts (*Vormundsrechnungen*), receipts (*Quittungen*), copies of court judgments (*Kopien eines Urteils oder Bescheids vor Gericht*), letters (*Missiven*), divisions of property (*Teilungen*), and finally, to inscribe property deeds into the town records (*Kaufe zu Protokollieren*). Prices of all these latter documents again varied according to length and complexity.

In the baroque era, official record keepers in German villages, towns, cities, and states were accustomed to using professional script in documents and protocol books, with headings and title pages often in elaborately flourished fraktur script. It is not implied that every document penned by these officials was fraktur art, but calligraphy was often used as a decorative element. Even in the village church registers one frequently comes upon title pages or pages marking the installation of a new pastor, which would pass as fraktur art anywhere. It is always a pleasure, then, to open a seventeenth- or eighteenth-century record book in a European town archive and be greeted by a full-fledged fraktur title page.

As previously stated, these official documents prepared by town officials were in most cases examples of the elite level of baroque calligraphy and, as such, served as models for the folk-level documents dealing with baptism, marriage, and other occasions, as prepared by the village schoolmaster or town clerk.

It must also be remembered that the Lutheran and Reformed clergymen of Württemberg, the Palatinate, Alsace, Hessen, and other Rhineland states, were also frequently skilled penmen. The church registers they opened and continued during their ministry often reveal fraktur title pages and subheadings. Hence, it is quite understandable that many emigrant pastors who came to Pennsylvania and other colonies, and some of the first generation of clergy born here, were expert calligraphers and demonstrated their skills in preparing personal documents. Some, such as Henry Melchior Mühlenberg, prepared no-nonsense

baptismal certificates for individuals, on request, in masterly cursive script, with no addition of calligraphic ornamentation. Among the emigrant clergy who went beyond cursive script to execute fraktur flourishes and watercolor decoration on baptismal certificates, New Year's wishes, and other documents, certainly Daniel Schumacher stands in the forefront. Among the first generation of American-born clergy to make such fraktur must also be noted the well-traveled Reformed minister George Geistweit.

The term "*Brief*," as used in many genres of European fraktur art (*Taufbrief, Geburtsbrief, Lehrbrief, Meisterbrief,* and so on), can of course be translated as *letter*, the primary meaning of the German word. However, it basically means any written document or certificate with official status. We have the parallel English word *brief* in the legal sense of a court document, and we even sometimes carry *briefcases*, which can hold letters or documents or both! In the case of *Himmelsbrief*, to be discussed later, the word is usually translated *letter from Heaven*. The root of the word in both German and English is the Latin *breve*: summary, or short catalogue.[11]

Evidence on the widespread use of the term *Brief* for official documents in the baroque era is found in the writing manual of Johann Christoph Sattern of Leipzig, printed by Johann Hoffman in Nürnberg, 1665. It bears the title: *Etliche Initial- und andere Buchstaben Wie solche in Chur- und Fürstl: Cantzleyen, Ämptern Rahthäusern, vor Lehen-Innung-Gebuhrts-Lehr- und andere Briefe, Item Kundschaffte(n) und dergleichen Zugebrauchen seindt.*[12] This can be translated: "Some Initial and Other Letters, as such are applied in Electoral and Princely Chanceries, Offices and City Halls, for Title-Deeds, Guild Charters, Birth Certificates, Apprenticeship Letters and Other Certificates, Likewise Notices and the Like." Note the consistent use of the word *Brief* for four official documents whose models the book offers.

Fraktur Script and Catholic Folk Art

One of the problems in researching the European background of our Protestant fraktur tradition is that most books on European folk art concentrate heavily on Catholic examples, with only token references to Protestant forms. An example is the volume *Bilder und Zeichen religiösen Volksglaubens*, by Lenz Kriss-Rettenbeck, long-time director of the Bavarian National Museum. Most of this book deals with pictorial Catholic art, beginning with the *ex votos*—

paintings recording miracles and answers to prayer, often hung in the chapel where the original prayer for help was made. This is essentially pictorial art, since Catholic artists delighted in portraying God's actions in the human world in pictorial rather than textual form, whereas Protestant art is for the most part (although not exclusively) centered on the Word—the Divine Word, the Scriptures, and hymnodic and other devotional texts.[13]

As implied, there are exceptions on either side of the former confessional and cultural gulf between Catholicism and Protestantism. Protestants, especially Lutherans, were encouraged by Luther to use (but not misuse) religious pictures as aids to devotion.[14] Catholics also produced a certain amount of textual folk art, especially in the form of manuscript prayer books and hymnals. Kriss-Rettenbeck refers to the profession of *Briefschreiber und -maler* (document scrivener and painter) and ascribes to the growing "book-culture" of the eighteenth and nineteenth centuries the growth of "folk" manuscript books. These were personalized art forms in the baroque era of Catholicism, made for individuals just as Protestant fraktur was made for individuals.

This Catholic manuscript tradition developed alongside Protestant manuscript art, reaching its highest point between 1760 and 1840.[15] In this period, Protestants produced bookplates and baptismal letters, which are less known in Catholic regions. The larger number of manuscript prayer

books in Catholic cultures stems from the fact that Protestants had "simpler needs" in this area than Catholics, who carried such books with them to mass. Prayer books also proliferated among Catholics because they were often prepared and given as "love gifts" (*Liebesgaben*).

More detail is provided on the Catholic manuscript prayer book tradition by Leopold Schmidt, former director of the Austrian Museum of Folk-Culture in Vienna and professor of Folk-Cultural Studies at the University of Vienna. In an essay on manuscript prayer books and hymnals in Austria and Bavaria from the seventeenth to the nineteenth centuries, he claims that these Catholic examples of calligraphic art are actually little known compared with the examples of Protestant art such as the Burgenland *Haussegen*, which derive from a manuscript folk tradition characteristic of Protestantism.[16]

In his analysis of the Catholic manuscript prayer books, Professor Schmidt makes the interesting point that not all the prayers included on their pages derived from printed prayer books, but were evidently gathered together from broadsides and other printed ephemera. Hence, these manuscript books served a special function in rural Catholic society, by registering the marginal areas of Catholic spirituality and baroque folk belief.[17]

Leopold Schmidt's *Volkskunst in Österreich* (Wien/ Hannover: Forum Verlag, 1966) also discusses

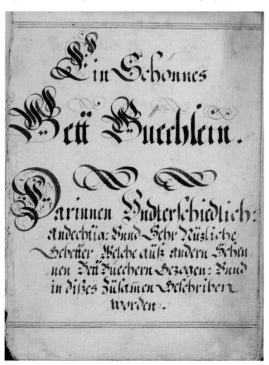 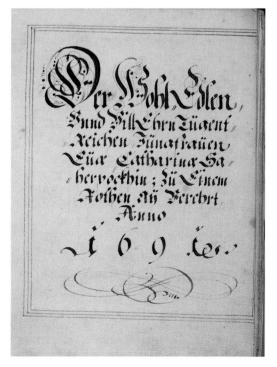

Fig. 20 a, b. **Catholic Prayer Book Double Bookplates for Eva Catharina Sahervöckh.** Central Europe, 1691. Hand-lettered on laid paper. 7¼ x 5¼ in. (each page). The fraktur-scripted title page reads: "A Beautiful Little Prayer-Book, in which various devotional and very useful prayers drawn from other beautiful prayer-books have been compiled into this." The dedication page notes that the book was given to Eva Catharina Sahervöckh as an Easter present (literally "as a red egg"), in 1691. (Roughwood Collection.)

Protestant manuscript art (house blessings and marriage contracts of the Burgenland); love letters (*Liebesbriefe*), often given on the day of betrothal; and *Taufbriefe* complete with the coin gifts. He, too, uses the term *Briefmaler* (letter painter, document painter) for the producer of manuscript art and mentions reading wills from the Waldviertel section of Lower Austria that refer to *gemalt brieff an der Wandt* (a painted document on the wall), which points to a functional application of these ornamental writings in the Austrian peasant farmhouses.[18]

To summarize, while the bulk of Catholic folk art was pictorial in nature, there was also among Catholics the use of calligraphic fraktur texts, particularly in the form of individualized prayer books given as personal gifts in Catholic villages (Fig. 20 a,b).

Regional Backgrounds: Switzerland

Because of Switzerland's role as the ancestral homeland of many of Pennsylvania's German Reformed adherents, along with the Mennonites and Amish, let us look at the role manuscript art exercised in the Protestant cantons, particularly Zürich and Bern. It was from these regions that most of Pennsylvania's Reformed and Mennonite families came.

Of all the German-speaking areas of Europe that were ancestral to the Pennsylvania-German people, Switzerland appears to have produced more scholarly treatments of its baroque manuscript art than any other.[19] Several of these treatments deserve extended notice.

The origins and background of the *Vorschrift* tradition are presented in an essay by the Swiss collector and scholar Walter Tobler.[20] He tells us what was frequently said of the Pennsylvania *Vorschrift*: that it was prepared by the schoolmaster to be copied by the pupils. "Such colorful written papers with more or less richly flourished initial letters and a border of various ornamental decorations were once prepared by the schoolmaster as

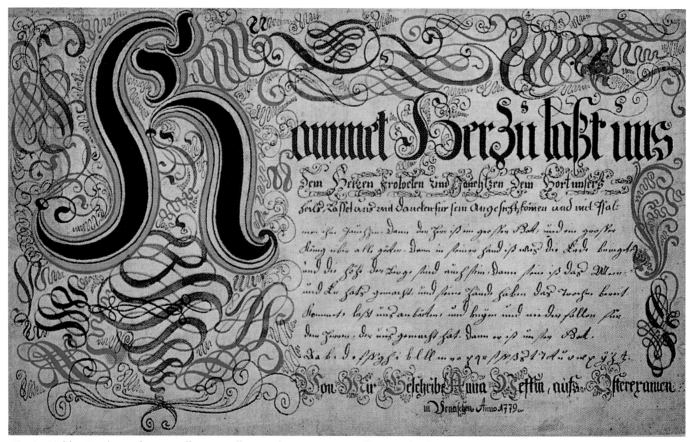

Fig. 21. **Writing Specimen of Anna Neff.** Anna Neff, Urnäsch, Canton Appenzell, Switzerland, 1779. Hand-drawn, lettered and colored on laid paper. 7 x 10½ in. This example of a student's work *(Probeschrift)* is dated at the Easter examination at Urnäsch in 1779. The text (drawn from Psalm 95, verses 1-7) begins with the call: "Come ye here, let us rejoice in the Lord and shout for joy to the shield of our salvation." (Collections of the Museum der Kulturen, Basel, Switzerland. All rights reserved.)

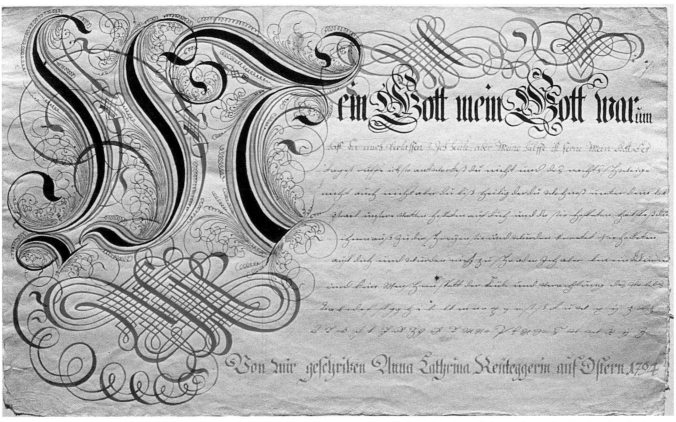

Fig. 22. **Writing Specimen of Anna Cathrina Reutegger.** Anna Cathrina Reutegger, Switzerland, 1794. Hand-drawn, lettered and colored on laid paper. 6 x 9³⁄₄ in. A second Swiss examination fraktur *(Probeschrift)* was written by Anna Cathrina Reutegger at Easter 1794. The text begins with the words, "My God, my God, why hast thou forsaken me?" (Matthew 27:46; Mark, 15:34; based on Psalm 22:1.) (Collections of Basler Papiermühle, Museum für Papier, Schrift und Druck, Basel, Switzerland.)

copy models, to promote the art of calligraphy in every possible way among their pupils." The students' copies were called *Probeschriften* (test writings or specimen writings) and were judged at the spring (often Easter) examinations to rank the students as to their proficiency in penmanship (Figs. 21, 22). What was laid before the student was usually not a completed page of intricate work (a finished *Vorschrift*, in other words), but a religious text written in large lines of script, with the usual elaborate initial letter.

Schoolmasters in Switzerland and Pennsylvania also produced fully filled out *Vorschrift* pages, but these were not necessarily copybook material—unless the scholar was very talented and wished to try his hand and pen at complex designs and texts. Rather, these finished examples, masterpieces in many cases of the schoolmaster's own skills, were intended as gifts, graduation gifts, in a sense, at Eastertime, when the Swiss church schools often closed. These farewell tokens, which often included the scholar's name, were called in Switzerland *Osterletze*, a term also applied to gift *Vorschriften* in Pennsylvania.[21]

The production of writing specimens was such an important activity in the Swiss schools that the 1719 Cantonal School Law (*Landschulordnung*) of Canton Zürich included the production of new student copy models (*Vorschriften*) among the monthly duties of the village schoolmaster. These were to be "decorated with beautiful texts from the Old and New Testaments."[22]

The best representative collection of Swiss calligraphy in book form is the volume *Schreibkunst: Schulkunst in der deutschsprachigen Schweiz 1548 bis 1980*.[23] Based on an exhibit at Zürich's Kunstgewerbemuseum in 1981, this work was edited by Oskar Bätschmann, who also wrote several of the introductory sections. The date 1548 is derived from the publication year of the first extant Swiss writing master's manual by Urbanus Wyss, *Von Mancherley Geschriften ein Zierlich nüw fundament büchle*, published at Zürich. The second edition (1549) of the Wyss opus includes the following scripts: Current, Chancery, Fraktur, and Italian and French Cursive Script. Several German and Italian writing manuals appeared even earlier than Wyss's 1548 work.

Fig. 23. **Decorated Grain Bag.** Southeastern Pennsylvania, 1818. Tow, ink. 52 x 20 in. The bag belonged to the Ranck family, and probably originated in the Jonestown area of Lebanon County. It passed through the hands of early collectors Arthur Feeman, Charlotte Sittig, and Titus Geesey, the last of whom sold it to its present owner. (Dr. Donald A. Shelley Collection.)

Oskar Bätschmann's chapters, "*Schreiben als Kunst,*" and "*Schreibmeister und ihre Werke*" include absolutely stunning illustrations of sample pages from printed and manuscript writing master books. He closes with a useful section on the tools of the penman (*Schreibwerkzeuge*).[24]

The lengthy section of the book by Theo Gantner, former director of the Swiss Folk-Cultural Museum in Basel, deals with the relation of the Swiss school and schoolmaster to the writing of the Swiss people. It is entitled: "*Kalligraphie—von der Schreibkunst zur Schulschrift*" ("Calligraphy—from the Art of Writing to School Script").[25] Forty-three pages of full-page plates, some in color, demonstrate Swiss manuscript styles, with highly competent examples of *Vorschriften* and *Probeschriften* produced in the Swiss schools.

Finally, the chapter by Hildegard Gantner-Schlee, discussing the place of rural calligraphy in everyday life, provides additional examples of Swiss fraktur art. Here, we move beyond the *Vorschrift* and *Probeschrift* to other genres of manuscript art: manuscript prayer books, spiritual mazes, bookplates, memorial pieces, wedding wishes, love tokens, and New Year's greetings.[26]

In addition to Zürich and Bern, one of the other cantons of Switzerland that seems to have produced spectacular fraktur work is Graubünden, a place of mixed religion (Catholic, Reformed) and mixed language (German, Rumantsch). The Safiental, or Safien Valley area, in particular has been studied by Professor Paul Zinsli of the University of Bern.[27] The Safien scriveners derived many of their designs directly from a writing manual printed at Nürnberg in 1604.[28]

In addition to studying Swiss baptismal documents, Swiss scholars have also looked at the art produced in connection with other Protestant

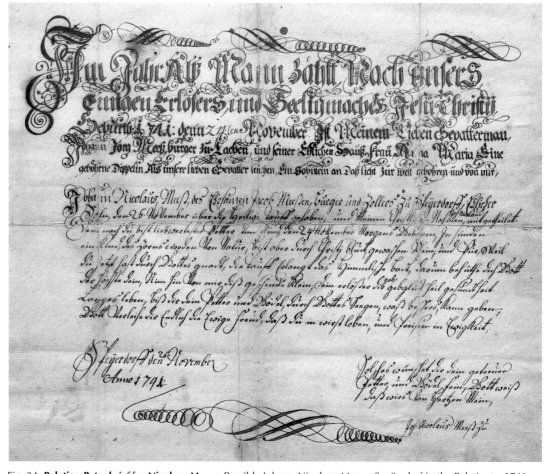

Fig. 24. **Palatine *Patenbrief* for Nicolaus Meess.** Possibly Johann Nicolaus Meess, Speÿerdorf in the Palatinate, 1741. Hand-lettered and colored on laid paper. 13¹/₂ x 16¹/₄ in. This early example, with minimal decoration, is important for its detailed text. Despite its *Patenbrief* format, it bears full birth and baptismal information about the child, worthy of a *Taufschein*, and explains the significance of baptism. Through Christ's Blood, in the Heavenly Bath of baptism, a child born in sin is washed clean and pure. The inscription ends with a reference to the document as a gift. (Dr. Donald A. Shelley Collection.)

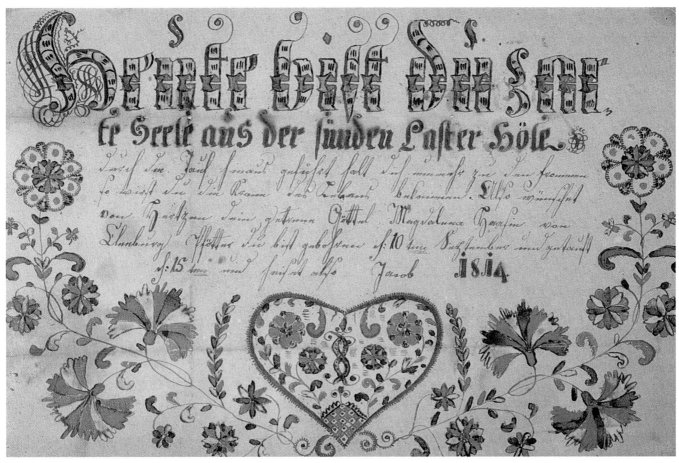

Fig. 25. Alsatian *Göttelbrief* for Jacob ____. Cleeburg, Alsace, 1814. Hand-drawn, lettered and colored on wove paper. 8¹/₄ x 12³/₈ in. This piece, with its good wishes from godmother *[Göttel]* to godson *[Pfetter]*, shows the flat heart format, with carnations and other flowers growing symbolically out of the heart. The initial lines of the text are expertly rendered. The inscription reads, in part: "Today art thou, tender soul, through baptism, led forth out of Sin's Den of Iniquity, to the ranks of the righteous. So wilt thou receive the Crown of Life." This document was passed down through Jacob's direct Alsatian descendants to Marguerite Northrup, for many years manager of the Metropolitan Museum of Art Information Desk, who gave it to its present owner. (Dr. Donald A. Shelley Collection.)

rites of passage. For example, the Protestant rite of confirmation in the Swiss Reformed churches is treated thoroughly in Christine Burckhardt-Seebass, *Konfirmation in Stadt und Landschaft Basel* (Basel, 1975), Vol. 57 in the Series: *Schriften der Schweizerischen Gesellschaft für Volkskunde.*

For Swiss manuscript art connected with the rite of marriage, the work of Christian Rubi is instructive.[29] Rubi notes that in preparation for a wedding, the families of the young couple outlined the bridal dowry and wedding agreements in a document known as an *Ehebrief, Ehevertrag,* or *Ehecontract*—a marriage contract. This was drawn up by a notary or official scrivener. In most cases, the two fathers of the bridal couple made the agreement and signed it. Very few documents of this sort have turned up in Pennsylvania.

For comparative purposes, Catholic Switzerland, too, had a fraktur tradition. Though heavy on

carvings, creches, and devotional paintings by talented nuns, Swiss Catholic folk art occasionally featured calligraphy.[30] A magnificent calligraphed drawing (1761) is known of a crucifix combined with the "spies" carrying a huge bunch of grapes from Canaan, the fabled Grapes of Eshcol (Numbers 13:23). It is executed without textual additions, but with expert pen flourishes by the Luzern penman Joseph Cornel Mahler. Intriguingly, Luzern writing specialists also decorated grain sacks with owners' names, coats of arms, and baroque ornamentation—an unusual genre of fraktur art, although grain sacks bearing owners' names in fraktur lettering are not unknown in the Pennsylvania hinterlands (Fig. 23).

Regional Backgrounds: The Palatinate

In dealing with regional European origins of Pennsylvania's fraktur art, it would be improper to

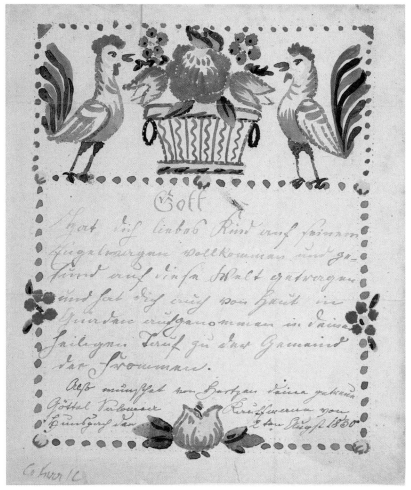

Fig. 26. **Alsatian *Göttelbrief*.** Hunspach, Alsace, 1830. Hand-drawn, lettered and colored on wove paper. 8¼ x 7 in. In this piece the confrontal roosters are portrayed as crowing, to suggest the joy over the baptism of a child. The basket of flowers and other designs are outlined by pinpricking, a technique found occasionally on Pennsylvania fraktur. The text reads: "God hath, dear child, conveyed thee into this world healthy and perfect on his Angel Wagon, and hath also this day received thee in grace through thy Holy Baptism into the Congregation of the Righteous. This is the heartfelt wish of thy faithful godmother Salomea Kauffman from Hunspach, the 2nd of August 1830." (Roughwood Collection.)

omit evidence from the Palatinate. The Electoral Palatinate, which existed until 1806 when Napoleon redrew the boundaries of the German states, was the Rhenish place of origin of countless Pennsylvania-German emigrant families. From their old homeland along the Rhine these emigrants brought the skills necessary to create Pennsylvania's fraktur art in their new transatlantic world. Some even brought along examples of Palatine fraktur in their emigrant chests.

Theodor Zink, the most knowledgeable student of the Palatine folk culture in the first half of the twentieth century, offered the seminal analysis of Palatine manuscript folk art.[31] In a 1938 book, he discussed the main genres of fraktur art. As in

Switzerland, the *Vorschrift*, penned by village schoolmasters, served as model for the test writings (*Probeschriften* or *Examenletze*) of their pupils. This art form was found also in the manuscript books decorated by pastors and teachers, and often, as in Pennsylvania, in family records inscribed on the end papers of massive eighteenth-century family Bibles.

The *Patenbrief* (or *Göttelbrief*) was also common, from the pens of teachers, clergymen, and village scriveners (Fig. 24). Later these came to be printed—as did Pennsylvania *Taufscheine*—with the personal data filled in by a scrivener. *Patenbriefe* were found chiefly in Protestant localities of the Rhine Plain (*Vorderpfalz*), and more frequently in country villages than in cities. This form of local art was practiced from the late eighteenth century into the 1860s. In the Western Palatinate (*Westrich*), only a few villages which formerly belonged to the Duchy of Zweibrücken turned up such examples. The Zweibrücken territories in fact produced some of the most striking manuscript art done by eighteenth-century Palatine schoolmasters.

According to Zink, the manuscript *Patenbrief*, which included good wishes and blessings from godparents to a baptized child, testified also to the people's joy in bright colors—glowing reds, greens, and yellows were favored. The painted designs included roses, tulips, and carnations, along with "two little doves, billing and cooing," and "stiff angels with even stiffer wings." It would almost seem that in writing these words the author had before him examples of the Pennsylvania *Taufschein*!

In the same year that Dr. Zink's book appeared, Donald Shelley made his exploratory trip to the Rhineland looking for prototypes of Pennsylvania's fraktur art. In his 1961 book, Dr. Shelley reproduced four eighteenth-century letters of apprenticeship from the Palatine towns of Kreuznach, Kürn, Meisenheim, and Rockenhausen—all in the horizontal format and decorated similarly to Pennsylvania *Vorschriften*.[32]

Regional Backgrounds: Alsace

Like Switzerland and the Palatinate, Alsace, which adjoins both, was also seminal ground for Pennsylvania's folk cultural patterns. The Alsatian collections of manuscript art in the Musée Alsacien in Strasbourg, and in regional and town museums, include much Protestant (and related Jewish) artwork. Among it are examples of the Alsatian version of the *Patenbrief*, called the *Göttelbrief* (Figs. 25, 26).

In an article based on his massive, 1,169-page dissertation at the Sorbonne, Dominique Lerch analyzed the characteristic texts found on the *Göttelbriefe* and the themes they express about the rite of infant baptism.[33] For an extensive bibliography on the Alsatian baptismal documents, called in French *lettres de baptême*, a direct translation of *Taufbriefe*, see also the work of Jean Cuisinier, *Die Volkskunst in Frankreich: Ausstrahlung, Vorlagen, Quellen*.[34]

Finally, of great comparative importance for Pennsylvania fraktur research is Georges Klein's study of the Alsatian house blessing, which functioned both in Protestant and Catholic sections of Alsace. Dr. Klein traces the history of this genre of household art to the times of pestilence in the late Middle Ages, when documents called *Pestbriefe* (pestilence letters) were sold at fairs and peddled all over Europe.[35]

Later there were the *Feuerbriefe* (fire letters) to protect one's house from burning, with prayers directed to the Three Holy Kings, often brought back from pilgrimages to their shrine at Cologne. These were intended to guard the house and the bearer against fire and other dangers. They usually featured the letters *CMB* for Caspar, Melchior, and Balthasar—the legendary names of the Three Holy Kings. In Catholic areas, these initials (now *KMB*) are still today chalked to doorframes of Catholic houses on Three Kings Day (January 6) to protect and bless the house.[36]

Additional patterns of Catholic house blessings were directed to the Virgin Mary, or, in the Sundgau of Southern Alsace, to St. Agatha, a special protectress against *Feuer und Brand*. In Catholic areas there were also specialized *Stallsegen* (stable blessings) invoking St. Leonhard or St. Blasius, protectors of horses. There was even a special blessing addressed to St. Florentius, protector of house animals.[37]

Another house-blessing tradition, in Alsace and in Pennsylvania, focused on the doorway of the dwelling. An early manuscript blessing dated 1708 in Alsace bears the simple but all-inclusive inscription: "Lord Jesus Christ, Thou Door of Life, be with me as I go out and come in." This suggests also the stone tablets, in Alsace sometimes placed above the massive arched farmstead gates beside the house, with inscriptions blessing all those who enter or leave. These were also common in the earlier period of Pennsylvania-German settlement.

I have named them *blessing stones*, although the common designation is *date stone*.[38]

The fire letter, or *Feuerbrief*, appeared in broadside form in Pennsylvania. As in Alsace, they featured the CMB monogram as they promised to protect the house and its residents from fire. Reprinted from European originals in nineteenth-century Pennsylvania, they usually circulated without imprint or date. However, there was an edition published in Kutztown, Berks County, by the printing firm of Urick and Gehring and dating to the 1870s.[39]

A document related to the house blessing, the so-called *Himmelsbrief* (letter from Heaven), was extremely popular in Pennsylvania and was reprinted many times in German and English in the nineteenth and twentieth centuries. Occasionally it turns up in manuscript form. This is a curious document purporting to be a post-biblical revelation (one of its attractions, of course) warning against sin and promising, if the owner fulfills a long series of moral commandments, to protect both the person who carries it and the house in which it is found. Thus, the *Himmelsbrief* was a house blessing of sorts and a kind of folk insurance policy with occult dimensions. The Pennsylvania versions tell us that a person "who carries this letter with him, and keeps it in his house, no thunder will do him any harm, and he will be safe from fire and water; and he that publishes it to mankind, will receive his reward and a joyful departure from this world." Apart from the German examples in Europe and Pennsylvania, variant versions have turned up in the British Isles, Scandinavia, and the Mediterranean countries.[40]

The manuscript art of Alsatian Judaism, previously mentioned briefly, needs expansion at this point. We have looked comparatively at the manuscript art of Central European Catholicism; we need to do the same for Jewish parallels to Pennsylvania fraktur art.[41] At various times throughout the Middle Ages and down through the seventeenth and eighteenth centuries—the time of the Pennsylvania-German transatlantic migration—Jewish families lived in villages, towns, and cities as neighbors to their non-Jewish German, Austrian, Swiss, and Alsatian countrymen. In village life, there were close contacts, and a kinship in motifs, decoration, and biblical themes can be found between Rhineland and Pennsylvania fraktur and Jewish manuscript art.

Fig. 27. **Silesian**
***Geburtsbrief* for Anna**
Dorothea Rössel.
Rentschen, Glogau, 1793.
Hand-drawn, lettered and
colored on laid paper.
20¹/₂ x 28¹/₂ in. This
official birth certificate,
sworn to and signed with
official seals by the village
mayors and town court of
Rentschen in the
Principality of Glogau,
was made out for Anna
Dorothea Rössel at her
baptism in the Protestant
parish church. The text is
detailed and written in
elaborate late-baroque
German phraseology.
(Roughwood Collection.)

This artistic kinship is particularly true of
Alsace. The rooms devoted to village-centered
Jewish folk culture in the Alsatian Museum show
many examples of similar art, among them house
blessings, calligraphed prayers, wedding certificates,
and amulets. Among the shared motifs are crowns,
tulips, vases of flowers, royal lions, springing deer,
even "confrontal birds," as Preston Barba delighted
in calling them.

This cultural kinship continued in the New
World. The Jewish pioneers who settled in Pennsylva-
nia in the eighteenth and early nineteenth centuries
maintained close contacts with their German-
speaking neighbors. In Pennsylvania the two arts
overlapped. One has only to consider the striking
Mizrah decorated by Samuel Bentz,[42] the Mount
Pleasant Artist, and the many printed *Taufscheine*
filled in and signed, often in Hebrew script, by
itinerant scrivener Martin Wetzler.[43]

Besides Switzerland, the Palatinate, and Alsace,
there are undoubtedly other historic German cultural
regions where fraktur flourished but of which, alas,

there has been only minimal study of calligraphic
traditions. Among these is Württemberg,[44] an
important source of Pennsylvania's Lutheran
population, Hessen, Franconia, the two Saxonies,
Hanover, and Westphalia. Finally, there is Silesia,
important for Pennsylvania-German religion as a
major center for the spread of Protestant mysticism.
The Schwenkfelder tradition stems from Silesia, and
the manuscript book production that they brought to
Pennsylvania—of hymnals, in particular—certainly
belongs in the fraktur category, although decoration
appears to have been minimal on the manuscripts
produced before emigration.[45] But fraktur did exist
and flourish in Silesia. The magnificent official
Lutheran *Geburtsbrief* of 1793 (Fig. 27), points to a
strong village fraktur tradition.

Finally, on the subject of European backgrounds,
there is the work of Ethel Ewert Abrahams on the
fraktur production of the Dutch, Prussian, and
Russian Mennonites in their Northern European
homelands before they came to America in the
1870s and later.[46] Indeed, the Russian-German

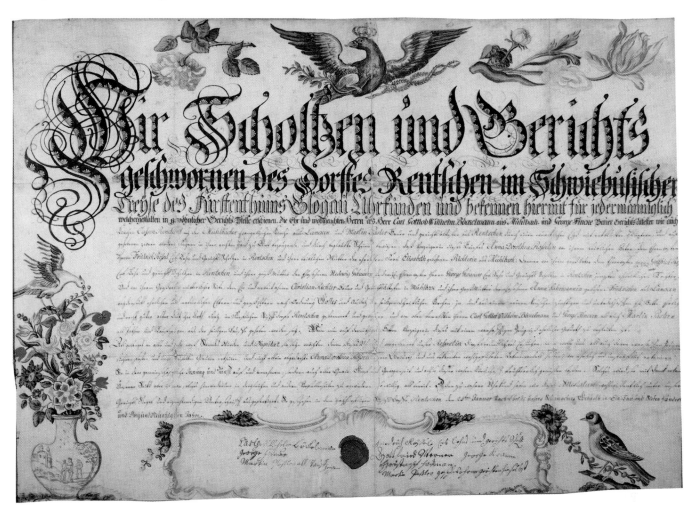

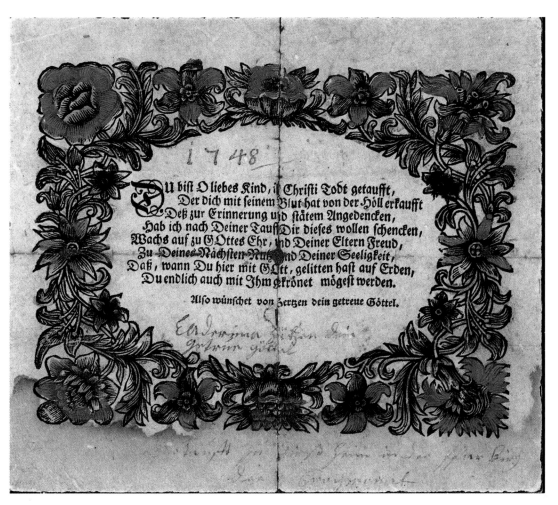

Fig. 28. **Alsatian *Göttelbrief.*** Alsace, 1748. Printed on laid paper. 6 x 6¹/₂ in. This printed example, with its elaborate floral border, is typical of the Alsatian/Palatine *Patenbrief* in that it has almost no information about the child, except that he or she was baptized in the parish church at (Surss?)heim in June of 1748. The inscription reads, in part: "Grow up to God's honor, and the joy of thy parents, to the benefit of thy neighbor, and thy salvation, so that, when thou hast here on earth suffered with God, thou mayest at last be also crowned with him. This is the cordial wish of thy faithful godmother, Caderina Hütz." (Roughwood Collection.)

Mennonites are well covered in the literature. It is all the more distressing then that we know so little about the fraktur backgrounds of the Swiss/Palatine/Alsatian Mennonites who came to Pennsylvania. Most studies of the education of these Mennonites while still in Europe are sketchy and inadequate for our purpose. Did they have schools of their own in the seventeenth and early eighteenth centuries? Or did they attend Lutheran and Reformed village schools like everybody else? Certainly in Pennsylvania their fraktur talents flowered gloriously, with their strong *Vorschrift* and music book tradition. The big question is, was this American development rooted in Anabaptist culture in Europe or was it derivative from the surrounding Protestant culture? We can only ask the question here, hoping for clarification after further research on both sides of the Atlantic.

Patenbrief to *Taufschein:* New Evidence

One of the most pressing problems in fraktur scholarship is the relationship of the Pennsylvania-German *Taufschein* to the European *Patenbrief.* In Pennsylvania, particularly among Lutheran and Reformed church communities, the most frequently encountered fraktur form is the *Taufschein* or baptismal certificate, usually a birth and baptismal certificate. Very little has been written on the *Taufschein* in Europe. There is, however, much work devoted to a parallel document relating to infant baptism—the so-called *Patenbrief* (godparent letter), *Taufwunsch* (baptismal wish), *Taufbrief* (baptismal letter), or *Taufzettel* (baptismal paper). The important work on the *Patenbrief* by Christa Pieske of Lübeck[47] includes many examples from Alsace, where as previously noted, they are called *Göttelbriefe* (Fig. 28).[48]

Swiss examples of this genre of baptismal art are featured in Konrad Weber's *Berner Taufzettel: Funktionen und Formen vom 17. bis 19. Jahrhundert* (Wabern-Bern: Benteli Verlag Bern, 1991). The purpose of these documents, which appeared first in manuscript form, later supplanted by attractive printed forms, was to provide good wishes and pious

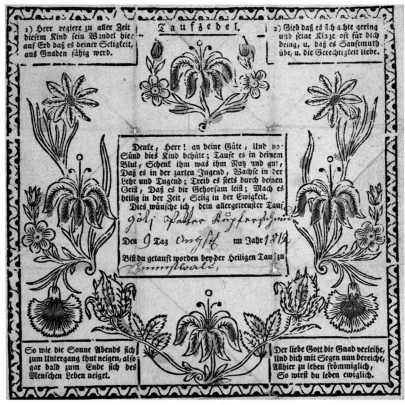

Fig. 29. **Swiss *Taufzettel*.** Summiswald, Canton Bern, Switzerland, 1812. Printed and hand-colored on wove paper. 6½ x 6½ in. This printed and completed "*Taufzedel*," in square format and folded for the coin-gift, is dated August 9, 1812, at Summiswald. Note the carnations and rose-hips among the floral sprays. The central box reads: "Remember, Lord, thy goodness, and guard this child from sin. Baptize it in thy Blood, grant it what will be good and useful, so that in tender youth it may grow in precept and virtue. Urge it on constantly through thy spirit, that it may lend obedience unto thee. Make it holy in time, blessed in eternity. This I wish thee, thy most faithful godfather, Peter Kupferschmid, the 9th day of August in the year 1812. Thou art baptized in the rite of Holy Baptism at Summiswald." (Roughwood Collection.)

admonitions from the godparents to the baptized child (Fig. 29). They were often folded to include a coin, the so-called *Göttibatzen*. Weber's book focuses principally on the printed Bernese *Taufzettel*, most of them from the nineteenth century. He classifies them according to decorative motifs—birds (doves), flowers (floral wreaths, roses, and sunflowers), grapes, angels, baptismal scenes, and other subjects. Most of the featured examples are square in format, with evidence of having been folded to include the baptismal gift.

The latest and most thorough discussion of the relation of the Pennsylvania *Taufschein* to the European *Taufpatenbrief | Taufzettel | Göttelbrief* can be found in Klaus Stopp, *The Printed Birth and Baptismal Certificates of the German Americans*.[49] Stopp includes an image of the earliest known Pennsylvania *Patenbrief*, dated 1751, which follows Alsatian models in format, text,

and decoration (two flying angels and stylized floral border). It was made for Frantz Paul Seybert, son of Jacob and Susanna Seybert, born in Tulpehocken in what is now Berks County in 1751. The godparents (*Petter* and *Göttel*) who presented it to the child were Frantz Wenrich and his wife Esther. Strangely enough, the date of birth is inscribed on it but not the date of baptism.[50]

Following this introductory discussion of the *Patenbrief* in Europe and America, I must offer a caveat on the relation of *Patenbrief* to *Taufschein*. In the light of mounting evidence in Europe of a somewhat stronger *Taufschein* tradition than was suspected by earlier fraktur analysts, it may not be completely correct to claim that the *Taufschein* was invented in Pennsylvania, out of the *Patenbrief* (Fig. 30) or *Taufwunsch* as has long been supposed. It is of course true that a few early examples of *Taufwünsche* have turned up in Pennsylvania, dating from the middle of the eighteenth century, after which the *Taufschein* takes over the field. But in surveying fraktur backgrounds across the Atlantic, European *Taufscheine* do appear here and there. Hence I offer an alternate theory on the origin of the Pennsylvania *Taufschein* tradition. It is my opinion that the Pennsylvania *Taufschein* evolved not from the *Patenbrief* alone, but rather from a combination of the official European *Geburtsbrief* (see Fig. 27) and the folk-cultural *Patenbrief | Taufzettel* in response to American needs.

Two examples of European *Taufscheine* prepared by village pastors for parishioners who were emigrating to America in the eighteenth century can be cited. First, is the "Baptismal Certificate for the Honorable Master Cartwright Lorentz Albert at Michelrieth, His Wife and Three Children, 1754."[51] The minister, Johann Michel Dennscherz, who had been pastor of the parish for thirty-eight years, and therefore had baptized the parents, combined a beautifully written *Taufschein* with character recommendations and prayers for his departing parishioners. He also presented them with a copy of his 1741 prayer book which he had compiled for the Lutheran churches of the county of Löwenstein-Wertheim.

The second example is the "*Tauf-, Ehe- und Toden-Schein für Sebastian Schweiker, Bürger und Schreiner in Bodelshausen, Tübinger Ober-Amts*," dated 1772.[52] The document's title can be translated: "Baptismal, Marriage, and Death Certificate for Sebastian Schweicker, Citizen and

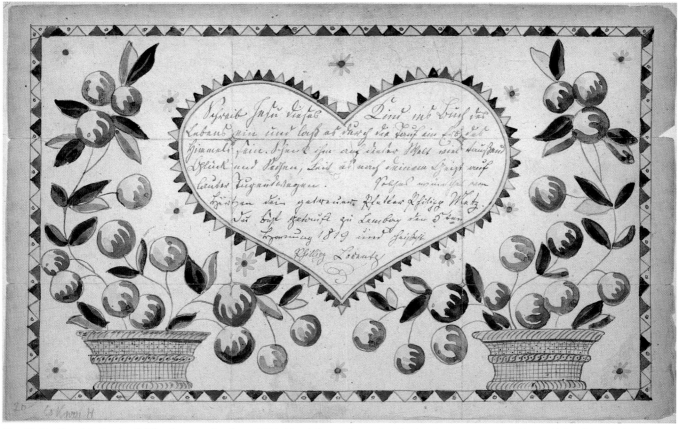

Fig. 30. **Baptismal Letter for Phillipp Lorentz.** Lemberg, 1819. Hand-drawn, lettered and colored on wove paper. 8³⁄₈ x 13¹⁄₂ in. This colorful *Taufbrief*, horizontal in format, and with the text in a flat heart, resembles a Pennsylvania *Taufschein* outwardly but in text is a *Patenbrief*. The inscription in the heart reads, in part: "Jesus, inscribe this child into the Book of Life and let it through baptism be an heir of Heaven. Grant it in this world a thousand happinesses and blessings. Lead it according to thy spirit on pure paths of virtue." (Roughwood Collection.)

Cabinetmaker in Bodelshausen, District of Tübingen, Württemberg."

That the *Taufschein* was known to the emigrant generation of Pennsylvania-German families is evident from many eighteenth-century sources. As we have just learned, there are references in Rhineland church registers and town records to the parish minister preparing a *Taufschein* for an emigrant who was leaving for the New Land. But a *Taufschein* might also be sent across the Atlantic after emigration. The latter case is illustrated in a letter sent by an apprentice tailor, Martin Stoll of Strasburg Township, Lancaster County, April 15, 1770, to his parents in the village of Pfalzgrafe-weiler, Oberamt Dornstatt, Württemberg, near the larger town of Freudenstadt in the Black Forest.[53]

Stoll had arrived at Philadelphia on St. Michael's Day, 1764, on the ship *Polly*. His passage was paid by a master tailor from Lancaster County, for whom he worked for six years, and who had given the young man his freedom. In Stoll's letter home, he confessed that he would have written sooner except that a good opportunity for sending the message across the sea was lacking. The writer asked his parents, brothers and sisters to inform him if they were still living. He requested his parents in particular to write a letter to him. "And please," he added, "send along my *Taufschein*, so that I know how old I am, and make me happy, please, again, with your writing."

In addition to its obvious role in informing individuals of their exact age, the *Taufschein* was put to other official uses in America. In examining early Lutheran and Reformed church registers in Pennsylvania, it is obvious that many emigrants must have brought their *Taufscheine* with them across the Atlantic. Upon the emigrant's death, these were frequently handed to the parish minister by the family. Occasionally, the data included was read out by the preacher as part of the funeral sermon, and very often the minister used the document in inscribing the emigrant's obituary into the church register. Out of the dozens of such obituaries recorded in the Burial Register of Trinity Lutheran Church, Reading (1754–1813), one example will suffice.

The register for 1796 reports the burial on November 4 of Michael Rosch Sr., a carpenter by trade, an emigrant of 1751, and a long-time resident of Reading. He was born February 27, 1703, at Remmingsheim in Württemberg, the son of Thomas Rosch, Master Carpenter, and his wife Agnesa. At the time of his baptism, his godparents were village mayor Hanss Vihel, and Catharina, wife of Jacob Dupper. From his youth onward, he confessed the Evangelical Lutheran doctrine (a reference to his confirmation) and very frequently partook of Holy Communion, to the strengthening of his faith. His wife was Catharina Fischer, born January 28, 1704, daughter of Hanss Fischer. They were married September 10, 1726, and lived in matrimony forty-nine years. They produced nine children, four sons and five daughters, of whom two sons and four daughters, with 125 grandchildren and great-grandchildren, were living in 1796. His wife died in 1775, and he lived as a widower until his death on November 2, 1796, at the age of 93 years, 8 months, and 6 days.[54]

It is highly unlikely that such detail on European births, baptisms, and godparents could have been gathered solely from memories of the children at the time of the emigrant's funeral. The precision of detail points to a *Taufschein* as a probable source, although, in rare instances, bible records might yield the same sort of data, or church register extracts prepared by a European pastor to accompany the emigrant on the voyage. In the latter case, however, the format would in fact have been that of the *Taufschein*, as in the Lorenz Albert *Taufschein* of 1754 (previously cited).

It is obvious that a transformation—from the European *Patenbrief* to the Pennsylvania *Taufschein*—took place here in America. But no one thus far has suggested the reasons why this change came about. Nor has anyone yet pointed out the transitional forms extant during the metamorphosis from the European to the America format.

Let us look, then, at (1) possible reasons that produced this change, and (2) the connecting links of transitional forms between the classic European, expecially the Swiss/Alsatian/Palatine *Patenbrief* and the full-blown Pennsylvania-German *Geburts- und Taufschein*.

First of all, let us consider the American Revolution and its effects on Pennsylvania-German identity. Evidence of an upswing in the production of *Taufscheine* in response to the Pennsylvania Militia Law of 1777 appears in the Journals of Henry Melchior Muhlenberg, Pennsylvania's leading Lutheran clergyman.[55] For example, on Saturday, May 3, 1777, he wrote: "Prepared several baptismal certificates because the Militia Act requires all inhabitants from their eighteenth to their fifty-third year to engage in military exercise and to be ready, in emergency, to help defend the land. Accordingly parents must prove when their sons were born."[56]

Peter Becker, a member of Muhlenberg's congregation, had approached the pastor on May 2 requesting a certificate for his son. This is what Muhlenberg wrote out for him:

These are to certify that Jacob a Son of Mr: Peter Becker and his Wife Elizabeth, Inhabitants of Newprovidence Township Philadelphia County, was born and christened Mense Octobris Anno Domini 1760, when at the Baptism stood Evidences [witnesses] Mr: Jacob Peterman and his Espouse Mary Ann, as witnesseth my hand this 2d Day of May 1777.

H:M. Senr: Min: of the G[ospel][57]

Another example was recorded a few weeks later, May 21, 1777: "Also had to prepare a baptismal certificate, on account of the Militia Act," this time for Johann Georg Starck, son of Jacob and Margreth Starck, born March 31, baptized May 30, 1762.[58]

And yet another example. On April 26, 1781, George Michael Bastian "desired a certificate of his age and sent his wife for it." The pastor records that he was unable to find the date of birth in the church register, but did "find recorded the first time of his receiving the Lords Sup[per] as an adult." The year was 1746 and Muhlenberg certified it in writing, which in that situation made it official.[59] It is obvious that these certificates were considered official documents. In fact, many decades later in the 1830s, when Revolutionary War veterans or their wives applied for U.S. service pensions, they sometimes submitted the veteran's *Taufschein* as his official birth certificate.[60]

This pressing need for an official birth certificate during the Revolution is, then, our first point. This governmental demand for official certification of birth (in these cases by the pastor who performed the baptism) for army participants was reinforced by other factors that accompanied the Revolution. The growth of democratic individualism, promoted by the struggle for American independence, continued into the federal period of our history. At

that time, Pennsylvania Germans, like other American citizens, were increasingly conscious of their hard-won American rights, freedoms, constitutions, civic duties, and the way in which they related to them as individuals. Citizenship, with all of its rights and privileges, underscored and strengthened this new individualism and sense of American identity.[61]

Hence, beginning with the Revolution the old inherited European *Patenbrief*—with its frequent lack of definite vital statistical data and its traditional overweighting with pious wishes and admonitions from godparents to a baby—was phased out, and the official or semiofficial *Taufschein* (better, *Geburts- und Taufschein,* or birth and baptismal certificate) was phased in. There are undoubtedly other factors involved in the transformation of *Patenbrief* into *Taufschein,* but these political and identity-related reasons should be good for a start.

There are, as one might expect, transitional forms combining elements of both *Patenbrief* and *Taufschein.* An extremely pertinent example that has recently turned up in a private collection is the *Taufschein* that Daniel Schumacher prepared for Johannes Krämer, son of Bernhard and Susanna Catharina (Lantz) Krämer.[62] The child "first saw the light of this world in Pennsylvania, in the Township of Albany or Allemängel" on September 11, 1777, and was baptized on the nineteenth of October in the Weissenburg Church. At the baptism, the witnesses were Johannes Jürg Hand and his wife Anna Margaretha. The pastor added: "This is herewith certified (*bescheiniget*) for the child by me, Daniel Schumacher, p.h.t. Evangelical Lutheran pastor in Pennsylvania mpp." In other words, the pastor was making this an official birth and baptismal certificate.

But at the bottom of the document a last lingering evidence of the *Patenbrief* format appears: "This, dear godson, is given to you as a remembrance by your godfather and godmother Johannes Jürg Hand and Anna Margaretha Hand" [*Zum Andenken Schencken Dir lieber Petter dieses dein Petter und Gothe Johannes Jürg Hand und Anna Margaretha Handin*]. Evidently the sponsors paid the pastor for the certificate and presented it, treating it as a *Patenbrief.* Note also that the traditional words for godfather and godmother—*Petter* and *Goth[e]*—were employed, and that the godson was also referred to as *Petter.*

To summarize our points, (1) *Taufscheine/Geburtsscheine* were known in Europe before the transatlantic Germanic migration; (2) the Revolution apparently forced a transformation from *Patenbrief* to *Taufschein* as an official identity document for prospective soldiers; and (3) as is the case with any radical transformation in culture, transitional forms do exist.

Conclusion

The fraktur art of the Pennsylvania Germans has captured national attention in the twentieth century. Art historians, folklife scholars, anthropologists, ethnographers, social and cultural historians, collectors, and museum personnel have all studied it. With the profusion of books, monographs, and articles issuing from this multidisciplinary scholarship we are today much further ahead than a century ago when Henry C. Mercer wrote his pioneer article announcing his fraktur discoveries.

It has been a pleasant and absorbing task to trace the European origins of Pennsylvania fraktur, looking for models, formats, symbols, and texts. We have concentrated on the seventeenth century, "the immediate background," which—with its religious ferment, hymnody, symbols and emblems, and above all, baroque calligraphy—was the direct source of much that would appear on Pennsylvania's fraktur art. While medieval and earlier roots can properly be cited, as Henry Mercer did in 1897, fraktur's immediate origins clearly lie in the seventeenth century.

To summarize, then, there were essentially three steps in the development of the fraktur tradition in Europe and its transmission to Pennsylvania:

1. *The rise of calligraphy in the elite echelons of European culture during the Renaissance and its flowering in the German-speaking lands in the baroque era.* This included the rise of professional calligraphers who practiced the fine art of decorative penmanship, the teaching of such skills in urban writing schools, the publication of a select number of engraved writing master manuals presenting the various Renaissance scripts and alphabets, and the production of copy models (*Vorschriften*) demonstrating how a skilled calligrapher could inscribe and decorate a document.

2. *The widespread use of writing master's manuals by public officials in the German-speaking lands—clergymen, schoolmasters, state, city, and town clerks, notaries, and others.* These individuals used the aforementioned copybook models in their own preparation of official documents for their communities.

3. *The lowering of the art of baroque calligraphy to the village and rural culture of Switzerland, Germany, Austria, and Alsace.* There, local officials—again, the village pastors, schoolmasters, and town clerks—prepared church records, birth and baptismal certificates, marriage agreements, and other documents that joined elite calligraphy with folk motifs—geometric, pictorial, and symbolic—that had come down from the Middle Ages and earlier stages of European culture.

It was this third and last development that registered itself here and led to the amazing proliferation of fraktur, now honored as Pennsylvania's chief contribution to the arts of the early United States. As we have seen, Pennsylvania clergymen and schoolmasters often owned personal copies of European writing master's manuals from which they developed designs for documents.

To take another direction, let us look at some additional sources for the iconography and texts found on fraktur—apart from the pivotal baroque writing manuals. It would be wrong, for example, to neglect the illustrated German Bibles of the seventeenth and eighteenth centuries as a source for iconography as well as texts of Pennsylvania fraktur.[63] For iconography the Biblical models are particularly noticeable on printed fraktur, although manuscript fraktur pieces reveal Biblical models as well.[64] Examples are crucifixion scenes, baptismal scenes (John the Baptist baptizing Jesus in the Jordan), Jesus, Satan, angels (found frequently on both manuscript and printed fraktur), lilies, lions, eagles, springing deer, sun and moon, the New Jerusalem, the Agnus Dei (or Lamb of God), Adam and Eve complete with Tree of Knowledge and Serpent, the Prodigal Son, hearts, crowns—but no crosses except in crucifixion scenes. Among Pennsylvania-German Pietists, whether churchly or sectarian, the cross was preached and sung but rarely pictured. Protestants accented the interior cross, rather than the outward cross as symbol.

Hence crosses did not normally appear even on church towers or chancels until the twentieth century.

Another printed source for themes and texts of selected fraktur genres can be identified in the German broadsides of the seventeenth century. Before the era of regular newspapers, broadsides proliferated, offering news, reports of tragedies, songs, satires, and social criticism. These included religious broadsides for the edification of the common people. Among the themes displayed graphically were the Wounds of Christ, the Memento Mori (Death as a skeleton aiming his arrows at Man), the Ages of Man and Woman, the Golden ABC (lettered in manuscript by Schwenkfelder and Mennonite frakturists), the House Blessing, and the Spiritual Clockwork (*Geistliches Uhrwerk*) with the Twelve Hour Devotion, which appeared in Pennsylvania both in print and in manuscript form.[65]

With that summary of European sources, we must ask, what happened to the European forms and formats once they had become transplanted here? Like the rest of the hybrid Pennsylvania-German culture within which it developed, fraktur represents a melding of European and American influences. Basically European in background and intent, American fraktur nonetheless differed from its Old World models. First, our baptismal certificates, though considered official by the clergy, lacked the full official, governmental character of their European counterpart, the *Geburtsbrief*. Second, the art here was, in a sense, democratized. While the majority of the extant examples were products of professionals, prepared for the people by schoolmasters and clergymen, enough pieces by other lay individuals have turned up to back the statement that in the New World, indeed, fraktur became a people's art. The examples by Schwenkfelder women, Susanna Hübner, Maria Kriebel, and others, and the Amish bookplate artist Barbara Ebersol, can be cited as evidence. Third, the design vocabulary changed in America. Eventually American symbols came to be used on fraktur—the American eagle, the Pennsylvania coat-of-arms, Egelmann's cluster of farm tools, harps on shields, sheaves of wheat, tall case clocks, praying children, primitive portraits, circular garden houses or bowers, cornucopias—all this with confrontal parakeets, unicorns, and mermaids! Finally, the Pennsylvania examples continued to combine, as in

Europe, the elite intricacies of the baroque writing manuals with folk designs. Huppert Cassel's masterpiece *Vorschrift* of 1769, for example, features on one side a handsome calligraphed swan, straight out of the writing manuals, and on the other, an equally handsome folk design, a tree of tulips growing out of a double heart. It also expresses an Americanizing mood in presenting an English translation of the favorite German hymn, "*Wie schön leuchtet der Morgenstern,*" executed even in English script.[66]

As American culture developed after the Revolution, elite-level artistic movements produced new motifs which likewise registered themselves at the folk level. In the first quarter of the nineteenth century, fraktur documents appeared in Pennsylvania framed not by the seventeenth-century heart but by pillars, urns, pyramids, and other accoutrements of neoclassicism.[67] Familiar examples are the *Taufschein* pieces engraved and printed by Carl Friederich Egelmann of Berks County and copied by Gabriel Miesse.

New generations of scholars need to look at the motifs in Pennsylvania fraktur, tracing each separate design to its earliest known stages through art-historical analysis.[68] This includes the tulips, the carnations, the roses, the confrontal birds, the ancient geometrical designs, and all the other folk symbols used by fraktur producers in the classic period of fraktur production. This will yield different results than the theological analysis provided by John Joseph Stoudt in *Consider the Lilies* (1937), without supplanting it.

This approach is especially needed here at this time in the history of fraktur research, since our European colleagues have begun to take a new across-the-board look at symbolism and its application in European folk art. This subject was in fact the focus theme debated by the entire 1995 sessions of the German Society of Folk-Cultural Studies (*Deutsche Gesellschaft für Volkskunde*).[69]

To summarize, it should be abundantly clear that printed models were a major influence on Pennsylvania fraktur. Included in this hitherto largely unsuspected influence are not only the calligraphy manuals, but illustrated Bibles, prayer books, hymnals, and broadsides. All these elite cultural productions have to be counted as evidence that folk art, while an identifiable artistic genre produced for and ministering to a folk community, is never independent of the surrounding cultural world. While individual folk artists did develop recognizable styles, in the long run we must place fraktur against the broader cultural setting of elite art and consider changing artistic fashions as they were mediated to folk artist and folk community via printed models.[70]

To conclude, as a key index to Pennsylvania-German culture, ramifying into all phases of that culture, fraktur can be seen for the highly complex artistic and religious phenomenon that it was. We pay tribute to the many folk artists—ministers, schoolmasters, peddlers, tramps, and ordinary farmers and farmers' wives—who produced such a striking, unmatched body of visual imagery and devotional texts. This gallery of characters (and many of them were just that) enriched as well as exemplified Pennsylvania-German culture while at the same time creating Pennsylvania's most significant contribution to the arts of America.[71]

Notes

1. For a concise introduction to the term *fraktur*, its background in Europe and its use in America, see Donald A. Shelley, *The Fraktur-Writings or Illuminated Manuscripts of the Pennsylvania Germans* (Allentown, Pa.: 1961), in *Publications of the Pennsylvania German Folklore Society* 23 (1958–1959): 21–37.

2. For fraktur as a typeface, see S. H. Steinberg, *Five Hundred Years of Printing*, rev. ed. (Baltimore: Penguin Books, 1966), 40–42, et passim. In German printing, Fraktur type lasted four hundred years, until its replacement in our time by Latin type. Steinberg's reason "for the prevalence of the black-letter in Germany and the Scandinavian and Slavonic countries in cultural dependence on her may be found in the preponderance of theological over humanistic writings in Germany" (42). Non-German texts, classical works for example, always appeared in antiqua type.

3. These ship lists, unique for the thirteen colonies, are published in Ralph Beaver Strassburger and William John Hinke, *Pennsylvania German Pioneers*, 3 vols. (Norristown, Pa.: Pennsylvania German Society, 1934), with facsimiles of the signatures in vol. 2.

4. For the memoirs of a German emigrant schoolmaster and his trials among the Pennsylvania Germans while teaching at the Moselem Church in Berks County, see Jonas Heinrich Gudehus, "Journey to America," Larry M. Neff, trans., in *Ebbes fer Alle-Ebber, Ebbes fer Dich/ Something for Everyone—Something for You: Essays in Memoriam Albert Franklin Buffington*, in *Publications of the Pennsylvania German Society* 14 (1980): 183–329.

5. For the history of calligraphy in relation to Fraktur, see Richard Beitl, ed., *Wörterbuch der Deutschen Volkskunde*, 2nd ed. (Stuttgart, Germany: Alfred Kröner Verlag, 1955), "*Schönschrift*," 677, and "*Schrift*," 679–680. Additional articles deal with *Patenbriefe*, *Heiratsbriefe*, and *Neujahrswünsche*. The exhibit catalogue compiled by Dorothy E. Miner, et al., *Two Thousand Years of Calligraphy* (Baltimore, 1965) provides a useful overview. A second catalogue, F. W. Filby, comp., *Calligraphy & Handwriting in America, 1710–1962* (Caledonia, NY: Italimuse, 1963) is also relevant, though minimally, on fraktur art. For the best list of the German writing master manuals, see Werner Doede, *Bibliographie deutscher Schreibmeister-bücher von Neudörffer bis 1800* (Hamburg, 1958).

6. Elizabeth C. Kieffer, "Penmanship: The Art of the Scrivener," *The Pennsylvania Dutchman* 5:13 (March 1, 1954): 3, 12, 15.

7. For the title page of the chorale book he used as organist beginning in 1796, see Don Yoder, *The Picture-Bible of Ludwig Denig: A Pennsylvania German Emblem Book*, 2 vols. (New York: Hudson Hills Press, 1990), 1:82.

8. For Egelmann's career, see Louis Winkler, "Pennsylvania German Astronomy and Astrology VII: Carl Friederich Egelmann (1782–1860)," *Pennsylvania Folklife* 23 (Autumn 1973): 2–12.

9. Carroll Hopf, "Calligraphic Drawings and Pennsylvania German Fraktur," *Pennsylvania Folklife* 22 (Autumn 1972): 2–9.

10. Jürgen Hermann Rauser, *Künzelsauer Heimatbuch: I: Stadtgeschichte* (Künzelsau: Stadt Künzelsau, 1981), 477–478. This is volume 8 in the series: *Heimatbücherei Hohenlohekreis*, all edited by Rauser, who served many years as city archivist of Künzelsau.

11. For the German use of the word *Brief* for document, see Beitl (1955), 110–111.

12. Alexander Nesbitt, ed., *200 Decorative Title-Pages* (New York: Dover Publications, 1964), plate 106.

13. Votive pictures or *ex votos* have been widely studied in various Catholic cultures. They are the best possible example of Catholic pictorial art, portraying miracles, healings, rescues from danger, and so forth. They are valuable for folklife studies since they register peasant and middle-class house interiors, furnishings, and costumes, all dated evidence. A basic introduction to *ex voto* art is Lenz Kriss-Rettenbeck, *Das Votivbild* (Munich: Verlag Hermann Rinn, 1958).

14. Exhibits and books on the influence of Luther and the Reformation on art proliferated in the Luther anniversary year 1983. Two studies in particular deserve mention here: (1) Werner Hofman, ed., *Luther und die Folgen für die Kunst* (Munich: Prestel-Verlag, 1983); and (2) *Kunst der Reformationszeit* (West Berlin: Elephanten Press Verlag, 1983). Both are exhibit catalogues, with authoritative texts, beautifully illustrated and massive.

15. These dates are surprisingly consonant with the approximate dates American scholars use for the flowering and decline of classic Pennsylvania fraktur production. This coincidence of dating is true also of other genres of what is now called folk art—decorated furniture, redware pottery, and so forth.

16. Leopold Schmidt, *Ein Kapitel Volk und Schrift: Geschriebene Gebet- und Gesangbücher aus Österreich und Bayern von 17. bis zum 19. Jahrhundert*, in *Anzeiger der phil. hist. Klasse der Österreichischen Akademie der Wissenschaften* 108. Jahrgang (1971), So. 5, 129–148, plus five pages with ten illustrations (Vienna, 1971). See also: Konrad Kupfer, "*Geschriebene Gebetbücher des 18. und 19. Jahrhunderts*," in *Bayerisches Jahrbuch für Volkskunde* (1954): 137 ff.

17. For American parallels, he cites in particular the evidence from Pennsylvania, as revealed to him in Frank Sommer's *Pennsylvania German Prints, Drawings and Paintings: A Selection from the Winterthur Collections* (Winterthur, Del.: Henry Francis DuPont Winterthur Museum, 1965). For American folk art as influenced from Europe, see Hans Jürgen Hansen, ed., *Europas Volkskunst und die europäisch beeinflusste Volkskunst Amerikas* (Oldenburg/Hamburg: Gerhard Stallings Verlag, 1967).

18. For additional treatments of Catholic folk art in Europe, see (1) Manfred Brauneck et al., *Religiöse Volkskunst: Votivgaben, Andachtsbilder, Hinterglas, Rosenkranz, Amulette* (Cologne: DuMont Buchverlag, 1978); (2) Bernward Deneke, *Zeugnisse religiösen Volksglaubens aus der Sammlung Erwin Richter* (Nürnberg: Germanisches Nationalmuseum, 1965); (3) Reinhard Peesch, *Volkskunst: Umwelt im Spiegel populärer Bildnerei des 19. Jahrhunderts* (Berlin: Akademie-Verlag, 1978); (4) Helmut Nemec, *Alpenländische Volkskunst: Eine Darstellung für Sammler und Liebhaber* (Vienna: Prisma Verlag, 1966); and (5) Klaus Beitl, *Volksglaube: Zeugnisse religiöser Volkskunst* (Salzburg/Wien: Residenz Verlag, 1978). Finally, (6) for the images and art of the Catholic Counter-Reformation, see John B. Knipping, *Iconography of the Counter Reformation in the Netherlands: Heaven on Earth*, 2 vols. (Amsterdam: Erasmus Antiquariaat en Boekhandel, 1974).

19. The standard work on Swiss folk art is the magnificently illustrated *Volkskunst in der Schweiz* (Paudex: Editions de Fontainemore, 1970), by René Creux. The book is a symposium by leading folk art scholars, with a foreword by the former dean of folk art studies in Switzerland, Robert Wildhaber.

20. Walter Tobler, "*Zierschriften und Gedenkblätter*," in *Volkskunst in der Schweiz*, 238–251.

21. For the etymology of the term *Osterletz*, see my second paper in this publication, "Fraktur Texts and Pennsylvania-German Spirituality," n.14.

22. For the Swiss schools especially of Canton Zürich and the production of fraktur art, see Albert Hauser, *Alte Volkskunst am Zürichsee* (Zürich: Verlag Neue Zürcher Zeitung, 1992), "*Illustratoren und Schönschreiber*," 101–118.

23. Oskar Bätschmann, ed., *Schreibkunst: Schulkunst in der deutschsprachigen Schweiz 1548 bis 1980* (Zürich: Kunstgewerbemuseum der Stadt Zürich, Museum für Gestaltung, 1981).

24. Ibid., 8–10, 12–54, and 55–57.

25. Theo Gantner, in Bätschmann, 60–110.

26. Hildegard Gantner-Schlee, "*Ländliche Kalligraphie im Alltag des Volkes*," in Bätschmann, 112–144.

27. Paul Zinsli, "*Volkstümliche Schreibkunst in Safien vom 17. bis ins 19. Jahrhundert*," in *Schweizerisches Archiv für Volkskunde* 47 (1951): 275–288. Zinsli's work is beautifully illustrated with 12 plates.

28. Discussed in a follow-up article to Zinsli by Leo Zihler, "*Die von den volkstümlichen Schreibkünstlern Safiens im 17. Jahrhundert verwendeten Kupferstichvorlagen*," in *Schweizerisches Archiv für Volkskunde* 52 (1956): 227–233.

29. Christian Rubi, *Hochzeit im Bernerland* (Wabern: Büchler-Verlag, 1971), 15–19, 24–29.

30. See Adolf Reinle, *Luzerner Volkskunst* (Bern: Verlag Paul Haupt, 1959), vol. 92 in the series: *Schweizer Heimatbücher*.

31. Theodor Zink, *Deutsche Volkskunst: Die Pfalz* (Weimar: Böhlau Verlag, 1938), vol. 12 in the series: *Deutsche Volkskunst*. For students of Pennsylvania folk culture as well as folk art, Theodor Zink's book offers immense riches. Apart from its somewhat limited but balanced discussion of manuscript folk art, the book covers folk architecture in farmhouse and urban dwellings; house inscriptions; church buildings, cemeteries, and tombstone art; house furnishings; craftsmanship of various sorts, including glassmaking and pottery; and finally, costume. As a survey of the material folk culture of the Palatinate, ancient homeland of so many Pennsylvania families and the central source of our language, it is highly recommended as background for the study of Pennsylvania folk culture, particularly in the colonial period of our settlement history.

32. Unfortunately, since 1938 there has been very little published on Palatine fraktur. One helpful treatment is an article by Dr. Wolfgang Kleinschmidt, "*Handgemalte Pfälzische Patenbriefe*," which appeared in *Volkskunst: Zeitschrift für volkskundliche Sachkultur* 6 (November 1983): 199–205.

33. See Dominique Lerch, "*Die Göttelbriefe im Elsass: Quelle der Mentalitätsgeschichte im deutschsprachig-protestantischen Raum*," in *Jahrbuch für Volkskunde*, Neue Folge 15 (1992): 161–176. Also, his dissertation, *Imagerie populaire et pieté populaire en Alsace (vers 1600, vers 1900)* (Nancy, France: Presses Universitaires, 1992).

34. Jean Cuisinier, *Die Volkskunst in Frankreich: Ausstrahlung, Vorlagen, Quellen.* (Munich: Verlag Georg D. W. Callwey, 1976); original edition *L'Art Populaire en France* (Fribourg/Suisse: Office du Livre, 1975).

35. Georges Klein, "*Haussegen im Elsass*," in *Volkskunst: Zeitschrift für volkskundliche Sachkultur* 4 (November 1981): 205–211.

36. For "*Feuerbriefe*" and other subjects relating to the Three Kings cult, see Beitl (1955), "*Dreikönig*," 145–148, with extensive bibliography.

37. For stable blessings, see Beitl (1955), "*Haus und Stallsegen*," 306.

38. For date stones and their texts, see John Baer Stoudt, "House Mottoes in Eastern Pennsylvania," *A Collection of Papers Read Before the Bucks County Historical Society* 6 (1932): 65–78; also Martha Ross Swope, "Lebanon Valley Date Stones," *The [Pennsylvania] Dutchman* 6 (June 1954): 20–22. For Swiss house inscriptions, see Robert Tuor, *Berner Hausinschriften* (Bern, 1981), in the series: *Berner Heimatbücher*, No. 127.

39. For a reproduction of the Kutztown Fire Charm, see Don Yoder, "Kutztown and America," *Pennsylvania Folklife* 14 (Summer 1965): 2–9. The broadside charm appears on p. 8.

40. For the *Himmelsbrief* in America and its various forms, see Edwin M. Fogel, "The Himmelsbrief," *German American Annals*, New Series 6 (Philadelphia, 1908): 286–311; and Wilbur H. Oda, "The Himmelsbrief," *The Pennsylvania Dutchman* 1 (December 1949): 3.

41. Out of the growing bibliography on Jewish folk art in Europe, I have found useful the two-volume exhibit catalogue, *Monumenta Judaica: 2000 Jahre Geschichte und Kultur der Juden am Rhein* (Cologne, 1964); Norman L. Kleeblatt, *Memories of Alsace: Folk Art and Jewish Tradition* (New York: The Jewish Museum, 1989); Herman Pollak, *Jewish Folkways in German Lands (1648–1806): Studies in Aspects of Daily Life* (Cambridge, Massachusetts: The MIT Press, 1971); and the splendid catalogue, *Juden im Elsass* (Basel, 1992), detailing the joint exhibit of 1992–1993 mounted by the Jüdisches Museum der Schweiz and the Schweizerisches Museum für Volkskunde. And finally, for the American relationships, there is the volume by Norman L. Kleeblatt and Gerard C. Wertkin, *The Jewish Heritage in American Folk Art* (New York: Universe Books, 1984).

42. See Frederick S. Weiser, "Samuel Bentz, the 'Mount Pleasant Artist,'" in *Der Reggeboge: Journal of the Pennsylvania German Society* 20:2 (1986): 33–42; also Russell D. Earnest and Corinne P. Earnest, *Papers for Birth Dayes: Guide to the Fraktur Artists and Scriveners*, 2nd ed., 2 vols. (East Berlin, Pa.: Russell D. Earnest Associates, 1997), 1:90–93.

43. Earnest and Earnest, *Papers for Birth Dayes*, 2:811–814.

44. For Württemberg, there is the book by Martin Scharfe, *Evangelische Andachtsbilder: Studien zu Intention und Funktion des Bildes in der Frömmigkeitsgeschichte vornehmlich des schwäbischen Raumes* (Stuttgart: Verlag Müller & Gräff, 1968). While this focuses on religious pictures, the text is an excellent introduction to the function of art in Protestantism, especially in Pietist contexts.

45. Dennis K. Moyer, *Fraktur Writings and Folk Art Designs of the Schwenkfelder Library Collection* (Kutztown, Pa.: Pennsylvania German Society, 1998), in *Publications of the Pennsylvania German Society* 31 (1997).

46. Ethel Ewert Abrahams, *Frakturmalen und Schönschreiben: The Fraktur Art and Penmanship of the Dutch-German Mennonites while in Europe, 1700–1900* (North Newton, Kans.: Mennonite Press, 1980). The great majority of the pieces illustrated in this book are decorated arithmetic texts, but there are also *Vorschriften, Haussegen*, choral books, family registers, *Liebesbriefe*, and Christmas and New Year's wishes. There are even pictures of documents pasted to the inner lids of chests!

47. See Christa Pieske, "*Über den Patenbrief*," in *Beiträge zur Deutschen Volks- und Altertumskunde* (Hamburg: Museum für Hamburgische Geschichte) 2/3 (1958): 85–121, plus ten plates of illustrations. This is the most thorough treatment of the *Patenbrief*. The author discusses not only the history of the custom, but outlines the regional variations of the manuscript and printed forms in Saxony and adjoining states, Alsace, and the Sudeten area now in the Czech Republic.

48. The now archaic words for godfather and godmother among the Pennsylvania Germans were *Petter* and *Goth*. Technically, the word *Pate* in *Patenbrief* can mean either godfather or godchild, although the German language developed specific words for the baptized child: *Patenkind, Pätchen*, and *Täufling*. The dialect Alsatian/Palatine word *Göttel* in *Göttelbrief* also means a goddaughter, and *Petter*, a godson.

49. Klaus Stopp, *The Printed Birth and Baptismal Certificates of the German Americans*, 6 vols. (Mainz, Germany, and East Berlin, Pa.: by the author, 1997–2001), 1:15–31, with illustrations. Several volumes in Professor Stopp's series have been published. Others are in preparatory stages.

50. Ibid., 24–26.

51. Don Yoder, *Pennsylvania German Immigrants, 1709–1786* (Baltimore: Genealogical Publishing Company, 1980), 267–270.

52. Ibid., 16–21, with a facsimile of the original document on 17–20.

53. Friedrich Krebs, "*Amerika-Auswanderer des 18. Jahrhunderts aus dem deutschen Südwesten*," in: *Genealogie* Heft 7 (1972): 216–220 (quotation on 220).

54. *Kirchen Buch Vor die der Augspurgischen Confession Zugethanen Evangelisch-Lutherischen Heiligen Dreifaltigkeits Kirche In Reading Berks County...Anno Domini 1754*, 81–82. This item was the 54th burial in the congregation for 1796. Archives of the Trinity Lutheran Church, Reading, Pa.

55. Theodore G. Tappert and John W. Doberstein, trans., *The Journals of Henry Melchior Muhlenberg In Three Volumes* (Philadelphia: The Muhlenberg Press, 1945–1958).

56. Ibid., 3:37. For backgrounds, see Hannah Benner Roach, "The Pennsylvania Militia in 1777," *The Pennsylvania Genealogical Magazine* 23:3 (1964): 161–229.

57. Ibid., 3:37.

58. Ibid., 3:43.

59. Ibid., 3:417.

60. Howard H. Wehmann and Monroe H. Fabian, "Pennsylvania German Fraktur: Folk Art in the National Archives," *Prologue* (Fall 1970): 96–97.

61. For the development of the Pennsylvania-German sense of identity as Americans, see Wolfgang M. Splitter, *"A Free People in the American Air:" The Evolution of German Lutherans from British Subjects to Pennsylvania Citizens 1740–1790* (Baltimore: by the author, 1993). This 417-page Ph.D. dissertation, done at Johns Hopkins University, is the product of thorough

research in eighteenth-century sources, and is full of important new insights, although the *Taufschein* problem is not mentioned.

62. This certificate is not included in "Daniel Schumacher's Baptismal Register," translated by Frederick S. Weiser, in *Publications of the Pennsylvania German Society* 1 (Allentown, 1968): 185–407. The baptisms in the original manuscript volume end with the year 1773.

63. For biblical themes in general in American religious folk art, with some references to fraktur evidence, see C. Kurt Dewhurst et al., *Religious Folk Art in America: Reflections of Faith* (New York: E. P. Dutton, Museum of American Folk Art, 1983), 84–106. Pennsylvania examples can be found in the picture sections throughout the entire book.

64. An exciting breakthrough revealing the European source for the Lutz and Scheffer printed *Taufschein* has been reported by Edward Rosenberry, who is working on a book on Gustavus S. Peters and his associates and successors in Carlisle and Harrisburg. Pastor Rosenberry discovered that the elaborate pictorial frame of the text of this printed *Taufschein* was adapted, in reverse, from the title page of the first edition of the King James Version of the Bible (1611). For both prints, see Stopp, *The Printed Birth and Baptismal Certificates of the German Americans*, 1:76–77.

65. William A. Coupe, *The German Illustrated Broadsheet in the Seventeenth Century: Historical and Iconographical Studies*, 2 vols. (Baden-Baden: Verlag Librairie Heitz, 1966, 1967), vols. 17 and 20 in the series: *Bibliotheca Bibliographica Aureliana*.

66. The Cassell Vorschrift of 1769 appears in John Joseph Stoudt, *Early Pennsylvania Arts and Crafts* (New York: A. S. Barnes and Co./London: Thomas Yoseloff, 1964), fig. 301. The tulip tree rising out of a double heart he calls "a simplified rendering of the old medieval 'root of Jesse', Aaron's rod, rising to bloom again from a God-possessed heart." The piece is also reproduced in Hopf, "Calligraphic Drawings," fig. 7; and in Don Yoder,

Vernon Gunnion and Carroll Hopf, *Pennsylvania German Fraktur and Color Drawings* (Lancaster, Pa.: Pennsylvania Farm Museum of Landis Valley, 1969), pl. 55. A color reproduction is available in Don Yoder, "Fraktur in Mennonite Culture," *The Mennonite Quarterly Review* 48 (July 1974): 321 (fig. 1), with commentary, 311–313; and in Moyer, *Fraktur Writings and Folk Art Designs*.

67. Of course, columns were also used earlier in the history of typography to frame Renaissance title pages, forming symbolic portals to the book within. For examples, see Nesbitt, *200 Decorative Title-Pages* (1964), for dozens of title pages dating from 1495 to 1650 pictured with columns or columns supporting an arch or doorway.

68. The most complete analysis of the fraktur motifs thus far is available in Shelley, *Fraktur Writings*, 81–94.

69. For the most recent research on symbolism in European folk art, see Rolf Wilhelm Brednich and Heinz Schmitt, eds., *Symbole - Zur Bedeutung der Zeichen in der Kultur: 30. Deutscher Volkskundekongress in Karlsruhe vom 25. bis 29. September 1995* (Münster: Waxmann Verlag, 1997).

70. A doctoral student of mine, Yvonne Lange, who became Director of the Museum of International Folk Art at Santa Fe, conclusively showed the influence of two-dimensional religious prints upon the three-dimensional *santos*, statues used by Hispanic Americans in their devotions. See her article, "Lithography, An Agent of Technological Change in Religious Folk Art: A Thesis," *Western Folklore* 33 (January 1974): 51–74.

71. Finally, let me pay personal tribute to twelve of my colleagues in this field—all of whom I have known personally and whose works I consult constantly: Henry S. Borneman, John Joseph Stoudt, Preston A. Barba, Alfred L. Shoemaker, Monroe H. Fabian, Donald A. Shelley, John L. Ruth, Mary Jane Lederach Hershey, Russell and Corinne Earnest, Klaus Stopp, and Frederick S. Weiser. And again, Henry Mercer, thank *you*!

... Wo ich dir daß mich

... du bey mir daß

... und alt, er kn...

... du bey

...

...

... und

... mich ...

... Tod und

... mich ...

... zum

...

...

Diese Vorschrift ...

Abraham ...

The Fraktur Texts and Pennsylvania-German Spirituality

Don Yoder

Some thirty years ago at a University of Texas Symposium on the German language in America, I made a suggestion which, in part, I am following up here. This is what I said to a large audience of professors and students, all Germanists from Europe and America:

Folk-cultural analysis should be undertaken on German-language texts from Pennsylvania and the areas influenced folk-culturally from Pennsylvania. By "texts" is meant not only German poetry, but tombstones, house inscriptions, the texts (as well as the symbols) of the *fraktur*, wills, account books, personal correspondence, spiritual testaments, baptismal letters, Bible records, prayers, and funeral texts.[1]

So in this paper I am offering an analysis of what we can learn from studying the texts that appear on Pennsylvania-German fraktur manuscripts, particularly but not exclusively those of Bucks County, emphasizing the religious underpinnings of these texts and how they reflect Pennsylvania-German religion and folk culture. And since most fraktur research thus far has overweighted the images and designs that appear on fraktur pieces, I will concentrate here on the written texts.

This is not to say that there has been no content analysis of fraktur texts. John Joseph Stoudt's seminal book, *Consider the Lilies How They Grow: An Interpretation of the Symbolism of Pennsylvania German Folk Art* (1937), did look at the fraktur texts, but drew from them an elaborate theory that connected the origins of both texts and symbols with medieval Catholic and later Protestant mysticism, an interpretation which some reviewers found excessive.[2] The book was later revised and expanded into *Pennsylvania Folk-Art: An Interpretation* (1948).[3]

A less extreme view appears in one of Dr. Stoudt's later works.[4] In dealing with the verses on fraktur he makes the suggestion that a great many of them, especially those that cannot be identified in European hymn collections, must have been composed here—products indeed of "the Pennsylvania German muse."

In addition, the work of Frederick S. Weiser, and his lengthy series of exciting "detective" reports identifying formerly unidentified frakturists, should be cited. In all of his publications, we are presented with full German texts, their translations, and pertinent commentary. A final example of this thorough approach is an essay by Robert G. Mickey entitled "Religious Dimensions," published in 1987.[5]

I have divided this paper into four sections: (1) what we can learn of Pennsylvania-German spirituality from studying the *Taufschein* or baptismal certificate; (2) what we can learn of Pennsylvania-German spirituality from studying the *Vorschrift* or writing exercise; (3) what we can learn of Pennsylvania-German morality from these texts; and (4) conclusions.

Three caveats before we begin:

1. It will be obvious that I take a synoptic view of Pennsylvania-German culture. In studying

these texts, I find such striking similarities between the sentiments expressed on sectarian fraktur and those on Lutheran and Reformed examples that, despite their differences in such areas as peace and war, I feel it best to unite the Plain Dutchman and Dutch Churchman under the same spiritual banner of Pietism, that powerful awakening in seventeenth-century Europe. Pietism reshaped Protestantism in ways that have lasted into our century.[6]

2. I prefer and shall use throughout my paper the term *spirituality*, which more than *religion* reflects attitudes and reactions of the individual to his or her universe.

3. Finally, my translations were made directly from the German texts. In the case of Bible verses, I did not substitute the more familiar translations from the English King James Version of 1611, but instead preferred to suggest the nuances I found in the German Bible texts.

The *Taufschein* or Baptismal Certificate

In Pennsylvania-German churches (Lutheran and Reformed) the rite of baptism was highly honored.[7] Infant baptism was a sacred ritual in which the child was formally christened with his or her Christian or baptismal name. In the earlier period, the child was also given godparents—often but not always close relatives of the parents—who stood as witnesses beside the parents at the christen-

ing, and in case of the parents' deaths promised to take over the rearing of the infant. In the plain groups, adult baptism, which brought the individual fully into the church community, was no less sacred, but had a different significance.[8]

Beyond and under the outward aspects of the rite, there were ancient theological underpinnings. The hymn which most frequently appeared on Lutheran and Reformed baptismal certificates was *"Ich bin getauft, ich steh im Bunde"* [I am baptized, I am a member of God's Covenant] (Fig. 31). The belief was that in baptism the child was brought into the covenanted community of the church in preliminary membership, to graduate eventually into full membership with the rite of confirmation—which *confirmed* or strengthened the grace received in baptism. From confirmation on, the teenager was considered a full member of the *Gemeinde*, or congregation, and could take Holy Communion as a visible symbol of his or her covenanted relationship with God and the church community.[9]

The Covenant Theology, developed primarily by the Reformed Pietists of Holland and Germany, influenced Pennsylvania Germans in their conception of the church and their relation to it.[10]

The favorite baptismal hymn, found on most printed and many manuscript baptismal certificates, usually had five verses and appeared in the prayer book of Johann Friedrich Stark (1680–1756), one of the most widely used devotional works among the Pennsylvania-German people. A rather quaint Victorian translation of Stark's hymn appeared in English in 1855:[11]

1. I am baptized! I am united
 And have a covenant with God;
 And thus, in gladness and in sorrow,
 And though I sink beneath the sod,
 I have what I can never lack,
 The joy that of the Lord doth smack.

2. I am baptized! I have the garment
 That of me makes a wedding guest,
 Wherein I may appear in glory
 Among the legions of the blest;
 For Jesus' blood and righteousness
 My beauty is, my gorgeous dress.

3. I am baptized! To me was given
 The blessing of the Holy Ghost;
 To cleanse my life and conversation,

Fig. 31. **Baptismal Certificate for Jesse Koder.** Unidentified artist, Haycock Township, Bucks County, c. 1816. Hand-drawn, lettered and colored on laid paper. 11¾ x 14¾ in. (Private collection.)

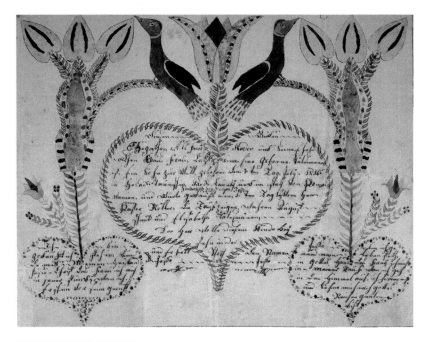

And that I never may be lost.
O gift beyond all thanks and praise
That gives me everlasting days!

4. I am baptized! my name was written
 Into the Lamb's own book of life;
 My father evermore will love me,
 And guard me well in every strife.
 God knows my name, and whispers it,
 For in his book of life 'tis writ.

5. I am baptized! And though I perish,
 O grave, where is thy victory?
 My patrimony is in heaven,
 And it shall never fall from me.
 When death arrives, I shall receive
 Far purer joys than those I leave.

The covenanted community into which the Lutheran or Reformed infant was brought through baptism was the church, the central spiritual and cultural force in the world of the Pennsylvania-German people.

A *Taufschein* was not only a personal and at least semiofficial ecclesiastical record of birth and baptism. It was also a devotional piece filled with spiritual suggestions and/or admonitions to the child. He or she treasured it through life, and—we hope—occasionally took it out of the bureau drawer, or dower chest, or Bible, and read it over. The *Taufschein* for Johann Adam Knappenberger, born in 1769 in Macungie Township in what is now Lehigh County (Bucks County until 1752), and baptized by the Lutheran pastor Jacob van Buskirk, includes four hearts containing inscriptions—either composed by or collected by the frakturist from his own devotional reading (Fig. 32).

The devotional texts on the Knappenberger *Taufschein* are as follows:

1. Place thy trust only in God, on human help thou shalt not rely. It is God alone who keepeth his faith, other than that there is nothing to be trusted anywhere in the world. Preserve thine honor, guard thyself against disgrace, honor is verily thy highest security.

2. Verily I say unto thee that the sufferings of this age are not worth glory. Forget not to do good and to share, for such sacrifices are well pleasing unto God. It has been said unto thee, O man, what is good and the Lord will

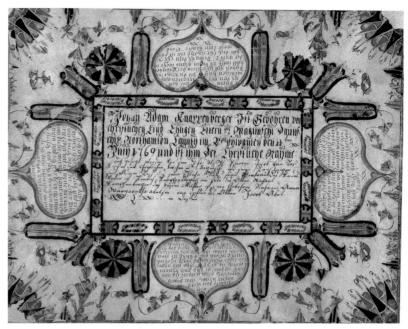

Fig. 32. Baptismal Certificate for Johann Adam Knappenberger. Unidentified artist, in the manner of Henrich Weiss, Macungie Township, Northampton (now Lehigh) County, c. 1769. Hand-drawn, lettered and colored on laid paper. 13 x 16 in. (Spruance Library/ Bucks County Historical Society, SC-58. No. B-04.)

demand of thee, namely, keep God's Word, exercise love, and live humbly.

3. I know that my Redeemer liveth, and he will raise me from the dead, out of the earth, and I shall thereafter be clad in this body of mine, and I will see God in my flesh. The same will I behold and mine eyes shall look again upon him.

4. Jerusalem, Jerusalem! Thou that killeth the prophets and stonest those who are sent to thee. How often have I wanted to gather thy children, as a mother hen gathers her little flock under her wings, and thou hath refused it.[12]

The *Taufschein* of Samuel Röder (Fig. 33), born 1779 in Hereford Township, Berks County, and baptized by the Reformed pastor Theobald Faber of New Goshenhoppen in Montgomery County, warns the child to beware of Satan:

Awake ye and be sober,
for your Adversary the Devil
goeth about like a roaring lion,
seeking whom he may devour.

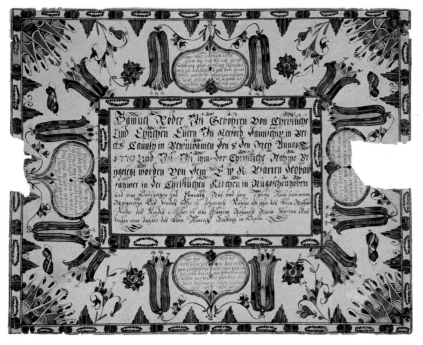

Fig. 33. **Baptismal Certificate for Samuel Röder**. Unidentified artist, in the manner of Henrich Weiss, Hereford Township, Berks County, c. 1779. Hand-drawn, lettered and colored on laid paper. 13¹/₂ x 16³/₄ in. (Spruance Library/Bucks County Historical Society, SC-58. No. B-05.)

A somewhat more optimistic text fills a second heart: "All those who choose to live a godly life in Christ Jesus must suffer persecution. Everyone who is born of God overcometh the world. Faith is the Victory that overcometh the world."[13]

The two-story universe of Earth and Heaven is reflected in the simple verse of an 1819 *Taufschein* for Isaac Wiewer, from Tinicum Township, Bucks County. The text reads: "Hold fast to God's Word. It is thy happiness on earth, and, as surely as God exists, will be thy happiness in Heaven."

The purpose of the *Taufschein* was not only to record the birth and baptism of a Pennsylvania-Dutch child. It registered—diagrammed in a sense—the network of relationships into which the child was initiated through the baptismal rite. This network included the *parents* (representing the home and family), the *minister* who performed the rite (representing the church, the holy community of faith into which the child was covenanted), and the *baptismal witnesses*, *sponsors*, or *godparents* (representing the surrounding human community in which the growing child was to take his or her place). Based on ancient theological tenets, baptism also freed the child from the stain of original sin, giving the child a clean slate, so to speak, with which to begin life, a covenanted member of God's family. The rite was also a rebirth into God's family, as the child had first been born into the human family. German church registers often used the terms *"natus"* and *"renatus"*—born

and reborn—to signify the child's birth and baptism.

Finally, the baptismal act was sacramental, a sacred rite in which the child's parents were also caught up in faith and promise in their child's life. Hence the *Taufschein* was a record of this sacred act and holy occasion to be treasured throughout life by the child for whom it was prepared. And the frakturist who prepared it customarily introduced into the texts moral and spiritual advice, with hopes and blessings for the child. Thus, *Taufschein* and *Vorschrift* overlapped in purpose and function.

The *Vorschrift*

The *Vorschrift*, or writing exercise, is an even more abundant and fruitful source for analyzing and understanding Pennsylvania-German spirituality. These were, as we know, done principally by the schoolmasters who taught writing to their pupils along with other basic subjects, including reading, in which the Bible or Testament was the usual text. The *Vorschriften* were set before the pupils as models for practicing calligraphy or given as a parting gift (*Osterletz*) to the child as the parish school closed its door usually at Eastertide.[14]

In either case—as copy model or parting gift—the purpose of the *Vorschrift* was to present moral and spiritual advice to the pupils, or, as they were usually called in Pennsylvania, "scholars." These textual admonitions to morality and encouragement in the spiritual life were to be taken to heart and become part of the student's outlook on life. The text prepared by the teacher was a moral lesson, a sermonette, for the student. Since textbooks such as became available in the schools of the nineteenth century—readers, histories, geographies, and so forth—were not available in the church schools of the eighteenth century, the *Vorschrift* concentrated Biblical and hymnodic wisdom into graphic and attractive form for teaching schoolchildren. These beautifully calligraphed texts were indeed lessons that supplemented and reinforced the teachings of the meager printed books used in pioneer schools—Testament, Psalter, hymnbook, and catechism.

The 1788 Barbara Wismer *Vorschrift* (Fig. 34) features the Pietist hymn, *"Auf Leiden folgt die Herrlichkeit"* [After suffering followeth glory], which appeared among other places in the sectarian hymnal, *Das Kleine Davidische Psalterspiel*. The *Vorschrift* contains the same eight

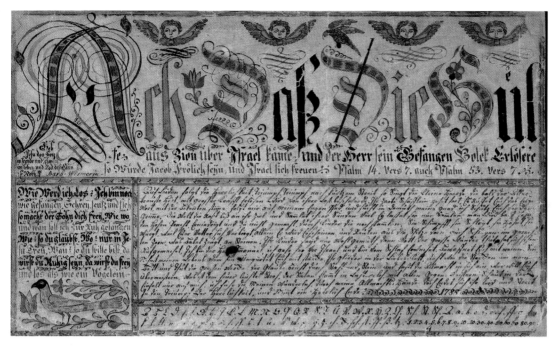

Fig. 34. **Penmanship Model for Barbara Wismer**. Attributed to Johann Adam Eyer, probably Hilltown Township, 1788. Hand-drawn, lettered and colored on laid paper. 8 x 13⅛ in. (Spruance Library/Bucks County Historical Society, SC-58. No. A-07.)

verses as in the hymnal.[15] The hymn begins with the theme of the Faithful Shepherd, and later generalizes on the destruction of worldly culture—with the sinful world and its "high pomp brought low."

> After suffering followeth glory,
> triumph, triumph!
> After a short struggle then the little flock
> singeth.
> For soon the most Faithful Shepherd will,
> with great power,
> Redeem them from the annoyance of their
> burden.
>
> Ye tender little sheep, go forth,
> The Eternal Word calleth unto thee with the
> familiar voice.
> Follow me on my narrow path, and seek my
> grace in humility.
> I will shield thee from the fury.
>
> The world that rageth all the way to its end
> and amasseth its sins aplenty. Ah, just let
> it amass them!
> Thou wilt soon see the high pomp brought
> low, and made into nothing...

This hymn features both the Pietist and Anabaptist fear of the world and its culture. It also includes the verse from the Psalms: "O, that out of Zion help would come over Israel, and the Lord would redeem his captive people. Then would Jacob be joyful, and Israel rejoice" (Psalm 14:7; 53:6).

The Anabaptist ballad tradition, seen in the narrative songs of martyrdom in the *Ausbund*,[16] may have a distant reflection in a *Vorschrift* made by or for Isaac Gross which centers on *"Der Edle Hirte, Gottes Sohn."* The Noble Shepherd, Son of God, left his kingdom, concealed his crown, and went about in sadness, seeking his poor lost little sheep. In a curious verse, the Shepherd, holding the rescued lamb safely in his arms, fends off the Wolf and his band of attackers, the hounds of hell. In the struggle, the Shepherd dies and is carried to the grave, but God dispatches the Wolf. The last verse shifts focus in an interesting manner:

> This dearly preserved little sheep art thou,
> O my soul!
> For thee he came into this pain,
> For thee to his sepulchre.
> So go thou now and tell him thanks with
> faithful and pure living,
> And give thyself to him, body and soul,
> as a Hymn of Praise.

This hymn, as originally titled, *"Der Edle Schäfer, Gottes Sohn,"* was written by Johann Scheffler (1624–1677), a Lutheran mystic better known as Catholic convert "Angelus Silesius."[17] As one of the most popular baroque hymnists of seventeenth-century Germany, many of his productions have

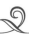
been translated into English. The hymn cited here appeared first in Scheffler's *Heilige Seelenlust, oder geistliche Hirten-Lieder* [The Soul's Holy Joy, or Spiritual Shepherd Songs], printed in Breslau in 1657. The first phrase was changed to *"Der Edle Hirte"* when the hymn appeared in Frelinghausen's *Gesangbuch* of 1705. The English translation by P. H. Molther, "The True Good Shepherd, God's Own Son," was included in the *Moravian Hymn Book* of 1789.

Here we have the perfect example of the penetration of high-baroque religious poetry, in this case emanating from Silesian Catholicism, into Pennsylvania's Mennonite world. The hymnals of our Pennsylvania forebears were indeed ecumenical in subject matter and feeling, compiled as they were from many parts of the Christian world.

This theme of Jesus the Good Shepherd, of course, has strong Biblical roots, and comes down in devotional literature and hymnody to the present day. I cannot refrain from mentioning here the Protestant gospel song on this theme, "The Ninety and Nine," by Pennsylvania hymnist Ira D. Sankey, song leader of the influential Moody and Sankey Revivals in the American cities in post-Civil War America.[18]

Another ballad-like hymn pictures as its hero Jesus the Warrior, the Lion of Judah. Jesus is also referred to in one verse as the Duke (*Herzog*),[19] adding yet another to the long series of images applied to Jesus. My favorite from the Pietist world is a hymn that appeared in several Pennsyl-

vania-German hymnals, "Jesus the Blacksmith," whose hammer shapes the human heart on his heavenly anvil. When I wrote *Pennsylvania Spirituals* in 1961, I was of the opinion that this somewhat odd production had been composed here in Pennsylvania, but later I discovered that it came from the pen of the leading Rhineland Pietist of the eighteenth century, Gerhard Tersteegen, whose books were popular here and often reprinted.[20]

At any rate, Jesus the Duke appears on a *Vorschrift* included by Henry C. Mercer in his pioneering essay on fraktur in 1897. He calls it an "illuminated leaflet" with a "floriated text."[21] The poetry narrates the struggle of Jesus versus Satan, under the name of Belial the Great. To provide something of the flavor of this very curious hymn, here are several verses:

1. O joyful hours, O glorious time! Now in the struggle the Duke [Christ] hath prevailed. The Lion [Christ] hath battled, the Lion hath triumphed, despite enemies, Devil, Hell, and Death. We live set free of affliction and peril.

2. With might the Warrior [Christ] put the world to flight, and Satan tormented the wretched sinners by day and by night. Hell nonetheless hath till now punished the Master, and grimly aimed at conquering our souls.

Fig. 35. **Penmanship Model for Abraham Oberholtzer**. School of Johann Adam Eyer, Bedminster Township, 1782. Hand-drawn, lettered and colored on laid paper. 8 x 12 ¾ in. (Spruance Library/Bucks County Historical Society, SC-58. No. A-15.)

3. There was here to be found no David the Bold, who could overcome the Giant's power, nor courageously slay Belial. No Joshua could overcome the Mighty One, and let him go without armor and weapons.

4. There was found no warrior but Jesus alone, Who as Warrior and Victor rose from the grave...

It *is* an odd production indeed, with some extremely odd imagery. But its purpose was to underscore the Protestant doctrine of Salvation through victory with Christ over the powers of evil.

A sidebar or secondary text to this *Vorschrift* heightens the gloom, since it presents one of the strongest statements on human mortality in the world of fraktur art:

> O dear man, whatever thou dost,
> Just remember that thou must die.
> Yet oh, how short is thy life!
> And thou must give God a reckoning of it.
> Therefore reflect on thyself quite plainly,
> How thou shouldst continually lead thy life.
> Hold God before thine eyes,
> And consider quite well
> Whither thy body and soul shall journey.
> For death is certain, the day, the hour uncertain.

Appearing in several *Vorschrift* texts, including Abraham Oberholtzer's of 1782 (Fig. 35), is the verse: *"Ich habe Lust abzuscheiden, und bei Christo zu seyn"* [I have a desire to depart, and be with Christ; Philippians 1:23]. The central text of this *Vorschrift*, however, is a gloom-filled hymn asking for God to stand by when everything else has deserted the singer. The hymn begins, *"Kein Stündlein geht dahin..."* [No brief hour passeth that I don't remember, wherever I am, that Death will put me in the final misery. O God, when everything else forsaketh me, then do thy best for me]. The latter is a refrain ending each successive verse.[22]

As the verses continue, the picture of Death gets worse. Verse 2 reads: "Here there is no sojourn. Death hath the power. He devoureth and wreaketh havoc on young and old. He teareth us out of our earthly condition and place." In verse 3, we learn that "there is no medicine versus Death. No howling or outcry, no brother can set us free." Verse 4: "No bold hero's courage availeth against

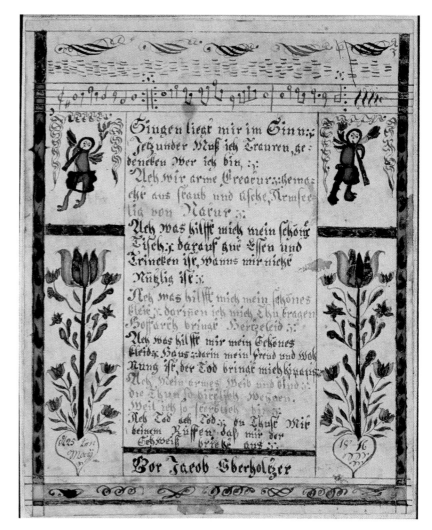

Death's fury and rage." But at least verse 6 offers some hope: "When sin and Satan overwhelm me as a trial, who is it that hath mercy upon me?" Obviously God, who is asked, the refrain pleads, "When everything else forsaketh me, then do thy best for me."

This dreadful, frightening personification of Death, like the common English phrase the *Grim Reaper*, with its connotation of a gruesome harvest, has, of course, long iconographic traditions in Christian art as well as theological roots in the Bible.

That these verses were meant for schoolchildren reveals plainly how much of the medieval Catholic worldview of Salvation and Damnation, Heaven and Hell, Immortality and Mortality was absorbed and continued by Protestantism at the time of the Reformation. In the seventeenth century, these central ideas were sharpened and made even more graphic by the Pietist theologians and hymnists whose works influenced the Pennsylvania Ger-

Fig. 36. **Hymn for Jacob Oberholtzer.** Unidentified artist, Bucks County, 1816. Hand-drawn, lettered and colored on laid paper. 7¼ x 5¾ in. (Spruance Library/Bucks County Historical Society, SC-58. No. A-06.)

mans, churchmen and sectarians alike.

In their thinking about religion and the relation of the individual to the spiritual universe, both the Plain groups and the Lutheran and Reformed Pietists constantly underlined human mortality.[23] This life was in most cases undervalued in favor of Heaven. There are, of course, biblical roots for this idea, and much stress upon it in medieval Catholicism, but the Pietist clergy of the seventeenth century accented mortality to an extreme degree.

Jacob Oberholtzer's little song dated May 25, 1816 (Fig. 36), furnishes one of our best examples. It reflects in its opening lines and in two verses a hymn from the Anabaptist-Mennonite-Amish hymnal, the *Ausbund*.[24] However, the *Ausbund* hymn has forty verses, and this hymn only eight. This is how it goes:

> I have it in my mind to sing
> But now I must mourn
> To think who I am.
>
> Oh, we poor creatures!
> Made of dust and ashes,
> Miserable by nature.
>
> Oh, what help to me is my fine table
> Decked with good food and drink,
> When it is no longer of use to me?
>
> Oh, what help to me is my raiment,
> In which I do transport myself.
> Pride bringeth grief.

> Oh, what help to me is my fine house,
> In which are my joy and dwelling?
> Death will take me out of it.
>
> Alas, my poor wife and child,
> Who do weep so bitterly,
> Because I am so mortal.
>
> Oh Death! Oh Death!
> When thou callest
> I break out into a cold sweat.

All of this Pietist pessimism and the historical reasons for it are summarized by the British scholar William A. Coupe, in his volume on seventeenth-century German broadsides:

> Like the late Middle Ages the seventeenth century is obsessed with the fact of death and the darkness and corruption of the grave. The brief "Lutheran pause," when the medieval concern with death, although never completely forgotten, was overlaid by the welter of religious controversy and the joy at the re-discovery of Justification by Faith, is over. The inherent pessimism of the age is intensified by one of the most destructive wars in the history of mankind, and the skeleton is a natural symbol in which the pathetic vanity of all human aspirations and dignities may be subsumed. Without exception, the innumerable considerations of death all speak the traditional language of Christian belief, yet in their pathological preoccupation with the physical decompo-

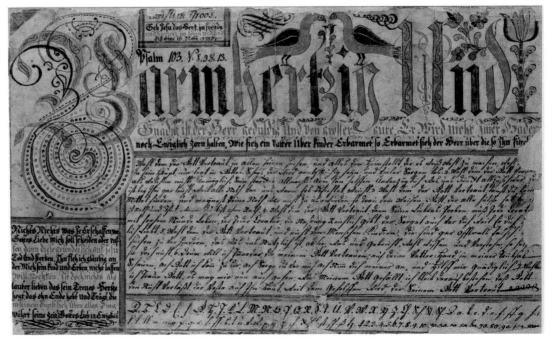

Fig. 37. **Penmanship Model for Christian Groos [Gross].** Attributed to Johann Adam Eyer, Bucks County, c. 1785. Hand-drawn, lettered and colored on laid paper. 8¼ x 13¼ in. (Spruance Library/Bucks County Historical Society, SC-58. No. A-14.)

sition of the body and the feverish nature of their vision of the transience of all created things, many of them bear witness to a deep-seated *malaise* which is tantamount to a failure of belief.[25]

This emphasis was particularly true, the analysis continues, of Protestant writers. As an example, the poetry of Andreas Gryphius is cited, in which "there is little trace of the joyous *fides fiducialis* which had proclaimed itself in so many of Luther's hymns...."[26]

If mortality was a common theme in the fraktur texts, assurance of salvation—as in the nineteenth-century hymn, "Blessed Assurance"—is occasionally expressed.[27] In an undated *Vorschrift* for Christian "Groos" (Fig. 37) based on Psalm 103:8, 9, 13, the thought appears:

> Merciful and gracious is the Lord, patient and of great goodness. He will not always quarrel, nor hold his wrath forever. As a father showeth mercy to his children, so the Lord showeth mercy to those who fear him.

The left sidebar on this piece adds an even more comforting thought:

> Nothing, nothing that hath ever been created,
> Shall separate me or snatch me away from God's love,
> For this love is grounded in the death and dying of Jesus.[28]
> Him I implore full of faith, who neither will nor can desert me, his child and heir.
> Surely it is nothing but pure love that his true heart containeth,
> That everlastingly exalteth and sustaineth those who exert themselves in his service.
> Everything lasteth its time, God's love lasteth for eternity.

Most of the inscriptions in the *Vorschrift* writing exercises or copybooks reflect the spirituality of the teachers who prepared the documents. Margaretha Wissmer, "pupil of writing in the Perkasie School," was given a copybook (Fig. 38) in which the schoolmaster wrote this prayer for the little girl:

> O Lord, sigh forth thy Spirit on this Margreth, and lead her through the world, up to thy heavenly home, that she may follow after thee, also trust

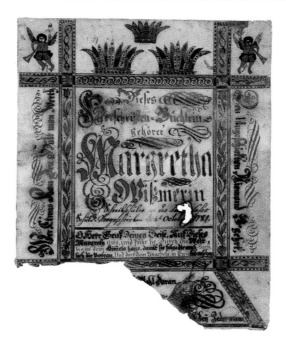

Fig. 38. **Copybook for Margaretha Wissmer [Wismer]**. Attributed to Johann Adam Eyer, Perkasie School, Hilltown Township. Hand-drawn, lettered and colored on laid paper. 8 x 6⅝ in. (Spruance Library/Bucks County Historical Society, SC-58. No. A-04.)

thee with her whole heart, and there contemplate thy countenance...

This is in spirit similar to a prayer on a Berks County *Taufschein* filled out by the immigrant schoolmaster Carl Gock:

> Joyous, and accompanied with pleasure and blessing, may, good Samuel, thy earthly pilgrimage be. And at the end of thy life, move with blessing into a better Fatherland. This thy friend Carl Gock wishes for thee.[29]

Before returning to the analysis of the *Vorschrift*, I include yet another short but moving inscription, this time from a bookplate. Jacob Kintzi's copy of the Marburg Reformed hymnal contains a bookplate (Fig. 39) dated April 29, 1788, at Rockhill Township, Bucks County, with this verse:

> I myself cannot rest, nor do I wish to,
> The great God's mighty deeds
> Awaken all my senses.
> I sing along when everyone sings,
> And let flow from my mouth
> What resoundeth to the Highest.[30]

It is easy to picture the little boy "singing along" in one of the great Reformed or union churches of the area, as the schoolmaster-organist led the music.

Now, back to the *Vorschrift*. The cult of the Wounds of Christ, which developed in the Catholic

of 1841 bearing the name Joel Cassell (Fig. 40) features the Pietist wounds hymn, *"Jesu, deine heilge Wunden"* [Jesus, thy holy wounds] which appeared in many Pennsylvania-German hymnals.[32]

The hymnist finds consolation in the wounds and passion of Christ, meditation upon which keeps man on the Narrow Way:

1. Jesus, may thy holy wounds, thy torture and
 bitter death,
 Console me every hour in times of bodily and
 spiritual need.
 When something evil falleth to my lot, let me
 think of thy pain,
 So that I ponder in my heart thy anxiety and
 sorrows.

2. My ruined flesh and blood want to delight in
 sensual pleasure.
 Let me consider that thy passion must quench
 the fires of Hell.
 If Satan presseth in to me, help me to hold
 before him
 Thy wound marks and signs so that he must
 retreat from me.

3. When the world tryeth to lead me astray onto
 the broad way of sin,
 Wilt thou therefore govern me that I may
 then behold
 The heavy burden of thy agony that thou hast

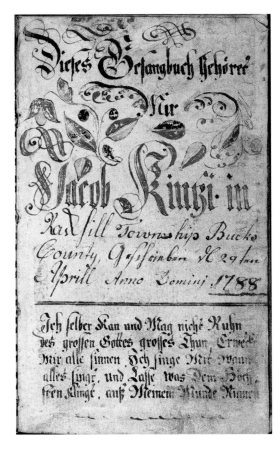

Fig. 39. **Bookplate for Jacob Kintzi.** Unidentified artist, Rockhill Township, 1788. Hand-drawn, lettered and colored on laid paper. 6 x 3⅝ in. (Spruance Library/Bucks County Historical Society, SC-58. No. C-12.)

Middle Ages, was even more eagerly promoted in the Catholic Counter-Reformation and Protestant Pietism during the baroque era of the seventeenth century. It also survived in several Bucks and Montgomery County *Vorschriften*.[31] A religious text

Fig. 40. **Penmanship Model.** Probably Joel Cassell, Montgomery County, 1841. Hand-drawn, lettered and colored on wove paper. 7¾ x 12¼ in. (Spruance Library/Bucks County Historical Society, SC-58. No. A-20.)

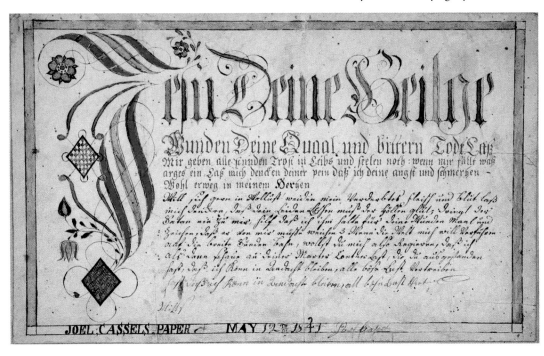

endured,
So that I can remain in devotion and drive away every evil desire.

This Pietist gearing of Christ's passion into the devotion of the individual is similar to the Counter-Reformation stations of the cross in Catholicism. Catholicism does it with a procession around the church aisles, stopping and praying at each of the fourteen pictorial representations of the passion, the fourteen stations. Protestantism does it less theatrically but nevertheless in an equally moving manner through hymnody, the congregation singing together of the passion of Christ.

Contemplation of the Passion of Christ (in German, *Das Leiden Christi*) reached high Pietistic heights in the *Vorschrift* booklet of a probable but as yet unidentified Pennsylvania-German schoolmaster named Christian Gottfried Weber (Fig. 41). His title page tells it all: "Mournful, Comforting, and Grateful Feelings on Contemplating the Passion of Jesus, Inspired on Holy Palm Sunday, 1786. Piously glorified by Christian Gottfried Weber."

In several beautifully tailored German verses, the schoolmaster-poet compares Mt. Tabor, the mount of the Transfiguration of Christ, with Golgotha, where Christ died in misery, and, to the world, disgrace. In the last verse, the poet asks Jesus to "impress this upon my heart" as a living testimony. "Let it, in times of suffering and pain, be for me consolation and comfort. Let me praise thee gratefully for the bloody proofs of thy faithfulness." Each verse to this five-verse supplication ends with *Amen, Amen!*

To counter these gloomy theological themes inherited from the Middle Ages, let us end this section on the more optimistic and pleasant note of the wonders of God's creation and humanity's appreciation of it. For German hymnals also featured hymns for the church year—New Year's, Easter, Pentecost, and Christmas, of which the Christmas offerings were the most joyous. They also included seasonal hymns, lovely nature-oriented paeans to Spring, Summer, Autumn, and Winter, which praised creation and expressed human joy over the changing seasons—*die vier Jahreszeiten*, as they are called in German.

One of these is the matchless Summer Hymn, *"Geh aus, mein Herz, und suche Freud,"* by the Lutheran hymnist Paulus Gerhard (1606–1676).[33] The Schwenkfelder frakturist Susanna Hübner

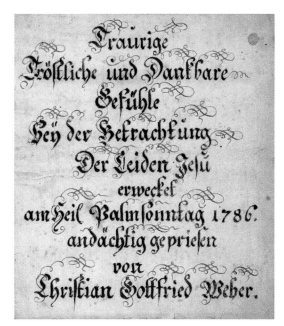

Fig. 41. **Copybook of Christian Gottfried Weber.** Christian Gottfried Weber, probably Pennsylvania, 1786. 9 x 7³/₄ in. (Spruance Library/Bucks County Historical Society, SC-58. No. A-41.)

decorated several *Vorschriften* with this hymn. It is presented here in English:

1. Go forth, my heart, and seek delight
 In all the gifts of God's great might,
 These pleasant summer hours:
 Look how the plains for thee and me
 Have deck'd themselves most fair to see,
 All bright and sweet with flowers.

2. The trees stand thick and dark with leaves,
 And earth o'er all her dust now weaves
 A robe of living green;
 Nor silks of Solomon compare
 With glories that the tulips wear,
 Or lilies' spotless sheen.

3. The lark soars singing into space,
 The dove forsakes her hiding place,
 And coos the woods among;
 The richly-gifted nightingale
 Pours forth her voice o'er hill and dale,
 And floods the fields with song.

4. Here with her brood the hen doth walk,
 There builds and guards his nest the stork;
 The fleet-wing'd swallows pass;
 The swift stag leaves his rocky home,
 And down the light deer bounding come
 To taste the long, rich grass.

5. The corn springs up, a wealth untold,
 A sight to gladden young and old,
 Who now their voices lift

To him who gives such plenteous store
And makes the cup of life run o'er
	With many a noble gift.

6. Thy mighty working, mighty God,
Wakes all my powers; I look abroad
	And can no longer rest:
I, too, must sing when all things sing;
And from my heart the praises ring
	The Highest loveth best.

7. I think, art thou so good to us,
And scatterest joy and beauty thus
	O'er this poor earth of ours;
What nobler glories shall be given
Hereafter in thy shining heaven,
	Set round with golden towers.[34]

The Pennsylvania Germans were for the most part farmers, living and working on their own land, tilling, cultivating, and gathering in the harvests on which they depended for their life and livelihood. Hence such hymns as this one, in praise of Creation, ministered to their spirits and led to prayers of thanksgiving. This expression of gratitude was formalized in the churches with the Pennsylvania-German thanksgiving service called *Harvest Home*.

Fraktur and Pennsylvania-German Morality

This section discusses the central themes in Pennsylvania-German morality, as inculcated both in the Plain and the Pietist lifestyles. Here, one of the key concepts in both Anabaptist and Pietist spirituality and morality is *Demuth*—humility. It is, of course, the opposite of *Hochmuth*, or pride—the pride that, as we learned as children, goeth before a fall.

One of Henry Mercer's fraktur discoveries was an undated *Vorschrift* (Fig. 42) with the curious text, *"Der Kinder Lieb ist sonderlich"* [The love of children is special].[35] It tells us that the love shown by little children is indeed special as long as it remains in simplicity. But as soon as children leave simplicity behind, they want to be big and therefore they fall.

Hence ye little children dear,
Love humility and keep yourselves small.
You will rejoice in eternity,
But the opposite will bring you rue.

As stated, the Anabaptist emphasis on *Demuth*, which continues in the present generations of the Plain churches, was shared by the Lutheran and Reformed Pietists. It was also decidedly shared by Anglo-American Puritans, Quakers, and Shakers, as well as other evangelical Protestant movements.[36] There is a charming little hymn, "The Valley of Humility," which appeared in the song and prayer book, the *Geistliches Gewürz-Gärtlein* [The Spiritual Spice-Garden], compiled by Jacob Stoll (1731-1822), Dunkard elder from Lancaster County. It was published at Ephrata by Johannes Baumann in 1806.[37]

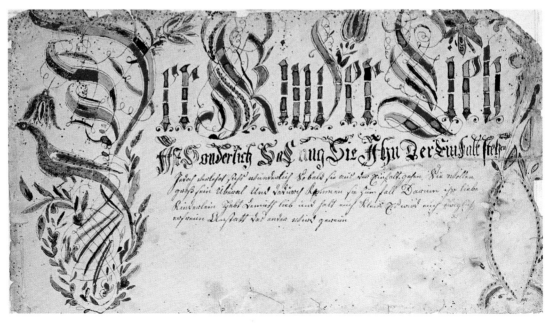

He who tarries in the Valley of Humility
 And spends his time therein,
Fares much more safely than the man
 Who seeks the world's proud esteem.

This Valley of Humility is also the Valley of Peace (*Friedens-Thal*), recalling the memorable word *"Friede"* [peace] that was used as a name for countless *Friedens-Kirchen* (peace churches) among the Pennsylvania Germans. The whole concept of humility and peace as it is worked out in Pennsylvania-German spirituality reminds one of the Shaker song, "Tis the gift to be simple," and even brings to mind the call in Chinese mysticism to be low, dwell low, dwell in the valley.

Fraktur very often reveals the deepest ideals of the Pennsylvania-German people, whether churchly or sectarian. Protestants followed Luther's revolutionary idea that people find their "calling" (Latin: *vocatio*) in their everyday work—not in separating themselves as clergymen, monks, or nuns from the world. The medieval meaning of the word *vocatio* was just that—a calling to serve God as clergy in a higher status than the laity. Luther's equally revolutionary idea of the "priesthood of all believers" reconfirmed this, by underlining humanity's direct, immediate approach to God rather than through a priesthood removed by ordination from the laity. By this universalizing of the priesthood to include all men and women, the Protestants said that we, all of us, minister to each other in our everyday relationships with family and community. Certainly the Plain sects took this to its logical conclusion in treating every man as *brother* and every woman as *sister* in the community. This came also to be a key point in the Pietist construction of the church as the holy community of like-minded brothers and sisters.

If equality before God and mutual ministry were Protestant teachings, so too was "work as vocation" considered a key Protestant ideal. In fraktur texts, the call to perfection in work was repeated many times.

Whoever can do something is highly esteemed,
There is no call for an unskilled person.

We are also encouraged in our daily work by the words on a Huppert Cassel *Vorschrift* of 1766: "Therefore I perceive that there is nothing better than that a man should rejoice in his work." The

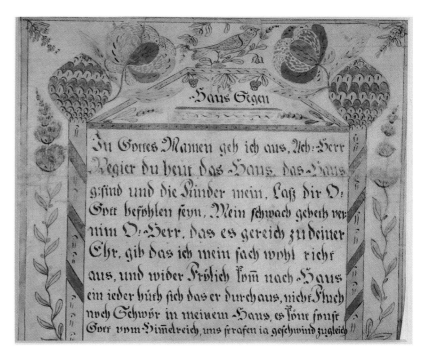

Fig. 43. **House Blessing**. Attributed to Bernhard Misson, Bucks County, c. 1820. Hand-drawn, lettered and colored on laid paper. 8 x 9¹⁄₂ in. (Spruance Library/Bucks County Historical Society, SC-58. No. A-16.)

Pennsylvania Germans, plain or churchly, shared with medieval Benedictinism the call to work and prayer as the two foci of the Christian life. The Benedictine motto was *ora et labora*, work and pray—or pray and work, putting the prayer first.[38]

The Christian household, well-governed and presided over by a devout father, was another moral concept embedded in fraktur. Here the concept of *blessing* comes into focus. God's blessing was asked at the pious farmer's table every day, at every meal in some families. In another manifestation of the concept, newly built Lutheran and Reformed churches were consecrated with formal blessing services attended by the neighboring pastors. New church organs also received a blessing or consecration at special services. The church groups, with their closer relation to the Catholic heritage of the Middle Ages, probably emphasized the blessing of material things more than did the Plain groups, to whom all things in God's world were blessed already.

But both groups stressed the blessing of the house and household. One relatively common genre of fraktur was the *Haussegen*, or house blessing. An unusual example from Bucks County is a prayer for the household in the absence of the father who has to leave on business (Fig. 43):

In the name of God I go out. O Lord, govern thou today this house, the domestic servants and my children. Let them be, O God, committed unto thee. Hear my humble prayer, O Lord, that

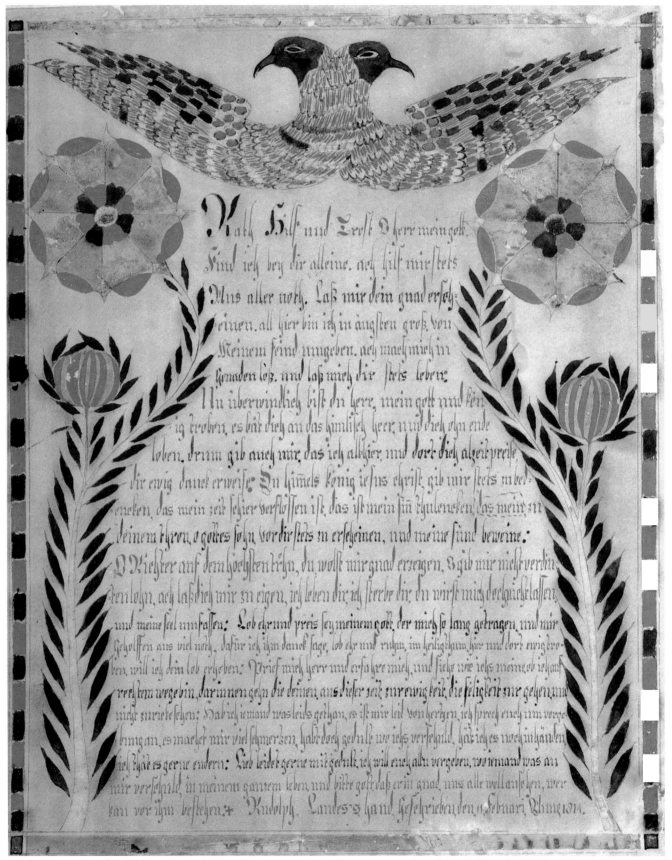

Fig. 44. **Hymn Text of Rudolph Landes**. Rudolph Landes (1789–1852), Bucks County, 1814. Hand-drawn, lettered and colored on wove paper. 10 x 7³/₄ in. (Rare Book Department, The Free Library of Philadelphia, FLP 398.)

it may redound to thy glory. Grant that I may carry out my business well, and return home rejoicing. May each one keep absolute watch that he neither curseth nor sweareth in my house, else God from Heaven could swiftly punish us all together.[39]

This text reflects the domestic prayer books that Pennsylvania Germans read in their homes for devotion.[40] Many of these eighteenth- and nineteenth-century volumes contained prayers for setting out on a journey and returning home from one.[41] And that last phrase—that God is quick to punish refractions of his law—reminds us that the Pennsylvania Germans, like the New England Puritans, believed in direct punishment and its more pleasant reverse, special providence.

Finally, forgiveness appears as an ideal in personal relations within the Pennsylvania-German community. In his sixty-fifth year (1796) Rudolph Landes (1732–1802), first deacon of the Deep Run Mennonite congregation, composed a thirteen-verse hymn beginning: *"Rath Hilf und Trost, O Herr mein Gott, Find ich bei Dir alleine"* [O Lord my God, I find with thee alone counsel, help, and consolation].[42] This hymn, represented in fraktur by an eight-verse version penned in 1814 by the deacon's grandson (Fig. 44), is an acrostic, with the first letters of each of the thirteen verses spelling out the name RUDOLPH LANDES. Although a baroque technique, it was used occasionally in Anabaptist hymnody, supposedly to conceal an author's name in times of persecution.

The Landes hymn also resembles the *Sterbelieder* (dirges) of earlier Anabaptist writers. For example, verse 8 is addressed to his friends, verse 10 to his children, and verse 12 to all his friends, wife, children, and brothers and sisters with their households. The word *friends* here can refer to the writer's wider family network as expressed in the Pennsylvania-German word *Freindschaft*. Verses 7 and 8 reflect the Protestant, Christian, and Pennsylvania-German ideal of mutual forgiveness:

7. If I have injured anyone in any way, I am deeply sorry. I ask you all for forgiveness....

8. ...I want to forgive you all, where anyone has been guilty toward me in my entire life, and pray God that he may look upon us all in grace. Who can stand before him?

With this high note of forgiveness and reconciliation between family and friends, we close our analysis of the fraktur texts and move on to our conclusions.

Conclusions

In summary, what are the major themes we have discovered in this preliminary investigation of the spiritual underpinnings of Pennsylvania-German fraktur texts?

First, basic to the general body of fraktur is the biblical perspective of man as creature, part of God's creation, but with special duties owed to that God. The full three-story universe of historical Christianity, with earth, heaven, and hell, is found as well, with man in the middle of it all choosing by his moral actions and his faith his destination for eternity in salvation or damnation. The spiritual universe reflected in the texts includes God, Christ, and the Holy Spirit, along with a heavenly host of angels and departed spirits. It also encompasses the forces of evil—constantly attacking and tempting man—gruesomely personified in a very real Devil and his hounds of hell.

Second, the legacy of seventeenth-century Pietism, the great movement that reshaped Protestantism, is seen in the heart symbolism that flowered in European religious art in the seventeenth century, in the cult of the Wounds of Christ (brought to its ultimate perfection by the Moravians),[43] and in the constant recalling of the Passion of Christ. These *cults* (and I use the term here to mean a focus of devotion), while resting on biblical images, were intensified by Protestant Pietism in the seventeenth century, as well by the Catholic Counter-Reformation. On both sides of the Protestant-Catholic divide, they represent the new devotion of the baroque era.

Third, fraktur documents were not looked upon as art for display, as in Catholicism. They were devotional pieces, belonging to individuals whose birth and baptism they recorded or out of whose days in the parish schools of the Lutheran, Reformed, Mennonite, and other denominations they had come. We have little evidence that they were ever framed and put on display on the walls of the Pennsylvania-German home (there were no "fraktur rooms" as at Winterthur and elsewhere in the museum world). Their purpose was not decoration but edification. They were intensely individual

pieces, to be treasured through life and occasionally looked at with devotion, remembering the fraktur artists, pastors, and schoolmasters, and their moral teachings. In these pieces, which we treat as *art* today, the Pennsylvania-German boy or girl, man or woman reconfirmed the moral ideals taught him or her by parents, schoolmasters, and ministers. These ideals included devotion to God, love of neighbor and service to humanity, a life of humility and honor, daily work, meditation with preparation for death and eternity, prayer and blessing.

Fourth, the themes I have found and outlined in the texts seem at first glance to have a preponderance of—at least to us living today—gloomy, world-denying ideas, with the thought of human mortality prominently featured. But if there was gloom and warnings to follow not the broad way but the narrow way, there was also joy. Among the most delightful productions of Pennsylvania's fraktur artists were the baptismal certificates of Johannes Spangenberg, the highly talented Reformed schoolmaster of Easton, Northampton County.[44] Many of his productions pictured musicians and dancing figures—one can almost hear the music—suggesting the joy over the birth and baptism of a Pennsylvania-Dutch infant, for whom the church community signified its blessing by providing a godfather and godmother. And, we know from other sources that the eighteenth-century Dutch sometimes held a baptismal party to celebrate the community act of baptism. Hence, everything was balanced, and Pennsylvania-Dutch *Gemütlichkeit*, brought from the Rhineland villages of Lutheran and Reformed emigrants, was accompanied with and tempered by *memento mori*, reminders of mortality.

The birds and flowers, animals, angels, and humans that appear in bright colors on fraktur must have given joy to the child and adult for whom these documents were originally made and given as gifts. They, too, represented features of God's creation, the world in which the Pennsylvania-German Protestant,

whether churchly or sectarian, could delight. The world that was forbidden and dangerous was not that of original creation but rather the world of manmade culture, with its forbidden temptations.

Fifth, and finally, is this thought: The study of fraktur texts leads us to an understanding of that ancient and ongoing stream of spirituality in which succeeding generations of Christians, Catholic *and* Protestant, churchly *and* sectarian, expressed their concept of the relationship of man to his universe. Henry Mercer was right in pointing out the medieval roots of fraktur illumination, even though he neglected the seventeenth-century baroque calligraphy which was fraktur's immediate inspiration. Indeed, all the themes that we have drawn from our study of fraktur texts had earlier roots, often long and complicated ones, stretching in some cases back to the Old and New Testaments.

But the stream of spirituality continues. When fraktur production in the classic sense (with a few exceptions) died a natural death by the Civil War era, the same themes—Heaven and Hell, the Passion of Christ, the Wounds of Christ, and especially the Blood of Christ—made a new and powerful appearance in song. They reemerged in the American Protestant gospel songs of the post–Civil War period, mentioned at several points previously. Protestant hymnals were second only to the Bible as devotional literature for the Pennsylvania-German household, and one often recalls phrases from favorite hymns as illustrations.

Perhaps the best way to close is to call to mind the mosaics along the walls of the Church of St. Apollinare in Classe, at Ravenna on the Adriatic coast of Italy, which portray the Church as an ongoing procession through time. A procession, after all, is moving and dynamic—not static. The spirituality of the Pennsylvania Germans who produced and treasured these fraktur pieces represented one way station of that complex, protean, fascinating—and dynamic—religious movement known as Protestantism.

Notes

1. Don Yoder, "Pennsylvania German Folklore Research: A Historical Analysis," in *The German Language in America*, Glenn G. Gilbert, ed. (Austin: University of Texas Press, 1971), 70–105, 148–163, quotation on 101.

2. John Joseph Stoudt, *Consider the Lilies How They Grow: An Interpretation of the Symbolism of Pennsylvania German Folk Art* (Allentown, Pa.: Pennsylvania German Folklore Society, 1937).

3. Stoudt, *Pennsylvania Folk-Art: An Interpretation* (Allentown: Schlechter, 1948).

4. Stoudt, *Pennsylvania German Poetry 1685–1830*, in *Publications of the Pennsylvania German Folklore Society* 20 (Allentown: Schlechter, 1956).

5. Robert G. Mickey, "Religious Dimensions," in *Fraktur: A Selective Guide to the Franklin and Marshall Fraktur Collection* (Lancaster: Franklin and Marshall College, 1987).

6. The intricate relations between Anabaptism, the older sectarian movement, and Pietism, which developed within the Lutheran and Reformed churches but produced radical, sectarian, and separatist offshoots, have been treated by Robert Friedmann in several articles in the *Mennonite Quarterly Review* in 1940–1941 and surveyed in his book, *Mennonite Piety Through the Centuries* (Goshen, Ind.: Mennonite Historical Society, 1949). See also the indispensable work of Max Goebel, *Geschichte des Christlichen Lebens in der rheinisch-westphälischen Evangelischen Kirchen*, 3 vols. (Coblenz: Karl Bädeker, 1849, 1852, 1860); Rufus M. Jones, *Spiritual Reformers in the Sixteenth and Seventeenth Centuries* (London: The Macmillan Co., 1914); and the extremely useful treatments by F. Ernest Stoeffler, *The Rise of Evangelical Pietism* (Leiden: E.J. Brill, 1965); and *German Pietism During the Eighteenth Century* (Leiden: E.J. Brill, 1973). Also relevant is the symposium he edited, *Continental Pietism and Early American Christianity* (Grand Rapids, Mich.: William B. Eerdmans, 1976).

7. The best study thus far on infant baptism among the Pennsylvania-German church people is Frederick S. Weiser, "The Concept of Baptism among Colonial Pennsylvania German Lutheran and Reformed Church People," in *Lutheran Historical Conference Essays and Reports* 4 (1970): 1–45. See also his article, "Piety and Protocol in Folk Art —Pennsylvania German Fraktur Birth and Baptismal Certificates," *Winterthur Portfolio* 8 (1973): 19–43; and for textual comparisons, "Baptismal Certificate and Gravemarker: Pennsylvania German Folk Art at the Beginning and the End of Life," in *Perspectives on American Folk Art*, Ian M. G. Quimby and Scott T. Swank, eds. (New York/London: W. W. Norton & Co., 1980), 134–161.

8. For Anabaptist/Mennonite concepts of adult baptism, see *The Mennonite Encyclopedia*, 5 vols. (Hillsboro, Kans.: Mennonite Brethren Publishing House, et al., 1955–1982), 1:224–228; for their reasoning against infant baptism, see 3:34–38.

9. On confirmation in the Pennsylvania–German churches, see Charles H. Glatfelter, *Pastors and People: German Lutheran and Reformed Churches in the Pennsylvania Field, 1717–1793*, 2 vols. (Breinigsville, Pa.: Pennsylvania German Society, 1979, 1981), 2:253; also Henry Eyster Jacobs and John A. W. Haas, eds., *The Lutheran Cyclopedia* (New York: Charles Scribner's Sons, 1899), 130–131.

10. For the Covenant Theology, also called the Federal Theology, as developed in the Reformed churches of Holland and Germany, see James I. Good, *The Origin of the Reformed Church in Germany* (Reading, Pa.: Daniel Miller, 1887). The concept of God's covenants with man has exercised a powerful influence upon Protestantism, from Pietism and Puritanism in the seventeenth century, to Dispensationalism in our days. The Anabaptists individualized the covenant idea, believing that "at baptism the [adult] individual makes a voluntary covenant with God, of which baptism is the symbol, and that the church is actually a brotherhood of such 'covenanters'" (*Bundgenossen*). Some Reformation scholarship has held that the Anabaptist emphasis on such covenants led the Reformed Churches in Switzerland to develop their own views. See *The Mennonite Encyclopedia*, 1:726–727.

11. Johann Friedrich Stark, *Daily Handbook for Days of Rejoicing and of Sorrow* (Philadelphia: I. Kohler, 1855, 1879), 274–275. Johann Friedrich Stark was a leading Lutheran Pietist and pastor at Frankfurt-am-Main. His prayer book, *Tägliches Handbuch in guten und bösen Tagen*, appeared first in 1727 and was enlarged into its present form in 1731. It has had a "phenomenal circulation" in Europe, and was undoubtedly the leading prayer book used in private devotions among the Pennsylvania Germans. For the author's career, see Jacobs and Haas, *The Lutheran Cyclopedia*, 454.

12. Of these texts, no. 2 obviously reflects Micah 6:8; no. 3 is based on Job 19:25–27; and No. 4 on Matthew 23:37.

13. The warning against the Devil is from I Peter 5:8; the contents of the second heart reflect II Timothy 3:12, and I John 5:4.

14. For the curious term *Osterletz* and its etymology, see Don Yoder, "Fraktur in Mennonite Culture," *The Mennonite Quarterly Review* 48 (July 1974): 305–342. A Pennsylvania *Vorschrift* of 1765 is signed: "*Marthin Däthweyler, Der hat Diese Osterletz geschrieb[e]n allhir in der Schul im Jahr 1765.*" For the text of this piece and the European background of the term *Osterletz*, see 315–316, and fig. III, 323.

15. In making this comparison, I used a copy of the Ephrata edition of the *Psalterspiel* (1795), which according to a manuscript note written in it was used for many years in a Mennonite congregation in Lancaster County.

16. For the hymns of the *Ausbund*, see "Hymnology of the Anabaptists," in *The Mennonite Encyclopedia*, 2:869–871, and "Ausbund," 1:191–192; J. William Frey,

"Amish Hymns as Folk Music," in *Pennsylvania Songs and Legends*, George Korson, ed. (Philadelphia: University of Pennsylvania Press, 1949), 129–162; and William I. Schreiber, "The Hymns of the Amish Ausbund in Philological and Literary Perspective," *The Mennonite Quarterly Review*, 36 (1962): 36–60.

17. For Scheffler and his hymnodic production, see John Julian, *A Dictionary of Hymnology*, rev. ed. (London: John Murray, 1915), 1004–1007.

18. Ira D. Sankey, a Pennsylvania Methodist, coined the term *gospel hymn* and wrote the music for many favorite numbers still sung by millions of Protestants. For Sankey's career, see Julian, *Dictionary of Hymnology*, 994, 1698.

19. The curious theme of Jesus the *"Herzog"* appears in several hymns published in the *Erbauliche Liedersammlung* (1786), official hymnal of the Lutheran Ministerium of Pennsylvania. In the fourth edition (Germantown, 1811), Hymn No. 342 reads: *"Herzog unsrer seligkeiten, zieh uns in dein heiligthum."* It was by the church historian Gottfried Arnold (1665–1714). Another is No. 357, which begins: *"Schönster Immanuel, Herzog der frommen."* The *"Herzog unsrer seligkeiten"* also appears in *Das Kleine Davidische Psalterspiel* (1795), No. 192. Perhaps the title of *"Duke"* as assigned to Jesus is not so strange after all, since in many other hymns he is awarded the titles King, Prince, Captain, and Knight (*Ritter*).

20. For "Jesus the Blacksmith," see Don Yoder, *Pennsylvania Spirituals* (Lancaster: Pennsylvania Folklife Society, 1961), 373–375. The German hymn is *"Die geistliche Schmiede-Kunst"* [The Spiritual Blacksmith's Art], following the tradition of spiritual hymn composition where something everyday and secular is spiritualized. The hymn appeared in the 1825 edition of the Evangelical Association hymnal, *Die Kleine Geistliche Viole* (New Berlin: 1825). For the original version, see Gerhard Tersteegen's immensely popular devotional work, the *Geistliches Blumen-Gärtlein*, 8th ed. (Germantown: Michael Billmeyer, 1800), Hymn No. 92, 444–446.

21. This *Vorschrift* is described in Henry C. Mercer's original article, "The Survival of the Mediæval Art of Illuminating Writing Among Pennsylvania Germans," *Proceedings of the American Philosophical Society* 36 (September 1897): 424–433. See Plate V, with commentary on 426–427.

22. *"Kein Stündlein geht dahin"* appears in the *Erbauliche Liedersammlung* (1786). In the fourth edition (1811) it is No. 577 (494–495), with ten verses.

23. For the expression of the theme of human mortality in Christian art on both elite and folk levels, see the exhibit catalogue of the Münchner Stadtmuseum: Sigrid Metken, ed., *Die letzte Reise: Sterben, Tod und Trauersitten in Oberbayern* (Munich: Hugendubel, 1984).

24. For background materials, see Rudolf Wolkan, *Die Lieder der Wiedertäufer: ein Beitrag zur deutschen und niederländischen Literatur- und Kirchengeschichte* (Berlin: B. Behr, 1903), 295. The version in our text

uses verses 1 and 2 of the 40-verse *Ausbund* hymn, and parts of verses 22 and 23, making a song on man's transitory possessions. For the 40-verse text, see the eleventh edition of the *Ausbund* (Elkhart, Ind.: Mennonitische Verlagshandlung, 1913), no. 138: 796–802.

25. William A. Coupe, *The German Illustrated Broadsheet in the Seventeenth Century: Historical and Iconographical Studies* (Baden-Baden: Librairie Heitz, 1966), 1:31–32. The work is vol. 17 in the series: *Bibliotheca Bibliographica Aureliana.*

26. Ibid., 1:32

27. The doctrine of assurance of salvation, as a feature of Pietism, was especially played up by the Methodist movement in England and America. The gospel hymn referred to was written by the blind hymnist Fanny J. Crosby Van Alstyne in 1873 and begins: "Blessed assurance, Jesus is mine! / Oh, what a foretaste of glory divine! / Heir of salvation, purchase of God. / Born of His Spirit, washed in His blood." This text is typical of the neo-Pietist taste that captured most of America's evangelical denominations after the Civil War. It is Pietist to the core and surprisingly similar to baroque effusions such as *"Jesus, Jesus, nichts als Jesus,"* written in 1668 by the Countess of Schwarzburg-Rudolstadt. For this and similar baroque Jesus hymns that made it across the Atlantic, see Don Yoder, *The Picture-Bible of Ludwig Denig: A Pennsylvania German Emblem Book*, 2 vols. (New York: Hudson Hills Press, 1990), 1:81–85, Ch. 21: "And into His Courts with Praise."

28. This text appears to be a paraphrase of Romans 8:35, 38–39.

29. Carl Gock was the maverick schoolmaster who stirred up storms in Eastern Pennsylvania in the 1820s by opposing, in a pamphlet war, the new movement to found theological seminaries—which he called *Pfaffenmühlen*, "priest mills" or "priest factories." Carl Gock's story has never been completely told, but when it is, the prayer he wrote for little Samuel Kaufman, born in Richmond Township, Berks County, in 1813, and baptized by the Reformed pastor Herman, should serve to tone down some of the more combative lines in his character. For a reproduction of this *Taufschein*, see Don Yoder, "Kaufman-Kauffman: Maidencreek and Oley," *Der Reggeboge* 29 (no. 2, 1995): 28–31.

30. The frakturist used verse 8 of the hymn, *"Geh aus, mein Herz, und suche Freud,"* for which see the conclusion of this section.

31. For the cult of the Wounds of Christ and its deposit in Christian art, see Phoebe Lloyd, "The Wounds of Christ" (M.A. thesis, New York University, 1971).

32. *Jesu, deine heilge Wunden* was written in 1644 by the Lutheran clergyman Johannes Heermann (1585–1647). It appears in some hymnals as *"Jesu, deine tiefen Wunden."* The change from *holy* to *deep* may reflect a lowering or defusing of the cult of the Wounds of Christ, or at least a change in ecclesiastical taste.

33. For Paulus Gerhard and a list of his most important hymns and their translations into English, see Julian, *Dictionary of Hymnology*, 409–412, 1565, 1639.

34. The translation is from Catherine Winkworth, *Lyra Germanica*, 2nd American ed. (Boston: 1868), 136–139.

35. This *Vorschrift* is described in Mercer, "Illuminative Writing," 427. However, he misread the hymn as *"Die Kinder Lieb ist Wunderlich."*

36. The favorite prayer book of the Pennsylvania Germans, Stark's *Tägliches Handbuch* (Philadelphia: The Kohler Publishing Co., n.d.), 120–122, contains the hymn, *"Demuth ist die schönste Tugend"* [Humility is the finest virtue]. A lengthy prayer for humility accompanies it, in which the petition occurs, *"...so gieb mir Kraft und Stärke, dass ich alles mit Demuth, Gelassenheit und Geduld ertragen möge"* [give me power and strength, so that I may bear all things with humility, resignation, and patience]. The scripture text for the section is I Peter 5: 5–6.

37. For the *Geistliches Gewürz-Gärtlein* (1806), see Clarence Edwin Spohn, "The Bauman/Bowman Family of the Cocalico Valley: Printers, Papermakers and Tavernkeepers," *Journal of the Historical Society of the Cocalico Valley* 19 (1994): 31; also Donald R. Hinks, *Brethren Hymn Books and Hymnals, 1720–1884* (Gettysburg: Brethren Heritage Press, 1986), 91–94, 135.

38. Protestantism does indeed emphasize work, not only working out one's salvation in fear and trembling (Philippians 2:12), but work as well in the everyday sense. The so-called Protestant ethic based upon work is underscored by Max Weber's sociology of religion, particularly in connection with the Calvinists.

39. This *Haussegen* text appears on broadside examples printed by the Bauman family at Ephrata. See Spohn, "The Bauman/Bowman Family," figs. 23–24, *Haussegen* printed by Johann Baumann in 1803 and 1808, with a slightly variant text; fig. 39, *Haussegen* printed by Samuel Baumann, 1813, same text as 23–24; and figs. 53–54, undated *Haussegen* by S. Baumann, with an expanded text, which, however, includes the admonition against cursing.

40. Some prayer books included house blessings. Cf. *Ein schöner Christlicher Haus-Segen, für alle fromme Haus-Väter*, which was featured in the *Neueröffneter Himmlischer Weyhrauch-Schatz, Oder Vollständiges Gebätt-Buch* (Basel: Emanuel Thurneysen, 1798), 753. This book was compiled by the Swiss Reformed clergyman Johannes Zollikofer, first edition 1691, and was a favorite in Pennsylvania. The house blessing begins: *"Jesu! wohn in meinem Haus, / Weiche nimmermehr daraus,"* a verse found on several manuscript Pennsylvania-German examples, including the Heinrich Weiss *Haussegen* dated 1791, in the Schwenkfelder Library.

41. These two prayers appeared in the popular American edition of the *Himmlischer Weihrauchschatz* (1837), enlarged and edited by the Reformed pastor of Kutztown and vicinity, A. L. Herman. The fourteenth edition (Philadelphia: J. B. Lippincott & Co., 1861), includes them on pp. 314–317.

42. For Rudolph Landes and the background of this hymn, see Yoder, "Fraktur in Mennonite Culture," 337–340, illustrated in fig. X, 330. Rudolph Landes, descendant of the early Landis/Landes family of Anabaptists in Canton Zürich, Switzerland, was born at Oberflörsheim in the Palatinate and emigrated in 1749. I am indebted for this information to Ada Kadelbach, *Die Hymnodie der Mennoniten in Nordamerika (1742–1860): Eine Studie zur Verpflanzung, Bewahrung and Umformung europäischer Kirchenliedtradition* (Mainz: Johannes Gutenberg-Universität, 1971), 144–147, 204.

43. For the exaggerated Moravian devotion to the Wounds of Christ during the so-called Sifting Time in the mid-eighteenth century, see Jacob John Sessler, *Communal Pietism Among Early American Moravians* (New York: Henry Holt and Co., 1933), 156–181; also Gillian Lindt Gollin, *Moravians in Two Worlds: A Study of Changing Communities* (New York/London: Columbia University Press, 1967), 11–16, and especially 229–230, n. 12, evaluating the historiography of the Sifting Time.

44. For representative reproductions of Spangenberg's work, see Monroe H. Fabian, "The Easton Bible Artist Identified," *Pennsylvania Folklife* 22:2 (Winter 1972–1973): 2–14.

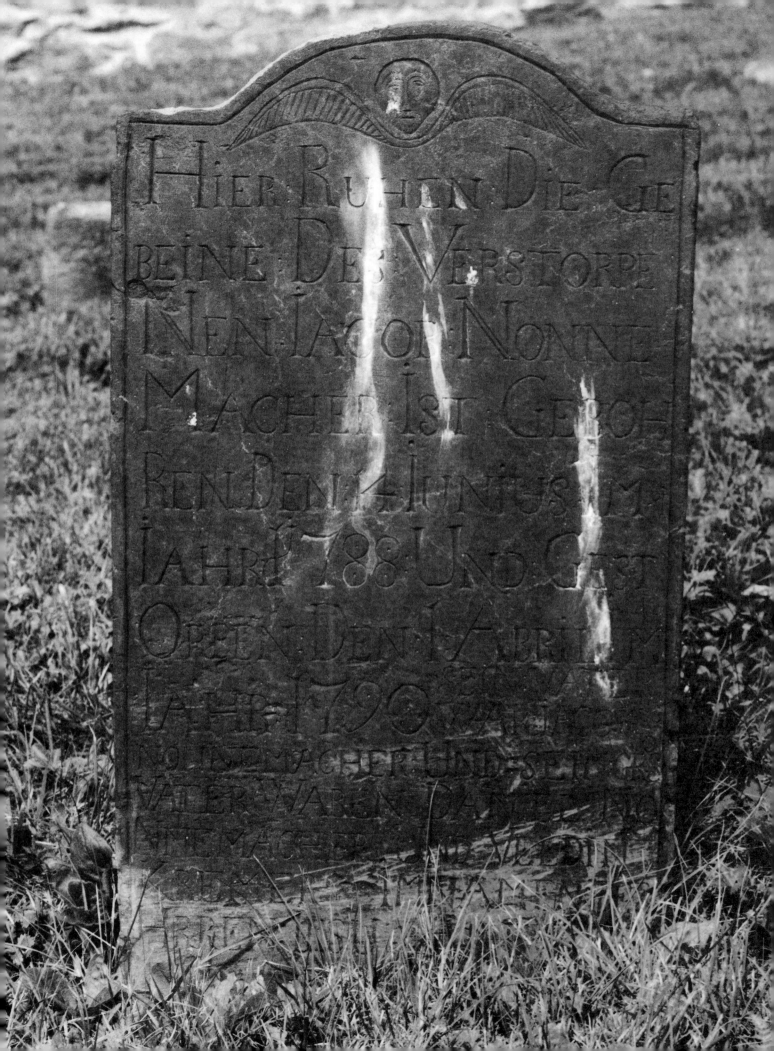

HIER RUHEN DIE GE
BEINE DES VERSTORBE
NEN IACOB NONNE
MACHER IST GEBOH
REN DEN 4 IUNIUS IM
IAHR 1788 UND GE
TORBEN DEN 14 APRIL IM
IAHR 1790 ...
NO ... MACHER UND SEIN
VATER WAREN ...

Bucks County in the Age of Fraktur

Terry A. McNealy

Throughout most of its history, Bucks County has been characterized by rather strong regional differences. This was certainly true during the period of a century or so, from 1750 to 1850, when the art of fraktur arose, reached its heights of artistic expression, and then gradually declined to the status of a lost art. When Henry C. Mercer (Fig. 45) "discovered" fraktur in 1897, he thought of his finds in these terms, lamenting that this and other traditional art forms had been "forgotten." Surely many people of German ancestry in Pennsylvania still remembered the brightly colored pieces of paper they had received as rewards of merit from their teachers, and treasured the baptismal certificates passed down in their families. Mercer, however, was a scholar, a man with connections that enabled him to present his discovery in a paper read before the prestigious American Philosophical Society, an organization unfamiliar to most Pennsylvania-German families.[1] Perhaps most significant, Mercer was a WASP, a man of English ancestry, with no German blood in his veins. He had traveled widely in Europe, and particularly in Germany and Austria, and admired the civilization of those countries. His sister had even married a member of the Austrian nobility. Mercer's championing not only of fraktur, but of all the arts, and indeed of all the culture, of the German-settled sections of Bucks County and Pennsylvania, helped to introduce that often remote and isolated culture to the rest of America.

Of course, Mercer was not single-handedly responsible for preserving and drawing attention to the Pennsylvania-German way of life. Many other collectors, historians, and museum curators played their part. But Mercer was among the first, and his discovery of a curious little paint box and of the folk art on paper that was produced with its contents, neatly reflect the distinctive cultural geography of his native county of Bucks.

Stated in its broadest terms, a cultural dichotomy existed in the county's demographic composition. Expressed geographically, the southern part of the county was predominately settled by Quakers from the British Isles, with a few Dutch and Swedes. The

Fig. 45. **Henry Chapman Mercer (1856–1930)**, c. 1895. (Spruance Library/Bucks County Historical Society.)

Map 1. **Bucks County, Pennsylvania: The Northern Townships, c. 1750–1850.**

northern part, on the other hand, attracted mostly settlers from the Germanic regions of central Europe. Of course, this characterization is an oversimplification. Other ethnic groups also were involved in the peopling of the county. Scots-Irish settlers scattered themselves throughout Bucks, especially along the borderlands between Quakers and Germans, from Newtown to Tinicum and Bedminster. Welsh Baptists created an enclave in New Britain and Hilltown. And Quakers carved out a small niche in upper Bucks in the community still known as Quakertown.

All of these diverse groups of differing ethnic, national, and religious backgrounds got along reasonably well, in keeping with the vision and tolerant principles of the colony's founder, William Penn, who welcomed all who wished to settle in Pennsylvania regardless of their religion. As history has played out its peculiar course, the boundary, if it can be called that, between the traditionally English part of Bucks County and the traditionally German part, can be drawn across the middle of the county through Doylestown, the county seat since 1812 (Map 1).

Bucks County was one of the three original counties created by Penn when he first arrived in his new domain in October 1682. The other two were Chester and Philadelphia. On early maps, it might seem that these three counties were equal entities,

lined up along the Delaware River like crows on a fence rail. However, Bucks County was the farthest up river, and thus the most remote. Chester County had experienced considerable white settlement for decades before Penn's arrival, and Philadelphia County also had numerous existing settlements. At best, Bucks County in 1682 had only a dozen or so European enclaves.[2]

The peopling of all three counties advanced at a remarkable pace in the decades following the establishment of Penn's colonial government. As a consequence of Penn's personal visits to the Rhineland, and other encouragements, many Germans took advantage of his offer of religious freedom and economic opportunity and left their homelands for Pennsylvania.

Most of Bucks County's earliest settlers arrived at the Port of Philadelphia, then continued up the Delaware River to the places where they made their homes. Penn was scrupulous in making sure that he or his agents arranged for "purchases" of land from the Lenape (or Delaware) Indians who occupied his new province. Despite the almost insuperable chasm between an Englishman's concept of real estate ownership and the equally well-organized but radically different Native American view of humanity's relationship to the land, Penn managed to remain on friendly terms with the Lenape. His purchases allowed the survey and settlement of areas as far north as Tohickon Creek. Beyond that was Indian territory during Penn's lifetime, with only a few exceptions. Settlers filled up some of the area made available through purchase from the Lenape, while speculators bought up other land to wait for higher prices as demand grew.

In the early decades of the eighteenth century, prospective settlers began using another route into Bucks County. This route also followed a waterway out of Philadelphia, coursing first up the Schuylkill River, then along Perkiomen Creek and its tributaries. English Quakers followed this course to make a community that eventually led to the founding of Richland Monthly Meeting of Friends in 1743. It is still the only meeting in Bucks County that is not a part of Bucks Quarterly Meeting, but of Abington Quarterly Meeting (centered in neighboring Montgomery County). German pioneers followed hard on the heels of the Quakers and the woodlots, meadows, and swamplands of upper Bucks County began to move to a different cultural rhythm. The Germans soon outnumbered the Quakers, and their

ascendancy has determined the character of this region ever since. Though the Quaker enclave remained, and Richland Meeting still survives, German culture prevailed in upper Bucks.[3]

A watershed occurred in 1737, nearly two decades after William Penn's death. His sons, who inherited his proprietorship of the colony, did not share his ethics regarding relations with Native Americans. New settlers still flowed into the province and they continued to be welcomed as they provided income for the Penns. Immigrants seeking their own stake in the province purchased land warrants and funded surveys, paid quitrents, and contributed to the general prosperity of Pennsylvania. The Penn brothers conspired with provincial officials to gain new land that could be opened to settlement. This led to the notorious Walking Purchase of 1737, a complex scheme by which the Penns pulled off an enormous land grab that took from the Lenape thousands of acres of land and put an end to good relations between them and the Pennsylvania government.[4] By an accident of provincial politics and immigration trends, it was on the land gained through the Walking Purchase that a great number of German people settled in Bucks County and the areas to the north that were to become the counties of Northampton and Lehigh.

The northern portion of Bucks County quickly filled with new settlements, most with a distinctly German character, and the new communities extended well beyond the present-day county boundaries. (Originally, the county had no specified northern boundary—it extended indefinitely into the wilderness.) The valley of the Lehigh River was rapidly populated by Germans and Scots-Irish after the Walking Purchase, and included significant communities like Bethlehem and other settlements founded by the sect known as Moravians.

As the population of these newly settled areas swelled, local government expanded to accommodate their needs. Rockhill became a township in 1739, while Bedminster and Nockamixon were formed in 1742, Springfield in 1743 and Tinicum in 1747. Roads were laid out that gave the new settlements access to markets in Philadelphia, and that made it easier still for more newcomers to find and establish homesteads in the region. Two roads led to the Moravian town of Bethlehem by different routes, one through modern-day Sellersville and Quakertown, the other by a more easterly path through Hilltown and Haycock Townships. Still

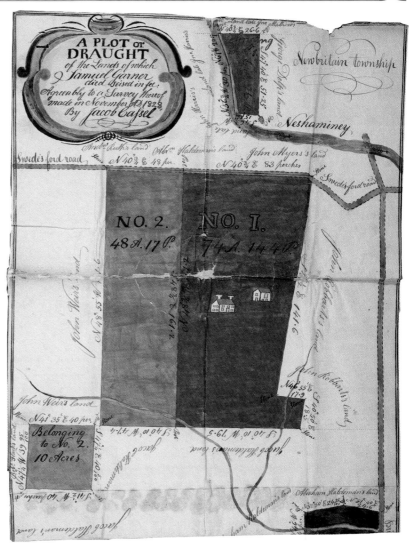

Fig. 46. *A Plot or Draught of the Lands of which Samuel Garner died seized...(detail)*. Jacob Cassel, New Britain Township, 1828. Hand–drawn, lettered and colored on wove paper. 29³/₄ x 12¹/₄ in. This is an example of another purpose to which a Pennsylvania German—in this instance a surveyor—could put ink, watercolor, and paper. (Bucks County Orphans' Court Records, Spruance Library/Bucks County Historical Society.)

another route called the Allentown Road made its way through the northwestern corner of the county. All grew to be major lifelines between the German districts and essential markets in Philadelphia.

The quality of the land in these newly populated areas varied widely, from the highly fertile and productive valleys of streams like Deep Run, to steep slopes strewn with rocks in parts of Tinicum and Rockhill. Most of the newcomers made their living in some way connected with agriculture, and they had to adapt to the conditions of the land that was surveyed and granted to them. Still, for most, the ownership of any land at all had not been an option in the old country, and the opportunity to have title to even a poor plot of real estate was perceived as a great advantage (Fig. 46).

Fig. 47. **Tohickon Union Church**. Constructed in 1838, this stone edifice still stands in northwest Bedminster Township near the Rockhill Township line. It is probably the third or fourth building erected for the local Lutheran and Reformed congregations on or near the site. The union arrangement was dissolved in the 1950s and new church buildings constructed. (Spruance Library/Bucks County Historical Society, SC-29. No. 14-E-01.)

Political figures in Pennsylvania viewed the flood of German immigrants with trepidation. They feared that the Germans might soon overwhelm the predominately British population and quickly come to dominate provincial elections and politics. Since the idea of equal representation in government was an idea still far in the future, a solution to this perceived threat was easily reached. Each of the three original counties were given eight representatives in the colonial legislature. New counties were then created in those areas dominated by Germans (as well as by the Scots-Irish, a troublesome group also perceived as a political threat). However, the law provided that these new counties would have only one or two delegates to the assembly. In 1752, the colonial legislature passed a law creating a new county called Northampton, thus establishing the present northern boundary of Bucks County. Berks County was created in the same year, slicing off the German-dominated upper end of Philadelphia County for the same reason. Similar motivations had resulted in the earlier creation of Lancaster County in 1729.

If the eighteenth-century German people of Pennsylvania were largely iced out of the political process, the colonial government could not dispossess them of other aspects of their lives. Important to many of these people was their religious

life. To some, the desire to practice their religion freely and unfettered was the single most important factor that had caused them to pull up stakes in Europe and risk an uncertain passage to America. Even those who did not experience religious persecution in Europe, and who emigrated primarily for economic reasons, were often quick to set their churchly roots in their new communities.

New settlers, trying to carve out farmsteads from virgin wilderness and create homes for their families, had little time and less money to establish churches and pay for the services of clergymen. While a percentage of the newcomers displayed surprisingly little interest in religious matters, the faith of other settlers was strong. In their quest for religious order, the latter persisted in attempts to continue old traditions in the face of great hardship and difficulty.

The Germans who migrated to Pennsylvania came from a variety of religious traditions, often representing deep differences traceable to the fragmented political and cultural landscape of central Europe. By the time that the great flood of immigration to Pennsylvania occurred in the first half of the eighteenth century, the Reformation was already two centuries in the making. During this interval had raged religious wars of unbelievable ferocity, including the Thirty Years War, which entirely depopulated large portions of Germany.

When Germans came to Pennsylvania, they found themselves in an environment in which a Lutheran might reside next to a Mennonite, who in turn lived next to a Schwenkfelder, who himself lived next to a Reformed (or a Presbyterian, or an Anglican, or a Quaker, or a Baptist, or a Roman Catholic, or to one who was entirely indifferent to religious matters). None had the right to complain to a civil authority in order to drive the other out. This was the point of the tolerant vision of Penn's "Holy Experiment." There was no "established" religion, supported by the state. The Germans who came to Bucks County, as well as to other parts of Pennsylvania, seem to have embraced this freedom of religion heartily, and yet without compromising the distinctive character of their own religious denominations and beliefs.

One of the means by which small, struggling congregations dealt with their financial limitations was by creating union churches in which congregations of different denominations—most commonly Lutheran and Reformed—joined forces to build a church edifice that the two groups could share (Fig. 47). In Bucks County, early Lutheran and Reformed

union churches were established at Great Swamp (c. 1730s), Tohickon (c. 1740s), Springfield (c. 1750), Lower Milford (c. 1760s), and Nockamixon (c. 1770). Sometimes union churches involved three faiths, and included Presbyterians or even Mennonites. Such an arrangement would have been unthinkable in most parts of Europe.

The various German denominations and sects suffered from a variety of problems during the colonial period, but all seem to have flourished. The Lutherans and Reformed, who depended upon clergy possessing credentials only obtainable in Europe, experienced a chronic lack of recognized ministers. As a result, their pulpits were often filled by men of questionable qualifications. Sects such as the Mennonites had a somewhat easier time providing continuity, since their religious leaders generally arose from their own midst.

Aside from language and religion, another aspect of the lives of the German settlers that could be neither controlled nor extinguished was the folklife brought with them from Europe. Though the flourishing of folk art and material culture generally had to wait until more essential needs were met, Bucks County's Germanic settlers eventually found the means to express their traditions in a new setting. Fraktur, of course, was one of the primary

Fig. 49. **Schnedecker Log House**. Haycock Township, late eighteenth century. This three-room, central chimney, Germanic style log house was one of several documented by Henry Mercer during his "old house" research in the 1910s. The photo was taken in 1918. (Spruance Library/Bucks County Historical Society, BM-B-408.)

expressions, but painted furniture and decorative arts, architecture, ironwork, and gravestone carving also took on a decidedly Germanic flair in the county's northern townships (Figs. 48–54).

Though provincial authorities sought to limit the political power of German immigrants, it was inevitable that the Germans would achieve some foothold in the capital of the colony. The first significant success in this realm in Bucks County was made by a man named Peter Schaeffer, who anglicized his name to Peter Shepherd in public life. A miller in Rockhill Township, Schaeffer had contact with a multitude of his countrymen. He was a member of the Reformed congregation at the Tohickon Union Church, just across the township line in Bedminster, where the baptisms of his children are all duly recorded. His political aspirations first bore fruit in his ascent to the position of county assessor in 1760, and then, in October 1764, he became the first person of German origin to be elected as a delegate to the Provincial Assembly from Bucks County. He remained in office for ten one-year terms.[5] In 1773 he sold his mills to John Heany, another German, who also succeeded to his seat in the assembly, serving from 1774 to the fateful year of 1776.[6] Heany's name, which often appears as Haney and looks remarkably like an Irish surname, was originally Hönig. Both he and his predecessor in the Assembly were emblematic of a dilemma in the

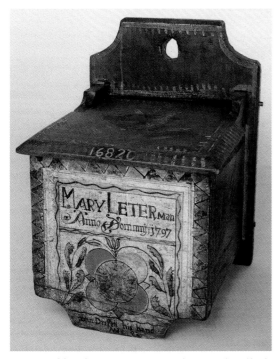

Fig. 48. **Saltbox for Mary Leterman**. John Drissel, Milford or Bedminster Townships, 1797. Paint on white pine. 11¼ x 7⅞ x 8⅜ in. (Mercer Museum/Bucks County Historical Society, No. 16820.)

Fig. 50. **Krouse-Treffinger House**. Deep Run, Bedminster Township, built c. 1757. This photograph was taken in 1897 by Henry Mercer and a colleague. (Spruance Library/Bucks County Historical Society, BCHS Album.)

Pennsylvania-German community: whether to maintain a distinctive culture with its own language, religion, and folkways, or to assimilate, learn English and change other habits and customs to fit more completely into the prevailing Anglo-American society.

The debate within the Pennsylvania-German community over the issue of tradition versus assimilation must have been intense, and it is unfortunate that few documents seem to have survived regarding the controversy. Many German immigrants anglicized their names from Schaeffer to Shepherd, from Schwartz to Black, and from Mueller to Miller. On the other hand, many felt no compunction to make such changes and clung tightly to their traditions and language.

The American Revolution brought significant changes to the Pennsylvania-German community, not just in Bucks County but throughout Pennsylvania. The Revolution was fought not only against Great Britain, but also against the Penn family's hegemony, and against the old political regime that gave Bucks County eight votes in the assembly and Northampton County two. Many old issues concerning the minority constituencies in the state came to a head, and the German portion of the population sought its due. Germans demanded and achieved entry into the political arena and would make their power felt for generations to come. New opportunities came not just in the realm of political participation, but in commerce, business, and industry.

As American civilization expanded in the aftermath of the Revolution, German culture also flourished as part of the new nation, especially in

Pennsylvania. Small towns grew and prospered, with churches, schools and academies, newspapers, and other evidences of rural sophistication. In Doylestown, the county seat, there was a German-language newspaper by 1820.[7] In the 1830s and 1840s, the practice of publishing newly passed laws and other public documents in both English and German came close to suggesting that Pennsylvania might become an officially bilingual state.

But even as certain institutions helped preserve German traditions, improvements in transportation and other technological advances added to the pressure to assimilate. The opening of the Delaware Division of the Pennsylvania Canal system in 1832 directly affected the eastern edge of the German section of Bucks County, but when the railroad era followed, it drove through the heart of the traditionally German regions. The North Pennsylvania Railroad opened in 1857 and its line passed through Perkasie and Quakertown, changing forever the patterns of life in the townships of upper Bucks by stimulating the growth of towns, creating new markets, and making the homogenizing culture of the United States far more accessible to an area that had previously been dominated by a localized folk culture.

As the nineteenth century advanced, Pennsylvania Germans became more conscious of their identity as a distinct element within American culture at large. Homer T. Rosenberger pointed out that Abraham H. Cassel began collecting books and other materials that documented Pennsylvania-German traditions as early as 1868. The same year saw the beginning of the publication of writings in the Pennsylvania-German dialect, and of descriptive writing about the subculture. The period from 1875 to 1882 has been characterized as a time when there was a "flood" of literature published in the dialect.[8]

Finally, in 1891, came the founding of the Pennsylvania German Society, the ultimate expression, perhaps, of the notion that the descendants of German settlers had a distinctive culture worthy of study and preservation, and that at the same time this culture was vulnerable and that conscious efforts were required to insure that it would continue to exist. Only six years passed between the founding of the Society and the time when Henry C. Mercer, an out-of-work archaeologist with a sensitivity for interpreting cultures of the past from their physical remains, made his pioneering explorations of fraktur and of other manifestations of Pennsylvania-German folk art.

Though citizens of British descent generally lived peacefully with their neighbors whose ancestors came from Germany, they often knew little about one another. As a result, there existed some level of mutual distrust and suspicion. The first man to undertake the task of writing a full-length history of the county was William Watts Hart Davis (1820-1910), whose family ties, like Mercer's, were all in Britain. He was a lawyer, a military man, a newspaper editor, and a politician. He was also the founder in 1880 of the Bucks County Historical Society, and its first president, holding that post for thirty years. Davis's history was published in 1876, and he contributed many papers to the Historical Society. His treatment of the German population in his writings is revealing. In a description of Plumstead Township in 1885, he wrote:

> Plumstead belongs to that group of townships which, settled by English-speaking people, have become pretty well Germanized. Among them are Durham, Nockamixon, Tinicum, Hilltown, New Britain and others. Fifty years ago the Germans in Plumstead were largely in the minority, now they predominate, and are increasing yearly. It may be said this increase is going on in nearly every township in the county. The Germans have been exceedingly aggressive since they settled in Bucks. Seating themselves in the extreme northwest corner of the county, they have overrun the upper townships, and in some of them have nearly rooted out the descendants of the English race. Like their ancestors, which swept down from the North on to the fair plains of Italy, they have been coming down county for a century and a half with a slow, but steady trend. They are now found in every township below Doylestown, and there is hardly a community in which the language of Luther is not spoken and German ballots voted. Where this advancing Teutonic column is to halt is a question to be answered in the future. They seem to be in a fair way to root out all others who have not the same attachment to the soil.

Then he concludes on a mollifying note, "As citizens they are not excelled by any nationality."[9]

The same grudging respect can be seen in his 1892 description of Bedminster Township, just north of Plumstead:

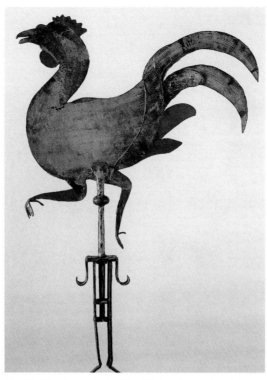

Fig. 52. **Weathercock**. Unidentified maker, Springfield Township, c. 1800. Painted wrought and sheet iron. 28 x 18½ x 1⅛ in. (Mercer Museum/Bucks County Historical Society, No. 26088.)

> Speaking of the parent and child, that is, of Plumstead and Bedminster, it may be re-marked right here, that they were both settled by English-speaking people, but were subsequently overrun by the Germans. Other townships were conquered in the same peaceful way, and the Germans are still marching toward the lower Delaware like an army with banners. They have great staying qualities, and when they once plant their stakes in the fertile fields south of Doylestown, they are as hard to rout as were their war-like ancestors after they had crossed the Rhine in pursuit of the Roman legions. When I was a boy, the German language was seldom heard in lower Bucks, but today it is spoken in almost every neighborhood, and German ballots are voted at every poll.[10]

Davis may have thought that the Scots-Irish were the first settlers of Bedminster, but the truth is that as much land in the township, if not more, was first laid out to German warrantees as to British. Likewise, the German language speakers that he encountered in lower Bucks were more likely to be

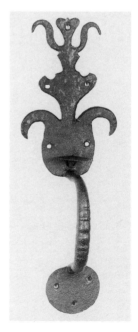

Fig. 51. **Door Latch**. Unidentified maker, Rockhill or Hilltown Townships, 1770–1800. Wrought iron. 12 x 4 in. (Mercer Museum/Bucks County Historical Society, No. 17177.)

Fig. 53. **Gravestone of Jacob Nonnemacher (1788–1790)**. Tohickon Union Cemetery, Bedminster Township. (Photo by Cory M. Amsler.)

quickly became an admirer not only of the heritage of the Germans of Bucks County, but also of German civilization itself, which he defended loudly during World War I.

Mercer approached history as a scientific discipline. Bucks County was his first laboratory for experimenting with a new kind of history, and fraktur was one of his most significant discoveries. If he had not noted its significance, surely some other scholar or collector would have. But his inspiration upon finding that initial paint box was indeed a turning point in the history of American folk art.

newly arrived nineteenth-century immigrants, part of an immense wave that came directly from Germany, rather than the shock troops of an invasion from the older settlements of upper Bucks.

Davis was correct, however, in his description of the spread of the older German population and its traditions across upper Bucks. Townships like Hilltown and New Britain, which were largely settled by Welsh Baptists, gradually became German strongholds. Plumstead, settled by Quakers, saw its farms sold one by one to Germans. Doylestown, the county seat after 1812, was the dividing line between the German north and the British south. Again, this is an oversimplification, but it serves to define two spheres of influence that affected patterns of culture, language, religion and politics. To find a significant piece of fraktur created south of Doylestown would be a rare find indeed.

Henry C. Mercer, who at age twenty-four was one of the founders of the Historical Society, and in 1920 Davis's successor as president, may in his youth have shared Davis's ethnic chauvinism. Such prejudices were part of the fabric of nineteenth-century America. But as his exploration of Bucks County's material culture got under way in 1897, he

Fig. 54. **Gravestone of Christian Gross (d. 1832)**. Deep Run Mennonite Cemetery, Bedminster Township. (Photo by Cory M. Amsler.)

Notes

1. Henry C. Mercer, "The Survival of the Mediaeval Art of Illuminative Writing Among Pennsylvania Germans," *Proceedings of the American Philosophical Society* 36 (September 1897).

2. The literature available on the history of Bucks County is vast. The two standard classics are William Watts Hart Davis, *History of Bucks County*, 1st ed. (Doylestown, Pa.: 1876), 2nd ed. (New York: Lewis Publishing Co., 1905); and J.H. Battle, ed., *History of Bucks County* (Chicago: A. Warner, 1887). Both have been reprinted in recent years.

3. Clarence V. Roberts, *Early Friends Families of Upper Bucks* (Philadelphia: C.V. Roberts, 1925).

4. William J. Buck, *History of the Indian Walk Performed for the Proprietaries of Pennsylvania in 1737* (n.p.: by the author, 1886); Francis Jennings, "The Scandalous Indian Policy of William Penn's Sons: Deeds and Documents of the Walking Purchase," *Pennsylvania History* 37 (1970): 19–39.

5. Pennsylvania Patent Book A–19, 238, 240; William J. Hinke, *A History of Tohickon Union Church* (Meadville, Pa.: Pennsylvania German Society, 1925), 76, 77, 98, 114, 120, 126. The reference to him as assessor can be found in Bucks County Criminal Papers, no. 1373, Spruance Library/Bucks County Historical Society, Doylestown, Pa. (hereafter SL/BCHS); his assembly career can be traced in *Pennsylvania Archives*, 8th series, v. 7–8. Shepherd had other real estate interests in Bucks County. He moved to Baltimore, Md. by 1778. See Deed Book 18, p. 59, SL/BCHS.

6. The deed from Shepherd is unrecorded, but it is recited in Heany's deed when the latter sold the mills to George Phillips in 1777. See Deed Book 18, p. 494.

7. Clarence S. Brigham, *History and Bibliography of American Newspapers, 1690–1820*, 2 vols. (Worcester, Mass.: American Antiquarian Society, 1947), 2:841.

8. Homer T. Rosenberger, *The Pennsylvania Germans, 1891–1965* (Lancaster, Pa.: Pennsylvania German Society, 1966), 53–72.

9. William Watts Hart Davis, "Plumstead Township," in *A Collection of Papers Read Before the Bucks County Historical Society* (Doylestown, Pa.: Bucks County Historical Society, 1908), 1:312–313.

10. Davis, "Bedminster Township," ibid., 2:70.

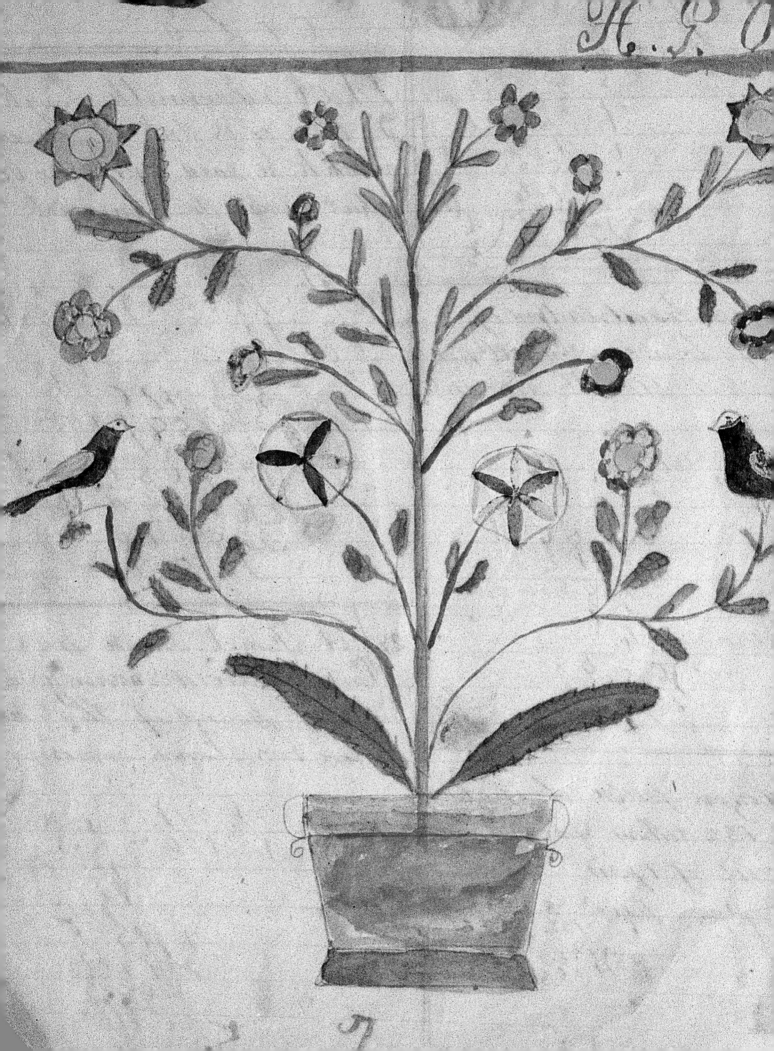

Pennsylvania-German Schools in Bucks County

Terry A. McNealy and Cory M. Amsler

Education in Pennsylvania has a long, rich, and varied history, reflecting in its course the prevailing values, political ideas, social trends, and religious attitudes of the time. The same is true of education in other states, but in Pennsylvania the narrative is further complicated by the historical presence of large numbers of people of Germanic ancestry. This population tended to maintain its own distinctive language, religious traditions, and other aspects of culture that helped to create a way of life unique in its cultural expressions, ranging from architecture to foodways to folk art. As with any culture, sustaining such traditions required the ability to pass them on to youth, either informally through social institutions like the family, or more formally in an explicitly educational setting.

No public school system existed in Pennsylvania before 1834. Prior to that time, and in many areas for years afterward, Pennsylvania Germans who wished to educate their children had limited options. Schools were either parochial, operated by those local churches strong enough to support such an adjunct to the church itself, or they were community or neighborhood schools, not connected to the church but rather supported by subscriptions and tuition payments. In Bucks County, surviving evidence suggests that the earliest schools in the northern, Pennsylvania-German townships were parochial institutions, established and run by congregations of various religious denominations.

In Europe, religious wars and persecution had raged for centuries, with local princes alternately offering religious freedom at times when they needed to bolster their populations after devastation by war, and then cracking down on various denominations when times improved. Penn's Woods, however, harbored no autocratic princes playing politics. William Penn's plan offered nearly complete religious freedom to Lutherans, Reformed, Mennonites, Amish, Dunkers, Schwenkfelders, Catholics, Moravians, and many other faiths. Nearly all of these denominations operated parochial schools at one point or another. For Pennsylvania Germans, these helped to perpetuate such traditions as language, religious doctrine, music, and even the art of fraktur.

Little is known, however, regarding the specific functioning of these institutions. What is known may be culled from early church accounts and records. The Lutheran congregation at the place in Bedminster Township later known as "Kellers Church" was frequently referred to in contemporary accounts as a poor one, unable for a long time to afford the salary of a preacher. This little community built a school and parsonage years before it was able to erect a church building. The church book was opened in 1751, and among its earliest entries is a baptism for which Abraham Deck, a schoolmaster, was sponsor. Baptisms and marriages are recorded as having taken place in the schoolhouse prior to the construction of the church itself in 1763. John Henry Schaum was described as a minister and schoolmaster there between 1754 and 1759, and Otto Haase referred to himself in the records as the "public teacher, preacher and schoolmaster of this congregation" in 1762. In

1770, John Philip Lambach, schoolmaster and widower, married Barbara Benner. Both belonged to the Reformed congregation at the church, but their marriage was entered in the Lutheran records. A generation later, in 1797, it was recorded that the child of yet another schoolmaster, Henry Lohr, died and was buried in the churchyard.

These are for the most part random references to men who kept school at Kellers Church. The church register does not systematically record the comings and goings of teachers other than those who also served as minister. On December 27, 1762, it noted that "Regulations were drawn up regarding the preacher and schoolmaster, the church and the school, by the elders and deacons, with the consent of the members," but the text of the regulations was not included. On March 7, 1768, church elders paid five shillings to John Niemand "for a plate stove in the schoolhouse" out of alms money. Then, on June 3, an additional two shillings and six pence was disbursed to "the widow Barbara Niemand, for the plate stove," bringing the cost to a total of seven shillings and six pence.[1]

At other churches, the records are less revealing but it is clear that they, too, supported schools of their own. For instance, the register of St. Luke's Lutheran Church in Nockamixon Township, founded in 1766, reveals that only four years later the congregation spent £9 7s 5p to build a school-house and supply it with an iron stove and other necessities.[2]

Springfield Township's Lutheran church was the beneficiary of a bequest a few years later from John Caspar Hitter, who left £50 in his will to support the education of poor children. The text suggests that the school was already in existence as a subscription school, and that his charity extended the provision of education to those families who could not afford to pay tuition.[3]

Tohickon Union Church, on the eastern route of the road to Bethelehem, which divided Bedminster and Rockhill Townships, must have maintained a school, though few references to it have been found. The Reformed records relate tersely that "Joseph Long, Schoolmaster," was buried on March 13, 1801.[4] No tombstone marks his grave, no estate file remains in the county records, and nothing else is known of him.

Mennonite churches also were centers of education. They maintained singing schools, sometimes organized in concert with, and some-

times separately, from the main curriculum that taught reading, writing, and arithmetic. The singing schools are notable because of the fraktur legacy they left behind: manuscript tune books with highly decorated title pages (Fig. 55). When the earliest of these booklets appeared around 1780 in the Perkasie and Deep Run schools, these schools were already well established. As is clear from the work of other writers in this volume, at least some of the teachers were accomplished fraktur artists, such as Johann Adam Eyer and, later, David Kulp.[5]

Singing schools survived among Mennonites long after the decline of fraktur, but they also became fashionable far beyond the Mennonite community. Under the rubric "Winter in the Country," a local newspaper in 1860 remarked, "Now singing schools are attractive, and debating societies are in their zenith."[6] There is even an instance, in 1867, of the prosecution of one Lewis Koch for disrupting a "Singing school convened for moral, social and literary improvement." Isaac Eckhart was his accuser, and those involved appear to have been members of St. Peter's Union Church in Hilltown. This unseemly tumult was probably a tempest in a teapot. Koch was found not guilty, and parties split the court costs.[7]

Community schools unrelated to a particular congregation appeared not long after parish schools. This pattern was comparable to that in English-majority areas, where schools that were not church-related likewise arose. These educational institutions were often ephemeral, arising when a few neighboring families felt they had both the need and the resources to erect a building and hire a teacher. A subscription was taken to cover construction costs and other expenses, and a more or less formal board of trustees or managers was organized. The schools were typically located on the land of one of the farmers in the community who allowed the corner of a meadow or field to be used on an informal basis. There may have been a lease for the use of the property, but seldom was a deed formally drawn up and placed on record. A relatively rare case in which a deed was executed occurred in Bedminster Township in 1765, when Harman Tettemer and his wife Cathrina conveyed an acre of ground to Frederick Salladay, Christian Fretz, and Philip Stone, trustees of "a public school now erected" for Bedminster and neighboring townships. The deed itself was not placed on record in the county deeds office, however, until 1807.[8]

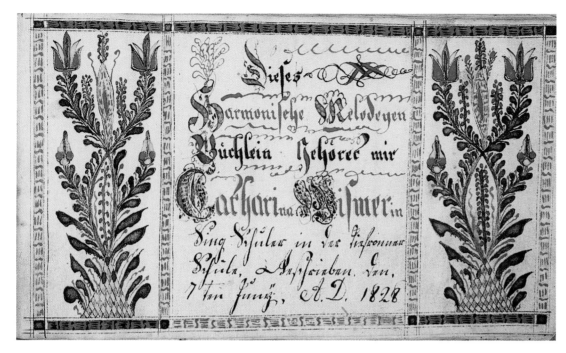

Fig. 55. **Manuscript Tune Book and Bookplate for Catharina Wismer.** Attributed to Samuel Moyer, Deep Run School, Bedminster Township. Hand-drawn, lettered and colored on wove paper. 3⁷/₈ x 6¹/₄ in. (Private collection.)

An unusual instance in which the schoolmaster actually owned the school may be found in Hilltown Township. Samuel Meyer or Moyer (1767–1844), described in the deed as a "schoolmaster," and his wife Anna, conveyed a small lot of land on the Bethlehem Road to Abraham Hunsberger Sr., Samuel Moyer Sr., Jacob Kolb Sr. and George Sipel, miller, "Trustees of the Jerman Schoolhouse in Hillton aforesaid Near to the said George Siples Mill," on April 21, 1800.[9] Meyer had acquired the lot four years before from his brother Joseph. Samuel was the son of Rev. Jacob Meyer (1730–1778), a Mennonite minister. Family tradition records that Samuel was a *"Vorsinger"* (hymn leader) in meeting, and also taught singing schools. He was also a fraktur artist, known definitely for only one example dated 1784. He sold the schoolhouse to become a leader in the Mennonite migration to Canada West (Ontario), where a significant Mennonite community grew up in which Meyer was a prominent figure.[10]

The school, and Sipel's Mill, were located near the intersection of Route 113 and the Old Bethlehem Road, east of Blooming Glen. A book of minutes of the proprietors of this school from 1817 to 1854 has survived. Other than recording the annual election of directors, it is disappointingly uninformative, naming neither the teachers nor the students in the school. Because it is entirely written in English (probably by a series of unidentified schoolmasters acting as recording secretaries),

rather than in German script, it also is not helpful in matching penmanship to that found on fraktur of the period.[11]

In 1866, the then "Trustees of the German School House in Hilltown Township near Sipels Mill" conveyed the property to the Hilltown School District for the nominal sum of $1.00. Shortly afterward, the district sold the old school lot to David Angeny, noting that the schoolhouse was "no longer necessary for the purposes aforesaid."[12] The sale took place years after the public school system had been made universal in Pennsylvania. It is not clear whether this old subscription school continued to be active through the end of the Civil War, or whether it had closed its doors many years before.

By the 1790s, if not before, subscription schools established specifically as bilingual institutions began to appear. Such schools were a practical response to the linguistic diversity of Bucks County's northern townships, to a perceived need for bilingual education, and to a scarcity of community resources which would not allow for separate buildings. On April 23, 1796, Adam Tinsman of Bedminster Township granted a small tract of land on the Durham Road in Bedminster Township for a "School for the promotion and Instruction of Youth in the English and German Tongue." According to the deed, a stone schoolhouse already existed on the property ("on the South Side of the Deep Run Creek"), which, it may be assumed, was already functioning as a bilingual

institution. As was common in such subscription school arrangements, the indenture specified that the English and German languages were to be "taught either together at one and the same time or Alternately, as the…Trustees or a Majority of them shall from time to time Direct."[13] In practice, the latter seems to have been the more common arrangement.

Surviving deeds document the founding of several such schools in Bucks County's northern townships. One was located on the Swamp Road in Hilltown Township where, in 1805, John Funk agreed to let a quarter-acre of his land be used by the inhabitants of Hilltown, Bedminster, Plumstead, and New Britain for a school for "teaching Children the english and German languages." After Funk's death, the administrators of his estate formally conveyed it to trustees Andrew Wilson, Henry Anglemoyer, and John Titwiler.[14]

Yet another bilingual subscription school was established in New Britain Township, near the "boundary line" between areas predominantly German and English. In 1811 Andrew Steer deeded a quarter-acre of land to Ashbel Jones, Jacob Shliffer and Captain Benjamin James, "Trustees of the English & German School to be known and distinguished by the name of the Union School."[15] Apparently this was the first Iron Hill School, sited on the east side of Iron Hill Road, south of Creek Road. No trace of the building remains today. In 1853, a replacement schoolhouse was constructed across Iron Hill Road, following the township's adoption of the common school system.[16]

Trustees Jones and James were descendants of Welsh immigrants who had founded the first settlements in New Britain and Hilltown Townships early in the eighteenth century. Shliffer was the sole German among them. Unlike the Germans, Bucks County's Welsh settlers did not display a strong desire to retain their native tongue. (The Welsh language was already in decline in Wales, not to experience a significant revival until the nineteenth century.) The deed specified that trustees were to be chosen annually by the school's "subscribers" on the first Saturday in September. No records of the school have survived, so the composition of the board over the lifetime of the school cannot be traced.

A bilingual school was likewise established in Tinicum in 1810, when Philip Harpel provided a small lot on Durham Road to Lewis Sommer, John Meyer and Frederick Wolfinger, "Trustees duly chosen and appointed of the English and German School at Durham Road near Red Hill."[17]

Some school deeds are less specific about the bilingual nature of their aims, but profiles of the trustees make such an arrangement likely. On March 31, 1812, for the nominal sum of one dollar, Daniel Solliday of Tinicum conveyed a lot of land "for the use and no other of building a School House thereon and keeping & maintaining a school therein." The grantees were Joseph Smith, Michael Weisel, Henry Worman, Henry Overholt, Jacob Nash, Henry Stover, Emanuel Solliday, Joseph Ridge, Christian Ruth, Conrad Closson, James Van Fossen, James Carrell, Henry Ridge, William Ridge, Isaac Worman, Abraham Wyker, Samuel Hughes, Jacob Fox, John Fox, Arnold Lear, John Wildonger, Hezekiah [?], and Samuel Hughes. These men, clearly representing both the German- and English-speaking residents of the neighborhood, were termed "guardians of the Stony Batter" (though the origin and meaning of the term "Stony Batter" is unknown).[18]

Even those schools closely associated with local German churches began to offer bilingual education. On October 30, 1824, Michael Dech made an agreement with thirty-three subscribers in Nockamixon Township to "teach & keep an English School in Reeding writing spelling and Arithmetick for the space of seventy two days in the stone school house at the Nockamixon Church from the twenty ninth of November next untill said seventy two days is Expired." At the end of the term Dech was to be paid $1.50 for each scholar or three cents a day for those sent by the day. The subscribers were to provide firewood for the school. When his agreement was renewed on April 4, 1825, it was specified that Dech was to keep "an English & A German School" for 72 days at the same location. The arrangement was again renewed on October 20, 1825, for a term to begin on December 5. All of the names on the subscription lists are German, including Wolfinger, Trauger, Stout, Clymer, Messer, and others. Some of the subscribing names are noted to be "by the County," meaning presumably that the children belonged to poor families whose education was to be subsidized by public funds, an arrangement described in detail below.[19]

In 1816, Abraham Hunsberger conveyed a tiny lot in Hilltown Township to the trustees of a

community school near Dublin. It became the "United German and English School House in the North East Section of Hilltown." Fortunately, the record book of this school survives, and provides additional insight into the creation and operation of such institutions.[20] On January 13, 1816, local residents met at the home of Henry Hunsberger to consider two possible sites on which a schoolhouse might be erected. "After an interchange of sentiment," the citizenry resolved to meet again in two weeks to consider the matter further. Gathering at a neighbor's house on January 26, community members settled on a piece of land owned by Abraham Hunsberger, "lying upon the road leading from the Bethlehem road to Dublin Village."

The plan called for the schoolhouse to be constructed, and four trustees elected to govern it—two from the German-speaking community and two representing the interests of English residents. By March 9, after trustees had compared and examined other schoolhouses in the area, the group agreed on a design, and had arranged with several individuals to provide some of the necessary materials, especially white oak logs. Not until June, however, did the trustees and subscribers gather to break ground and begin construction. The following November the school's patrons came together again to clear debris from the completed building and make it ready for classes. The school opened officially to students on December 16. Thus, the entire process, from conception to realization, took nearly one year. Even so, by the end of the year the trustees realized that a shortfall existed in funding for the project and resolved to seek additional support and subscriptions from area residents, a project that likely occupied their attention well into 1817.

The trustees of the school took great pains to work out an instructional schedule and plan that would be equitable to both their English- and German-speaking constituencies. Suggesting that previous united school arrangements had not always worked smoothly, the school rules were carefully worded "to avoid any misunderstanding or confusion among the trustees or subscribers:"

The time for the school to commence shall be about the 1st day of October yearly and every year beginning with 1817. The trustees shall decide whether the Germans or English shall have the first quarter—and immediately after the expiration of three months, the school in the other language from what was taught the preceding quarter, may commence and continue for three months, and so on alternately through the year if they choose...And that particular attention be paid that the Germans and English occupy the first quarter from the time beginning alternately year about, so as to divide the seasons regularly among them....

When a German school is wanted, the German trustees shall have the selecting or approving of the teacher, and when an English school is wanted the English trustees shall have the selecting and approving...neither party being controlled by the other; but they may counsel each other upon the subject if deemed necessary. But it shall be the duty of the trustees unitedly to take care that the schoolhouse suffer no abuse by the schools of the other language.

Given that the school minute book was written in German, and that subscribers with obviously German surnames contributed substantially to the schoolhouse's construction, one would assume that the number of German-language classes held in the building during its first few years would exceed, or at least equal, English-language ones. Surprisingly, however, the German trustees relinquished the first quarter to their English neighbors. Moreover, during the first ten quarters in which classes were actually held, from 1817 through the fall of 1821, only two sessions were conducted in German. Apparently, many of the local German residents were content to send their children to English school.

The last German-language session conducted in the schoolhouse met during the winter quarter of 1841. By July of 1847, English classes also apparently ceased, although the school still held an election of trustees in December of that year. In 1866, fifty years after the "United German and English Schoolhouse in the NE section of Hilltown" was founded, the trustees finally turned over the property to the Hilltown School District, just as the directors of the school near Sipel's Mill had also done.[21]

Despite the close of classes at the Hilltown school by 1847, other communities still tried to encourage bilingual education. A deed, dated 1848, from Frederick Keeler to the trustees of a school in Bedminster Township, makes it clear that the parties to the agreement expected that a German and English school would continue to operate in their community.[22] Even as late as 1866, an old Hilltown

Township schoolhouse was reportedly the site of a German subscription school taught by Mennonite schoolmaster Samuel Musselman.[23] Still, the days of bilingual instruction were numbered. The same year that Musselman supposedly taught classes in German, state education statistics noted that in Bucks County only 50 students, out of a total enrollment of more than 15,000, were still learning German.[24]

Whether the schools were parochial or subscription, mono- or bilingual institutions, all required teachers to make them run. For those individuals—the vast majority of them men—who pursued teaching as their sole profession, life could be difficult. The work was not steady, but seasonal. Fewer schools operated in mid-summer, when all hands, including children, were needed in the fields. The pay also was not good, and teachers often had difficulty collecting tuition from the parents of their pupils. Parochial schoolmasters might be called upon by the congregation they served to play organ, sing at funerals, or even carve tombstones—all for modest compensation.[25] It is not surprising that many chose to capitalize on their talents with a pen to produce a commercially viable product—a fraktur baptismal certificate, bible record, or bookplate—that could bring them additional income.

Many (though not all) schoolmasters lived a transient life, moving about to find work. There was no system of teacher education, no licensing to distinguish qualified educators from charlatans, and no screening process other than the face-to-face interview between a school's proprietors and a prospective teacher. Schoolmasters were thus often perceived not as respected professionals, but as servants paid for their daily labor. Add to this the problems of maintaining order in a room full of boisterous youth, ranging from small children to robust teenagers, with no principal's office down the hall to which to send unruly students, and the life of a schoolmaster was clearly a challenge. The great eighteenth-century Lutheran minister, Henry Melchior Muhlenberg, frequently lamented in his journals the shortage of qualified teachers, and the lack of money in many localities to support schools adequately.[26]

The prospects for finding competent teachers did not improve much in the nineteenth century. The proprietors of one institution in Springfield Township advertised in 1810 for a teacher, noting

that "A man of good moral character, well qualified for an instructor of Youth will meet with suitable encouragement by applying to Jacob Trichler and others." They added, "A middle-aged man would have the preference," suggesting that the younger men who typically applied for such positions might have been regarded as inexperienced in dealing with the children in their charge, or that they were too unsettled and might not finish out their terms of employment.[27]

In 1816, the trustees at the United German and English Schoolhouse in Hilltown spelled out their own process for selecting and overseeing instructors:

> When any person presents himself to the trustees under the Character of a Teacher, whether upon his own recommendation or the recommendation of others, it shall be the duty of the trustees to use their best endeavour to become acquainted with his character and qualifications [before he is] admitted to teach in the schoolhouse; and if any person so recommended and approved shall be employed for any given time; and it shall afterwards be discovered that he is totally unqualified for teaching, or if any gross charges shall be brought against him while in the employment of the subscribers or trustees, the subject shall be fairly inquired into and upon due examination and enquiry the charges against him shall be found of such a nature as shall justify their dismissing of him, the trustees or any two of them may eject him, with allowing him his wages only for the time he has been actually engaged in teaching.[28]

The regulations also stipulated that the English trustees of the school were to be responsible for hiring the teacher for sessions taught in the English language, while the German trustees would approve the instructor for classes conducted in their native tongue.

The lack of a common set of standards for schoolteachers before the advent of the public school system meant that instructors' backgrounds, experience and commitment to the classroom varied widely. While some men, like Eyer, Kulp, and others, clearly devoted a large segment of their lives to the cultivation of young minds, others worked only briefly as teachers. Some were undoubtedly skilled, others much less so. While many were marginalized, underpaid and transient servants,

others were not. Particularly in the early nineteenth century, at least some of those who served as schoolmasters did so while also conducting other trades and occupations. They might be rooted in their communities rather than transient, and possess skills and intelligence that made them respected and successful in the eyes of their neighbors. The unusual case of the Mennonite Samuel Meyer who not only taught school but also owned the property on which the school was sited, has already been noted. It is important, therefore, not to paint too broadly the "typical" schoolmaster in the parochial or community schools of the late eighteenth and early nineteenth centuries.

The diversity of the teachers who presided over classes in Bucks County's northern townships can be illustrated by just a few examples. Michael Dech, Sr. (1775–1859) worked as a hatter in Northampton County before moving to Nockamixon Township, Bucks County, sometime between 1800 and 1810. In addition to documenting his hatmaking accounts, his "Debit and Credit Book" also names the nine children born to him and his wife between 1797 and 1820. In Bucks County, Dech continued his hatmaking enterprise; operated a mercantile business selling yard goods, watches and other items; wrote deeds, wills, and mortgages for his neighbors; clerked at vendues; and served as township tax assessor. As noted above, this multifaceted man also instructed youth at a schoolhouse associated with the Nockamixon Union Church.[29]

Dech taught at least from the early 1820s to about 1830, perhaps longer. During these years he was also a leading figure in his church, and at one point served as a trustee of the school in which he taught.[30] His enthusiasm for education may be evidenced by the tutoring services he offered to his students in the evening hours. In 1824–1825, for example, he charged Michael Messer 0.22\frac{1}{2}$ for "15 nights night schooling for Charles and Laurence."[31] Toward the end of his life the census recorded his occupation as "conveyancer," a writer of deeds and other documents akin, perhaps, to a Notary Public today.[32] Dech's stature in the community is made clear by a surviving letter, requesting from him a recommendation through which the writer hoped to secure an appointment from the governor of Pennsylvania. The office seeker sang Dech's praises, expecting to find approval both for his political leanings and his

facility with the language: "I know of no man in this township that I am better acquainted with than you…You are well acquainted with our representatives and by your influence that of our representatives will be strengthened. I am a firm and consistent Democrat. I can speak the German and English languages, and I believe that I am well beloved by all who know me…A thousand thanks shall attend you if you will do this favour for me…."[33]

Though not a wealthy man, Dech owned property and was a consistent presence on the local tax rolls. His annual assessment and tax liability place him at the middle of the local economic structure.[34] In sum, he was an educated man of the middle class, active in his church and community, for whom teaching was only one part of a more complex career.

A similar profile can be drawn of Michael Fackenthal, Jr. of Durham Township. Like Dech, Fackenthal evidently obtained a solid education, perhaps partially under the tutelage of the schoolmaster-fraktur artist Johannes Spangenberg. Spangenberg prepared a *Taufschein* for young Michael at the child's birth and baptism in 1795. According to the Fackenthal family genealogy,

> Michael, Jr. followed the profession of scrivener, conveyancer and land surveyor…and in addition to his professional work he had his lumber business and his farm to look after. As a land surveyor he was considered an expert, and his services were greatly in demand. He was also frequently employed in writing wills, deeds and other documents, for which he had a special aptitude. He was often entrusted with the settlements of estates, and often acted as executor or administrator, as well as trustee and guardian for minor children. At different times he served as justice of the peace. For 19 years…he served as president of the Riegelsville Delaware Bridge Company….[35]

Although the compiler does not mention it, between 1820 and 1826 (at least) Fackenthal taught at a schoolhouse in Durham Township.[36] An obviously learned man, for him teaching school was probably an entry-level job, a way-station on the road to a professional career. It should be noted that neither Dech nor Fackenthal are known to have made fraktur.[37] Despite their status as schoolteach-

ers, such inchoately successful men may well not have needed the extra income that fraktur-for-pay could provide. Although many fraktur artists were teachers, by no means were all German schoolmasters fraktur artists.

Another category of individuals who found work as schoolteachers in Bucks County's German schools were tradesmen, especially stonemasons. This may seem strange at first; after all what should qualify a mason to teach? However, if the tradesman was more than simply a stone setter, but also a stone carver, the linkage becomes evident. A competent stone carver would be able to plot and cut decorative lettering in tombstones, datestones, and other masonry products. As such, he may have been a bit more literate than his fellow tradesmen in other occupations.

Among the stonemasons known to have kept school in upper Bucks County during the early nineteenth century were Isaac Lewis, George Textor, John Musselman, and (probably) Michael Crouse. According to family tradition, Lewis (1800–1875) began teaching school at the age of twelve in a log structure on the grounds of the Lower Baptist Church in Hilltown Township. Later he purchased a farm in Leidytown.[38] As early as 1797, Textor (1775–1848) is recorded as a mason on the Haycock Township tax rolls. Particularly during the winter months, when work out-of-doors would have been difficult, he found supplemental employment teaching school in Haycock.[39] John Musselman (1791–1857) was a "marble cutter" and schoolmaster who is known to have taught in Springfield, Hilltown, Richland, and Rockhill Townships during the 1810s and 1820s.[40] And Crouse the mason is likely the same individual who filed several invoices with the county for teaching poor children in Nockamixon Township.[41] Of these four individuals, three were of Germanic ancestry. Textor and Musselman are also suspected of being fraktur artists, though definite proof is lacking (see entries under the Pseudo-Engraver Artist and Samuel Musselman in the catalogue section of this volume).

Others for whom teaching was a secondary (and probably subordinate) occupation include George Scheetz, a Bedminster Township hatter, and John W. Stover, a shoemaker and farmer in Nockamixon. Stover also served as a tax assessor and clerk of the Bucks County Orphans' Court for a time.[42] It is likely that many more of the teachers in northern Bucks County's German-English schools fit similar profiles. Some may have served only briefly in the classroom, filling in when needed before returning to their primary occupations. These were the less transient, less marginalized element in the teaching "profession" of the day.

Clearly, however, there existed many schoolmasters who can best be characterized as poor journeymen, for whom teaching was their primary livelihood. These individuals followed school appointments between townships, counties and even states. Some produced fraktur to augment their incomes. Because of their wanderings, and relative poverty, their careers are often difficult to illuminate. This is especially true of eighteenth-century schoolmasters, although many nineteenth-century teachers fit this profile as well. Included among them are fraktur artists like Johannes Mayer, Bernhard Misson, Jacob Brecht, Anthony Rehm, and many others.

The economic and intellectual diversity among these early teachers is perhaps best seen in microcosm. In Nockamixon Township, where relatively successful, literate tradesmen like Dech and Stover taught school, poorer and more transient schoolmasters also found work. In 1824, for example, Charles Frederick Kinkely taught at the Stone Schoolhouse at Nockamixon Church for at least two terms. He briefly appeared on the tax roll, assessed only for an unspecified occupation and owing just $0.10, but was crossed off the roll by 1826.[43] A few years earlier, Herrmann Diederich Bremer also apparently served the same neighborhood, teaching at "the schoolhouse near the crossroad in Nockamixon." A resident of Northampton County, Bremer taught intermittently in Nockamixon between 1814 and 1823. His marginal economic status is attested to both in local tax records and in his own estate papers.[44] Perhaps it was community dissatisfaction with transient teachers like Bremer and Kinkely that led Dech and Stover to enter and be sustained in the classroom.

Another schoolmaster who taught extensively in Nockamixon as well as in several other Bucks County townships was John Lowder (or Louder). As early as 1817 and as late as 1828 he presided over classes at an institution in the township referred to only as "John Lowder's School." Despite his many years of service to the people of Nockamixon, his economic station, like that of Bremer and Kinkely, was well below the median. Township tax lists show that he owned only one acre of land. In 1821, for

example, he paid just $0.18 in taxes, far below the average.[45]

The relative poverty of Lowder, Kinkely, and Bremer raises the issue of teacher salaries. It is clear that for schoolmasters who relied primarily on income from their teaching activities poverty could be a way of life. Most teachers in subscription schools charged parents about $1.50 per student per term, or something on the order of $0.03 per day. Based upon the invoices teachers submitted to the county for educating poor children, this rate did not change much throughout the first quarter of the nineteenth century, despite obvious economic fluctuations during the period. In 1811, for example, John Lowder charged the county the standard $0.03 per day for teaching poor children. Seventeen years later, in 1828, he still earned only three pennies a day for each of his charges.[46] Given that attendance was irregular, and that parents only paid for those days on which their children actually attended classes, a teacher could not count on receiving a consistent income. Supplementing that income by small-scale farming, work as a scrivener—or by fraktur production—could easily become an economic imperative. Those individuals who owned or had inherited significant acreage, or who pursued other, more lucrative trades in addition to teaching, clearly had an advantage over their less diversified colleagues.

In addition to paying the teacher's salary, the subscribers to a neighborhood school also generally pledged to provide firewood for the building's cast iron stove. They might do so by contributing the wood directly, or paying the cost for the wood in cash or trade. In his accounts, Michael Dech carefully noted payment from parents for both tuition and firewood, as well as for certain other essentials.[47] Parents could be charged for paper, pens and other school supplies—as could the county in the case of poor children who could not afford them. Of course, teachers might collect their salaries and reimbursements for supplies in services rather than cash. Thomas Jefferson Lewis, an English-language schoolmaster who taught German students in Milford, Bedminster, Hilltown, and Springfield Townships, received payment for part of an 1832 tuition bill in the form of a new pair of pantaloons.[48]

The buildings in which all of these teachers toiled varied considerably in quality. The earliest schools were built of logs, sometimes covered with siding. Later, church congregations and subscription school trustees began constructing some out of more durable stone. In northern Bucks County, no descriptions of eighteenth-century structures seem to survive, but there are several accounts of nineteenth-century schoolhouses.

The building constructed to house the United German and English School in northeast Hilltown Township measured 27 feet long and 23 feet deep. In designing the building, the trustees agreed that "the front face the road and that the door be placed in the east corner of the front." It is unclear whether the building was primarily stone or log, although stones for either the foundation or walls were to be quarried from Michael Derstine's meadow.[49]

Several schools in northern Bucks County were built on the so-called "eight-square" or octagonal plan, including ones in Plumstead, Springfield, and New Britain Townships. Thomas Stewart provided the land and most of the materials for the New Britain school, located on Ferry Road near present-day Fountainville, with the intention that it would alternately offer classes in the English and German languages. Constructed on a woodlot, the building "was octagonal in shape, stone, one story, with a roof that came to an apex over the center of the room."[50]

On the interior, furnishings were generally spartan. According to the recollections of a former student at the "Red School House," located in a predominantly Mennonite community on the Doylestown-New Britain Township line (Fig. 56),

Fig. 56. ***The Old Red Schoolhouse.*** M.A. Hewes, Bucks County, c. 1900. Watercolor on paper, 10¼ x 14¼ in. This picture was drawn apparently by the daughter of a student who had attended the school on the New Britain-Doylestown Township line, based upon the memories of her father. (Mercer Museum/Bucks County Historical Society, No. 02738.)

The furnishings of the old school house were decidedly appropriate for use. The teacher's desk was six by four feet, his chair was big and roomy, having been built for a pedagogue who tipped the scales at over two hundred pounds, and in front of his desk was a spittoon two feet square. The writing desks for the pupils were hinged that they might be turned up against the wall, to make room for other gatherings. There were backless benches, both for the pupils and for these special meetings.[51]

This description hints at the other uses to which school buildings might be put. In many cases they served as community halls in which singing schools—separate from the regular curriculum— and debating societies might be held.

Early Bucks County historian William J. Buck recalled the appointments of yet another school- house on Haycock Run in Springfield Township:

It [was] a small stone building standing on a bank by the roadside, plastered without and of humble appearance within, the desks were placed against the three sides of the wall while towards the front was the master's table and the door. In the centre was a large old fashioned stove for burning wood, around which were placed in the form of a parallelogram four benches designed especially for the accomodation of smaller children who did not stand in need of desks for writing.[52]

The eight-square school at Fountainville presented a similar appearance, featuring

wooden desks, with lids...ranged around the interior wall...The teacher had a rough wooden desk, which usually stood opposite the entrance door, the only door in the building. In the center stood a huge ten-plate wood burning stove, with benches around it, where the pupils were allowed to take turns in seating themselves to 'get warm.'[53]

Whether conveyed in religious or secular settings, or something in between, in most localities the curriculum in the early schools was quite rudimentary. When Henry Hertzel and Michael Derstine granted land for a school on the border of Rockhill and Hilltown Townships in 1775, their

objective was simply to promote "Christian Learning and Knowledge."[54] Generally, this meant the basic skills of reading, writing, and simple arithmetic, infused with a goodly dose of "moral instruction." Occasionally, singing and the reading of music might be added to the curriculum. In 1825, when Michael Dech solicited parents in his Nockamixon neighborhood to send their children to his "English and German School," he pledged to teach only "Reeding, Writting, Spelling & Arith- metic."[55] At about the same time in Hilltown Township, however, the Mennonite schoolmaster Jacob Oberholtzer added "singing" and "praying" to his course of study.[56] Nevertheless, especially learned teachers could sometimes enrich the experience of promising students by introducing more sophisti- cated subject matter, even in the most primitive of schools. More economically privileged youth might even be able to study the "higher branches" in the few private academies that existed.

Some detail of the education of one student from a prominent Pennsylvania-German family has survived. Ralph Stover (1811–1896) was the grandson of a state legislator of the same name, and came from a relatively wealthy and distinguished Mennonite family. He first attended school at Deep Run, which family tradition relates, "was then surrounded by the primeval forest." Then, in 1824, at about age 13, he went to a school in Springtown taught by David McCray, boarding with the town's postmaster Jacob Funk. Afterward, he attended a school at Red Hill (now Ottsville in Tinicum Township), "studying higher branches under the tuition of William Smith." Finally, he completed his studies at the "Doylestown (Pa.) Academy under Robert P. Dubois." The latter, better known as the Union Academy, was founded by Presbyterian minister Uriah DuBois. Clearly, this student started his career with a basic education in a traditional Mennonite school, probably taught in German, and then went on to schools taught in the English language by schoolmasters of British ancestry. Stover grew up to become a wealthy and influential businessman with interests in milling and the lumber trade, among other things.[57]

In both English- and German-language schools, attendance and schedules could be extremely irregular. Students went to school when their parents could afford to send them; when they were not needed around home, farm, or shop; when a teacher was ready and available to conduct classes;

and when weather permitted. An analysis of attendance for one quarter in a school taught by Enos Godshalk in New Britain Township conveys a sense of the frequency of student attendance. Godshalk enrolled 56 students in the fall quarter of 1821, and held classes for a total of 75 days. About a third of his pupils did not actually begin attending classes until the quarter was half over. On average, his students attended classes for only 29 days out of the 75. His average daily attendance amounted to just twenty-two scholars.[58] In addition to family economic imperatives, sickness, apathy, and other factors, weather could also limit attendance, especially in the winter months. In the winter of 1835–1836, Beriah Jones began teaching English-language classes at the school in the northeast section of Hilltown but was forced to suspend classes, "very deep snow prevent[ing] his continuing."[59]

Although the trustees of a school like the one in the northeast section of Hilltown might plan for classes to begin "about the 1st day of October yearly," the reality was often quite different. Based on the list of school terms recorded in the trustees' book, only occasionally did classes actually begin during the first week of October. Fall terms just as commonly began in September or November as teachers came forward to offer their services and tuition was collected.[60]

It is commonly supposed that few schools held classes during the summer months when students might be needed on farms to support the family economy. While generally true, the irregularity of school terms meant that sometimes classes were held during the summer—particularly in June and August as terms ended and then began anew. Enos Godshalk taught on the so-called quarter system at the New Britain Union School, although his quarters did not necessarily conform to the calendar year. His roll book records six quarters of instruction between the spring of 1821 and the winter of 1822–1823. A term begun in March of 1822 actually extended through June, and then in mid-August Godshalk again began offering classes. A school that he convened in April, 1821 even continued into early July.[61] Indeed, an examination of surviving teacher invoices for instructing Bucks County's poor children show that, at least in the early nineteenth century, schools began in every month of the year, including June, July, and August.[62]

Despite the irregularity of the school "calendar,"

however, patterns do appear. Classes were more commonly convened during the late fall, winter and early spring. A sampling of *Notenbüchlein*, or manuscript tune books, presented to children learning singing and musical notation in the German schools, hints at this annual pattern. These books were probably given to students near the end of the school term, either in regular classes or as part of separate singing schools. Of 90 tune books with presentation dates, 38 (or 42%) were made and presented in the months of January, February, or March when winter terms were concluding. Nineteen (or 21%) were received by scholars in May and June when spring terms often ended. Few, however, bear dates during July and August (only 2%) when fewer students were enrolled in singing schools or regular classes.[63]

During each term or quarter, the hours that students attended classes probably also varied considerably. They might be quite long, even in the winter months. In his report of activities at "Schovel's School," teacher A.J. Dannehower noted that "daily exe[r]cises...commenced between the hours of 7 & 8 in the morning and one hour for noon and closed between the hours of 4 & 5 in the evening."[64] Such hours would be kept either five or six days out of the week, Saturday classes not being uncommon.

The rules and regulations governing teacher and student behavior survive from several early schools, and are remarkably similar in tone and content. They generally admonish both the instructor and scholars to exhibit moral and decent behavior, encourage cleanliness, and stress the importance of order. Some of their stipulations also stemmed from attempts to correct what were undoubtedly typical forms of misbehavior. In the rules of a school at the Lower Baptist Meeting House in Hilltown Township (not a German school), the trustees chose to emphasize that the "tutor," or schoolmaster, was responsible for his charges from the moment they left their respective homes to the time they returned, and could correct them "Severely for Misbehaviour on the Road."[65]

Even more revealing, though hardly surprising, are the regulations of an unidentified, early nineteenth-century Bucks County school. Among them were that "scholars must not stare at people who may come into the schoolhouse;" "ramble about into any enclosed fields, meadows or orchards;" throw things at passersby; engage in

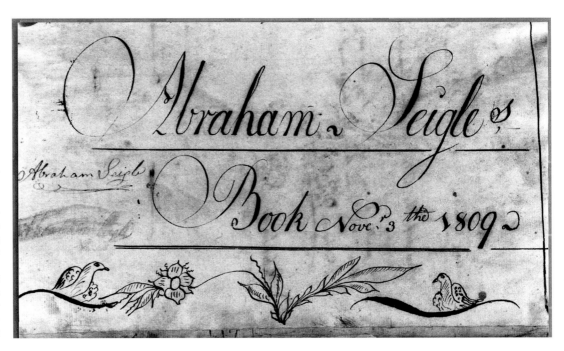

"wrestling, fighting, swearing, lying, gaming, trading or any indecent behaviour;" or "defase [*sic*] the writing desks either by cutting or scratching them."[66]

The material culture that remains from the early schools is limited, but tantalizing. Most of the schools themselves, at least from the period before the common school era, are gone, along with their furnishings and accoutrements. Although numerous printed school readers, spellers, ABC books, and other such texts abound in collections throughout the region, those were mass-produced publications, revealing how the educational process was perceived from the point of view of textbook writers. Certain other documents, however, reveal how education actually took place at the schoolhouse level.

Printed schoolbooks were expensive. Consequently, most students wrote their lessons in school exercise books, or copybooks, in which they laboriously copied mathematical problems and other exercises (Figs. 57, 58 a,b). Many of these manuscript copybooks have survived, and many have decorated title pages, page headings, colored illustrations of problems in geometry, surveying, and other disciplines, as well as miscellaneous sketches and doodles. Those that come from Pennsylvania-German schools reveal clearly how pervasive was the inclination to decorate and to use color and fancy lettering. Considering that at least some of the teachers of the students who created such decorations were fraktur artists, it is not hard

to imagine the role of the schoolmaster-artist in inspiring his (or occasionally her) students to make decorative drawings and lettering in their copybooks.

The culture of the schools, not just those in the Pennsylvania-German tradition but of English schools as well, provided for special rewards or gifts to students who completed their lessons exceptionally well. Little scraps of paper, with colorful drawings and perhaps a line of text, conveyed the teacher's pleasure and encouragement to a good student (Figs. 59, 60). At first, the teacher created these little gifts himself. In later years, as education became widespread and teachers could not keep up, perhaps, with the pace needed to create individualized pieces for even their best students, printers supplied forms for rewards of merit, often with illustrations and moral admonitions (Fig. 61).

In considering these educational documents from the fraktur "era," especially the exercise books and rewards of merit, it is interesting to observe how ubiquitous was the urge to decorate. Fraktur did not exist in a vacuum. The schoolteachers who were the primary creators of the art form had students, colleagues, and others who emulated their work with varying degrees of success (Fig. 62).

The early parochial schools were the initial strongholds of German language and traditional

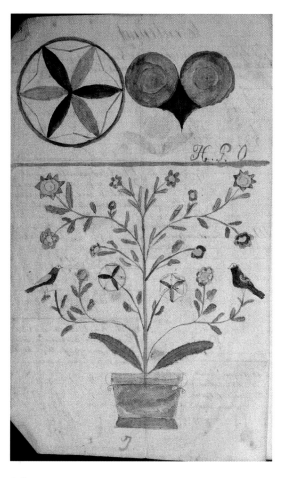

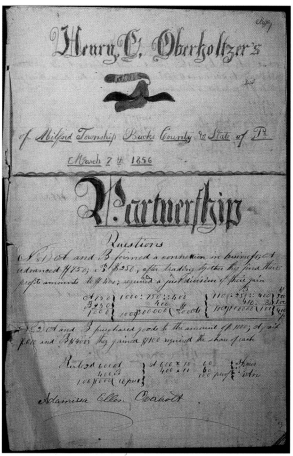

Fig. 58 a, b.
Cyphering Copybook of Henry Oberholtzer.
Henry Oberholtzer, Milford Township, 1856. Hand-drawn, lettered and colored on paper. 12 x 7⅝ in. (Spruance Library/ Bucks County Historical Society, MSC 699, Fol. 7.)

folkways. When alternatives to these institutions arose—for example, in the form of the subscription or neighborhood school—they helped lead the way toward assimilation, bilingualism, and more secular approaches to education. Even so, in these schools vestiges of the old traditions lingered for a time in alternating German-language instruction, in the artistry and penmanship incorporated into manuscript copybooks, in the practice of giving rewards of merit, and in student drawings and "doodles." Eventually, even the parochial schools (the few that remained) became assimilationist, and taught their classes in English. Prominent among these institutions was the Deep Run Mennonite school (Fig. 63), once the epicenter of fraktur production, where English was the language of instruction by the 1840s.[67]

Perhaps it can be argued that by that time many, if not most, people of German ancestry were functioning in a bilingual mode. German was the language of religious worship and of conversation at home and within the local community, while English was the necessary language of commerce and law, and of anyone who had the slightest

ambition in politics, higher education, or other pursuits beyond the local villages and farms.

This relationship between language and the nature of social contacts no doubt led to some tensions. Education in rural schools, even at its best, was deficient in many respects. Many German speakers who learned English learned it not very well, and their lack of proficiency helped lead to the stereotype of the "dumb Dutch," who did not function well in the milieu of English customs and traditions.

On the other hand, many ambitious, bright, and talented Pennsylvanians of German ancestry rose to positions of power, wealth and importance in the English-speaking world and overcame any problem of language or culture. To offer a few examples, John Peter Gabriel Muhlenberg (1746–1807), son of the Lutheran patriarch Henry Melchior Muhlenberg, was a brigadier general in the Revolution and later served in both the U.S. House of Representatives and the Senate. His brother, Frederick Augustus Muhlenberg (1750–1801), was a member of the Continental Congress and was the first Speaker of the U.S. House of Representatives.

Fig. 59. **Reward of Merit for Daniel Landes.** Attributed to Johann Adam Eyer, Perkasie School, Hilltown Township, 1781. 5⅝ x 3 in. Hand-drawn, lettered and colored on laid paper. (Schwenkfelder Library and Heritage Center.)

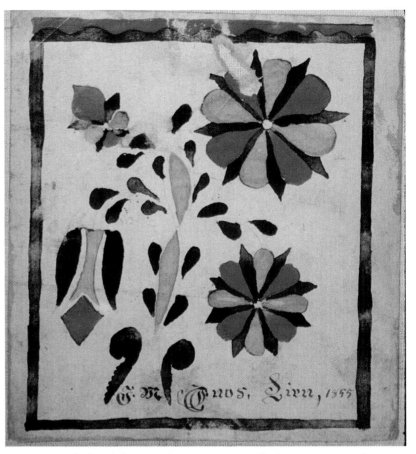

Fig. 60. **Reward of Merit for Enos Bien.** F.M. [poss.], Bucks County, 1855. Hand-drawn and colored on wove paper. 4³⁄₈ x 4 in. (Spruance Library/Bucks County Historical Society, SC-58. No. A-26.)

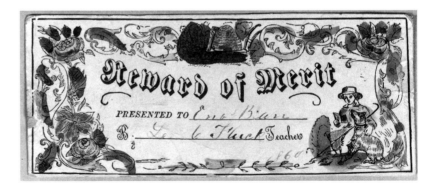

Fig. 61. **Reward of Merit for Enos Bean.** Bucks County, 1860. Printed and hand-colored on cardboard. 2¼ x 5³⁄₈ in. (Spruance Library/Bucks County Historical Society, SC-33, Fol. 035.)

Simon Snyder was the first governor of Pennsylvania of German ancestry, serving from 1808 to 1817. Others who followed him were Joseph Hiester, governor from 1820–1823, John A. Schulze, 1823–1829, George Wolf, 1829–1835, Joseph Ritner, 1835–1839, and Francis Rawn Shunk, 1845–1848. More specific to Bucks County, Ralph Stover (1760–1811), the descendant of a Pennsylvania-German milling family with interests across upper Bucks, represented the county in the state legislature from 1790 until 1799, and served in several other public offices. To succeed in politics and business, men such as these needed not only a command of the English language, but a familiarity with the social behavior and customs of the broader society as well.

The road between languages, of course, went both ways. Not only were some Germans interested in learning English; a few English speakers actually wanted to master German. A remarkable example was Charles B. Trego, a young Quaker from Upper Makefield Township in lower Bucks County. The German language was not, of course, taught in the schools available to him. "When barely of age, through his studious habits, he formed the scheme of going to some one of the upper townships to teach school in the English branches, with the object of acquiring a knowledge of the German language, that he might thus become enabled the readier to read and speak it." Around 1815 he secured a job teaching at a school north of Pipersville on the Easton Road, where Deep Run flowed into the Tohickon Creek, and where most of the pupils spoke German. He taught there for at least two years, and probably at other Pennsylvania-German schools as well, trading his fluency in English for his pupils' facility with German. Trego went on to become a prominent geologist and botanist, as well as a politician, serving in the State Assembly and Philadelphia City Council.[68]

The notion that the state might have a compelling interest in the education of the general public was tied closely to the political aims set forth during and after the American Revolution. If electoral power in a democracy was to be extended not only to a propertied and privileged elite but to the broader citizenry, it was important that all of those citizens should be able to comprehend the issues of the day.

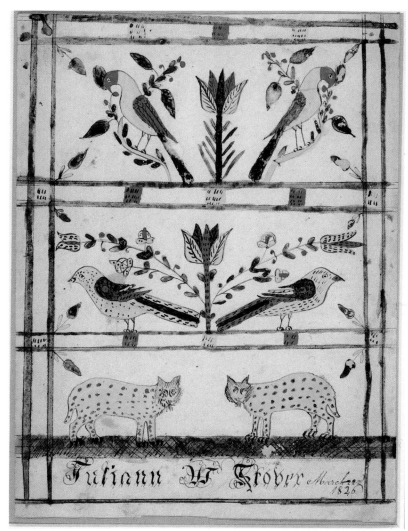

Fig. 62. **Drawing of Juliann W. Stover.** Probably Juliann Stover, Bucks County, 1846. Hand-drawn, lettered and colored on wove paper. 10½ x 8 in. This is probably a student work derived from the fraktur of schoolmaster Bernhard Misson or one of his copyists. (The Library Company of Philadelphia.)

Just as many religious denominations supported education in the belief that their members should be able to read the Bible and other religious texts, so too did the political establishment desire citizens who could read the Constitution and Federalist Papers, as well as pamphlets, tracts, and newspapers informing them about current events, electoral campaigns, and public policy.

In Pennsylvania, as in other states, there was a long interval between the expression of such democratic ideals and their actual implementation. The state constitution of 1776, hammered out in the heat of the struggle, contained the provision that the legislature should establish schools in each county "with such salaries to the masters paid by the public as may enable them to instruct youth at low

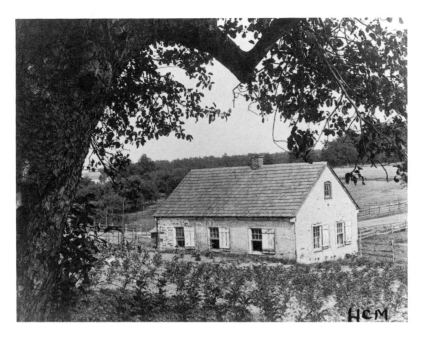

Fig. 63. **Deep Run Mennonite Schoolhouse.** Bedminster Township, built 1842. This photograph, and those illustrated as figs. 66 and 67, were taken by Henry Mercer in 1897. (Spruance Library/Bucks County Historical Society, BCHS Album.)

prices." No subsequent laws were passed to implement this conviction, however. A new constitution in 1790 tempered the generally radical principles of its predecessor, but its statement regarding education was even stronger, allowing the legislature to "provide by law for the establishment of schools throughout the State, in such a manner that the poor may be taught gratis."[69]

Though the principle was in place, and public education debated frequently, politicians created no plan for implementing it for more than a decade. Not until 1802 did the legislature finally pass a law providing for the education of poor children at public expense. Even then the language had to be repeatedly revised in the years that followed before a workable system was developed. The program allowed children whose parents could not afford the tuition at private or church-operated schools to attend classes at the expense of the county. Teachers submitted bills for tuition costs and other expenses, such as books and paper, to school trustees. Upon approval, the trustees in turn forwarded the invoices to the county commissioners, who paid the teachers out of public funds. The records of these transactions, when they have survived, provide an invaluable source for the history of education during the three decades in which the system was in place (Fig. 64).[70] Although in Bucks County virtually all of the bills were submitted in the English language—even those drawn up by Pennsylvania-German instructors—some of the invoices clearly document that lessons were taught

in the German tongue. One notes, for example, that George Funk, Jr. instructed "Poor Children in the German Language of the Townships of Bedminster & Haycock held at the school house near Keller's Church" in 1820.[71]

While broadened access to education boded well for democracy in Pennsylvania, it also laid the groundwork for societal changes that would lead to the demise of the culture that had nurtured the rise of fraktur artistry. It was not as though the state set out to destroy Pennsylvania-German traditions. On the contrary, the law of 1804 specifically designated that the education of poor children might be carried out in either English or German. Indeed, Pennsylvania was effectively a bilingual state for much of the early nineteenth century. New laws, legislative proceedings and other public documents were published officially in both languages.

But in 1834 Pennsylvania passed an act providing for the free public education of all children. Obviously the product of much compromise, it provided that each township would vote on whether to adopt or reject the system. Initially, most townships in Bucks County rejected the scheme, especially those in the north where citizens of Germanic ancestry were concerned about the law's homogenizing implications. It took many more years for the idea to gain wider acceptance.

If a township approved the public school law, voters then elected a board of school supervisors, charged with acquiring land for local schools, constructing school buildings, and hiring teachers. When the system was up and running, there were usually several schools established in each township. These were the "common" or "district" one-room schools that became objects of nostalgia for generations of Americans. Many still stand today, converted into homes or businesses.

At first, the common school system operated haphazardly, with teachers demonstrating minimal training or qualifications and school boards providing little guidance. But in 1854 a new law made the common school system mandatory, drawing in all of the townships that had declined to accept the system twenty years earlier. It also instituted the office of County Superintendent, responsible for examining teachers, visiting the schools and reporting on their quality, and otherwise bringing a degree of professionalism to the educational effort. Their reports are an important source for local school history, and document what

must have been a difficult struggle to reform a rather chaotic educational system.

Bucks County's first school superintendent was Joseph Fell of Buckingham Township. Fell wrote in 1855, in a portion of his report called "Mixed schools," that "a good many" schools in Bucks County were taught in English and German "simultaneously," and he ventured the opinion that more rapid progress would be made if instruction in the two languages was done separately. He also noted that two or three schools still were taught exclusively in German during the previous winter, at which "attention was principally paid to reading, spelling and singing." These schools, he added, were "largely attended," and in them he lamented the lack of geography, grammar, and arithmetic instruction, to the detriment of the scholars.[72]

In the same report, Superintendent Fell spelled out the "Order of School exercises" in three English schools and a German school. The latter was the Hilltown Union Schoolhouse, presided over by John Proctor. In Proctor's class, 21 students spent two periods reading from a German Testament, followed by 14 pupils reading from the same book (perhaps at a more advanced reading level). Then, "A class reads and spells in [a] German spelling book," and "Two or three scholars say a lesson in German primer." Fell goes on to say, "All the classes say two lessons in the forenoon. Two classes spell out of book; one from German grammar, the other from Benner's spelling book. The scholars sing twice a day and are instructed in the art scientifically, by the teacher. The afternoon exercises are the same as the forenoon."[73]

Fell may have been critical of German schools, but he was equally concerned with poor teaching in English-language institutions, directing his criticism at teachers who spent their time reading the newspaper instead of teaching, who failed to keep their schoolhouses clean, who did not know their geography, and one who divided his class into two equal groups, passed out clubs, and set them upon one another in a primitive lesson in military science!

In contrast to the bilingualism that marked many early private schools, common schools eventually meant a common language. And, despite pockets of resistance, that language was English. Still, advocates of German-language instruction in Bucks County persisted in making a case for bilingualism. By 1860 there was a proposal to elect

a county superintendent who spoke German as well as English. This resulted in the election of Simeon S. Overholt, who served in the post from 1860 until 1869. But despite such efforts, the decline of German as the language of common education was rapidly becoming inevitable.[74]

By the end of the Civil War, traditional Pennsylvania-German arts and music that had been associated with the old schools were becoming a distant memory. In the community, however, the dialect remained strong. In 1868, the Association of the German Press of Pennsylvania, a group that included editors, publishers, clergy, and teachers, made a series of intriguing proposals that clearly represented the attitude of a large number of Pennsylvania-German intellectuals. Their ideas took the form of a petition to the directors of public

Fig. 64. **School Bill.** John O. Allem, Springfield Township, Bucks County, 1821. (Spruance Library/Bucks County Historical Society.)

Fig. 65. **Reward of Merit for Mary Overholt.** Samuel Godshalk, probably Deep Run School, Bedminster Township, 1840. Hand-lettered on wove paper. 2 x 7³/₈ in. (Spruance Library/Bucks County Historical Society, SC-33, Fol. 132.)

schools in the state. First thanking the school system for introducing the study of the German language into many of the high schools, they asked that it be extended to the lower grades in the free public schools. Such a policy made sense, they claimed, since few pupils ever rose so far as high school; half of the state's church members attended German-language services; nearly 100 newspapers were published in German across Pennsylvania; German was the mother tongue of half the parents in the state; and German was useful in business, social intercourse, and travel. The Press Association acknowledged that many children already spoke the Pennsylvania-German dialect, and should be taught "pure German." By this time, of course, Pennsylvania had multitudes of new German immigrants who were never part of the distinctive Pennsylvania-German tradition but who might have strengthened the state's place as a Germanic stronghold. The petition's final argument opined that Pennsylvania was the "Old German State," and that distinction should be respected.[75]

One of the strongest advocates of Pennsylvania-German culture in Bucks County was a native of Springfield Township, Abraham Reeser Horne (1834–1902). Horne was convinced of the vitality of the German language and culture that had thrived in Pennsylvania for well over a century. German was alive and well in church services and newspapers throughout the region. More recent immigrants had spread the language across the nation, especially in the Midwest. Horne likewise believed that to function well in American society, all German-speakers had to be equally conversant in English. Thus, he advocated that schools should be bilingual in those areas with a significant German-speaking population. He even proposed that the Pennsylvania-German dialect should be employed in bilingual

education, this at a time when many thought of the dialect as a debased form of "genuine" German. Horne founded the Bucks County Normal and Classical Institute in Quakertown in 1858, edited a publication called the *National Educator* for forty years, and published the *Pennsylvania German Manual*, one of the earliest works about the dialect. The latter was intended to teach English to speakers of Pennsylvania's unique form of the language, and it went through several editions.[76]

Such proposals, however, had little effect on the trend toward English-language instruction in the common schools, and assimilationists eventually won out over traditionalists. An intriguing figure among the assimilationists was Samuel Godshalk, a schoolmaster who entered the classroom in 1841 and who directed the change to English-language instruction at the Deep Run school. Samuel was the son of Abraham Godshalk (1791–1838), a minister at the Doylestown Mennonite Church and author of several devotional books, all published in German though some were later translated into English. Perhaps at the urging of Samuel, the old school-house at Deep Run, where Eyer and Kulp had once taught, was torn down in 1842 and replaced with a new stone building. It is not known whether Godshalk ever created any fraktur, though some simple manuscript rewards of merit, all in English, are by his hand (Fig. 65).[77]

Godshalk went on to become an ordained Mennonite minister, travelled as a missionary, and remained prominent in his community for the rest of his life. He wrote entirely in English. Among his writings was an elegy composed after the sudden death of his son soon after the latter moved to Kansas in 1879: *Encouragement to Early Piety, For the Young. By Samuel Godshalk, Relating to the Death of his Son, Henry.*[78]

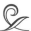

Fig. 66. **Ceiling Beams with Shape Note Music.** Deep Run School, Bedminster Township. (Spruance Library/Bucks County Historical Society, BCHS Album.)

Long after the end of Godshalk's teaching career, in the 1890s, a revival of interest in German language and culture took place at the Deep Run schoolhouse. In a letter, he wrote, "We have a German School in the old Schoolhouse, which I visit occasionally for pas time [*sic*]. Mostly such as are nearly grown up, in number between 30 and 40."[79] It was perhaps during this period of revival (around the time that the Pennsylvania German Society itself was founded), when a new enthusiasm struck for learning the traditional language and music of earlier generations, that Godshalk was moved or persuaded to inscribe the music of his youth on the beams of the schoolhouse (Fig. 66). He may also have created the colorful fragment of musical notation, on paper clearly of late nineteenth-century origin, that Henry C. Mercer found at the school and retained for his collection.[80]

Nostalgia and revivalism, however, could not alter the fact that the common school system had begun to work well in Pennsylvania, even as it forced the closing of local, private schools. Of course, the one-room public school of the last hundred years is now itself a distant recollection of our oldest citizens. The last one-room public schools in Bucks County closed in 1957. The nostalgia of the people who attended those schools is as intense as that which must have been felt by some Pennsylvania Germans who learned their lessons in German before 1850, whose traditions Henry Mercer sought so vigorously to preserve, and who faithfully treasured and saved the vibrant and colorful bits of paper that we now value so highly as fraktur.

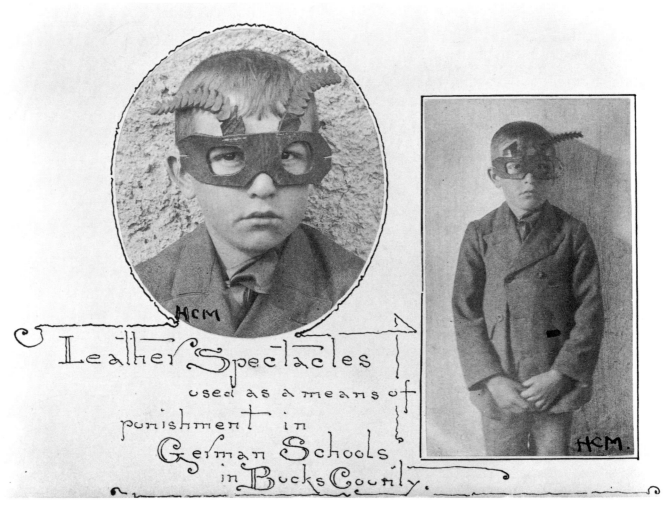

Fig. 67. **Bocks-Brille or Goat Spectacles.** Deep Run School, Bedminster Township. According to information collected by Henry Mercer, teachers at the Deep Run School used these spectacles—the equivalent of a "dunce cap"—to discipline unruly (or especially dense) students. (Spruance Library/Bucks County Historical Society, BCHS Album.)

Notes

1. Kellers Evangelical Lutheran Church, Bedminster Township, Bucks County, Pennsylvania, 1751–1870 (Doylestown, Pa.: Bucks County Historical Society, n.d.), 10–25, 32, 37–38, 97–98, 104, 152–155.

2. Thomas G. Meyers, trans./comp., *Church Records of St. Luke's Evangelical Lutheran Church, Nockamixon Township, 1766–1921* (Doylestown, Pa.: Bucks County Historical Society, 1991), 72.

3. Meyers, trans./comp., *Church Records of Trinity Evangelical Lutheran Church, Springfield TWP., 1797–1913* (Doylestown, Pa.: Bucks County Historical Society, n.d.), 128.

4. William J. Hinke, *A History of Tohickon Union Church, Bedminster Township, Bucks County, Pennsylvania* (Meadville, Pa.: Pennsylvania German Society, 1925), 272.

5. Russell D. and Corinne P. Earnest, *Papers for Birth Dayes: Guide to the Fraktur Artists and Scriveners,*

2nd. ed., 2 vols. (East Berlin, Pa.: Russell D. Earnest Associates, 1997), 1:256–60.

6. John C. Wenger, *History of the Mennonites of the Franconia Conference* (Telford, Pa.: Franconia Mennonite Historical Society, 1937), 328; also *Bucks County Intelligencer* (Doylestown, Pa.), 3 January 1860.

7. Criminal Papers, File No. 9118, Bucks County Archives, Spruance Library/Bucks County Historical Society, Doylestown, Pa. (SL/BCHS).

8. "Deed of Sale from Hartman Teeterman to Frederick Sallate, et al.," April 16, 1765 (recorded May 12, 1807), Deed Book 37, p. 289, SL/BCHS.

9. "Deed of Sale, Samuel Moyer to Trustees of the German School House in Hilltown," April 21, 1800 (recorded May 13, 1800), Deed Book 30, p. 475, SL/BCHS.

10. A.J. Fretz, *A Genealogical Record of the Descendants of Christian and Hans Meyer* (Harleysville, Pa.: News

Printing House, 1896), 80–81, 100–102, 143; also Earnest, *Papers for Birth Dayes,* 2:551.

11. "Proceedings of Trustees of the German School House in Hilltown," MSC 694, Fol. 1, SL/BCHS.

12. "Deed of Sale, Jacob Hunsicker to School District of Hilltown," February 24, 1866 (recorded May 26, 1866), Deed Book 132, p. 605, SL/BCHS.

13. "Deed of Sale, Adam Tinsman to the Trustees of the German-English School in Bedminster Township," April 23, 1796, Loux Family Papers, MSC 87, Fol. 1, SL/BCHS.

14. "Deed of Sale, Estate of John Funk to Andrew Wilson, et al," June 5, 1819 (recorded August 28, 1822), Deed Book 49, p. 192, SL/BCHS.

15. "Deed of Sale, Andrew Steer to Ashbel Jones, et al," August 24, 1807 (recorded August 28, 1811), Deed Book 40, p. 184, SL/BCHS.

16. "Deed of Sale, Martin Moyer to School Directors of New Britain," March 10, 1853 (recorded April 25, 1853), Deed Book 82, p. 489, SL/BCHS.

17. "Deed of Sale, Philip Harpel to Lewis Sommer, et al," May 10, 1810 (recorded May 29, 1811), Deed Book 40, p. 73, SL/BCHS.

18. "Deed of Sale, Daniel Solliday to Joseph Smith, et al," March 1, 1812 (recorded May 28, 1822), Deed Book 49, p. 114, SL/BCHS.

19. Michael Dech, "Subscription Agreements," October 30, 1824 and April 4, 1825, Grim Family Papers, MSC 662, Fol. 4, SL/BCHS.

20. "German-English School, Hilltown Township, Bucks County, 1816–1847," transcribed and translated by John Ruth, Mennonite Heritage Center, Harleysville, Pa.

21. "Deed of Sale, Abraham Huntsberger to John Huntsberger, et al," February 5, 1816 (recorded September 21, 1816), Deed Book 44, p. 645; and "Deed of Sale, Jacob Hunsberger, et al to School District of Hilltown," February 24, 1866 (recorded May 30, 1866), Deed Book 132, p. 626, SL/BCHS.

22. "Deed of Sale, Frederick Keeler to the Trustees of an English and German School in Bedminster Township," MSC 389, Fol. 11, SL/BCHS.

23. Henry C. Mercer, "The Survival of the Mediaeval Art of Illuminative Writing Among Pennsylvania Germans," *Proceedings of the American Philosophical Society* 36 (September 1897): 432.

24. *Bericht des Superintendenten der Volks-Schulen des Staates Pennsylvanien* (Harrisburg, Pa.: Singerly & Myers, 1867), 20.

25. Fredrick S. Weiser, "Fraktur," in *Arts of the Pennsylvania Germans,* Scott T. Swank, ed. (New York: W.W. Norton & Company, 1983), 230–1.

26. Frederick S. Weiser, "I A E S D: The Story of Johann Adam Eyer (1755–1837), Schoolmaster and Fraktur Artist with a Translation of His Roster Book, 1779–1787," in *Ebbes fer Alle-Ebber, Ebbes fer Dich/Something for Everyone—Something for You: Essays in Memoriam Albert Franklin Buffington,* in *Publications of the Pennsylvania German Society* 14 (1980); also Henry Melchior Muhlenberg, Journals.

27. *Pennsylvania Correspondent and Farmer's Advertiser* (Doylestown, Pa.), August 20, 1810.

28. "German-English School, Hilltown Township, Bucks County, 1816–1847."

29. "Debit and Credit Book of Michael Dech," SC–58. No. C–16; "Personal Account Book of Michael Dech, 1822–1830," Michael Dech Papers, MSC 42, Fol. 37; "Account Book of Michael Dech," BM B–82; "License to make Hats, Caps and Bonnets," MSC 164, Fol. 170; "A Book for Michael Dech, Teacher, 1829," Michael Dech Papers, MSC 42, Fol. 39; 1828 Tax List, Nockamixon Township, Bucks County; all SL/BCHS. Also Michael Dech, "Bill for Schooling John Rigle, et al, August 29 through December 2, 1825, Nockamixon Township," December 8, 1825, Bucks County School Bills, County Commissioners' Records, SL/BCHS (hereafter B.C. School Bills).

30. "Bill for Schooling John Rigle, et al, November 29, 1824 through April 16 1825, Nockamixon Township," April 16, 1825, B.C. School Bills.

31. "School Book for Michael Dech from the 29th November 1824 to the 1st of April 1825," Grim Family Papers, MSC 662, Fol. 4, SL/BCHS.

32. U.S. Census of 1850, Nockamixon Township, Bucks County, Pa., p. 247.

33. George [page torn] to Michael Dech, n.d., Michael Dech Papers, MSC 42, Fol. 29, SL/BCHS.

34. See, for example, the 1820 Tax List, Nockamixon Township, Bucks County.

35. B.F. Fackenthal, Jr., *Fackenthal Family Genealogy,* 1742–1936 (Riegelsville, Pa.: by the author, 1965), 235.

36. See, for example, "Bill for Schooling Elias Raub, 1825, Durham Township," September 10, 1825, B.C. School Bills.

37. Although Dech was clearly proficient with the pen. The cover of the 1828 tax list for Nockamixon Township displays his own name in fraktur lettering.

38. Mary Jane Erwin, Morris Lewis and His Descendants (Lewis-Jones Association, 1936), 42–43.

39. 1797–1826 Tax Lists, Haycock Township, Bucks County; "Bill for Schooling John and George Reasor, et al, 1823, Haycock Township," April 3, 1823, B.C. School Bills.

40. "Musselman Family," Musselman Family File, SL/BCHS; Rev. A.J. Fretz, *A Genealogical Record of the*

Descendants of Christian and Hans Meyer (Harleysville, Pa.: News Printing House, 1896), 598; Der Friedens Bote (Allentown, Pa.), July 22, 1813; "Bill for Schooling Moses Textar, et al, 1823, Rockhill Township," April 22, 1823, B.C. School Bills (for example).

41. See, for example, the 1820 Tax List, Nockamixon Township, Bucks County; also "Bill for Schooling Aaron Stoneback, et al, December 10, 1820 through March 10, 1821, Nockamixon Township," May 28, 1821, B.C. School Bills.

42. J.H. Battle, *History of Bucks County, Pennsylvania* (Spartanburg, South Carolina: The Reprint Company, 1985), 683, 1061; 1828 Tax List, Nockamixon Township SL/BCHS; "Bill for Schooling John and Jonas Gordon, et al, September 3 through December 8, 1826, Nockamixon Township," B.C. School Bills.

43. Charles Frederich Kinkely, "Bill for Schooling John Stoneback, et al, March 15, 1824 through June 15, 1824, Nockamixon Township," August 21, 1824; "Bill for Schooling Jacob Stoneback, et al, August 9, 1824 through November 9, 1824, Nockamixon Township," December 9, 1824, B.C. School Bills; also 1825–1826 Tax Lists, Nockamixon Township, Bucks County, SL/BCHS.

44. See entry under Bremer in fraktur artists' biographical section at the end of this volume.

45. For Lowder's teaching, see "Bill for Schooling Samuel Harwick, et al, April 23 through September 5, 1823, Nockamixon Township," September 5, 1823, B.C. School Bills; also 1821 Tax List, Nockamixon Township, Bucks County, SL/BCHS.

46. John Lowder, "Bill for Schooling Seth Higgs, et al, May 27 through September 27, 1811, Bedminster Township," May 20, 1812; "Bill for Schooling Jacob Keller, et al, December 10, 1827 through April 21, 1828, Nockamixon Township," April 21, 1828, B.C. School Bills.

47. "School Book for Michael Dech from the 29th November 1824 to the 1st of April 1825," Grim Family Papers, MSC 662, Fol. 4, SL/BCHS.

48. "Account Book of Thomas Jefferson Lewis, 1830–1846," BM B–188, SL/BCHS.

49. "German-English School, Hilltown Township, Bucks County, 1816–1847."

50. Fred F. Martin, "The Highlands," n.d. (typewritten mss.), MSC 472, Fol. 5, SL/BCHS.

51. "Historic Building 'Old Red School House' in Doylestown Township," MSC 26, Fol. 5, SL/BCHS.

52. William J. Buck, *Local Sketches and Legends Pertaining to Bucks and Montgomery Counties, Pennsylvania* (n.p.: by the author, 1887), 219–220.

53. Martin, "The Highlands."

54. "Deed of Sale, Henry Hertzel and Michael Derstine to Samuel Detweiler, et al," 30 January 1775 [not recorded], Schwenkfelder Library, Pennsburg, Pa.

55. Michael Dech, "Subscription Agreement," 4 April 1825, Grim Family Papers, MSC 772, Fol. 4, SL/BCHS.

56. Jacob Oberholtzer, "School Announcement," 1822–1823. For copy see Bucks County Fraktur File, SL/BCHS. We are indebted to Ronald Trauger for bringing the original document to the attention of the Mercer Museum, and for its translation.

57. A.J. Fretz, *A Genealogical Record of the Descendants of Henry Stauffer and Other Stauffer Pioneers* (Harleysville, Pa.: Harleysville News, 1899), 106–108.

58. "School Record Book of Enos Godshalk," MSC 185, Fol. 158, SL/BCHS.

59. "German-English School, Hilltown Township, Bucks County, 1816–1847."

60. Ibid.

61. "School Record Book of Enos Godshalk."

62. Based on an analysis of over 300 school bills in the collection of SL/BCHS.

63. Based on an analysis of 90 tune books recorded in the Bucks County Fraktur File, SL/BCHS.

64. A.J. Dannehower, "Report of Schovel's School," 1846, Bucks County Schools, MSC 26, Fol. 5, SL/BCHS.

65. "Rules and Regulations to be Observed By the Tutor and Schollars of a School to be Kept at the Lower Baptist Meeting House," n.d., MSC 200, Fol. 11, SL/BCHS.

66. "Rules for the Regulation of the School," n.d., Bucks County Schools, MSC 26, Fol. 5, SL/BCHS.

67. Forty-one rewards of merit, dated 1841–1849, given by Samuel Godshalk as teacher to his pupil Abraham High at Deep Run School are in the High Family Papers, MSC 544, SL/BCHS. All are written in English. One is dated February 1, 1827, probably a scribal error, for Godshalk writes on it, "Excuse my bad Writing time is Precious." In the same collection are several of Abraham High's school exercise books from the same period and presumably from the same school, all in English. One has a double title page in German and English, dated February 23, 1846, written "By me Jacob K. Overholt for Abram High."

68. Buck, *Local Sketches and Legends,* 68–74.

69. James Pyle Wickersham, *A History of Education in Pennsylvania* (Lancaster, Pa.: Inquirier Publishing Company, 1886), 255–259.

70. These "school bills," ranging in date from about 1810 to 1829, are housed with the Bucks County archives at SL/BCHS. Generally, they include the name of the teacher, dates of instruction, names of students and school trustees, and the charges billed to the county. Sometimes they also note the location and/or name of the school as well. Because they were usually made out by the teacher himself, or herself, they also provide a sample of the schoolmaster's handwriting and signature. Nearly all, however, are written in English rather than German.

71. George Funk, Jr., "Bill for Schooling Samuel Farrel, et al, March 1 through May 15, 1820, Bedminster Township," August 26, 1820, B.C. School Bills.

72. *Report of the Superintendent of Common Schools of the Commonwealth of Pennsylvania for the School Year Ending June 4, 1855* (Harrisburg, Pa.: Dept. of Common Schools, 1855), 53.

73. Ibid., p. 56.

74. *Bucks County Intelligencer* (Doylestown, Pa.), March 20, 1860; Hugh B. Eastburn, "The Early County Superintendency of Bucks County," *Proceedings of the Bucks County Historical Society* 2 (1908): 253–266.

75. *Doylestown Democrat* (Doylestown, Pa.), August 25, 1868.

76. Alexander Waldenrath, "Abraham Reeser Horne: Proponent of Bi-Lingual Education," *Bucks County Historical Society Journal* 2 (Spring 1977): 16–26.

77. See n. 67. Other evidence that Godshalk was a promoter of the English language includes his decision to publish all of his writings in English, e.g. *Encouragement to Early Piety, For the Young* (Elkart, Ind.: Mennonite Publishing Co., 1880) and "Travel Notes of Samuel Godshalk, 1869," Mennonite Historical

Bulletin 3 (December 1942), et. seq.; his use of English in a long narrative poem recounting his own life history, cited below in n. 80; and his ownership and use of a self-inscribed English-language penmanship book, *Rand's System of Penmanship* (Philadelphia: 1819), SL/BCHS. Finally, and most convincingly, the Souderton diarist William Souder Hemsing wrote on Sunday, August 23, 1885, "This afternoon I did not like to go to Sunday School. Rev. Mr. Godshall from Deep Run addressed the Sunday School in German. English is more easy for him to speak." See the Diaries of William Souder Hemsing (Souderton, Pa.: Indian Valley Printing, 1987), 58.

78. For a recollection that the Deep Run School was still taught in German by Godshalk about 1861, see H.W. Gross, "Mennonite School and Meeting House, With Sketch of Mr. Moritz Loeb," *Proceedings of the Bucks County Historical Society* 4 (1917): 537–539.

79. Letter of Samuel Godshalk, Mennonite Historians of Eastern Pennsylvania.

80. This piece of manuscript music is catalogued as SC–58. No. A–53, SL/BCHS. Perhaps the most tantalizing relic that Samuel Godshalk left behind was a poem, actually a series of quatrains, written also in English, that served as his autobiographical record. In it, he wrote at least one four-line passage describing every year of his life from his 1817 birth until 1896, the year of his death. When the Bucks County Historical Society held its annual meeting at the Deep Run schoolhouse in 1914, Samuel's grandson Samuel Y. Godshalk read passages from this epic. A few of the quatrains were later published in the Society's proceedings. Sadly, the location of the poems today, if they still exist, is unknown. See "Bedminster Township Meeting," *Proceedings of the Bucks County Historical Society* 4 (1917): 533–537.

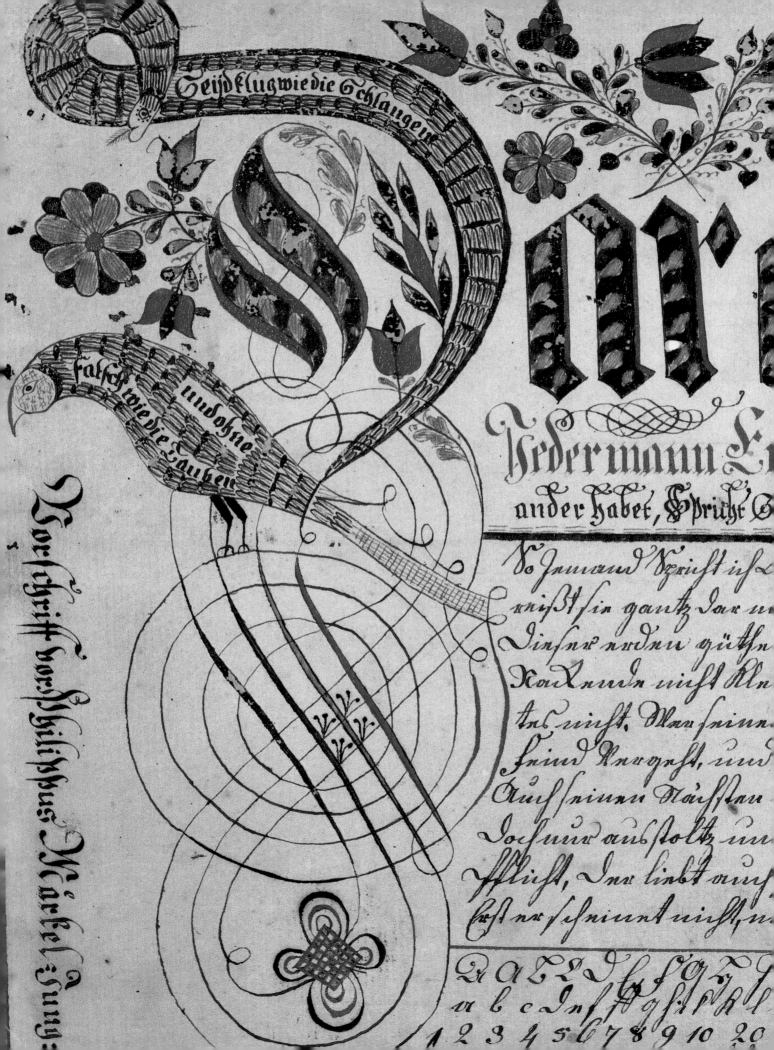

Seid klug wie die Schlangen

falsch wie die Tauben

und ohne

Vorschrift vor Philippus Merkel Jung

Seid klug wie die Schlangen ...

Jedermann ...

ander habet, Spricht G ...

Skippack to Tohickon and Beyond: The Extended Community of Bucks County Mennonite Fraktur Artists

John L. Ruth

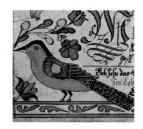

Mennonite fraktur is a recognizable contribution to a larger Pennsylvania-German phenomenon. As with the overall subject, the profile of this component has only gradually been coming into focus. When Henry Chapman Mercer began to collect Bucks County fraktur a century ago, to be followed by Henry S. Borneman and Levi Yoder at both the western and eastern ends of the oldest Mennonite community in Pennsylvania, they knew nothing of the identity of the best eight or nine of the Mennonite artists involved. In fact, only in the last two decades have even the names of these persons begun to emerge from the oblivion and confusion of lost memories. While many valuable identifications have been made, experience teaches that due caution must be observed in our claims of new attributions.

As with Lutheran and Reformed practitioners of fraktur, in its Mennonite form the art was concentrated in the hands of schoolmasters. While the otherwise popular *Taufschein/Geburtschein* genre is hardly represented among the nonchristening Mennonites, beautiful *Vorschriften* and bookplates abound, presenting an especially cherished glow of beauty against an otherwise aesthetically austere background.

The geographic framework for the Mennonite fraktur produced in Bucks County is a cluster of settlements linked in kinship and mutual awareness in a five-county region roughly outlined by the Delaware, Schuylkill, and Lehigh Rivers (Map 2). The Bucks County region is thus at the northeastern

end of the configuration described. The entire grouping is the fruit of a series of Swiss/Palatine immigrations of Mennonites occurring over the seven decades leading up to the Revolutionary War—again, a small component of a much larger migration of German-speaking people.

The Mennonite region examined here is slightly older than its larger sister community of Lancaster, which extends from eastern Chester County westward across the Susquehanna into York County. Lancaster, too, produced fraktur, as early as 1750. The simplest way to visualize spatially the easternmost Montgomery-Bucks Mennonite cluster might be to consider Pennsylvania Route 113, running from Phoenixville on the Schuylkill, via Skippack, Salford, and Franconia, to Hilltown and Bedminster, as the spine of the main community (Map 2, detail). This southwest-to-northeast corridor, winding through and among Lutheran, Reformed, Schwenkfelder, and Dunker neighborhoods, runs transversely across roads pointing southeastward toward the Delaware. As previously implied, there are also significant outlying pockets other than this central zone, once colloquially dubbed by Mennonites of smaller outposts in northern Bucks County as *"Menishteland"*—Mennonite country. Incidentally, the generic term *Franconia Conference* (derived from the name of a township central to the spine), which is sometimes employed to distinguish this Mennonite community from that of Lancaster, was not in use at the time covered in this essay.

My observations are based on a chronology of some 330 *datable* examples of fraktur *by* or *for*

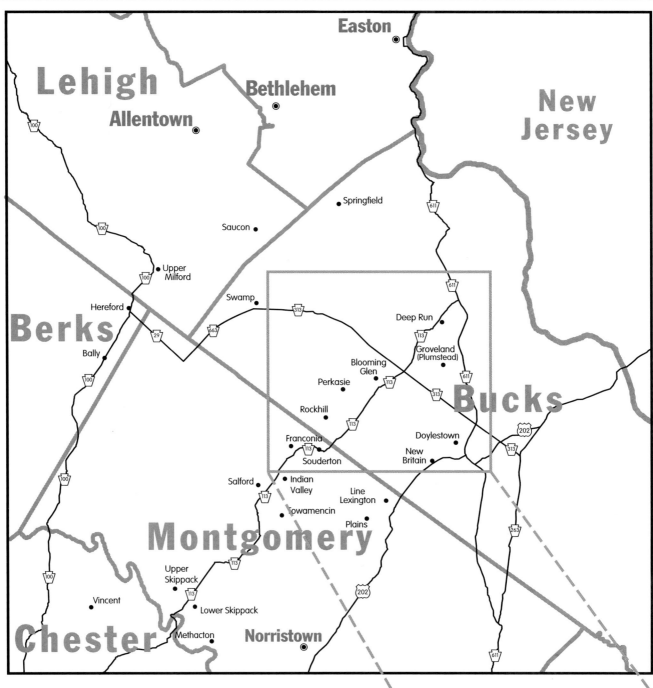

Map 2. **The Mennonite communities of Bucks, Montgomery, and nearby Chester, Berks, and Northampton Counties.**

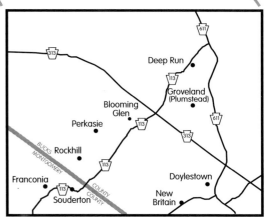

Map 2. (detail). **Menishteland.**

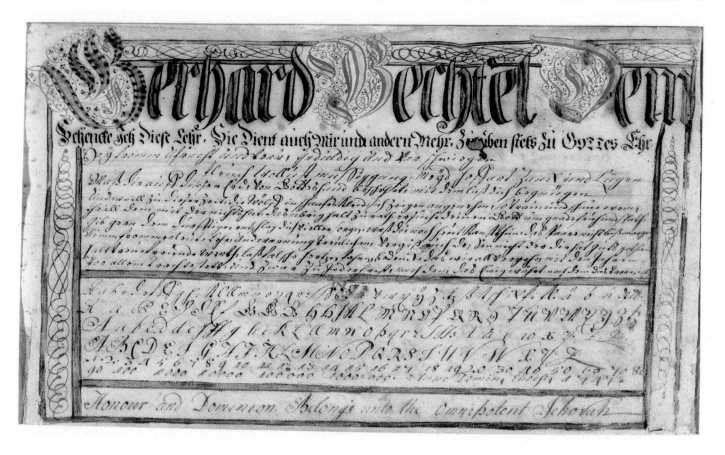

Fig. 68. **Penmanship Model for Gerhard Bechtel.** Attributed to Christopher Dock, Skippack, Montgomery County, 1747. 7½ x 12 in. Hand-drawn, lettered and colored on laid paper. (Schwenkfelder Library and Heritage Center.)

someone in the *extended Mennonite community* of which Bucks County comprises an eastern wing.[1] Ranging from the 1740s into the 1860s, the list is restricted to items for which the date is either explicitly visible on the document or certainly established by other evidence. This amounts, of course, to perhaps only a fourth of Pennsylvania's easternmost Mennonite examples known to survive today in homes, museums, and private collections. Nevertheless, the list helps to frame my limited subject. In almost every case, either the creator or the recipient is named; often both can be determined. Of 300 main pieces, there are 56 *Vorschriften*, 73 *Notenbüchlein* (title pages of singing school booklets); 10 rewards (though otherwise numerous, most of such fraktur *Belohnungen* are not signed or dated); 16 *Vorschriftbüchlein* or *Schreibbücher* (writing practice or example booklets); 118 vertical bookplates; 21 *Bilder* (pictures); and half a dozen family registers. At least thirty-six Mennonite artists can be identified,[2] and the list of names of those to whom the various pieces belonged exceeds 175. Twenty-seven place names, from Montgomery, Bucks, Lehigh, Berks, and Chester Counties, appear.[3] These indicate either the location of a school or the residence of persons named.

Since statistics do not do justice to the human element of the fraktur phenomenon, the emerging Mennonite profile must be supplemented with anecdotal material illustrating the multiple cross-country connections among the people involved. In this essay, I will take note of several intriguing items somehow related to the fraktur-producing community.

The earliest datable Pennsylvania Mennonite fraktur[4] is an unusual *Vorschrift* by Christopher Dock in 1747, made for Gerhard Bechtel (Fig. 68).[5] Though it is unsigned, the date, handwriting, and design make the attribution virtually certain.[6] Dock was an immigrant German schoolmaster who was then teaching in two schools in Lower Salford and Skippack, in present-day Montgomery County. His Bechtel *Vorschrift* (surely not his first) was done two years before Johann Adam Eyer's father Martin arrived in Pennsylvania. It was also nine years after Dock had returned to teaching, and three years before he wrote his famous *Schul-Ordnung* of 1750 (not published until 1770).[7] It appears that Dock taught in both the Salford and Skippack Mennonite meetinghouses, some two and five miles, respectively, from his Upper Salford plantation. He had already taught school as a young man in Germany

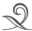

Fig. 69. **Penmanship Model for Ludwig Benner.** Unidentified artist, Rockhill Township, Bucks County, 1773. Hand-drawn, lettered and colored on laid paper. 8 x 12¼ in. (The Library Company of Philadelphia.)

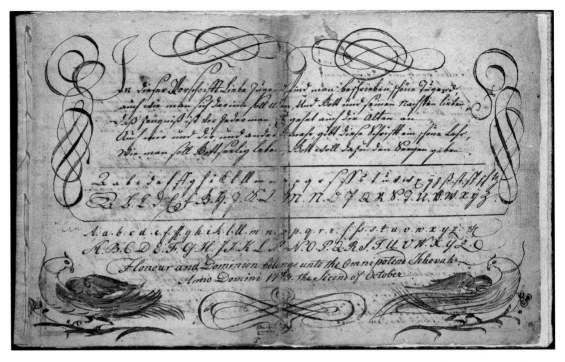

and had taken up this vocation for the first decade of his life in Pennsylvania, from about 1717 to 1727. Some discouragement may have been his motive for leaving his calling for a decade, before returning to the classroom in two Mennonite meetinghouses around 1737–1738. His pattern of teaching three days weekly at each of these two schools is mentioned in his famous *Schul-Ordnung*, datelined "*Sollford, den 8ten August 1750.*"[8] Further research is needed on the provenience of both Dock and his art, and on his having apparently joined the Mennonite community, though living near the Old Goschenhoppen Lutheran-Reformed Church.[9]

Dock tells us that when he wished to have a student help another less-gifted one, he would ask, "Who will instruct the child for such and such a time, in order to get a *Vorschrift* or bird [*wer um eine Vorschrift, oder Vogel, solche und solche Zeit das Kind unterweisen will*].[10] That opportunity, Dock wrote, seldom failed to find a taker. Again, to a beginning pupil who had done well in identifying characters on the blackboard, "I owe," remarked the kindly old teacher, "perhaps a flower painted on paper, or a bird."[11]

Certainly Dock had brought his penmanship along from the Old Country. Since he taught for over three decades (his second stint ran from about 1738 until his death in 1771), there was ample time for him to pass on his art to several generations of pupils. Nor was he the only Skippack

schoolmaster making *Vorschriften*. Herman Ache, a non-Mennonite resident of Lower Salford, signed at least one *Vorschrift*, a rather full and sizable one, for Simon Pannebecker of Skippack in 1758.[12] So there must have been a two-fold influence on Skippack pupils such as the brothers Huppert[13] and Christian[14] Cassel, and Christian Stauffer[15]— all of whom produced *Vorschriften* of their own during the 1760s and 1770s.

Characteristic motifs of Dock's *Vorschriften* are a first capital letter decorated with miniscule calligraphic ornament, simple borders, compartments for alphabet and numerals within double-lined borders, and a closing section in English. And if the motif of double symmetrical birds (either facing or turned away from each other) is of his initiation locally, as seems likely, it becomes a means of tracking his artistic progeny into Bucks County.

Also in these years fraktur was appearing in a Mennonite community adjacent to Dock's Salford: Franconia Township. From that community survive three simple *Vorschriften* "for Jacob Sauter" dated June 1–4, 1762.[16] Three years later, young Martin Detweiler, grandson of an immigrant Meyer family, produced a *Vorschrift*-like "Osterletz." Again in 1769, he penned a rather similar *Vorschrift*.[17] These Dock-influenced Skippack/Salford/Franconia fraktur of 1747–1772 are the apparent forerunners of the regional Mennonite corpus that was to emerge over the next century.

An intermediary community between the older Skippack/Salford/Franconia district and the Hilltown/Deep Run areas of Bucks County was the region later defined as West Rockhill Township, just inside the Bucks County line. Here, Skippack Mennonites had settled since 1738, along with Lutheran and Reformed neighbors. The pioneer Mennonite schoolmasters seem to have been two preachers, Abraham Gehman (d. 1792) and his son Samuel (1767–1845). From this community, under the date of October 2, 1773, survives a *Vorschrift*-with-ABC-poem "for Ludwig Benner," written in quite excellent cursive German (Fig. 69).[18] While not in the ordinary Skippack format, it clearly follows Christopher Dock in its use of the same English quotation, at the bottom, as had appeared in the same place in Dock's *Vorschrift* for Gerhard Bechtel of 1747: "Honour and Dominion belongs unto the Omnipotent Jehovah." Further, the ABC poem that follows, beginning *"An Gottes gnad und milden segen"* is the same as used by the aged Dock in a document of July 18, 1768.[19] This datum, if better understood, may prove to be a key link in the eastward flow of Mennonite fraktur into Bucks County. Specifically, it predates by seven years the appearance at the Rockhill school of the more significant schoolmaster-fraktur artist Johann Adam Eyer.[20]

The locations we have mentioned so far were settled by Mennonites earlier than those appearing farther east in Bucks County. The year 1727, however, brought a second wave of Palatine immigrants that included fresh Mennonite land seekers. And, by the 1740s, immigrants of the earlier main wave of 1717 had children who also needed space for new homesteads. So, from Skippack and Salford (where meetinghouses and schools had been established prior to 1728), as well as from Franconia, Mennonite sons and cousins moved on to Virginia, the Carolinas, and—closer to home—to Bucks County. In the latter case, they migrated eastward, toward the sources of the Northeast Branch of the Perkiomen Creek, through Rockhill, Hilltown, and Bedminster Townships, all the way into the watershed of the Tohickon. Here they bought land from English speculators or first settlers and built solid communities. The two main ones in addition to Rockhill (in the area around Michael Dirstein's mill), were "Perkasie" (around the site of present-day Blooming Glen), and Deep Run (around the

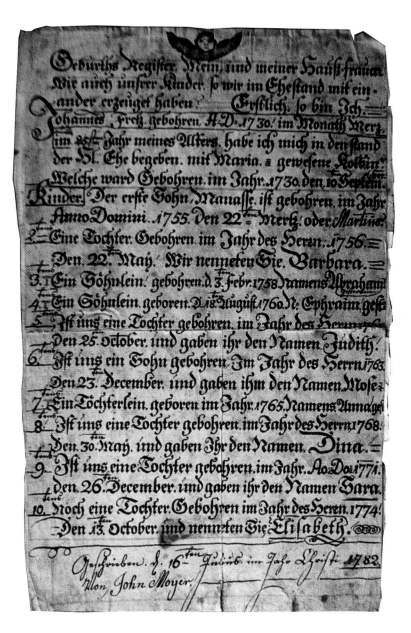

site of the two present-day Mennonite meetinghouses carrying that name).

The Mennonite Hunsberger, Kolb, Kratz, Landes, and Meyer families appearing on Bucks County plantations were mostly cousins of people of the same name who had gotten their earlier start in 1717–1718 back in Skippack or Salford or Franconia Townships. Thus, it has been very tempting, while observing the recent emergence from the shadows of an early Bucks County fraktur artist variously signing his name Johann Mayer or John Moyer, to assign him a connection with the Mennonite Meyers who had come to Hilltown and Deep Run from Salford. This seemed a logical conclusion particularly when it became apparent

Fig. 70. **Family Record for Johannes Fretz.** John Moyer (Johannes Mayer), Bedminster Township, Bucks County, 1782. Hand-drawn, lettered and colored on laid paper. Dimensions not available. The location of this fraktur is presently unknown. (Photo courtesy of the author.)

101

Fig. 71. **Bible Bookplate for Madteis Schnebelli.**
Unidentified artist, Ibersheimerhof, Germany, 1708. In the bible for which it was made. Hand-drawn and lettered on laid paper. (Mennonite Heritage Center, Harleysville, Pa., 90.19.1.)

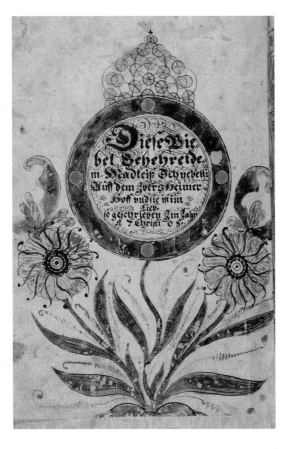

that Mayer/Moyer had taught in the school at the Deep Run Mennonite meetinghouse before the more famous Johann Adam Eyer, and penned items in fraktur for the Mennonite Landes and Fretz families (Fig. 70). But a lengthy Moyer genealogy of 1896 provides no such identification, just as Bechtel records identify no one named Gerhart Bechtel, the recipient of Christopher Dock's unusual *Vorschrift* of 1747. The fact that various baptismal records and communicants' lists from several Bucks County Lutheran and Reformed congregations seem to be in the distinctive hand of Johannes Mayer/Moyer also casts further doubt on a Mennonite identification. Nevertheless, this self-styled "Schoolmaster at Tohickon" *(S.M.st' an Tohecke)*[21] was certainly a close neighbor to Mennonites, taught them in school, and prepared a family register for a family of Mennonite Fretzes, which they took with them when migrating to Canada in 1799.[22]

It is also intriguing to note the close connection of the Lutheran Johann Adam Eyer, the most accomplished of all fraktur artists of the region, with the Mennonite schools of Bucks County. His experience teaching in predominantly Mennonite schools is an interesting parallel to the Pietist Christopher Dock's similar choice of schools. Was

there some kind of Mennonite attitude that drew good teachers of other German-oriented backgrounds?[23] From 1779 to 1786, Eyer taught at no less than three hot spots for fraktur, all with heavy or mostly Mennonite enrollment: Rockhill, Hilltown (Perkasie), and Deep Run. The latter two schools, at least, were in Mennonite meetinghouses, and the one at Rockhill was close to another. In these schools, for which Pastor Frederick Weiser has found Eyer's careful records, Eyer taught young Gottschalls, Hunsickers, Kintzis, Kratzes, Kolbs and Landeses— mostly nephews and nieces of farmers from Skippack, Salford, Towamencin, and Franconia.

An interesting foreshadowing of Eyer's frequent use, on title pages, of a circular motif within which to inscribe names, places, and dates is found in an ancient Bible owned by a Mennonite Bachman family of the Saucon area (present-day Coopersburg) in Lehigh County, just north of Bucks. Probably brought in the immigration of 1717, this quarto-sized Bible published by Zürich's Christophel Froschauer in 1536[24] was a favorite version among Mennonites of Swiss background. Thus it had probably been in the Schnebelli/Bachman family line for generations before it had received, in 1708, an extra tipped-in page with a bookplate inside the front cover (Fig. 71). The fraktur inscription indicates the ownership of Madteis Schnebelli (a family name native to Canton Zürich), then living on the well-known Ibersheimerhof (sometimes nicknamed the Mennonitenhof) along the Rhine just north of Worms. The fact that this Bible contains, on a bound page, an undated register of the Georg Bachman family by Johann Adam Eyer indicates that the artist must have seen the circular medallion motif very early in his career. Of course, to have borrowed it, Eyer would have had to see it by 1780, the date of his first known use of a similar device on a singing-school book for Henrich Honsperger of the Perkasie school (Fig. 72).[25]

Eyer seems to have been the first to produce the singing-school *Notenbüchlein* that frequently appeared thereafter across the extended five-county Mennonite community, as well as in Lancaster County. He also continued a Lower Milford teacher's and Johannes Mayer's practice of making "writing-booklets" for pupils.[26] While both of these forms seem to have been taken back into the older Mennonite communities at Skippack, Salford, and Franconia, nowhere else was there so rich an output as in Hilltown and Deep Run, where Eyer's early

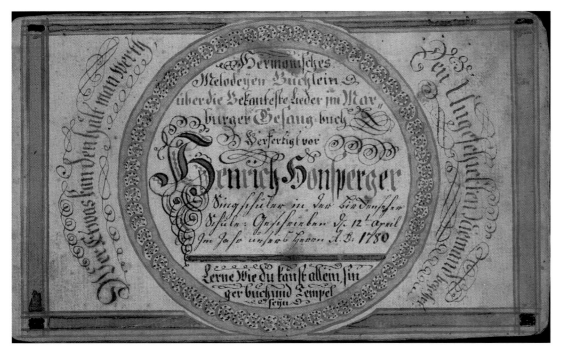

Fig. 72. **Manuscript Tune Book and Bookplate for Henrich Honsperger.** Attributed to Johann Adam Eyer, Perkasie School, Hilltown Township, Bucks County, 1780. Hand-drawn, lettered and colored on laid paper. 4^{1}/$_{8}$ x 6^{3}/$_{4}$ in. (Rare Book Department, The Free Library of Philadelphia, FLP 845.)

influence was strongest. There are still unexplained factors here: how the local singing schools began and flourished, and why the Mennonite proportion of known singing-school *Notenbüchlein* is so high.[27] Interestingly, the chronology on which this essay is based includes twenty-five dated examples of this genre, with Mennonite names, before the year 1803, when the local Mennonites published their own first hymnbook.[28]

Another intriguing Bucks County Mennonite connection with fraktur concerns an indentured servant in a family by the name of Fretz—common among local Mennonites. In 1802, an artistic German immigrant named George Homan, with wife Catharine and son Caspar, were brought to Bedminster from Philadelphia in the Fretzes' market wagon. After about a year with the Fretzes, the young servant became attached to a non-Mennonite neighbor, Nicholas Buck, and got the Fretzes' permission to work for Buck while Mrs. Homan and their son remained on the Fretz farm. In the following year, Homan allegedly produced a *Taufschein* some 12 by 16 inches in size, centering on a heart surrounded by gaudily colored birds, flowers, and angels. He had learned to do this, he reported, in his native Germany. He then proposed that Mr. Buck allow him to spend part of his time doing such work. Many years later, a son of Mr. Buck related how young Homan was so quickly successful in making *Taufscheine* that he was able by peddling them to work off his debt of indenture to the Fretzes within ten months. Later,

having moved to Reading and gone into business with printed *Taufscheine*, he was able thereby to pay off his house within sixteen years.[29]

Interestingly, in writing this story in 1887, William J. Buck used the term *Fractur-Schrift*[30] a decade before Henry Chapman Mercer began to make the term fraktur popular again.

In the very years (late 1780s) when Johann Adam Eyer was hitting his stride in the Bucks County Mennonite schools, two significant fraktur artists were emerging in the older Skippack/Salford community. While there is no evidence of a cause and effect relationship between the two sets, certain parallels suggest more than coincidence. Andreas Kolb (1749–1811) had almost certainly been a pupil of Christopher Dock's at Skippack. Like Eyer, he taught in a circuit of Mennonite schools, moving among those at Swamp (Quakertown, Bucks County area), Saucon, Franconia, Salford, and even Worcester Township. There, he created *Notenbüchlein, Vorschriften*, rewards, and bookplates similar in spirit to what Eyer had been practicing, but with a style of his own. Whether or not he took his singing book title page format from Eyer is unknown, but he certainly worked in the same spirit.

Like his contemporary Eyer, Andreas Kolb was a bachelor schoolteacher, whose fraktur evinces a similar kind of dedicated joy in his calling. Particularly suggestive is a folk song on the schoolteacher's vocation, *"Prezeptor bin ich genannt"* [I am called

Fig. 73. **Marriage Greeting for Christian Meyer and Maria Landes.** Johann Adam Eyer, Bedminster Township, Bucks County, 1784. Hand-drawn, lettered and colored on laid paper. 9⅞ x 7¾ in. (Rare Book Department, The Free Library of Philadelphia, FLP 636.)

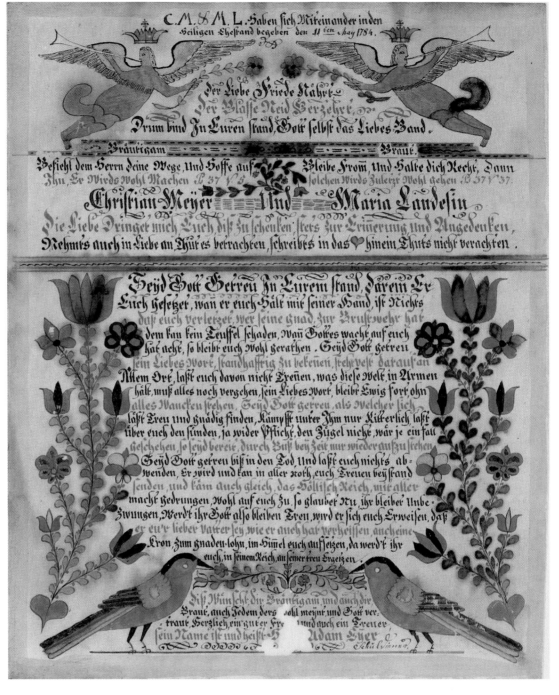

preceptor], which has not been found appearing earlier than in the singing-school book prepared by Kolb for his pupil Maria Bächtel at Swamp, dated October 27, 1788, today in the Schwenkfelder Library. The teacher professes that *"Es gefällt mir wohl im ledigen Stand"* [the single life well pleases me]. Like Eyer, he was also musical: *"Und wann die Schüler singen, / So hör ich meine Freud"* [and when the scholars sing / I hear my very joy]. Long after both Eyer and Kolb were gone, this song was remembered and sung in the local Mennonite

community, in fact as late as 1960.[31] A Deep Run Mennonite schoolmaster born in 1794 (and thus probably a pupil of fraktur artist David Kolb), did an adaptation of the poem, *"Die Schulmeisters Liebstück"* [the schoolmaster's favorite].[32] And, as late as 1855, a teacher from Upper Salford in Montgomery County included the poem on a large broadside published at Skippack.[33]

In 1784, Andreas Kolb seems to have copied Eyer's form of fraktur marriage certificate (Figs. 73, 74).[34] It is further suggestive to learn that with

Eyer's papers, long after he had moved away from the scene of his youthful teaching in Bucks County, was found Kolb's greatest known fraktur work, a complex interweaving of visual and scriptural motifs around the themes of eagles, angels, and crown of life.[35]

A contemporary of Kolb at the Salford and Skippack schools, Henrich Brachtheiser, had become a Mennonite after his career as a Hessian mercenary soldier in the Revolutionary War. This phenomenon (postwar Hessians teaching school) occurred repeatedly in Lancaster County, where former soldiers with names like Dullheuer, Lutz, Rossman, and Strenge taught the children of pacifist Mennonite families. In 1787, Brachtheiser, then teaching at Skippack, created a *Vorschrift* (Fig. 75) whose design and text echoes a similar piece, in a hand very close to J. A. Eyer's, found pasted on the inside of the lid of a chest.[36] Also in 1787, Brachtheiser presented an unsigned *Vorschrift* to nine-year-old Gertraut Altdörfer,[37] from a farm along the Branch Creek in Lower Salford. Seven years earlier, Gertraut's cousin Gertraut Kolb (named for the same Skippack-born grandmother), had been a writing pupil in Eyer's schoolroom in Hilltown some eight miles up the Branch.[38]

Perhaps the most direct influence of Johann Adam Eyer on the Skippack/Salford/Franconia area came via the schoolteaching career of another of his pupils at Deep Run. By 1792, twelve years after being listed in Eyer's roll book for Deep Run,[39] Jacob Gottschall (1769–1845) had moved across country to the older community of Skippack. Here, he created *Vorschriften* and *Notenbüchlein* in a school formerly taught by Henrich Brachtheiser, who had died young. Whereas Gottschall seems to have brought along from Deep Run an affinity for long-tailed peacocks, he, too, had a distinct style of his own. His fine penmanship can be found on documents from Skippack schools up to about the time when he was ordained a minister for the Mennonite congregation at Franconia. Several of his sons (perhaps as many as four) took over the schoolteaching role, and one of them, Samuel (b. 1808), achieved such an affectionate combination of color and design in his twenties as to have his work enshrined on the poster announcing the Philadelphia Museum of Art's tricentennial exhibit of Pennsylvania-German culture (Fig. 76). The art of the Gottschalls, peaking in Franconia in the

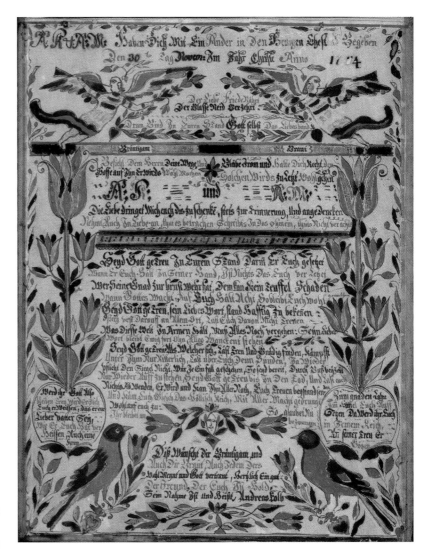

1830s, could truly be called a grandchild of the Deep Run Mennonite school, taught by Johann Adam Eyer.

Another promising pupil listed in Eyer's roll book for Deep Run, 1783–1786, had been little David Kolb.[40] He may have been an uncommonly promising pupil, since Eyer seems to have inscribed to him, at the age of six or seven, an exquisitely done hymnal bookplate (1783). Born in 1777, this cousin of Skippack's Andreas Kolb was about six years younger than Jacob Gottschall, whose last appearance in Eyer's roll book had come three years earlier than David's first. David seems to have been just old enough to benefit from Eyer's artistic example before Eyer moved from the community around 1787.[41] Unlike Gottschall, David Kolb stayed in the Deep Run community and became a teacher there himself (as well as in Hilltown). Next to his mentor Eyer, Kolb was the best of the Deep Run fraktur artists, carrying on the

Fig. 74. **Marriage Greeting for Abraham Kolb and Anna Meyer.** Andreas Kolb, Montgomery County, c. 1784. Hand-drawn, lettered and colored on laid paper. 10¼ x 7¾ in. (Private collection.)

Fig. 75. **Penmanship Model for Phillip Markel [Markley] Jr.** Henry Brachtheiser, Skippack, Montgomery County, 1787. Hand-drawn, lettered and colored on laid paper. 8 x 12⅞ in. (Mennonite Heritage Center, Harleysville, Pa., 98.9.1.)

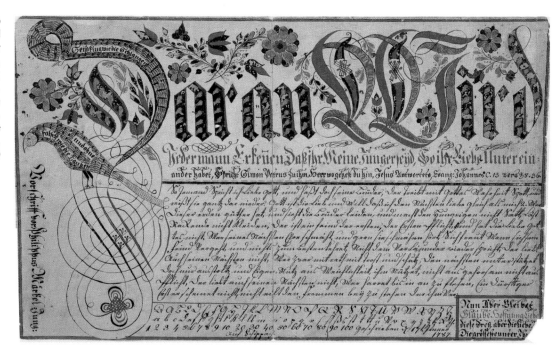

tradition of his own teacher and the earlier Johannes Mayer (Fig. 77). His distinctive style was characterized by a simpler range of colors than Eyer's. Specifically, Kolb favored orange, yellow, and brown. For years, as the authorship of his sure-handed script went unrecognized, his work was attributed to the Brown Leaf Artist (see essay by Joel Alderfer in this volume). His *Notenbüchlein* title pages equal the best of that genre by Eyer, and he seems to have been followed at Deep Run, even after his death in the 1830s, by a cluster of imitative and lesser artists, as the fraktur phenomenon waned. During his prime, Kolb seems to have been as prolific in his fraktur production as Eyer had been; each has been noted a little over thirty times in my chronology of dated Mennonite fraktur.

As with Andreas Kolb, there seems to have been a favorite poem in David's teaching career. Found here and there in eastern Pennsylvania fraktur, it was carefully copied by David into the ledgerlike book of his school documents. Beginning with the strange question, *"Wilt du bald ein Doktor werden?"* [Would you like to become a doctor quickly?], it functions as an ABC song to help the pupil learn the alphabet enjoyably.[42] Since this poem, too, has not been found in an earlier appearance than here in the Deep Run community, one is tempted to ask, did David Kolb write it? Even more provocative, however, is the way it mysteriously turned up among the Amish of eastern Lancaster County—

specifically, in the possession of scholar John Lapp in Caernarvon Township, in 1809.[43] Preliminary examination suggests that it came via the Lapps of New Britain Township in Bucks County, where the poem was well known, when they moved to a daughter Mennonite settlement in Chester County, near Exton. Here several sons and daughters of New Britain Mennonites intermarried with Amish spouses. Given this lineage, it is conceivable that the Lancaster County Amish fraktur tradition, modified and simplified in appearance but still frequently found in bookplates, was influenced by Bucks County precedents.

A more precise claim can be made for Eyer's influence on fraktur production in the Mennonite communities of Lancaster County and southern Ontario. The former transfer seems to have come about through western sojourns of both Johann Adam Eyer and his brother Friedrich. Surprisingly, less than a month and a half after Johann Adam had dated one of his singing booklets for Maria Gross at Deep Run on November 12, 1788, his hand appeared on another for Johannes Dentlinger of *"Strassburg Taunschip Lancaster Caunty: Geschrieben dn 22ten December Anno Do: 1788."*[44] Then a few months later he was active at Vincent,[45] in Chester County just west of the Schuylkill River, in still another Mennonite community, albeit a much smaller one than either Deep Run or Strasburg. Teaching a few years later

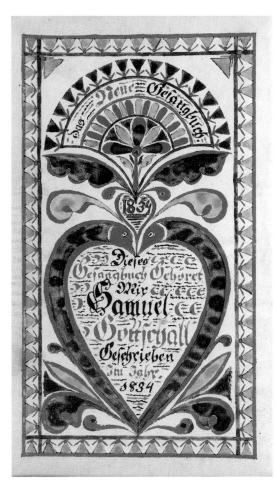

Fig. 76. **Bookplate for Samuel Gottschall.** Samuel Gottschall, Montgomery County, 1834. Hand-drawn, lettered and colored on wove paper. 6⁵/₈ x 3⁷/₈ in. (Mennonite Heritage Center, Harleysville, Pa., 89.13.1.)

our present purposes, it is fascinating to observe again how two non-Mennonite fraktur artists were drawn to teach in primarily Mennonite schools (Alsdorff, first in Hempfield, then Earl Township in Lancaster County). Alsdorff's known fraktur, records Johnson, was done "mainly for Mennonite children." Thus, not only Bucks County scholars, but also those from Lancaster County, were confronted with the figure of the large-hatted, long-coated, breeches-wearing schoolmaster on their writing booklet covers, a design that seems to have originated with Eyer.[46]

The Eyer influence is just as clear in the fraktur that was taken to and practiced on recently cleared farms in what we now call Ontario. Moyers of Hilltown and Fretzes of Tohickon were among the string of wagons that arrived on the Niagara peninsula between Lakes Ontario and Erie in the fall of 1799. In their wagons, somehow making it across the Niagara River without ruining the papers carried up from Bucks County, were fraktur drawings of Eyer's that were as fine as anything he had done between 1780 and 1787 (Fig. 78). Here, in rough new schools the tradition flourished,

in New Hanover Township, just across the Schuylkill from Vincent, was another fraktur artist, Christian Alsdorff. His extant dated work begins around 1791, a year before he is known to have taught briefly in New Hanover. Somewhere and some time in this era he was heavily influenced by Eyer's fraktur style and genres. Without going into detail here, we may simply note the comment of David R. Johnson, student of Lancaster County fraktur. He finds the influence "clear that Alsdorff literally was working from Adam Eyer pieces, imitating them as patterns." In addition, there are pieces by Adam's brother Friedrich "that look enough like Alsdorff's to be mistaken for his." This leads Mr. Johnson to the conclusion that "Christian Alsdorff and Johann Friedrich Eyer, if not also Johann Adam, must have been well acquainted with each other." For

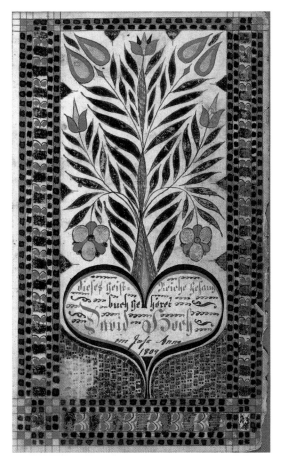

Fig. 77. **Bookplate for David Hoch.** Attributed to David Kulp, Bedminster Township, Bucks County, 1809. Hand-drawn, lettered and colored on laid paper. 6¹/₂ x 3³/₄ in. (Private collection.)

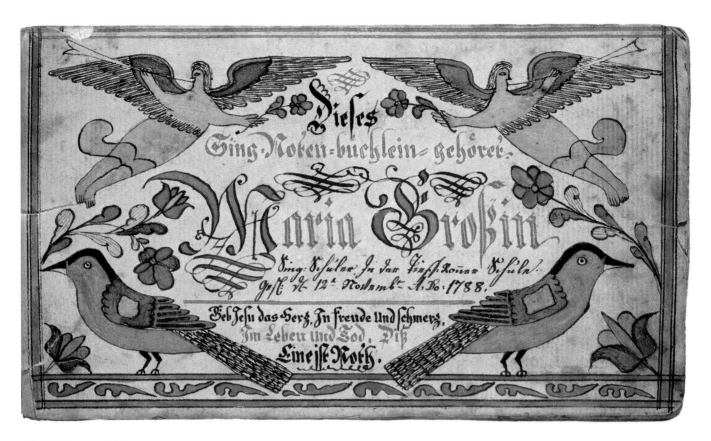

Fig. 78. **Manuscript Tune Book and Bookplate for Maria Gross.** Attributed to Johann Adam Eyer, Deep Run School, Hilltown Township, Bucks County, 1788. Hand-drawn, lettered and colored on laid paper. 3¹⁄₈ x 5¹⁄₄ in. (Jordan Historical Museum, Jordan, Ontario.)

producing decorated singing-school books for another three decades.[47] Illustrative of the living mutual awareness of the Bucks County and Niagara Mennonite communities are letters back and forth, some of them in the hand of schoolmaster-scrivener David Kolb of Deep Run.

Not every Bucks County pocket of fraktur-producing Mennonites is covered in this essay. From the Swamp community just west of Quakertown, where Andreas Kolb had briefly taught in the 1780s, came Geissinger and Musselman fraktur on both paper and tombstones. In New Britain, too, where nephews of Jacob Gottschall lived, and where Jacob Rohr had an exquisite *Schreibkistlein* (little writing chest) done for him by John Drissel in 1795,[48] appeared fine examples. In 1997, the Alderfer Auction House of Hatfield, Pennsylvania, sold an intriguing *Schreibbuch* (writing practice book) signed by Jacob Rohr's daughter Catharina and containing several *Vorschriften*. At the bottom of two of these appeared the double bird motif, familiar from the work of Christopher Dock and his followers (Fig. 79).

To close the ring of the Bucks County Mennonite fraktur diaspora, we might note the sojourn of a Canadian fraktur artist among relatives after the heyday of the art had passed. This was the skilled

penman Isaac Z. Hunsicker (1803–1870), a native of the Skippack area, who must have attended school in the same years as his contemporary Henry G. Johnson (1806–1879) of the same community. Neither of these accomplished frakturists-schoolmasters was born soon enough to have been personally influenced by Skippack native Andreas Kolb (d. 1809), or the non-Mennonite immigrant Durs Rudy, who was briefly in the Skippack schoolroom around 1805-1806, or the Eyer-trained Jacob Gottschall, who had taught in Skippack as early as 1792 before moving to Franconia Township. But the penmanship of Kolb, Gottschall, and Rudy was certainly being carefully preserved among families whose students were in Hunsicker's and Johnson's classes.

Whereas Henry G. Johnson became a fixture in the Skippack School (and was later ordained a Mennonite minister), Hunsicker, who dated a fraktur for Salford schoolgirl Susanna Altorffer in 1831, joined the flow of Mennonites toward Canada a year or two later. In 1837, he was listed as a schoolteacher at Eby's School in Berlin (later Kitchener) in Waterloo County, Ontario. Here, in a very precise hand, he produced family records that did not display the prolific iconography usual in the fraktur of his Pennsylvania community. But the durability of his pen hand was such that as late as the Civil War era he

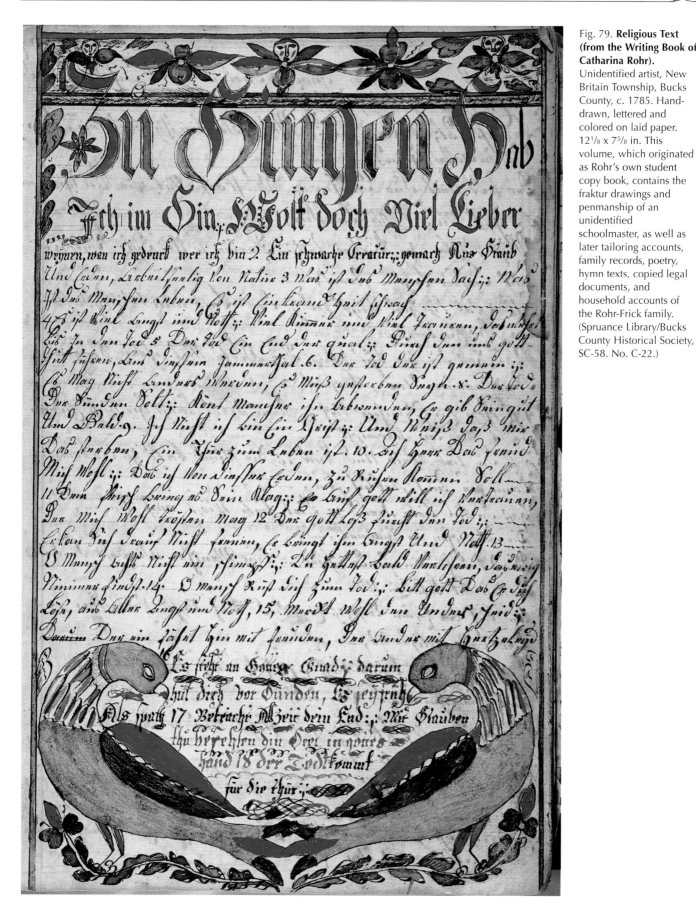

Fig. 79. **Religious Text (from the Writing Book of Catharina Rohr).** Unidentified artist, New Britain Township, Bucks County, c. 1785. Hand-drawn, lettered and colored on laid paper. 12 1/8 x 7 5/8 in. This volume, which originated as Rohr's own student copy book, contains the fraktur drawings and penmanship of an unidentified schoolmaster, as well as later tailoring accounts, family records, poetry, hymn texts, copied legal documents, and household accounts of the Rohr-Frick family. (Spruance Library/Bucks County Historical Society, SC-58. No. C-22.)

109

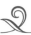

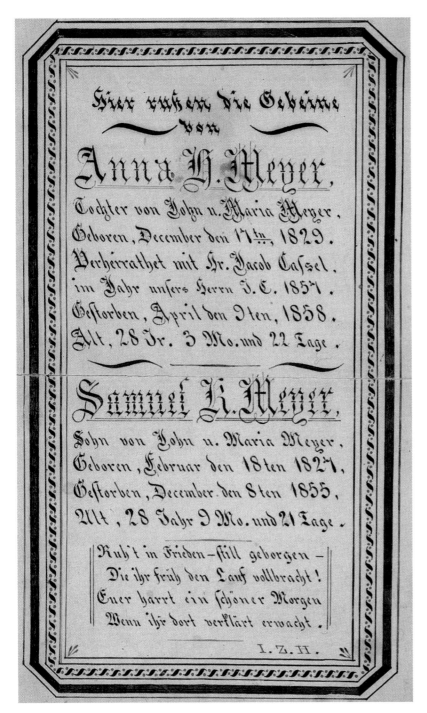

was not only still active around Waterloo, but could bring his art along while sojourning in his native region in Pennsylvania (Fig. 80). A letter home to "Dear Friends" in Canada, written on November 29, 1864 from Bridgetown (South Perkasie), reveals that the sixty-one-year-old traveler is almost overwhelmed with requests by Mennonite relatives and friends for certificates and family records. Some were to be inscribed in Bibles, others on mere "writing paper." Among his clients were a minister at the Perkasie (Blooming Glen) Mennonite Church, Henry Moyer, and Abraham K. High in Bedminster. Other requests made it necessary for him to travel back to Skippack. Having been already away from his Canadian home for two months, and realizing that his return might be late in the winter, he gave careful instructions to have his supply of ink taken out of a bureau drawer where it might freeze in the coming winter of 1865.[49]

In the demand this elderly penman experienced for his abilities in Bucks County farmhouses of 1864, we can observe the sharp decline of the availability of skilled calligraphers in the older fraktur mode. For all practical purposes, the day of fraktur among this folk community had passed nearly three decades earlier. After 1834, state-supported English-language schools and schoolmasters had supplanted the parochial German ones, and there was now a printing press in every sizable town.

Fig. 80. **Meyer Family Record.** Isaac Z. Hunsicker, Hilltown Township, c. 1860. Hand-drawn and lettered on paper. 8 x 5 in. (Mennonite Heritage Center, Harleysville, Pa., 88.8.1.)

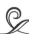
Notes

1. This short list of 330 datable examples has been compiled by the author over many years. Mary Jane Hershey of Harleysville, Pennsylvania, has also recorded a total of well over a thousand examples of fraktur of all types from the extended Mennonite community surveyed here.

2. These names, in alphabetical order, are Henry Bauer (Bower), Henrich Brachtheiser, Huppert Cassel, Christian Cassel, Jacob Clemens (Klemens), Martin Detweiler, Henrich Dirstein, Christopher Dock. Johannes Gehman, Abraham Geissinger, Jacob Geissinger, Jacob Gottschall, Martin Gottschall, Samuel Gottschall, Isaac Gross, Jacob Hummel, Isaac Z. Hunsicker, Henry G. Johnson, George Kassel, Andreas Kolb, David Kolb (Kulp). Moses Kolb, Henry Kulp, Isaac L. Kulp, Levi O. Kulp, Jacob Landes, John Landes, Rudolph Landes, Joseph Moyer, Samuel D. Meyer (Moyer), Samuel Musselman, Joseph Oberholtzer, Jacob Rosenberger, Jacob Sauter, Christian Stauffer, Andrew Stover.

3. Place names from Bucks County include, in alphabetical order, Bedminster, Deep Run (*Tieff Ronn*), Haycock, Hilltown, New Britain, Perkasie (*Birckenseh*), Plumstead, Richland, Rockhill (*Rakkil*), Springfield, Swamp, Tinicum, Tohickon, Upper Milford. Names of townships outside of Bucks County include Douglas, Franconia, Hereford, Limerick, Pikeland, Lower Salford (*Loer Sollfort*), Skippack (*Schibbach*), Towamencin, Vincent, Worcester.

4. A fraktur clearly dated 1729 appears in facsimile in Cornelius Weygandt, *The Red Hills: A Record of Good Days Outdoors and In, With Things Pennsylvania Dutch* (Philadelphia: University of Pennsylvania Press, 1929), 124, but no Mennonite or other specific identification is provided. The earliest dated *Vorschrift* (March 14, 1757) in the Philadelphia Free Library Collection, displaying only simple floral decoration and no actual fraktur lettering, is by Johannes Blanck of Tulpehocken.

5. This *Vorschrift* begins with fraktur printing, "*Gerhard Bechtel Dem Schencke Ich Diese Lehr, Sie Dient auch mir und andern mehr, zu üben stets zu Gottes Ehr.*" On the verso are six stanzas in cursive of the "student's song" beginning, "*Edler Meister alle Tugend / Jesu lehre meine Jugend….*" Schwenkfelder Library and Heritage Center, Pennsburg, Pa.

6. In past decades the identification of Dock's authorship of various works of fraktur has been quite speculative. However, meticulous comparison by Mary Jane Hershey, myself, and others of both handwriting and design among *Vorschriften* in the Historical Society of Pennsylvania, the Schwenkfelder Library, and a deed in the collection of the Mennonite Historians of Eastern Pennsylvania (Harleysville, Pa.), has satisfied us of the virtual certainty that the Bechtel *Vorschrift* is from Dock's hand. At the very least, there is a school of almost identical fraktur artists, 1747–1770, in the Skippack area that are otherwise not accounted for.

7. An English translation of Dock's treatise is available in Gerald C. Studer, *Christopher Dock: Colonial Schoolmaster* (Scottdale, Pa.: Herald Press, 1967).

8. See a facsimile of Dock's *Eine Einfältige und gründlich abgefaßte Schul-Ordnung* (Germantown: Christopher Saur, 1770) in Martin G. Brumbaugh, *The Life and Works of Christopher Dock* (New York: Arno Press and the New York Times, 1969), 36. Several of the originals are in the Beegley Library, Juniata College, Huntingdon, Pa.

9. "On May 25, 1760, Elisabeth Fischer was regularly confirmed and permitted to go for the first time to the Holy Supper. Her age 19 years; at the time mentioned she stayed with Christopher Dock as his serving girl; urged steadily by a great desire for the true and pure teaching, she did not wish to accept his faith as a Mennonite. May the Almighty God grant her the Grace and the help of the Holy Ghost." Quoted by Joyce Clemmer Munro, "From the Records of the Old Goschenhoppen Lutheran Church," *Mennonite Historians of Eastern Pennsylvania Newsletter*, 5 (March 1978): 8.

10. Dock, *Schul-Ordnung*, 41.

11. Ibid., 43–44.

12. On the verso is inscribed, "*Fürschrift Vor Simon Pannebecker in Schibbach, und ist im gemacht Worden Zur Lehr im Jahr Christi Anno 1758 Durch mich H. M. Ache.*" At the Samuel R. Pennypacker estate, Schwenksville, Pa.

13. See Huppert Cassel's *Vorschriften* of 1769 and 1771 (Schwenkfelder Library), in John Joseph Stoudt, *Early Pennsylvania Arts and Crafts* (New York: A. S. Barnes and Company, 1964), figs. 291, 301.

14. Ibid., figs. 294, 295.

15. See a fraktur letter of 1767 from pupil Stauffer in Lower Salford to Yilles Kassel at Skippack, in Frederick S. Weiser and Howell J. Heaney, *The Pennsylvania German Fraktur of the Free Library of Philadelphia: An Illustrated Catalogue*, 2 vols. (Breinigsville, Pa.: Pennsylvania German Society, 1976), 1:fig. 237.

16. Photocopies in the possession of Mary Jane Hershey.

17. Facsimiles of both *Vorschriften* (from the Schwenkfelder Library) are in Don Yoder, "Fraktur in Mennonite Culture," *Mennonite Quarterly Review*, 48 (July 1974): 322–322.

18. Photocopy in possession of Mary Jane Hershey, Harleysville, Pa.

19. Facsimile in Brumbaugh, *Christopher Dock*, 240–244.

20. Eyer's school at what he calls "the Lower end from Hilltown" in October 1779 was at Rockhill. This becomes clear when information about the school gathered by John D. Souder, reproduced in Charles H.

Price Jr., *A Hartzell-Price Family History and Genealogy* (Telford, Pa.: by the author, 1971), 41–42, is compared with the first entry in Eyer's Roster Book, in Frederick S. Weiser, "I A E S D: The Story of Johan Adam Eyer (1755–1837) Schoolmaster and Fraktur Artist with a Translation of his Roster Book," in *Ebbes fer Alle-Ebber Ebbes fer Dich/Something for Everyone—Something for You: Essays in Memoriam Albert Franklin Buffington*, in *Publications of the Pennsylvania German Society* 14 (1980): 481–482. In this connection, compare with Eyer's style that of the interesting reward for "the best singer in the second class" dated 1779, in Weiser and Heaney, *Pennsylvania German Fraktur*, 1:fig. 138.

21. Three out of four of the pages of a writing sample booklet by Mayer conclude with interesting information. P. 1: "*Vorgeschriben Vor Abraham Landes an Tieffronn. A.D. 1779.*" P.2: "*Abraham Landes D. 21ten September im Jahr des Herrn. Anno 1779.*" P. 4: "*Johann Maÿer. S. M. st' an Tohecke 1779.*" This *Schreibbuch* was photographed in 1982 while in the possession of Mrs. Edward Mininger of Elkhart, Indiana, whose mother-in-law, Hattie Kulp, had come from Danboro in Bucks County.

22. "*Geburths Register*" for the family of Johannes Fretz, signed "John Moyer," present whereabouts unknown. Photograph in the Bucks County Fraktur File, Spruance Library/Bucks County Historical Society, Doylestown, Pa. (SL/BCHS).

23. In Lancaster County, the prolific schoolteacher-fraktur artists Christian Strenge and Christian Alsdorff, both non-Mennonite, also seemed to have been drawn to schools in largely Mennonite communities.

24. In the collection of the Mennonite Historians of Eastern Pennsylvania, Harleysville.

25. Facsimile in Frederick S. Weiser, "I A E S D," 443.

26. David Spinner, Lower Milford (1771) and Johannes Mayer for Abraham Landes, Deep Run (September 21, 1779).

27. A recent student of the *Notenbüchlein* phenomenon observes: "The *Notenbüchlein* were...an attractive tool for cultural transmission at a time when the German culture was being threatened." Suzanne Gross, "The *Notenbüchlein* (Manuscript Songbooks) Tradition in Early Franconia Conference Mennonite Communities," *Mennonite Historians of Eastern Pennsylvania Newsletter*, 21 (November 1964): 5.

28. *Die kleine geistliche Harfe der Kinder Zions, oder auserlesene geistreiche Gesänge* (Germantown, Pa.: Michael Billmeyer, 1803). Prior to this, the Mennonites used either Lutheran and Reformed hymnbooks or their own older *Ausbund* (still used by the Amish in the 1990s). An unusual number of surviving copies of the 1803 and later editions of the *Harfe* published by the Franconia Conference Mennonites contain fraktur bookplates indicating ownership. Bedminster schoolmaster David Kolb, in particular, is frequently represented as the artist. Of special interest is the inclusion in a *Zugabe* (addition) to the *Harfe's* third (1820) edition of a farewell poem by the elderly

Rudolph Landes of Deep Run, several verses of which appear on an 1814 fraktur in the Free Library of Philadelphia Collection (see Weiser and Heaney, *Pennsylvania German Fraktur*, 1:fig. 239). Whereas only the first stanzas appear on the fraktur mentioned, the full acrostic based on Landes's name appears as hymn no. 21 in the 1820 *Zugabe*.

29. William J. Buck, "George Homan and His Taufscheins," *Local Sketches and Legends Pertaining to Bucks and Montgomery Counties, Pennsylvania* (n.p.: William J. Buck, 1887), 180–183. Buck's ancedotal impressions can be supplemented or perhaps corrected with information in Wilbur H. Oda, "John George Homan: Man of Many Parts," *The Pennsylvania Dutchman*, 1 (August 18, 1949): 1.

30. Buck, "George Homan," 182. For further discussion of Homan see the catalogue segment of this volume, p. 215.

31. Tape-recording of Sallie G. Landis, Franconia Township, in possession of Isaac Clarence Kulp, Jr., Vernfield (Harleysville), Pa. Mrs. Landis learned this from the daughter of Franconia Township schoolteacher Henry Neiss, who in turn was the son-in-law of Mennonite Bishop Jacob Gottschall, who had been a pupil of J. A. Eyer at Deep Run.

32. Abraham A. Meyer, *Christliche Lieder. Gedichtet und zum Theil gesammelt von Abraham A. Meyer, an der Deep Run, in Bedminster Taunschip, Bucks County, Pa.* (Milford Square, Pa.: J. G. Stauffer, 1877), 63–64. Of another intriguing poem in this homely collection, describing the calling and lot of a Christian schoolmaster, Meyer states, "The author of this little song was an organist. As a schoolmaster in the faith" (*Als Schullehrer im Glauben*). J. A. Eyer, who had taught in Meyer's community before Meyer was born, was probably both organist and schoolmaster. See Weiser, "I A E S D," 460.

33. Samuel K. Cassel, comp., *Des Saengers Harmonie*, (Skippackville, Pa.: J. M. Schüneman, 1855), broadside in possession of Isaac Clarence Kulp Jr., Vernfield, Pa.

34. Compare Weiser and Heaney, *Pennsylvania German Fraktur*, 1:fig. 193, and Mary Jane Hershey, "Andreas Kolb, 1749–1811," *Mennonite Quarterly Review*, 41 (April 1987): 121–201, Plate XV.

35. See Hershey, "Andreas Kolb," Pl. XX, and p. 134.

36. Joel D. Alderfer, "*H. B., Schuldiener Auf Schippach*: Henrich Brachtheiser (1762–1788), 'Hessian' Mercenary Turned Schoolmaster & Fraktur Artist, of Lower Salford and Skippack," *Mennonite Historians of Eastern Pennsylvania Newsletter* 23 (November 1996): 4–6. On the comparable Eyer-like Fraktur, See Frederick S. Weiser, *The Gift is Small The Love is Great: Pennsylvania German Small Presentation Frakturs* (York, Pa.: York Graphic Services, 1994), 36.

37. Weiser and Heaney, *Pennsylvania German Fraktur*, 2:fig. 948.

38. Weiser, "I A E S D," 482.

39. Ibid., 486.

40. Ibid., 488, 493, 495, 499, 503. Note that in the first instance listed, the entry is for "David Kolb of Dav. Hen." There was also a "Dil. Hen." Kolb among the pupils' parents (499). In fact there were four persons named David Kolb in Bedminster Township at this time. The David in question here is a son of Henry (who was a son of David) and Catharine Kolb of Bedminster. See Joel D. Alderfer, "David Kulp, His Hand and Pen, Beet it if You Can: Schoolmaster David Kulp of Deep Run, the *Brown Leaf Artist* Identified," *Mennonite Historians of Eastern Pennsylvania Newsletter*, 23 (January 1996): 3.

41. Weiser, "I A E S D," 439.

42. For a transcription, see John L. Ruth and Joel D. Alderfer, "David Kulp, His Hand & Pen: The 'Brown Leaf Artist' Identified?" *Mennonite Historians of Eastern Pennsylvania Newsletter* 22 (January 1995): 9.

43. Around 1980, Amish family historian Amos Fisher of Leacock Township, Lancaster County, in some puzzlement, gave me a photocopy of a *Vorschrift* based on this poem and signed, *"Hannes Lapp in Canerwen Taunschip Lancaster Caunty Anno Domini 1809 19ten Merz."* Fisher was not able to connect this poem with known Amish history.

44. Donald A. Shelly, *The Fraktur-Writings or Illuminated Manuscripts of the Pennsylvania Germans* (Allentown, Pa.: 1961), in *Publications of the Pennsylvania German Folklore Society* 23 (1958–1959): fig. 143. Shelley incorrectly attributes the tune book to Jacob Oberholtzer.

45. Weiser, "I A E S D," 470.

46. David R. Johnson, "Christian Alsdorff, the 'Earl Township Artist,'" *Der Reggeboge: Journal of the Pennsylvania German Society*, 20 (1986): 45–58.

47. See Michael S. Bird, *Ontario Fraktur: A Pennsylvania-German Folk Tradition in Early Canada* (Toronto: M. F. Feheley Publishers Limited, 1977), 55–64.

48. Collection of the Mennonite Historians of Eastern Pennsylvania, Harleysville. A somewhat similar painted box containing correspondence of Andreas Kolb was collected by Samuel W. Pennypacker.

49. Isaac Hunsicker to "Dear friends," November 29, 1864, Bridgetown, Pa., Archives of the Mennonite Church, Goshen, Ind.

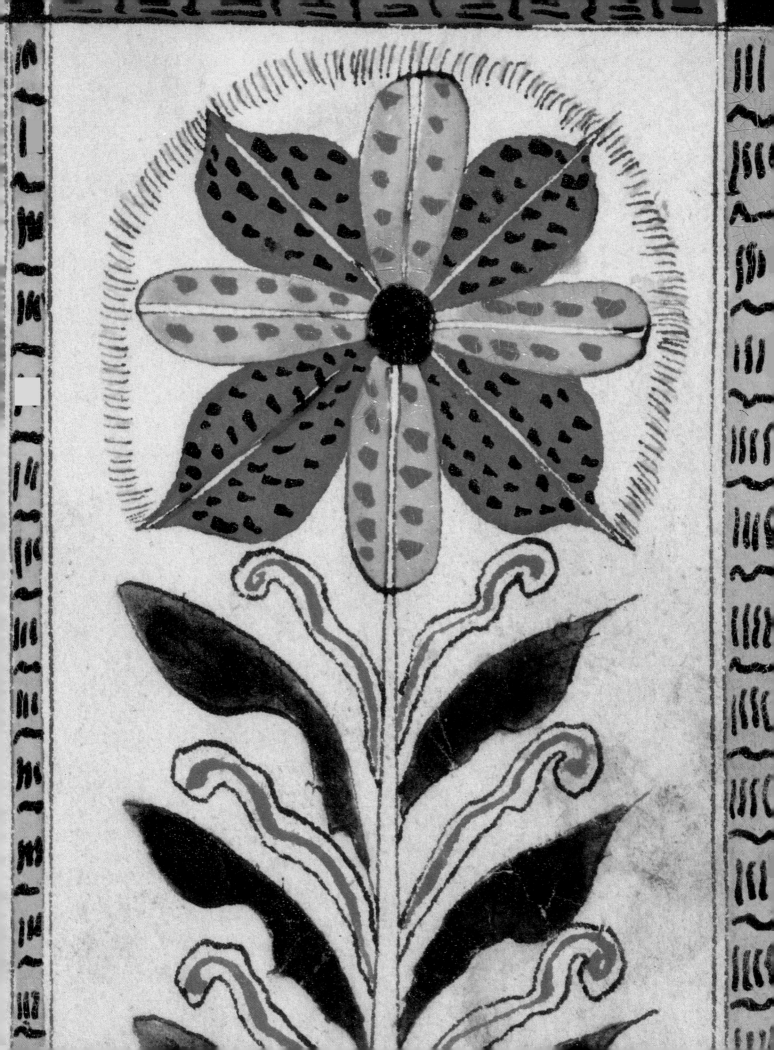

The *Notenbüchlein* Tradition in Eastern Pennsylvania Mennonite Community Schools, in an Area Known as the Franconia Conference, 1780 to 1845

Mary Jane Lederach Hershey

Henrich Honsperger, a Bucks County youth studying at a schoolhouse near the future village of Blooming Glen, received a gift from his schoolmaster during the winter quarter of 1780. Three days before the term ended, Henrich's teacher designed a bookplate for Henrich's small booklet of hymn tunes (Fig. 81). The schoolmaster drew a double-edged center circle that encroached upon the top and bottom of the bookplate's border. In the circle, the master recorded that on April 12, 1780, Henrich was a student in the *Birckenseh* School, that the tunes were for hymns in the Marburg (Lutheran) hymnal, and that Henrich should learn to be "singer, book and temple."[1]

Henrich's *Notenbüchlein* is the first known example of a group of 168 presently known hymn tune booklets, all with fraktur-type bookplates, made for students in eastern Pennsylvania Mennonite meetinghouse and community schools.[2] This

Fig. 81. **Manuscript Tune Book and Bookplate for Henrich Honsperger**. Attributed to Johann Adam Eyer, Perkasie School, Hilltown Township, 1780. Hand-drawn, lettered and colored on laid paper. 4¹⁄₈ x 6³⁄₄ in. (Rare Book Department, The Free Library of Philadelphia, FLP B-13.)

Fig. 82. **Manuscript Tune Book and Bookplate**. P. Messerli, Lenk in the Simmen Valley, Canton Bern, Switzerland, 1701. Hand-drawn, lettered and colored on laid paper. 8¾ x 11⅞ in. (Bernisches Historisches Museum.)

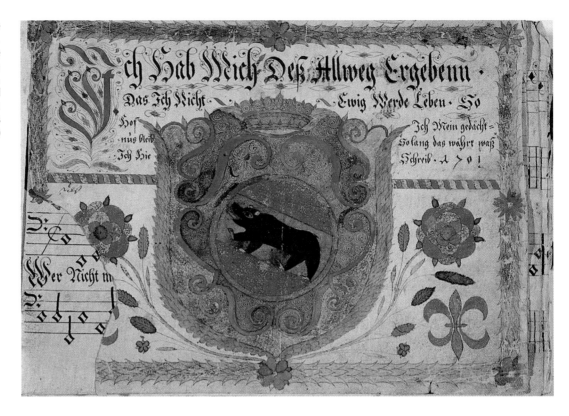

earliest surviving example was drawn and lettered by an extraordinary schoolmaster, Johann Adam Eyer (1755–1837), a Lutheran who taught in Bucks County subscription schools from 1779 to 1789, and possibly longer.[3]

What prompted Schoolmaster Eyer to create hymn tune notebooks with fraktur-lettered bookplates, a legacy that would continue for sixty-five years in Bucks County? What stirred Eyer's imagination? Was Henrich among the first of numerous gifted Mennonite singers in Eyer's Bucks County classrooms? Could it be that the inspiration for these appealing *Notenbüchlein* bookplates came with Eyer's family or with other immigrants who arrived in Bucks County a generation prior to Johann Adam's birth? Were similar treasured booklets brought with the settlers who made Bucks County their home? Did the children hear over and over the stories about their European roots, about the martyrdom of their ancestors and the hymns their forefathers and foremothers sang as they were being imprisoned and killed? Is it possible that these special hymn tunes were recorded in small manuscript booklets? Only conjecture can answer these questions, but perhaps Eyer's origins may offer a clue.

Schoolmaster Eyer was the son of immigrant Martin Eyer who arrived in Philadelphia in 1749. It is possible that the Eyer family roots were in Switzerland where the tradition of making booklets solely for the recording of tunes was practiced. A manuscript book in the collection of the Bernisches Historisches Museum in Berne includes a bookplate dated 1701 (Fig. 82). A colorful depiction of a Bernese bear centered on a shield and framed by flowers and a wreathlike border is the frontispiece for this handwritten book which contains several hundred tunes for psalms. The design is not unlike the circular center design on Henrich's 1780 *Notenbüchlein*.[4] The interior pages of the Swiss book are decorated with tulips, faces, dragons, and snakes.

Although this European example is similar to the *Notenbüchlein* with bookplates designed by Johann Adam Eyer, it is unlike Eyer's booklets in that the tunes have tenor and bass parts and the book's dimensions and contents are double the size of a typical Mennonite related booklet. Many of the Mennonite children Eyer taught were descendants of immigrants from Switzerland who may have brought with them treasured examples of hymn tune booklets. However, as of this writing no manuscript tune books made in Europe have been found in the eastern Pennsylvania Mennonite community included in this study.[5] The focus of this essay is on an area now known as the Franconia Mennonite Conference, a geographic region that

includes all of Bucks and Montgomery Counties and portions of Berks, Lehigh, Northampton, and Chester Counties (Map 3).

For Mennonite children, learning the tunes for the hymns sung at the meetinghouse was an important part of their education. Schoolmasters in Bucks and Montgomery County Mennonite schools were expected to be able musicians and to teach the children to sing and memorize hymn tunes (Fig. 83).[6] In worship services that the children attended, hymns were sung a cappella since Mennonite meetinghouses did not have organs. The printed hymnbooks used by the worshipers contained only words—tunes were sung by memory or from manuscript tune books brought to the meeting.[7] Many hymn tune notebooks, with and without fraktur bookplates, survive. Some are well thumbed with smudged finger marks on the lower right corner of each page.

A perusal of the construction and contents of the booklets on the inventory included with this essay reveals a number of details. The booklets come in two sizes. Prior to 1810 the dimensions are typically

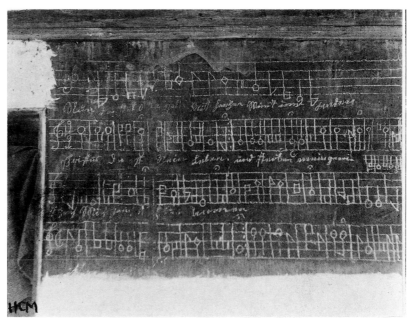

Fig. 83. **"Shape Note" Music on Blackboard Wall**. Deep Run Schoolhouse (built 1842), Bedminster Township. Photograph by Henry C. Mercer, 1897. (Spruance Library/Bucks County Historical Society, BCHS Album.)

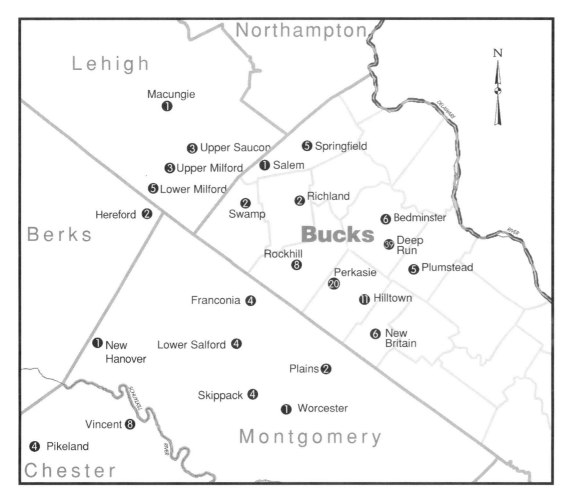

Map 3. **Distribution of Extant Notenbüchlein with Place Names in a Six-County Region (now the Franconia Mennonite Conference)**.

9–10 x 15–17 centimeters (3¹/₂–4 x 5⁷/₈–6³/₄ inches). About 1810 a larger size, 10–10.5 x 19.5–20 centimeters (4–4¹/₄ x 7³/₄–8 inches), is found. However the bulk of the genre is in the smaller size. The pre-1800 booklets usually have fragile paper covers, and it appears that the schoolmaster constructed the booklet by cutting, assembling, and sewing the cover and pages together with flax thread. Later, especially in David Kulp's schools (1801–1817), the books have hard covers with leather spines, marbleized paper covering, and leather triangles on four corners. Some are completely leatherbound with tooled designs. On most of the paper-covered booklets, the fraktur bookplate is on the first or second page. In the more substantial hard-covered books, often there are three blank pages before the bookplate. In many of the pre-1800 *Notenbüchlein,* the first page includes a series of scales and notes placed on the musical staff in intervals, a system designed to teach the children to quickly recognize pitches and intervals. Sometimes on the initial page or on the first page of tunes, a hymn, "*Jesulein, bleibe mein,*" is found. Often, for this first tune, and in the booklets dated before 1800, the words of *Jesulein* are included under the staff, making it easier for the beginner to connect notes and words. Following the first page, each page includes four tunes marked above the staff with the first words of the hymn, but with no text under the notes (Fig. 84). After the 1803 publication by the Franconia Conference of their first hymnal, *Zion's Harfe,* some of the tune books are marked with the numbers that correspond to the words in the new hymnal.[8]

Many of the tunes are chorales of European origin. A few booklets include English melodies, although with German text. The tunes are monophonic, meaning that the music is comprised of a single melodic line without additional parts or accompaniment. Most of the booklets contain only monophonic melodies with some ornamentation which is indicated by eighth or sixteenth notes. Except for the ornamentation, there was little variation in rhythm.[9] Some of the early nineteenth-century booklets have harmony lines marked on the same staff as the monophonic melody.[10] But later books, beginning in the latter part of the second decade of the 1800s, include a few tunes written in the same style as twentieth-century part singing with lines for soprano, alto, and/or tenor and bass on two or three adjoining staffs. Seldom are tunes included for songs that have other than a hymn text.

In numerous booklets it is evident that several schoolmasters entered tunes. The student owners of many Deep Run tune books, for example, used their booklets over several terms with different teachers. In Johannes Honsperger's 1815 booklet, schoolmaster David Kulp entered the first thirty-two tunes. Later, another teacher continued to add and teach hymn tunes. He numbered Johannes's book to eighty-eight. Magdalena Gross's 1818 book exhibits a change in penmanship, suggesting that two or three teachers inscribed hymn tunes. And, in Anna Letherman's 1827 book, her teacher first entered a section of "shape notes" in black ink.[11] Later another hand drew a series of plain notes in brown ink. One unusual example is a booklet that first belonged to "Andres Drumbor" (probably Andreas Trumbauer) at Rockhill. His bookplate was dated 1805. Six years later, a second Rockhill student, Adam Nunemacher, obtained the booklet and carried it to school. On January 30, 1811, his schoolmaster created a new bookplate with Adam's name.

Many bookplates are dated during the months from December to June. However, almost one-third of those listed in the following inventory were created in the winter months of December, January, and February. None are dated in July and only four in August, with a few in each of the autumn months. The names on the booklets confirm that daughters were educated equally with and perhaps to a greater extent than were sons. More than half of the booklets were made for girls.

Johann Adam Eyer, the schoolmaster who drew the first known bookplate for a Pennsylvania tune booklet, placed considerable emphasis on teaching

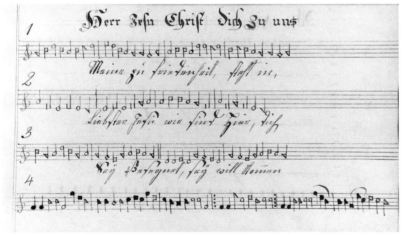

Fig. 84. **Detail of Manuscript Tune Book Musical Notation.** From the tune book of Enos Staud, Perkasie School, Hilltown Township, 1823. The notation in this booklet uses the "shape note" system of musical instruction. (Spruance Library/Bucks County Historical Society, SC-58. No. C-06.)

children to sing hymns. In this endeavor, he continued the pedagogic pattern of Christopher Dock, a Mennonite schoolmaster who taught at the Montgomery County Skippack and Salford meetinghouse schools during the colonial period. Dock wrote hymns, one of which continues to be sung to this day by both congregations.[12] He arrived in this country about 1718 and spent the rest of his long life, with the exception of ten years when he farmed in Upper Salford Township, teaching in the two schools. He also taught four summers in the Germantown Mennonite community. His innovative methods of teaching were shared in a book on school management written in 1750, but not published until 1770, a year before his death.[13] Dock felt that God had "assigned" him the vocation of teaching and had given him "the grace of a special love for youth."[14] He used a system of rewards to encourage learning. To children who "could say the A-B-C correctly," Dock wrote,

His father owes him a penny, and his mother must fry him two eggs for his industry; he gets this reward when he takes each step forward, for instance when he learns the words. But when he begins to read I owe him a certificate [*zeugniss*] (if he has worked hard and in the proper time.)[15]

For students who had trouble learning, Dock asked other children in the classroom to tutor the special needs child:

If it is a boy I ask the boys, and if it is a girl I ask the girls which of them will take care of this child and teach him. Depending on whether the child is a stranger or well-known, or whether he looks pleasant or unpleasant, frequently many or a few volunteer to teach the child. If there are no volunteers I ask who will teach the child for a certain time for a motto [*Vorschrift*] or a bird. Then there is no lack of volunteers.[16]

Because Dock taught three days a week at each school, he encouraged students to write letters to each other which Dock carried back and forth from school to school:

When I returned to the school in Salford the pupils in Skippack gave me letters to take along, and when I came back the Salford pupils did likewise. It was arranged that pupils of the same

grade exchanged letters. If it happened that one was later of a higher rank he wrote to a different pupil whom he thought of equal rank with himself. The salutation was simply this: My friendly greeting to N.N. The content of the letter was a brief rhyme or a Bible verse; besides this something of their school practice was added (the memory verse for the week, its location and the like). Sometimes the writer added a question to be answered by a verse from the Holy Scriptures.[17]

Two letters from Dock's schools, dated 1764, were written by Henry Cassel of Lower Salford and Huppert Cassel from the Skippack School. The letters are on one large document, 31 x 38.5 centimeters (12 1/4 x 15 3/8 inches), in decorative *Vorschriften* form,[18] and record a pietistic rhyme on the top half and a second on the bottom half. Both are written in German with a scripture verse in English across the center. The upper half appears to have been written by Henry Cassel while the lower half seems to be by Huppert. At the bottom are their two signatures; to the left, Huppert Cassel's with a note to Henry, "I beg of you Send me a letter again."[19]

Dock not only focused on teaching reading and writing "for the glory of God and the welfare of youth." He knew that helping the children learn spiritual truths through singing hymns and psalms enhanced and strengthened his primary goal, the spiritual development of youth. In writing about "How the School Day is Begun," Dock relates,

When they are all assembled and have been inspected as to washing and combing, a morning song or a Psalm is given them to sing: I sing and pray with them.[20]

In teaching the Scriptures, Dock wrote, "A Psalm or a hymn is given them to sing that contains the same teaching."[21] Dock said about himself,

I have been given freedom in singing to teach hymns and psalms. And so I have sung hymns and psalms with them, because the Holy Spirit is the creator of both, namely, spiritual songs and psalms.[22]

The reverse side of an early (1747) *Vorschrift*[23] made for Gerhard Bechtel contains a staff with a tune for a "Scholar's Song" titled "Ornament thyself, O

Fig. 85. **Manuscript Tune Bookplate for Maria Alderfer**. Unidentified artist, Lower Salford Township, Montgomery County, 1785. Hand-drawn, lettered and colored on laid paper. 3³/₄ x 6¹/₂ in. (Mennonite Heritage Center, Harleysville, Pa., 2000.23.1.)

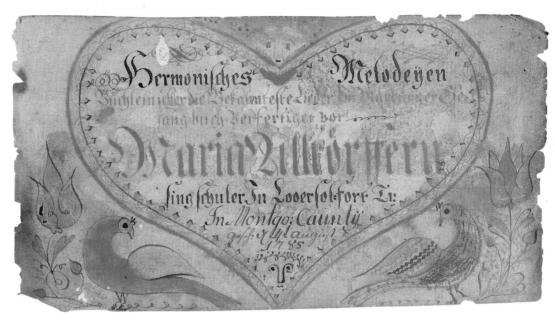

dear soul." The appealing words to the song ask that "Jesus, in my youth, instruct me....Give us wisdom and perception, Teach us faith and give us love....Teach us watching, Teach us praying....Jesus, teach and lead us, young ones, Lead us then in all thy ways."[24] This is the earliest known example of a schoolmaster's teaching model and the earliest known illustration of an instructor using a staff of music on a fraktur (in the geographic area covered by this essay).

Dock's commitment to his calling permeates his writings and provides an example for other school-masters who followed in the Bucks and Montgom-ery County Mennonite schools. Just as Dock taught for almost his entire lifetime, so did one of his students, Andreas Kolb. Kolb's teaching career in Montgomery, Bucks, Chester, and Lehigh Counties began by 1774 and continued until his death in 1811.[25] Another teacher who was a neighbor of Dock and Kolb, Lutheran Herman Ache, lived in Lower Salford, was a township auditor and supervi-sor and taught quarter terms periodically from 1758 to 1771 at Mennonite-related schools in Skippack, Franconia, and Lower Salford Townships. Indeed, the stability of the Mennonite community schools was unusual when contrasted with conditions in other Pennsylvania areas where Lutheran- and Reformed-sponsored schools found it difficult to procure and keep adequate teachers, and where parents were unable to properly compensate schoolmasters.[26] Because the Mennonite settlements were often characterized by mutual aid and community building, the economic success and the social cohesiveness of the group enabled them to adequately pay and retain teachers for long tenures. These teachers would have had access to Dock's book on school management. They continued Dock's practice of affirming successful students by making special rewards. The gifts drawn by these competent, dependable schoolmasters were cherished by the community, passed through many generations, and consequently a large number (over 1,000 identified pieces) are available for study and enjoyment today.

Less than a decade after Dock's death in 1771, Johann Adam Eyer, who like Dock was given "a special love for youth," began a decade of exceed-ingly productive and effective teaching in schools associated with Bucks County Mennonite meeting-houses. Eyer recorded these years in a journal he called "Chief Record." In this book, Eyer identifies the schools where he taught from 1779 to 1787 as "Upper End from Hiltown" which he calls "*Birckenseh*" (a Germanization of *Perkasie*), a school related to the Blooming Glen congregation in Hilltown Township; "*Tiep Ronn Bedminster Taunsch*," a school at the Deep Run Meetinghouse in Bedminster Township; and "Lower End from Hiltown," a school known as "Bean's" near the Rockhill Mennonite Meetinghouse.[27] And it was at *Birckenseh* on April 12, 1780, that Eyer carefully created for Henrich Honsperger's *Notenbüchlein* the bookplate introduced in the opening paragraph of this essay.

Henrich's bookplate is the first of twelve *Notenbüchlein* bookplates included in the accom-panying inventory that were lettered by Eyer from

1780 to 1794.[28] A perusal of the first four bookplates in the inventory, each from the hand of Johann Adam Eyer, reveals that all four are on a bordered oblong page, in size approximately 10 x 15–17 centimeters (4 x 5⅞–6¾ inches) Each has a center circle containing the child's name, the date, and the place. Each has calligraphic decoration and words or a musical staff flanking the circular center. Henrich's contains an admonition, "Learn how you alone can be singer, book and temple."[29] This sentence is used frequently on *Notenbüchlein* bookplates during the second decade of the nineteenth century by Eyer's student, David Kulp, one of several teachers who continued Eyer's hymn tune notebook legacy. Of the first four of Eyer's surviving bookplates, only Jacob Hunsicker's January 29, 1783, bookplate contains a flower. But each have some color. Catarina Hunsicker's includes red, green, and blue in a flowing leaflike design in the border of the center circle.

Surprisingly, the next four examples in the inventory are from Montgomery County. Of these four, the first two are obviously copied from Eyer. Both are an interpretation of Eyer's circular design and were drawn in May and June 1784 at Franconia. However, on the next two Montgomery County

pieces, dated August 4, 1785, at Salford and February 13, 1787, at Plains, the design changes. At Salford, Maria Alderfer's name is in a large center heart with a delicately drawn bird and flower on each side of the lower section of the heart (Fig. 85). The Plains bookplate made for Elizabeth and Barbara Fretz also has the large center heart surrounded by flowers and two half-circles.

A review of the bookplates listed in this inventory dated after 1787 shows designs incorporating flowers, hearts, and birds plus an array of visually arresting designs. A careful scrutiny of the bookplates reveals an astonishing display of well-conceived and finely drawn motifs: colorful trumpeting angels, blooming tulips, fringed dandelions, sprouting hearts, "Sophia" faces,[30] spreading angel wings, full-blown lilies, solidly rooted, sturdy, and brown-leafed vegetation, birds—singing and gazing, climbing and flying. Most bookplates also include calligraphic pen work in spiral and swirling designs. On many bookplates, the pen work on the designs, as well as the lettering and handwriting, is exceptional.

From 1787 and continuing on into the next century, a majority of the *Notenbüchlein* were made for students in Bucks County schools (Fig. 86). Of the 168 recorded examples, 16 have Montgomery

Fig. 86. **Manuscript Tune Book and Bookplate for Elisabeth Kolb**. Attributed to Johann Adam Eyer, Perkasie School, Hilltown Township, 1787. Hand-drawn, lettered and colored on laid paper. 3⅞ x 6⅜ in. (Schwenkfelder Library and Heritage Center.)

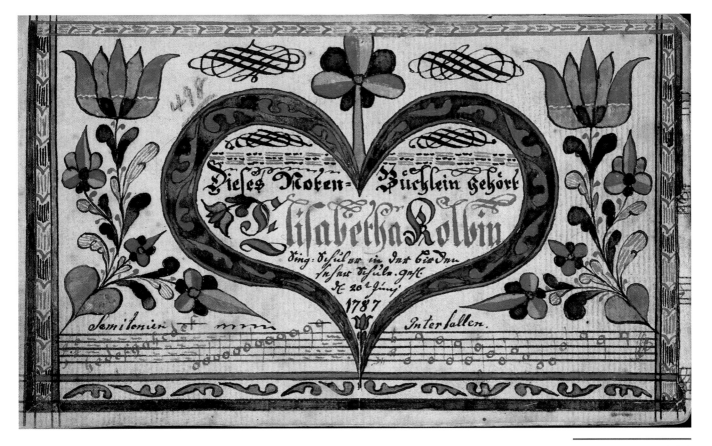

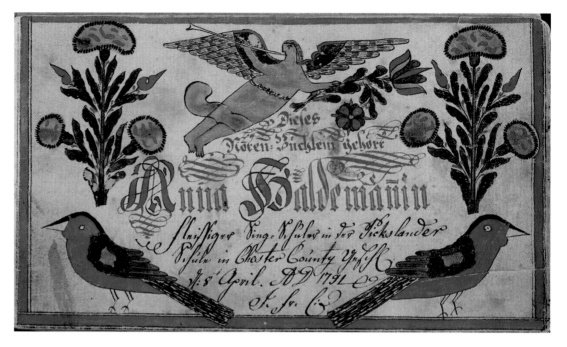

Fig. 87. **Manuscript Tune Book and Bookplate for Anna Haldeman**. Johann Friedrich Eyer, Pikeland School, Chester County, 1791. Hand-drawn, lettered and colored on laid paper. 3³/₄ x 6³/₈ in. (Chester County Historical Society, West Chester, Pa.)

County place names, 10 are identified with Chester County and a few were made for students in Lehigh, Northampton, and Berks Counties. Well over 100 of the *Notenbüchlein* have Bucks County place names or can be traced through family history to a Bucks County Mennonite school.

Johann Adam Eyer, the schoolmaster who started the Bucks County tradition of including fraktur bookplates in his students' tune books, also continued Christopher Dock's practice of rewarding children for their successes.[31] Eyer's first known booklet was made three days before the end of the winter quarter term in 1780.[32] Perhaps Eyer had promised his student a bookplate if he learned to sing the tunes assigned during the winter term. Another example, the third booklet on the inventory made by Eyer for Jacob Hunsicker at Perkasie, may also have been a reward for being successful in singing. If Jacob attended Eyer's school for the quarter term which began November 4, 1782, it seems plausible that the term would have been completed at the end of January, 1783. Jacob's booklet is dated January 29, 1783.[33] The following term, Elisabetha Lädterman attended Eyer's Deep Run school for a quarter that ended about May 10, 1783. Her booklet is dated April 29, 1783.[34]

Eyer's practice of drawing a design into a *Notenbüchlein* toward the end of the term may indicate that tunes were placed in the booklet before the bookplate, and that the subsequent creation of the fraktur was a reward for mastering musical skills.

This is documented in later tune books. Abraham Geissinger's bookplate is dated December 22, 1810. This exceptionally large tune book has tunes numbered to 665. After tune 522 the year 1810 is written. In Magdalena Gross's Deep Run booklet dated February 25, 1818, her name is inscribed in script in the upper-right corner of the first page of tunes, perhaps identifying the owner of the booklet by the cursive notation before the bookplate was made. It was the practice of schoolmaster David Kulp to write the student's name in tiny script on the inside of the front cover, possibly before he created the bookplate. This has been observed on six of the booklets Kulp made and on one made by Johann Friedrich Eyer and one by Samuel Moyer. Johannes Brackter's bookplate is dated January 13, 1830, but after tune 14 and tune 330, the date 1829 is noted.

The records in Johann Adam Eyer's roll book end with a four-month winter term at Perkasie from December 11, 1786, to April 11, 1787. However, his extant works (noted in the accompanying inventory) prove that he continued to teach in Bucks County from June 1787 to December 1789. After 1789, it is difficult to verify whether Eyer continued to teach on a regular basis.[35] This dilemma is magnified because Eyer's brother, Johann Friedrich Eyer, who was fifteen years younger than Adam, also made bookplates for *Notenbüchlein*. Johann Friedrich's fraktur seem to duplicate those of

his brother. One piece signed by Friedrich is the bookplate made for Anna Haldeman at the Chester County Pikeland school on April 8, 1791 (Fig. 87). It is initialed, center bottom, "J. Fr. E."[36] On Friedrich's signed example, the design includes a trumpeting angel at center top with a "dandelion" design on each side. At the bottom, a standing bird stares at each border. On both birds there is a noticeable pouch under each beak. Some researchers believe this pouch is evidence that Johann Friedrich drew the fraktur that include similar birds. If this is the case, it may indicate that Friedrich was helping his brother when Adam was teaching in Bucks County on April 22, 1786. On that date, an Eyer-type bookplate for a *Vorschriftbüchlein* (writing book) was made for student Abraham Hackmann at Deep Run. Both birds on this example have a pouch under their beak.[37]

The pouched bird motif was used on two later examples made for Johannes Fischer and Daniel Keller, both dated May 14, 1804, in Tulpehocken, Berks County. Both may be the work of Johann Friedrich Eyer.[38] These, however, are not included on the accompanying inventory since they are

beyond the geographic boundaries of this essay.

At about the time Johann Adam Eyer was leaving the Bucks County Mennonite school scene, schoolmaster Andreas Kolb (1749–1811), who had studied with Christopher Dock at the Montgomery County Skippack Meetinghouse School, made a *Notenbüchlein* dated October 27, 1788, for student Maria Bächtel at the Bucks County Swamp School (Fig. 88). Maria's booklet is the first known tune book made by Andreas Kolb with a fraktur bookplate. However, an earlier *Notenbüchlein* from Kolb's hand, but without a bookplate, exhibits the dates May 20, 1774–April 29, 1776, written in script on the inside of the front paper cover.[39] Kolb's scholars would have seen the booklets Eyer made for their cousins and friends at Deep Run and Perkasie and, through these contacts, Kolb may have seen hymn tune bookplates. Or, Kolb may have become aware of the practice of making bookplates because he and Eyer, both excellent schoolmasters and both teaching in a cohesive Mennonite community, were friends and exchanged ideas about classroom methods. Indeed, evidence exists that Johann Adam Eyer and Andreas Kolb had contact with each other

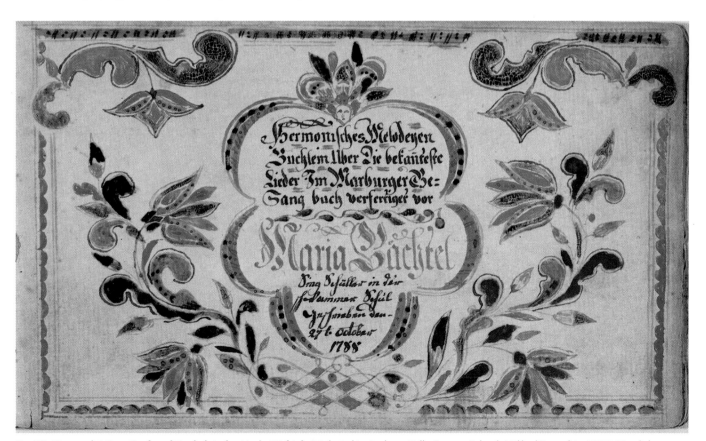

Fig. 88. **Manuscript Tune Book and Bookplate for Maria Bächtel.** Attributed to Andreas Kolb, Swamp School, Milford Township, 1788. Hand-drawn, lettered and colored on laid paper. 4¹/₈ x 6³/₄ in. (Schwenkfelder Library and Heritage Center.)

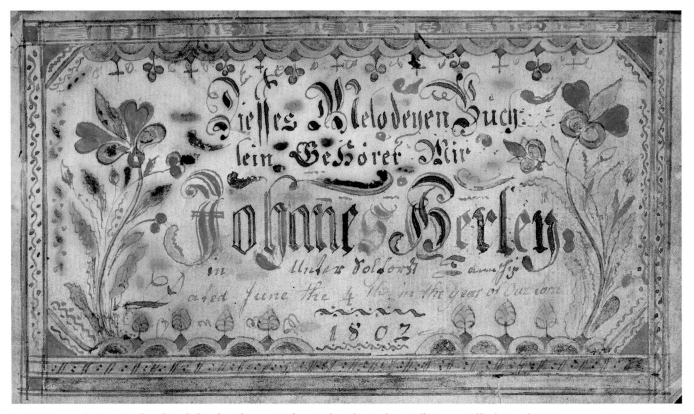

Fig. 89. **Manuscript Tune Book and Bookplate for Johannes Herley**. Attributed to Andreas Kolb, Lower Salford Township, Montgomery County, 1802. Hand-drawn, lettered and colored on laid paper. 3³/₄ x 6¹/₂ in. (Schwenkfelder Library and Heritage Center.)

during the years Eyer was teaching in Bucks County.

Two hundred years after Johann Adam Eyer started his roll book at Perkasie and Deep Run, a fraktur collector found Eyer's school records in the possession of a descendant who lived in Monroe County (where Eyer died in 1837). With Eyer's attendance book was a large fraktur-type "teaching piece" signed by Andreas Kolb.[40] Another indication that Eyer and Kolb knew each other is made evident by comparing two marriage certificates, one signed by Eyer and the other by Kolb. Eyer's certificate was made for a Deep Run Mennonite couple who were married in 1784. Kolb's records the marriage of his brother Abraham Kolb to Anna Moyer in 1784. The size and format are the same. However, the birds, angels, and flowers are interpreted in styles easily identified as being drawn by Eyer or Kolb. The Scriptures and poetry on both are identical, except that each artist has made the second last line rhyme with his own name.[41]

Eyer moved to Northampton County a few years after he wrote the last record in his roll book in April 1787. Although Eyer was no longer teaching in Bucks County, the *Notenbüchlein* tradition continued and flourished. Nine booklets created by

Eyer's fellow teacher, Andreas Kolb, survive (Fig. 89). And Eyer's exemplary classroom practices influenced one of his students, David Kulp, to become a teacher and follow Eyer's model of encouraging learning through creating special gifts. In 1783, when David was six years old, Eyer, teaching at Deep Run, made a bookplate for David's printed hymnal inscribing his name, the date, and the phrase, "I intend to sing." Perhaps Eyer intuitively felt the potential of the young David, because David sang, taught singing, and in his classrooms produced an astounding array of booklets that show him to be the most productive of all the teachers who made bookplates for *Notenbüchlein*.

The inventory of extant tune books documents that David Kulp taught at Deep Run, Perkasie, Plumstead, and Bedminster from 1801 to 1817. From those sixteen years, twenty-nine known *Notenbüchlein* survive. In Kulp's first known booklet (May 22, 1801) he entered the tunes in alphabetical order according to the first letter of the text for each tune. Although not his usual practice, he used this method in at least three other hymn tune books. In one particularly productive winter term in January

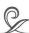

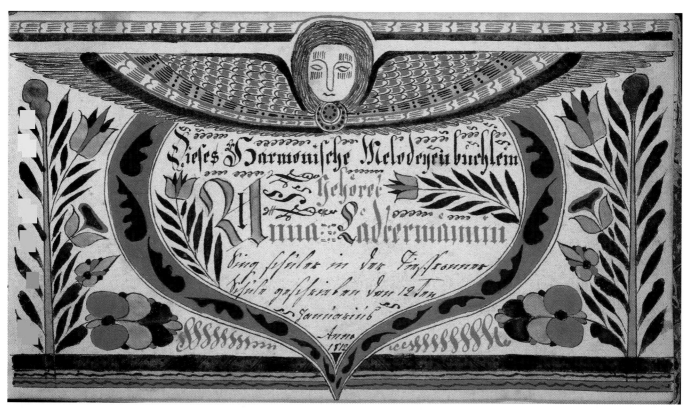

Fig. 90. **Manuscript Tune Book and Bookplate for Anna Lädtermann**. Attributed to David Kulp, Deep Run School, Bedminster Township, 1812. Hand-drawn, lettered and colored on wove paper. 3³/₄ x 6¹/₄ in. (Rare Book Department, The Free Library of Philadelphia, FLP B-1036.)

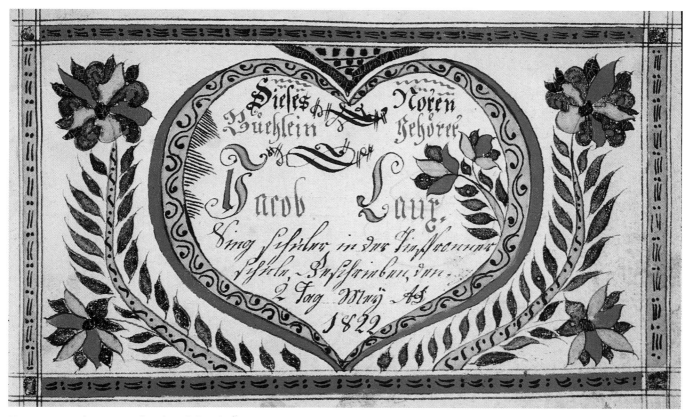

Fig. 91. **Manuscript Tune Book and Bookplate for Jacob Laux**. Attributed to Jacob Oberholtzer, Deep Run School, Bedminster Township, 1822. Hand-drawn, lettered and colored on wove paper. 4¹/₈ x 6⁷/₈ in. (Clements Library, University of Michigan.)

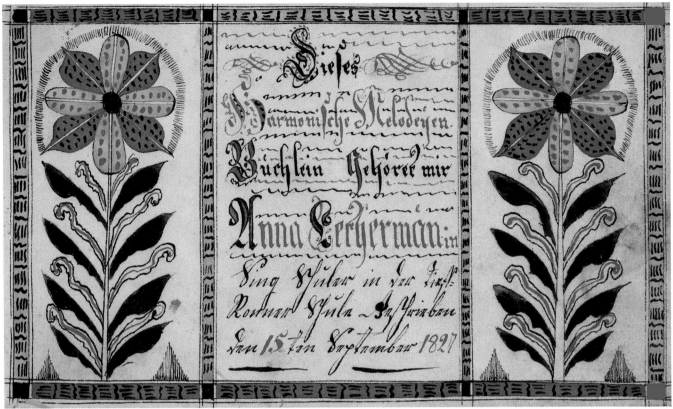

Fig. 92. **Manuscript Tune Book and Bookplate for Anna Letherman**. Attributed to Samuel Moyer, Deep Run School, Bedminster Township, 1827. Hand-drawn, lettered and colored on wove paper. 3³/₄ x 6³/₈ in. (Mennonite Heritage Center, Harleysville, Pa., 98.27.1.)

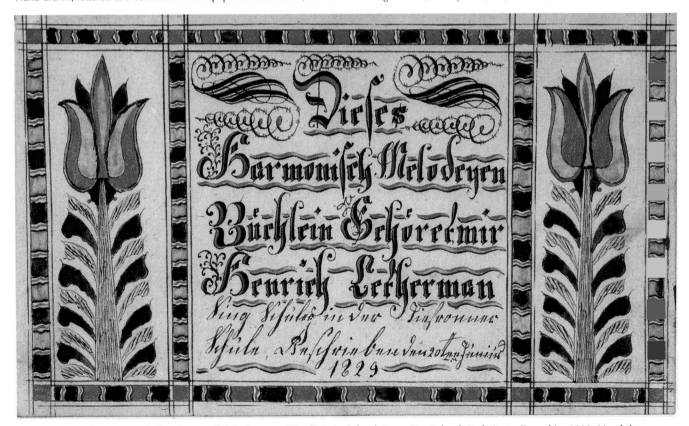

Fig. 93. **Manuscript Tune Bookplate for Henrich Letherman**. "Swirl" Artist School, Deep Run School, Bedminster Township, 1829. Hand-drawn, lettered and colored on wove paper. 3³/₄ x 6¹/₈ in. (Private collection.)

1812, Kulp made four elaborate, almost identical hymn tune bookplates for girls studying in his Deep Run classroom (Fig. 90).[42]

In addition to classroom teaching during quarter terms, David Kulp may have offered community members special sessions to learn and practice singing. It is known that singing schools were offered at least by 1816 when a German-English school was built in Hilltown Township.[43] The rules for the school state, "And there may be singing schools kept there also if desired. Those who patronize them are to observe good order and pay for any injury that may be sustained by wilful abuse or through neglect, either to the house or seats, while occupied by them."[44]

In Bucks County, the *Notenbüchlein* tradition flourished until 1835. After David Kulp, schoolmasters who continued the practice included John Hunsberger, Levi O. Kulp, Joseph Moyer, Philip Mumbauer, Samuel Musselman, and Jacob Overholt (Fig. 91). Samuel Moyer, teaching at Deep Run from May 1826 to January 1829, also produced a group of at least six finely executed booklets (Fig. 92).[45] Another teacher, Jacob Landes, taught at Bedminster, Hilltown, Haycock, and Durham during the years 1820 to 1827. Surely Jacob Landes created more *Notenbüchlein* than the sole copy credited to him in the inventory.[46] Deserving additional study is a series of manuscript hymn tune books dated 1829 to 1835 (Fig. 93) from an unnamed Bucks County schoolmaster teaching in Deep Run, Hilltown, and New Britain (identified in the inventory as the Swirl Artist). A careful perusal of the accompanying inventory may lead to more discoveries as well as to the identification of the as yet unnamed artist-teachers who worked in Bucks County during this era.

In Montgomery County, after the productive 1783 to 1787 period, only a few *Notenbüchlein* are found. Three of these were made by Jacob Gottschall (1769–1845) who had studied in Johann Adam Eyer's classroom. Eleven-year-old Jacob, with his brother Herman enrolled in Eyer's Perkasie school during the 1780 late-summer quarter.[47] Following in Eyer's footsteps, Jacob became a teacher and taught at the Skippack Meetinghouse school during the late-summer term of 1792. In August and September of that year, he made and signed *Notenbüchlein* for Abraham and Susanna Kassel (Fig. 94). He also taught at the Salford Meetinghouse school and at the Franconia school,

continuing his teaching career at least until 1800 when, on January 10, he made an alphabet page for Joseph Pannebaker at Franconia.[48] In the two Kassel *Notenbüchlein* listed in the accompanying inventory as well as on the reverse side of Joseph Pannebaker's alphabet page, Jacob Gottschall records the place he was teaching and signs his name in large, boldly flowing penmanship, identifying himself as a "Sch.D." (*Schule Diener*, or schoolmaster). Gottschall's practice of signing his work is a notable exception to the pattern set by Christopher Dock, whose signature is found only on legal documents.

In 1804, at the Franconia congregation, Jacob was given the "preaching ministry" and nine years later was given "the full ministry as confirmed minister" (bishop). He and his wife, Barbara Kindig, had eleven children, seven of whom were sons. Of these seven sons, several became teachers and during the 1830s produced an amazing array of fraktur.[49] However, with the possible exception of the February 19, 1835, *Notenbüchlein* for Heinrich Gottschall (one of the seven sons of Jacob and Barbara) and the booklet for Rahel Bischop dated March 8, 1835, both of which may have been created by Heinrich himself, no *Notenbüchlein* created by Jacob's sons have been found.[50]

About the same time as Jacob Gottschall was making booklets for the Kassel children, a Lower Salford teacher of Schwenkfelder children imprinted a group of clover leaf designs in the *Notenbüchlein* he made. This unidentified schoolmaster has been dubbed the Block Print Artist. Four examples survive from his hand. He appears to have taught Schwenkfelder children who lived in Lower Salford Township. The Schwenkfelders came to Pennsylvania from 1731 to 1734.[51] Some of the settlers lived in close proximity to Mennonites in the Montgomery County townships of Lower Salford, Towamencin, Skippack, and Worcester and in the Berks County community near Hereford. The following inventory shows that at times Schwenkfelder children attended Mennonite-related schools where *Notenbüchlein* with fraktur bookplates were made for them.

At the Schwenkfelder Library in Pennsburg, Pennsylvania, are three *Notenbüchlein* that appear to be uniquely Schwenkfelder because the opening format is remarkably different than the initial pages in hymn tune booklets made for Mennonite children. Each of the three opens with a series of questions and answers that aim to teach the children

"elementary theory in which the notes, elements of time, clefs, sharps and flats, et cetera, are explained."[52] The first of these three, made for Isaac Schultz and dated 1771 and 1772, begins with nine pages of questions and answers relating to musical understandings.[53] Preceding the questions are three colorful pages. Isaac's tunes have notes on two or three staves for several voice parts, a practice not typically found in Mennonite children's booklets. The first page of the second example has a simple, small flowing design, but no name or date. The following pages contain twenty-six questions and answers. Toward the back is a six-page list of the contents of the book and "J. S. December 12, 1808." The third in this group of musical question and answer booklets contains Wilhelm Schultz's name, does not have a fraktur bookplate, but does have notes for the tunes written on a single staff for one voice as do the Mennonite booklets.[54]

Although the Schwenkfelders made and used manuscript tune books, few have colorful bookplates. Two exceptions with typical Schwenkfelder designs and motifs are a multicolored, profusely decorated booklet made for Susanna Yaeckel on March 27, 1815, and a *Melodeyen Büchlein* dated 1817 with Samuel Kriebel's name inscribed in red and black.[55] The Schwenkfelder Library has more

than twenty manuscript tune books with no bookplates. A Schwenkfelder feature not found in Mennonite booklets is a register in the back half of the tune book. The register lists the titles of the hymns in the book, followed by the page number for that hymn in the 1762 Schwenkfelder *Neu-Eingerichtetes Gesang-Buch* printed by Christopher Sauer in Germantown. The Schwenkfelder booklets typically have tunes with two or three voice parts on two or three staves, while the Mennonite booklets generally have one staff and one voice part.

As the accompanying inventory reveals, the Schwenkfelder Library includes a collection of Mennonite *Notenbüchlein*. Some were purchased when portions of the library of Montgomery County historian and collector Governor Samuel Pennypacker were dispersed in the early part of this century. Others were obtained in Franconia Township at an estate auction after the 1942 death of Mennonite historian John Derstine Souder.

One of the last Montgomery County Mennonite teachers who made *Notenbüchlein* was Henry Johnson, a long-term schoolmaster at Skippack. In 1826, he made for himself a wonderful hymn tune notebook containing three bookplates. A motif used solely by Johnson is the palm tree, a design he drew on one of his own bookplates and also copied into

Fig. 94. **Manuscript Tune Book and Bookplate for Susanna Kassel**. Jacob Gottschall, Skippack School, Montgomery County, 1792. Hand-drawn, lettered and colored on laid paper. 3³/₄ x 6¹/₈ in. (Private collection.)

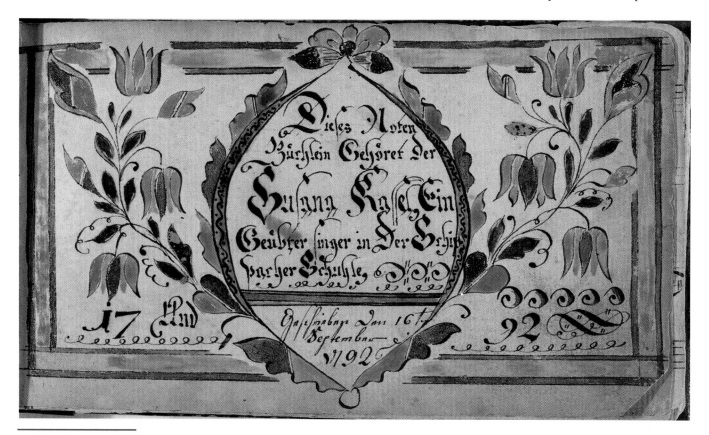

the *Notenbüchlein* he made for his student Elisabeth Kolb. Remarkably, both Henry's and Elisabeth's complete *Notenbüchlein* have survived. A comparison of the two reveals that in the two books, the tunes on pages 1 to 39 are almost identical and are in the same order.[56]

In the Berks County Mennonite community at Hereford, a schoolmaster who was an expert calligrapher made a *Notenbüchlein* in 1808 for Catharina Latshaw and one in 1815 for George Wiegner. Both are noticeably the same with only a center circular motif in a style similar to the first 1780 *Notenbüchlein* made by Johann Adam Eyer.

Evidence of the *Notenbüchlein* fraktur bookplate tradition has not been found in other Pennsylvania communities with the exception of a few created by two schoolmasters in Lancaster County. One of these, Christian Alsdorff, was teaching in December 1791 in Earl Township and in March 1792 in Hempfield Township, both Mennonite-populated areas in Lancaster County. However, in June 1792, Alsdorff was in New Hanover Township, Montgomery County, an area not too far from Pikeland in Chester County where Johann Friedrich Eyer signed the *Notenbüchlein* fraktur he made for Anna Haldeman in April 1791. From the motifs Alsdorff used on his fraktur, it is obvious that he knew the work of Johann Adam Eyer and Johann Friedrich Eyer. This is evident when a bookplate for a *Vorschrift* (writing) booklet made by Alsdorff in 1791 for a student in Earl Township is compared with a bookplate made by one of the Eyer brothers in 1789 for a scholar in the Vincent School in Chester County. Both have a man standing on a heart with stars at each corner. The similarity is clearly apparent.[57] A few *Notenbüchlein* made by Christian Alsdorff have been found. One of these was drawn for Elisabeth Kauffman in Hempfield, Lancaster County, on February 17, 1794.[58] Alsdorff also created hymn tune notebooks for Magdalena Martin at the Earl School in 1791 and for Elisabeth Miller at Hempfield in 1793.[59] The other Lancaster

Countian who made *Notenbüchlein* for Mennonite children is Christian Strenge. He taught in Hempfield Township from 1787 to 1811 where he made at least two *Notenbüchlein*—for Daniel Maurer in January 1796 and Mary Swarr in March 1797.[60]

With the exception of the work of these two Lancaster County teachers, the production of *Notenbüchlein* must be recognized as a Bucks County phenomenon with secondary projections into Montgomery County and other areas where small Franconia Conference settlements were located. But beyond the borders of Pennsylvania, the Bucks County *Notenbüchlein* tradition thrived in yet another Mennonite community. Beginning about 1786, Bucks County Mennonite families started to settle on the Niagara Peninsula in Ontario, Canada, in an area known as *The Twenty*. Prior to 1803 at least thirty-three Bucks County Mennonite families had made new homes there. The children of these Mennonite immigrants attended the Clinton School, where by 1804 they were learning to sing from decorated and inscribed *Notenbüchlein*.[61] From 1804 to 1830, a series of *Notenbüchlein* made for children with the surnames Meyer, Kratz, Schwartz, Frey, Hoch, and Hauser survive. Some *Notenbüchlein* made in Bucks County were carried with the immigrants to the Niagara Peninsula. These can be found at the Jordan Museum of The Twenty, close to Vineland, Ontario. In addition, some Bucks County booklets remain in Ontario in the possession of the descendants of the original settlers.[62]

The inventory included with this essay should be viewed as an evolving document. This summary and the list of *Notenbüchlein* is offered as a beginning, not as a definitive text. After many years of active research to locate and identify these treasured booklets, it seems that the study has only begun.[63] The writer invites readers to join in recording the development of this intriguing folk art form.[64]

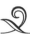

Notes

1. Frederick S. Weiser and Howell J. Heaney, *The Pennsylvania German Fraktur of the Free Library of Philadelphia: An Illustrated Catalogue*, 2 vols. (Breinigsville, Pa.: The Pennsylvania German Society, 1976), 2:fig. 845. The Marburg hymnal had a 1716 European edition. It was reprinted by Christopher Sauer (Germantown) in 1757. It became the hymnal used by all the German Protestant sects in Pennsylvania. See n. 7.

2. Donald A. Shelley, *The Fraktur-Writings or Illuminated Manuscripts of the Pennsylvania Germans* (Allentown, Pa. 1961), in *Publications of the Pennsylvania German Folklore Society* 23 (1958–1959): 50. In this seminal publication on fraktur, Shelley identifies Manuscript Music Books as among the "most numerous" of illuminated books. Second on a list of ten fraktur classifications is "Mennonite Manuscript Music Books (horizontal)."

3. Frederick S. Weiser, "I A E S D: The Story of Johann Adam Eyer (1755–1837), Schoolmaster and Fraktur Artist with a Translation of His Roster Book, 1779–1787," in *Ebbes fer Alle-Ebber, Ebbes fer Dich/Something for Everyone—Something for You: Essays in Memoriam Albert Franklin Buffington*, in *Publications of the Pennsylvania German Society* 14 (1980). For a full discussion of Johann Adam Eyer's teaching career, see pp. 437–508. Subscription schools were organized by members of the community and parents paid tuition directly to the schoolmaster.

4. The author reviewed and photographed this manuscript book at the Bernisches Historisches Museum in November 1987. It is catalogued as no. 284. Place names noted on the book are Lenk (near Berne) and Uebischi (near Thun), both areas where Mennonites, then known as Anabaptists (rebaptizers), lived. The book's size is 21.5 x 27.5 centimeters (8¹/₂ x 10⁷/₈ inches). John L. Ruth photographed this book at an earlier date and kindly shared information about its existence. Also, see his article in this volume for another possible source of inspiration for Eyer's designs.

5. It is unusual to find in the eastern Pennsylvania Mennonite community colorful, fraktur-lettered bookplates made in Europe. One prized example is in the collection of the Mennonite Historians of Eastern Pennsylvania (MHEP) at the Mennonite Heritage Center in Harleysville. It is in a 1536 Froschauer Bible from the Schnebelli family who originally lived near Zürich. The bookplate contains flowers on spreading stems with a central circle motif containing (in German) these words: "The Bible belongs to the Matthias Schnebly at the Ibersheimerhof, and this is in love so written in the year of Christ. 1708." The Schnebelli family had fled from persecution in Zürich to Ibersheimer Hof, just north of Worms in the Palatinate. For additional information see Joel Alderfer, "Froschauer Bible Acquired," *Mennonite Historians of Eastern Pennsylvania Newsletter* 18 (March 1991), n.p.

6. David Kulp, who taught in Bucks County Mennonite community schools from 1801 to 1817 attested on May 7, 1814, that during a quarter term he was being contracted to teach at Hilltown he would "learn them [the children] in Reading, writing, **Singing** and Arithmetic." See John L. Ruth and Joel D. Alderfer, "David Kulp, His Hand &

Pen: The 'Brown Leaf Artist' Identified?" *Mennonite Historians of Eastern Pennsylvania Newsletter* 22 (January 1995): 7. Jacob Overholt announced that he would teach at the Hunsberger school house in Hilltown beginning on January 5, 1823, and he promised to "teach the children in reading, writing, **singing**, praying and spelling." (Manuscript privately owned.)

7. Before the 1803 printing of their own hymnal, *Zions Harfe*, the Franconia Conference congregations used: (1) the *Ausbund*, containing hymns sung by the Anabaptists in Switzerland, Austria, and southern Germany. The *Ausbund* contains "persecution ballads" which reflected the experience and thinking of persons who were martyred for their faith during the sixteenth century. The *Ausbund* was reprinted by the Sauer press in Germantown in 1742. (2) The *Lobwasser* (Marburg edition) was from the Reformed tradition of Southern Germany and Switzerland. It was printed by the Sauer press in 1753 and 1763. (3) Two Lutheran hymnals known as *Halle* and *Marburger*. (4) A Brethren hymnal titled *Das Kleine Davidische Psalterspiel*. This information taken from a dissertation by Suzanne E. Gross, "Hymnody of Eastern Pennsylvania German Mennonite Communities: *Notenbüchlein* (Manuscript Songbooks) from 1780 to 1835." (Ph.D. dissertation, University of Maryland, 1994), 24–29.

8. *Die Kleine Geistliche Harfe der Kinder Zions*, published by Michael Billmeyer of Germantown, "Upon the order of the Mennonite Churches," 1803. Cited in John C. Wenger, *History of the Franconia Mennonites* (Scottdale, Pa.: Mennonite Publishing House, 1937), 312 with facsimile of title page between 320–321.

9. An overview of Suzanne Gross's dissertation, "Hymnody of Eastern Pennsylvania German Mennonite Communities," is included in the *MHEP Newsletter* 21 (No. 6): 5–8. Information about monophonic singing can be found on pp. 5–7.

10. Ibid., 7.

11. The use of shape notes is a system to help singers learn to vocalize a tune. Each note on the scale has a different shape. Clarence Fretz, ed., *Anabaptist Hymnal* (private printing, 1987), on the second page of his Preface explains, "In order to promote and sustain the Anabaptist practice of congregational singing without instrumental accompaniment, we have incorporated the use of shape notes. No denomination has ever attained or long maintained full-bodied four-part, a capella congregational singing without the use of shape notes, unless they used some other special help such as the use of numbers."

12. "O Little Children Gather," in *Hymnal, a Worship Book*, (Scottdale, Pa.: Mennonite Publishing House, 1992), no. 489.

13. Christopher Dock, *Schul-Ordnung*, (Germantown, Pa.: Christopher Sauer, 1770.) All of the following quotations are taken from a translation of Dock's writings by Elizabeth Horsch Bender included in a publication by Gerald C. Studer, *Christopher Dock: Colonial Schoolmaster*, (Scottdale, Pa.: Herald Press, 1967).

14. Studer, 295.

15. Ibid., 273.

16. Ibid., 273–74.

17. Ibid., 280–81.

18. Fraktur identified by the German term *Vorschriften* are large, decorated, colorful writing exercises (typically 15–20 x 25–30 centimeters, or approximately 6–8 x 10–12 inches) containing hymn text and/or scriptures and spiritual teaching, the alphabet in upper and lower-case (sometimes in both German and English) and the numbers. Sometimes the child's name is included. *Vorschriften* were made by the schoolmaster to teach the children to read and write, to instruct them spiritually, and to bring design and beauty into their world. Christopher Dock wrote in his book on school management (*Schul-Ordnung*, see n. 13) that he rewarded the children with a certificate (*Zeugnisz*). Dock's certificates may be what are today known as *Vorschriften*.

19. Abraham Harley Cassell Collection, MS 4X, Juniata College, Huntingdon, Pa.

20. Studer, 274.

21. Ibid., 278, 284.

22. Ibid., 302.

23. Gerhard Bechtel's *Vorschrift* is at the Schwenkfelder Library, accession no. 4–1.

24. Translation by Isaac Clarence Kulp Jr., Vernfield, Pa. See author's data record sheet H349 for complete translation.

25. For more on Andreas Kolb, see Mary Jane Lederach Hershey, "Andreas Kolb, 1749–1811," *The Mennonite Quarterly Review*, 61 (April 1987): 121–201.

26. Writing in 1764, Henry Melchior Muhlenberg relates an incident regarding paying and providing living quarters for the schoolmaster. Muhlenberg, a Lutheran pastor, served a parish in Trappe, Montgomery County, a few miles southwest of Lower Salford Township. See his journal, vol. 2 (Philadelphia: Muhlenberg Press, 1945), 61–62. In Volume 3, Muhlenberg writes in 1784 (p. 588): "Oh, how rare good schoolmasters are here!" At an English school, the Union Schoolhouse in Buckingham Township, Bucks County, opened in March 1797, the notes for the second quarter of the new school state, "At a meeting of the Trustees 16th day of the 1st month, 1798, Joseph Stradling, Isaac Pickering and John Gillingham, Jr., all present, the reason for which was an account of our Tutor taking strong drink to such excess the day before in time of School house that he was unfit to take care of the scholars...." See Buckingham Union Schoolhouse Trustees' Book, BM A–49, Spruance Library/Bucks County Historical Society, Doylestown, Pa. (SL/BCHS). Many of the teachers who taught at Mennonite meetinghouse schools were well-established members of the community and in Lower Salford and Franconia Townships, schoolmasters Dock and Herman Ache owned the farms on which they lived. Because the Mennonite schools had competent, dependable schoolmasters who seemed to have learned from each other the tradition of rewarding students, a huge body of fraktur from these Franconia Conference schools is available for study. As of this date, the author has documented over 1000 examples. One scholar believes that the reason colonial Mennonite communities in the Franconia Conference are provided a stable environment and a strong economy, where parents could pay the schoolmaster and retain competent teachers, was because "Strong local leaders, especially in rural areas, exhorted members to purity of doctrine, sobriety, domestic responsibilty, hard work, and mutual help. Thus for the sake of gain, both material and social, Mennonites and Quakers formed societies of discipline, emulation, and mutual aid." James T. Lemon, *The Best Poor Man's Country* (Baltimore: The Johns Hopkins Press, 1972), 20.

27. Weiser, "Story of Johann Adam Eyer," 439. At the time he wrote this article, Weiser could not identify the location of the "Lower end from Hiltown," Information about this school is in Charles H. Price Jr., *A Hartzell-Price Family History and Genealogy* (Telford, Pa.: by the author, 1971), 41–42. The school lot was "situated partly in Rockhill and partly in Hilltown." The document giving the land for the use of a "Union Christian School" is dated January 1775. The names on the document include Henrich Hertzell, Michael Derstine, Adam Cope, Phillip Wagener, Samuel Detweiler, Isaac Derstine, and John Sellers. A perusal of the quarter terms when Eyer taught at this school show that children with all of the preceding surnames studied there.

28. Later Eyer taught in Northampton County where in 1797 he made *Notenbüchlein* for a Ludwig Beck. Weiser and Heaney, *Free Library Fraktur*, 1:fig. 199.

29. The phrase "Learn how you alone can be singer, book and temple" was an admonition with special meaning to students whose parents were Mennonites. The word *singer* related to the Mennonite belief of being a "doer of the Word," that is, to be active in helping your neighbor; *book* would pertain to a life of discipleship; and *temple* was interpreted as having God's spirit dwelling in your body.

30. In folk art, the Virgin Sophia is a symbol of wisdom. In the Franconia Mennonite community, the face of Sophia was used on bookplates, rewards, teaching pieces, and *Vorschriften*. John Joseph Stoudt in *Consider the Lilies How They Grow* (Pennsylvania German Folklore Society, 1937), 124–132, discusses the history of the use of the Sophia symbol.

31. Johann Adam Eyer seems to have been the first teacher of Mennonite students to have created bookplates for *Notenbüchlein*. However, *Vorschriften Büchlein* were made prior to Eyer's tenure. Christopher Dock created booklets containing the Golden ABCs dated 1762 and 1768. In Rockhill Township, a schoolmaster made an ABC booklet for Ludwig Benner in 1773. David Spinner's teacher in Lower Milford Township made a *Vorschriften Büchlein* for David in 1771. When an adult, David Spinner became a justice of the peace in Milford

Township and validated school bills for children during 1824–1827. On a bill to pay William Overholtzer for teaching poor children in Milford Township, David Spinner is listed as a school director. See Bucks County School Bills, County Commissioners' Records, SL/BCHS (B.C. School Bills).

32. Weiser, 483.

33. Ibid., 489–490. Jacob Hunsicker is not listed. However, Weiser notes that "entire page is missing." A Johannes and Elisabetha Honsperger are listed.

34. Ibid., 490. The page for this term is missing. However, payments are noted to May 10, 1783. At the Schwenkfelder Library is a fragment of a *Notenbüchlein* made for Henrich Landes (accession no. 7–16). The date is missing, but it appears to be one of the bookplates Johann Adam Eyer made in the early 1780s. A Henrich Landes is listed as a scholar in Eyer's school at the "Upper End from Hiltown" for the late-summer term that began July 29, 1780.

35. A *Notenbüchlein* was made for Johannes Dentlinger in Strasburg Township, Lancaster County, on December 22, 1788. It appears to be the work of Johann Adam Eyer. Shelley, *Fraktur-Writings*, fig.143.

36. In the collection of the Chester County Historical Society.

37. Weiser, 451, fig. 7.

38. Both were in private collections when recorded in 1986. Data record sheets H789, H807.

39. Schwenkfelder Library, accession no. VD1-32. The first page of this booklet is almost exactly like Kolb's later-dated books with bookplates.

40. Hershey, "Andreas Kolb," Plate XX. *Teaching piece* is explained on 130–132.

41. For a discussion of the Eyer-Kolb connection, see Ibid., 132–34. Kolb's marriage certificate is Plate XV. Eyer's marriage certificate is illustrated in Weiser and Heaney, 1:fig. 193.

42. In a similar burst of creativity, another schoolmaster (who lacked David Kulp's artistic skills) made bookplates on February 25, 26, and 27, 1818. See accompanying inventory.

43. Ruth and Alderfer, "The 'Brown Leaf Artist' Identified?" 4–9. Also see essay in this publication by Joel D. Alderfer.

44. From a transcription of the records of "German-English School, Hilltown Township, Bucks Co., 1816–1847," a school known as the Hunsberger School. Copy on file at the Mennonite Heritage Center, Harleysville, Pa. These records show that an Eliza Jones "commenced a reading and sewing school 1819 and closed 1819."

45. Samuel Moyer taught at the "Bedminster Menonist Schoolhouse" from April 2, 1827 to October 26, 1827, and from March 10, 1828 to June 6, 1828. B.C. School Bills.

46. Jacob Landes kept school as follows: (1) Bedminster: "October 20, 1820 School Commenced" (received pay for 21 days); "April 9, 1821, School Commenced" (received payment for 13 days); "April 9, 1822 School Commenced" (received payment for 55 days; this would have been the term when Johannes Gross's booklet was made); "Commenced December 9, 1822 and continued till March 17, 1823"; "in the year of our Lord 1824" (received payment for 58.5 days); "commenced on the 11th day of April 1826 Continued till the 30 Day of August 1826"; (2) Hilltown: "September 24, 1821 School Commenced" (teaching at least 42 days); "in the Year A.D. 1824" (teaching at least 50.5 days); (3) "Township of Bedminster, Haycock & Durham School Commences September 1827" (teaching at least 57.5 days); (4) Rockhill, bill dated April 16, 1827. B.C. School Bills.

47. Weiser, 486.

48. Schwenkfelder Library, 6–4.

49. The sons of Jacob H. Gottschall (1769–1845) and Barbara Kindig Gottschall (1775–1843) were John (1796–1869), Martin (1797–1870), Jacob (1799–1888), William (1801–1876), Samuel (1808–1898), Henry (1812–1895), Herman (1818–1905). The sons of Jacob who have been documented as following their father's example of teaching and creating fraktur during their young adult years include Martin, William, and Samuel. Herman also is documented as being a schoolteacher. However, no fraktur have been credited to Herman. The author believes that Jacob and Henry also made some of the fraktur attributed to one of their brothers. A signed Martin piece remains in the Franconia Mennonite community. Samuel's name is on several existing pieces. William taught in the Salford community during the years recorded on many dated pieces with the names of Salford children. The author questions the validity of the attribution to Martin of many widely reproduced fraktur. Genealogical information from Gladys Price (Nyce) Mease and Gwendolyn Price (Nyce) Hartzel, comps., *The Abraham and Leanna (Godshall) Nyce Family: Their Ancestors and Descendants*, (Nyce Manufacturing Company, 1986), passim.

50. Heinrich's is illustration no. 151 in Shelley, *Fraktur-Writings*. If Heinrich made these two *Notenbüchlein* in 1835, he was twenty-three years old. This follows a pattern in which young men taught for a few years before they went into farming or other occupations. He may have taught in New Britain for a quarter term. Heinrich would have connections there because his father was born in New Britain.

51. The Schwenkfelders came from a European background of persecution for their religious beliefs. Their name comes from a Silesian nobleman who was a lay evangelist and reformer, Caspar Schwenckfeld von Ossig (1489–1561). Prior to coming to Pennsylvania, Schwenkfelders lived in Lower Silesia and Saxony. As a group, they were well educated. Their first schools in Pennsylvania started in 1764, with the children meeting in homes. One of these home schools was in the Towamencin, Skippack, and Lower Salford area. The second home school was called the Goschenhoppen School. This is an area encompassing portions of Montgomery, Bucks, Lehigh, and Berks

Counties where Schwenkfelder immigrants had settled. The home schools started prior to organizing themselves into The Society of Schwenckfelders in 1782 and the building of their first meetinghouse in 1789. Two rewards survive from the hand of the Block Print Artist. See Weiser and Heaney, no. 609, and accession no. 1147 at the Schwenkfelder Library. The second has six of the clover leaf prints. Schwenkfelder Library catalogue information records it as being from the Pennypacker collection. Pennypacker wrote that is was "found between the leaves of an old Schwenkfelder book which belonged to the Seip family."

52. J. Edward Moyer, "The Hymn-Tunes of the Schwenkfelders" (Master of Music dissertation, Westminster Choir College, 1941), 19, on file at the Schwenkfelder Library. For his thesis, Moyer examined twenty-five "Copy Books." With the exception of the 1791 Isaac Schultz and one for "J. S." in 1804, none have fraktur bookplates except the last two on his list, Rosina and Christina Kriebel's 1793 booklets, which are Mennonite in form and are included on the inventory attached to this essay.

53. An Isaac Schultz taught school for four months in the fall of 1797 at the Schwenkfelder school in Hereford. He taught again at the "new schoolhouse" in Hereford for four months beginning in December 1799. From the Goschenhoppen *Scul-Buch* Records, 1764–1842, on file at the Schwenkfelder Library.

54. Schwenkfelder Library catalogue information follows: Isaac Schultz, VD1-10BP; S.J. December 12, 1829, VD1-15; Wilhelm Schultz, VD1-26.

55. Susanna Yaeckel's formerly owned by Henry J. Kauffman, present ownership unknown; Samuel Kriebel's is in the Schwenkfelder Library, VD1-2.

56. See note under Henry Johnson in alphabetical listing of tune book owners following the accompanying inventory.

57. David R. Johnson, "Christian Alsdorff, the 'Earl Township Artist,'" *Journal of the Pennsylvania German Society* 20 (No. 2, 1986): 45–59, fig. 2. Also Weiser, 457, fig. 14.

58. Johnson, "Christian Alsdorff," 54.

59. Catalogue, Horst Auction Company, Ephrata, Pa., May 11, 1991, lots 167, 168.

60. David R. Johnson, *Christian Strenge's Fraktur* (East Petersburg Historical Society, 1995), unpaginated. Mary Swarr's booklet is illustrated. For Daniel Maurer's booklet, see Beatrice B. Garvan, *The Pennsylvania German Collection* (Philadelphia: Philadelphia Museum of Art, 1982), 322. Another bookplate was made by an unidentified schoolmaster for Esther Miller on November 5, 1816. It is illustrated in a Conestoga Auction Company catalogue, May 20–21, 1977, lot 558, and came from the collection of Henry J. Kauffman. The school and county cannot be determined from the catalogue photograph.

61. Michael S. Bird, *Ontario Fraktur* (Toronto: M. F. Feheley Publishers Limited, 1977), 20–21, illus. 29–36, 50–54. Bird illustrates eight *Notenbüchlein* bookplates, all from

the Clinton School. The author of this essay has also found in a private collection one made for Abraham Hausser, singing scholar in the Clinton School, May 17, 1828. H812.

62. Such is the case with the *Notenbüchlein* made by David Kulp for Jacob Meyer at Perkasie on May 17, 1811. This large-sized and unusually well-detailed book was owned by a descendant of Jacob who lives in Vineland, Ontario. It is now in the collection of the Jordan Historical Museum, Jordan, Ontario.

63. Many fraktur are related to hymns, tunes, and musical performance. (1) Numerous *Vorschriften* contain the words to hymns sung in the meetinghouse. Two *Vorschriften* believed to be by David Kulp place the tune line above the words of the first verse of the hymn (H139 and H424—both in private collections). One of these records a hymn from a Moravian hymnal printed in London in 1753 (H424). (2) An unusual fraktur dated March 25, 1816, and marked "*Vor Jacob Oberholzer*" has a line of music above several verses of a song, and on each side are two lovely dancing angels blowing horns (SL/BCHS, SC–58. No. A–06). (3) Maria Miller, studying with one of the Eyer brothers in Vincent in 1789, was doubly rewarded with two music-related pieces. On February 7, she received a finely executed "*Sing=Bild*" (sing picture) with prancing lions on each side of the oval containing her name and with the lions standing on a huge heart containing words of exhortation (Winterthur G57.1248). Seven months later on September 16, the same teacher made a bookplate for her printed hymnal in which Maria is called "a Diligent singer" (Private collection, H572). (4) The hymn "*Ich will lieben und mich uben,*" ["I will love and practice loving"], a favorite of Franconia Conference Mennonites, is included on two identical large (16.6 x 20.6 centimeters, or approximately $6^1/_2$ x $8^1/_8$ inches) rewards dated eleven years apart. The earliest, dated 1782, seems to be a sample because the heart at center bottom is blank. On the 1793 copy the heart contains the words, "best singer in the first class." On the reverse is Susanna Kraut's name. Both may be the work of Johann Adam Eyer. (1782, fig. 214 in Weiser/Heaney; 1793, private collection, H607). (5) Smaller rewards include those made for (a) Daniel Landes, "Selected and confirmed singer, Class No. 7...is in the order of singers at the school in Perkasie. He who is able to read this should understand that he is become a seventh singer." Possible by Johann Adam Eyer and dated May 3, 1781. Daniel Landes is not listed in Eyer's roll book. (Schwenkfelder Library 7–108); (b) Two rewards made on March 24, 1783, at the Lower Salford Meetinghouse school for someone who was in "First Class #3," "Sing unto him a new song, play skillfully with a string music." (Psalm 33), (Schwenkfelder Library, 7–155); and another who was in the "First Class #6," Sing unto him a new song; play skillfully with a loud noise." (Psalm 33), (Unk.). (6) A small, fraktur-type drawing of colonial-garbed boys sitting around a table with what appears to be songbooks opened in front of each boy (Private collection, H912).

64. Special thanks for information used in this essay to Joel D. Alderfer, Cory Amsler, Suzanne Gross, Alan G. Keyser, Isaac Clarence Kulp Jr., David Luz, Dennis Moyer, John L. Ruth, and Ron Trauger.

A Chronological Inventory of *Notenbüchlein*
Made for Children in Mennonite Community Schools in Eastern Pennsylvania,
an Area Now Known as the Franconia Conference, 1780 to 1845

Date	Scholar	School	Schoolmaster	Source*
April 12, 1780	Henrich Honsperger	Perkasie	JAE	FLP No. 845
March 20, 1781	Catarina Hunsicker	Perkasie	JAE	HSP AC982
January 29, 1783	Jacob Hunsicker	Perkasie	JAE	FLP No. 825
April 29, 1783	Elisabetha Lädterman	Deep Run	JAE	FLP No. 826
May 27, 1784	Elisabeth Hege	Franconia		BCHS C-03
June 11, 1784	Elisabeth Schwarz	Franconia		PC, Ref. 9, No. 30
August 4, 1785	Maria Alderfer	Lower Salford		PC
February 13, 1787	Elisabeth & Barbara Fretz	Plains		LCP 7952.F2
June 20, 1787	Elisabeth Kolb	Perkasie	JAE	SL VD1-34BP
November 27, 1787	Maria Fretz	Deep Run	JAE	FLP No. 827
January 18, 1788	Abraham Nees	Rockhill	JAE	FLP No. 859
May 26, 1788	Jacob Finckbeiner	Vincent	JAE	PC, Ref. 17, No. 1301
May 29, 1788	Catarina Carlin	Vincent	JAE	CCHS
October 27, 1788	Maria Bächtel	Swamp	AK	SL VD1-17BP
November 12, 1788	Maria Gross	Deep Run	JAE	JMT
March 21, 1789	Samuel Reyer	Vincent		Ref. 9, No. 36
December 4, 1789	Esther Gross	Perkasie	JAE	PC
1791	Isaac Schultz			SL VD1-10BP
April 8, 1791	Anna Haldeman	Pikeland	JFE	CCHS 76.980
June 1, 1792	Elisabetha Breÿan	Deep Run		SL VD1-36BP
June 13, 1792	Susanna Kraut	Deep Run		PC
August 21, 1792	Abraham Kassel	Skippack	JG	PC
September 16, 1792	Susana Kassel	Skippack	JG	PC
October 15, 1792	Rossina Reinwalt		BPA	FLP No. 841
December 6, 1792	Jacob Meyer	Franconia		HSP
1793	Regina Kriebel	Lower Salford		SL VD-1
January 15, 1793	George Nees	Rockhill		PC
January 22, 1793	Maria Emrich	Pikeland	JFE	UNK
February 8, 1793	Rosina Kriebel		BPA	SL VD1-20BP
February 27, 1793	Christophel Kriebel		BPA	SL VD1-33BP
May 10, 1793	Christina Kriebel		BPA	SL VD1-18BP
June 6, 1793	Johannes Fretz	Bedminster		PC
January 7, 1794	Elisabeth Moyer	Upper Milford	JAE	BC M-1056
March 12, 1794	Hanna Baum	Springfield	AK	MM No. 1485
February 27, 1795	William Gottschall		JG	FLP (no no.)
March 11, 1795	Jacob Ruth	New Britain		PC
April 2, 1795	Margreta Meyer	Pikeland		SL 7-2
December 27, 1797	Veronica Histand	Upper Milford		Ref. 12, p.100
[1798]	Maria Yoder		AK	PC
February 22, 1798	Anna Geissinger	Upper Saucon	AK	SL VD1-39BP
March 8, 1798	Johannes Kratz	Perkasie		JMT
May 2, 1798	Elizabeth Bergey	Lower Salford	AK	PC
January 25, 1799	Saloma Brauer	Vincent	AK	PC

* A key to the abbreviations and reference sources used in the chronological and alphabetical inventories of *Notenbüchlein* may be found on pp. 148–149.

Date	Scholar	School	Schoolmaster	Source
August 23, 1799	Barbara Meyer	Deep Run		PC
September 6, 1799	Susanna Hackman	Deep Run		FLP No. 846
September 6, 1799	Elisabeth Nesch	Deep Run		PC
January 18, 1800	John Dotterer	Upper Saucon	AK	WM
March 12, 1800	Eleanora Ruth	Vincent	JFE	FLP No. 837
March 10, 1801	William Strunck	Lower Milford		PC
May 22, 1801	Maria Kolb	Deep Run	DK	PC, Ref. 8, No. 12
November 1, 1801	Jacob Stähr	Swamp		PC
April 3, 1802	Phillip Miller	Pikeland	JFE	Ref. 19, No. 946
June 4, 1802	Johannes Herley	Lower Salford	AK	SL VD1-28BP
August 15, 1802	Ulrich Hackman	Deep Run	DK	PC
February 3, 1803	Eva Schumacher	Springfield		FLP No. 843
September 17, 1803	Maria Bien	Worcester	AK	MHEP 88-15-1
October 25, 1803	Jacob Oberholtzer	Deep Run	DK	FLP No. 196
November 1, 1803	Elisabeth Oberholzer	Plumstead	DK	FLP No. 195
1804	Jacob Ruth	Plains		PC
February 13, 1804	Sara Kolb	Perkasie		MHEP 88-6-1
October 20, 1804	Henrich Meyer	Bedminster	DK	MHEP
October 31, 1804	Jonas Fretz	Bedminster	DK	PC
1805	Andreas Drumbor	Rockhill		CL
April 20, 1805	Samuel Detweiler	Rockhill		SL VD1-45BP
September 12, 1805	Jacob Meyer	Deep Run	DK	SL VD1-40BP
February 4, 1806	Jacob Ruth	New Britain		PC
March 21, 1806	Samuel Wissler	Bedminster	DK	PC
December 5, 1806	Joseph Schleiffer	Lower Milford		SL VD1-19BP
May 5, 1807	Anna Landes		DK	FLP No. 197
1808	Ester Aderhold			PC
January 26, 1808	Catharina Latshaw	Hereford	HA	SL VD1-43BP
May _, 1808	Elisabeth Miller	Vincent		Ref. 14, p. 14
May 3, 1808	Rudolph Hoch			FLP No. 764
September 29, 1808	Catharina Klemer	Lower Milford		UNK
January 18, 1809	Elisabeth Landes	Richland		PC
April 5, 1809	Abraham Gerhart	Perkasie	DK	PC
December 14, 1809	Jacob Kriebel			SL VD1-61BP
December 17, 1809	George Miller	Vincent		WM 61.310
February 21, 1810	Isaac Grobb	Vincent		FLP No. 192
April 15, 1810	Susanna Fretz	Perkasie	DK	Ref. 13, p. 59
April 19, 1810	Maria Hunsicker	Perkasie	DK	PC, Ref. 9, No. 32
December 22, 1810	Abraham Geissinger			PC, Ref. 9, No. 28
January 30, 1811	Adam Nunemacher	Rockhill	BM	CL
May 2, 1811	Elisabeth Jost	Perkasie	DK	MHEP
May 17, 1811	Jacob Meyer	Perkasie	DK	JMT
January 12, 1812	Anna Lädtermann	Deep Run	DK	FLP No. 194
January 22, 1812	Maria Oberholtzer	Deep Run	DK	FLP No. 832
January 27, 1812	Maria Gross	Deep Run	DK	PC
January 29, 1812	Barbara Gross	Deep Run	DK	BCHS C-18
February 2, 1812	Jonas Reinewalt			SL VD1-46BP
November 4, 1812	Jacob Derstine	Rockhill		BCHS C-05
June 15, 1813	Maria Lädterman	Deep Run	DK	WM G57.1242
1814	Johannes Hetrick			BCHS C-02

Date	Scholar	School	Schoolmaster	Source
March 3, 1814	Anna Honsperger	Perkasie	DK	FLP No. 830
June 7, 1814	Abraham Oberholtzer	Deep Run	DK	BCHS C-01
June 19, 1814	Christian Gross	Deep Run	DK	PC
September 21, 1814	Christian Meyer	Plumstead		PC
November 5, 1814	Anna Oberholtzer	Deep Run	DK	FLP No. 834
November 5, 1814	Elisabeth Oberholtzer	Deep Run	DK	FLP No. 835
December 16, 1814	Elisabeth Henrick	Perkasie	DK	PC
1815	Abraham Hunsberger			PC
January 2, 1815	Anna Geissinger	Saucon	SMU	SL VD1-60
January 17, 1815	Johannes Honsperger	Perkasie	DK	FLP No. 831
January 25, 1815	George Wiegner	Hereford	HA	SL VD1-41BP
January 28, 1815	Catharina Gerhart	Perkasie	DK	Ref. 4, No. 44
February 5, 1815	Sarah Oberholtzer	Deep Run	DK	MHEP 88-2-1
April 5, 1815	Elisabeth Kiefer	Rockhill		FLP No. 842
April 7, 1815	Sara Nonemacher	Rockhill		FLP No. 839
May 19, 1815	Jacob Angene	Hilltown		PC
March 6, 1816	Samuel Landes	Bedminster		PC
1817	Jacob Kratz	New Britain		FLP No. 851
1817	Elisabeth Oberholtzer			GC
January 14, 1817	Barbara Meyer	Springfield		JC 093/Pe1817/36344
February 2, 1817	Isaac Gross	Deep Run	DK	PC
October 5, 1817	Jacob Oberholtzer			SMP 84.50.4
January 22, 1818	Elisabeth Geissinger			PC, Ref. 9, No. 33
February 25, 1818	Magdalena Gross	Deep Run		BCHS C-04
February 26, 1818	Sara Kolb	Deep Run		MHEP 90-1-1
February 27, 1818	Barbara Hackman	Deep Run		PC, Ref. 9, No. 34
1819	Johannes Schleifer	Richland		UNK
February 18, 1819	Joseph Miller	Lower Milford	PM	UNK
April 11, 1819	Samuel Musselman		SMU	UNK
June 1, 1819	Catharina Lädermann	Deep Run		FLP No. 854
November 11, 1819	Joseph Oberholtzer	Hilltown		PC
December 18, 1819	Jacob Kolb	Perkasie		PC, Ref. 9, No. 29
[1820]	Elisabeth Christman	Upper Milford		FLP No. 198
March 3, 1820	Daniel Schelly	Lower Milford	JO	SL VD1-41BP
April 2, 1820	Elisabeth Hunsperger	[Hilltown]	JH	GC
April 2, 1820	Barbara Hunsperger	Hilltown	JH	FLP No. 848
September 18, 1820	Maria Meyer	Perkasie		UNK
February 13, 1821	Anna Schimmel	Springfield	JO	PC, Ref. 9, No.31
May 15, 1821	David Angene	Hilltown		FLP No. 853
December 24, 1821	Maria Oberholtzer	Deep Run	JO	PC
March 7, 1822	Sarah Schattinger	Plumstead		PC
May 2, 1822	Jacob Laux	Deep Run	JO	CL
June 1, 1822	Johannes Gross	Deep Run	JL	GC
February 12, 1823	Angenes Meyer	Plumstead		GC
February 27, 1823	Jacob Kratz	Hilltown	JO	FLP No. 200
May 8, 1823	Elisabeth Läderman	Deep Run	JO	PMA 58.110.36
December 16, 1823	Enos Staud	Perkasie	JM	BCHS C-06
1825	Abraham Rosenberger	[Franconia]		PC
May 20, 1825	Johannes Hoch	Deep Run	JO	FLP No. 210
1826	Henry Johnson	[Skippack]	HJ	PC

Date	Scholar	School	Schoolmaster	Source
[1826]	Elisabeth Kolb	[Skippack]	HJ	PC
January 3, 1826	Elisabeth Musselman	Perkasie		MHEP
May _, 1826	Elisabeth Detweiler	Deep Run	SM	Ref. 18, 216a
May _, 1826	Samuel Detweiler	Deep Run	SM	Ref. 18, 216a
1827	Sarah Wismer	Plumstead		PC
September 12, 1827	Johannes Hoch	Deep Run	SM	PC
September 15, 1827	Anna Letherman	Deep Run	SM	PC
May 30, 1828	Levi Meyer	Deep Run	SM	GC
June 7, 1828	Catharina Wismer	Deep Run	SM	PC
June 20, 1829	Henrich Letherman	Deep Run	SA	PC
December 27, 1829	Sophia Gross	Hilltown	SA	SL VD1-16BP
January 12, 1830	Johannes Schittinger	Hilltown	SA	FLP No. 844
January 13, 1830	Johannes Brackter	Hilltown	SA	FLP No. 849
February 14, 1830	Johannes Detweiler	Hilltown	SA	MHEP 76-14-2
April 20, 1830	Joseph Gross	Hilltown	SA	UNK
1832	David Heistand	Macungie		UNK
March 25, 1832	Elisabeth Hauch	New Hanover		SL VD1-38BP
January 7, 1833	Chatarina Fulmer	New Britain	SA	BCHS C-17
February 13, 1834	Esther Joder	Salem		FLP No. 852
February 19, 1835	Heinrich Gottschall	New Britain		PC
March 8, 1835	Rahel Bischop	New Britain		PC
September 3, 1835	Abraham Meyer		RTA	PC
1837	Aaron Schmidt	Springfield	LOK	FLP No. 749
February 4, 1845	Anna Engert	Bedminster		PC
May 13, 1845	Barbara Meyer	Octagon		FLP No. 840

Alphabetical Inventory

Aderhold, Ester, 1808. The design is not typical of Bucks County bookplates. A single bird dominates the center with an oval growing out of the bird's tail feather. The oval contains Ester's name and the date. PC. H207.

Alderfer, Maria, Lower Salford Township, August 4, 1785. Maria was the eight-year-old daughter of John Alderfer, a miller who lived close to the Salford Mennonite Meetinghouse. This bookplate is the first documented deviation from the center circular design used on the six bookplates dated prior to Maria's in this inventory. Maria's design includes a center heart and a bird and tulip at each bottom lower corner. PC. H208.

Angene, David, Hilltown School, May 15, 1821. David's book has a paper cover and is about half full of unnumbered tunes. Angene is a French Huguenot name. The emigrant, Johann Nicolaus Angene, came to Deep Run about 1736 where his descendants operated a mill. David's grandmother was

Elisabeth Wismer and his mother, Barbara Gehman; thus the Mennonite connection. FLP.

Angene, Jacob, Hilltown School, May 19, 1815. PC.

Bächtel, Maria, Swamp School, October 27, 1788. Schoolmaster Andreas Kolb. In manuscript notebook with block-printed cover. Several decorated inside pages. This is the earliest documented date for a hymn tune book with bookplate made by Schoolmaster Andreas Kolb. While Kolb copied the idea from Johann Adam Eyer, his designs are original. "Edwin S. Anders, October 1, 1923, purchased from William Springer, Kulpsville, Pa." SL. Ref. 2, Plate VI. H390.

Baum, Hanna, Springfield School, March 12, 1794. Schoolmaster Andreas Kolb. In manuscript notebook with tunes numbered 1 to 148. The page after 142 is dated 1798. MM. H759.

Bergey, Elisabeth, Lower Salford Township, May 2, 1798. Schoolmaster Andreas Kolb. Elisabeth was

the ten-year- old daughter of Christian and Mary Bergey, members at the Salford Mennonite Meetinghouse. Owned by the descendants of Schoolmaster Henry D. Kulp of Skippack. Twenty-five pages of tunes. H442.

Bien, Maria, Worcester School, September 17, 1803. Schoolmaster Andreas Kolb. MHEP. Ref. 2, Plate IX. H456.

Bischop, Rachel, New Britain School, March 8, 1835. PC.

Brackter, Johannes, Hilltown School, January 13, 1830. An unknown schoolmaster called the Swirl Artist. In addition to the six hymn tune bookplates made by the Swirl Artist and listed in this inventory, at least five additional book plates made for printed hymnals are easily identifiable as being done by this artist during the period 1829 to 1836. Johannes Brackter's bookplate and Johannes Schittinger's bookplate are dated one day apart. Each book goes to no. 160 and the tunes seem to be exactly the same. However, Schittinger's book continues to no. 166. Brackter's book contains no hymn texts while Schittinger's has a few texts and also has some tunes marked with the Psalm that fits the tune. Brackter's book has *1829* written at the end of tune no. 14 and tune no. 30. This seems to imply that the booklet was used before the bookplate was drawn. Book is about three-quarters full. FLP.

Brauer, Saloma, Vincent, January 25, 1799. Schoolmaster Andreas Kolb. Bookplate only. PC. Ref. 2, Plate VIII. H790.

Breÿan, Elisabetha, Deep Run School, June 1, 1792. Book has tunes numbered to forty. Paper cover. SL. H395.

Carlin, Catarina, Vincent School, May 29, 1788. Schoolmaster Johann Adam Eyer. This is the earliest documented hymn tune notebook with the angel motif. The birds on Catarina's bookplate are similar to Maria Fretz's bookplate dated November 29, 1787. CCHS.

Christman, Elisabeth, Upper Milford, c. 1820. Hardcovered booklet with lovely printed paper. Unique book because it contains a double bookplate. The unnumbered tunes are entered by a hand not seen in other booklets. Toward the back, a hymn text is signed "J S." FLP.

Derstine, Jacob, Rockhill Township School, November 4, 1812. On another leaf: "Isaac Derstine, 1856 March 2." Bookplate has two lines of red fraktur script and two lines of black cursive script, and even though there are no motifs

included, the overall effect is decorative. It is most unusual for hymn tune notebooks from the era under consideration to have a table of contents. This booklet has a three-page table of contents in red fraktur script. Another unique detail is that when a page is opened, the tune goes across two pages. Gift of E. C. Beans in 1906. An interesting companion piece to Jacob's book is a manuscript music book also donated by E. C. Beans in 1906. This larger book (16 x 19.5 centimeters, or 6^1/$_4$ x 7^3/$_4$ inches) belonged to John Martin Szeiss, preceptor and director of music and organist at St. Peters, "Heydelb." This book contains the same type of table of contents as Jacob's and also spreads the music across two pages. It appears that John Martin Szeiss' book is earlier than Jacob's and that Jacob copied the format from John Martin's book. It is possible that the earlier, larger book is from Heidelburg, Germany. BCHS.

Detweiler, Elisabeth, Deep Run School, May __, 1826. Schoolmaster Samuel Moyer. Sold with Samuel Detweiler's booklet at Pook & Pook Auction, January 12, 1991, catalogue no. 216a. Marked "Himmelreich." Samuel's and Elisabeth's booklets appear to be the first of a group made by schoolmaster Samuel Moyer for Johannes Hoch, Anna Letherman, and Catharina Wismer at Deep Run between 1826 and 1829. UNK.

Detweiler, Johannes, Hilltown School, February 14, 1830. Swirl Artist. Companion piece to Sophia Gross's December 27, 1829 bookplate in this inventory. MHEP. H204.

Detweiler, Samuel, Deep Run, May __, 1826. Schoolmaster Samuel Moyer. See Elisabeth Detweiler, 1826. UNK.

Detweiler, Samuel, Rockhill Township, April 20, 1805. SL. H398.

Dotterer, John, Upper Saucon Township, January 18, 1800. Schoolmaster Andreas Kolb. WM. Ref. 5, p. 298, fig. 292. H575.

Drumbor, Andreas, Rockhill Township, 1805. This booklet contains a second section of tunes dated January 30, 1811, also at Rockhill. The second bookplate was made for Adam Nunemacher by schoolmaster Bernhard Misson. CL.

Emrich, Maria, Pikeland School, January 22, 1793. Schoolmaster Johann Friedrich Eyer. Color picture on flyer for Horst Auctioneers, March 23, 1996. UNK.

Engert, Anna, Bedminster, February 4, 1845. PC.

Finckbeiner, Jacob, May 26, 1788, Vincent, Chester County. Schoolmaster Johann Adam Eyer. Sold at Horst Auction, December 6, 1997. Pictured in color on back cover of catalogue. UNK.

Fretz, Elisabeth, and Barbara Fretz, Plains School, February 13, 1787. This is one of only two pieces of fraktur known to be from the Plains Mennonite Meetinghouse School. The other is in this inventory, dated 1804 for Jacob Ruth. This is the second documented deviation from the use of the central circular motif. This bookplate contains a center heart surrounded by two half circles and flowers. LCP. H691.

Fretz, Johannes, "This nice little note book belongs to Johannes Fretz, singing scholar *at the upper end of the Branch* in Bedminster Township, Bucks County, written the 6th of June in the year anno 1793." PC. H556.

Fretz, Jonas, Bedminster School, October 31, 1804. PC.

Fretz, Maria, Deep Run School, November 27, 1787. Schoolmaster Johann Adam Eyer. A Maria Fretzin is listed in Johann Adam Eyer's roll book in the late winter term "from 30 January to the last day of April 1786." Her brother Christian also attended this term. Her father is listed as "Chr." First instance of Eyer using birds on a hymn tune notebook. The design includes a cleft with lines and spaces marked with letters and half notes ascending. In this, one of the earliest hard covered books with leather spine, the bookplate is glued to the inside front cover. Tunes are numbered to 115, but the booklet is only one-eighth full. FLP. H577.

Fretz, Susanna, Perkasie, April 15, 1810. Schoolmaster David Kulp. Ref. 13, p. 59.

Fulmer, Chatarina, New Britain School, January 7, 1833. Swirl Artist. Tunes 1 to 28 are in shape notes. BCHS. H455

Geissinger, Abraham, "This little harmonic melody book belongs to me Abraham Geissinger, for your instruction and for God's honor, written the 22nd of December Anno Domini 1810." This notebook places each letter of the alphabet on a separate page and extensively decorates that page. The letters I and J are combined on one page. Missing are letters Q, X, and Y. Tunes are numbered from 1 to 665. Tune 522 is dated 1810. This suggests that the tunes were placed in the book over a period of time before the bookplate was drawn. It seems unlikely that 522 tunes would have been placed in the book during one year, and certainly

not after December 22 of that year. This is an unusually decorative and inclusive tune book. PC. Ref. 4, Plate 149; Ref. 9, no. 28. H942.

Geissinger, Anna, Upper Saucon Township, February 22, 1798. Schoolmaster Andreas Kolb. SL. Ref. 2, Plate VII. H396.

Geissinger, Anna, Saucon, January 2, 1815. Schoolmaster Samuel Musselman. SL.

Geissinger, Elisabeth, January 22, 1818. "...use this for good instruction and the glory of God." One-third full of unnumbered tunes. PC. Ref. 9, no. 33. H956.

Gerhart, Abraham, Perkasie School, April 5, 1809. Schoolmaster David Kulp. Sold at Alderfer's Auction, December 27, 1990. PC.

Gerhart, Catharina, Perkasie School, January 28, 1815. Schoolmaster David Kulp. PC. Ref. 4 #44.

Gottschall, Heinrich, New Britain School, February 19, 1835. PC. Ref. 4, fig. 151. Also, Ref. 15, p. 111.

Gottschall, William, February 27, 1795. Schoolmaster Jacob Gottschall. Instructions on flats and sharps written on the adjoining page. On the cover, in Jacob's flowing hand is written William's name and the date. The cover is lined with paper marked "Super Fine London Pins." William (b. 1781) was Jacob's brother, twelve years younger than Jacob. FLP.

Grobb, Isaac, Vincent School, February 21, 1810. Design is similar to those made by Johann Adam Eyer and Johann Friedrich Eyer. Possibly drawn by Johann Adam. Tunes numbered to eighty. Found with booklet made for Elisabeth Miller, May —, 1808. Ex-Himmelreich collection. FLP. See Ref. 14, p. 14.

Gross, Barbara, Deep Run School, January 29, 1812. Schoolmaster David Kulp. One of four almost identical bookplates David Kulp made at Deep Run in January 1812 for Maria and Barbara Gross, Maria Oberholtzer, and Anna Lädterman. Each has a Sophia at center top with huge spreading wings hovering over a heart which contains the ownership information. Hard cover with marbleized paper and leather spine. Tunes numbered 1 to 76 with twenty pages of unnumbered tunes. BCHS. H787.

Gross, Christian, Deep Run School, June 19, 1814. Schoolmaster David Kulp. PC.

Gross, Esther, Perkasie School, December 4, 1789. Schoolmaster Johann Adam Eyer. Paper-covered booklet containing ninety-four tunes.

Written in back, "Barbara Shelly," "Charles Shelly, 1871." The design is nearly identical to one made for Isaac Gross in the Vincent School, Chester County, February 21, 1810 (FLP No. 192). PC. H808.

Gross, Isaac, Deep Run School, Feb. 2, 1817. Schoolmaster David Kulp. PC.

Gross, Johannes, Deep Run School, June 1, 1822. Schoolmaster Jacob Landes. Although this appears to be a companion piece to bookplates for Maria Oberholtzer (December 24, 1821) and Elisabeth Läderman (May 8, 1823) in this inventory, the cursive writing is in another hand. Bucks County School Bills (Spruance Library/Bucks County Historical Society) record that Jacob Landes was paid for teaching five poor students at the Bedminster school commencing April 9, 1822, and continuing for fifty-five days. Written in the book: "Samuel Gehman, Plumstead, Son-in-law of Johannes Gross." GC. H62.

Gross, Joseph, Hilltown School, April 20, 1830. The Swirl Artist. From photograph found in Henry Mercer's notebook, MSC 291, series 16, fol. 8. Vol. 4, p. 535 of the Bucks County Historical Society Papers refers to a Joseph M. Gross who made and owned several manuscript tune books, c. 1830. This detail is embedded in the minutes of the 1914 Bedminster meeting of the BCHS with the account continuing as follows: "...Mr. Wismer exhibited some homemade music books such as were used in the old school, which contained the music and first line of the works of each hymn, which was passed around among the pupils to study. The fly leaves of their books were usually embellished with some beautiful fraktur...." UNK.

Gross, Magdalena, Deep Run School, February 25, 1818. Hard cover with leather spine. Her name is written upper right in script on the first page of music. This may show that the tunes were entered before the bookplate was made. Book contains tunes numbered from 1 to 60 with twenty-six more unnumbered pages of tunes. It appears that two or three schoolmasters entered tunes in this book. The same schoolmaster made similar bookplates on the next two days for Sarah Kolb on February 26, 1818, and for Barbara Hackman on February 27, 1818. BCHS.

Gross, Maria, Deep Run School, November 12, 1788. Schoolmaster Johann Adam Eyer. JMT. Ref. 1, Illus. 26. H998.

Gross, Maria, Deep Run School, January 27, 1812. Schoolmaster David Kulp. One of four almost identical bookplates made in January of 1812. See notes under Barbara Gross and Anna Lädtermann. PC.

Gross, Sophia, Hilltown School, December 27, 1829. The Swirl Artist. Companion piece to Johannes Detweiler's February 19, 1830, bookplate in this inventory. SL. H671.

Hackman, Barbara, Deep Run School, February 27, 1818. Booklet contains tunes from 1 to 67. Notation in book, "Maria Beck, Bedminster". See notes under Magdalena Gross. PC. Ref. 9, No. 34. H954.

Hackman, Sussanna, Deep Run School, September 6, 1799. One schoolmaster entered tunes numbered 1 to 25; the second teacher filled her book with unnumbered tunes. FLP.

Hackman, Ulrich, Deep Run School, August 15, 1802. Schoolmaster David Kulp. PC.

Haldeman, Anna, Pikeland School, April 8, 1791, *signed "J. Fr. E."* This is Schoolmaster Johann Friedrich Eyer, brother of Johann Adam Eyer. Anna Haldeman's booklet is the sole known signed example of a tune book from the pen of Johann Friedrich Eyer. CCHS. H280.

Hauch, Elisabeth, New Hanover, March 25, 1832. SL.

Hege, Elisabeth, Franconia School, May 27, 1784. Prior to the date of this booklet, there are four documented examples of hymn tune note books, all four from the hand of Johann Adam Eyer, and all four made for students in Perkasie and Deep Run. The next four on the attached inventory are made for students in Montgomery County schools. See books made for Elisabeth Schwarz, Maria Alderfer, and Elisabeth and Barbara Fretz. Also see notes under Elisabeth Schwarz. Booklet lacks cover. Contains tunes from 1 to 23 and 43 to 69 (24 to 42 are missing). BCHS. H440.

Heistand, David, Macungie Township, Lehigh County, 1832. Sold at Horst Auction, June 23 & 24, 1989 from collection of Earl and Ada Robacker. Catalogue no. 872 described as 1832 and having "18 PGS of manuscript music many W/red fraktur titles, balance of PGS are blank." This bookplate was sold again at the 1997 Machmer auction at Kutztown. UNK.

Henrick, Elisabeth, Perkasie, December 16, 1814. Schoolmaster David Kulp. PC. H202.

Herley, Johannes, Lower Salford Township, June 4, 1802. Schoolmaster Andreas Kolb. SL. H388.

Hetrick, Johannes, 1814. Two inside decorated pages. Cover completely leatherbound. First page

after bookplate explains shape notes, but tunes are not in shape notes. Book has tunes to 17; however, tunes 5 to 16 are missing. Tune 4 is dated 1833. This is a substantial book and it is strange that so few pages are used. Handwritten on inside of back cover is "Johannes Hutorik, 1811" and the date 1831 is written at the bottom. BCHS. H142.

Histand, Veronica, Upper Milford School, December 27, 1797. Companion piece to Johannes Kratz, March 8, 1798. PC. Ref. 12, p. 100.

Hoch, Johannes, Deep Run School, May 20, 1825. Schoolmaster Jacob Overholt. Hardcover book with leather spine. Johannes's name is entered in small script on front cover. Only six pages are used. FLP.

Hoch, Johannes, Deep Run School, September 12, 1827. Schoolmaster Samuel Moyer. Identical to the bookplate made for Anna Letherman, September 15, 1827, in this inventory. Pictured in the *Pennsylvania Dutchman*, June 1954, p. 16. See Elisabeth and Samuel Detweiler, 1826, and additional information under Catharina Wismer, June 7, 1828. UNK. H53A.

Hoch, Rudolph, "Rudolph Hoch's notebook. Written May 3 in the year of our Lord 1808." This booklet has an unusual arrangement. Tunes extend across both pages when the book is opened flat. There are three tunes on each page instead of the customary four. The G cleft sign commonly used in twentieth-century hymns is a surprisingly atypical symbol in this booklet. FLP.

Honsperger, Anna, Perkasie School, March 3, 1814. Schoolmaster David Kulp. Her name is written in tiny script on the blank page before the bookplate. Tunes numbered to 58 followed by another hand entering nine pages of unnumbered tunes. FLP.

Honsperger, Henrich, Perkasie School, April 12, 1780. Schoolmaster Johann Adam Eyer. Henrich is listed in Eyer's roll book, "Late winter quarter from 15 January to 15 April 1780" and "Late summer quarter from 29 [July to...1780]," both at the "Upper End from Hilltown." In Henrich's first name the *H* is colored in green. Every other letter in his name is red. The border is filled with green. The first page is recycled paper previously used for penmanship practice. The bookplate is on the second page. Tunes are numbered to 73. The book is full and appears to be well used. At the end is written, "Bonus Finis." *This is the first documented hymn tune notebook made by Johann Adam Eyer and*

the first book in the chronological inventory. Ref. 7, p. 483, 485. FLP.

Honsperger, Johannes, Perkasie School, January 17, 1815. Schoolmaster David Kulp. Johannes's name is written in tiny script on blank page before bookplate. Also, on the cover, his name is written with the date 1820. David Kulp entered tunes to no. 32. Another teacher entered tunes from 33 to 88. FLP.

Hunsberger, Abraham, 1815. Information about this hymn tune notebook is included in *The Hunsbergers, a Portion of the Genealogical History of a Few Swiss Hunspergers*, compiled, edited, and published by George S. Hunsberger, Germantown, N.Y., 1969, p. 566. "Abraham Hunsberger was a great singer....There is extant a most interesting song book or hymn book compiled by Abraham. It consists of 74 pages, each measuring eight inches by six and a half inches, written in German script with many flourishes of the pen and multitudes of dots decorating the first letter of each line of verse. On page 22 we find at the bottom the date 1815 and the words *'Abraham Hunsperger sein Buch'* [Abraham Hunsperger, his book]." UNK.

Hunsicker, Catarina, Perkasie School, March 20, 1781. Schoolmaster Johann Adam Eyer. Catarina is listed in Johann Adam Eyer's roll book, "Late summer quarter from 29 [July to...1780], Upper End from Hilltown" and "Early Summer Quarter from 22 April 1782 on, one quarter year." Ref. 7, p. 486-487. Notation in booklet, "Henry Berge 1832." HSP. H513.

Hunsicker, Jacob, Perkasie School, January 29, 1783. Schoolmaster Johann Adam Eyer. "Sing, pray and go on God's ways. Only perform your obligations truly." The first of Johann Adam Eyer's booklets to contain a flower. The first part contains Psalm tunes numbered to 30. After four blank pages, the remainder of the booklet is filled with tunes numbered to 37. FLP.

Hunsicker, Maria, Perkasie School, April 19, 1810. Schoolmaster David Kulp. PC. Ref. 9, No. 32. H953.

Hunsperger, Barbara, Hilltown Township, April 2, 1820. Schoolmaster John Hunsberger. Barbara's book is the large size with leather cover and a tooled border design. Tune 6 is dated 1820. Most of book is blank. Several hands appear to enter tunes to 25. Ten pages at the back of the book are written by another person. See next entry for Elisabeth Hunsperger. FLP.

Hunsperger, Elisabeth, April 2, 1820. School-master John Hunsberger. This bookplate and the bookplate for Barbara Hunsberger have the same date. The records of the Union School, also known as the Hunsberger School, in Hilltown Township, 1816–1847 state "John Hunsberger commenced a German school March 14, 1820 and closed about the middle of June following—3 months." The Bucks County school records for educating poor children document that John Hunsberger was teaching at the Union Schoolhouse in Hilltown Township for sixty-five days beginning November 1, 1820. Notation inside book, "Samuel Gahman 1890" and "Plumstead." GC. H78.

Joder, Esther, New Salem Schoolhouse, Spring-field Township, February 13, 1834. Book cover has marbleized paper in pink, blue, and gray. The unnumbered tunes fill about three-quarters of the booklet. "Hetty Yoder" written on the inside front cover. FLP.

Johnson, Henry. This Skippack Mennonite schoolmaster's book contains three bookplates. The first stating solely "Henry Johnson"; the second, "This note book belongs to me, Henrich Johnson, A.D. 1826"; the third, "E Pluribus." A comparison of teacher Henry's book and student Elisabeth Kolb's book show that the tunes from page 1 to page 39 are similar with just a few exceptions. In Elisabeth's book several pages are blank. Was Elisabeth absent on the days those tunes were taught? Elisabeth's book stops on page 39, but resumes with 51. PC. H271.

Jost, Elisabeth, Perkasie School, May 2, 1811. Schoolmaster David Kulp. Book contains fifty-five tunes. MHEP.

Kassel, Abraham, Skippack School, August 21, 1792. Schoolmaster Jacob Gottschall. Signed on second page, "Jacob Gottschall Sch D." This Jacob H. Gottschall (1769–1845) may be the "Jacob Gottschalck" listed in Eyer's school at "Upper End from Hiltown" in the "Late Summer Quarter from 29 [July to …1780]." Ref. 7, p. 485–486. Jacob includes a first page, as did Eyer, "N. B.: (Note Well) When a 'flat' stands in front of a note, it means that this same note is lowered a half tone. However, when a 'sharp' stands in front of a note, it means it is raised a half tone." Underneath this statement, Jacob signs his name. As a young adult Jacob was a schoolteacher and taught in schools at Mennonite meetinghouses in Montgomery County. In 1804, he was chosen by lot to be a

minister at the Franconia Congregation and in 1813 he was made bishop. Some sources relate that his sons Martin, William, Samuel, and Herman were schoolteachers and made fraktur. There is evidence that another son, Jacob, was also a fraktur artist. PC. H809.

Kassel, Susanna, Skippack School, September 16, 1792. Signed by schoolmaster Jacob Gottschall. See note under Abraham Kassel. Previously owned by a descendant of Susanna who wrote, "She was the sister of…Jacob the Miller of Skippack." PC. H994

Kiefer, Elisabeth, Rockhill School, April 5, 1815. Paper covered-book with tunes numbered to 33, three tunes to a page. The book is half full. FLP.

Klemer, Catharina, Lower Milford School, September 29, 1808. From the slide collection of John Joseph Stoudt. UNK.

Kolb, Elisabetha, Perkasie School, June 20, 1787. Schoolmaster Johann Adam Eyer. First documented hymn tune notebook by Eyer with center heart. Also contains cleft with half notes, whole notes, and with the lines and spaces marked with letters. Book has paper cover and numbered tunes to 134. Elisabeth Kolbin "of Jacob" is listed in Eyer's roll of the Perkasie School, winter term, 1787. Ref. 7, p. 505. This bookplate is similar to Ref. 6, Plate 199. SL. H389.

Kolb, Elisabeth [1826]. Schoolmaster Henry Johnson. Bookplate contains only her name "Elisabeth Kolb." Noted on back cover, "Elizabeth Reiff, Mary Reiff, Henry Reiff." Tune no. 55 is titled "Skippack." See notes under Henry Johnson. MHEP. H3.

Kolb, Jacob, Perkasie School, December 18, 1819. Booklet has a beautiful block printed cover. Tunes are numbered to 23. The rest of the booklet is blank. Made by the same schoolmaster who made bookplates for Maria Meyer at Perkasie (September 18, 1820) and for Catharina Lädermann at Deep Run (June 1, 1819). PC. Ref. 9, No. 29. H835.

Kolb, Maria, Deep Run School, May 22, 1801. Schoolmaster David Kulp. Earliest date on a hymn tune notebook attributed to David Kulp. This is a special book with tunes grouped to begin with a letter of the alphabet ranging from A to Z. Some letters cover two or three pages each. Many of the staffs are in red. The bookplate is perfect and retains bright colors in red, green, and yellow. Marbleized cover with leather spine and corners. PC. Ref. 8, No. 12.

Kolb, Sara, Perkasie School, February 13, 1804. MHEP. H203.

Kolb, Sara, Deep Run, February 26, 1818. Made by same schoolmaster who made hymn tune notebooks at Deep Run for Magdalena Gross (February 25, 1818), and Barbara Hackman (February 27, 1818). MHEP.

Kratz, Jacob, New Britain, 1817. This is the smallest book seen by this writer, about 9 x 11.7 centimeters (3⅝ x 4⅝ inches). The book has only a few pages and is full with tunes numbered to 19. FLP.

Kratz, Jacob, Hilltown School, February 27, 1823. Schoolmaster Jacob Overholt. Bucks County School Bills (Spruance Library/Bucks County Historical Society) document that Jacob Overholt taught "Hannah Yost of Hilltown township from the 6th January 1823 till the 21st March 1823, 31 days." Two schoolmasters entered tunes in the booklet. FLP.

Kratz, Johannes, Perkasie School, March 8, 1798. Executed by same schoolmaster who did a bookplate for Veronica Histand, December 27, 1797, at Upper Milford. JMT. Ref. 1, p.49, Illus. 28. H447.

Kraut, Susanna, Deep Run School, June 13, 1792. Design may be by Johann Adam Eyer, although cursive writing is not. Instead, it appears to be by same person who did the cursive writing on a bookplate made for Barbara Meyers at Deep Run, August 23, 1799. PC.

Kriebel, Christina, May 10, 1793. Block Print Artist. Pink cover of booklet is block printed with a star formed of diagonal lines across the front and back covers, the same paper used to cover the book of Rosina Reinwalt, October 15, 1792. Booklet has three tunes to a page. SL.

Kriebel, Christophel, February 27, 1793. Block Print Artist. The cover is laid paper with a light green background and block printed in a floral design in pink, deep rose, and white. Each page has three of the four leaf clover-type block prints, the same as Rosina Kriebel's book. There are three tunes to a page. SL.

Kriebel, Jacob, December 14, 1809. Mennonite in style, this booklet has mostly one voice part to a tune. SL.

Kriebel, Regina, 1793, Lower Salford. This bookplate has no color, but contains Regina's name, date, and place and is decorated with swirls and calligraphy designs. SL.

Kriebel, Rosina, February 8, 1793. Block Print Artist. The bookplate has 8 four leaf clover-type block prints. Book contains sixty-two tunes with three tunes to a page. Each page has three of the same design block printed on the left edge. Rosina's name is not on the bookplate. However, on the last page is the phrase, in German, "This booklet belongs to me, Rosina Kriebelin." SL.

Läderman, Elisabeth, "in the Deep Run," May 8, 1823. Schoolmaster Jacob Overholt. Contains twenty-seven pages of music. See note under Johannes Gross in this inventory. PMA. H287.

Lädermann, Catharina, Deep Run School, June 1, 1819. Her name is written in small script on the blank page before the bookplate. Contains tunes numbered to 23. The book is only one-quarter full. Catharina's bookplate appears to have been made by the same person who made Jacob Kolb's, December 18, 1819. FLP.

Lädterman, Elisabetha, Deep Run School, April 29, 1783. Schoolmaster Johann Adam Eyer. Elisabetha is listed in Eyer's record book, "Late summer quarter, from 5 August on 1782 a quarter year, Tiep Ronn," Ref. 7, p. 488. The booklet has a marbleized cover, the paper having been dipped into water containing gray, pink, and brown ink. Inside the booklet are these notations: "Brenner" and "Ron Gratz." Tunes are numbered to 79. FLP.

Lädterman, Maria, Deep Run School, June 15, 1813. Schoolmaster David Kulp. WM. H314.

Lädtermann, Anna, Deep Run School, January 12, 1812. Schoolmaster David Kulp. Her name is entered in tiny script on the first blank page before bookplate. This is one of four bookplates with the "Sophia" and spreading wings made by David Kulp in January of 1812. See note under Barbara Gross. In Anna's book, some tunes appear to be entered a page at a time, with four tunes on each page. This is evident by the change in the thickness of the pen and by the ink appearing slightly lighter or darker from page to page. There are twenty pages of unnumbered tunes plus two more pages each containing four rows of empty musical staffs. The remainder of the book is blank. Booklet has hard cover with marbleized paper and a leather spine. FLP.

Landes, Anna, May 5, 1807. Schoolmaster David Kulp. Anna's name is written in tiny script on the first blank page before the bookplate. Her tunes are grouped by the letters of the alphabet. Many staves are in red with fourteen pages of text only. Toward the end of the booklet a date is written, "February 18, 1827." FLP.

Landes, Elisabeth, Richland School, January 18, 1809. Ref. 10 #164 in color. PC.

Landes, Samuel, Bedminster School, March 6, 1816. Samuel was the great-great uncle of Reuben D. Landes, "one of the bachelor brothers from the old homestead in Bedminster Township" according to the owner of the tune book. The booklet is about one-third full with unnumbered tunes. Hardcover with marbleized paper, leather spine, and four leather corners. PC.

Latshaw, Catharina, Hereford School, January 26, 1808. Same hand and first page as George Wiegner, 1815. Pages have beautiful red lettering. Mennonite Historian John D. Souder (d. 1942) owned this book and wrote on first page, "June 10, 1928. This song book I bought of Mary Yoder. It being given to her by her mother a born 'Latshaw' of Chester County. Sister Yoder is now 93 years young with a perfect faculty, was born on the County Line hill farm known as 'Hood's Farm,' now 'Smith.' She walked often through Telford when there were two houses and three where Souderton is located. She worked many a day for 25 cents and one day she received 40 cents, but her parents compelled her to take 15 cents back—it was too much." SL.

Laux, Jacob, Deep Run School, May 2, 1822. Schoolmaster Jacob Overholt. CL.

Letherman, Anna, Deep Run School, September 15, 1827. Schoolmaster Samuel Moyer. First section of book has tunes written in shape notes. Pages and tunes are unnumbered until the twenty-second page where the third tune starts with number 1, the ink changes from black to brown, and a different hand is entering the tunes which are not shape. From this page on, the tunes are numbered from 1 to 34. Tune 3 is marked "AL." Booklet has a hard, marbleized cover with leather spine. See Johannes Hoch (September 12, 1827) in this inventory. PC. H53.

Letherman, Henrich, Deep Run School, June 20, 1829. The Swirl Artist. Freed auction, Perkasie, November 13, 1993. PC.

Meyer, Angenes, Plumstead School, February 12, 1823. Written inside book, "John M. Myers, Dublin." GC. H69.

Meyer, Abraham, September 3, 1835, Rockhill Township Artist. PC.

Meyer, Barbara, August 23, 1799, "Deep Run School at Bedminster." See note under Susanna Kraut. PC.

Meyer, Barbara, Springfield School, January 14, 1817. One interior page has a row of nineteen little faces across the top of the page. JC. H872.

Meyer, Barbara, Octagon School, May 13, 1845. Booklet has shape notes entered in blue ink. Tunes are numbered from 1 to 52. Back of book contains information about a Kratz family's children ranging in age from "Baby" to Francis, who is twenty-two. Includes death dates for David and Barbara Yothers and Jonas Myers. One of the few booklets written in blue ink. FLP.

Meyer, Christian, Plumstead Township, September 21, 1814. PC.

Meyer, Henrich, Bedminster School, October 20, 1804. Schoolmaster David Kulp. The tunes in this booklet up to no. 50 are the same as in Jacob Oberholtzer's October 25, 1803, booklet. However, the numbering is not exactly the same. The notebook goes to tune 117, but the book is not full. The leather cover is only partially intact. MHEP. H209.

Meyer, Jacob, Franconia School, December 6, 1792. HSP.

Meyer, Jacob, Deep Run School, September 12, 1805. Schoolmaster David Kulp. SL. H393.

Meyer, Jacob, Perkasie School, May 17, 1811. Schoolmaster David Kulp. Large booklet with extensive tune selection. Tunes are not numbered, but are grouped alphabetically, A to Z. Some pages decorated with tulips. Formerly owned by a descendant of Jacob Meyer; now in JMT. H853.

Meyer, Levi, Deep Run School, May 30, 1828. Schoolmaster Samuel Moyer. Written inside book in script and ink, "Ladi Mayar." Notation in pencil: "Samuel Gehman." This book, in excellent condition, has a hard cover with marbleized paper. GC. H60.

Meyer, Margreta, Pikeland School, April 2, 1795. Bookplate only. SL. H82.

Meyer, Maria, Perkasie School, September 18, 1820. See note under Jacob Kolb, December 18, 1819. Sold at the auction of Arthur Loux, Red Hill, Pa., October 26, 1984. Sold again at the Horst Auction Robacher Sale, Catalogue No. 774, May 26, 1989. H603.

Miller, Elisabeth, Vincent School, May __, 1808. Design similar to those made by Johann Adam Eyer and Johann Friedrich Eyer. Found with bookplate for Isaac Grobb, February 21, 1810. Ref. 14, p. 14.

Miller, George, Vincent School, December 17, 1809. Design typical of Johann Friedrich Eyer and Johann Adam Eyer. Similar to bookplate done for Margreta Meyer, listed in this inventory. Eleven pages of tunes, remainder blank. Genealogical information about Miller family penciled on inside covers and back pages. WM. H308.

Miller, Joseph, Lower Milford School, February 18, 1819. Schoolmaster Philip Mumbauer. Recorded from John Joseph Stoudt's slide collection. UNK.

Miller, Phillip, Pikeland School, April 3, 1802. Schoolmaster Johann Friedrich Eyer. Similar to the bookplate made for Eleanora Ruth, March 12, 1800 at Vincent. Both the Pikeland and Vincent schools are in Chester County. As in Eleanora Ruth's book, recycled student writing practice paper is used on the inside of the cover opposite Phillip Miller's bookplate. Ref. 19, #946.

Moyer (Mayerin), Elisabeth, Upper Milford School, January 7, 1794. Schoolmaster Johann Adam Eyer. Elisabeth married Peter Mack. She was fifteen years old when bookplate was made. BC.

Musselman, Elisabeth, Perkasie School, January 3, 1826. PC. H729.

Musselman, Samuel, April 11, 1819. The bookplate is in a manuscript hymn tune notebook. From the slide collection of John Jacob Stoudt. Another slide shows a double interior page of the booklet with tunes for four hymns. The tunes are unusual in that they seem to have parts for three voices. One of the tunes is written in shape notes. (For information about shape notes, see n. 11.) Stoudt photographed a collection of fraktur apparently drawn by Samuel Musselman. The pieces are dated 1816 to 1821 and include a printed hymnal bookplate made for Samuel Wisler dated 1816; a practice book with numerous examples of bookplates; a design with four birds and huge hanging flowers marked "Samuel Musselman, 1816"; and a large reward. Bucks County School Bills document that Samuel Musselman taught at the "Mananist meeting house" in Rockhill Township from October 20, 1818, to March 20, 1819, and from September 27, 1819, to February 7, 1820. Samuel made this bookplate for himself, apparently between the two terms that the Bucks County records show he was teaching. It is uncertain which of the Mennonite Samuel Musselmans this person is. It may be the Samuel M. Musselman who in 1844 published a choral book, *Die Neue Choral Harmonie* and is remembered as a schoolteacher and a gravestone cutter.

Nees, Abraham, Rockhill School, January 18, 1788. Schoolmaster Johann Adam Eyer. Eyer taught at a school "organized by two Mennonite and Reformed families straddling the Hilltown-Rockhill township line, [where] he had a crop of young Biehns, Dersteins, Detweilers, Gehmans, and

Haldimanns." Ref. 3, p. 158. FLP.

Nees, Georg, Rockhill Township, January 15, 1793. Unusually creative design. PC. H134.

Nesch, Elisabeth, Deep Run School, September 6, 1799. Susanna Hackman's bookplate at Deep Run has the same date. PC.

Nonemacher, Sara, Rockhill School, April 7, 1815. "Let gloria be sung to thee, with tongues of men and angels." Sara's book is about half full with 3 tunes to a page. Another hand entered additional tunes numbered 1 to 5. FLP.

Nunemacher, Adam, Rockhill Township, January 30, 1811. Bookplate contains verse 2 of the hymn, "Awake, Awake for Night is Flying." This is an unusual booklet as it was used by two students with bookplates created by different teachers. Andreas Drumbor [Trumbauer] first used this booklet at Rockhill in 1805. CL.

Oberholtzer, Abraham, Deep Run School, June 7, 1814. Schoolmaster David Kulp. Hardcover with marbleized paper and leather spine. Book is unnumbered and is one-quarter full. BCHS. H438.

Oberholtzer, Anna, Deep Run School, November 5, 1814. Schoolmaster David Kulp. Her name is written in tiny script on the blank page before the bookplate. On the cover is written, "My grandmother's book, Magdalena Shaddinger Landis. This was my mother's book, H. G. Shaddinger." Elisabeth Oberholtzer's book contains the same date as Anna's. Anna's and Elisabeth's booklets contain the same tunes up to no. 60 with the exception of 1 and 13 which are interchanged in the two booklets. FLP.

Oberholtzer, Elisabeth, Deep Run School, November 5, 1814. Schoolmaster David Kulp. See preceding notes for Anna Oberholtzer. Elisabeth's book has small numbers to the right of some tunes. These numbers correspond to the hymn text numbers in *Zions Harfe*, the Mennonite hymnal first printed in 1803. FLP.

Oberholtzer, Elisabeth, "This little melody book belongs to me, namely Elisabeth Oberholtzer, for my instruction and God's glory, 1817." The booklet is full with eighty-three numbered tunes, many with decorations. Number 78 contains two colorful birds. This colorful bookplate is strikingly different from other documented notebooks from the same era. The pages with musical notes are among the finest this recorder has seen. Notation in pencil: "Mrs. Lizzie Meyers, Danboro" and "Franconia." GC. H74.

Oberholtzer, Jacob, Deep Run School, October 25, 1803. Schoolmaster David Kulp. "As a little flower quickly wilts, so our life is seen." See notes under Elisabeth Oberholtzer, November 1, 1803. Jacob's booklet is full and ends with a tune that includes the text written in English, "The day is past and gone." The last section of the book appears to have several hands entering tunes. Some pages have shaped notes. The booklet has a leather cover. FLP.

Oberholtzer, Jacob, October 5, 1817. SMP. H736.

Oberholtzer, Joseph, Hilltown School, November 11, 1819. PC.

Oberholtzer, Maria, Deep Run School, January 22, 1812. Schoolmaster David Kulp. One of four similar bookplates Kulp made during January 1812. See notes under Barbara Gross and Anna Lädtermann. FLP.

Oberholtzer, Maria, Deep Run School, December 24, 1821. Schoolmaster Jacob Overholt. Hard covered booklet with interesting block-printed cover, leather spine, and four leather corners. Tunes are numbered 1 to 72, followed by series of blank pages with another hand starting to enter tunes numbered 1 to 55 in shape notes. Usually in hardcovered books there are three blank pages before the bookplate. In this booklet there are *seven* blank pages that precede the bookplate. According to Bucks County School Bills, Jacob Overholt taught at the Bedminster Meetinghouse school, October 11, 1821 to December 28, 1821. See note under Johannes Gross in this inventory. PC. H290.

Oberholtzer, Sarah, Deep Run School, February 5, 1815. Schoolmaster David Kulp. MHEP. H210.

Oberholzer, Elisabeth, Plumstead School, November 1, 1803. Schoolmaster David Kulp. A comparison of Elisabeth's booklet and Jacob Oberholtzer's booklet (October 25, 1803), from the Deep Run School, shows similarities and differences. Jacob's is numbered by pages to 44, but Elisabeth's is numbered by tunes to 138. Elisabeth's book contains tunes on both sides of each page, while Jacob's are on only one side of a page. Elisabeth's and Henry's tunes are the same up to no. 50. After that, many of the tunes are the same, but they are not in identical order. This may suggest that after students had mastered fifty tunes, another system of learning tunes came into play. FLP.

Reinewalt, Jonas, February 2, 1812. Most tunes have two or three voice parts. Bookplate drawn in Schwenkfelder style. SL.

Reinwalt, Rossina, October 15, 1792. Block Print Artist. Cover has same block printing as Christina Kriebel's May 10, 1793, booklet. Book is full with tunes numbered to 100. Ref. 16, Plate XIX. FLP No. 841.

Reyer, Samuel, Vincent School, March 21, 1789. Ref. 9, No. 36.

Rosenberger, Abraham, Franconia, 1825. Abraham was a Vorsinger at Franconia and it is likely that he made the bookplate himself. The booklet has ninety-two tunes with German titles except for the last two tunes which are written in English. The notes are shape. Tune 71 is captioned, "*Mein Jusus meine lust*" and has three staffs connected on the left with a calligraphy design. The staffs contain lines for soprano, alto, and bass. This is a substantial leatherbound book with a tooled design on front and back covers. UNK. H37.

Ruth, Eleanora, Vincent School, March 12, 1800. Schoolmaster Johann Friedrich Eyer. Her name is written in script on the first page before the bookplate. The papered-covered book is less than half full with tunes numbered to 20. Recycled student writing practice paper was used for the first page. FLP.

Ruth, Jacob, New Britain School, March 11, 1795. In possession of descendants of Jacob Ruth. H4.

Ruth, Jacob, Plains School, 1804. In possession of descendants of Jacob Ruth. Family oral history relates, "Grandfather Michael Moyer used a chicken feather to draw." H5.

Ruth, Jacob, New Britain School, February 4, 1806. This 1806 booklet contains the earliest record of the song "*Preceptor bin ich genand, Weil ich die jugend lere.*" Loosely translated by Alice Parker: "Preceptor they title me, because I love the children." Inside the front cover is written in script, "Catherine Ruth." Jacob Ruth was the son of Mennonite Bishop David Ruth. PC. H205.

Schattinger, Sarah, Plumstead School, March 7, 1822. Book has paper cover wrapped in student practice penmanship paper dated March 14, 1822. Tunes are numbered 1 to 37. Remainder of book is blank. In possession of a descendant of Sarah.

Schelly, Daniel, Lower Milford School, March 3, 1820. Schoolmaster Jacob Overholt. Bucks County School Bills show that Jacob Overholt taught in the "Township of Lower Millfort from the 9th November 1819 till the 9th February 1820." The schoolhouse was "about two miles above Quakertown." "Matthew" watermark. SL. H391.

Schimmel, Anna, Springfield School, February 13, 1821. Schoolmaster Jacob Overholt. Bucks County School Bills prove that Jacob Overholt was teaching at the "Springfield School House near Christian Agenbacks" from October 23, 1820, to February 23,

1821, and at the "Springfield School House near Christs Tavern" from December 31, 1821, to March 29, 1822. Block-printed cover with leatherbound spine in excellent condition. Booklet filled with unnumbered tunes. PC. Ref. 9 #31. H834 & H952.

Schittinger, Johannes, Hilltown School, January 12, 1830. Swirl Artist. See notes under Johannes Brackter. Tunes numbered to 166. FLP.

Schleifer, Johannes, Richland School, 1819. Includes 4 pages of "15 Rules for Singing," total of 124 pages. Robacher Auction, No. 737, 5/27/89. Pictured in *Pennsylvania Folklife* 14 (Spring 1965): 4. UNK.

Schleiffer, Joseph, Lower Milford, December 5, 1806. First seven pages have first letter in red ink. The cover has a leather spine and block-printed paper. Book is filled with tunes and is well executed. SL.

Schmidt, Aaron, "This note book belongs to me, Aaron Schmidt, 1837, Springfield Township, Bucks County, Pennsylvania, November 30, 1837. By Levi O. Kulp." On May 1, 1840, Levi O. Kulp made a merit award for Christena Ruth in Williams Township, Northampton County: "This is to certify that Christena Ruth merits my approbation in spelling in the first class, by Levi O. Kulp." PC. FLP.

Schultz, Isaac, 1791 and 1792. Booklet with three bookplates; the first with Isaac's name, the second with a drawing of a fenced and gated garden with trees and birds, and the third with the words "*Kurtze anweilung zur Vocal Music Frag und Antwort Gestellet*," ["Short instruction in vocal music, basic questions and answers"]. Each bookplate has a border with a geometric design. Some of the interior pages containing hymn tunes are decorated with long-stemmed tuliplike flowers. The caption above each staff is written in calligraphy with color added. Many of the tunes are for a single voice, as is the pattern in the Mennonite booklets. SL.

Schumacher, Eva, Springfield School, February 3, 1803. Page after bookplate says, "Eva Kline," "Enos." Book full of numbered tunes to 83, and six tunes at the end in a different hand. Many pages cut out of the back of the booklet. FLP.

Schwarz, Elisabeth, Franconia School, June 11, 1784. "To sing I have intended, God to praise and honor." (See notes in entry for Elisabeth Hege.) In comparing the tunes in the Schwarz and Hege book, many but not all of the tunes have the same page number. It is obvious that the students were studying in the same classroom. In Hege's book, the tunes from 24 to 42 are missing. The tunes in Hege's book from 48 to 58 are the same as those in Schwarz's book,

although the numbering is different. Hege's book is full, ending at no. 69. Schwarz's book stops numbered tunes at 62, but continues with six unnumbered pages, which completes the booklet. PC. Ref. 9, No. 30. H955.

Stähr, Jacob, Swamp School, November 1, 1801. PC.

Staud, Enos, Perkasie School, December 16, 1823. Schoolmaster Joseph Moyer. "Use it for good instruction and to the glory of God." Tunes are written in shape notes from nos. 1 to 15, plain notes from nos. 16 to 21, and shape notes again from nos. 22 to 45. Joseph Moyer taught at the Hilltown Schoolhouse from October 6, 1823, to January 10, 1824. The school records of the "German-English School in Hilltown Township, commonly known as the Hunsberger School," record that "Joseph Myars kept 1 quaerer of German school in the fall of 1823." Joseph Moyer's school bill was certified by Isaac Kolb and John Hunsberger, both of whom were elected as school trustees on December 26, 1823. BCHS. H143.

Strunck, William, Lower Milford School, March 10, 1801. Paper-covered booklet with tunes numbered from 1 to 66. PC.

Wiegner, George, Hereford School, January 25, 1815. Unknown schoolmaster called the Hereford Artist. Many pages with beautiful red lettering. SL.

Wismer, Catharina, Deep Run School, June 7, 1828. Schoolmaster Samuel Moyer made bookplates for Elisabeth and Samuel Detweiler in 1826 and for these students at the Deep Run School: Johannes Hoch, September 12, 1827; Anna Letherman, September 15, 1827; and Levi Meyer, May 30, 1828. Tunes with shape notes numbered from 1 to 28. Early use of G cleft sign. Another section with tunes in plain notes with much ornamentation numbered to 65. Booklet ends with section of unnumbered tunes in shape notes. Date 1837 written on inside of back cover. Owned by a descendant of Catharina.

Wismer, Sarah, Plumstead School, 1827. PC.

Wissler, Samuel, Bedminster School, March 21, 1806. Schoolmaster David Kulp. Differs in design from most of Kulp's work. The booklet is full. The first tunes are numbered 1 to 69. After no. 69 a different hand inscribes tunes numbered 1 to 8, the last being the tune for Psalm 81. The booklet is full. PC. H38.

Yoder, Maria, [1798]. Schoolmaster Andreas Kolb. Undated, but similar to the bookplate for Anna Geissinger, February 22, 1798, Ref. 2, Plate VII. Pictured in *Pennsylvania Folklife* 14 (Spring 1965): 5. UNK.

H numbers in the above inventory refer to numbered data sheets that form the basis for a study of Mennonite fraktur from the Franconia Conference area, 1747 to 1845. Franconia Conference has the greatest concentration of members in Montgomery and Bucks Counties. Smaller settlements are found in Berks, Chester, Lehigh, and Northampton Counties. *Mennonite fraktur* refers to pieces made by or for Mennonites. Data sheets for over 1,000 pieces of fraktur are available. Information recorded includes size, type of paper and watermark, any known history, current location, and in some instances, translation of text and a color photograph and slide. This is a dynamic inventory, always changing and unfolding. The data sheets will become a part of the collection of the Mennonite Historians of Eastern Pennsylvania at the Mennonite Heritage Center, 565 Yoder Road, Harleysville, PA 19438.

Key to Abbreviations in Chronological and Alphabetical Inventories — Sources

BC Bluffton College.

CL Clements Library, University of Michigan.

CCHS Chester County Historical Society.

FLP Free Library of Philadelphia. Number following refers to Frederick S. Weiser and Howell J. Heaney, *The Pennsylvania German Fraktur of the Free Library of Philadelphia: An Illustrated Catalogue*, 2 vols. (Breinigsville, Pa.: Pennsylvania German Society, 1976).

HSP Historical Society of Pennsylvania.

JC Juniata College, Beeghly Library.

JMT Jordan Museum of the Twenty.

LCP Library Company of Philadelphia.

MHEP Mennonite Historians of Eastern Pennsylvania.

GC Mennonite Historical Library, Goshen College.

BCHS Spruance Library, Bucks County Historical Society.

MM Moravian Museum, Bethlehem.

PC Private collection.

PMA Philadelphia Museum of Art.

SL Schwenkfelder Library.

SMP The State Museum of Pennsylvania.

UNK Unknown collection (many from the slide collections of John Jacob Stoudt, Harry Rinker, John L. Ruth and Jan Gleysteen).

WM Winterthur Museum.

Key to Abbreviations in Chronological and Alphabetical Inventories — Schoolmasters

AK	Andreas Kolb	JL	Jacob Landes	
BM	Bernhard Misson	JM	Joseph Moyer	
BPA	Block Print Artist	JO	Jacob Overholt	
DK	David Kulp	LOK	Levi O. Kulp	
HA	Hereford Artist	PM	Philip Mumbauer	
HJ	Henry Johnson	RTA	Rockhill Township Artist	
JAE	Johann Adam Eyer	SM	Samuel Moyer	
JFE	Johann Friedrich Eyer	SMU	Samuel Musselman	
JG	Jacob H. Gottschall	SA	Swirl Artist	
JH	John Hunsberger			

References Noted in Inventories, by Number

1. Bird, Michael S. *Ontario Fraktur*. (Toronto: M.F. Feheley, 1977).

2. Hershey, Mary Jane Lederach. "Andreas Kolb, 1794–1811." *Mennonite Quarterly Review* 61 (April 1987): 121–201.

3. Ruth, John L. *Maintaining the Right Fellowship*. (Scottdale, Pa.: Herald Press, 1984).

4. Shelley, Donald A. *The Fraktur-Writings or Illuminated Manuscripts of the Pennsylvania Germans*. (Allentown: Pennsylvania German Folklore Society, 1961).

5. Swank, Scott. *Arts of the Pennsylvania Germans*. (New York: W. W. Norton & Co., 1983).

6. Weiser, Frederick S., and Howell J. Heaney, *The Pennsylvania German Fraktur of the Free Library of Philadelphia: An Illustrated Catalogue*, 2 vols. (Breinigsville, Pa.: The Pennsylvania German Society, 1976).

7. Weiser, Frederick S., "I A E S D: The Story of Johann Adam Eyer (1755–1837), Schoolmaster and Fraktur Artist with a Translation of His Roster Book, 1779–1787," in Albert F. Buffington et al., *Ebbes fer Alle-Ebber, Ebbes fer Dich*. (Breinigsville, Pa.: Pennsylvania German Society, 1980), 437–508.

8. David A. Schorsch, Inc., Catalogue—American Folk Art, Selected Examples from the Private Collection of the Late Edith Gregor Halpers, N.Y., 1994.

9. Alderfer Auction Company Catalogue, September 27, 1990.

10. Alderfer Auction Company Catalogue, March 16, 1995.

11. Alderfer Auction Company Catalogue, September 28, 1995.

12. Weiser, Frederick S. *Fraktur*. (Science Press, 1973).

13. Kauffman, Henry. *Pennsylvania Dutch American Folk Art*. (New York: Dover Publications, 1964).

14. Pennypacker Auction Brochure, May 30–31, 1958, Himmelreich collection, p. 14.

15. Lipman, Jean, and Alice Winchester. *The Flowering of American Folk Art*. (New York: Viking Press, 1974).

16. Borneman, Henry S. *Pennsylvania German Bookplates*. (Philadelphia: Pennsylvania German Society, 1953).

17. Horst Auction Company Catalogue, December 5–6, 1997.

18. Pook & Pook Auction Catalogue, January 12, 1991.

19. Sotheby Auction Catalogue, January 30, 1987.

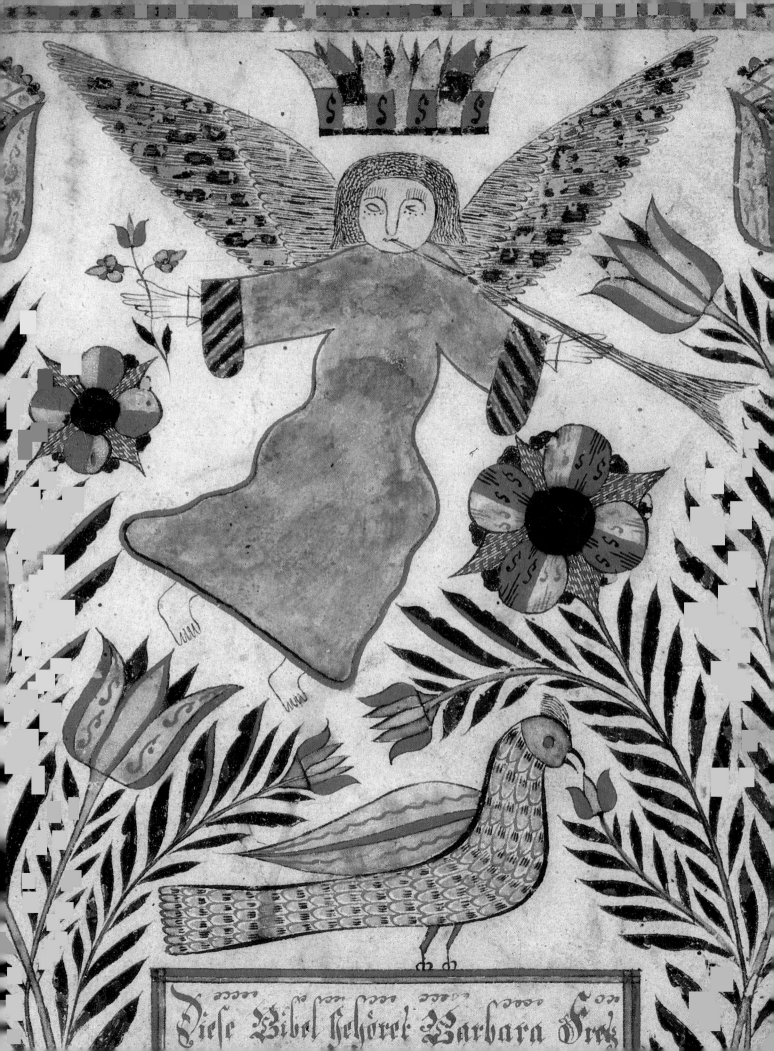

Diese Bibel gehöret Barbara Fre...

"David Kulp, His Hand and Pen, Beet it if You Can": The Bucks County Brown Leaf Artist Identified

Joel D. Alderfer

Preceptor bin Ich Genannt

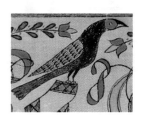

Preceptor bin ich genannt,
Weil ich die Jugend lehre,
Es g'fällt mir wohl im ledigen stand,
und das ist meine ehre,
und wan die Schüler Singen
So hör ich meine freud,
gefall ich nicht den menschen allen
Wann ich nur kan Gott gefallen,
Das ist meine lust
und das ist meine freud.

Preceptor they title me,
Because I teach the children;
The single life well pleases me
And is indeed my honor.
And when the class is singing
I hear my very joy.
Although I may not please all men
If I can only please my God,
This is my true desire,
And this is my delight.[1]

This hymn text, used by several Mennonite schoolmasters in Bucks and Montgomery Counties in the late eighteenth and early nineteenth centuries, was titled on a later printed broadside: *"Des Schulmeister's Liebstück"* [The Schoolmaster's Favorite Piece]. The text is given here as it appears (in German script) in the copybook of Schoolmaster David Kulp of Bedminster Township, around 1807.[2] It nicely summarizes the career of the pious preceptor identified in this essay.

Over the past twenty-five years, persons familiar with the field of fraktur collecting and scholarship have noted references to the Brown Leaf Artist, known also as the Bucks County Brown Leaf Artist and the Bucks County Music Book Artist. The fine, consistent, and growing body of known work from this sure-handed schoolmaster-artist has become

increasingly recognizable. Looking carefully at his work, we almost have to conclude that this schoolmaster was one of the neatest, most consistent, and most prolific of all fraktur artists, at least among those of Mennonite heritage, in southeastern Pennsylvania.

Who was the artist behind this amazing collection of work? Since he seems to have been such a competent teacher, why haven't we been able to learn anything significant about him, until recently? Only through an unlikely discovery can we confirm his identity as David Kulp of Deep Run, Bedminster Township, Bucks County. Schoolmaster Kulp's copybook was found at the bottom of a box of late, nondescript German-language books donated to the Mennonite Heritage Center (Harleysville, Pa.) in 1994. It is the German script, or handwriting, in this copybook that matches precisely the script on the fraktur of the Brown Leaf Artist (Figs. 95–97). In this essay, the evidence, both

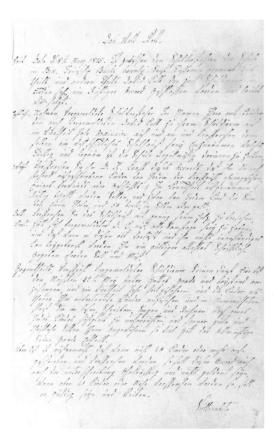

Fig. 95. Sample of German Script from the Copybook (no. 2) of David Kulp. David Kulp. Bedminster Township, Bucks County, 1810–1815. (Mennonite Heritage Center, Harleysville, Pa., Hist. Mss. 1–135.)

visual and written, of Kulp's identity is reviewed, and the sparsely documented story of this previously unidentified Deep Run schoolmaster reconstructed.

David Kulp (or Kolb) was born in June 1777, in Bedminster Township, Bucks County, the son of Henry Kolb (d. 1786) and Catharine Kulp Kolb. His paternal grandparents were David Kolb (d. 1786) and Ann Oberholtzer Kolb, and the maternal grandparents probably Martin (d. 1772) and Anna Maria Kulp, all of Bedminster.[3] To further complicate our search, David Kulp (1777–1834) also had an uncle, a cousin, and a nephew of the same name, all living in Bedminster Township during the same years. As a child, David had the good fortune of being a student of the talented Lutheran schoolmaster and prolific fraktur artist John Adam Eyer. Kulp was enrolled in Eyer's classes at the Deep Run School from at least August 1782 to April 1786, according to Eyer's roll book.[4] He must already have been a promising young scholar at the age of six, for on May 8, 1783, at the end of the school term, Schoolmaster Eyer made a fraktur bookplate in a 1758 *Geistreiches Gesangbuch* (Halle) for "*David Kolb an der Tieff Ronn*" (Fig. 98).[5]

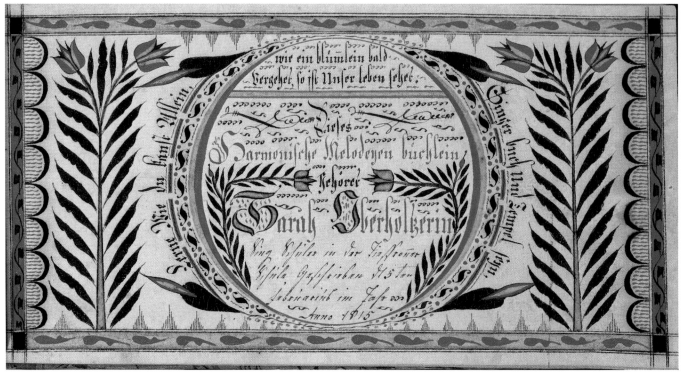

Fig. 96. Manuscript Tune Book and Bookplate for Sarah Oberholtzer. Attributed to David Kulp, Deep Run School, Bedminster Township, Bucks County, 1815. Hand-drawn, lettered and colored on laid paper. 4¼ x 8¼ in. (Mennonite Heritage Center, Harleysville, Pa, 88.2.1.)

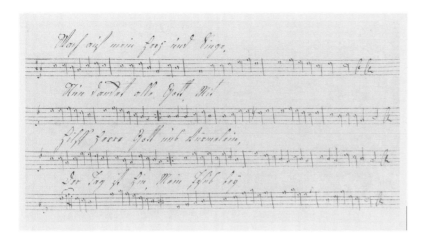

Fig. 97. **Sample of German Script from Oberholtzer Tune Book** (Fig. 96). Attributed to David Kulp, Deep Run School, Bedminster Township, Bucks County, 1815. (Mennonite Heritage Center.)

Our next evidence of David Kulp's life and work is in 1801, about the time he begins teaching in the Deep Run–Plumstead area. The earliest surviving piece of fraktur attributable to him is a manuscript hymn-tune notebook (*Notenbüchlein*), dated May 1801 (Fig. 99).[6]

An inventory of Kulp's surviving fraktur shows at least twenty-eight hymn-tune notebooks dated from 1801 to 1817. It is the German script in these *Notenbüchlein* that consistently matches the penmanship in the copybook of schoolmaster Kulp, dated 1806–1822,[7] thus confirming his identity as the elusive Brown Leaf Artist. Several local students of early German script have verified this comparison.[8] Three dated school subscription documents in his copybook also correlate with the dates and school names on several hymn-tune notebooks made by Kulp. He continued teaching until at least 1819, when we find the latest reference to his career: a bill for teaching poor children in Hilltown Township, submitted by Kulp.[9] Unfortunately, no school bills from Bedminster Township, before 1819, seem to have survived in the Bucks County Commissioners' records. These would have helped to further document David Kulp's career in that township. However, from the evidence in his copybook, and evidence on his fraktur work, we know that he taught in subscription schools in Bedminster, Hilltown, and Plumstead Townships on

Fig. 98. **Hymnal Bookplate for David Kolb.** Attributed to Johann Adam Eyer, Deep Run, Bedminster Township, Bucks County, 1783. Hand-drawn, lettered and colored on laid paper. 5⅞ x 3⅜ in. Schoolmaster Johann Adam Eyer drew this bookplate in a 1758 *Geistreiches Gesangbuch* (Halle) for his six-year-old student David Kolb (Kulp). (Rare Book Department, The Free Library of Philadelphia, PaGer foreign imprints 1758 Halle.)

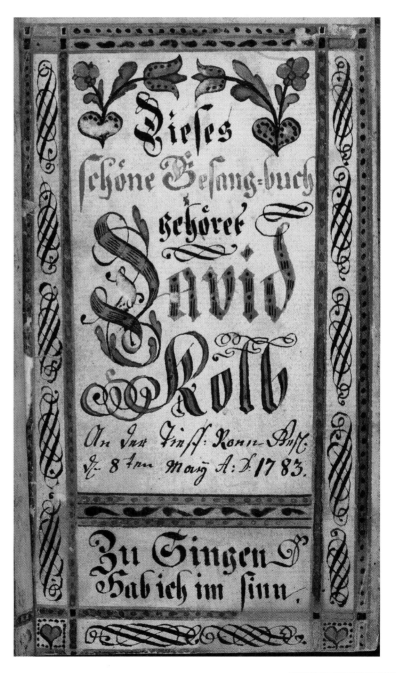

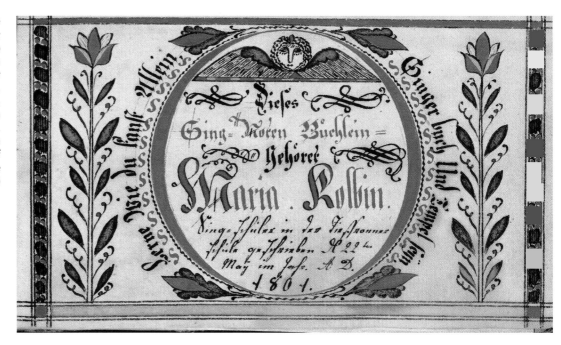

Fig. 99. **Manuscript Tune Book and Bookplate for Maria Kolb.** Attributed to David Kulp, Deep Run School, Bedminster Township, Bucks County, 1801. Hand-drawn, lettered and colored on laid paper. 6½ x 3¾ in. This is the earliest known fraktur from the hand of David Kulp. (Private collection.)

a rotation-by-term basis. In 1814–1815, he was paid $1.50 per student for a three-month term; in 1818–1819, $0.04 a day per student.[10]

Here follows a selection of documents as found in David Kulp's copybook (the first a subscription school agreement, translated by John L. Ruth):

God Willing,

Today On the date of March 8, 1815, a proper agreement between the school directors of the school in Bed. Township, otherwise named Deep Run, of the one part and David Kolb of the other part, presently schoolteacher at Perkasie, is concluded as follows:

First. The above-mentioned school directors, in the name of their brethren, accept the above-mentioned David Kolb for their schoolteacher for an ordinary quarter-year term off and on, and promise to have a suitable schoolhouse emptied that will be fit and pleasant for the regular holding of school,

Second. They promise him D. K. according by the power of this accord that he shall be rightly paid for the remaining registered children from every one promised without application …except in case of sickness, from each child the sum of one dollar and fifty cents, in silver or gold.

Third. They promise to supply the school-house with sufficient firewood,

Fourth. The above-mentioned D. K. reserves free for himself all Saturdays, and that when he leaves this place, and nothing unbecoming is attributed to him, an authentic written recommendation shall and must be given him,

Conversely, the above-mentioned school-teacher promises by God's grace and help to begin his service here by the next May 22, and to proceed for a quarter year, and to regard the children as precious pledges made to him and to instruct them with untiring diligence in reading, writing, singing and reckoning to the end of each child's salvation, and further to acquaint them with good and Christian morals, to the extent that the almighty God imparts his grace.

Beyond this it is decided that if fewer than 40 children or more are registered and promised, this agreement, according to the subscribers, shall be without force and invalid. However, if 40 or more children are promised, it shall be and remain valid.

In confirmation of this agreement we of either party have personally subscribed on the day and date mentioned at the beginning, subscribed in our presence D. K. Schuld[iener] I. M. D. K. [David Kulp] M. F. A. M.

A School Subscription

We whose Names are underwritten here Do Promise to pay or cause to be paid unto David Kulp of Bedminster Township the sums Annexed

to our Names: In consequence of Having A German and English school taught by him for the space of three Months in the Schoolhouse in Hilltown Township under the Directions of George Syple, Martin Fretz, Joseph Moyer & Abraham Moyer, Trustees of the said School-house, Wherefore Each of us do Promise to pay One dollar and fifty cents per Schollar, and Furnish the Schoolhouse with a Sufficient Quantity of firewood, Wherefore I do Obligate Myself to use Every Lawfull Method, for the Progress and Education of the Schollars; to learn them in Reading, Writing, Singing and Arithmetic, Both German and English, to which I subscribe my hand this 7ᵗʰ Day of May 1814. David Kulp.

Note: The school is to commence on the 20ᵗ Day of November 1815 [should this read 1814?] if thirty schollars or near the number will be subscribed.

I allow it to my honored fellow citizens to subscribe their names to these briefly stated condtions if they approve my plan.

A School Subscription

Know All Men by these presents that we the Subscribers Living in the Township of Bedminster in the County of Bucks & state of Pennsylvania do hereby Employ David Kulp to Teach school for the space of One quarter of a year Upon his own Expence, for which we faithfully Promis to pay the above Named David Kulp, for every scholler here under Subscribed One Hundred and fifty cents Lawfull money of Pennsylvania afore said, on Demand after his Sarvice, and further that we the Proprietors shall and will give him the Posession of A Sufficient School House Conveniant for a Regular School, and Likewise see a Sufficiant quantity of fire wood provided, for which upon the amount of thirty Schollars said school is to Commence on the 28th Day of this present Month in Reading, Writing, and Arithmetic, Both German and English, Any person or persons Subscribing and not sending without a Lawful Excuse, Shall be liable to pay wether he or they send or not,
Made and Concluded the 19th Day of March Anno D. 1815

A copy of one of Kulp's school bills to the Bucks County Commissioners for the education of poor children is also found in his copybook:

The Commissioners of the County of Bucks, Dr. [debtor]
 To David Kulp.
For Schooling Isaac Yost of the Township of Hilltown from the 21st September 1818 till the 23 December 1818 50 days
 - Schooling Catherine Yost, same Township and within the same time, 50 days
 - Schooling Hannah Yost, same Township & within the same time, 50 days
 - Schooling Jacob Lichtel, same Township & within the same time, 37 days
 - Schooling Jonas Lichtel, same Township & within the same time, 37 days
 224 Days
224 Days at 4 cts per day $8.96

We the undersigned trustees of Hilltown School House near Seiples Mill have examined the original entries of the teacher of said School, David Kulp, and find that they are correct and charged at the Common price of tuition.
 J.S. A.G.

Yet another of Kulp's school bills is found in the Bucks County Commissioners' Records, Spruance Library, Bucks County Historical Society:

The Commissioners of the County of Bucks, Dr. [debtor]
 To David Kulp,
For Schooling Catherine Yost of the Township of Hilltown from the 22t March 1819 till the 22t June 1819. 72¹/₂ Days
 Schooling Hannah Yost, same Township and within the same time72
 144¹/₂ Days
144¹/₂ Days at 4 cts per day, $5.78

We the undersigned Trustees of the Hilltown School House near Dublin village have examined the original entries of the teacher of said school, David Kulp, and find that they are correct and charged at the Common price of tuition.
 Jacob Detwiler
 Jacob Landes

Fig. 100. **"Setting of the Sun" Table from the Copybook (no. 1) of David Kulp.** David Kulp, Bedminster Township, Bucks County, c. 1805. Hand-drawn and lettered on laid paper. 12½ x 7¾ inches. (Mennonite Heritage Center, Harleysville, Pa., Hist. Mss. 1–135.)

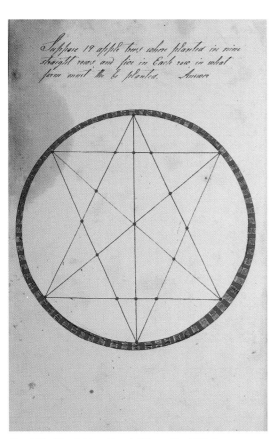

Fig. 101. **"Apple Tree Puzzle" from David Kulp Copybook (no. 1).** David Kulp, Bedminster Township, Bucks County, c. 1805. Hand-drawn, lettered and colored on laid paper. 12½ x 7¾ inches. "Suppose 19 apple trees were planted in nine straight rows and five in Each row, in what form must they be planted[?]" (Mennonite Heritage Center, Harleysville, Pa., Hist. Mss. 1–135.)

Kulp's 1806–1822 copybook, along with a previously discovered copybook by his hand written entirely in English (Figs. 100, 101), show that he was completely literate and taught competently in both German and English from the beginning of his career. An inventory of twenty-eight surviving hymn-tune notebooks now attributed to Kulp (Figs. 102, 103) indicates the school circuit in which he taught:[11]

	Date	Student's Name	School Name
1.	May 22, 1801	Maria Kolb	Deep Run
2.	August 15, 1802	Ulrich Hackman	Deep Run
3.	October 25, 1803	Jacob Oberholtzer	Deep Run
4.	November 1, 1803	Elizabeth Oberholtzer	Plumstead
5.	October 20, 1804	Henrich Meyer	Bedminster
6.	October 31, 1804	Jonas Fretz	Bedminster
7.	September 12, 1805	Jacob Meyer	Deep Run
8.	March 21, 1806	Samuel Wisler	Bedminster
9.	May 5, 1807	Anna Landes	none given
10.	May 3, 1808	Rudolph Hoch	none given
11.	April 5, 1809	Abraham Gerhart	Bedminster
12.	April 15, 1810	Susanna Fretz	Perkasie
13.	April 19, 1810	Maria Hunsicker	Perkasie
14.	March 2, 1811	Elisabeth Jost	Perkasie
15.	May 17, 1811	Jacob Meyer	Perkasie
16.	January 12, 1812	Anna Leatherman	Deep Run
17.	January 22, 1812	Maria Oberholtzer	Deep Run
18.	January 27, 1812	Maria Gross	Deep Run
19.	January 29, 1812	Barbara Gross	Deep Run
20.	June 15, 1813	Maria Leatherman	Deep Run
21.	March 3, 1814	Anna Honsperger	Perkasie
22.	June 7, 1814	Abraham Oberholtzer	Deep Run
23.	June 19, 1814	Christian Gross	Deep Run
24.	December 16, 1814	Elisabeth Hendricks	Perkasie
25.	January 17, 1815	Johannes Honsperger	Perkasie
26.	January 26, 1815	Catharine Gerhart	Bedminster
27.	February 5, 1815	Sarah Oberholtzer	Deep Run
28.	February 2, 1817	Isaac Gross	Deep Run

A contemporary of David Kulp was the schoolmaster Rudolph (Ralph) Landes (1789–1852)[12] of Hilltown Township. Landes taught in Hilltown and New Britain Townships at least during 1814 and 1815, according to surviving school bills from those townships.[13] There are at least two signed pieces of fraktur by Rudolph Landes from these years and several others that can be attributed to him. His style was similar to David Kulp's, but his work was not as fine. One of these fraktur contains an acrostic hymn-text composed by his grandfather Rudolph Landes, an early deacon of the Deep Run Mennonite Congregation, the first letter of each verse spelling out his name.[14] Some of Rudolph Landes's work can easily be mistaken for that of Brown Leaf Artist Kulp, but a closer look reveals that two different hands and styles were at work.

About 1808, David Kulp married Mary Landis (1789–1872), a daughter of Henry Landis (d. 1833) of Plumstead Township. She was the granddaughter of Preacher Abraham Landis (d. 1791) and Magdalena Oberholtzer Landis of the Deep Run Mennonite Congregation. The 1810, 1820 and 1830 census records of Bedminster Township, Bucks County all list one male child, and sometimes a female child, living with David and Mary Kulp. But when David died in 1834 there were no surviving children. After his death, Mary wedded her husband's first cousin, also a David Kulp (1784–1846). For her third husband, she married Jacob

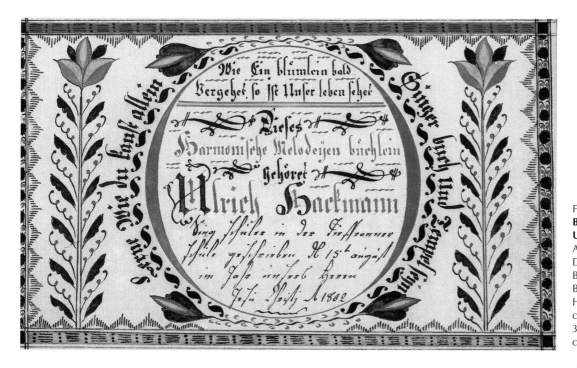

Fig. 102. **Manuscript Tune Book and Bookplate for Ulrich Hackman.** Attributed to David Kulp, Deep Run School, Bedminster Township, Bucks County, 1802. Hand-drawn, lettered and colored on laid paper. 3³⁄₄ x 6¹⁄₈ in. (Private collection.)

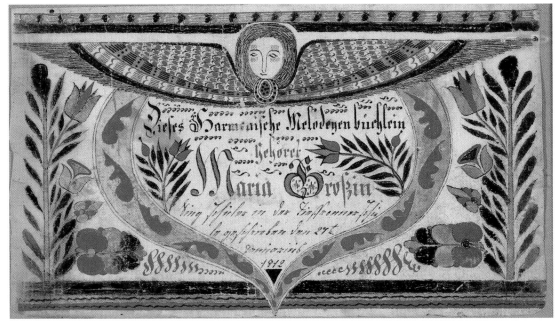

Fig. 103. **Manuscript Tune Book and Bookplate for Maria Gross.** Attributed to David Kulp, Deep Run School, Bedminster Township, Bucks County, 1812. Hand-drawn, lettered and colored on laid paper. 3³/₄ x 6³/₈ in. This is one of three nearly identical tune booklets decorated by Kulp in the course of one week: January 22–29, 1812. (Private collection.)

Fig. 104. **Deep Run Mennonite Meetinghouse.** Bedminster Township, built 1766. Photograph by Samuel DuBois, 1872. Here David Kulp attended meeting and likely led the singing. Nearby was the old Deep Run schoolhouse where he conducted classes. This image was taken just before the meetinghouse was razed and replaced with a new structure. (Spruance Library/Bucks County Historical Society, SC–29–01.)

Leatherman (1792–1879), who had previously been married to Mary's sister Magdalena Landis (1793–1855). All are buried in the old Deep Run Mennonite Cemetery near the meetinghouse (Fig. 104).[15]

David Kulp, together with his brother Henry (1784–1846), purchased 115 acres of land in Bedminster Township on April 1, 1808 from Valentine and Sarah Thoman. This was Kulp's first land transaction. In his second copybook is a copy

of a transfer or reassignment of an obligation from Valentine Thoman to Jacob Overholt, which Kulp wrote and witnessed on April 1, 1815. On June 5, 1826, David Kulp, "weaver," and Mary his wife, with "Henry Kulp Farmer of New Britain Township and Ann his wife," sold this same 115-acre tract to Jacob High of Bedminster Township. But strangely, fifty-seven acres (one-half) of this tract or of another unrecorded fifty-seven tract of land from Valentine and Sarah Thoman, was released by the survivors of David Kulp to his widow Mary (who was given a life right to the land), on February 7, 1834, less than a month after David died. This miscellaneous deed or release is the only recorded legal document relating to David Kulp's estate.[16]

David Kulp's name first appears in the Bedminster Township annual tax returns of 1807, when he is listed as "single" and, fortunately, as "schoolmaster." Beginning in 1808, and continuing for about ten years, he is assessed for 100 acres of land and various head of livestock, but the schoolmaster designation disappears. Then in 1819 and continuing until 1834 (the year of his death), his acreage drops to fifty. In these years, he is usually listed as "David Kulp Sr.," in this case meaning the elder (or older) David Kulp, not the father of a David Kulp "Jr." Then for two years, 1834–1835, "Mary Kulp, widow," is taxed for this acreage, along with, surprisingly, a "clover mill."

There is also another David Kulp "Jun." listed in the Bedminster Township tax returns in these same years, owning no land, and sometimes referred to as

"weaver."[17] This is probably Schoolmaster David Kulp's younger cousin (1784–1846). In the front of Schoolmaster Kulp's copybook of 1806–1822 are recipes for dyeing wool, linen, and cotton, and limited instructions for warping a loom, confirming that the schoolmaster was also doing some dyeing and weaving. And, of course, he is called a weaver in the 1826 deed. Following is a transcription of one of David Kulp's dyeing recipes:

> To make a Blue Colour
> Take one pound of Indigo, Grine [sic] it fine and one ounce of Nuraltick of tin, put these 2 Articles together in one Barrel of water, stir it twice in 24 hours, then put the Cotton 5 Minutes in it, and you will have it Deep Blue, this will be for 25 pounds of Cotton, or linen and 34 pounds of wool.

In 1820, Kulp himself became the tax assessor for Bedminster Township and recorded his itemized bill for services rendered to the county commissioners in his copybook. An examination of the tax returns for that year confirms that they are also in David Kulp's hand. From other notes in the copybook, we know that he also served the community as auction clerk, appraiser, auditor, and scrivener (a writer of official documents),[18] or what we might today call a notary public. In a community with few talented penman, his fellow citizens recognized his fine hand. Consequently, they employed him in various record-keeping roles. Examples of estate inventories, vendue lists, agreements, appraisals, and other legal/official documents in Kulp's hand continue to be discovered.

According to the early Deep Run Mennonite Burial Records, kept by Deacon Abraham Wismer (1791–1859), who himself had been a student of schoolmaster Kulp, David must have died on or about January 15, 1834. His funeral and burial in the Deep Run cemetery occurred on January 18 with Preacher John Geil of Line Lexington giving the sermon from the text Psalm 94:19. Deacon Wismer noted that Kulp "died of fever," "aged 56 years, 6 month, 21 days."[19] We might wish that Wismer had noted Kulp's former occupation of schoolmaster, but even this simple reference to his role in the community is absent. One precious, contemporary, manuscript reference to *"David Kolb der schulmeister"* does exist, however. It appears in a letter written by Mennonite Preacher Christian Gross (1776–1865) of Deep Run. On February 21,

Fig. 105. **Gravestones of Henry Kulp (1784–1846) and David Kulp (1819–1850).** Deep Run Mennonite Cemetery, Bedminster Township, Bucks County, 1998. These tombstones mark the burial places of the brother and nephew of Schoolmaster David Kulp. Although Kulp's own gravestone has not survived, it is likely that he would have been interred in this plot. (Photo by Joel D. Alderfer.)

1834, Preacher Gross wrote to one "Bruder Jacob" at "The Twenty" Mennonite settlement in Lincoln County, Ontario. He reported simply that "David Kolb the schoolmaster" and others "have recently been summoned into eternity by the trumpet of death."[20] Fortunately, this reference confirms that the David Kulp who died in January 1834 was indeed David Kulp the schoolmaster.

Unfortunately, no gravestone seems to have survived for this David Kulp (Fig. 105). No obituary for him was placed in either of the contemporary Doylestown newspapers. Neither is there any will, administration papers, estate inventory, or Orphans Court proceedings relating to his death on file at the Bucks County Courthouse in Doylestown. What does this suggest about the Pennsylvania-German Mennonite community's regard (or lack thereof) for the work of this one-time pious, artistic schoolmaster and proficient scrivener in their midst, or for that matter, the work of any schoolmaster? Likely, his traditional, no-nonsense, hard-working farming community would not have regarded the schoolmaster more highly than anyone else. Apparently, Kulp left his teaching career by 1820, and for the remainder of his life must have been known primarily as a scrivener and, apparently, a weaver. Then, too, David Kulp left no children and only a small estate at the time of his death, which might help explain the lack of the usual legal documents. Sixty-five years later, Doylestown anthropologist Henry C. Mercer in his

Fig. 106. **New Testament Bookplate for Anna Landes.** Attributed to David Kulp, Bedminster Township, Bucks County, 1807. Hand-drawn, lettered and colored on laid paper. 6¼ x 3½ in. (H. Richard Dietrich Jr., Philadelphia, Pa. Photo by Will Brown.)

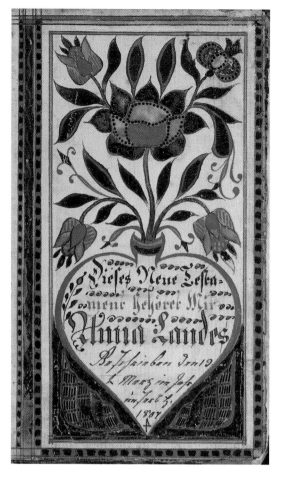

book, *The Tools of the Nation Maker*, referred only briefly to the fraktur work of "...David Kulp, David Seiple and Jacob Gross...later masters of the art," suggesting that their names and work had been, and were still, generally well-known in the Deep Run–Doylestown Mennonite community.[21]

The following are short quotes from Kulp's two known copy/ciphering books. Perhaps the most intriguing and appropriate inscription from Kulp's pen, in his earlier ciphering/copy book, reads simply: "David Kulp his hand and pen, Beet it if You can, Januari 22th, 1806." He seemed to know that he was one of the best scrivener-artists around! It now seems that local historical research and fraktur collecting has confirmed Kulp's assessment. On another page in the ciphering book, Kulp wrote: "Labour for learning Before you get Old, for learning is better then Silver and gold, Says I David Kulp" [1806]. Who better to give such good advice? Then there's a couplet with which nearly everyone can agree: "A man Without money and none he can Borrow, Small is his Creadit [sic] and Great is his Sorrow"! Or this: "A man without money, Learning or Vit [wit], to

travel the World is werry [very] unfit"! Again he writes: "David Kulp his hand and pen, he will be a Scholler [scholar], But Deer nose when" [1806]. On another page: "David Kulp is my name, and Garmony [Germany] is my nation" [1807].[22] Clearly English was both his second language and second culture.

The task of identifying, locating, photographing, and inventorying all of David Kulp's known work is well underway through the research of fraktur scholar Mary Jane Hershey, and the Bucks County Historical Society (Mercer Museum) Fraktur Project. It will also continue in the research of this author and others. The writer welcomes any additional information on the life and works of David Kulp, as well as of other Bucks County Mennonite schoolmasters. At this point, about seventy surviving pieces can be attributed to Kulp's hand. These include bookplates, several *Vorschriften*, rewards of merit, hymn-tune notebooks, family registers, and pictures without text (Figs. 106–113). Through this amazing collection of work, Mennonite schoolmaster and scrivener David

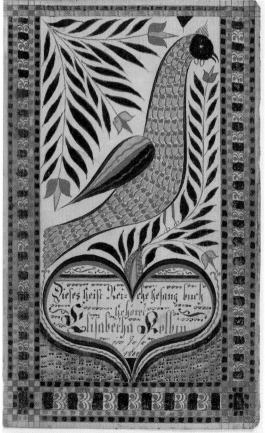

Fig. 107. **Hymnal Bookplate for Elisabetha Kolb.** Attributed to David Kulp, Bedminster Township, Bucks County, 1809. Hand-drawn, lettered and colored on laid paper. 6½ x 3⅞ in. (Private collection.)

Kulp continues to show us "his hand and pen," and challenges us to "Beet it if You can!"

The following are transcriptions of other documents found in David Kulp's copybooks. All original spellings and punctuation have been retained:[23]

To all People whome this may concern Whereas it Is agreed by the Neighbours of Hilltown, Bedminster Plumstead and New Britain, To have a School House built on John Funks Land close to New Britain Road for the use of Teaching Children English, The House is to be built with stone about 20 feet by 18 which the said John Funk Promises to give a good and Sufficient Lawful Deed of conveyance for the Same clear of all incumbrance for Ever, And now we The undernamed Subscribers Do Promise to Pay the Several Sums of money Enexed to our Names honestly without dispute. [n.d.; c. 1807.]

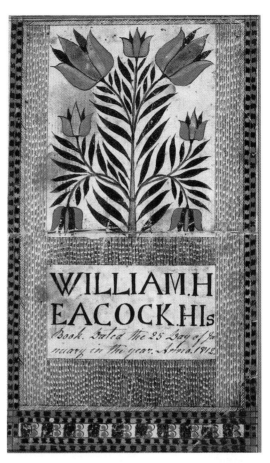

Fig. 108. **Bookplate for William Heacock.** Attributed to David Kulp, Hilltown or Bedminster Township, Bucks County, 1812. Hand-drawn, lettered and colored on laid paper. 6⅞ x 4 in. (Private collection.)

Bedminster April 1st 1820
County of Bucks Dr.
To David Kulp assessor of Bedminster,
To 1 days attendance at the
Commisioners office $2.00
To 10 days taking lists of
taxables .. 10.00
To 3 days with his two assistants in making the rates upon the Taxables .. 9.00
To 2 qualifications and certificates of qualifications of assistants assessors 1.00
To 1 day for taking Transscript of Taxables to the Commisioners office 2.00
To 10 days serving notices notices upon Taxables assessed .. 10.00
To 1 days attendance at the appeal 1.00
$35.00

To the Commissioners of the County of Bucks, We the Subscribers Being Called by F. G. in Bedminster Township to appraise 4 sheep as the Property of the said F. G. which were Killed by Dogs on the 26 of March 1818. And we appraised said sheep 9 Dollars, witness our hands this 27 Day of March Anno Domini 1818.
Appraisers fees 50 Cents Each 9.00
1.00
C. H. J. K. 10.00

To the Commissioners of the County of Bucks, We the subscribers two of the auditors elected to settle the accounts of the supervisors of High ways of Bedminster Township, have this day appraised four sheep as the property of J. M. at ten Dollars & fifty cents, which ware Killed by dog, or dogs, and is to be paid out of the fund arising from the Taxt on dogs-witness our hands and seals this 4th of May 1818.
appraisers fees $1.00 J. K.
10.00 D. K.[David Kulp]

Notice
The inhabitants of Bedminster Township are hereby notified that an Election will be held agreeable to law on Saturday the 19th of this Inst at the House of Lewis Lunn in the said Town-ship, to Elect a Constable & Supervisors of the Roads for the ensuing year, And persons to settle the accts of the (Overseers of the poor and) Supervisors of the Roads for this year — (when and where also the Keeping of the poor of said Township will be contracted for, the Term of one year.)
January 9t 1810 Jacob L.

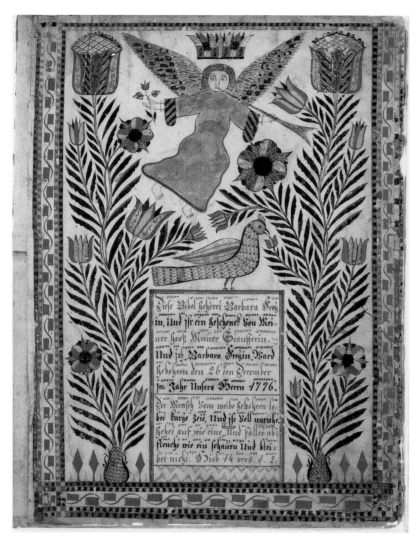

Fig. 109. Bible Bookplate for Barbara Fretz. Attributed to David Kulp, Bedminster Township, Bucks County, c. 1813. Hand-drawn, lettered and colored on laid paper. 9 x 12 in. One of David Kulp's most elaborate pieces, this bookplate was found in an 1813 "Somerset" Bible (the first Bible printed west of the Allegheny Mountains). The bible was a gift from Barbara Fretz's "grandmother Stauffer" according to the inscription. (Private collection.)

These are to certify that all and Every Expression or Accusation Prejudicial to the Character of William M. and his wife of Bedminster Township & County of Bucks Made and spread by me were totaly unfounded and the sole Effect of passion & anger of Consiquence of a Quarrel at that time Existing Between us In Testimony of which I hereunto Supscribe my self this Eights Day of November 1800.
in presence of A true Copy G. B. [?]
Isaac Burson
Cyrus Cadwalader
Isaac Hicks

The Conditions of the Sale of a Messuage and tract of ninty four acres and One Hundred and fifty perches of land in Hilltown Township the residue of the real Estate late of John Funk Decd, offered at publick vendue this 26 Day of

We the subscribers duly Elected auditors to settle the accounts of the supervisors of the High ways, for the Township of Bedminster, having Examined the foregoing accounts of the Supervisors for the year last past and find the same as above stated to be just and correct; Witness our hands and seals this twenty seventh Day of March, in the year of our Lord one thousand Eight Hundred & Eighteen.
C. H.
J. K.
H. W.
D. K. [David Kulp]

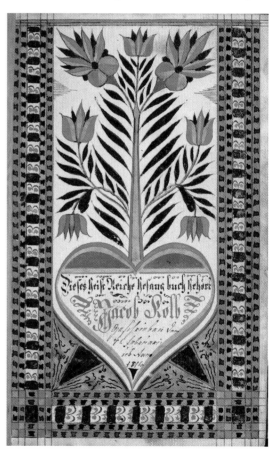

Fig. 110. Hymnal Bookplate for Jacob Kolb. Attributed to David Kulp, Hilltown Township, Bucks County, 1814. Hand-drawn, lettered and colored on laid paper. 6½ x 4 in. This is one of two nearly identical bookplates that survive from Kulp's hand. He drew them one day apart, on February 7–8, 1814. (Mennonite Heritage Center, Harleysville, Pa., 2000.5.1.)

October A.D. 1822 are as follows, Viz the highest and best Bidder to be the buyer. If sold one third of the purchase money to be paid on the first Day of April 1823 when a good and sufficient title will be made the purchaiser and possession of the premises given, One other third on the first of April 1824, the whole on lawfull Interest from the Day of Sale, the remaining third to be paid at the Death of Esther Funk widow of the aforesaid John Funk Decd, the Interest thereof to be paid to the said Esther Funk anually and every year during her natural life, the grain on the ground on the premises excepted, Also the Tenants in posession of the same to have privilege of firewood till the first of April. - - - The purchaser to secure the payments by a mortgage on the premises.

Sale adjourned for want of Buyers to the 23d of Nov. next. I the subscriber do acknowledge myself to be the purchaiser of the above property at Twenty Dollars and nine cents per acre, fair sale. Witness my hand this 23d of November 1822. D. K.[David Kulp]

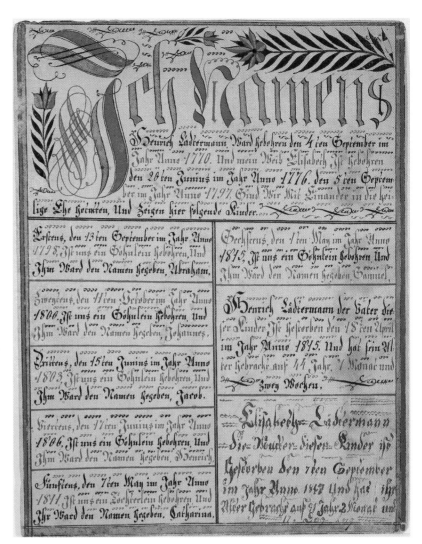

Fig. 111. **Family Record of Henrich Lädtermann (b. 1770).** Attributed to David Kulp, Bedminster Township, Bucks County, c. 1815. Hand-drawn, lettered and colored on laid paper. 9⅝ x 7¼ in. The last entry in David Kulp's hand is dated May 1815. (Mennonite Heritage Center, Harleysville, Pa., 90.13.1.)

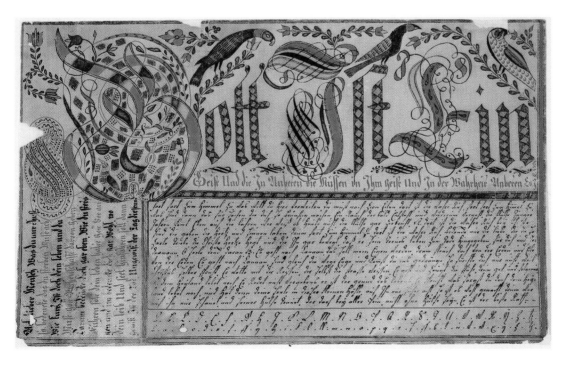

Fig. 112. **Penmanship Model.** Attributed to David Kulp, Bucks County, c. 1810. Hand-drawn, lettered and colored on laid paper. 7⅞ x 13 in. (Rare Book Department, The Free Library of Philadelphia, FLP 372.)

163

Finally, a transcription of one more German text—a song to teach the alphabet—from the back of Kulp's second copybook:

Wilt du bald ein doctor werden [Would you quickly become a doctor?]

1. *Wilt du bald ein docter werden,*
 Ohne grose müh,
 Kanst du alle Kunst auf Erden,
 Das diers fehlet nie,
 Das heist viel in wenig stunden
 In dem A B C gefunden,
 Wie du siehest hie,

2. *A soll alle ding verlassen,*
 Bosheit streift das B,
 C das Creuz mit freuden umfassen,
 Demuth gibt das D,
 E führt in das ewige leben,
 F die freud im hertzen geben,
 Gedult gibt das G.

3. *H gebühret heilig zu leben,*
 J inbrünstig seÿn,
 K kan kortze worte geben,
 L liebt Gott allein,
 M soll mächtig seÿn und bleiben

N mit Nutz die zeit vertreiben,
O ohne falschheit sen,

4. *P die Pflicht der liebe zu haben,*
 Q soll quellend seÿn,
 R ein Reines Herz zu haben,
 S in Sanfftmuth seÿn,
 T soll Tugend andre lehren,
 U soll unter Thänig ehren,
 W soll wachtsam seÿn,

5. *X Xerxes wohl verstanden,*
 Der ein König war,
 Als er sich zu Gott hinwandte,
 Liebt ihn offenbahr,
 Der wird endlich ihn erlösen,
 Von der welt und allem bösen,
 Erretten aus der gefahr,

6. *Z das A.B.C. am Ende,*
 Auch bedeut die Zeit,
 Die sich wie ein auch gewendet,
 Nach der Ewigkeit,
 Du solt auch das zeitlich meiden,
 Und dich aus die strass bereiten,
 Nach der Ewigkeit.

Fig. 113. **Penmanship Model.** Attributed to David Kulp, Bucks County, c. 1810. Hand-drawn, lettered and colored on laid paper. 7³/₄ x 12¹/₄ in. (Private collection.)

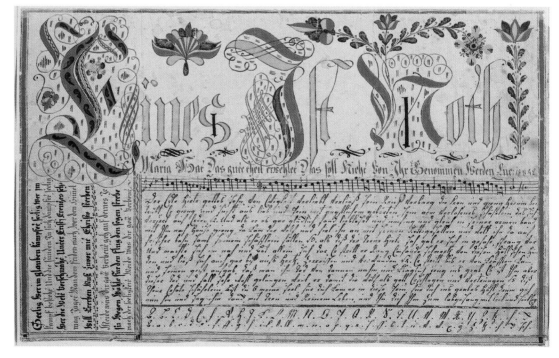

Notes

1. Metered translation by John L. Ruth, Harleysville, Pa.

2. Copybook of David Kulp, c. 1806–1822. Hist. Mss. 1–135.1, Mennonite Historians of Eastern Pennsylvania, Harleysville, Pa. This hymn text first appears in a 1788 manuscript *Notenbüchlein* from the Swamp Mennonite School in Milford Township, Bucks County. The tune book was compiled by bachelor schoolmaster Andreas Kolb (1749–1811), a second cousin of David Kulp (Kolb). The hymn appears repeatedly in later *Notenbüchlein* from local Mennonite schools and also on several broadsides, but it has not been found in other Pennsylvania-German communities, nor in the German hymnbooks of that era. The evidence currently points to Andreas Kolb as the author of the text.

3. Thomas G. Myers, comp., *A Record of the Descendants of David Kulp of Bedminster Township* (Freehold, NJ: 1990), 3.

4. Frederick S. Weiser, "I A E S D: The Story of Johann Adam Eyer (1755–1837), Schoolmaster and Fraktur Artist," in *Ebbes fer Alle-Ebber, Ebbes fer Dich/Something for Everyone—Something for You: Essays in Memoriam Albert Franklin Buffington,* in *Publications of the Pennsylvania German Society* 14 (1980): 488–503.

5. Ibid., 466. This fraktur is in the collection of The Free Library of Philadelphia.

6. Hymn tune booklet with decorated title page, dated May 22, 1801, made in the Deep Run School for Maria Kolb, from a private collection. See Bucks County Fraktur File, SL/BCHS

7. Copybook of David Kulp, Mennonite Heritage Center, Harleysville, Pa.

8. Consultations with Alan G. Keyser, East Greenville, Pa.; John L. Ruth, Harleysville, Pa.; Isaac Clarence Kulp, Vernfield, Pa.; all in 1996.

9. David Kulp, "Bill for Schooling Catherine and Hannah Yost, March 22 through June 22, 1819, Hilltown Township," February 28, 1820, Bucks County School Bills, County Commissioners' Records, SL/BCHS (B.C. School Bills).

10. Ibid., and copybook of David Kulp.

11. Inventory compiled by Joel D. Alderfer, with assistance from the Bucks County Fraktur File and Mary Jane Lederach Hershey.

12. Rev. A. J. Fretz, *Fretz Family History* (Elkhart, Ind.: Mennonite Publishing Company, 1890), 276–277.

13. Ralph Landes, "Bill for Schooling Barbara Christine, Hilltown Township," May 10, 1814; and "Bill for Schooling Night Bitting, New Britain Township," December 26, 1815, B.C. School Bills.

14. Frederick S. Weiser and Howell J. Heaney, *The Pennsylvania German Fraktur of the Free Library of Philadelphia: An Illustrated Catalogue,* 2 vols. (Breinigsville, Pa.: The Pennsylvania German Society, 1976), 1: fig. 239.

15. Myers, Descendants of David Kulp, pp. 3–4; U.S. Census, Bedminster Township, Bucks County, Pa.

16. "Deed of Sale from Valentine and Sarah Thoman to David and Henry Kulp," April 1, 1808 (recorded June 12, 1820), Deed Book 48, p. 78–79; "Deed of Sale from David and Henry Kulp to Jacob High," June 5, 1826 (recorded October 27, 1834), Deed Book 59, pp. 212–214; "Release from the Survivors of David Kulp to Mary Kulp," February 7, 1834 (recorded February 13, 1834), Misc. Book 58, pp. 142–143; SL/BCHS.

17. 1807–1835 Tax Lists, Bedminster Township, Bucks County, Pa., SL/BCHS.

18. Ibid., 1820; see also copybook of David Kulp.

19. Deacon Abraham Wismer, "Deep Run Mennonite Church Burial Records, 1830–1859," Deep Run East Mennonite Church Collection, Mennonite Historians of Eastern Pennsylvania.

20. Preacher Christian Gross Letters, Hist. Mss. 1–10, Box 1, File 10, Archives of the Mennonite Church, Goshen, Ind.

21. Henry C. Mercer, *The Tools of the Nation Maker* (Doylestown, Pa.: Bucks County Historical Society, 1897), 12.

22. Copy/Ciphering Book of David Kulp, 1805–1809. Hist. Mss. 1–135, Mennonite Heritage Center.

23. All transcriptions are by Joel D. Alderfer, with translations by John L. Ruth.

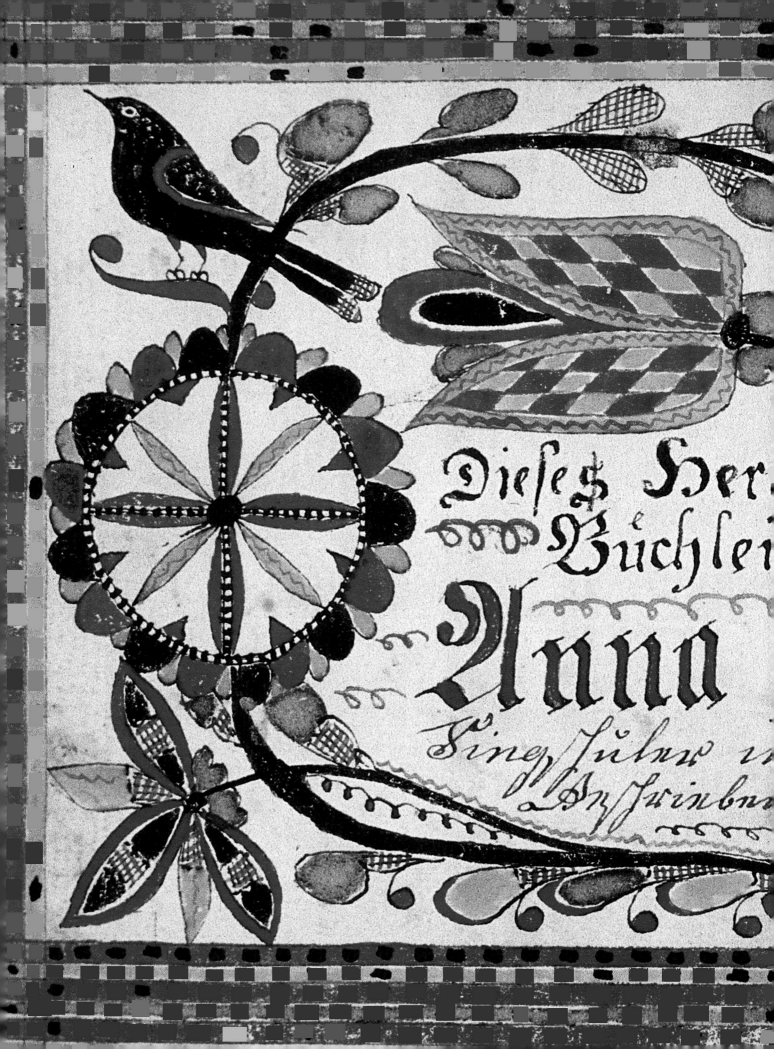

Dieses Her-
Büchlei-
Anna

Dieses Bild gehöret mir: Transforming Bucks County Fraktur in Canada

Michael S. Bird

In his 1998 essay on fraktur in Bucks County, Cory Amsler raised the question as to whether there is such a thing as a *Bucks County tradition*, given that county borders do not define the settings within which artists work.[1] While this observation makes sense in a Pennsylvania context with its denser population and relatively unbroken communication and travel from one county to the next, in Ontario the situation is, interestingly enough, quite different.

When Pennsylvania Germans, most of them Mennonites, migrated into a largely unpopulated region across the Niagara River known as Upper Canada (which eventually would become present-day Ontario), they established themselves in three locales relatively isolated from one another. These settlements comprised an inverted triangle, approximately 60 miles on each side, with its three points in the Niagara Pensinsula, in York County (Markham Township), and in Waterloo County. Although the geographical distance separating each of the three areas is not great by modern means of conveyance, historical evidence suggests that in the first half of the nineteenth century, social and economic contact was slight. Indeed, there appears to have been greater interaction between the people in these settlements and their Pennsylvania kin than among the three Ontario communities themselves.

Thus, an examination of fraktur produced in the three Mennonite communities of southwestern Ontario leads to an observation that there are, indeed, county traditions with readily discernible contours regarding technique, style, colors, and forms. One would have little difficulty recognizing the three regional fraktur traditions, popularly labeled as *Lincoln County, Markham Township*, and *Waterloo County*. To cite but one example, it is interesting to note that certain forms which are characteristic of one or two of these regions are not necessarily found in the other(s). The *Vorschrift*, found in Lincoln County, is virtually unknown in Waterloo County or Markham Township; the family register is common in Waterloo County but not elsewhere; the hand-drawn birth/baptismal certificate is found in abundance in Markham Township, but is conspicuously absent in Waterloo or Lincoln Counties.

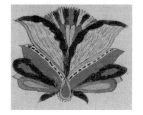

Lincoln County Fraktur

While fraktur in Lincoln County* may be easily distinguished from that of Ontario's other Mennonite communities, differentiating it from that produced in Pennsylvania, and specifically in Bucks County, is more difficult. It is not surprising that a number of Bucks County pieces found in Ontario were for some time believed to be of Niagara origin, and that some Niagara specimens discovered in the

* Because of reorganization of regional and municipal boundaries in the 1970s, the area formerly known as Lincoln County has been absorbed in a new political jurisdiction known as the Niagara Region. For our purposes, the terms *Lincoln County* and *Niagara Peninsula* are used interchangeably, with the caution that a small body of fraktur was also produced along the northern shore of Lake Erie, an area which fits the broader designation but which is outside of what had been known as Lincoln County.

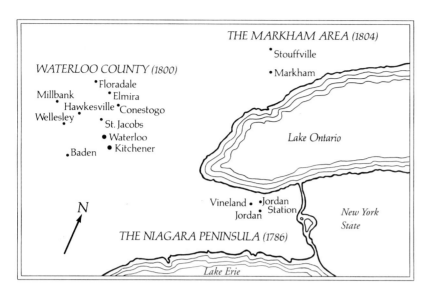

Map 4. **The German Communities of Upper Canada (Ontario).**

United States were assumed to be Pennsylvania-made examples. The largest single collection of fraktur in the Niagara region, housed at The Museum of The Twenty in the village of Jordan, includes many pieces from both Pennsylvania and Ontario. Were it not for epigraphical evidence (notably inscriptions referring to the Clinton School), it would be difficult to establish provenance for some of the illuminated songbooks in this collection. The collection is represented by the work of such Pennsylvania artists as Johann Adam Eyer (1755–1837) and also the Brown Leaf Artist, David Kulp (1777–1834).

It is interesting to note the large number of fraktur examples brought to Lincoln County by Pennsylvania settlers, a situation markedly different from that of the Waterloo and Markham settlements, in which brought-along items appear less frequently. In part, the presence of so many Pennsylvania examples in Lincoln County may be reflective of the earlier date of settlement (1786 for Lincoln County, in comparison to 1800 for Waterloo and approximately 1803 for Markham). It may say something, too, of a different community of Pennsylvania settlers. W. W. H. Davis's *History of Bucks County* indicates that at least thirty-three families migrated from Bucks County to Lincoln County between 1786 and 1802.[2] Lincoln County's Mennonites came precisely from that region of Pennsylvania where there was a strong tradition of hand-drawn and lettered tune books. By contrast, the Markham and Waterloo communities were comprised primarily of Mennonites from Lancaster County, where the tune book tradition was not so highly developed. Thus, in the case of Lincoln

County, both Pennsylvania artists and Pennsylvania art were present in the community.

In examining the forms and style of fraktur produced in Lincoln County, it would be useful to know more about the direct connection between artists in this settlement and their teachers in Bucks County. Significantly, many of the prominent Lincoln County family names do appear in Johann Adam Eyer's roll book, and one can reasonably wonder if some of his pupils were later to become the major fraktur artists who produced work in Lincoln County. Could the Vineland school teacher Samuel Moyer (1767–1844) and his cousin (and first Mennonite bishop in Canada) Jacob Moyer (1767–1833) be the Samuel Meyer and Jacob Meyer enrolled in Eyer's class in the late winter quarter of 1780?[3] Could this be the same Jacob Meyer who was recipient of the elaborate reward of merit made by Eyer in 1780, and which was brought to the Vineland area at early date (now in the collection of the Jordan Historical Museum)?

To be certain, numerous Bucks County *Vorschriften*-booklets (writing booklets) which came to Canada with these Mennonite settlers bear the names of pupils whose names can be found in Eyer's roll book. The name Barbara Gross appears in the summer term of 1785,[4] presumably the same Barbara Gross for whom Eyer inscribed a *Vorschriften*-booklet on October 4, 1785. This booklet came to Canada during the migration of the late eighteenth century, where it was handed down through Gross and Honsberger family members until coming into the public domain in the late 1970s.

The presence of large numbers of Bucks County tune books and *Vorschriften*-booklets in this early Canadian settlement may well have had a conservative influence on the production of fraktur in the new geographical setting, where they could serve as convenient models to be copied by local schoolmaster-artists and scriveners.

Case Study:
Six Lincoln County Fraktur Specimens and Pennsylvania Influences

Remarkably, at the time of this writing, there has not yet been located a single signed example of Lincoln County fraktur, although vague suggestions have been made with regard to the previously mentioned Samuel Moyer as a schoolteacher and scrivener at Vineland in Lincoln County. Connect-

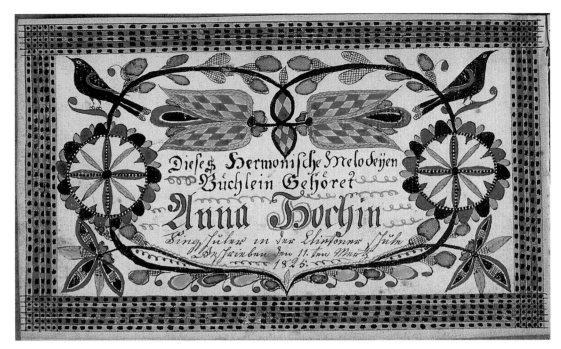

ing his name to any specific example is problematic, since no dates have been indicated regarding his purported role as a teacher there. Songbooks made for pupils at the Clinton School, and bearing written evidence of such provenance, bear dates over a chronological range from 1804 to 1834. Examination of calligraphic style alone leads to the suspicion that these are the work of a minimum of three different artists, if not more. Other forms of fraktur, notably in the form of decorated texts or of pictures *(Bilder),* may be the work of those same school-teacher-artists who executed the title pages of various songbooks, while some others seem quite unrelated to the tune books altogether.

In an attempt to consider representations of a Lincoln County fraktur tradition, we might take as a case study six interesting examples, all produced within a small time frame. While not necessarily all by the same hand, these pieces are stylistically and technically so similar as to suggest that one, two, or three artists were intimately aware of each other's work and were closely imitating one another. These half dozen specimens include three pictures, a decorated text, and two tune books, spanning the dates 1825–1834. There is a certain internal coherence to their design principles, and as a group they bear striking resemblance to Pennsylvania examples. With regard to this latter reference point, it is intriguing to observe that the similarities are both historical and contemporary. That is to say, this group of Lincoln County fraktur suggests a

historical influence from the earlier work of Johann Adam Eyer, but also a contemporary parallel with the work of certain later Pennsylvania artists (e.g., David Kulp) who also can be said to be derivative in relationship to Eyer. Thus, we can discern evidence of the phenomenon by which the work of a specific artist is reflected in the continuing work of subsequent artists, even when separated by considerable geographical distances.

The Lincoln County pieces for consideration are as follows:

Fig. 114 Anna Hochin, March 11, 1825
Fig. 115 Catharina Meyerin, November 4, 1829
Fig. 116 Catharina Hochin, April 18, 1830
Fig. 117 Catherina Meyerin, March 4, 1830
Fig. 118 Rebecca Moyer, 1833
Fig. 119 Magdalena Albrechtin, March 28, 1834

Of particular interest within this small group is the picture made for Catharina Meyer, dated November 4, 1829 (Fig. 115). This piece was located in recent years in New York State, but bears unmistakable stylistic similarity to the other pieces in this group, notably the 1830 picture for Catharina Hoch (Fig. 116). Like several specimens made in the Vineland area, its inscription designates it as a picture (*Bild*). Brief information, along with name of recipient and date, is set within a box at the bottom of the picture. Typical of these works is a

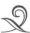

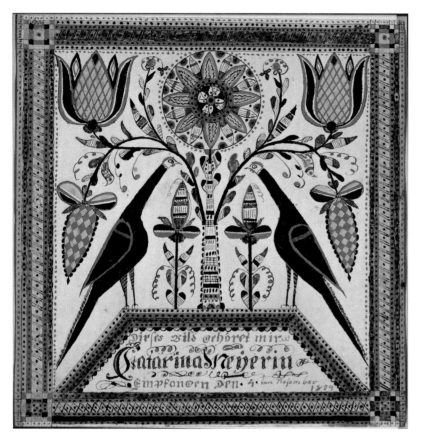

Fig. 115. **Drawing for Catharina Meyer.** Unidentified artist, Lincoln County, Ontario, Canada, 1829. Hand-drawn, lettered and colored on wove paper. 7³/₄ x 7¹/₂ in. (Private collection.)

(Figs. 115, 117, and 119). The example with a rather differently conceptualized border is the Rebecca Moyer picture of 1833 (Fig. 118), in which lozenges and floral motifs are utilized. But even here, single rows of dots define the edges of the upper and lower bands. There is in this technique a distant kinship in the work of Pennsylvania artist David Kulp (Fig. 120), but Kulp's border markings are not so much dots as rows of tiny boxes carefully outlined and colored.

It is interesting that these late Lincoln County artists have expended so much effort on the elaborate articulation of borders. The effect stands in noticeable contrast to an artist such as, say, Christian Aldsdorff, the Earl Township Artist, whose Lancaster County examples, for all their complexity of calligraphy and design, are framed in simple borders amounting to little more than two parallel lines framing a single band of color. At times, the use of dots and diagonal lines has an almost literal precedent in several Johann Adam Eyer borders which frame the covers of *Vorschriften*-booklets drawn in Bucks County in the early 1780s.[5] The lag time of nearly a half century may be fairly indicative of the late perpetuation of Pennsylvania-German design elements in the relatively isolated communities of southern Ontario.

rather wide border constituted by the placement of dots, slashes, or hyphenlike strokes in channels, characteristically defined by contrasting yellow and red colors.

In comparing the Catharina Meyer picture of 1829 with the one for Catharina Hoch dated 1830, several observations can be made. A prominent feature relating these two examples to each other (and to other Lincoln County specimens) is the specific manner of geometric composition within tulips and buds, rendered in the form of a diamond pattern. In each case, the alternating lozenges within the overall pattern are set into dramatic contrast by means of red and yellow coloration. This feature is present in all three of the pictures as well as the text.

Borders

Five of the six pieces are noteworthy by virtue of a simple device used to frame the compositions. In each of these examples, the artist has developed a border comprised of dots aligned within parallel channels of alternating red and yellow colors. In two cases, the border is based upon an intense concentration of dots or dashes in side-by-side rows (Figs. 114 and 116). In other instances, there is further compartmentalization by use of horizontal or diagonal lines between dots

Fig. 116. **Drawing for Catharina Hoch.** Unidentified Artist, Lincoln County, Ontario, Canada, 1830. Hand-drawn, lettered and colored on wove paper. 13³/₄ x 11 in. (Whereabouts unknown, photo courtesy of the author.)

Motif-Outlining:
Secondary Profile Devices

A strikingly distinctive feature of the pieces in this grouping is the method by which the visibility of prominent motifs is heightened. In large part, this process consists of reinforcement by the addition of a secondary profile around the figure. Such techniques of emphasis have an early history in manuscript illumination, demonstrated perhaps most conspicuously in pages from Medieval manuscripts such as the *Lindisfarne Gospels* (c. 698) and other Insular examples. In this early illuminated gospel, from a vastly different time and context, the meticulous application of rows of red dots serves to accentuate the contours of floral and other motifs as well as lettering in the text.

Closer to home, we find the same obsession with the possibilities of the dash or dot at work in the profiling of tulips, birds, angels, and other motifs within the composition of these various Niagara Peninsula fraktur pieces. In a manner reminiscent of the *Lindisfarne Gospels*, rows of dots are used to highlight tulips and buds in all three of the pictures (Figs. 115, 116, and 118) as well as the Catharina Meyer text of 1830 (Fig. 117) and the Magdalena

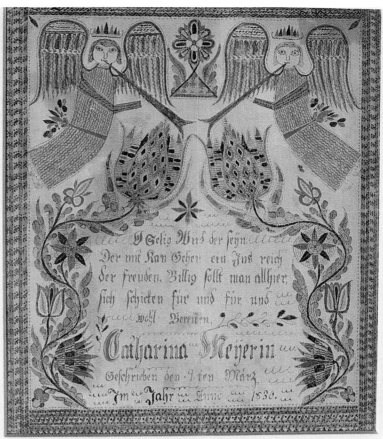

Fig. 117. **Religious Text for Catharina Meyer.** Unidentified Artist, Lincoln County, Ontario, Canada, 1830. Hand-drawn, lettered and colored on wove paper. 8⁷⁄₈ x 7⁵⁄₈ in. (Jordan Historical Museum, Jordan, Ontario.)

Albrecht songbook of 1834 (Fig. 119). In three pieces, angels are outlined in a virtually identical manner by means of closely spaced dots, while in a similar number of examples, the outer border is emphasized in this way. Curiously, this outlining technique seems to have had no appeal to artists in Bucks County, nor elsewhere in Ontario. It appears in brief form in Lincoln County as early as 1804, outlining the wings of paired angels on a songbook, but appears to have had its most prominent expression in several works from the 1820s and 1830s. The device is so unusual as to perhaps constitute a kind of later Lincoln County signature.[6]

Another profiling method is the use of the continuously undulating line to accentuate the curving profile of the floral device enclosing the

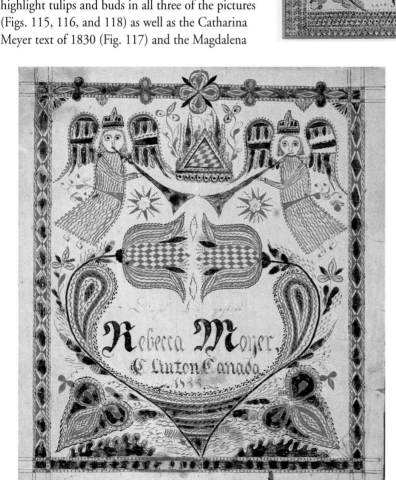

Fig. 118. **Drawing for Rebecca Moyer.** Unidentified artist, Clinton, Lincoln County, Ontario, Canada, 1833. Hand-drawn, lettered and colored on wove paper. 9 x 7³⁄₄ in. (Joseph Schneider Haus Collection, Kitchener, Ontario, 998.28.1.)

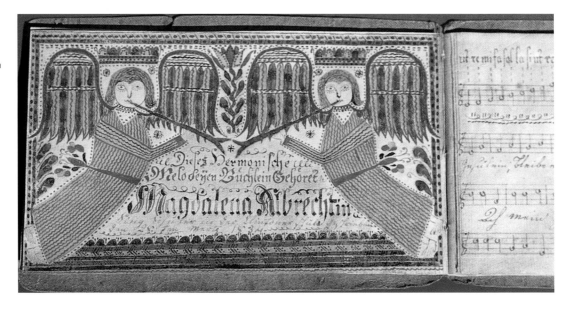

Fig. 119. **Manuscript Tune Book and Bookplate for Magdalena Albrecht**. Unidentified artist, Clinton School, Lincoln County, Ontario, Canada, 1834. Hand-drawn, lettered and colored on wove paper. 3³/₈ x 5³/₄ in. (Jordan Historical Museum, Jordan, Ontario.)

name and date on the Rebecca Moyer example (Fig. 118). This finely drawn device has counterparts in the work of several Montgomery County examples, including the work of Isaac Z. Hunsicker (1803–1870) who produced fraktur in both Pennsylvania and in Waterloo County, Ontario. This neatly inscribed undulation provides a parallel to the simpler wavy lines which appear repeatedly as internal decorative motifs in the figures on most of the examples. These squiggles are most dramatically used to fill in the bodies of the angels on three pieces. They have a more random equivalent in the form of scrolls which sometimes fill in vacant areas around lettering, notably in the case of the two tune books, but also with regard to the text and pictures as well. While the eye is more easily drawn to the carefully rendered central motifs in these various works, it seems no less significant that common ground may be found in the more accidental and unthinking flourishes executed by artists in their efforts to complete their compositions.

Spelling

Certain texts appearing on Niagara fraktur, especially music booklets, are quickly recognizable as continuations of those used earlier in Bucks County. A case in point is the motto *Geb Jesu Das Herz im Freude und Schmerz In Leben und Tod Diss Eine ist Noth* [Give Jesus your heart in joy and in pain, in life and in death, this one thing is necessary]. In Lincoln County, the hortatory verb is spelled *Gib*, while in Bucks County it is generally *Geb*. Another interesting spelling matter has to do

with the German rendering of *harmonic* in reference to the small musical booklets. An apparent peculiarity in the booklets produced by Lincoln County artists is the consistent spelling of the adjective as *Hermonische*. In Pennsylvania, the word was more typically spelled *Harmonische*, though several Bucks County examples using the *e* spelling are known, chiefly with dates prior to 1800.[7] Indeed, a 1780 booklet from the *Birckenseh* (Perkasie) School in Bucks County, prepared by Johann Adam Eyer, uses this formulation. Further, a 1798 booklet from the same school, and with the same spelling, was among effects brought along in the trek from Bucks to Lincoln County. This piece and examples produced at the Clinton School may all have been influenced by the early works of Eyer and his contemporaries.[8]

Angels and Trumpets

While the depiction of the trumpeting angel is an ubiquitous fraktur motif, much as it had earlier been a widespread element in Medieval decorative arts generally, its treatment in several Lincoln County works is noteworthy in relationship to the Pennsylvania background.

In Lincoln County fraktur, angels playing trumpets appear as free-floating beings, set in symmetrical arrangements in songbooks, pictures and text. At present, four Niagara-area examples are known, including an 1804 songbook, and three others within the grouping under consideration here. In each case, the angel is seen in profile, with one visible arm supporting a trumpet extending from the

mouth of the face turned toward the viewer. In contrast to Eyer's side-view approach, the Lincoln County portraits are more frontal. The angel wears a full-length gown, from which bare feet hang somewhat awkwardly. These Ontario pieces, dated 1804, 1830, 1833, and 1834, have an intriguing Pennsylvania parallel in a c. 1815 work attributed to David Kulp (Fig. 120). The simply sketched outline of a trumpet and the primitive depiction of bare feet protruding from a cloak are features common to both the Kulp and Ontario examples, raising questions about their shared iconographical source. The source for Kulp appears likely to be in the work of Eyer, who was his teacher at the Deep Run School. The basis for the Lincoln County pieces is less certain, although there may have been an indirect Eyer and a Deep Run influence. In every example illustrated in Frederick Weiser's important article on Eyer, the depiction shows both arms of the angel, whereas the Ontario pieces portray only one. In the Eyer examples, one hand supports a trumpet while the other holds a flower aloft. This tradition is retained by Kulp, but abandoned by the Lincoln County artists. There is much in the way of similarity in the work of these practitioners, but it is also quite evident that if indeed they do draw upon a common source, they go separate ways in their particular interpretation.

Trees

To the extent that much of fraktur composition is rigidly symmetrical in plan, with paired birds as a common pictorial motif, it is not surprising that the vertical axial of such designs takes the form of a tree or other plant. The particular manner of constructing this central arboreal image serves to establish the stylistic relatedness of two Lincoln County pieces, notably the Catharina Meyer and Catharina Hoch drawings of 1829 and 1830, respectively (Figs. 115 and 116).

What is curious about these treatments is the seemingly contradictory stylistic approaches evident in each case. In both drawings, the tree is a strange mixture of flowing naturalism and severely linear geometry. The trunk of the tree is comprised of tapering lines within which appear compartmentalized sections of smaller lines, dots, and dashes. While the trunk is, in effect, drawn with a ruler, the uppermost section is executed by means of another instrument, the compass. In the 1829 drawing for Catharina Meyer, the top of the tree consists of a complete circle, inside of which appears a compass-

inscribed eight-point rosette. In the case of the 1830 picture for Catharina Hoch, the upper section is again drawn by means of a compass, producing a canopylike three-quarter circle, inside of which is to be found a compass-drawn rosette (or that section of it required to fill the outer framework). Set against this strictly geometrical rendering is a more naturalistically drawn arrangement of branches flaring out from the midpoint of the trunk. Further departure from the geometric linearity of the obelisklike trunk occurs in the elaboration of leaves and buds along the curvature of these gracefully flowing branches. In a rather different context, some similar sense of this tension between geometry and naturalism is to be seen in the 1825 songbook for Anna Hoch (Fig. 114), in which two compass-drawn rosettes are juxtaposed with birds, leaves, buds, and vines stylistically woven into a heart-shaped framework surrounding the text.

The particular rendering of the tree trunk, with

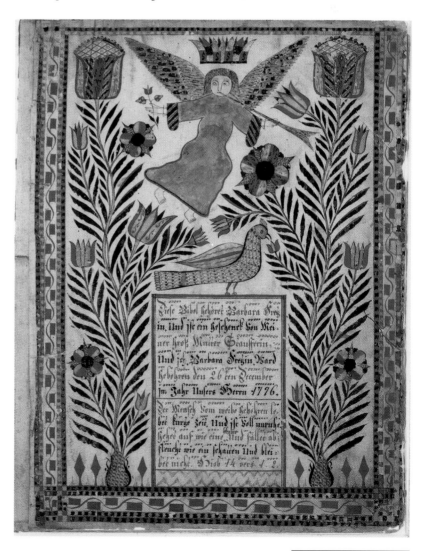

Fig. 120. **Bible Bookplate for Barbara Fretz**. Attributed to David Kulp, Bedminster Township, Bucks County, c. 1815. Hand-drawn, lettered and colored on laid paper. 9 x 12 in. (Private collection.)

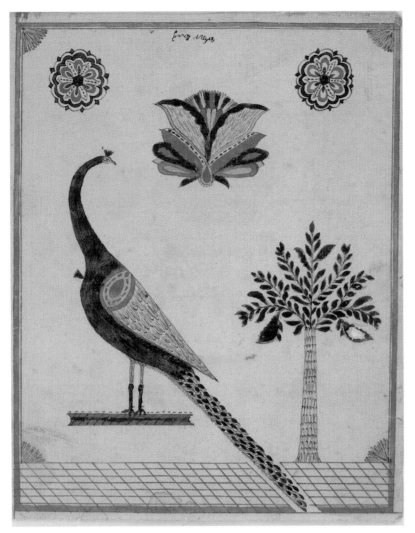

County, shows a peacock, tree, and floral motifs against a plain background (Fig. 121). The trunk of the tree is comprised of compartments of short vertical lines within horizontal divisions. This drawing, which is illustrated in Frederick Weiser's monograph on small presentation fraktur,[11] is a greatly simplified version of a typical Eyer composition and is said to have been executed c. 1810, about midpoint chronologically between the active periods of Eyer in Bucks County and of the Lincoln County artist(s) in Canada.

Birds: The Diagonal Peacock

The peacock is a not uncommon motif in fraktur. In some settings it has been associated with religious texts, where it sometimes has symbolic associations with the notion of spiritual immortality. Frequently, however, the motif is utilized as a design motif in itself, with no particular textual connection intended. Even when it appears in several compositions by Johann Adam Eyer, the text immediately adjacent to the peacock speaks of the virtue of student diligence and has no meaningful relationship to the image whatsoever.

This motif is utilized in the 1829 Catharina Meyer picture (Fig. 115) in a manner so strongly reminiscent of Eyer's work as to imply direct knowledge by the Lincoln County scrivener of the earlier artist. In this Canadian composition, two peacocks are placed in symmetrical arrangement flanking a central tree—a long-established and classic fraktur design principle. Indeed, it could appear that the peacock on the picture for Catharina Meyer was taken almost directly from this motif as it appears on the cover of a *Vorschriften*-booklet drawn by Eyer on October 4, 1785, for Barbara Gross (Fig. 122), his pupil in the Deep Run School. When the as yet unidentified Lincoln County artist executed the drawing of the peacock for Catharina Meyer in 1829, the Barbara Gross booklet had already been in Canada for several decades.

In several Eyer examples, the peacock is a dramatic diagonal device with neck and head reaching to the upper left-hand corner and elongated tail extending to the lower right-hand corner. In some cases, the tail actually breaks through the framework of the upper section, continuing into the lower compartment, as in the Barbara Gross example. It is interesting to see how the Lincoln County artist handles this situation. Almost as if to

its compartmentalized sections of short lines and dots can be found on earlier Pennsylvania examples, and especially in the Bucks County regions from which these Ontario Mennonites came to the Vineland district. Striking examples appear in the work of Eyer himself, as in the *Vorschriften*-booklet cover drawn for Barbara Gross in 1785, and which, as has been noted, came to Canada at an early date. A similar example was made by Eyer as late as 1804 for Catarina Arnold in Monroe County, Pennsylvania.[9] And it is found yet again in Eyer's unusual drawing of soldiers and ladies.[10]

If a particular device found in Eyer's work can be said to have been carried forward in time by his pupils or those otherwise influenced by him, can we find examples of other artists who may have worked more or less contemporaneously with the Lincoln County scrivener(s) discussed here? The answer would seem to be yes, and manifested in the work of an artist not geographically far removed from Eyer. An interesting example, probably from Bucks

accommodate this motif without such transgression of borders, he replaces the lower box and its continuous horizontal band in the Eyer composition with a trapezoidal framework which conveniently bends downward at each side, providing space for the extension of the birds' tails. The trapezoid is unusual, but does have an earlier Pennsylvania counterpart in a picture with diagonal peacock drawn for Susanna Detweiler in 1784 (Fig. 123).

Imitation of Eyer's compositions is to be seen again and again, as in the c. 1810 drawing (Fig. 121), in which the peacock and tree are taken from earlier contexts. This artist draws upon some later examples of Eyer's work, perhaps from the previously mentioned *Vorschriften*-booklet cover executed for Catarina Arnold in 1804 in Monroe County. In these later examples, the head of the peacock is turned backward. What is particularly evident in each case is the pervasive influence which Eyer was to have on early nineteenth-century artists in places as geographically disparate as Montgomery County in Pennsylvania and Lincoln County in Ontario. In the case of the c. 1810 example, there is fairly literal copying of Eyer's motifs (albeit rearranged), whereas the Lincoln County artist has produced more of a synthesis in which Eyer's designs appear in conjunction with motifs not associated with Eyer at all.

Fraktur as Picture

Many early forms of fraktur were tied closely to texts—songsheets, birth and/or baptismal certificates, bookplates, and *Vorschriften*, to name a few. The question arises, then, what inspired the considerable popularity in Lincoln County of examples that are given the overt pictorial designation *Bilder*?

In terms of design, several Lincoln County examples exhibit formal similarities to the covers of the *Vorschriften*-booklets, with minimal text identifying the owner and date of composition. Typical inscriptions look like simple substitutions: *"Dieses Vorschriften-Büchlein gehöret mir"* becomes *"Dieses Bild gehöret mir."* The earliest-known Lincoln County fraktur specimen using the word *Bild* is a small drawing for Magdalena Meyer drawn in 1804,[12] but it remains a solitary early example. The phenomenon becomes more widespread a quarter of a century later, with three larger and more complex compositions drawn between 1829 and 1833. The overall design of these later pictures is strongly reminiscent of the Eyer *Vorschriften*-

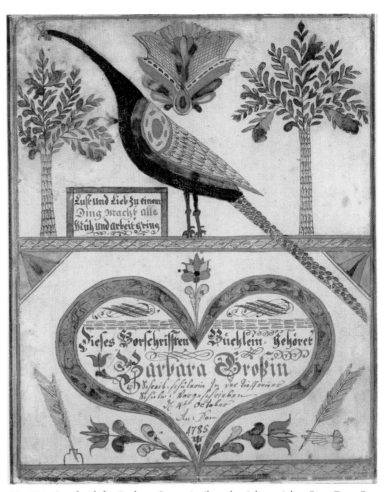

Fig. 122. **Copybook for Barbara Gross.** Attributed to Johann Adam Eyer, Deep Run School, Bedminster Township, Bucks County, 1785. Hand-drawn, lettered and colored on laid paper. 8 x 6¼ in. (Private collection.)

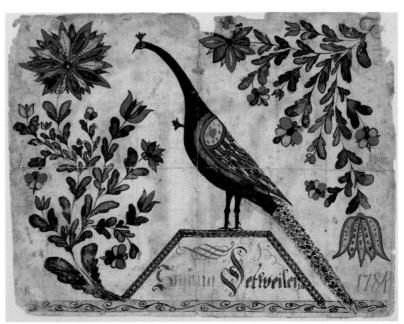

Fig. 123. **Picture for Susanna Detweiler.** Unidentified artist, in the manner of Johann Adam Eyer, probably Hilltown or Bedminster Townships, Bucks County, 1784. Hand-drawn, lettered and colored on laid paper. 6¼ x 7⅞ in. (Collection of Jean W. Rutherford.)

175

booklet covers, with a large pictorial section at top and a smaller box or cartouche for name and date at the bottom. Whereas the Eyer examples place this identifying information within a circle or heart, the Lincoln County artist has enclosed it within a rectangular box, a trapezoid, and an elliptical framework defined by leaf and floral motifs.

While the form of these Lincoln County examples may derive from Eyer booklet covers such as those previously discussed, the source of the actual designation *Bild* remains a question. Another possible source for the picture in Lincoln County fraktur is a form which has been said to be unique to Eyer. This is the *Singbild*, that is, a decorated musical text.[13] In compositional form, the *Singbild* resembles the format of the *Vorschriften*-booklet cover, with the text framed within a heart or other border. There may be more distantly related counterparts to this hymn-text/picture, as in a Continental German fraktur and text from a Paul Gerhard hymn ("O Sacred Head Now Wounded") which found its way to Ontario sometime after the 1830s.[14]

In the case of the Lincoln County examples, it would be but a small step to delete the reference to the music text and retain simply the decorative composition, thereby making a *Bild* out of what had formerly been a *Singbild*. All other elements in the composition remain intact, including the inscription as to owner and the symmetrical arrangement of floral and other motifs. All of this remains in the realm of speculation, of course.

All in All

Taking a group of stylistically related examples of Lincoln County fraktur, a number of interesting observations can be made with regard to influences and parallels. Not the least of these is that Lincoln County fraktur, even at a late date, reveals closer ties to the Bucks County background than to the contemporary fraktur production of Ontario's other Mennonite settlements in York and Waterloo counties. Although the case should not be over-stated, historical evidence indicates rather minimal contact among the three Ontario Mennonite communities during the first half of the nineteenth century. To be certain, fraktur in each of these three regions seems more reflective of Pennsylvania backgrounds than of interregional influences within Canada.

Within Lincoln County, the ghost of Eyer remains hauntingly present during virtually the entire 30-year period during which fraktur as an art form flourished in this particular region. There are early connections of the most immediate kind, as evident in the number of Eyer's pupils who were among the first settlers in the Vineland area, some of whom may well have become practicing artists in the Mennonite school in Lincoln County. By the 1820s and 1830s, this direct association may have begun to wane. Nonetheless, there is evidence of continuing travel back and forth even during these later years,[15] and Pennsylvania-born teachers such as Jacob and Samuel Moyer were to live on until 1833 and 1844 respectively. The spirit of Eyer's work specifically, and perhaps Deep Run fraktur generally, was to remain much in evidence. It would appear that Lincoln County artists utilized for their purposes a form no longer functional when they modified the decorative covers of *Vorschriften*-booklets and also those of music books, thereby producing pictures comprised of traditional decorative elements arranged in new contexts. In new skins, the old wine of Bucks County fraktur was preserved in Lincoln County well into the 1830s.

Notes

1. Cory M. Amsler, "Bucks County, Pennsylvania Fraktur," *Antiques* 153 (April 1998): 585.

2. Lewis J. Burkholder, *A Brief History of the Mennonites in Ontario* (Toronto: Livingstone Press, 1935), 30.

3. Cf. Frederick S. Weiser, "I A E S D: The Story of Johann Adam Eyer (1755–1837), Schoolmaster and Fraktur Artist with a Translation of His Roster Book, 1779–1787," in *Ebbes fer Alle-Ebber, Ebbes fer Dich/Something for Everyone—Something for You: Essays in Memoriam Albert Franklin Buffington*, in Publications of the Pennsylvania German Society 14 (1980): 482.

4. Ibid., 500.

5. Early Eyer examples illustrated in Weiser (n. 3) include 1783 and 1784 *Vorschriften*-booklet covers (456, 451).

6. Cory Amsler has pointed out that there are Pennsylvania artists, including David Kulp, who sometimes placed dots inside design elements. However, the device of external highlighting seems to be unique to Lincoln County.

7. Three are illustrated in Frederick S. Weiser and Howell J. Heaney, *The Pennsylvania German Fraktur of The Free Library of Philadelphia: An Illustrated Catalogue*, 2 vols. (Breinigsville, Pa.: Pennsylvania German Society, 1976), 2: figs. 841, 845, 854. These are dated 1792, 1780, and 1819, respectively.

8. Cf. fig. 28 in Michael S. Bird, *Ontario Fraktur: A Pennsylvania German Folk Tradition in Early Canada* (Toronto: M.F. Feheley Publishers, 1977), 49.

9. Weiser, "I A E S D," 453.

10. Ibid., 465.

11. Frederick S. Weiser, *The Gift is Small, The Love Is Great: Pennsylvania German Small Presentation Frakturs* (York, Pa.: York Graphic Services, Inc., 1994), 58.

12. Illustrated in Michael S. Bird, *Ontario Fraktur*, 60.

13. A piece by Eyer is shown in Weiser, "I A E S D," 470.

14. See Bird, *Ontario Fraktur*, 103.

15. Such continuing contact is evident, for example, in accounts of the Vineland weaver Samuel Frey (1812–1881), traveling to Bucks County in 1836 to undertake an apprenticeship for a year there, and of Bishop Jacob Meyer's 1833 visit to Bucks County (he died there and is buried near Hilltown).

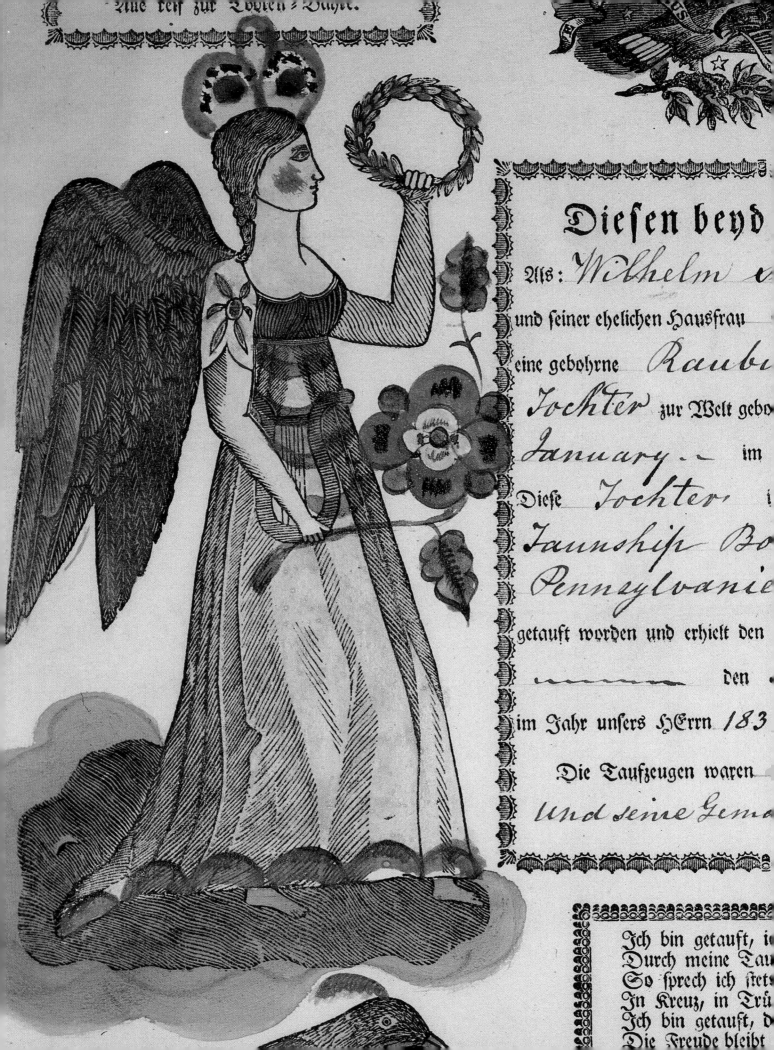

Diesen beyd

Als: Wilhelm e

und seiner ehelichen Hausfrau

eine gebohrne Raubi

Tochter zur Welt gebo

January im

Diese Tochter i

Taunship Bo

Pennsylvanie

getauft worden und erhielt den

—————— den

im Jahr unsers HErrn 183

Die Taufzeugen waren

Und seine Gema

Ich bin getauft, i
Durch meine Tau
So sprech ich stet
In Kreuz, in Trü
Ich bin getauft, d
Die Freude bleibt

Ausfullers und Dindamen: The Fraktur Scriveners of Bucks County

Russell D. Earnest and Corinne P. Earnest

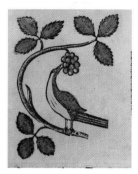

Traditionally, rural Pennsylvania-German families hired "scriveners," or professional penmen, to record personal data on *Taufscheine* (birth and baptismal certificates), in Bibles, on family registers, or on other types of genealogically significant records. Their writing skills were so greatly appreciated—and coveted—that these penmen of necessity turned to preprinted forms to keep up with demand. They were generally itinerant and they worked for hire. Thus, to fully understand them and their craft it is necessary to explore the commercial aspect of American fraktur, the printed forms available to the scriveners, and the remarkable penmanship used to record genealogical data for families of German heritage.

In his classic *The Fraktur-Writings or Illuminated Manuscripts of the Pennsylvania Germans,* Dr. Donald A. Shelley praised Bucks County Mennonite fraktur for its consistency in illumination and penmanship.[1] This consistency, found especially in bookplates, music books, religious texts, and writing exercises, makes attributions especially difficult, for Bucks County artists closely copied one another. But Bucks County *Taufscheine* are more typical of *Taufscheine* seen throughout southeast Pennsylvania. In this type of fraktur, attributions of works to the various artists and scriveners, although not foolproof, are easier to determine.

Bucks County has a long and important fraktur tradition, but that tradition is somewhat dissimilar to that of other fraktur-rich counties of Pennsylva-

nia. In areas settled predominantly by Lutheran and Reformed families, the *Taufschein* was by far the most common type of fraktur. But in Bucks County, especially in the eighteenth and early nineteenth centuries, much fraktur was made by or for Mennonites, who do not practice infant baptism. As a result, in Bucks the *Taufschein* competed with other fraktur forms, especially the decorated bookplates, manuscript tune books, and student writing exercises popular among the Mennonites. The higher percentage of these other types of fraktur that survive from Bucks County makes the region something of an anomaly.

Even in Lancaster County, with its significant Mennonite communities, the *Taufschein* dominated the early fraktur tradition. In fact, the popularity of *Taufscheine* throughout southeastern Pennsylvania (and beyond) owed much to printed fraktur first produced at Ephrata Cloister in northern Lancaster County in the last two decades of the eighteenth century. It can even be argued that the printed *Taufschein* from Ephrata brought standardization to the main text (especially the genealogical text) on German-American birth and baptismal certificates. For example, although some *Taufscheine* printed at Ephrata in the early 1780s failed to leave space for the mother's maiden name and even her given name, Ephrata printers quickly corrected this omission. And until late in the nineteenth century, printers of birth and baptismal certificates as well as artists making freehand *Taufscheine* followed Ephrata's lead and included space for the mother's given and maiden names. This is fortunate for family historians of Germanic heritage, for few

Fig. 124. **Birth and Baptismal Certificate for Heinrich Roth (b. June 17, —).** Printed by Enos Benner, Sumneytown, Montgomery County, Pa., 1836. Decorated and completed by an unidentified scrivener, Marlborough Township, Montgomery County, c. 1836. Printed, hand-colored and lettered on wove paper. 15³⁄₄ x 13 in. (Private collection.)

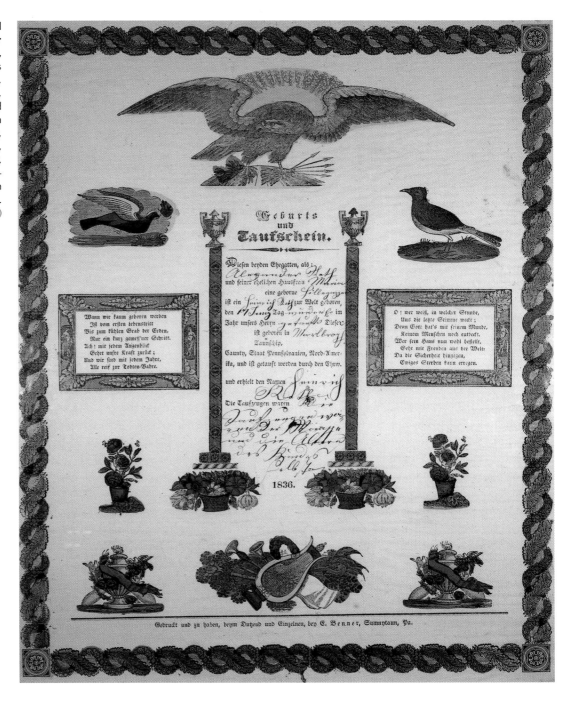

documents dating prior to the Civil War provide mothers' maiden names.

Using printed forms from Ephrata and elsewhere, highly influential artists and scriveners such as Henrich Otto (c. 1733–1799), Henrich Dulheuer (active c. 1780–1786), and Georg Friederich Speyer (active c. 1774–1801), among many others, marketed printed and freehand *Taufscheine* so effectively that they created a demand that would last into the twentieth century. It was at Ephrata Cloister that Otto and Dulheuer began ordering

printed birth and baptism certificates. Dulheuer was prolific in his brief fraktur career, yet he appears to have used printed forms exclusively. Many of these have decoration printed on them, and many appear to have been hand-colored by Otto. Thus, Dulheuer might be considered the first major American fraktur scrivener who simply infilled printed *Taufscheine*.

The *Taufschein* appears to be an American rather than European form. *Taufscheine* became especially popular following the American Revolution and

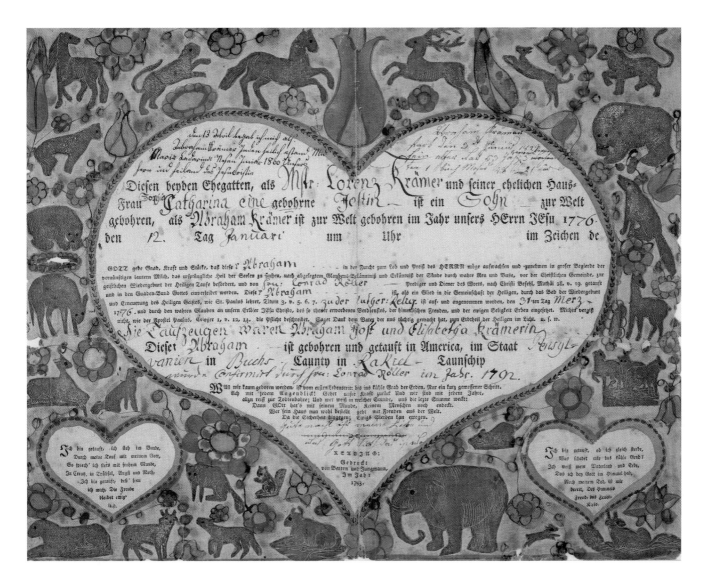

Fig. 125. **Birth and Baptismal Certificate for Abraham Krämer (b. 1776).** Printed by Barton and Jungmann, Reading, Pa. Decorated and completed by Friedrich Krebs (c. 1749–1815), Rockhill Township, Bucks County, c. 1793. Printed, hand-colored and lettered on laid paper with applied cutouts. 13¼ x 16 in. (Permanent Collection, Rothman Gallery, Franklin and Marshall College.)

were being printed by the early 1780s.[2] Thus, printed forms coexisted with freehand *Taufscheine*, and then came to dominate the market, eventually eclipsing freehand fraktur following the Civil War.

The density of Mennonite communities in Bucks County diminished the demand for *Taufscheine*. In fact, unlike most counties in southeast Pennsylvania, no printer of birth and baptismal certificates in Bucks County is known. Even Enos Benner, a printer in nearby Sumneytown, Montgomery County, apparently had a difficult time selling certificates and quit producing them after only two years, 1835–1836 (Fig. 124).[3]

Yet Friedrich Krebs, who worked after the Revolution until his death in 1815, found an eager market for his *Taufscheine* in Bucks County. This is especially curious since Krebs lived in Dauphin County, but appears to have made frequent trips to

Bucks County to sell certificates. Many of the forms he completed were printed in Reading, perhaps filling a void created by the lack of local prints.[4]

Krebs was probably the most prolific of all fraktur artists. Born about April 3, 1749 near Kassel, Germany, Krebs served as a Hessian soldier during the Revolution, but became a schoolmaster in Swatara Township, Dauphin County, following the War. He died probably in July 1815 after a long fraktur career spanning the years 1785 through 1815.[5] Krebs is well known for his freehand fraktur, especially *Taufscheine* and secular drawings. But he may have decorated and infilled more printed fraktur than any other artist—especially his contemporaries. Between 1801 and 1813, Krebs purchased 6,974 printed *Taufschein* forms from the Adler printing office in Reading.[6] Even though he lived and taught in Dauphin County, he made more

181

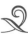

Fig. 126. **Birth and Baptismal Certificate for Samuel Laux (b. 1813).** Printed by H. Ebner and Co., Allentown, Pa. Decoration and lettering attributed to David Kulp (1777-1834), Bedminster Township, Bucks County, c. 1813. Printed, hand-colored and lettered on wove paper. 16 x 13 in. (Private collection.)

decoration became necessary. The Reading printers from whom Krebs purchased his forms had alleviated the artist's workload by printing much of the repetitive devotional text. Krebs needed only to fill in the appropriate genealogical information. During most of Krebs's working career, Reading's press operators did not print the decorative elements on certificates, so there was still the need to embellish around the text. Thus, Krebs was probably looking to keep up with demand using multiple shortcuts—first by purchasing printed texts, then by decorating them with stamps and cutouts.

Much of the scholarship concerning Bucks County fraktur has focused on the artists who made writing exercises, bookplates, religious texts, and music books. Accordingly, artists responsible for these types of fraktur, especially Johann Adam Eyer, Andreas Kolb, and David Kulp, have received the most attention. But a comprehensive evaluation of Bucks County fraktur is uncovering many important artists and scriveners that have been previously overlooked, including Anthony Rehm, Bernhard Misson (formerly the B.M./Durham Township Artist), Elisabeth Dieterly, Johannes Mayer, and the so-called Dotted One Artist. Recent research shows many of these artists both prepared freehand fraktur *and* infilled printed *Taufscheine*, so lines remain blurred as to who was an artist and who was simply a scrivener. Elisabeth Dieterly completed printed certificates as did David Kulp and other major artists. And documented works by individuals such as Krebs and the Dotted One Artist remain about half freehand and half printed examples.

Shelley indicated the Mennonite School of fraktur ended about 1856.[7] But as scholars, including Shelley, have found, such specific dates can be misleading. There was always a persistent enclave of German Americans practicing their art long after the form supposedly became extinct. Indeed, the homogeneous character of Bucks County fraktur evolved as tastes and the demographics of Bucks County evolved. The hand-drawn songbook became a quaint relic of the past. The modern resident of the county was more interested in an ornate printed birth and baptismal certificate that could be hung in the Victorian parlor.[8] Even Mennonite families used these forms, leaving the date of infant baptism blank, or recording instead an adult baptism. And all families, whether Lutheran, Reformed, or Mennonite, wanted entries

fraktur for residents of Bucks County than Dauphin County. Virtually all of Bucks County's northern townships are represented in Krebs's certificates, including Richland, Haycock, Hilltown, Nockamixon, Bedminster, Rockhill, Tinicum, Milford, and Springfield.

Luckily for scholars, Krebs's handwriting and decoration was distinctive, though his style evolved significantly over time. He is one of the few major fraktur artists who cut out brocade-decorated paper designs and pasted them on his fraktur (Fig. 125). He also hand-stamped design elements such as flowers, birds, and mermaids on what at first glance appear to be freehand fraktur. It is important to recognize he used these techniques not only to enhance decoration, but to expedite production. The more decoration he printed or pasted onto his forms, the less hand

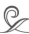
made in the family Bible in the fashionable handwriting of the day. By the middle of the nineteenth century, the printed birth and baptismal certificate ruled the day.

So, who were these craftsmen, skilled in the art of the fraktur lettering, who took up where the Eyers and Kulps supposedly left off? Research is revealing that many major freehand artists, such as Krebs, completed printed certificates for clients. If the fraktur artist lived during the reign of the printed form, especially after 1800, his or her hand should be looked for on printed birth and baptismal certificates.

Recent research has revealed that David Kulp, a student of Johann Adam Eyer, was one of Bucks County's most important fraktur artists. The work by Joel Alderfer and John Ruth indicates the artist previously known as the Bucks County Brown Leaf Artist and the Music Book Artist was, in fact, David Kulp (1777–1834).[9] Kulp apparently spent his entire life in Bedminster and Plumstead Townships. He served his community as schoolmaster, tax assessor, weaver, and scrivener. Although his freehand fraktur is becoming well documented, there is strong evidence that he also infilled printed birth and baptismal certificates (Fig. 126). This is somewhat unusual for a Mennonite, but Kulp did serve his community much like today's notary public. Therefore, he provided writing services for non-Mennonites, so it should come as no surprise he was hired to record genealogy data on *Taufscheine*.

The early fraktur artists were, with few exceptions, schoolmasters. In the second quarter of the nineteenth century, as more and more children went to English-language public schools, the need for the rural German schoolmaster diminished. Concurrently, printed *Taufscheine* were becoming fashionable, as was the Bible with the family name in gilt on the cover and an extensive family register bound between the Old and New Testaments. Most people could have filled in the genealogical data themselves, of course, but the extraordinary handwriting of the itinerant scrivener was greatly prized—to such an extent that some penmen charged $0.15 per word or phrase. Throughout the nineteenth century, German remained the first language of many rural households of southeastern Pennsylvania, so there was a great need for penmen, literate in German, to infill genealogical data on *Taufscheine* and in Bibles. The professional penman, the *Ausfuller* (literally,

Fig. 127. **Birth and Baptismal Certificate for Lidÿ Ana Fünck (Flück) (b. 1831).** Printed by Gräter and Blumer, Allentown, Pa. Decorated and completed by Francis Levan (d. 1850), Haycock Township, Bucks County, c. 1832. Printed, hand-drawn and lettered on wove paper. 13 x 16½ in. (Archives of Franklin and Marshall College.)

filler outer), rose to the occasion.

Initially by foot or horseback, then by buggy and eventually by train, the scrivener scoured the rural Pennsylvania countryside. With few exceptions, such as David Kulp, the professional penman did not serve as a local scribe writing official documents, such as indentures, deeds, wills, and other legal papers. Instead, the fraktur scrivener infilled *Taufscheine* and Bibles and many drew and decorated small watercolors as gifts for children. In other words, they created personal, not official, documents.

Francis D. Levan was typical of the nineteenth-century itinerant penman of southeastern Pennsylvania. He purchased printed *Taufscheine*, decorated them with watercolors, sometimes infilled them,

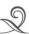

and sometimes sold them blank to other scriveners or to families anticipating eventual additions to their clan. As was typical of these itinerants, he ranged over several counties.

What was atypical about Levan is the number of errors he made on *Taufscheine*. Most scriveners were remarkably accurate in recording data—except for the family names they spelled phonetically—and they penned their words with no unsightly ink blotches. But Levan made frequent errors, most of which he simply scratched out, writing the correct data above. On a *Taufschein* he completed for Lidÿ Ana Flück, he correctly recorded the family name as Flück, but then wrote her name as Lidÿ Ana Fünck (Fig. 127).

Levan purchased most of his printed *Taufscheine*

Fig. 128. **Birth and Baptismal Certificate for Noah Ott (b. 1865).** Printed by Ritter and Co., Reading, Pa. Completed by Martin Wetzler, Bedminster Township, Bucks County, c. 1865. Printed and hand-lettered on wove paper. 17 x 14 in. (Spruance Library/Bucks County Historical Society, SC-58. No. B-36.)

Fig. 129. **Birth and Baptismal Certificate for Aelles Sähre [Alice Sarah] Hoffman (b. 1868).** Printed by E. D. Leisenring, Allentown, Pa. Decorated and completed by Martin Wetzler, Perry Township, Berks County, Pa., c. 1868. Printed, hand-colored and lettered on wove paper. 17 x 14 in. (Private collection.)

directly from Johann Ritter at the Adler Press in Reading. He then hand-colored and decorated them in bold, flashy color schemes. He added zany touches including fancy headdresses on the angels, bows on their shoes, tufts on the heads of birds, and more. He gaily colored the angels' gowns in a riot of colors and patterns—especially polka dots that make the gowns seem as if they are studded with sequins.

Levan was reportedly an alcoholic and he had trouble paying for his prints. The clerk at the Adler (which later became the Eagle Book Store) in Reading eventually gave up trying to collect from Levan and recorded beside his name, *"Gut fer Nichts,"* or "Good for nothing."[10] After a prolific fraktur career that began about 1826, Levan died in 1850 near Kutztown.

One of the most interesting of the scriveners was the Jewish *Dindamann*—Jewish Penman—Martin Wetzler. Although little is known of Wetzler's life, he is one of the few fraktur practitioners of which we have an eyewitness account. Henry Hagey reported that Wetzler slept on his family's porch in the summer and probably in the *"Beddle-mans* Bed" (peddler's bed) in the garret in the winter.[11] Wetzler

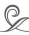

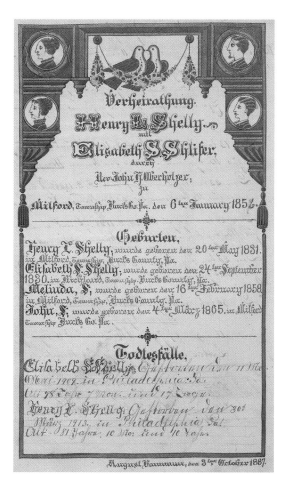

Fig. 130. **Family Record of Henry L. Shelly (b. 1831) and Elisabeth S. Shlifer (b. 1830).** In Bible printed by Emanuel Thurneysen in Basel, Switzerland, 1778. Decorated and completed by August Baumann, Milford Township, Bucks County, 1887. Hand-drawn, lettered and colored on paper. 14½ x 9¾ in. (Mennonite Heritage Center, Harleysville, Pa., 89.16.1c.)

was active about 1854 through 1888 and apparently walked from job to job. He may have committed suicide. The Jewish *Dindamann* worked in Bucks, Montgomery, Lehigh, Berks, and Schuylkill Counties.

Since Wetzler knew German, English, and Hebrew, he may have been better educated than some of his clients. He decorated as well as infilled birth and baptismal certificates and Bibles. Wetzler was prolific, and more than any other scrivener, he seemed able to convince clients they ought to find their existing *Taufscheine* so he could add genealogical data to them. Naturally, this marketing technique added to Wetzler's income. But it also meant families had to hunt through dresser drawers, in chests, or in their Bibles, or had to take the *Taufschein* off the wall and remove it from the frame

for Wetzler to add information. Thus, besides being collectible for the sometimes folky slap-dash way he applied dots and dashes in green and lavender to printed forms, he is a genealogist's delight for the added information regarding confirmation, marriage, and death. His writing hand was large and somewhat clumsy, and if it were not for the way he made his lower case *d* backward, it was legible. Wetzler used the Star of David more than any other fraktur artist or scrivener. He often signed his name in Hebrew and purchased most of his prints in Allentown (Figs. 128, 129).

A native of Hungary, August Baumann was a prolific scrivener of whom we also have eyewitness accounts. He did most of his traveling by train and tended to work in towns as opposed to tramping

Fig. 131. **Marriage Record of Nelson K. Leatherman and Lizzie Fretz (m. 1874).** In Bible printed by Thayer, Merriam & Co., Philadelphia, 1873. Decorated and completed by August Baumann, Doylestown, Bucks County, 1882. Hand-drawn, lettered and colored on paper. 11⅝ x 8⅞ in. (Spruance Library/ Bucks County Historical Society, SC-10. B-277.)

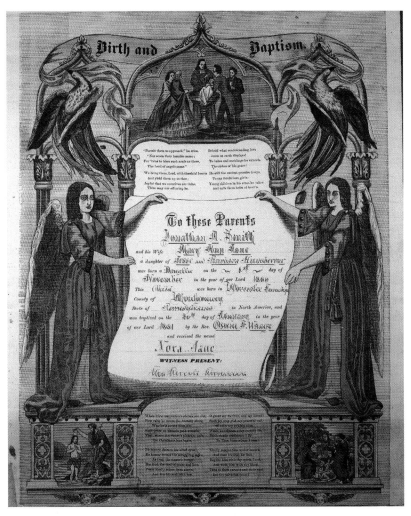

Fig. 132. Birth and Baptismal Certificate for Nora Jane Smith (b. 1880). Print attributed to Edmund Leisenring and Benjamin Trexler, Allentown, Pa. Lettering attributed to Christian G. Hirsch, Worcester Township, Montgomery County, c. 1881. Printed and hand-lettered on paper. 17 x 14 in. (Private collection.)

sweeping, and included a broad repertoire of writing styles, all expertly executed, usually in a crimson ink (Figs. 130, 131).

Christian G. Hirsch represents the best and the worst of the professional penmen. Like most scriveners, Hirsch knew German and English, and his hand could be extraordinarily beautiful in either language. Yet for some inexplicable reason, on several known English certificates, he decorated his letters to such an extent they are illegible. Some of his certificates appear as if he recorded data on top of existing infill, making much of it indecipherable (Figs. 132, 133).

Hirsch was active about 1875 to 1901, working for Bucks County families in Rockhill, Haycock, Hilltown, Bedminster, and New Britain Townships. He also labored in Berks and Montgomery Counties.[14]

Bucks County scriveners, as was true of almost all of the penmen, were artists as well. Many were active throughout the Victorian era and their work reflects the style of the day. Therefore, their artwork was usually not the Dutchy birds, hearts, flowers, and angels so common before 1840. Instead, it tended toward finely executed sprays of leaves and flowers in mixed colors as opposed to the earlier solid red, yellow, and green. In the scrivener's day, pink and

across the countryside. He was known to be an honest man whose "shoes always shone like a mirror."[12] He was active in southeastern Pennsylvania from about 1879 to 1905. He created family registers with architectural details. On these, his writing, in German and English, could be so exact the letters appear chiseled in stone. Somewhat atypical for a scrivener, he also painted signs for storefronts.[13] More than just a scrivener, Baumann was also an artist. He made lifelike drawings, in profile, of people on his *Taufscheine* and Bible records. Some have suggested the drawings were of the individuals for whom the certificates and Bibles were inscribed. However, many of his drawings have similar features, especially a Roman nose. Baumann drew hair so exactly that individual strands may be seen in the curls. His writing hand was large and

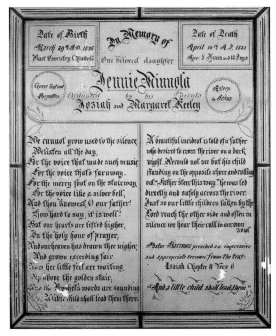

Fig. 133. Memorial Certificate for Jennie Minnola Keeley (1876–1881). Christian G. Hirsch, East Coventry, Chester County, c. 1881. Hand-drawn and lettered on paper. 13 x 16¼ in. (Private collection.)

lavender and aqua blue crept onto the artist's palette. Unlike most early fraktur artists, they became adept at shading, giving more depth to their work.

The professional penmen brought the art of handwriting to its zenith on *Taufscheine* and Bible records of the late nineteenth century, only to be replaced by simple cursive writing and eventually the typewriter. As America entered the twentieth century there was no longer an appreciation for penmanship, or at least not enough appreciation for the rural Bucks County family to pay a scrivener to write in a Bible. Instead, family members recorded the data themselves. And the omnipresent *Taufschein* with its flanking angels evolved to printed forms where the printer increasingly took over the design. These prints became tokens or souvenirs such as church member-ships and cradle rolls, often filled out by the preacher in a plain script.

As discussed, Bucks County scriveners could not buy their *Taufscheine* from a printer in Bucks County, but they did purchase prints from Northampton County printers in Easton, Allentown (in Lehigh County after 1812), and Bath, and perhaps at bookstores in the larger towns of Bucks County. At their first visit to a community, they would visit the undertaker and the preacher. The undertaker could tell them who died (a Bible entry) and the preacher could tell them who was born (a *Taufschein* cus-tomer). Then, as the penman headed toward the addresses of prospective customers, he would knock on doors offering his services. Very often the German farmer had tucked slips of paper in the family Bible. Recorded on them, in the layman's plain writing, were major family events of the past several months. The scrivener copied the data from these slips of paper—marriages, deaths, births, baptisms, dates of confirmation—and recorded data in an exceptional hand in the Bible, or if appropriate, on *Taufscheine*. Once the scrivener had a string of clients, he would visit them on a regular basis, the same as other peddlers of his day. In Bucks County, it was not uncommon for the frakturist to come from great distances, as in the case of Friedrich Krebs, to draw *Taufscheine* by hand or infill printed certificates.

Because few American fraktur were signed by the artist, scholars often turn first to visual cues to identify the freehand works of an artist. Decorative motifs, format, color, technique, and handwriting all must be considered to properly attribute unsigned works. The same is true for identifying the work of scriveners on printed forms. The form and origin of

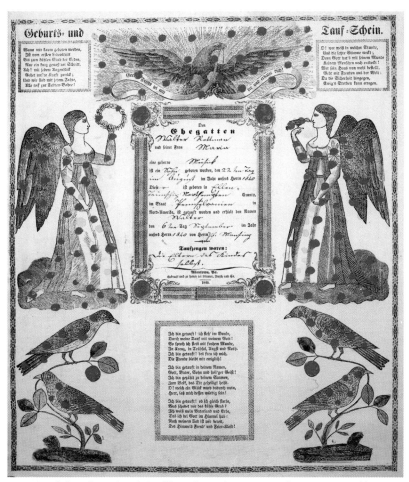

Fig. 134. **Birth and Baptismal Certificate for Walter Rottman (b. 1840).** Printed by Blumer, Busch and Co., Allentown, Pa. Decoration and lettering attributed to Conrad Kresh, Allen Township, Northampton County, c. 1849. Printed, hand-colored and lettered on wove paper. 17¹/₈ x 14 in. (Private collection.)

the prints themselves are often the first clues leading to identification. They serve as a preliminary screen, while analysis of the handwriting then confirms attributions. For example, Conrad Kresh preferred the immensely popular angel-type Allentown prints with angels in profile. He also favored German-rather than English-language prints. He either hand-colored these prints himself, using red and yellow polka dots, or he selected ones decorated in this manner (Fig. 134).

Although there is some question as to this scrivener's last name (it might be Kress or Kresge), Conrad Kresh is one of the most recognizable artists on printed certificates. Anyone who has carefully studied fraktur eventually notices the angel-type prints decorated with red and yellow polka dots. Most of these certificates were infilled by Kresh in plain German script as opposed to decorative fraktur lettering.[15] Kresh was active about 1842 to 1865 and

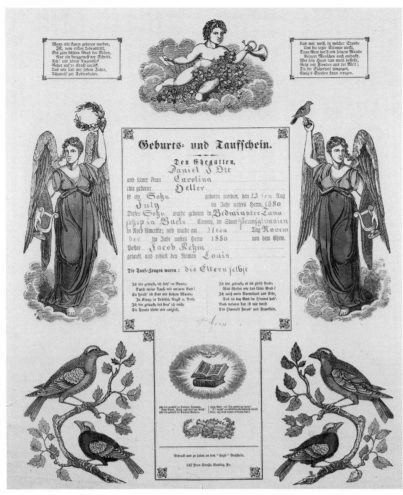

Fig. 135. **Birth and Baptismal Certificate for Louis Ott (b. 1880).** Printed by the Eagle Bookstore, Reading, Pa. Decorated and completed by William Gross, Bedminster Township, Bucks County, c. 1880. Printed, hand-colored and lettered on wove paper. 17 x 14 in. (Spruance Library/Bucks County Historical Society, SC-58. No. B-37.)

ink. While Gross preferred this red ink, Victorian tastes had changed and were leaning toward lavender, violet, and other shades of purple. Gross on occasion met this demand (Fig. 135).

Little is documented regarding William Gross, the penman, but it is possible he was William Gross the poet. Gross the poet was a Mennonite born near Fountainville, Bucks County, on March 2, 1839, and died in 1913. He married Anna Godshalk and they had nine children.[17]

John Henry Heins favored certificates printed by John Dreisbach in Bath. Most of Heins's customers asked for German prints, but Heins seemed comfortable with both the German and English languages. Dreisbach's prints are among the most handsome of angel-type *Taufscheine*. Heins may have preferred them because he used a printing process to insert the genealogical text, and had fonts that blended well with the typefaces used by Dreisbach. Heins often signed his certificates (in printed type), but even if he had not, his infill can be recognized by the care he took to match his typefaces with those on the print (Figs. 136, 137).

Other *Taufschein* peddlers used presses to record data on printed certificates and even in Bibles, but

Fig. 136. **Birth and Baptismal Certificate for Horace Sylvester Swope (b. 1863).** Printed by Theo F. Sheffer, Harrisburg, Pa. Completed by John Henry Heins, Tinicum Township, Bucks County, c. 1864. Printed with added type on wove paper. 17 x 15¼ in. (Spruance Library/ Bucks County Historical Society, SC-58. No. B-46.)

may have resided near Allentown where he purchased his forms. He completed *Taufscheine* for families in Milford and Springfield Townships, Bucks County, and for families in nearby Upper Milford Township, Lehigh County.

As printers took over certificate design, including color, scriveners had only to complete the forms. Some welcomed this development. For example, William Gross (active 1861–1884) appears to have avoided decorating prints, preferring the color lithographs of Allentown printers Eli Saeger, Edmund Leisenring, Benjamin Trexler, and Wilhelm Hartzell.[16]

Gross was prolific and signed most of his certificates. He was also one of the most traveled fraktur scriveners, ranging across Lebanon, Lehigh, Berks, Northampton, and Montgomery counties, as well as Bucks. His writing hand, in German and English, is legible and almost always written in red

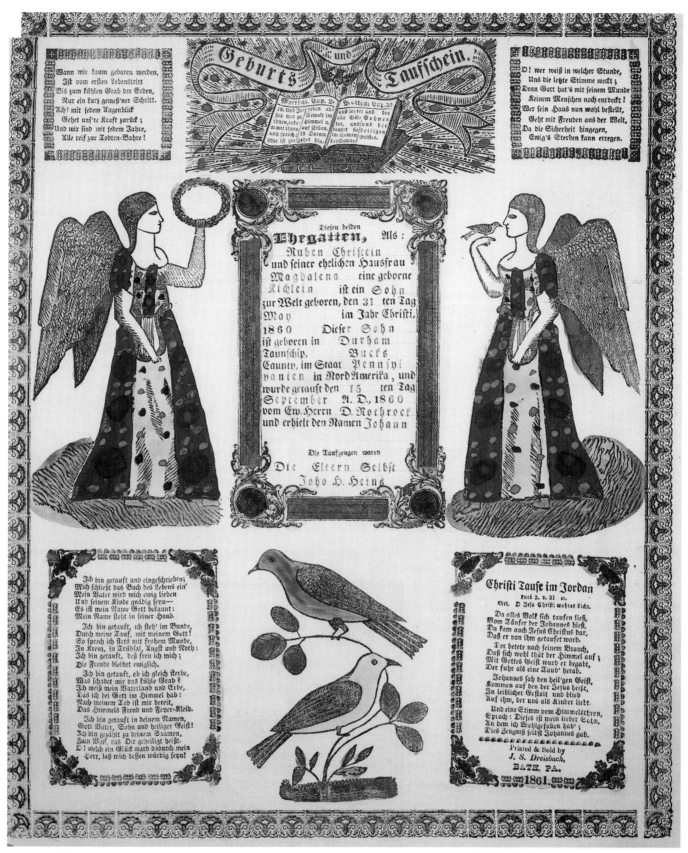

Fig. 137. **Birth and Baptismal Certificate for Johann Christein (b. 1860).** Printed by John Dreisbach, Bath, Northampton County, Pa. Decorated and completed by John Henry Heins, Durham Township, Bucks County, c. 1861. Printed and hand-colored, with added type on wove paper. 17 x 13⁷/₈ in. (Private collection.)

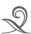
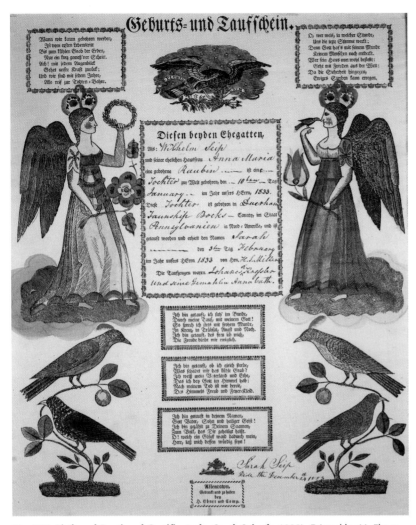

Fig. 138. **Birth and Baptismal Certificate for Sarah Seip (b. 1833).** Printed by H. Ebner and Co., Allentown, Pa. Decoration and lettering attributed to the Dotted One Artist, possibly Henry Wetzel, Durham Township, Bucks County, c. 1833. Printed, hand-drawn, colored and lettered on wove paper. 17 x 14 in. (Private collection.)

Heins was the most prolific of the printer infillers. He worked primarily in Bucks and Northampton Counties from about 1850 to 1878. Heins completed certificates for families in Nockamixon, Bedminster, Tinicum, and Durham Townships, and continued his fraktur activities throughout the Civil War—a time when most fraktur production slowed.

Completing certificates and family records using a printing technique must have been labor intensive. It would have been far simpler to pick up a pen and write the data. Heins probably printed infill line by line, but to achieve the correct spacing so that data fell within the blanks must have taken considerable time and skill. Moreover, this technique raises the question of how Heins accomplished this type of infill. Scrivener David Hinkel (active c. 1879–1898) worked north of Heins in Northampton County. He, too, printed infill as did a few other scriveners. Hinkel appears to have remained somewhat stationary, but Heins worked in Monroe, Northampton, and Bucks Counties. Most late scriveners were itinerant, so that is not surprising. What is surprising, however, is the yet unanswered question of how or if Heins carried with him a small printing press.

The Dotted One Artist, who has been tentatively identified as Henry Wetzel, was active between 1813 and 1845.[18] A review of his known Bucks County works indicates he worked primarily in the townships of Nockamixon and Tinicum, probably between 1813 and 1835. He also made fraktur in Berks, Montgomery, Lehigh, and Northampton

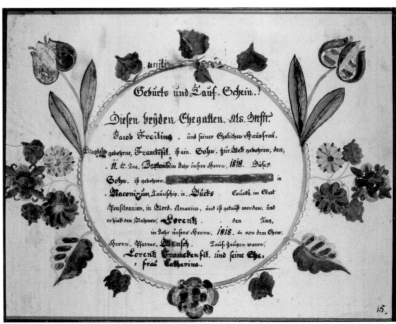

Fig. 139. **Birth and Baptismal Certificate for Lorentz Freiling (b. 1818).** Attributed to the Dotted One Artist, possibly Henry Wetzel, Nockamixon Township, Bucks County, c. 1818. Hand-drawn, lettered and colored on wove paper. 12½ x 15½ in. (Private collection.)

Counties (Fig. 138).

The Dotted One Artist can be recognized by his small, cramped writing style, his fancy capital *H*, and the dots he placed over numeral ones, although he was not the only artist to use the latter device. The Dotted One Artist presents an exception to the process of identifying an artist's work by the prints he used.[19] Like Krebs who made freehand fraktur and decorated and infilled prints, this artist/scrivener had his foot in both camps. Half his production were prints and the other half freehand.

The Dotted One Artist occasionally made errors in text. He corrected them by painting a wide band of red ink over the error, which usually served to highlight rather than conceal it. On one known example, he charged 0.15^{1/2}$ for a full-size fraktur. Full-size fraktur during his time usually cost about $0.25, so he may have discounted the *Taufschein* because of the error (Fig. 139).

Perhaps more than most other fraktur scriveners in southeastern Pennsylvania, the Dotted One Artist enjoyed variety. In his freehand work, this artist varied formats using circles, columns, or drapes to frame text. He drew potted flowers, roosters, and other fraktur motifs in a realistic as opposed to folky style. Again, perhaps to achieve variety, he oriented these works horizontally and vertically, and he used a variety of paper sizes. For printed forms, he selected three-heart and angel-type prints from Reading, Allentown, Easton, and beyond (Fig. 140).

Fig. 140. **Birth and Baptismal Certificate for Jacob Kohl (b. 1810).** Printed by H. & W. Hütter, Easton, Pa. Decoration and lettering attributed to the Dotted One Artist, possibly Henry Wetzel, Nockamixon Township, Bucks County, c. 1822. Printed, hand-drawn, lettered and colored on wove paper. 11$^{1/2}$ x 15 in. (Private collection.)

Sometimes he decorated the prints, but at other times he did not. Thus, scholars must be able to recognize his penmanship rather than rely on his freehand art or the print for identifying his works.

The Dotted One Artist, like Krebs, apparently knew little English or did not seem comfortable writing in English. A certificate is known in which he recorded data in German on an English print.

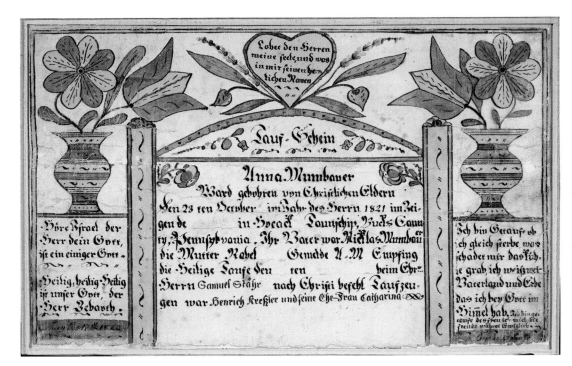

Fig. 141. **Birth and Baptismal Certificate for Anna Mumbauer (b. 1821).** Attributed to Bernhard Misson, Haycock Township, Bucks County, 1822. Hand-drawn, lettered and colored on wove paper. 8 x 12$^{3/4}$ in. (Private collection.)

191

This was unusual, for most scriveners matched the language of the infill with the language of the printed form.

Despite the uniformity printed forms brought to American fraktur, each *Taufschein* is nonetheless unique and teaches us something. The forms and the scriveners who used them demonstrate that in Bucks County, as in other counties throughout southeastern Pennsylvania, there existed a demand for *Taufscheine*. This was true even in a county where Mennonite communities abounded. Although no local printer seemed to think the market for *Taufschein* forms was economically viable, scriveners did find work here. To facilitate production, they simply brought their printed forms with them.

By understanding the sources from which scriveners obtained their prints and the types of prints they were likely to use, researchers have a greater understanding of the body of work of each scrivener. As noted, printed forms offer the same visual clues freehand decoration offers. In his study, *The Printed Birth and Baptismal Certificates of the German Americans*, Professor Klaus Stopp identified more than 1,200 variants of printed American *Taufscheine*.[20] Stopp brought organization and understanding to what seemed a hopeless maze of printed forms. Through his careful cataloguing, patterns have developed. One pattern that has emerged is that scriveners' work on Bucks County printed fraktur is most commonly seen on forms printed in Easton up to about 1815, Allentown from about 1814 to the end of the century, Bath about the mid nineteenth century, and Philadelphia in the second half of the nineteenth century. There are exceptions, however, such as the Dotted One Artist who purchased forms from Reading as well as in Easton and Allentown, and Krebs who probably stopped in Reading on his way from Dauphin County to purchase prints for use in Bucks County.

As mentioned, the penmanship of major freehand artists who worked after 1800 should be looked for on printed birth and baptismal certificates. For example, it would be surprising if Bernhard Misson, formerly the so-called B.M./ Durham Township Artist, did not use printed forms. He had already taken a first step toward maximizing production by preparing *Taufscheine* in advance of using them. His freehand examples are often written in two different inks, demonstrating that the infill was added to the *Taufschein* later (Fig. 141). This practice was common among fraktur artists. Either these artists preferred their own compositions over the printed forms, they lacked access to printed forms, or—the most likely scenario—they made fraktur in advance to speed production. The next logical step after making certificates in advance was to utilize printed forms. This certainly seems to be the case of the prolific artist, Friedrich Krebs, who first made freehand fraktur in which he often hand-stamped certain design elements, and then came to rely heavily on printed forms.

The mix of German peoples who settled Bucks County in the eighteenth century had an impact on the county's fraktur tradition. A demand for birth and baptismal certificates existed in Bucks, but the preprinted certificates had to be purchased elsewhere, especially from presses in Easton, Allentown, Bath, and later Philadelphia. Gradually, changes in social values, technologies, and the decline of German as a first language saw fraktur evolve from freehand to printed forms to souvenir tokens given by pastors to church members to show rites of passage. Thus, family birth and baptismal certificates migrated from the walls of the parlor to the attic, alongside the old German Bible. Some would claim that the American fraktur tradition suffered a decline late in the nineteenth century. It might be more accurate to say that fraktur evolved into other forms, and that German-America's appreciation for it declined.

But by the end of the nineteenth century, when interest in fraktur was on the wane, came Henry Mercer, one of the first to treat the decorated manuscripts as a serious art form. With Mercer, the appreciation for fraktur began a resurgence, so that one hundred years later more is being written on the subject than ever before. American fraktur is being mined as a primary source for genealogical data and modern practitioners and revivalists are springing up across the country. Today, fraktur is a staple in major folk art collections, just as it is a staple in publications on American folk art. After beginning as a simple form of self-expression among Pennsylvania Germans, fraktur assumed a position of status both as an art form and as personal documentation of the lives of Americans of German heritage.

Notes

1. Donald A. Shelley, *The Fraktur-Writings or Illuminated Manuscripts of the Pennsylvania Germans* (Allentown, Pa.: Pennsylvania German Society, 1961), 112.

2. Klaus Stopp, *The Printed Birth and Baptismal Certificates of the German Americans*, 6 vols. (Mainz, Germany and East Berlin, Pa.: by the Author, 1997–2001). See especially vols. 1 and 2 for discussions concerning early printed birth and baptismal certificates among German Americans.

3. Ibid. See vol. 5.

4. Russell D. Earnest and Corinne P. Earnest, *Papers for Birth Dayes: Guide to the Fraktur Artists and Scriveners*, 2nd ed., 2 vols. (East Berlin, Pa.: Russell D. Earnest Associates, 1997), 1:460–467. The Earnests list numerous examples of Krebs's *Taufscheine*. Their inventory of 240 of his works suggests that, though he lived in Dauphin County, he made more examples for Bucks County families than for those in Dauphin.

5. Frederick S. Weiser, "'Ach wie ist die Welt so Toll!' The mad, lovable world of Friedrich Krebs," *Der Reggeboge: Journal of the Pennsylvania German Society* 22 (no. 2, 1988): 49–88.

6. Stopp, *Printed Certificates*, 1:41.

7. Shelley, *Fraktur Writings*, 107.

8. Over many years of study, the authors have observed that a large number of these later nineteenth century printed certificates remain in what are quite obviously their original, period frames.

9. John L. Ruth and Joel D. Alderfer, "David Kulp, His Hand & Pen: The 'Brown Leaf Artist' Identified?" *Mennonite Historians of Eastern Pennsylvania Newsletter* 22 (January 1995): 4–9. Also in the same journal see Joel D. Alderfer, "David Kulp, His Hand and Pen, Beet it if You Can: Schoolmaster David Kulp of Deep Run, the Brown Leaf Artist Identified" 23 (January 1996): 3–6.

10. Alfred L. Shoemaker, "Good fer Nichts," *The Pennsylvania Dutchman* 1 (April 1950): 4.

11. Henry D. Hagey, *Some Local History of Franconia Township* (Souderton, Pa.: 1979), 57–58.

12. Frances Lichten, *Fraktur: The Illuminated Manuscripts of the Pennsylvania Dutch* (Philadelphia: The Free Library of Philadelphia, 1958), 18.

13. One of these store signs, in the collection of Lester Breininger of Robesonia, Pa., was displayed at the 1997 fraktur exhibit, "The Prints and the Penmen," at the Heritage Center Museum in Lancaster, Pa.

14. Josh Reeder, a student of nineteenth– and early twentieth-century fraktur scriveners, is currently studying Christian G. Hirsch in anticipation of publishing an article about his life and works.

15. Most professional scriveners used fraktur lettering on their *Taufscheine*. Fraktur is a decorative Germanic lettering somewhat comparable to Old English Gothic. In manuscript form, it is an angular style of hand-printing in which the pen is lifted between each character of the alphabet. Unlike many other scriveners, Conrad Kresh used German script (or cursive writing) as opposed to fraktur lettering. Script is a faster way of writing in which characters of the alphabet are strung together with ligatures to form words. Only between words is the pen lifted from the page. As is true in any written language, legibility is sacrificed to speed in cursive writing. Kresh's reason for using script is unknown. Late in the nineteenth century, many families began filling out their own *Taufscheine*, usually in plain script, and gradually, the beautiful fraktur lettering of earlier times all but disappeared.

16. See, for example, Stopp, *Printed Certificates*, 1:219, 238.

17. Elizabeth L. Gross, "Poet William Gross," *The Pennsylvania Dutchman* 4 (January 15, 1953): 12.

18. Cory M. Amsler, "New Discoveries in Bucks County Fraktur," paper presented at a symposium on Bucks County fraktur, Mercer Museum, Doylestown, Pa., October 25, 1997.

19. Earnest and Earnest, *Papers for Birth Dayes*, 1:197–199. The list of the Dotted One Artist's works indicate about half his production was freehand, the other half printed forms.

20. Prior to Stopp's monumental study, to be completed in six volumes by the year 2001, it was thought that fewer than 500 printed variants of American *Taufscheine* existed. Stopp's study has more than doubled this estimate. Due to short print runs of *Taufscheine*, many of these prints, such as those of Enos Benner, are quite rare.

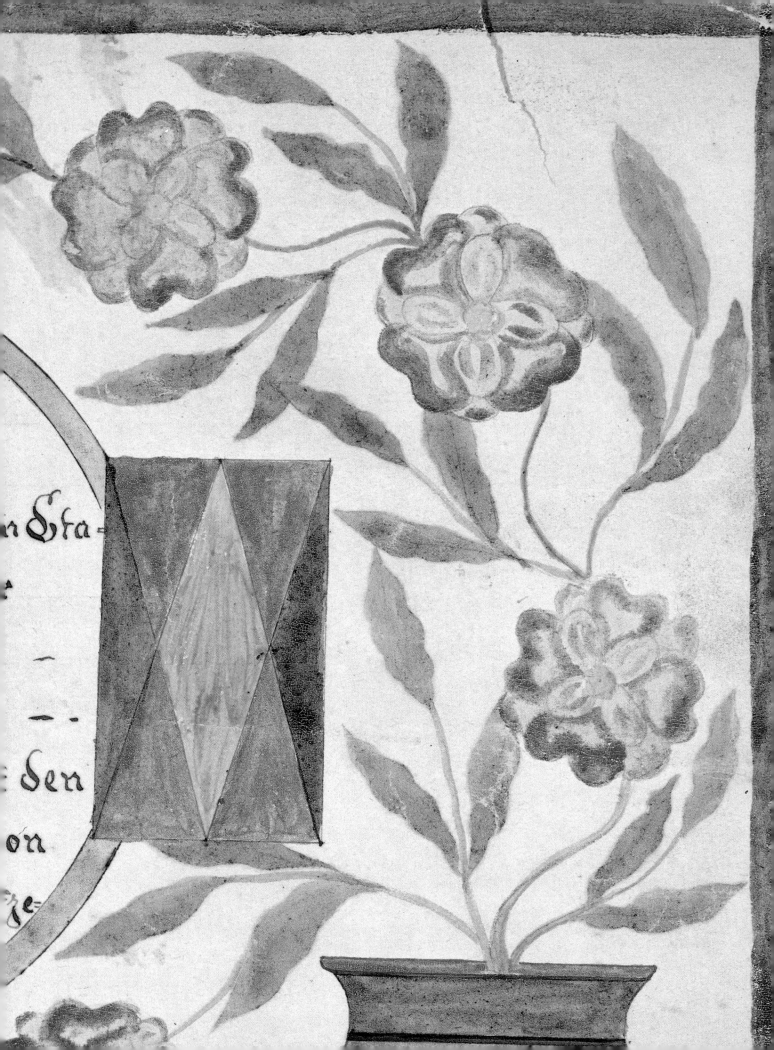

Bucks County Fraktur: A Catalogue and Guide to the Artists

Cory M. Amsler

When Henry Mercer first initiated his search for fraktur in 1897, he did not have to look far. In the northern townships of Bucks County, settled in the eighteenth century by land-hungry German and Swiss immigrants, numerous examples of the manuscript art form survived. Although many of the pieces first collected and documented by Mercer had originated in Bucks County's Mennonite communities, he realized that the fraktur tradition also had flourished among Lutheran and Reformed peoples, especially as embodied in the *Taufschein*, or baptismal certificate. He further understood that it had been teachers in the privately supported, parochial education system in the Pennsylvania-German community that had helped to perpetuate fraktur, and that the establishment of publicly funded, English language common schools by the 1850s had aided in its demise.

The names of few of these schoolteachers and fraktur artists were known to Mercer. Although he had heard that "a great teacher named Ayer or Oyer" had once produced fraktur in Mennonite schools at Deep Run and Hilltown, it would be many more years before the career of John Adam Eyer would be fully illuminated.[1] Neither was Mercer aware of Johannes Spangenberg, once known as the Easton Bible Artist, whose prolific work sometimes spilled over the border from Northampton into Bucks County.[2]

Indeed, many of the schoolteachers and itinerant scriveners who produced fraktur lived on the margins of Pennsylvania-German society. Minimally

respected, perhaps, for their writing or teaching skills, they struggled to eke out a living from their talents. Often poorly compensated, they rarely owned land or much personal property and, consequently, left little in the way of a paper trail to document their existence. Even a teacher's record book, diary, or other evidence is an extremely rare survival. Where such resources do exist, however, they deserve to be explored. By doing so, the lives of the individuals responsible for creating this devotional and pragmatic art may be better documented. Such is the purpose of this catalogue.

The illustrated, biographical entries that follow are an effort to summarize what is known, and what, in some cases, has only recently been learned, about more than forty fraktur artists who plied their craft within present-day Bucks County. These thumbnail biographies certainly do not include every artist-scrivener who made fraktur in the county, but rather offer a representative cross section of the men—and at least one woman—who produced the colorful manuscript art.[3]

Clearly there is no such thing as a Bucks County fraktur style (neither the art form nor its practitioners respected arbitrary geographic boundaries). Still, the pecularities of regional culture and the deeply felt influence of certain individual artists lent a singular character to at least a portion of the fraktur produced in Bucks County and its immediate environs. The large number of Mennonite tune books originating in the county, with their rather similar format, ornamentation, and text, is a primary example.

Many of the schoolmasters and scriveners who worked within the county's borders also developed

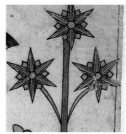

their own distinctive personal styles. Others were content to simply mimic the compositions of earlier influential artists. While some spent their entire working lives in Bucks County, others, attesting to the often itinerant life of the fraktur artist, worked throughout southeastern Pennsylvania. Some carried the fraktur tradition as far south as the Carolinas and as far north as Canada.

In Bucks County, it is helpful to consider two distinct streams or schools of fraktur production. One is the Mennonite stream, represented particularly by the decorated bookplate (*Bücherzeichen*), manuscript tune book (*Notenbüchlein*), and penmanship model (*Vorschrift*). This tradition is also marked by the conspicuous absence of the baptismal certificate, in keeping with Anabaptist theology. The other stream is that of the more numerous Lutheran and Reformed peoples, characterized most notably by the birth and baptismal certificate (*Geburts- und Taufschein*), expressing the importance of infant baptism

among these denominations. Of course, the swirling eddies of everyday life in Bucks County's mixed religious communities sometimes caused these streams to intermingle. Lutheran and Reformed schoolmasters, for example, also composed *Vorschriften* for their students, while talented Mennonite scriveners might have occasionally been induced to complete *Taufscheine* for their worldly neighbors. Indeed, it is striking that both of the fraktur streams traced in the following sections begin with Lutheran schoolmasters. Nonetheless, for comparison and contrast, and to clearly see the transmission of ornament, text, and penmanship styles from one artist-scrivener to the next, it is useful to consider Bucks County fraktur in light of these twin currents.

Within each stream, the biographies are organized roughly in chronological fashion and then grouped to show relationships between artists, their mentors, students, and copyists. Translations of each of the fraktur illustrated may be found in the appendix.

Notes

1. Mercer first mentions "Ayer or Oyer" in *The Tools of the Nation Maker: A Descriptive Catalogue of Objects in the Museum of the Historical Society of Bucks County, Penna.* (Doylestown, Pa.: Bucks County Historical Society, 1897), 65. For the definitive study on Eyer, see Frederick S. Weiser, "I A E S D: The Story of Johann Adam Eyer, Schoolmaster and Fraktur Artist," in *Ebbes fer Alle-Ebber, Ebbes fer Dich/Something for Everyone—Something for You: Essays in Memoriam Albert Franklin Buffington*, in *Publications of the Pennsylvania German Society* 14 (1980): 437–506.

2. For the chief work on Spangenberg see Monroe Fabian, "The Easton Bible Artist Identified," *Pennsylvania Folklife* 22 (Winter 1972–73): 2–14.

3. For the most part, these are also the artist-scriveners whose works were highlighted in the 1997 Mercer Museum/Bucks County Historical Society exhibit, *From Heart to Hand: Discovering Bucks County Fraktur.*

Bucks County Fraktur Artists: *The Lutheran and Reformed Stream*

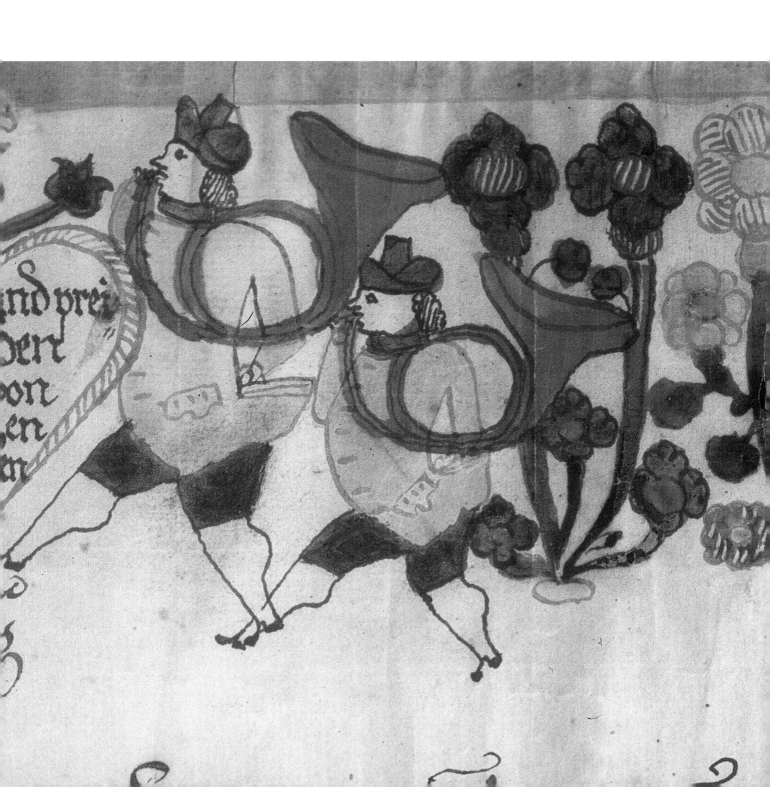

Johannes Mayer

(active c. 1769–1812)

Bedminster and Nockamixon Townships

Johannes Mayer (aka John Moyer) is the earliest Bucks County fraktur artist who can be positively identified, though little else is known about his life.[1] In a 1779 copybook for his student Abraham Landes (Fig. 142), Mayer identified himself as a schoolmaster "on the Tohickon," referring to the creek that forms the border between Bedminster and Haycock Townships. Though he may have taught young Landes and other Mennonite children in the school at Deep Run, Mayer's own religious background was more likely Lutheran. About 1776 he penned a family record for Henry Jungken which appears in the pages of the churchbook of the Lutheran congregation at *Tohecka*, later known as Keller's (Fig. 143). Three years earlier,

Fig. 143. **Family Record of Henry Jungken (b. 1717).** Attributed to Johannes Mayer, Keller's Church, Bedminster Township, Bucks County, c. 1776. From the *Tohecka (Keller's Lutheran) Church Book.*

he also produced a *Taufschein* for a member of the Tohickon Reformed (Union) Church in northwestern Bedminster Township (Fig. 144).

But it is the repeated appearance of his penmanship in communicants' lists and baptismal entries that links Mayer most closely to the Lutheran congregations at Tohecka and at Nockamixon.[2] Between 1776 and 1782 he is recorded as an occasional communicant at Keller's, his name appearing often in his own handwriting. During those same years he recorded several baptisms and compiled lengthy communicants' lists. In 1792, he even contributed two shillings and six pence toward the purchase of the church organ.[3] Although none of these entries identify him specifically as the

Fig. 142. **Copybook for Abraham Landes (Page).** Johannes Mayer, Deep Run, Bedminster Township, Bucks County, 1779. Hand-drawn, lettered and colored on laid paper. Present whereabouts unknown. (Photo courtesy of John L. Ruth.)

parochial schoolmaster, it is probable that he served in that capacity for at least several years.

In 1793, Mayer is first listed as a communicant at St. Luke's Lutheran (Union) Church in Nockamixon Township. He then appears off and on in the church records through October of 1810. Unfortunately, none of the communicants' lists are recorded in Mayer's own handwriting. He did, however, enter two baptisms in the churchbook, one for Sara Ruff [Rufe] and the other for Ludwig Drager [Trauger]. Along with his wife Catherine, Mayer also witnessed the baptism of the daughter of Christopher and Anna Maria Strauss of Nockamixon.[4] Perhaps significantly, Johannes Mayer the fraktur artist prepared a bookplate for a Philip Strauss of Nockamixon in 1806 (Fig. 145). A Philip Strauss appears also as a communicant at St. Luke's between 1802 and 1823.

Mayer also entered baptisms in the church register of the Reformed side of the Nockamixon Union Church.[5] The births and baptisms of three children, all dating from 1776, were probably recorded in the register a few years afterward by Mayer. Several page headings and a title page in the church book also flowed from the schoolmaster's hand.

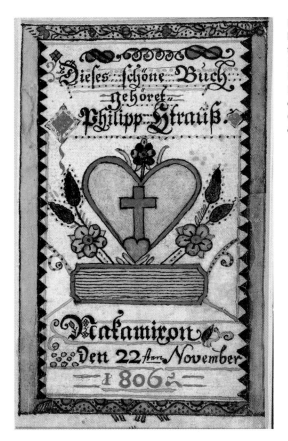

Fig. 145. **Bookplate for Philipp Strauss**. Attributed to Johannes Mayer, Nockamixon Township, Bucks County, 1806. Hand-drawn, lettered and colored on laid paper. 6½ x 3¾ in. (Private collection.)

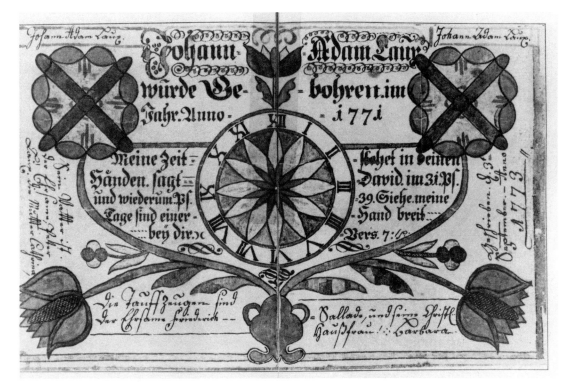

Fig. 144. **Birth and Baptismal Certificate for Johann Adam Laux (b. 1771)**. Attributed to Johannes Mayer, Bedminster Township, Bucks County, 1773. Present whereabouts unknown. Published in William J. Hinke, *A History of the Tohickon Union Church, Bedminster Township, Bucks County, Pennsylvania* (Meadville, Pa.: Pennsylvania German Society, 1925).

Fig. 146. **Drawing:** *Frederick III, the King of Prussia*. Johannes Mayer, Bedminster Township, Bucks County, 1769. Hand-drawn, lettered and colored on laid paper. 14 x 12¹⁄₂ in. (Spruance Library/Bucks County Historical Society, SC-58. No. A-54.)

Fig. 148. **Drawing**. Attributed to Johannes Mayer, Bucks County, 1798. Hand-drawn, lettered and colored on laid paper. 5¹⁄₄ x 3¹⁄₄ in. (Private collection.)

Fig. 147. **Drawing:** *Frederick II, King of Prussia*. Attributed to Johannes Mayer, Bedminster Township, Bucks County, c. 1770. Hand-drawn, lettered and colored on laid paper. 15⁵⁄₈ x 12⁵⁄₈ in. (Mennonite Heritage Center, Harleysville, Pa., 85.3.1.)

Other John Mayers appear in the records of the Tohickon Reformed congregation (as the father of Maria Catharina, baptized June 9, 1768), and in the churchbook of the Lutherans of Springfield Township (as the father of Johannes, born January 26, 1785). Unfortunately, neither of these last references, intriguing though they may be, can be definitively associated with the congregant at Keller's and Nockamixon who was the schoolteacher and fraktur artist John Mayer. Perhaps other data will yet come forward that can more fully illuminate his life.[6]

In the meantime, we are left with a relatively large body of Mayer's work to consider. Apart from the copybook for Abraham Landes which is signed, two other fraktur are known to bear Mayer's name. One is a family register recording the births, marriage, and children of Johannes and Maria Kolb Fretz of Bedminster Township. Signed and dated 1782, it found its way to Ontario, Canada, during the Mennonite migration following the Revolution.[7] The other piece is a picture of Frederick the Great of Prussia which is dated 1769 (Fig. 146). Found in fragmentary condition inside a chest in the collection of the Mercer Museum, it bears the unmistakable penmanship and partial signature of Johannes Mayer. As in his copybook for Abraham Landes, Mayer calls himself "Sch. Mstr," or schoolmaster. A nearly identical picture, not signed or dated but in much better condition, is in the collection of the Mennonite Historians of Eastern Pennsylvania (Fig. 147). The name Abraham Landes, probably the same student for whom Mayer created the copybook, appears on the reverse.

The two pictures of Frederick the Great are also of interest because of what they reveal about Mayer's sources of inspiration. He clearly derived his portrayal of Frederick from a woodcut published by Christopher Saur of Germantown in his almanac of 1762.[8] This connection is made even more certain by Mayer's repetition of the peculiar numerical designation that Saur used in his accompanying biographical sketch of Frederick. Saur referred to the monarch as "*Friederich der dritte*" (the third), rather than the more common designation of Frederick II.[9] Mayer repeated this nomenclature in his 1769 picture, though apparently altered it later in the piece he drew for Abraham Landes.

Whatever his background, and wherever he may have learned his craft, Johannes Mayer was clearly an accomplished penman. His handwriting was very

Fig. 149. **Drawing with Verse**. Attributed to Johannes Mayer, probably Bedminster or Nockamixon Townships, Bucks County, c. 1780–1800. Hand-drawn, lettered and colored on laid paper. 5 x 3¼ in. (Private collection.)

Fig. 150. **Drawing**. Attributed to Johannes Mayer, Bucks County, 1800. Hand-drawn, lettered and colored on laid paper. 4⅝ x 2¾ in. (Private collection.)

201

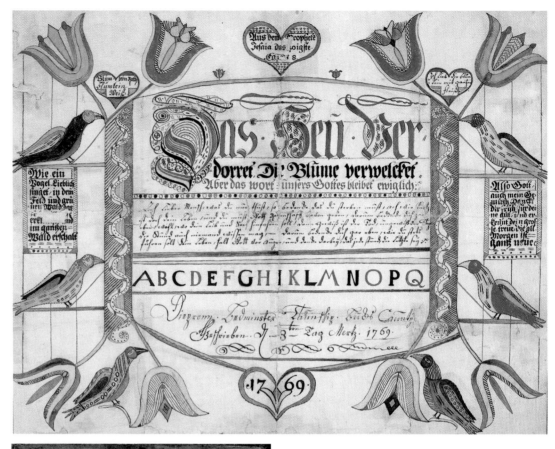

Fig. 151. **Penmanship Model.** Attributed to Johannes Mayer, Deep Run area, Bedminster Township, Bucks County, 1769. Hand-drawn, lettered and colored on laid paper. 15 x 18½ in. (Private collection.)

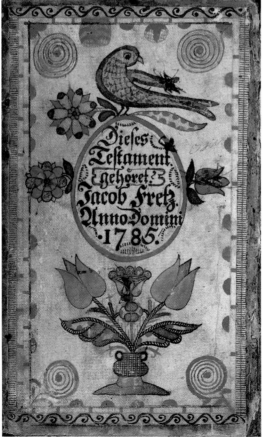

Fig. 152. **Bible Bookplate for Jacob Fretz.** Attributed to Johannes Mayer, Tinicum Township, Bucks County, 1785. Hand-drawn, lettered and colored on laid paper. 6⅞ x 4⅛ in. Curiously, this bookplate is one of two, inscribed to the same individual but by two different hands, that appear in the same bible. (Spruance Library/Bucks County Historical Society, SC-58. No. C-09.)

even, his lettering bold and deliberate. Decoratively, he employed a series of loopy spirals above and below lines of text (Fig. 147), clock faces with Roman numerals (Fig. 148), winged cherubs (Fig. 149), and thickly rendered sets of parallel lines forming small mounds along the borders of his compositions (Fig. 150). His color palette featured pale reds, greens and yellows (Figs. 151, 152). The last extant piece that may be attributed to him, a little picture for Elisabeth Stein dated 1812, shows a rather shaky hand and declining skill, and was likely executed near the end of Mayer's life (Fig. 153).

Notes

1. An exhaustive search of Bucks County church, cemetery, and legal records was undertaken to illuminate the life of Johannes Mayer. In the course of this research, several "John Moyers," living in the county during the late eighteenth and early nineteenth centuries, were identified. Two possible candidates, one from Bedminster and the other from Plumstead, died in 1814 and 1816, respectively. The former was a farmer (and possibly a weaver), and the latter, a blacksmith. As both were also Mennonites, however, it now seems unlikely that either could have been the fraktur artist. For the first John Moyer (d. 1814), see Bucks County Estate File No. 4057, Spruance Library/Bucks County Historical Society, Doylestown, Pa. (SL/BCHS); also

Bedminster Township Tax Lists 1782–1815 and Tombstone Inscriptions, Deep Run East Mennonite Cemetery. For the second John Moyer, see Estate of John Moyer, file no. 4286, SL/BCHS; and *Bucks County Intelligencer Deaths, 1804–1834* (Doylestown: Bucks County Historical Society, 1989), 74.

Among non-Mennonite Moyers there were several individuals who were eliminated from the search. A John Myers died in Tinicum Township in 1823, however nothing in his estate inventory suggested either learnedness or fraktur artistry. A John Mayer also died in 1803 according to Tohickon Reformed Church records, but he would have passed away prior to the dates on several fraktur that are certainly by the hand of John Mayer the schoolmaster. Yet another individual presented the opposite problem: a John Moyer who was born in 1762 and died in 1846 could hardly have produced the earliest fraktur from schoolmaster Mayer's pen. For information on these three Moyers see (first) Estate of John Myers, File No. 5236, and *Bucks County Intelligencer Deaths*, 74; (second) William J. Hinke, trans./comp., *A History of the Tohickon Union Church, Bedminster Township, Bucks County, Pennsylvania* (Meadville, Pa.: Pennsylvania German Society, 1925), 274; and (third) Hinke, 300, and Frances W. Waite, comp., *Bucks County Tombstone Inscriptions, Bedminster and Haycock Townships* (Doylestown: Bucks County Genealogical Society, 1988), K41.

2. The Lutheran congregation later known as *Keller's* in north central Bedminster Township was, in the eighteenth century, called *Tohecka* or *Tohickon*. To complicate matters, the union church in northwest Bedminster, nearly on the Rockhill Township line, was also referred to as *Tohickon*. Finally, the union church in Nockamixon, dating from c. 1770, was located in present-day Ferndale along the Easton Road. For the histories of these congregations see Charles H. Glatfelter, *Pastors and People: German and Reformed Churches in the Pennsylvania Field, 1717–1793* (Breinigsville, Pa.: Pennsylvania German Society, 1980), 268, 271–273.

3. *Keller's Evangelical Lutheran Church, Bedminster Township, Bucks County, Pennsylvania, 1751–1870* (Doylestown, Pa.: Bucks County Historical Society, n.d.), 157. This is a transcription and translation of the the original *"Kirchen Buch oder Protocol der ewangelisch lutherischen Gemeinde an der Tohickon,"* in the collection of the Evangelical and Reformed Historical Society, Lancaster, Pa. The money given by Mayer toward the organ purchase, an amount shared by several other congregants, was at the very bottom of the scale of contributions. Pastor Frederick Weiser, New Oxford, Pennsylvania, notes that this was about the same amount earned by a schoolmaster for singing at a funeral.

4. "Church Book of the Evangelical Lutheran Congrega-tion in Nockamixon," now in the possession of St. Luke's Church, Ferndale, Bucks County. I am indebted to Pastor Donna Deal for kindly making the original records available for study. The two baptisms entered in the register by Mayer apparently were recorded one to

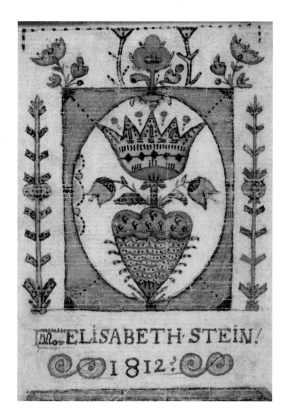

Fig. 153. **Drawing for Elisabeth Stein**. Attributed to Johannes Mayer, probably Nockamixon Township, Bucks County, 1812. Hand-drawn, lettered and colored on laid paper. 4⁷/₈ x 3³/₈ in. An Elisabeth Steen (Stein) took first communion at St. Luke's Lutheran church in Nockamixon in 1819. (Private collection.)

two years after the actual event. Though the baptisms occurred in 1789 and 1790 respectively, they were not entered in the register until the spring of 1791.

5. This *Kirchen Buch* (of the Reformed Congregation in Nockamixon) is in the archives of the Evangelical Reformed Church, Lancaster, Pa. A second volume of financial records, also in the Reformed Archives, bears a fraktur-decorated title page by Johannes Spangenberg.

6. A Johannes Mayer, possibly the same individual recorded in the Keller's and Nockamixon Church records (or a relative), arrived in Philadelphia aboard the ship *Halifax* in 1753. See Ralph Beaver Strassberger and William J. Hinke, *Pennsylvania German Pioneers*, 3 vols. (Norristown, Pa.: Pennsylvania German Society, 1934), 2:662. Pastor Weiser notes that many immigrants arriving in Philadelphia at this time were Lutherans from Württemberg.

7. I am indebted to John Ruth and Joel Alderfer of the Mennonite Historians of Eastern Pennsylvania for bringing this and other Mayer pieces to my attention.

8. Christopher Saur, publisher, *Der Hoch Deutsch Americanische Calender* (Germantown, 1762).

9. It appears that both designations (II and III) were used to enumerate Frederick in the period, with the confusion apparently stemming from two different ways of reckoning his descent. Information from Pastor Frederick Weiser, New Oxford, Pennsylvania.

Johann Nicolaus Andre

(active c. 1770–1775)

Nockamixon Township

Although Nicolaus Andre lived in Moore Township, Northampton County, he prepared at least one *Taufschein* for the child of a Bucks County family. On a somewhat sloppy but colorfully decorated certificate, he recorded the 1772 birth and baptism of Margaretha Schick, the daughter of Jacob and Margaretha Schick of Nockamixon Township (Fig. 154). Fortunately, he also signed his name, "J. Nicolaus Andre," to the work.

Andre, who sometimes spelled his name *Andreas* or *Andrews*, lived in Moore Township from about 1770, or earlier, until his death in 1814.[1] There he and his wife Anna had several of their children baptized between 1770 and 1782. For one of their offspring, Catharina, Nicholas Andre also produced a *Taufschein*, which survives in a private collection.

A Johann Nicolaus Andra or Andre arrived in Philadelphia from Europe, by way of Lewes, Delaware, in November of 1741. Since he was already twenty-four years old at the time of his immigration it is not likely that he was the fraktur artist, but perhaps the artist's father. Intriguingly, this Nicholas arrived on the same ship that brought Jacob Loeser, a teacher who kept school and provided basic pastoral services for an early Lutheran congregation in Milford Township, Bucks (later Northampton, then Lehigh) County.[2]

Decoratively, Nicholas Andre preferred to place his text between columns, set on plinths, with diagonal "barber pole" striping. His lettering appears crude and uneven. On his baptismal certificates, he tended to lead off his compositions with the given name of the child, connecting the letters with a horizontal bar.

Very few pieces attributable to Andre are known, and it is likely that he produced fraktur for a only short time.[3] In his will, proved in July 1814, he left legacies to his wife (who died soon after) and his nine children, including a John Nicholas Jr.[4] Unfortunately, the inventory of his estate contains no suggestion of Andre's one-time vocation, or sideline, as a fraktur artist.

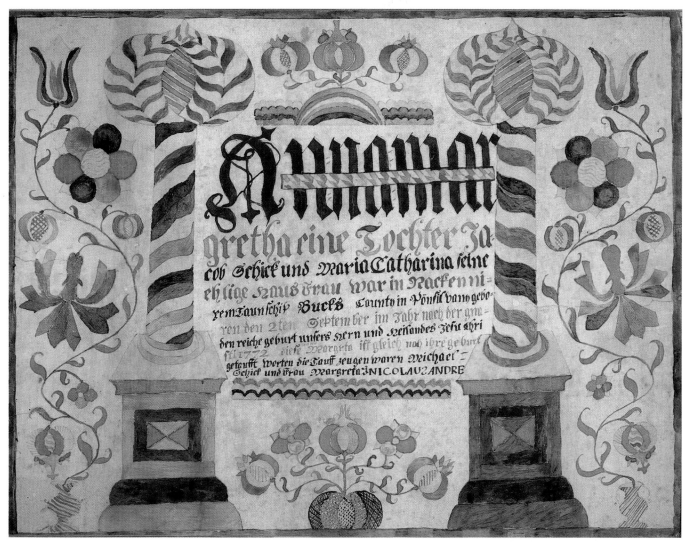

Fig. 154. **Birth and Baptismal Certificate for Anna Margretha Schick (b. 1772).** Johann Nicholas Andre, Bucks or Northampton Counties, 1772 or later. Hand-drawn, lettered and colored on laid paper. 13 x 16¹⁄₂ in. (Private collection.)

Notes

1. Bureau of the Census, *Heads of Families at the First Census of the United States Taken in the Year 1790, Pennsylvania* (Washington: Government Printing Office, 1908), 177; U.S. Census of 1800, Moore Township, Northampton County, Pa., 62; U.S. Census of 1810, Moore Township, Northampton County, Pa., 84; 1810–1814 Tax Lists, Moore Township, Northampton County Archives, Easton, Pa.; John T. Humphrey, *Pennsylvania Births: Northampton County, 1733–1800.* (Baltimore: Gateway Press, 1991), 3–4.

2. Ralph Beaver Strassburger and William J. Hinke, *Pennsylvania German Pioneers*, 3 vols. (Baltimore: Genealogical Publishing Company, 1966), 1:317–319; Charles H. Glatfelter, *Pastors and People*, 2 vols. (Breinigsville, Pa.: Pennsylvania German Society, 1980), 1:360.

3. In addition to the *Taufschein* illustrated in fig. 154, and the one for Catharina Andre, a life record for a member of the Schenck family may also be by Andre's hand. This latter piece is recorded in the Decorative Arts Photographic Collection, Winterthur Museum, Winterthur, Delaware.

4. Estate of John Nicholas Andrew, File No. 2993, Register of Wills, Northampton County Courthouse, Easton, Pa.

Johannes Spangenberg

(c. 1750–1814, active c. 1774–1812)

Springfield, Durham, and Nockamixon Townships

A schoolmaster and scrivener, Johannes Spangenberg remained unidentified for many years until the discovery of a signed *Taufschein* made it possible to assign a sizable group of fraktur to his hand. Up to that point the anonymous penman and decorator had been known only as the Easton Bible Artist.[1] Though he made certificates at times for children in Bucks County, most of his fraktur originated in the vicinity of Easton, Northampton County, and in neighboring New Jersey. In addition to his birth and baptismal certificates, he also drew a number of bookplates,

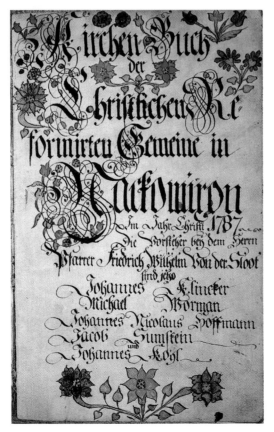

Fig. 155. **Bookplate for the Reformed Church of Nockamixon Churchbook**. Attributed to Johannes Spangenberg, Nockamixon Township, Bucks County, 1787. Hand-drawn, lettered and colored on laid paper. 12⁷/₈ x 7³/₄ in. (Evangelical and Reformed Historical Society, Lancaster, Pa.)

including entirely secular ones for the account books of craftsmen and merchants.

While serving in a Northampton County militia regiment during the Revolution, Spangenberg was present at the Battle of Long Island in 1776. Though a military court tried him for cowardice in an incident stemming from that fight, he was later acquitted.[2] After the war he lived in Easton, and, briefly, in Nockamixon Township, Bucks County. He is known to have taught school in Easton, possibly in a building that still stands today: the old schoolhouse of the Easton Reformed congregation, built in 1778.[3] As a scrivener, he also wrote the wills of several Easton-area residents.

Spangenberg was one of relatively few fraktur artists to include human figures on his baptismal certificates. Some are musicians, apparently heralding the birth and baptism of the child. Others may represent the child's family or the baptismal sponsors.

In Nockamixon, where Spangenberg lived (or visited regularly) between about 1786 and 1790, he also witnessed wills and made his scrivening services available to the local populace. It is likely, too, that he taught at the parochial school of the township's union church during these years. In 1787, the elders of the Reformed side turned to him to decorate the title page of the congregation's financial register (Fig. 155).[4]

One of the individuals for whom Spangenberg decorated an account book, hatter Michael Dech (1775–1859) of Forks Township, Northampton County, also had Nockamixon connections (Fig. 156). Dech moved from Northampton to Nockamixon between 1800 and 1810.[5] He taught school in Nockamixon between about 1824 and 1830, and also served as a scrivener, writing wills, inventories, and deeds for local residents.[6]

Another of Spangenberg's apparent protégés, Michael Fackenthal Jr., for whom the elder schoolmaster drew a baptismal certificate in 1795 (Fig. 157), also became a teacher in the schools of Durham Township.[7] Intriguingly, although both of these men—Dech and Fackenthal—had attractive penmanship and worked as scriveners, there is no evidence that either followed Spangenberg in producing fraktur. Perhaps this is because they found financial success in other pursuits. Fackenthal, for instance, became a prosperous surveyor, lumber dealer, farmer, and conveyancer.[8] Indeed, not every Pennsylvania-German schoolmaster found it necessary to peddle baptismal certificates and bookplates, or even to produce watercolor rewards for his pupils.

Among Spangenberg's other clients in Durham Township was the Koplin family, who lived nearly on top of the Northampton County border. About 1790, he drew a birth and baptismal certificate for Michael Koplin of Williams Township (Fig. 158), a child who had been born several years earlier in Berks County.[9] Proving that Spangenberg, like other fraktur artists, often made up the boilerplate of his certificates in advance, the county name *Northampton* is crossed out and *Berks* substituted on the Koplin *Taufschein*.

Fig. 156. **Account Book and Bookplate for Michael Dech.** Attributed to Johannes Spangenberg, Forks Township, Northampton County, 1796. Hand-drawn, lettered and colored on laid paper. 8 x 6³/₄ in. The cover boards of this book are also decorated. (Spruance Library/Bucks County Historical Society, SC-58. No. C-16.)

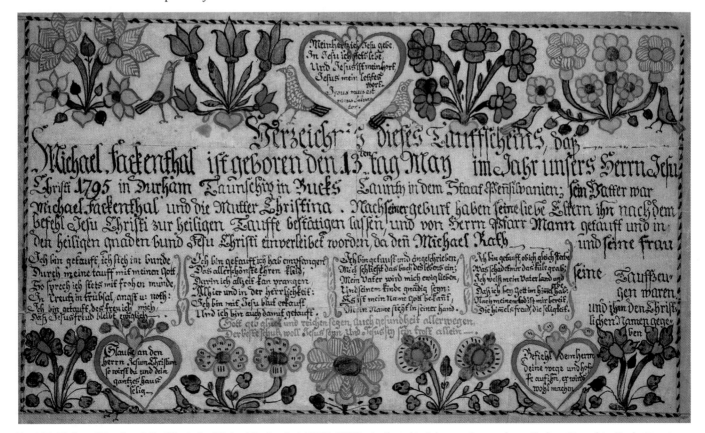

Fig. 157. **Birth and Baptismal Certificate for Michael Fackenthal (1795–1872).** Attributed to Johannes Spangenberg, Durham Township, Bucks County, c. 1795. Hand-drawn, lettered and colored on laid paper. 8¹/₄ x 13³/₈ in. (Spruance Library/Bucks County Historical Society, SC-58. No. A-10.)

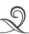

Fig. 158. **Birth and Baptismal Certificate for Michael Koplin (1782–1861).** Attributed to Johannes Spangenberg, probably Williams Township, Northampton County, c. 1790. Hand-drawn, lettered and colored on laid paper. 12³⁄₄ x 15¹⁄₄ in. (Collection of Bruce M. Koplin.)

Notes

1. See Monroe H. Fabian, "The Easton Bible Artist Identified," *Pennsylvania Folklife* 22 (Winter, 1972–73): 2–14.

2. Ibid., 7.

3. Ibid., 8.

4. Ibid., 8. Apart from the 1786 will of Michael Hoffman, mentioned by Fabian, John Spangenberg also penned and witnessed the 1788 will of Jacob Ruff of Nockamixon. See Estate of Jacob Ruff, File No. 2345, Register of Wills, Bucks County Courthouse, Doylestown, Pa. The financial book ornamented by Spangenberg is in the Evangelical and Reformed Historical Society Archives, Lancaster, Pa. Intriguingly, perhaps a few years before and for at least some years after Spangenberg's stay in the township, Johannes Mayer also taught school and made fraktur in Nockamixon. Mayer's hand decorates the title page of the Reformed Congregation's baptismal register, begun in 1773 (and also in the Reformed Archives).

5. The Federal Census records Dech in Northampton County in 1800, but in Nockamixon, Bucks County, in 1810. His burial site is marked in the Nockamixon churchyard. See Charles R. Roberts, trans., *Saint Luke's Union Church. Ferndale, Nockamixon Township, Bucks County, Pennsylvania, Records of the Reformed Congregation* (Allentown: by the author, 1923), 160.

6. See, for example, Michael Dech, "Bill for Schooling John Rigle, et al, from August 29, 1825 through December 2, 1825, Nockamixon Township," December 8, 1825, Bucks County School Bills, County Commissioners' Records, SL/BCHS (B.C. School Bills). Also, "A Book for Michael Dech, Teacher, 1829" in the Michael Dech Papers, MSC 42, Fol. 39, SL/BCHS. Dech's scrivening services are documented in a series of account books found in the Dech Papers.

7. Michael Fackenthal, "Bill for Schooling Edward Diley and Elias Raub," September 10, 1825, B.C. School Bills.

8. B. F. Fackenthal Jr., comp., *Fackenthal Family Genealogy, 1742–1936* (Riegelsville, Pa.: by the author, n.d.), 235.

9. I am indebted to members of the Koplin family for bringing this certificate and its family history to my attention. Michael Koplin, born in 1782, later became a resident of Durham Township, Bucks County. His father, John, also had a very accomplished hand and, like Spangenberg, aided friends and relatives with the writing of their wills. See Barbara (Koplin) Wentz to Cory M. Amsler, March 27, 1997, Bucks County Fraktur File, SL/BCHS.

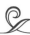

Friedrich Krebs

(1749?–1815, active c. 1780–1812)

Bedminster, Haycock, Hilltown, Milford, Nockamixon, Richland, Rockhill, and Springfield Townships

Krebs is one of the better-documented fraktur artists and so will receive relatively limited attention here. His life has been extensively researched by Pastor Frederick Weiser, and nearly 250 surviving examples of his work have been documented by Weiser, Corinne and Russell Earnest, and others.[1] Still, that number may be the tip of the iceberg given the prodigious amount of work that flowed from Krebs's pen. Indeed, many more of Krebs's fraktur were uncovered during the Bucks County Fraktur Survey in preparation for this book.

Although he kept school in present-day Dauphin County, Krebs produced fraktur for clients throughout southeastern Pennsylvania. He is known today as one of the most prolific fraktur artists. Between

Fig. 159. **Birth and Baptismal Certificate for Johannes Sehms (1788?–1871)**. Attributed to Friedrich Krebs, Dauphin County and Haycock Township, Bucks County, c. 1809. Block-printed, and hand-drawn, lettered and colored on laid paper. 7⅞ x 12¾ in. Krebs used a stamp to first outline the birds in this composition before coloring them. The artist also neglected to include the birth year of the child, but the latter is probably the Johannes Sehms born in 1788. (Private collection.)

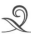

Fig. 160. **Birth and Baptismal Certificate for Christina Klein (b. 1803).** Attributed to Friedrich Krebs, Dauphin County and Lower Milford (now Milford) Township, Bucks County, c. 1803. Hand-drawn, lettered and colored, with applied cutouts, on laid paper. 15¾ x 12¾ in. (Private collection.)

1801 and 1813, he purchased nearly 7,000 printed *Taufscheine* to complete, decorate, and sell to his customers.[2] In addition, he drew many certificates completely freehand or with the aid of simple wooden stamps and applied cutouts of embossed paper, printed in Europe and exported (Figs. 159–161).

Probably arriving in America during the Revolution as a Hessian mercenary, Krebs remained in, or returned to, Pennsylvania after the war. His decorative style was fanciful and freewheeling, even a bit sloppy. At his death, his estate inventory listed

a large number of unused *Taufschein* forms and other "papers picterd."[3] It also recorded the supplies for making decorative boxes covered with wallpaper—evidently a profitable sideline that does not seem to have been copied by other fraktur artists.

Krebs worked for families in nearly all of Bucks County's northern townships. The number of surviving examples seem to be higher for Milford Township, perhaps suggesting more frequent trips through the far northwest corner of the county. It still is not clear, given Krebs's apparent rootedness in

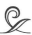

Fig. 161. **Birth and Baptismal Certificate for Anna Catharina Krämer (b. 1802).** Friedrich Krebs, Dauphin County and Rockhill Township, Bucks County, c. 1804. Printed, and hand-drawn, lettered and colored, with applied cutouts, on laid paper. 12⅞ x 16 in. (Dr. Donald A. Shelley Collection.)

Dauphin County, just how he sold his baptismal certificates so widely across southeastern Pennsylvania. It is assumed, however, that he made peddling trips by horse or on foot to meet his clients needs. His aggressive approach to selling fraktur in quantity must have placed him on par with the twentieth century's Fuller Brush man.

Notes

1. For the best study of Krebs's work, see Frederick S. Weiser, "'*Ach wie ist die Welt so Toll!*' The mad, lovable world of Friedrich Krebs," *Der Reggeboge: Journal of the Pennsylvania German Society* 22 (no. 2, 1988): 49–88. See also Russell D. Earnest and Corinne P. Earnest, *Papers for Birth Dayes: A Guide to the Fraktur Artists and Scriveners*, 2nd ed., 2 vols. (East Berlin, Pa.: Russell D. Earnest Associates, 1997), 1:460–467. The latter volume takes its title from an entry in the estate inventory of Friedrich Krebs.

2. Earnest and Earnest, *Papers for Birth Dayes*, 460.

3. Ibid., 461.

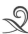

The *Ehre Vater* Artist

(active c. 1782–1828)

Springfield and Bedminster Townships

The so-called *Ehre Vater* Artist was named for a line of text with which he sometimes began his baptismal certificates: "*Ehre Vater und Mutter*" ["Honor Father and Mother"]. Although a few examples of his work are known from Bucks County, he traveled widely throughout Pennsylvania, Virginia, and the Carolinas.[1] In fact, based on the dates and places recorded on his fraktur, it is likely that he made several trips up and down the eastern seaboard. His earliest work, however, seems to have originated in the Carolinas.[2]

In Bucks County, he produced three known birth and baptismal certificates for Springfield Township families, two freehand pieces and the other a printed and completed example (Figs. 162–

164). Another printed certificate for a Bedminster Township family exhibits his distinctive free-hand decoration in the margins but was apparently completed by another scrivener. Based on these and other examples, the *Ehre Vater* Artist seems to have lived and worked close to the Bucks-Northampton-Lehigh County border area toward the close of his career. His unsteady penmanship on an 1828 certificate for a child in Williams Township, Northampton County, may attest to illness or the declining skills of old age.[3]

While many of the *Ehre Vater* Artist's certificates were entirely hand-drawn, he ordered a number of blank forms—some in English and others in German—from an Allentown printer, Joseph

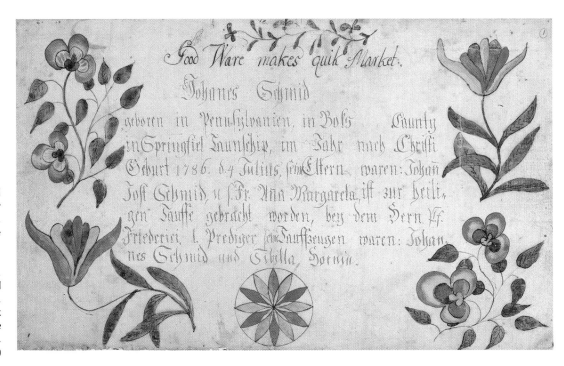

Fig. 162. **Birth and Baptismal Certificate for Johannes Schmid (b. 1786)**. Attributed to the *Ehre Vater* Artist, Springfield Township, Bucks County, c. 1795. Hand-drawn, colored and lettered on laid paper. 8 x 12³/₄ in. (Rare Book Department, The Free Library of Philadelphia, FLP 300.)

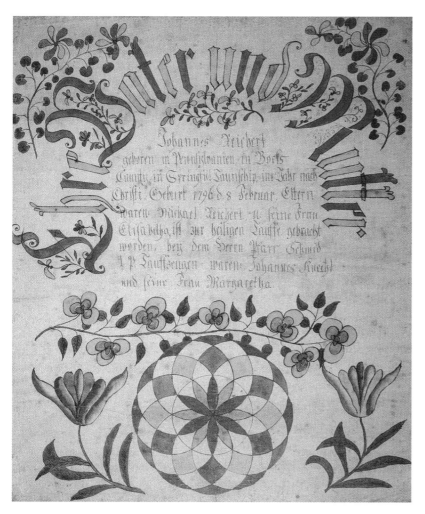

Fig. 163. **Birth and Baptismal Certificate for Johannes Reichert (b. 1796)**. Attributed to the *Ehre Vater* Artist, Springfield Township, Bucks County, c. 1800. Hand-drawn, colored and lettered on laid paper. 15½ x 12⅞ in. (Dr. Donald A. Shelley Collection.)

Ehrenfried & Company.[4] While he completed many of these himself, he frequently sold them to his customers as blank certificates to be completed by another scrivener, such as the Bedminster example for Jacob Fasberner (Fig. 164).

The *Ehre Vater* Artist may have been an itinerant scrivener or a schoolmaster. In any event, he did not discriminate based on the religious convictions of his customers. He is known to have produced certificates for members of the Lutheran, Reformed, and Moravian faiths.[5] And, in at least one instance, he completed a *Taufschein* form for a Mennonite child, leaving the place for the baptismal data blank (Fig. 165).[6]

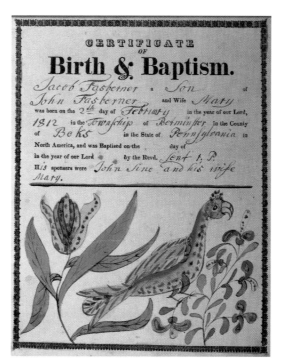

Fig. 164. **Birth and Baptismal Certificate for Jacob Fasberner (1812–1870)**. Printed by Joseph Ehrenfried & Company, Allentown, Pennsylvania. Decoration attributed to the *Ehre Vater* Artist. Completed by an unknown scrivener, Bedminster Township, Bucks County, c. 1820. Printed, hand-drawn, colored and lettered on wove paper. 12½ x 9⅞ in. (Permanent Collection, Rothman Gallery, Franklin & Marshall College.)

Fig. 165. **Birth and Baptismal Certificate for Maria Meyer (b. 1819)**. Printed by Joseph Ehrenfried & Company, Allentown, Pennsylvania. Decoration and lettering attributed to the *Ehre Vater* Artist, Springfield Township, Bucks County, c. 1820. Printed, hand-drawn, colored and lettered on wove paper. 9¹⁄₈ x 7³⁄₈ in. (Schwenkfelder Library and Heritage Center.)

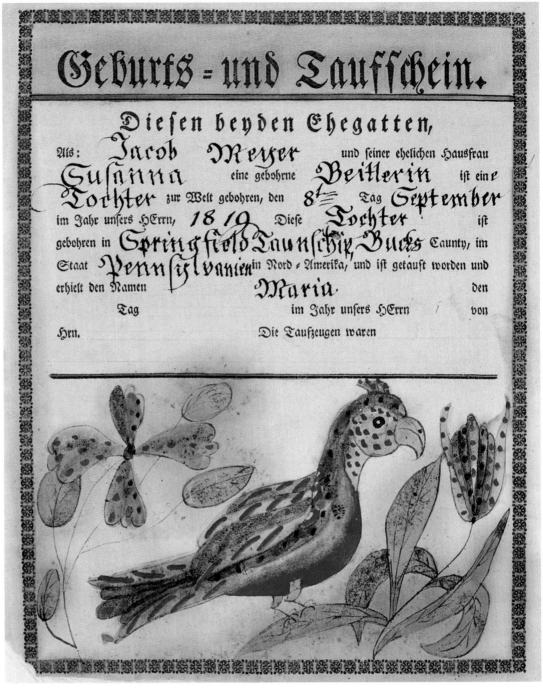

Notes

1. Russell D. Earnest and Corinne P. Earnest, *Papers for Birth Dayes: Guide to the Fraktur Artists and Scriveners*, 2nd ed., 2 vols. (East Berlin, Pa.: Russell D. Earnest Associates, 1997), 1:226–228.

2. Ibid.

3. Klaus Stopp, *The Printed Birth and Baptismal Certificates of the German Americans*, 6 vols. (Mainz, Germany and East Berlin, Pa.: by the author, 1997), 1:154.

4. Ibid., 1:154–5.

5. Earnest and Earnest make mention of this artist's activities among Moravians in North Carolina and Pennsylvania. In addition, of the four fraktur illustrated here, two are for Lutheran families, one is for a Reformed church household, and the other is a birth record only for a Mennonite child.

6. Although a search of published Meyer and Beidler (the mother's family name) genealogies failed to confirm the identity of this child or her faith, both Meyer and Beidler are typical Bucks County Mennonite surnames.

John George Hohman

(active c. 1802–1845?)

Bedminster, Nockamixon, and Springfield Townships?

wo intriguing accounts, separated in time by more than fifty years, point to George Hohman's role as a *Taufschein* artist or, at the very least, as a scrivener who completed printed forms. Unfortunately, no fraktur by his hand has as yet been discovered to corroborate these stories.

Hohman, who is best known for publishing a collection of powwowing spells and rituals entitled *The Long Lost Friend*, arrived in Philadelphia in 1802 aboard the ship *Tom* along with his wife and son. The price of his passage being paid by a Bucks County farmer, Hohman went to work on the man's farm to satisfy the debt.

It is at this point that the two stories diverge. According to one account, a New Jersey farmer purchased the services of Hohman's wife, Anna Catharine, and the family became temporarily separated. Hohman himself went to work for a man named Frankenfield in Springfield Township.[1] However, William J. Buck in his 1887 book *Local Sketches and Legends*, wrote that Hohman, originally bound out to a Bedminster Township farmer named Fretz, soon left Fretz' service and went to the Nockamixon Township farm of Nicholas Buck, who purchased the remainder of Hohman's indenture. Catharine and son Caspar Hohman, this account relates, continued to work for Fretz as part of the new arrangement.[2]

Not long after George Hohman's move to Nockamixon Township, he revealed to Buck a latent talent. "He stated that he had a knowledge of drawing and water color painting, which he had learned in early life in Germany, and was withal a poet and ready writer."[3] Drawing a sample *Taufschein* for his master as proof of his abilities, he then asked for time off from his farm labor in order to devote himself to producing fraktur. This request was apparently granted, and Hohman set out to earn enough money selling *Taufscheine* to purchase his family's freedom.

Relying extensively on information provided by the son of Hohman's second master, Nicholas Buck, William Buck continued his 1887 narrative:

> As George Homan was also an expert penman, he was in the practice of making at his home as many as fifty or one hundred of these taufschiens *[sic]*, when he would set off on his pedestrian peddling tour, selling them among the German settlers and farmers. The space within the heart was left blank to be afterwards filled up to suit the wishes of his patrons....His success was such in selling these that within ten months from starting in the business he realized sufficient to not only purchase his own but his wife's freedom....His business in this line became so extensive through his industry and perseverance that he got them engraved in outline after one of his designs and printed at Allentown, which he would afterwards color to suit his or the purchaser's fancy.[4]

If there is any truth to Buck's story, Hohman must have been a prolific producer of fraktur, not only in Bucks County but perhaps elsewhere. After leaving his servitude behind, Hohman eventually moved to Berks County where, from the Adler Press in Reading, he purchased printed *Taufschein* forms—about 450 of them between 1812 and 1815 alone. He also published several books and broadsides.[5] It seems odd, then, that no signed work or some other piece of information has come to light

that would enable researchers to assign a large body of work by a heretofore anonymous fraktur artist to Hohman's hand. A tempting candidate, however, might be the as yet unidentified *Taufzeugen* Artist who produced *Taufscheine* in both northern Bucks and Berks counties.

Though Buck recounts that Hohman was extremely successful in his peddling trips and eventually purhased himself "a snug house and home near the Borough of Reading," Berks County tax records suggest that he was not far from poverty.[6] In fact, in 1825 (one year after Nicholas Buck's son made a wedding tour to Reading to see him), Hohman's house went on the auction block to satisfy his debts. Perhaps the aging publisher was too proud to let on to his former master that he was a

financial failure. Hohman died sometime after 1846, the date of his last published book.

Although the George Hohmans in these parallel tales would appear to be the same individual, one author has suggested that the stories' inconsistencies—and the lack of any evidence that Hohman the publisher ever produced original fraktur art—actually point to two separate men with the same name.[7] This could be the case. Still, the existence of two men named George Hohman, both apprenticed out to Bucks County farmers in roughly the same years, both with a wife named Catharine and a son named Caspar,[8] and both engaged in some aspect of the *Taufschein* market, would seem to be an extraordinary coincidence.

Notes

1. Wilbur H. Oda, "John George Homan," *The Historical Review of Berks County* 13 (April 1948): 66. See also Oda, "John George Homan: Man of Many Parts," *The Pennsylvania Dutchman* 1 (August 1949): 1.

2. William J. Buck, *Local Sketches and Legends Pertaining to Bucks and Montgomery Counties, Pennsylvania* (n.p.: by the author, 1887), 180.

3. Ibid.

4. Ibid., 181–182.

5. Russell D. Earnest and Corinne P. Earnest, *Papers for Birth Dayes: A Guide to the Fraktur Artists and Scriveners,* 2nd ed., 2 vols. (East Berlin, Pa.: Russell D. Earnest Associates, 1997), 1:410. For Hohman's purchase of *Taufschein* forms, see an Adler/Ritter & Company daybook, 1812–1814, and ledger, 1814–1823 (F11MP A337) in the collection of the Historical Society of Berks County, Reading, Pa. Hohman purchased both "colored" and "plain" blank forms, suggesting that the Adler Press hired watercolorists to decorate some of its printed forms before selling them to regional scriveners.

6. Buck, 183; Earnest and Earnest, 1:410.

7. Chet Hagan, "Authors/Hohman," *Historical Review of Berks County* 57 (Fall 1992): 184–188, 199–202.

8. Buck's account states that George and Catharine Hohman came to Bucks County with their son Caspar. Oda's version notes, based upon the Strassberger-Hinke records, that George arrived in the Port of Philadelphia with Philip Hohman, a son. However, later Berks County tax records show that the name of John George Hohman (the publisher) was temporarily replaced on the 1834 list by a Caspar Hohman, presumably a son. This Caspar may have died in 1837. See Oda, "Homan," 71.

The *Taufzeugen* Artist

(active c. 1800–1815)

Bedminster and Springfield Townships

any fraktur artists traveled widely throughout southeastern Pennsylvania, and sometimes beyond. This anonymous penman's work is found in Northampton, Lehigh, Montgomery, and Berks counties as well as in Bucks.[1] His nickname derives from the manner in which he recorded the names of the baptismal sponsors as if they had signed the certificate as witnesses. Though occasionally this artist placed the baptismal information within hearts, his use of a circular field, composed of a series of triangles, is more typical.

Of the two examples of his work pictured here (Figs. 166, 167), the birth and baptismal certificate for Susanna Hess is of particular interest. Though unremarkable decoratively, it was prepared for the daughter of Joseph Hess, a musician and choir leader of note in Springfield Township,[2] and a

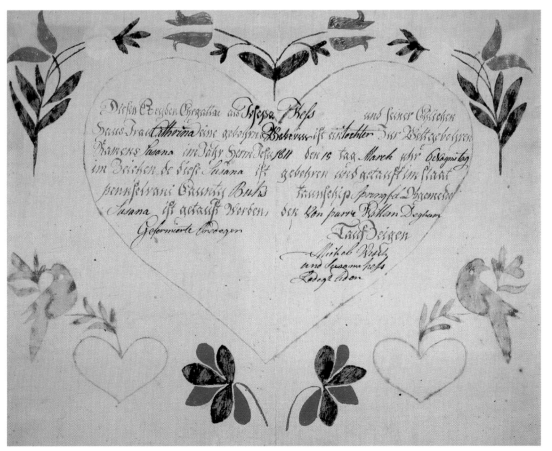

Fig. 166. **Birth and Baptismal Certificate for Susanna Hess (1811–1864).** Attributed to the *Taufzeugen* Artist, Springfield Township, Bucks County, c. 1811. Hand-drawn, lettered and colored on laid paper. 13³/₈ x 15⁵/₈ in. (Rare Book Department, The Free Library of Philadelphia, FLP 23.)

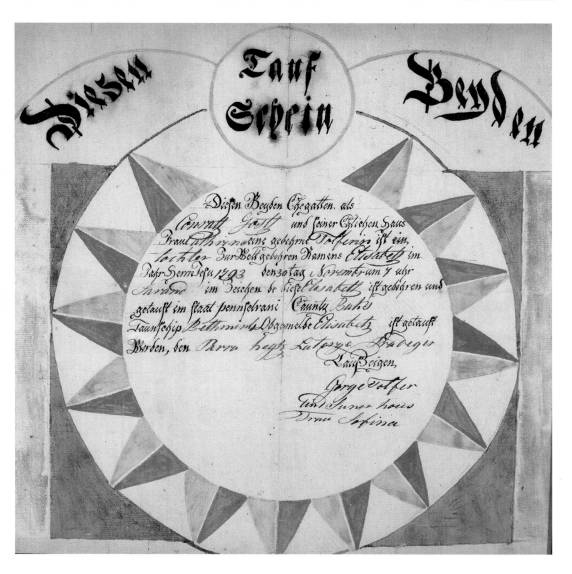

Fig. 167. **Birth and Baptismal Certificate for Elisabeth Yost (1793–1857?).** Attributed to the *Taufzeugen* Artist, Bedminster Township, Bucks County, c. 1800. Hand-drawn, lettered and colored on laid paper. 14 x 13³⁄₈ in. It is likely that the artist drew this certificate some years after the child's baptism. Elisabeth's birthdate on the *Taufschein* misses by several days that recorded in the churchbook of the Keller's Lutheran congregation. As she was likely the wife of George A. Hillpot of Tinicum, it also differs from the birthdate found on her gravestone. (Private collection.)

teacher at the Franklin or Octagon School between Springtown and Bursonville. Hess is also known to have produced *Notenbüchlein*:

Joseph Hess of Springtown...taught singing school in this school house [the Franklin School] during the fall from 1815 to 1817. The book containing the notes was written with a pen. The words and notes were all written by Joseph Hess. The book contained about sixty hymns. Jacob Hess of Springtown has one of the books in his possession and the late William J. Buck had one his mother used when she attended this singing school.[3]

Unfortunately, the whereabouts of both of these booklets is unknown, and it is certainly not clear whether they may have been embellished with fraktur. While it is unlikely that Hess was the

Taufzeugen Artist—he is not known to have traveled far from his farm in Springfield—the notion that a literate schoolmaster would hire another scrivener (with rather sloppy handwriting at that) to create a *Taufschein* for his daughter is an intriguing curiosity.

Notes

1. See also the entry under John George Hohman.

2. Asher L. Hess, *Genealogical Record of the Descendants of Nicholas Hess* (Philadelphia: by the author, 1912), 42–43, 106.

3. Transcribed clipping from the Easton (Pennsylvania) *News*, October 9, 1901, in the Eight-Square Schoolhouse Collection, MSC 163, Fol. 1, SL/BCHS.

The Strasburg Artist

(active c. 1804–1816)

Nockamixon and Springfield Townships

Few examples of this artist's work are known, though it is conceivable that in addition to his hand-drawn fraktur he also completed printed birth and baptismal certificates. Based on the locations named on his few surviving fraktur, it appears that he migrated from Virginia to Bucks County, or the reverse, in the early nineteenth century. His distinctive, curly-headed cherubs decorate certificates from both locales (Figs. 168, 169). The Strasburg Artist's popular nickname derives from the location in the Shenandoah Valley in which his Virginia fraktur originated.[1]

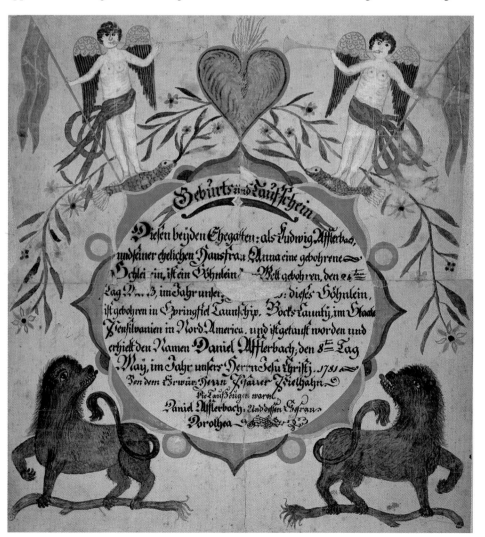

Fig. 168. **Birth and Baptismal Certificate for Daniel Afflerbach (1781–1856).** Attributed to the Strasburg Artist, Springfield Township, Bucks County, c. 1810. Hand-drawn, lettered and colored on laid paper. 14³/₄ x 12¹/₂ in. (Spruance Library/Bucks County Historical Society, SC-58. No. B-10.)

219

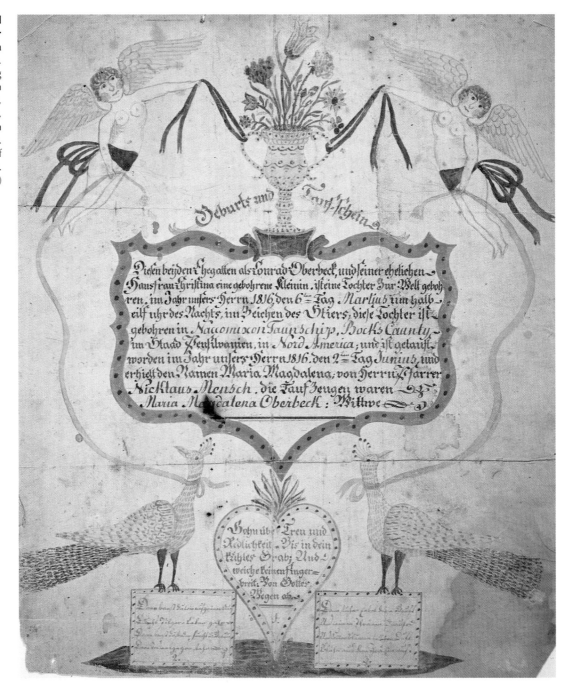

Fig. 169. **Birth and Baptismal Certificate for Maria Magdalena Oberbeck (b. 1816).** Attributed to the Strasburg Artist, Nockamixon Township, Bucks County, c. 1816. Hand-drawn, lettered and colored on laid paper. 15⅛ x 12⅝ in. (Philadelphia Museum of Art: Gift of Mr. and Mrs. Morris Thayer.)

Notes

1. For a somewhat longer discussion of the Strasburg Artist's work, see Russell D. Earnest and Corinne P. Earnest, *Papers for Birth Dayes: A Guide to the Fraktur Artists and Scriveners*, 2nd ed., 2 vols. (East Berlin, Pa.: Russell D. Earnest Associates, 1997), 2:741.

Bernhard Misson

(active c. 1808–1825)

Milford, Springfield, Haycock, Bedminster, Rockhill, and Durham Townships

A schoolteacher and prolific fraktur artist, Misson made much of the fraktur formerly attributed to the so-called BM and Durham artists (Figs. 170–172). Although his exact origins are uncertain, he is known to have toiled for several years at Honn's Schoolhouse in Haycock Township, near the Springfield Township border.[1] There, about 1820, he completed a *Taufschein* for the son of one of the school's trustees, Henry Borger (Figs. 173, 174).

About 1823, Misson moved on to teach at a school in Durham Township.[2] On several occasions, in both Haycock and Durham, he asked to be compensated by the county for teaching poor children who came to his school, charging the commissioners the standard tuition of 3 cents a day. On those documents he wrote in a script identical to that found on his fraktur. One of his "poor" students, eight-year-old Hannah Hefler, is likely the same child for whom Misson prepared a *Taufschein* in 1823 (Fig. 175).[3]

Misson's primary output consisted of baptismal certificates, often featuring oversized tulips with flat, tapering leaves. However, at least one bookplate for a manuscript tune booklet, a reward of merit, a decorated poem, a house blessing, and a few pictures are also known. His earliest works, as the BM Artist, date to about 1808–1810, while the latest fraktur that can be attributed to him from Durham Township is dated 1824.[4] Between about 1810 and 1820, Misson seems to have made little fraktur, although a sole bookplate from Montgomery County in the collection of the Free Library of

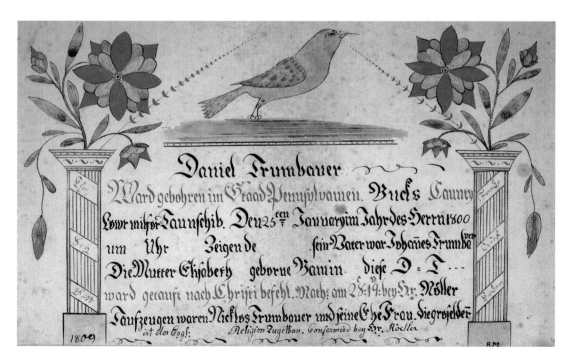

Fig. 170. **Birth and Baptismal Certificate for Daniel Trumbauer (1800–1894).** Attributed to Bernhard Misson, Milford Township, Bucks County, 1809. Hand-drawn, lettered and colored on wove paper. 7⅞ x 12⅞ in. (Private collection.)

221

Fig. 171. **Birth and Baptismal Certificate for Jacob Benner (b. 1805).** Attributed to Bernhard Misson, Rockhill Township, Bucks County, 1809. Hand-drawn, lettered and colored on laid paper. 7⁷/₈ x 13 in. (Rare Book Department, The Free Library of Philadelphia, FLP 1081.)

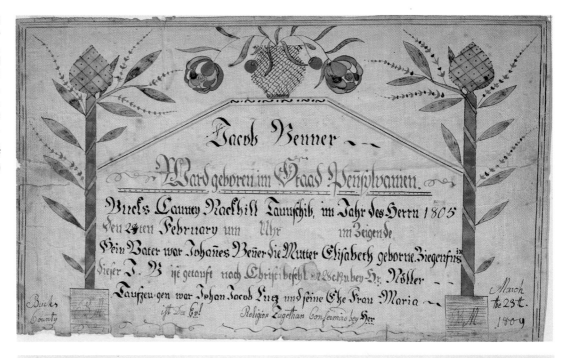

Fig. 172. **Birth and Baptismal Certificate for Margaret Heller (b. 1818).** Attributed to Bernhard Misson, Haycock Township, Bucks County, 1820. Hand-drawn, lettered and colored on wove paper. 8 x 13¼ in. (Historical Society of Pennsylvania.)

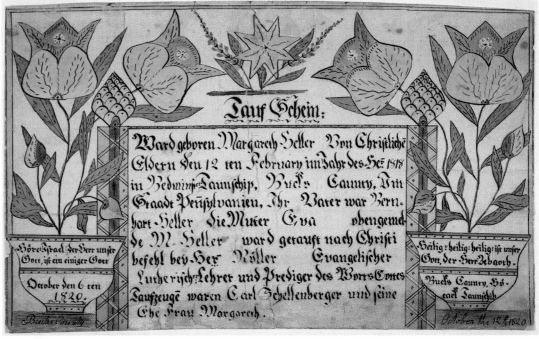

Philadelphia, dated 1812 and drawn for Catarina Dietz of Upper Salford, may aid in pinpointing his whereabouts.[5] Helpful, too, in this regard are the tax records of Milford Township, Bucks County, which show him residing there on fourteen acres of land between 1815 and 1817.[6] These lists also note that he owned a horse, cow, and dog, though by 1817 he had apparently sold two of the three animals—only the dog remained. By 1820, Misson had moved from the township. A Jacob Shelly was residing on "Mison's lot" in that year.[7]

Misson's experience provides a good example of the itinerant life of the schoolteacher. While in Bedminster Township in 1820, he married Sarah Trout, a widow. Two years later, in 1822, the couple were in Springfield where their daughter Susanna was baptized.[8] By the following year, the family had moved to Durham where Misson spent at least two years teaching at the Durham School before moving on to Lehigh County.[9] In Lehigh, he taught briefly at an institution called the Permanent Schoolhouse in Hanover Township.[10]

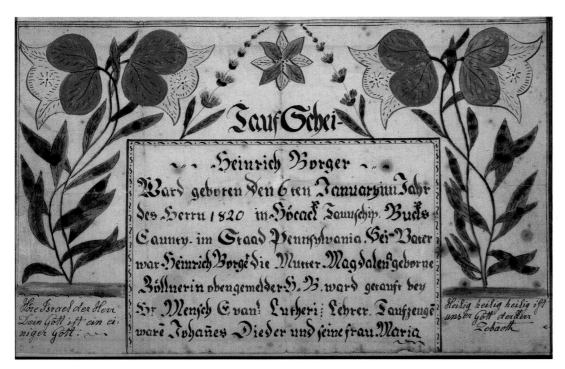

Fig. 173. **Birth and Baptismal Certificate for Heinrich Borger (1820– 1902)**. Attributed to Bernhard Misson, Haycock Township, Bucks County, c. 1820. Hand-drawn, lettered and colored on wove paper. 7⁷⁄₈ x 12¹⁄₂ in. The father of the child for whom Misson made this certificate was one of the trustees of Honn's Schoolhouse in Haycock where Misson kept school. (Private Collection.)

During Misson's short tenure at the school in Durham, he billed the county for teaching Solomon Misson, perhaps his own son from a previous marriage or the child of a relative.[11] In fact, it was not unusual for schoolmasters to list their own children on the bills they forwarded to the county (after all, why should they be expected to teach their own offspring for free?). While in Durham, Misson also produced one of the last and most dramatic pieces of fraktur that can be attributed to him (Fig. 176). Evidently inspired by American patriotic imagery, this drawing of eagles hovering above an urn bears the inscription *"Freyheit ist das leben der Welt und zwang ist der Todt"* [Freedom is the Life of the World, and Coercion is Death].

By 1830, Misson had moved to Northampton County, where he taught school for several years in Allen Township. An eight-month-old child, Samuel Mieson, lies in the Zion Stone Church Cemetery in Kreidersville, possibly one of Bernhard and Sarah's offspring.[12] As late as 1841, Misson is listed as a teacher on township tax lists, without real property but owning one cow. During those years, he paid the county annual taxes ranging from a low of $0.23 in 1840 to a high of $0.56 the following year. Those tax bills put him and his family close to the bottom of the local economic structure.[13]

Despite Misson's continued career in education, no fraktur from Lehigh or Northampton Counties has yet been attributed to his hand. It is possible that to expedite production, he had by then turned

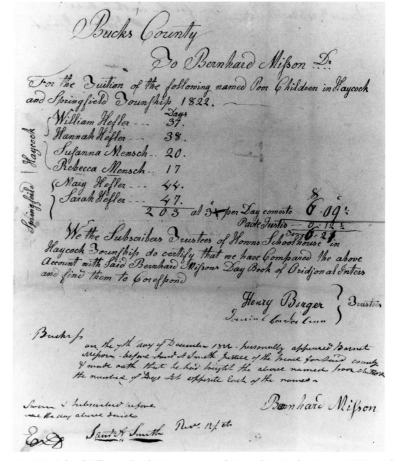

Fig. 174. **School Bill**. Bernhard Misson, Haycock Township, Bucks County, 1822. In this and other bills, Misson requested reimbursement from the county for teaching children whose parents could not afford his standard tuition of 3 cents a day. Note the name of Heinrich Borger as one of the school's two trustees. (Spruance Library/Bucks County Historical Society.)

Fig. 175. **Birth and Baptismal Certificate for Hannah Hefler (b. 1815).** Attributed to Bernhard Misson, Haycock Township, Bucks County, 1823. Hand-drawn, lettered and colored on wove paper. 7⅞ x 12⅞ in. (Courtesy, Christie's Images.)

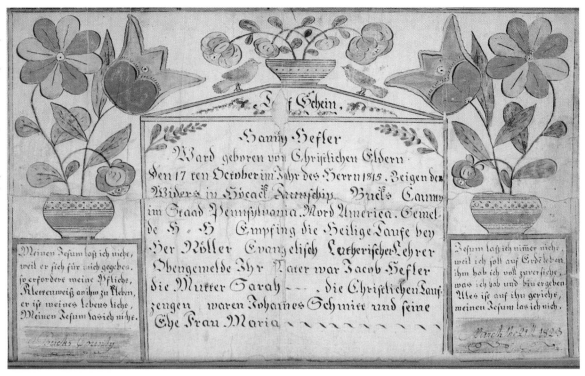

Fig. 176. **Drawing.** Attributed to Bernhard Misson, Durham Township, Bucks County, 1823. Hand-drawn, lettered and colored on wove paper. 9⅞ x 7⅛ in. (Courtesy, Christie's Images.)

to completing printed *Taufscheine*, in which case examples of his work as a scrivener might yet come to light. Other artists apparently picked up on Misson's style and decorative vocabulary, as some extant fraktur pieces are clearly derivative of his work (Fig. 177).

In 1842, Misson's name is crossed out on the Allen Township tax list. While it is possible that he had died, it seems more likely that he moved on to a new teaching position at a distant school. Nothing more is known of his career.[14]

Notes

1. See, for example, Bernhard Misson, "Bill for Schooling David Shitts, 1820, Haycock and Springfield Townships," February 26, 1821, B.C. School Bills. Eight other bills show that Misson taught at Honn's School from 1820 to 1823.

2. Misson, "Bill for Schooling Daniel Traut and Solomon Misson, Durham Township," November 14, 1823, B.C. School Bills. It is possible that Daniel Traut was the son of Misson's wife Sarah from a previous marriage. Similarly, Solomon may have been a child from Bernhard Misson's first marriage.

3. Misson, "Bill for Schooling William Hefler, et al, in the year 1822, Haycock and Springfield Townships," December 7, 1822, B.C. School Bills.

4. Two of the earliest baptismal certificates attributable to Misson, dated only one day apart in March 1808, bear the location *Marlborough* (a Montgomery County township). These are recorded in the Bucks County Fraktur File, SL/BCHS. It seems likely that Misson's origins were in that area.

5. Frederick S. Weiser and Howell J. Heaney, *The Pennsylvania German Fraktur of the Free Library of Philadelphia*, 2 vols. (Breinigsville, Pa.: Pennsylvania German Society, 1976), 2: fig. 720.

6. 1815–1817 Tax Lists, Milford Township, Bucks County, SL/BCHS.

7. 1820 Tax List, Milford Township.

8. Frances W. Waite, ed., *Bucks County Intelligencer Marriage Notices, 1804–1834,* 3 vols. (Doylestown, Pa.: Bucks County Historical Society, 1988), 1:141; *Unabhaeniger Republikaner* (Allentown, Pa.), May 11, 1820; and Thomas G. Myers, trans., *Church Records of Trinity Evangelical Lutheran Church, Springfield TWP., 1797–1913,* (Doylestown, Pa.: Bucks County Historical Society, n.d.), 24. Misson was evidently married previously. A "Bernard Misohn" and wife Magdalena had a son, Henry, baptized at Indianfield Lutheran Church in Montgomery County in 1806. See Annette Burgert and Raymond Hollenbach, *Church Record, Indianfield Lutheran Church, 1753–1831, Franconia Township, Montgomery County, Pennsylvania* (Worthington, Ohio: 1971), 63A.

9. This may have been Laubach's School in northeastern Durham Township or Long's Schoolhouse in Durham Village, just south of the Durham church.

10. Bernhard Misson, "Bills for Schooling Francis and Milton Buchecker, 1824, Hanover Township," February 7, and April 25, 1825, Lehigh County School Bills, Lehigh County Historical Society, Allentown, Pa.

11. B.C. School Bills, Durham Township, 1823.

12. "Burial Record of Zion Stone Church Graveyard and Cemetery Near Kreidersville, Allen Township, Northampton County, Pa., from 1772 to July 1st A.D. 1940," in William H. Dopke and William C. Emery, comps., *Northampton County Tombstone Inscriptions* (Doylestown, Pa.: Bucks County Historical Society, 1997), 50.

13. Northampton County Tax Records, Allen Township, 1834–1842.

14. No birth or baptismal record for Bernhard Misson has yet come to light. A Meissin family does appear in Upper Hanover Township, Montgomery County, in the late eighteenth century. See, for example, John T. Humphrey, *Montgomery County Births, 1682–1800,* (Washington, D.C.: 1993), 311. Other Meissens or Missons were associated with the Indian Creek Reformed congregation in Franconia Township,

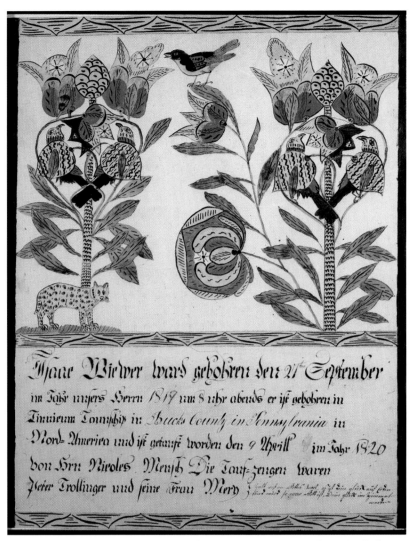

Fig. 177. **Birth and Baptismal Certificate for Isaac Weaver (1819–1877)**. School of Bernhard Misson, Tinicum Township, Bucks County, c. 1819. Hand-drawn, lettered and colored on wove paper. 16 x 13 in. Although the decoration is clearly related to Misson's work, the penmanship on this certificate does not appear consistent with his other fraktur. (Spruance Library/Bucks County Historical Society, SC-58. No. B-16.)

Montgomery County. Seventy-four year old Johannes Meissen was buried at Indian Creek in 1849. See John Young, *Der Neutralist, 1845–1853, Marriages and Deaths* (Skippackville, Pa.: 1988), 58; and Elaine Blaker Mellott, *Montgomery County, Pennsylvania Tombstone Inscriptions* (Woodland Park, Col.: 1996), 227. Given that Misson's earliest fraktur appears to have originated in Montgomery County, it seems plausible that he may have been related to these families. A Johann Peter Meissen, John Mason, and George Missen arrived in Philadelphia in 1747, 1791, and 1809, respectively, according to Ralph Beaver Strassburger and William J. Hinke, *Pennsylvania German Pioneers,* 3 vols. (Norristown, Pa.: Pennsylvania German Society, 1934), 1:367 and 3:47, 190. However, none of these individuals can be linked positively to the schoolmaster Bernhard Misson.

The Speckled Tulip Artist

(active c. 1818–1826)

Richland, Milford, and Rockhill Townships

The birth and baptismal certificates produced by this unidentified artist bear a striking resemblance to the fraktur of Bernhard Misson. The oversized tulips and banded urns appearing in the decoration, and even the formation of certain letters in the texts, suggest a common influence (Figs. 178, 179). However, the penmanship is sufficiently different to indicate two distinct hands at work. Most notably, the Speckled Tulip Artist's use of a more serpentine lowercase *s* in his fraktur lettering distinguishes him from Misson.[1] His similarly curved *f* is also distinctive. Both features are evident in a birth and baptismal certificate for Elias Scheib (Fig. 180). Another *Taufschein* that exhibits these same characteristics (though containing subtle differences), may also be by his hand (Fig. 181).

It seems obvious that this decorator and scrivener was familiar with the work of Bernhard Misson.

Although no evidence has been found to prove a connection, it is nonetheless an interesting coincidence that a teacher by the name of John Misson was also keeping school in upper Bucks County during the early 1820s.[2] Perhaps a brother or other relative of Bernhard, John Misson taught classes in Milford, Rockhill, Richland, and Haycock Townships—all locales in which the Speckled Tulip Artist produced birth and baptismal certificates.

John Misson lived in Rockhill Township with his wife Magdalena. Beginning in 1832, two of the couple's children are recorded on lists of poor children to be educated at the county's expense. In 1833, their father is specifically mentioned as "deceased" in these rolls.[3] Misson's wife, who died in 1865, is buried at the Tohickon Church cemetery. Although no stone survives, it is possible that her husband lies beside her.

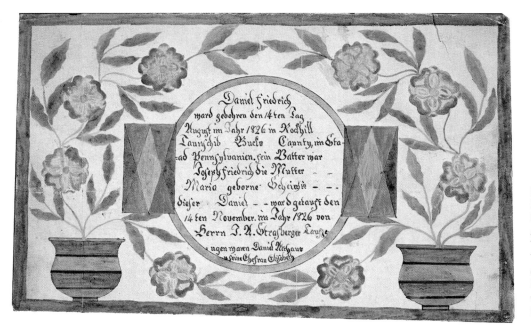

Fig. 178. **Birth and Baptismal Certificate for Daniel Friedrich (b. 1826).** Attributed to the Speckled Tulip Artist, Rockhill Township, Bucks County, c. 1826. Hand-drawn, lettered and colored on wove paper. 7⁷/₈ x 13 in. (Private collection.)

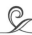

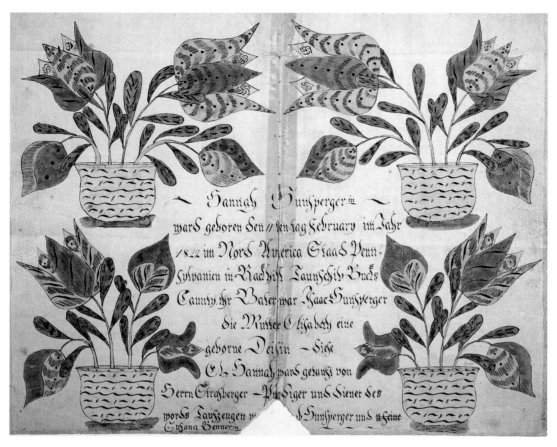

Fig. 179. **Birth and Baptismal Certificate for Hannah Hunsperger (b. 1822).** Attributed to the Speckled Tulip Artist, Rockhill Township, Bucks County, c. 1822. Hand-drawn, lettered and colored on wove paper. 12³/₄ x 15⁷/₈ in. The children for whom these first two certificates were made (Figs 178, 179), later became husband and wife. It is likely that they knew each other from childhood and attended the same school in Rockhill. (Private collection.)

Fig. 180. **Birth and Baptismal Certificate for Elias Scheib (b. 1823).** Attributed to the Speckled Tulip Artist, Richland Township, Bucks County, c. 1823. Hand-drawn, lettered and colored on laid paper. 8¹/₈ x 13⁵/₈ in. (Rare Book Department, The Free Library of Philadelphia, FLP 366.)

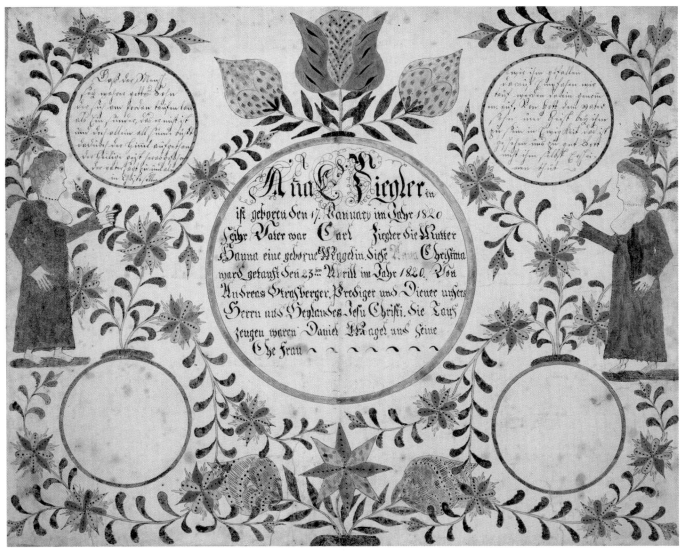

Fig. 181. **Birth and Baptismal Certificate for Anna Christina Ziegler (b. 1820).** Possibly by the Speckled Tulip Artist, Rockhill Township, Bucks County, c. 1820. Hand-drawn, lettered and colored on wove paper. 16 x 19 in. Although no location is mentioned on this certificate, Anna Ziegler's baptism is recorded in the register of the Tohickon Church in Bedminster. Her family lived just across the line in Rockhill Township. While this *Taufschein* exhibits some similarity in design and penmanship to works by the Speckled Tulip Artist, there are enough differences to warrant caution in making a firm attribution. (Permanent Collection, Rothman Gallery, Franklin & Marshall College.)

Notes

1. I am indebted to Pastor Frederick Weiser for pointing out this characteristic.

2. See, for example, John Misson, "Bill for Schooling John Durn, October 1, 1823 through April 10, 1824, Rockhill Township," April 10, 1824, B.C. School Bills.

3. Bucks County Historical Society, *Bucks County Poor School Children, 1810–1841*, (Doylestown, Pa.: Bucks County Historical Society, 1993), 136–137.

The Square Flower Artist

(active c. 1840–1845)

Rockhill and Hilltown Townships

Apparently a minor *Taufschein* maker, the so-called Square Flower Artist created very spare compositions, surrounding his design motifs with a great deal of empty space.[1] His characteristic pinwheel flowers also have a square, blocky appearance (Figs. 182, 183). The columns flanking the inscription blocks are similar, though not nearly as flamboyant, as those sometimes used by the schoolmaster-artist Bernhard Misson. Working rather late in the fraktur era, it seems plausible that this artist may also have completed printed certificates.

Notes

1. The nickname for this artist was suggested by Corinne Earnest and Russell Earnest.

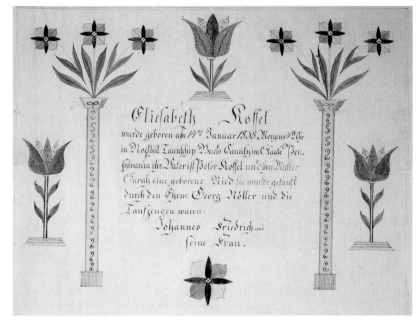

Fig. 183. **Birth and Baptismal Certificate for Elisabeth Koffel (1838–1922).** Attributed to the Square Flower Artist, Rockhill Township, Bucks County, c. 1838. Hand-drawn, lettered and colored on wove paper. 12¼ x 15¼ in. (Rare Book Department, The Free Library of Philadelphia, FLP 4.)

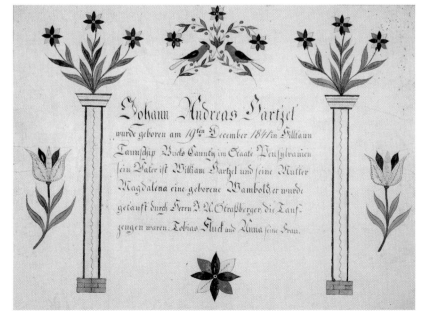

Fig. 182. **Birth and Baptismal Certificate for Johann Andreas Hartzel (b. 1841).** Attributed to the Square Flower Artist, Hilltown Township, Bucks County, c. 1841. Hand-drawn, lettered and colored on wove paper. 12¼ x 15¼ in. (Private collection.)

Philip Mumbauer

(1786–1851?, active c. 1811–1841)

Milford Township

Ascrivener and schoolmaster, Mumbauer taught the children of Lutheran, Mennonite, and Reformed families in Upper Milford Township, Lehigh County. In 1799, congregants representing all three Pennsylvania-German denominations in the vicinity of Dillingersville joined together to build a new community school. Work on the building concluded in 1802 and presumably classes began meeting shortly afterward. However, not until 1831 does a teacher's name—that of Philip Mumbauer—first appear in the trustees' accounts.[1] It is likely that Mumbauer began teaching at the school many years prior to his first mention in the trustees' book. In fact, as early as 1822 Mumbauer was serving as secretary to the Upper Milford Society for the Detection of Horse Thieves, an organization that met regularly in the school building.[2] Further, in an 1818 bookplate drawn by Mumbauer in one of his own texts, he called himself "Schoolmaster of Upper Milford Township."[3] Mumbauer is supposed to have presided over classes at the Dillingersville school until about 1839 when the trustees replaced him with another instructor.[4] However, his invoices to the county for instructing poor children show that he continued to teach at an unidentified school until at least 1841.[5]

A Philip Mumbauer (1786–1851) is buried with his wife Susanna (*née* Klein) in the graveyard of the Great Swamp Reformed Church (in southwestern Lehigh County just above Spinnerstown).[6] He may be the same individual who is recorded as a single

man in the Upper Milford Township tax records between 1810 and 1812.[7] Indeed, it is also possible that he was the schoolmaster and fraktur artist whose name appears in the trustees' accounts of the Dillingersville School. This Philip's father, Johann Philip Mumbauer (1750–1834), served as a trustee of Mumbauer's Schoolhouse, located in Milford Township, Bucks County, in the vicinity of Spinnerstown. Perhaps Philip Jr. even taught at this school (where George Gerhart also held classes in 1823). A position there certainly would have brought him closer to the Bucks County line and may explain the baptismal certificates he executed for Bucks County families.[8]

To complicate matters, however, another Philip also appears in the Mumbauer family tree. The son of Johannes and Catherine Mumbauer, this Philip was born January 21, 1789. Curiously, record of his baptism is found in the registers of Reformed congregations in both Lower Milford Township, Lehigh County, and in Trumbauersville, Bucks County.[9] Nothing more is known of this Philip Mumbauer, although he may be the same person who married Catharina Oberholtzer of Upper Milford in 1825, and whose estate was settled in Lehigh County in 1848.[10]

If not exactly prolific, Mumbauer the fraktur artist was certainly diverse. At least two hymn tune booklets, one freehand baptismal certificate (Fig. 184), one printed baptismal certificate, and several bookplates are known by his hand.[11]

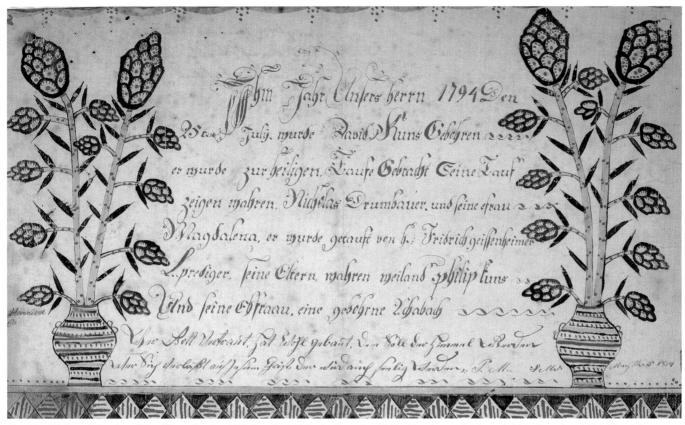

Fig. 184. **Birth and Baptismal Certificate for David Kuhns (b. 1794).** Attributed to Philip Mumbauer, Bucks or Lehigh Counties, 1814. Hand-drawn, lettered and colored on laid paper. 7¹/₂ x 12¹/₄ in. The baptizing minister named on this certificate, Frederick Geissenhainer, served both Trumbauer's and Schuetz' Lutheran congregations in Milford Township, Bucks County during the 1790s. (Rare Book Department, The Free Library of Philadelphia, FLP 1056.)

Notes

1. Andrew S. Berky, *The Schoolhouse Near the Old Spring* (Norristown, Pa.: Pennsylvania German Society, 1955), 33–45.

2. Ibid., 49.

3. Bucks County Fraktur File, SL/BCHS.

4. Berky, 45.

5. Philip Mumbauer, "Bill for Schooling Nathanael Heil, et al, 1840–41, Upper Milford Township," May 22, 1841, Lehigh County School Bills, Lehigh County Historical Society, Allentown, Pa.

6. Charles F. Seng, *Tombstone Inscriptions, Old Cemetery, Great Swamp Church, Lower Milford Township, Lehigh Co., Pa.* (1969), 3. Philip and Susanna were married in 1817 according to the *Unabhaeniger Republikaner* (Allentown, Pa.), 17 April 1817.

7. Northampton County Tax Lists, Upper Milford Township, 1810–1812, Northampton County Archives, Easton, Pa.

8. Charles Glatfelter, *Pastors and People: German Lutheran and Reformed Churches in the Pennsylvania Field, 1717–1793*, 2 vols. (Breinigsville, Pa.: Pennsylvania German Society, 1980), 1:347, notes that the Reformed congregation at Great Swamp had built a schoolhouse as early as 1762.

9. John T. Humphrey, *Pennsylvania Births, Lehigh County, 1734–1800* (Washington, D.C.: Humphrey Publications, 1992), 197; and *Pennsylvania Births, Bucks County, 1682–1800* (Washington, D.C.: Humphrey Publications, 1993), 205.

10. For this Philip's marriage see *Der Friedens Bote* (Allentown, Pa.), April 8, 1825. Also, see Estate of Philip Mumbauer, File no. 2092, Recorder of Wills, Lehigh County Courthouse, Allentown, Pa.

11. Russell D. Earnest and Corinne P. Earnest, *Papers for Birth Dayes: Guide to the Fraktur Artists and Scriveners*, 2 vols. (East Berlin, Pa.: Russell D. Earnest Associates, 1997), 2:565. See also Mary Jane Hershey's inventory of *Notenbüchlein* in this volume, and Bucks County Fraktur File, SL/BCHS.

The Dotted One Artist, Possibly Henry Wetzel

(active c. 1810–1845)

Bedminster, Nockamixon, and Tinicum Townships

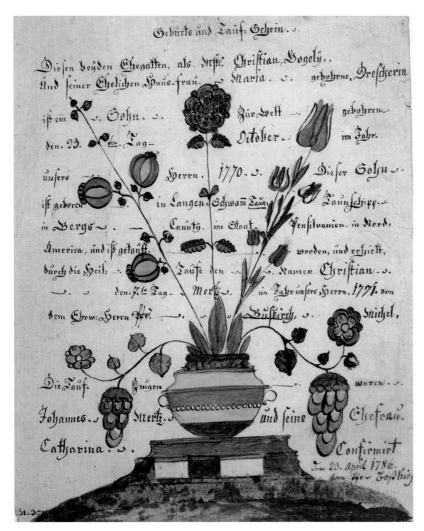

Fig. 185. **Birth and Baptismal Certificate for Christian Vogely (b. 1770)**. Attributed to the Dotted One Artist [possibly Henry Wetzel], Long Swamp Township, Berks County, c. 1810. Hand-drawn, lettered and colored on wove paper. 9¹/₈ x 7¹/₈ in. Note the unusual and distinctive uppercase *H* in the word *Herrn* [Lord]. (Private collection.)

Researchers have attributed a large group of related fraktur variously to a scrivener by the name of Michael Frölich; to an unidentified penman dubbed the Dotted One Artist; and, most recently, to an individual known only by the name of Henry Wetzel.[1] Sorting out these competing attributions is a considerable challenge.

A comparison of works attributed to the so-called Dotted One Artist with those signed by the scrivener Frölich clearly suggests two different hands at work. Further, there is no evidence that the Michael Frölich who signed printed baptismal certificates in Schuylkill County and elsewhere ever worked in Bucks County where many of the fraktur illustrated here originated. Conversely, though there existed an individual by the name of Michael Frölich who lived in Nockamixon Township, Bucks County for several years and later, apparently, in New Jersey, there are no indications that he traveled peripatetically around Pennsylvania producing *Taufscheine* or other fraktur.[2]

What is certain is that a substantial body of work by a single hand (characterized especially by the use of exclamation marks, "dotted ones," and "crazy *hs*") originated in Berks, Lehigh, Montgomery, and Northampton Counties, as well as in Bucks (Figs. 185–187).[3] Despite this array of locales, the greatest number of this artist's surviving works bear Berks and Lehigh place names. Including a few locations in northeastern Montgomery and western Northampton Counties, the bulk of his work originated roughly along a line running between Reading and Allentown, with the townships of Longswamp, Milford, and Macungie at its center. Perhaps significantly, Wetzel families were numerous in all of these locales.

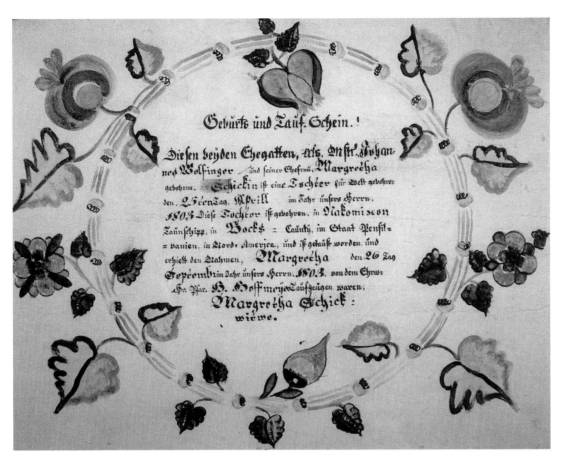

Fig. 186. **Birth and Baptismal Certificate for Margretha Wolfinger (b. 1803).** Attributed to the Dotted One Artist [possibly Henry Wetzel], Nockamixon Township, Bucks County, after 1803. Hand-drawn, lettered and colored on wove paper. 12 x 15½ in. (Private collection.)

Indeed, the discovery of a decorated poem (actually one-half of a longer secular verse) with the inscription "1838 A.D./Drawn by Henry Wetzel" on the reverse has suggested a new attribution for this group of fraktur (Figs. 188–190). Although written in what appears to be old sepia ink, two points lead us to question whether the inscription should be accepted at face value. First, no other English-language text has appeared in any of this artist's work, leading one set of authors to question whether he even knew English.[4] Thus, if this is his signature, his use of English seems a bit out of character. Second, the "A.D." in the date is actually out of place. Most fraktur artists were well aware that *Anno Domini* (Year of Our Lord) preceded, rather than followed, the date. Despite these inconsistencies, it is quite plausible that the inscription was placed on the back of the piece not by the artist but by the recipient, or even was placed there later by a relative. We might, then, allow for the misplaced "A.D." and the use of English.

Because of the circumstantial geographic evidence mentioned previously, a Wetzel attribution is a tempting one. There were several Henrys baptized to Wetzel families in Macungie, Upper

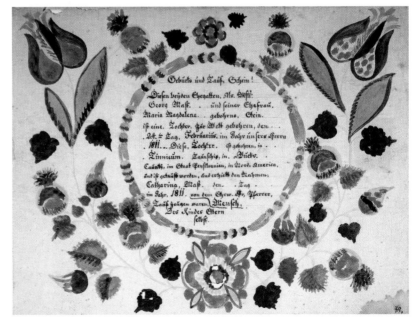

Fig. 187. **Birth and Baptismal Certificate for Catharina Mast (b. 1811).** Attributed to the Dotted One Artist [possibly Henry Wetzel], Tinicum Township, Bucks County, c. 1811. Hand-drawn, lettered and colored on wove paper. 12 x 16 in. (Private collection.)

Fig. 188. **Drawing with Verse:** *The Hen Speaks.* Attributed to the Dotted One Artist [possibly Henry Wetzel], probably Lehigh or Berks County, 1838[?]. Hand-drawn, lettered and colored on wove paper. 9¹/₂ x 7¹/₂ in. This is the second half of the complete decorated poem shown in Fig. 190. (Private collection.)

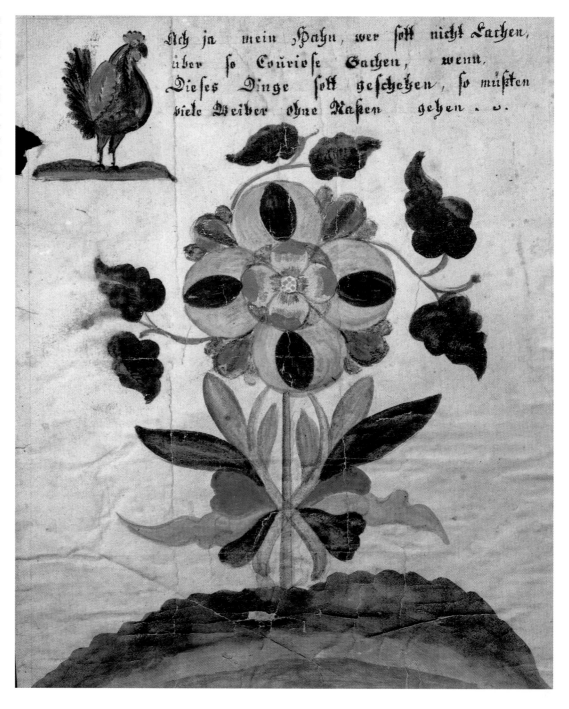

Fig. 189. **The Hen Speaks (reverse detail).** Shows the inscription featuring the name of Henry Wetzel on the reverse.

Fig. 190 a,b. **Drawing with Verse: *The Rooster Speaks to the Hen*** and ***The Hen Speaks.*** Attributed to the Dotted One Artist [possibly Henry Wetzel], probably Lehigh or Berks County, c. 1830. Hand-drawn, lettered and colored on wove paper. 9¹/₂ x 7¹/₂ and 9¹/₄ x 7³/₄ in. In this colorful, secular poem the jealous rooster ("Man") warns the hen ("Woman") not to cavort with "strange roosters." The hen, in turn, scoffs at the rooster's jealousy, suggesting that he is impotent in penalizing her for such behavior. (Collection of H. Richard Dietrich Jr., Philadelphia, Pa. Photo by Will Brown.)

Milford, and Longswamp Townships. However, without further corroborating documentation, a definite attribution is impossible. Whoever he was, this artist's foray down into Bucks County appears to be something of an aberration in his wanderings. Nonetheless, he is known to have produced at least four manuscript certificates and completed two printed ones (Fig. 191) for Bucks County families.⁵

Notes:

1. In his 1994 volume on small presentation fraktur, Pastor Frederick Weiser attributed a two-panel decorated poem by this hand to Michael Frölich, a scrivener who signed other work exhibiting similar penmanship. However, in their 1997 publication, Russell and Corinne Earnest contested that attribution, preferring to give this artist only the anonymous sobriquet the "Dotted One" Artist. Recently, a related fraktur has come to light with the sepia inscription "Drawn by Henry Wetzel, 1838 A.D." on the reverse. For references see Frederick Weiser, *The Gift is Small, the Love is Great* (York, Pa.: York Graphic Services, 1994), 56–7; Russell D. Earnest and Corinne P. Earnest, *Papers for Birth Dayes: A Guide to the Fraktur*

Artists and Scriveners, 2nd ed. 2 vols. (East Berlin, Pa.: Russell D. Earnest and Associates, 1997), 1:197–199; Bucks County Fraktur File, SL/BCHS.

2. For information on Michael Frölich the scrivener see Earnest and Earnest, 1:297–298. The Michael Frölich (or Fraley as the name was sometimes written) of Nockamixon had several children baptized at St. Luke's Reformed Church in Ferndale between 1793 and 1814. See Charles R. Roberts, trans., *Saint Luke's Union Church, Ferndale, Nockamixon Township, Bucks County, Pennsylvania, Records of the Reformed Congregation* (Allentown, Pa.: by the author, 1923), 21, 27, 31, 36, 43, 45, 47. Tax records and deeds show him to have

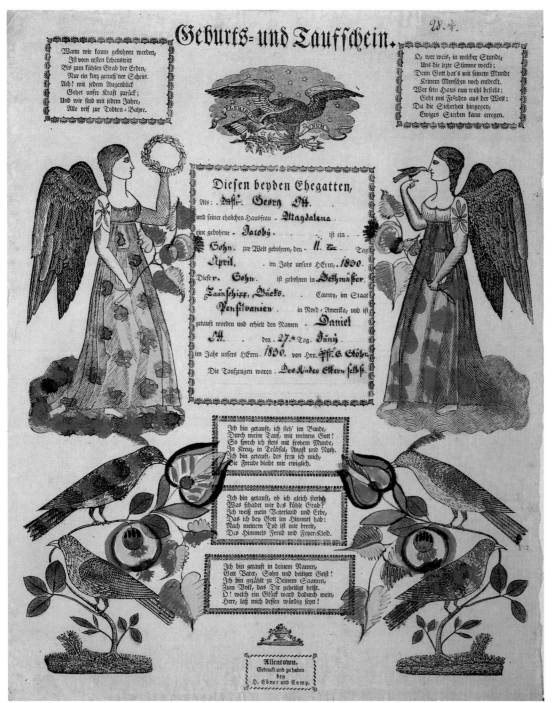

Fig. 191. **Birth and Baptismal Certificate for Daniel Ott (b. 1830).** Printed by H. Ebner & Company, Allentown, Lehigh County. Completed, with added decoration, by the Dotted One Artist [possibly Henry Wetzel], Bedminster Township, Bucks County, c. 1830. Printed, hand-lettered and colored on wove paper. 16⅝ x 13 in. (Spruance Library/Bucks County Historical Society, SC-58. No. B-18.)

been the owner of 150 acres of land in Bucks County and probably more in New Jersey. See, for example, 1794–96 Tax Lists, Nockamixon Township, Bucks County, Pa., SL/BCHS.

3.　Earnest and Earnest, 1:197. Regarding the "dotted ones," two schoolteachers in Lehigh County prepared bills for instructing poor children in a German script similar in some respects to that used by the Dotted One Artist. However, neither is sufficiently comparable to make a connection or positive attribution. See Henry Mühlhausen, "Bill for Schooling Jeremias Weiss, et al, April-June 1841, Upper Macungie and Lowhill

Townships," July 21, 1841; and Charles H. Wiedenmeyer, "Bill for Schooling Loisa Anna Fritz, et al, 1840, Weisenberg Township," January 28, 1841, Lehigh County School Bills, Lehigh County Historical Society, Allentown, Pa.

4.　Earnest and Earnest, 1:198.

5.　Bucks County Fraktur File, SL/BCHS.

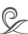

The Pseudo-Engraver Artist

(active c. 1814–1820)

Haycock Township

The artist who composed a birth and baptismal certificate for Catharina Textor in 1820 (Fig. 192) may have been influenced by another anonymous penman who worked in Berks and Northampton Counties. Though more crudely drawn, the exotic flowers and berries branching from a wreath on the Bucks County piece bear a strong resemblance to those that appear on fraktur by the so-called Engraver Artist (Fig. 193).[1] The nickname Pseudo-Engraver is intended to highlight this relationship, and the two artists' use of a similar design vocabulary (Fig. 194).

Catharina Textor was the daughter of George Textor (1775–1848), a Haycock Township stonemason, and his wife Maria (Trumbauer) Textor.[2] Seven of the couple's children were baptized at the Tohickon Union Church between 1806 and 1823.[3] Five of them, including Catharina, later appear on lists of poor children educated at the county's expense.[4] Young Moses and Hannah Textor are also named on an 1823 school bill submitted to the county by a teacher named George Textor, almost certainly their father.[5] Based on this and other school bills, Textor served as a schoolteacher on several occasions, particularly during the winter months.

The head of a relatively poor family for whom a *Taufschein* would have been an expensive luxury, George Textor himself may have made his daughter's certificate and a similarly decorated reward of merit, also from Haycock.[6] It is likely, too, that George had relatives among the many Textor families in Berks County, and so may have been familiar with the Engraver Artist's work. Unfortunately, no examples of George Textor's German script have been discovered to compare to the penmanship on the Pseudo-Engraver Artist's fraktur.[7] Until such a discovery occurs, a positive identification is impossible.

Fig. 192. **Birth and Baptismal Certificate for Catharina Textor (b. 1820)**. Attributed to the Pseudo-Engraver Artist, Haycock Township, Bucks County, c. 1820. Hand-drawn, lettered and colored on wove paper. 10³/₄ x 7⁷/₈ in. (Permanent Collection, Rothman Gallery, Franklin & Marshall College.)

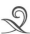

Fig. 193. **Birth and Baptismal Certificate for Johannes Seib (b. 1794).** Attributed to the Engraver Artist (active c. 1791–1804), Weisenberg Township, Northampton [now Lehigh] County, c. 1797. Hand-drawn, lettered and colored on laid paper. 8 x 13 in. (Collections of the Lehigh County Historical Society.)

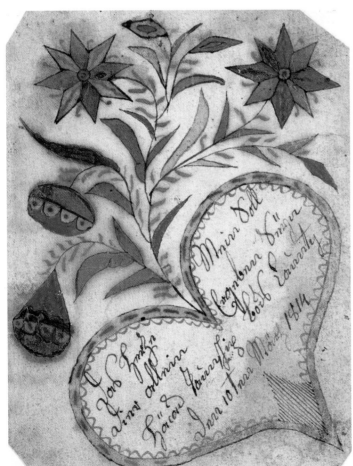

Fig. 194. **Drawing with Verse.** Attributed to the Pseudo-Engraver Artist, Haycock Township, Bucks County, 1814. Hand-drawn, lettered and colored on wove paper. 3¼ x 4¼ in. The pledge that appears on this small fraktur, "This heart of mine shall be devoted to thee alone," is one that is normally directed toward Jesus. However, in the absence of Jesus' name, it is possible that it was intended as a secular fraktur, perhaps even as a Valentine or other presentation piece. (Private collection.)

Notes

1. The Engraver Artist was named for the extreme precision that characterizes much of his work, derived possibly from his use of stamps or patterns. See Russell D. Earnest and Corinne P. Earnest, *Papers for Birth Days: Guide to the Fraktur Artists and Scriveners*, 2nd ed., 2 vols. (East Berlin, Pa.: Russell D. Earnest Associates, 1997), 1:242–243.

2. Bucks County Tax Records, Haycock Township, 1797–1814; William J. Hinke, *A History of the Tohickon Union Church, Bedminster Township, Bucks County, Pennsylvania* (Meadville, Pa.: Pennsylvania German Society, 1925), 224; and Frances Wise Waite, comp., *Bucks County Tombstone Inscriptions, Haycock and Bedminster Townships* (Doylestown, Pa.: Bucks County Genealogical Society, 1988), K10.

3. Hinke, *Tohickon Church*, 409, 411, 412, 413, 416, 421, 424.

4. Bucks County Historical Society, *Bucks County Poor School Children, 1810–1841*, (Doylestown, Pa.: Bucks County Historical Society, 1993), 48–51. Catharina Textor appears on these lists for the years 1828–1832.

5. George Textor, "Bill for Schooling John Reaser, et al., in the year 1823, Haycock Township," April 3, 1823, B.C. School Bills.

6. Intriguingly, one of the sponsors at Catharina's baptism, Johannes Ahlum, may be the John O. Allem who was also a schoolteacher in Haycock. Based on the school bills he submitted, John Allem had very fine penmanship and may himself have been a fraktur artist. The gracefulness of his hand, however, seems inconsistent with the sloppier work on the Pseudo-Engraver Artist's fraktur.

7. The German script on the Pseudo-Engraver Artist's fraktur is very different from the English lettering in George Textor's school bills. However, the formation of numbers in both documents is strikingly similar.

Herrmann Diederich Bremer

(d. 1824, active c. 1814–1824)

Nockamixon Township

Bremer's distinctive signature, written in large English-style script, has been found on at least two pieces of fraktur (Fig. 195).[1] Although neither are of Bucks County origin, their maker did teach school for several years in Nockamixon Township and it would be surprising if other pieces are not extant bearing his penmanship.

Though a resident of Lower Saucon Township, Northampton County, as early as 1810,[2] Bremer presided intermittently over classes in Nockamixon between 1821 and 1823.[3] He also taught there

briefly in 1814.[4] On a school bill dating from this earlier appointment, written in the German language, one of the children's surnames ("Ferner") appears as embellished fraktur lettering (Fig. 196).

The location of the schoolhouse mentioned on several of Bremer's poor bills, that is, "near the crossroads in Nockamixon," points to an institution situated close to the township's Union Church, St. Luke's. Likewise, the school trustees—among them John Shick, George Rapp, and Michael Crouse—all were congregants of St. Luke's, either on the

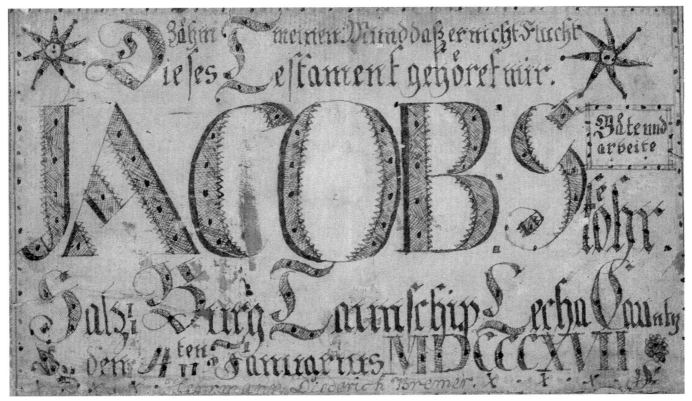

Fig. 195. **Bookplate for Jacob Stöhr.** Herrmann Diederich Bremer, Salisbury Township, Lehigh County, 1817. Hand-drawn, lettered and colored on laid paper. 3³/₄ x 6¹/₂ in. (Rare Book Department, The Free Library of Philadelphia, FLP B-60.)

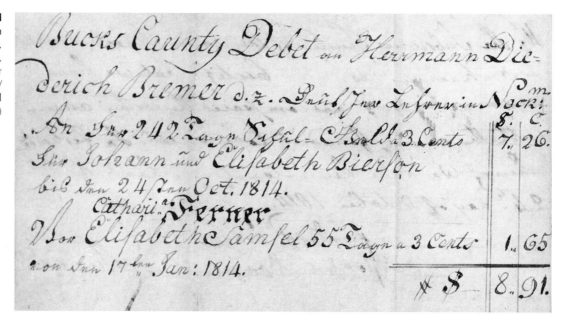

Lutheran or Reformed side.[5]

Bremer's exact origins are unknown. The records of the Upper Saucon or Friedens Union Church prove that he married his wife, Elisabeth Schütz, in 1797,[6] but no trace of his birth or baptism has been found. In fact, his surname is rare among early settlers in both Bucks and Northampton Counties. While it is possible that he was a late eighteenth-century immigrant to America, no record of his arrival in Philadelphia or elsewhere has been located. Perhaps he was related to the Frederick "Praymour" known to have resided in Richland Township, Bucks County in 1800.[7] In any event, Herrmann and Elisabeth had five of their children baptized at Friedens Church between 1800 and 1812, and the couple appeared frequently on communicants' lists.[8]

Lower Saucon Township tax records list Bremer's occupation as a teacher. Holding no real property, he was taxed at amounts ranging from a high of $1.05 to a low of $0.65 per annum. Following his death, Bremer's estate was taxed at even lower amounts in 1825 and 1826.[9] Orphans' Court and estate records show that when he died in early 1824, he left behind his wife Elisabeth and five children,

two of whom were under the age of fourteen.[10] Four of his offspring are named in the records: Peter, Herman, Henrietta, and Christina.

Little in the inventory of Bremer's estate hints either at his profession or his sideline as a fraktur scrivener. He did own several books, including a bible, prayer book, and hymnal, all valued at $2.75. Judging from the agricultural tools listed and the small amounts of hay and grain "in the ground," he cultivated a few acres of land along with raising several head of livestock. Most significant, however, may be the debt owed by Bremer's estate to Henry Ebner of Allentown, one of several publishers known to have produced baptismal certificates at their print shops.[11] While a portion of this debt might simply have been for publishing a notice in Ebner's newspaper, the especially large bill owed to the printer ($13.38) could well have been for *Taufschein* forms. Though none of these forms are mentioned specifically in the inventory, at least one of Ebner's prints with Bremer's signature is known.[12] Perhaps Bremer's hand will yet be matched with the penmanship on other Ebner certificates from the 1814–1824 period.

Notes

1. See Frederick S. Weiser and Howell J. Heaney, *The Pennsylvania German Fraktur of the Free Library of Philadelphia*, 2 vols. (Breinigsville, Pa.: Pennsylvania German Society, 1976), 2:fig. 717; and Russell D. Earnest and Corinne P. Earnest, *Papers for Birth Dayes: Guide to the Fraktur Artists and Scriveners*, 2nd ed., 2 vols. (East Berlin, Pa.: Russell D. Earnest Associates, 1997), 1:125.

2. U.S. Census of 1810, Lower Saucon Township, Northampton County, Pa., 6.

3. Herrmann Diederich Bremer, "Bill for Schooling Jacob and Elijah Foor, October 19 through December 7, 1821, Nockamixon Township," December 7, 1821; "Bill for Schooling Jacob and Elijah Foor, December 20, 1821 through March 2, 1822, Nockamixon Township," March 2, 1822; "Bill for Schooling Jacob and Elijah Foor, March 4 through May 20, 1822, Nockamixon Township," May 22, 1822; "Bill for Schooling Jacob and Elijah Foor, et al, May 20, 1822 through November 4, 1822, Nockamixon Township," n.d.; "Bill for Schooling John and Catherine Lefever, September 24, 1823 through October 14, 1823, Nockamixon Township," October 17, 1823, B.C. School Bills.

4. Herrmann Diederich Bremer, "Bill for Schooling Johann and Elisabeth Bierson, et al, 1814, Nockamixon Township," October 14, 1814, B.C. School Bills.

5. For evidence of these men's association with the Nockamixon Union Church see Thomas G. Myers, trans./comp., *Church Records of St. Luke's Evangelical Lutheran Church, Nockamixon Township, 1766–1921* (Doylestown, Pa.: Bucks County Historical Society, 1991), 118, 123, 125–127, 129; and Charles R. Roberts, trans./comp., *Saint Luke's Union Church, Ferndale, Nockamixon Township, Bucks County, Pennsylvania, Records of the Reformed Congregation* (n.p., 1923), 59, 65, 67, 72.

6. Donna R. Irish, comp., *Pennsylvania German Marriages* (Baltimore: Genealogical Publishing Company, 1982), 103.

7. U.S. Census of 1800, Richland Township, Bucks County, Pa., 158A.

8. *Union Church of the Upper Saucon or Friedens Church, 1763–1767 and 1793–1852* (Doylestown, Pa.: Bucks County Historical Society, n.d.), n.p.

9. Northampton County Tax Records, Lower Saucon Township, 1820–1826, Northampton County Archives, Easton, Pa.

10. Orphans' Court Records, 10:94–96, Northampton County Courthouse, Easton, Pa.; Estate of Herrmann Diederich Bremer, File no. 3443, Northampton County Register of Wills, Easton, Pa.

11. Ibid.; For information on Ebner's printing business, see Alfred L. Shoemaker, "A Checklist of Imprints of the German Press of Lehigh County, Pennsylvania, 1807–1900," *Proceedings of the Lehigh County Historical Society,* 16 (1947): 193, 201; and Klaus Stopp, *The Printed Birth and Baptismal Certificates of the German Americans,* 6 vols. (Mainz, Germany and East Berlin, Pa.: by the author, 1997–2000), 1:157–170.

12. Earnest and Earnest, 1:125.

Anthony Rehm

(active c. 1818–1825)

Milford Township

Anthony Rehm arrived in Philadelphia from the Dutch port of Amsterdam about 1816. In that year, he bound himself out as an indentured servant to John Nice, a Montgomery County miller. In return for Rehm's pledge of three years of service, Nice paid his passage across the Atlantic—a bill totaling $81.50.[1]

Having likely brought his talents with him from Europe, Rehm began to produce fraktur while still in service to Nice. His fraktur, too, has an old-world quality to it (Fig. 197), although he adapted some of his freehand work from the printed baptismal certificates produced in Pennsylvania during the 1810s and 1820s (Fig. 198). In addition to his watercolor decoration, Rehm also frequently incorporated a pin-pricking technique into his compositions.

At the close of his three years, Rehm married and eventually accepted a teaching position in Upper Salford Township, Montgomery County. Between 1830 and 1836, seven of his offspring appear on lists of poor children to be educated at the county's expense. In fact, it was typical of teachers like Rehm to bill the county for instructing their own children. But the presence of Rehm's children on those rolls likely attests to the family's limited means as well as to their father's profession and suggests the role that the sale of *Taufscheine* may have played in supporting the Rehm household.[2]

About 1837, Rehm left Upper Salford. He and his family eventually settled on Long Island, New York, where Rehm died in 1857.[3] All of his known surviving fraktur, however, come from an area along the border between Bucks and Montgomery Counties, a region from which he also probably drew his students.

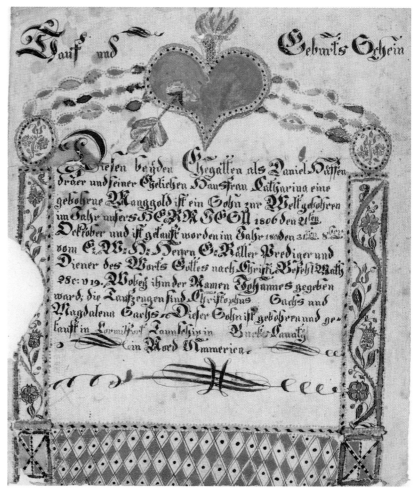

Fig. 197. **Birth and Baptismal Certificate for Johannes Hüffendraer (b. 1806)**. Anthony Rehm, Lower Milford [now Milford] Township, Bucks County, c. 1820. Hand-drawn, lettered and colored with perforations on laid paper. 7⁷/₈ x 6⁵/₈ in. (Rare Book Department, The Free Library of Philadelphia, FLP 506.)

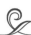

Fig. 198. **Birth and Baptismal Certificate for Elias Hettrich (b. 1813).** Anthony Rehm, with later text by Martin Wetzler, Lower Milford [now Milford] Township, Bucks County, 1818. Hand-drawn, lettered and colored with perforations on laid paper. 12¼ x 15½ in. Rehm produced this fraktur while still in the service of John Nice and probably before he began keeping school in Upper Salford. Wetzler, the scrivener who later added vital information to the form, was an itinerant Jewish *Dindamann*, or penman, who plied his trade in several Pennsylvania counties. (Private collection.)

Notes

1. Indenture of Anton Rehm, Philadelphia, 12 November 1816 [copy], Rehm Family File, Collections of the Historical Society of Montgomery County, Norristown, Pa.

2. Hannah B. Roach, comp., *Transcribed Translation of the Records of the Lutheran Church at Old Goschenhoppen* (Norristown, Pa.: The Historical Society of Montgomery County, 1955); "Names of Teachers with Their Assessments for the Education of Poor Children," clipping from unidentified Montgomery County, Pa.

newspaper, 1831, Schools File, Collections of the Historical Society of Montgomery County, Norristown, Pa.; Judith A. Meier, ed., *Poor Children to Be Educated at County Expense, Montgomery County, Pennsylvania* (Norristown, Pa.: The Historical Society of Montgomery County, 1992), 229–31.

3. Letter from Frank P. Rhame, January 3, 1952, Rehm Family File, Collections of the Historical Society of Montgomery County, Norristown, Pa.

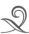

The Color Block Artist, Probably John W. Stover

(active c. 1820–1830)

Nockamixon Township

Apparently a minor scrivener and decorator, the Color Block Artist[1] incorporated rectangles of color into his *Taufschein* designs (Fig. 199). Sometimes these blocks contained text while at other times they were left empty. He flanked his devotional verses and baptismal data with stylized floral designs emerging from banded pitchers—the latter reminiscent of Bernhard Misson's similarly drawn urns. Within the text, his blocky numbers are especially distinctive. Although it is possible that this artist worked in other styles (he may well have completed printed certificates),

examples that can be attributed to him are few at present.

Among the schoolmasters active in Nockamixon Township during the 1820s was John W. Stover. Stover not only taught school in the township from late 1824 until at least 1829,[2] he also served as tax assessor for several years. On the cover of his 1828 tax roll, he wrote in elaborate fraktur lettering: "Transcript for the Townschip [sic] of Nockamixon, John W. Stover, May 6th, 1828" (Fig. 200). His execution of "Nockamixon," and the block letters and numbers he employed in his effort to decorate

Fig. 199. **Birth and Baptismal Certificate for Caroline Matilda Transu (b. 1821).** Attributed to the Color Block Artist [probably John W. Stover], Nockamixon Township, Bucks County, c. 1821. Hand-drawn, lettered and colored on wove paper. 12½ x 15½ in. (Rare Book Department, The Free Library of Philadelphia, PaGer additions 95–1734.)

an otherwise perfunctory document are strongly reminiscent of those on the Color Block Artist's certificates. Even more compelling is that the baptismal sponsors noted on this artist's *Taufschein* for Aaron Wismer (Fig. 201) are none other than John Stauffer, or Stover, and his wife Anna. Indeed, John W. Stover is known to have married Anna Nicholas (1802–1890) in 1818.[3] Finally, and most importantly, this certificate was drawn for the son of John Stover's younger sister, Mary (Stover) Wismer.[4]

Stover was born in Bucks County on November 24, 1793, the eldest son of Daniel and Mary Magdalena (Moyer) Stover of Tinicum and Nockamixon Townships. Although his father had been a Mennonite, and his mother a Lutheran, John W. Stover joined the German Reformed congregation in Nockamixon.[5] The Stover family history refers to him only as a "farmer and shoemaker," however he was evidently a well-educated and literate man who served his community in several official capacities. In addition to his roles as schoolmaster and tax assessor, Stover also aided local residents in administering their estates and served as Clerk of the Orphans' Court of Bucks County from 1836 to 1839.[6] He died May 11, 1865, and was buried at the Nockamixon Union Cemetery.[7]

Although it seems almost certain that John W. Stover was the penman and decorator who drew the certificates illustrated here, the evidence remains mostly circumstantial. Perhaps more direct proof will yet be found to confirm Stover's role as a fraktur artist and scrivener.

Fig. 200. **Cover of Tax Assessment Roll (detail).** John W. Stover, Nockamixon Township, 1828. (Spruance Library/Bucks County Historical Society.)

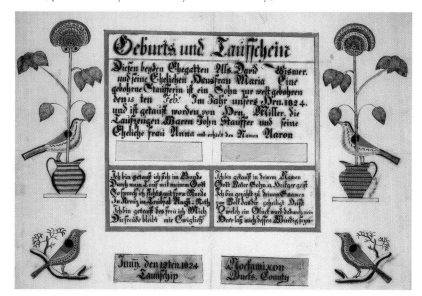

Fig. 201. **Birth and Baptismal Certificate for Aaron Wismer (b. 1824).** Attributed to the Color Block Artist [probably John W. Stover], Nockamixon Township, Bucks County, 1824. Hand-drawn, lettered and colored on wove paper. 11⅝ x 15⅝ in. (Private collection.)

Notes

1. This nickname was applied to the artist during the Mercer Museum's Bucks County fraktur exhibit project in 1997.

2. See, for example, John W. Stover, "Bill for Schooling John and Jonas Gordon, et al, September 3 through December 8, 1826, Nockamixon Township," December 8, 1826, B.C. School Bills. Prior to teaching in Nockamixon, Stover also instructed students in Springfield and Durham Townships. See, for example, John W. Stover, "Bill for Schooling Catherine Stover, et al, April 2, 1821 through October 25, 1821, Springfield Township," October 25, 1821, B.C. School Bills.

3. Rev. A.J. Fretz, *A Genealogical Record of the Descendants of Henry Stauffer and other Stauffer Pioneers* (Harleysville, Pa.: The Harleysville Press, 1899), 137–138.

4. Ibid., 139.

5. Ibid., 138.

6. See, for example, "Bond, Mary Ann Wilson to John W. Stover, Administrator of the Estate of Samuel Wilson," August 6, 1831 (recorded December 13, 1831), Misc. Book 6: 231–232, SL/BCHS. Also J.H. Battle, ed., *History of Bucks County, Pennsylvania* (Spartanburg, S.C.: The Reprint Company, 1985), 683.

7. Fretz, *Descendants of Henry Stauffer*, 138. See also Tombstone Inscription File, SL/BCHS.

Elizabeth Borneman Dieterly

(1798–1871)

Bedminster and Haycock Townships

Women educators—and hence women fraktur artists—were a rarity in pre-1860 Bucks County. Of fifty-three teachers known to have kept school in the townships of Bedminster and Haycock between 1812 and 1828, only two were female. In neighboring Rockhill and Hilltown Townships, five women teachers are recorded, but only one came from a German family.[1] Bridging this gender gap was Elizabeth Dieterly, Bucks County's only known female fraktur artist. While there may well have been others, at this date they remain anonymous.

Dieterly kept school in Bedminster and Haycock from about 1823 to 1826, and possibly longer.[2] It is likely that she taught in schoolhouses very near to Keller's Lutheran Church in north-central Bedminster Township, where she and other family members were regular communicants.[3] Nearly all of the children named on her school bills, and on her known fraktur, also had their baptisms recorded at Keller's.[4] Though she noted on one bill that her employers were the trustees of the "Haycock school

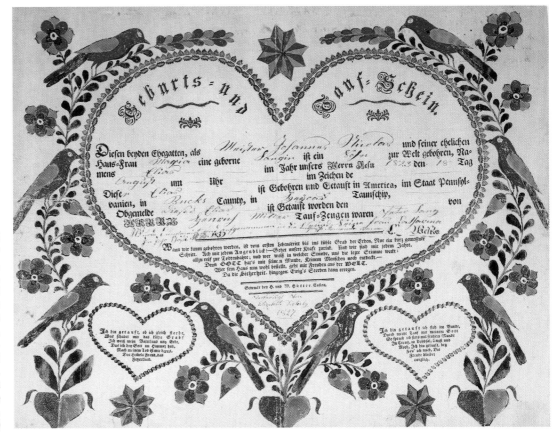

Fig. 202. **Birth and Baptismal Certificate for Elias Nicholas (b. 1823).** Printed by H. & W. Hütter, Easton, Pa. Decorated and completed by Elizabeth Dieterly, Haycock Township, Bucks County, 1827. Printed, hand-drawn, colored and lettered on wove paper. 9 x 12¼ in. (Rare Book Department, The Free Library of Philadelphia, FLP 1161.)

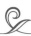

Fig. 203. **Birth and Baptismal Certificate for Elisabeth Schitz (b. 1825).** Printed by H. & W. Hütter, Easton, Pa. Decorated and completed by Elizabeth Dieterly, Bedminster Township, Bucks County, 1825. Printed, hand-drawn, colored and lettered on wove paper. 13 x 16 in. (Private collection.)

House,"[5] a second invoice makes it clear that she also taught in Bedminster. In fact, an 1850 Bucks County map shows a school just behind Keller's Lutheran Church, perhaps a one-time parochial institution.[6] It may have been in this building, at least for a time, that Dieterly instructed local youth.

Typical of Dieterly's decorative style are the heart-shaped tips seen on her flower buds, and her common use of red and mustard yellow tones (Figs. 202, 203). She purchased blank certificates from an Easton, Pennsylvania, printer, added the freehand decoration, and then filled in the birth and baptismal data. She even completed such a printed *Taufschein* for herself, though without decoration, noting her birth in December 1798 and her baptism by the Lutheran pastor Nicholas Mensch (Fig. 204).

One of three daughters of Michael Jr. and Barbara (Borneman) Dieterly of Haycock,[7] Elizabeth never married. Despite her single status, however, she apparently prospered. At a public sale of the possessions of her father after his death, she bought several of the most valuable items, including a Dearborn Wagon for $31, and a tall case clock for $25.[8] She also retained the family bible, now in the Bucks County Historical Society's collection.[9] Found within its pages was a small slip of paper on which Elizabeth apparently wrote out the text of her father's tombstone. How long she may have continued to teach is unknown, but she died at the age of 72, and was buried near her father at Keller's Church (Fig. 205).[10] In her estate at the time of her death was a bookcase, slate, piano, maps, and ten "picktures," any of which might have recalled her one-time occupation as a schoolteacher.[11]

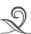

Fig. 204. Birth and Baptismal Certificate for Elisabeth Dieterly (1798–1871). Printed by H. & W. Hütter, Easton, Pa. Lettering attributed to Elizabeth Dieterly, Bedminster Township, Bucks County, c. 1822. Printed and hand-lettered on wove paper (cut from full sheet). 9 x 12¼ in. (Spruance Library/Bucks County Historical Society, SC-58. No. B-66.)

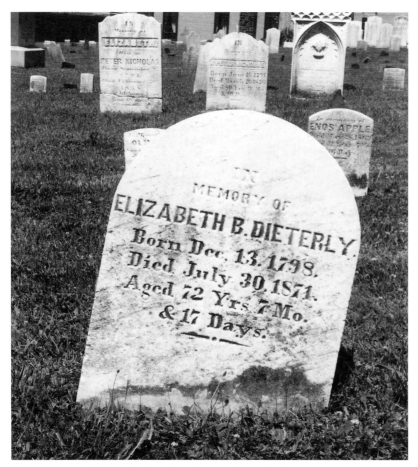

Fig. 205. Grave of Elizabeth Dieterly. Keller's Lutheran Church Cemetery, Bedminster Township, Bucks County. (Photo by Cory Amsler.)

Notes

1. Based on an analysis of 320 invoices for teaching poor children from Haycock, Bedminster, Rockhill, and Hilltown Townships, 1812–1828, B.C. School Bills.

2. Elizabeth Dieterly, "Bill for Schooling Samuel and Henry Stoneback, et al, November 17, 1823 through February 20, 1824, Haycock Township," December 18, 1824; and "Bill for Schooling John and Susanna Nicholas, May 2, 1825 through September 16, 1825, Bedminster Township," April 24, 1826, B.C. School Bills.

3. An Elizabeth Dieterly, probably the schoolteacher and fraktur artist, appears with other family members on lists of communicants from 1816 (possibly the year of her first communion) through 1822–1823. See the collection of compiled and translated records entitled *Keller's Evangelical Lutheran Church, Bedminster Township, Bucks County, Pennsylvania, 1751–1870* (Doylestown, Pa.: Bucks County Historical Society, n.d.), 147–149.

4. Ibid. See, for example, the baptisms of Elias Nicholas and Elisabeth Schitz recorded on pp. 70–71.

5. Dieterly, "Bill for Schooling Samuel and Henry Stoneback."

6. *Map of Bucks County, Pennsylvania* (Philadelphia: R. P. Smith, 1850).

7. J.H. Borneman, *The History of the Borneman Family in America* (Boyertown, Pa.: by the author, 1881), 26. See also baptismal certificates of Elisabeth Dieterly, SC-58. No. B-66, and Michael Dieterly, Jr., SC-58. No. B-47, SL/BCHS.

8. "Vendues of Michael Deterley, deceased," Haycock Township, 16 February and 23 March 1832, Bucks County Vendue Lists, MSC 354, Fols. 11 and 19, SL/BCHS.

9. Dieterly Family Bible, B-222, SL/BCHS.

10. Frances Wise Waite, comp., *Bucks County Tombstone Inscriptions, Bedminster and Haycock Townships* (Doylestown, Pa.: Bucks County Genealogical Society, 1988), G15.

11. Estate of Elizabeth Deaterly [Dieterly], File No. 13049, Register of Wills, Bucks County Courthouse, Doylestown, Pa.

Dieterly School

(c. 1830–1840)

Bedminster, Haycock, and Hilltown Townships?

Several other extant fraktur pictures, book plates, and baptismal certificates bear the color palette and distinctive red-tipped or heart-shaped flower buds seen on Elizabeth Dieterly's signed *Taufscheine*. Indeed, it is tempting to attribute many of these to Dieterly. However, making such a firm attribution is inadvisable given the lack of evidence. Many of these pieces contain minimal text, and some have no text at all (Figs. 206–208). Others incorporate decorative fraktur lettering (Fig. 209), but since Dieterly did not use any calligraphy on her signed certificates we have no documented examples of her fancier penmanship to make a comparison. And, some in this group appear much cruder, either in text or in decoration, than the signed Dieterly pieces. Thus, until proof becomes available, these fraktur are designated here only as "Dieterly School." Of course, Elizabeth Dieterly herself may have adopted her distinctive style through the influence of yet another, anonymous schoolmaster.

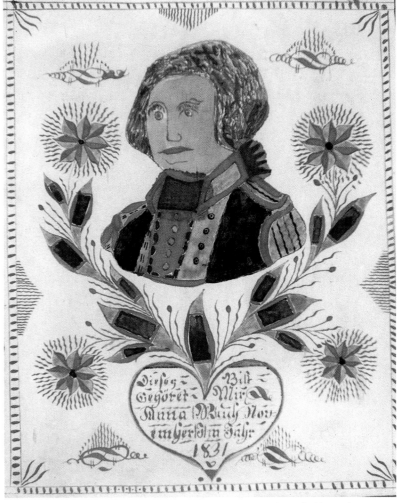

Fig. 206. **Drawing for Anna Ruuh**. School of Elizabeth Dieterly, probably Bucks County, 1831. Hand-drawn, lettered and colored on wove paper. 8¼ x 6½ in. This is probably intended to portray George Washington. Another version of this subject, drawn for Susanna Bechtel, is also known and is documented in the Bucks County Fraktur File at the Bucks County Historical Society. (Private collection.)

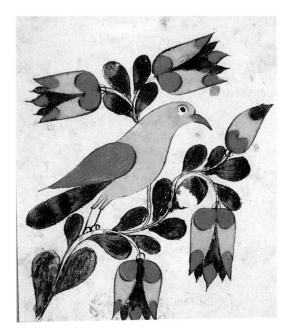

Fig. 207. **Drawing of a Bird**. School of Elizabeth Dieterly,
Bucks County, c. 1830. Hand-drawn and colored on
wove paper. Dimensions unavailable. (Private collection.)

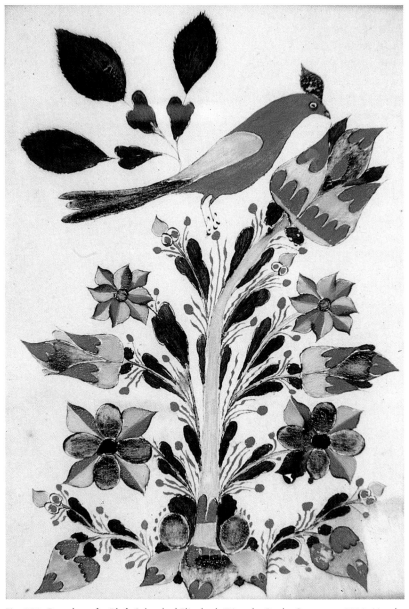

Fig. 208. **Drawing of a Bird**. School of Elizabeth Dieterly, Bucks County, c. 1830. Hand-
drawn and colored on wove paper. 6 x 4 in. (Private collection.)

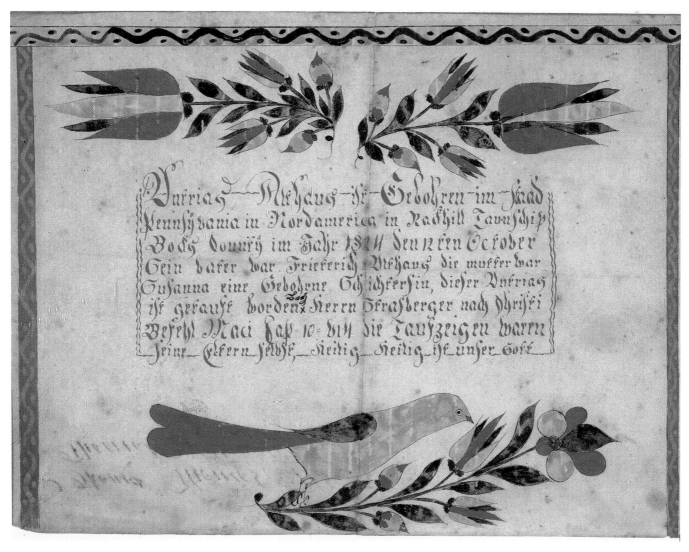

Fig. 209. **Birth and Baptismal Certificate for Antrias Althaus (b. 1824)**. School of Elizabeth Dieterly, Rockhill Township, c. 1824. Hand-drawn, lettered and colored on wove paper. 7³/₄ x 10¹/₈ in. Although bearing some resemblance decoratively to the work of Elizabeth Dieterly—especially in the red-tipped flower buds and the beady-eyed bird—the lettering cannot be positively attributed to her hand. (Private collection.)

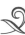

The Ebner Print Copy Artist

(active c. 1825–1830)

Nockamixon, Haycock, and Tinicum Townships

The Ebner Print Copy Artist's[1] nickname is derived from his apparent design source: the "angel-type" printed baptismal certificates produced by Allentown, Pennsylvania, printer Henrich Ebner.[2] A close examination of one of Ebner's 1818 prints (Fig. 210) shows that the posture and positioning of the angels flanking the text block, the bird-on-branch designs at lower left and right, and the angel with trumpet at top are common to both the printed and hand-drawn certificates. Of course, the copy artist reinterpreted each of these elements freehand to suit his tastes and those of his clients (Figs. 211–212).

Most, though not all, of the known examples of this artist's work were made for children baptized by Pastor Samuel Stähr (1785–1843) at St. Luke's Reformed (Union) Church in Nockamixon. Among them was Stähr's own daughter, Catharina Anna Sara, born in 1826 (Fig. 213). *Taufscheine* for the children of ministers are relatively rare, perhaps because they were seen as extravagances.

If this artist saw and copied Ebner's printed certificates in freehand, chances are good that he also saved time occasionally by simply filling in some of the blank forms for his clients.

Fig. 210. **Birth and Baptismal Certificate for Maria Schmidt (1795–1867).** Printed by Henrich Ebner, Allentown, Lehigh County, 1818. Completed by an unidentified scrivener, Springfield Township, Bucks County, c. 1820. Printed, hand-lettered and colored on wove paper. 16 x 13¼ in. Printed certificates such as this one served as a copy model for the freehand work of this artist. (Spruance Library/Bucks County Historical Society, SC-58. No. B-32.)

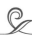

Fig. 211. **Birth and Baptismal Certificate for Franklin Meyer (b. 1830).** Attributed to the Ebner Print Copy Artist, Haycock Township, Bucks County, c. 1830. Hand-drawn, lettered and colored on laid paper. 15⁷/₈ x 12¹/₂ in. (Collection of Mr. and Mrs. Harry T. Hinkel.)

Notes

1. Authors Corinne and Russell Earnest deserve the credit for proposing an appropriate nickname for this artist.

2. Klaus Stopp, *The Printed Birth and Baptismal Certificates of the German Americans*, 6 vols. (Mainz, Germany and East Berlin, Pa.: by the author, 1997–2001), 1:157–170.

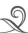

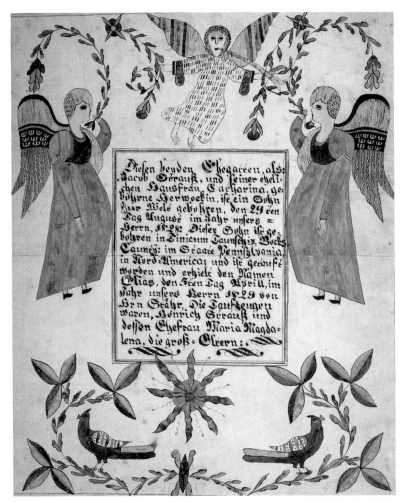

Fig. 212. **Birth and Baptismal Certificate for Elias Strauss (b. 1828).** Attributed to the Ebner Print Copy Artist, Tinicum Township, Bucks County, c. 1830. Hand-drawn, lettered and colored on wove paper. 15⅛ x 12¼ in. (Rare Book Department, The Free Library of Philadelphia, FLP 730.)

Fig. 213. **Birth and Baptismal Certificate for Catharina Anna Sara Stähr (b. 1826).** Attributed to the Ebner Print Copy Artist, Nockamixon Township, Bucks County, c. 1830. Hand-drawn, lettered and colored on wove paper. 12 x 11½ in. (fragment). The text of this certificate notes that the child was baptized by "the father himself," that is, Pastor Samuel Stähr. (Private collection.)

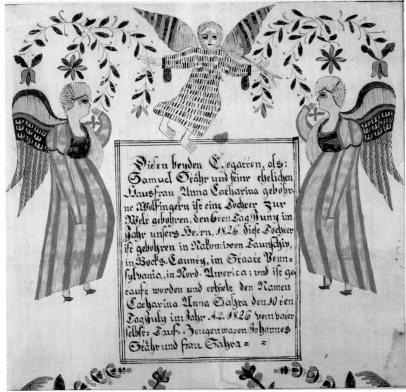

Bucks County Fraktur Artists:
The Mennonite Stream

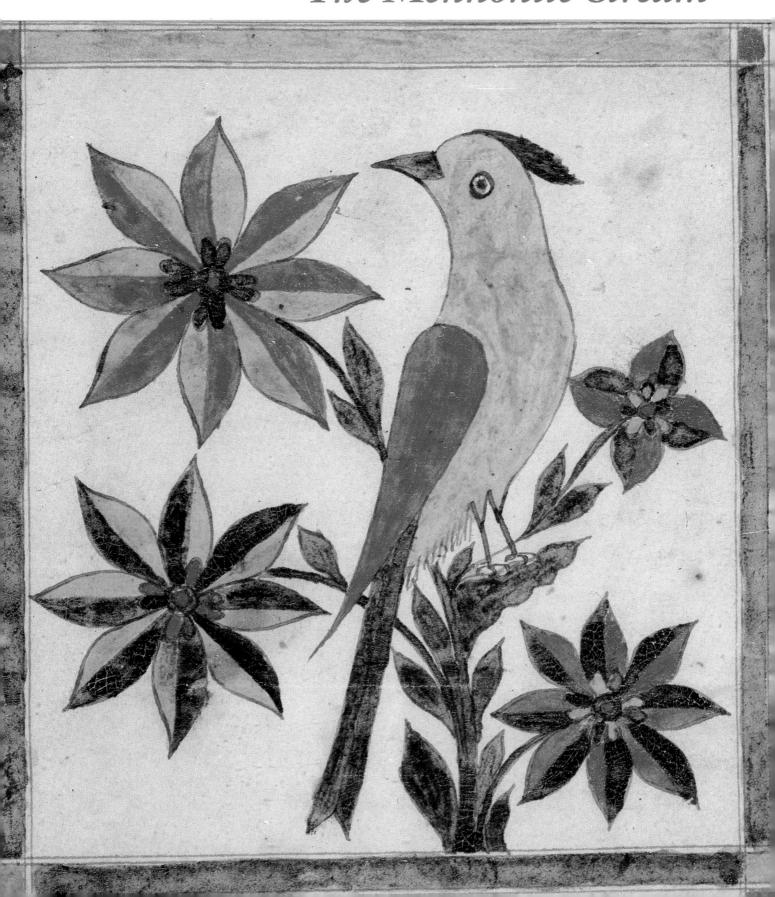

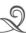

Johann Adam Eyer

(1755–1837, active c. 1780–1820)

Hilltown, Bedminster, and Durham Townships

Johann Adam Eyer may well have been Bucks County's most prolific, influential, and talented fraktur artist. No other penman seems to have had such a far-reaching impact on the forms, motifs, and language of fraktur—especially Mennonite fraktur—as this dedicated and successful schoolmaster. Though a Lutheran by birth, Eyer taught in the predominantly Mennonite schools at Deep Run, *Birckenseh* (today's Blooming Glen in Hilltown Township), and the "lower end of Hilltown." His roll book from the 1780s identifies several of his students whose names appear on surviving fraktur.[1]

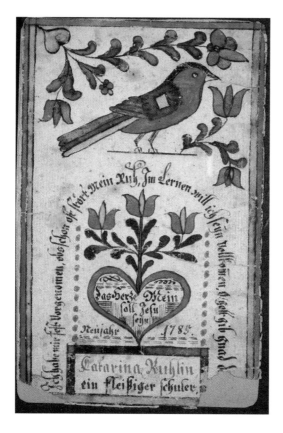

Fig. 214. **Reward of Merit for Catarina Ruhl**. Attributed to Johann Adam Eyer, Hilltown Township, Bucks County, 1785. Hand-drawn, lettered and colored on laid paper. 6 x 3¾ in. (Private collection.)

Lacking instructors in their own midst—at least initially—Bucks County Mennonites found in Eyer a trusted mentor for their children and a man who apparently shared their own values and philosophies on education. He brought to the classroom what teachers today might call positive reinforcement, in the form of rewards of merit, decorated penmanship models, and colorful bookplates (Figs. 214–218). Whether he spared the rod entirely is unknown, but he seems to have followed the path of the earlier Pennsylvania schoolmaster Christopher Dock in articulating a gentler, more progressive philosophy of classroom management—one that de-emphasized corporal punishment as a tool of behavior modification.[2]

As Eyer's career advanced, he moved in wider circles, teaching in Pennsylvania-German enclaves in Chester and Lancaster counties, and finally in upper Northampton County. Wherever he went, he left a trail of fraktur *Vorschriften*, rewards, bookplates, religious texts (Fig. 219), and even the occasional *Taufschein* (Fig. 220). Despite his Lutheran upbringing, he seems to have largely eschewed the latter form. Perhaps this was due to the many years he spent among the Anabaptists, who would not have provided a receptive market for baptismal certificates. Or, it could have been the result of an inability to compete effectively with other *Taufschein* artists, many of whom could quickly turn out a product unencumbered by the same dedication to precision and careful workmanship that Eyer demonstrated throughout his work.[3] It may be, too, that Eyer, who was surprisingly successful financially as a businessman, investor, and teacher, did not need the income that *Taufscheine*-for-pay could bring. Perhaps he left that market to the poorer scriveners and schoolmasters.

Eyer possessed extraordinarily fine penmanship, a broad storehouse of visual imagery and religious verse, and a knack for catchy, poetic admonishments that might encourage his students to learn their lessons. On several fraktur he wrote: *"Wer Etwas Kan den halt man Werth, Den Ungeschickten Niemand B'gehrt"* [Whoever can do something is in demand, the unskilled person no one desires] (Fig. 221). Eyer desired especially that his students become skilled writers. Perhaps no other teacher of the day stressed penmanship instruction as much as he—as evidenced by the number of *Vorschrift*-booklets, or writing copybooks, which survive inscribed to his various students.

In addition to his talents as teacher, calligrapher, and watercolor artist, Eyer was also an accomplished musician, though it is not known where he acquired his training. In the course of his teaching, he may well have introduced the *Notenbüchlein*, or manuscript tune booklet, into the Pennsylvania-German schools as a means of teaching musical notation. The earliest known fraktur-embellished example of this instructional genre, dated 1780, bears his elegant penmanship (see the essay by Mary Jane Hershey in this volume, Fig. 81).[4]

Eyer's fraktur was frequently copied, even after his death, by many other artists. Some were Eyer's own students, who flattered their teacher by perpetuating certain motifs and repeating favorite admonishments. No doubt Eyer had done the same in his youth, influenced perhaps by schoolmasters

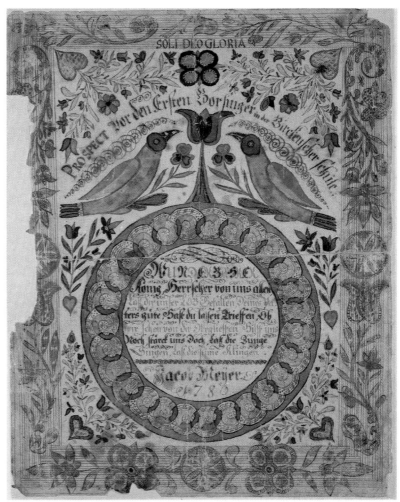

Fig. 215. **Reward of Merit for Jacob Meyer**. Attributed to Johann Adam Eyer, Perkasie School, Hilltown Township, Bucks County, 1780. Hand-drawn, lettered and colored on laid paper. 10¼ x 8¼ in. (Jordan Historical Museum, Jordan, Ontario.)

Fig. 216. **Penmanship Model for Barbara Wismer.** Attributed to Johann Adam Eyer, Perkasie School, Hilltown Township, Bucks County, 1788. Hand-drawn, lettered and colored on laid paper. 8 x 13⅛ in. (Spruance Library/Bucks County Historical Society, SC-58. No. A-07.)

257

Fig. 217. **Manuscript Tune Book and Bookplate for Esther Gross.** Attributed to Johann Adam Eyer, Perkasie School, Hilltown Township, Bucks County, 1789. Hand-drawn, lettered and colored on laid paper. 4 x 6½ in. (Private collection.)

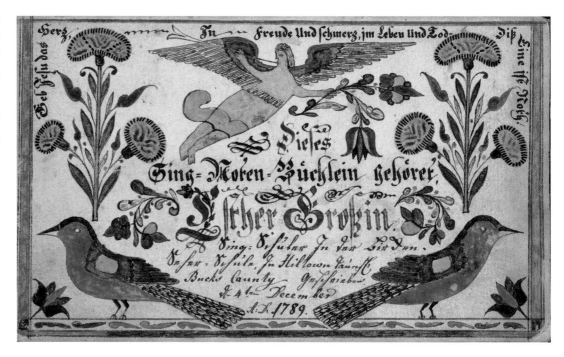

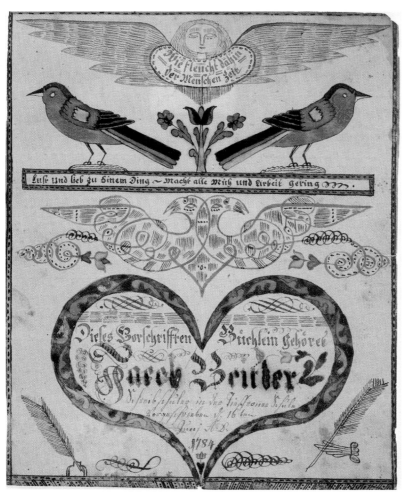

Fig. 218. **Copybook for Jacob Beitler.** Attributed to Johann Adam Eyer, Deep Run School, Bedminster Township, Bucks County, 1784. Hand-drawn, lettered and colored on laid paper. 8 x 6½ in. (Mennonite Heritage Center, Harleysville, Pa., 75.70.1.)

centered in nearby Montgomery County.[5] Curiously, however, there is little in Eyer's work to suggest the influence of the fraktur artist Johannes Mayer, even though Mayer clearly taught in Bedminster Township where young Eyer was born and raised. It should be noted that the "signature" pen, hand, and inkwell designs (Fig. 222) which appear on some of Eyer's fraktur, though usually associated with Eyer, were also mimicked by others. He probably derived the designs from printed copybooks of the period.

Following a teaching stint in Chester County, Eyer seems to have finally departed Bucks County sometime around 1790, moving with other family members northward to Upper Mount Bethel Township in Northampton County where he had purchased land.[6] Despite this change in residence, Eyer evidently returned to Bucks on occasion over the ensuing few years. A group of fraktur from Deep Run, all bearing dates in the autumn of 1791, are almost certainly by his hand (Fig. 223). In addition, Eyer inscribed a copybook cover to student Maria Eichlin in the Durham (Bucks County) School as late as 1796 (Fig. 224).[7] A few years afterward, however, he again relocated, migrating across the Kittatinny Mountain to Hamilton Township, in present-day Monroe County. There he continued to teach and produce fraktur until his death in 1837.

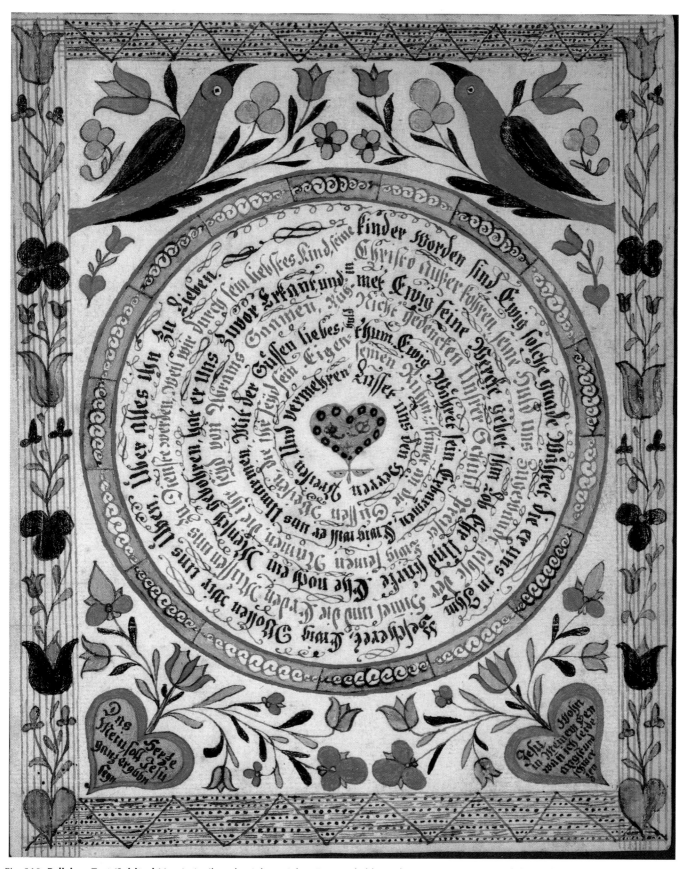

Fig. 219. **Religious Text (Spiritual Maze).** Attributed to Johann Adam Eyer, probably Bucks County, c. 1783. Hand-drawn, lettered and colored on laid paper. 8⅝ x 7 in. (Private collection.)

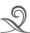

Fig. 220. **Birth and Baptismal Certificate for John Philip Hilgert (b. 1785).** Attributed to Johann Adam Eyer, Upper Mount Bethel Township, Northampton County, c. 1790. Hand-drawn, lettered and colored on laid paper. 13 x 8¼ in. (Private collection.)

Notes

1. For the translation of Eyer's roll book, see Frederick S. Weiser, "I A E S D: The Story of Johann Adam Eyer (1755–1837), Schoolmaster and Fraktur Artist with a Translation of His Roster Book, 1779–1787," in *Ebbes fer Alle-Ebber, Ebbes fer Dich/Something for Everyone—Something for You: Essays in Memoriam Albert Franklin Buffington*, in *Publications of the Pennsylvania German Society* 14 (1980): 437–506. One of the most thoroughly researched fraktur artists, Eyer and his career are covered in depth in this article. The author also gratefully acknowledges Pastor Weiser's direct assistance and criticism in the preparation of this and the following essay on Eyer's copyists.

2. For a description of Dock's methods, see Gerald C. Studer, *Christopher Dock, Colonial Schoolmaster* (Scottdale, Pa.: Herald Press, 1993), which also includes Dock's own essay on "A Simple and Thoroughly Prepared School Management" (originally published in 1770). Also see the essays by John Ruth and Mary Jane Hershey in this volume.

3. This hypothesis was suggested to the author by Pastor Frederick Weiser.

4. Frederick S. Weiser and Howell J. Heaney, *The Pennsylvania German Fraktur of the Free Library of Philadelphia: An Illustrated Catalogue*, 2 vols. (Breinigsville, Pa.: Pennsylvania German Society, 1976), 2:fig. 845. It should be noted, however, that Mary Jane Hershey has located an earlier, undecorated tune book which she attributes to Andreas Kolb. See her essay, p. 123.

5. Weiser, "I A E S D," 438–439. See also the essay by John Ruth in this volume.

6. Ibid., 471.

7. In the collection of the Henry Francis DuPont Winterthur Museum, Winterthur, Delaware (acc. no. M60.347a,b).

Fig. 221. **Copybook for Abraham Hackman.** Attributed to Johann Adam Eyer, Deep Run School, Bedminster Township, Bucks County, 1786. Hand-drawn, lettered and colored on laid paper. 7⅞ x 6⅛ in. (Schwenkfelder Library and Heritage Center.)

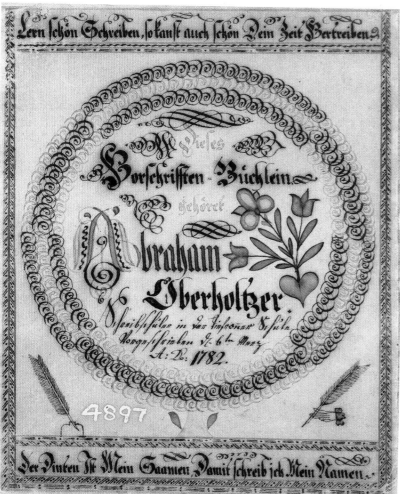

Fig. 222. **Copybook for Abraham Oberholtzer.** Attributed to Johann Adam Eyer, Deep Run School, Bedminster Township, Bucks County, 1782. 8¼ x 6¾ in. Note the G-Clef that appears in the initial letter of the student's name—evidence perhaps that music was never far from Eyer's mind. (Spruance Library/Bucks County Historical Society, SC-58. No. A-17.)

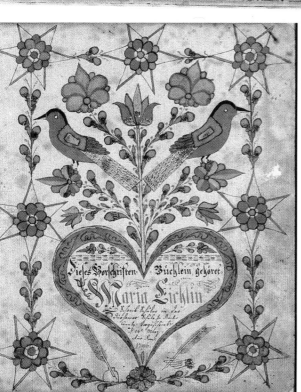

Fig. 223. **Bookplate for Maria Gross.** Attributed to Johann Adam Eyer, Bedminster Township, Bucks County, 1791. Hand-drawn, lettered and colored on laid paper. 5⅜ x 3⅛ in. (Jordan Historical Museum, Jordan, Ontario.)

Fig. 224. **Copybook for Maria Eichlin.** Attributed to Johann Adam Eyer, Durham School, Durham Township, Bucks County, 1796. Hand-drawn, lettered and colored on laid paper. 7⅞ x 6½ in. (Courtesy, Winterthur Museum.)

Eyer School

(c. 1790–1810)

Bedminster, Hilltown, Milford, Plumstead, Tinicum, and Other Townships

Johann Adam Eyer left a fraktur legacy that was widely copied. Wherever he taught, and more broadly, wherever his influence was felt, subsequent artists often utilized motifs, formats, and phrases that paid homage to him and his trail-blazing work. This was especially true among the Mennonites, who began to rely increasingly on schoolmasters and fraktur artists arising in their own communities. Mennonite children who had attended Eyer's schools—among them David Kulp of Bedminster, and perhaps Samuel Moyer of Hilltown and Ontario, Canada—picked up the pen and brush themselves and continued in their schoolmaster's footsteps.

Other teachers who followed Eyer's lead include Jacob Oberholtzer (1794–1880), Isaac Gross (1807–1893), Rudolph Landes (1789–1852), and Samuel Meyer (active c. 1827–1828). Of course, these individuals often did not learn their art directly from Eyer, but from other teachers, such as David Kulp, whose artistry served to link Eyer with later penmen.

So much of Eyer's early work must also have survived in the hands of community members in Bedminster and Hilltown that it represented a significant storehouse of visual imagery upon which these later artists drew.

In addition to works by known schoolmaster-artists, many pieces of fraktur are also known that clearly follow in the design tradition promulgated by Eyer, but for which attributions to specific artists cannot yet been made. Some of these are illustrated here and perhaps represent a missing link between Eyer and later penmen who worked in a similar ouevre.

Among this Eyer-school fraktur are several tune books that apparently postdate Johann Adam Eyer's tenure in the Deep Run and Hilltown schools. Dating mostly from 1792–1793, these booklets survive from the Deep Run school (Fig. 225) and from a school at the "upper end of the branch in Bedminster Township."[1] A later tune book, dated

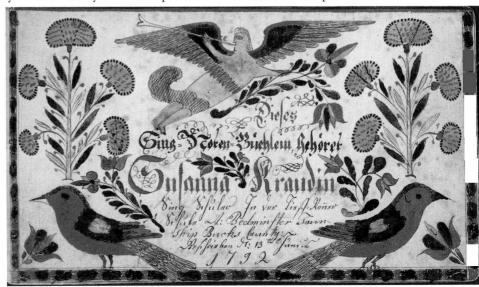

Fig. 225. Manuscript Tune Bookplate for Susanna Kraud. School of Johann Adam Eyer, Deep Run School, Bedminster Township, Bucks County, 1792. Hand-drawn, lettered and colored on laid paper. 3⅝ x 6¼ in. (Private collection.)

1801, was drawn for a student in the Swamp School.[2] Although displaying Eyer-like motifs such as birds with wing patches and draped and trumpeting angels, the imprecision of the drawing and the relatively unrefined penmanship suggest they are the work of less-accomplished hands.

Other Eyer-school pieces seem likely to have been done as singular works, perhaps by the very students named on the fraktur themselves. These include a *Bild* (picture) for Johannes Detweiler (Fig. 226) and another drawing, clearly derived (if not traced) from one of Eyer's copybooks, for Esther Gross (Fig. 227). Unfortunately, while a Johannes Detweiler does appear in Eyer's roll book, there is no sign of Esther Gross.[3]

Yet another set of seemingly Eyer-inspired fraktur works all contain related motifs featuring perching and hovering birds. Two of these are pictures with no dates or text (Figs. 228, 229). While it is conceivable that these are by Eyer himself, the lack of both a temporal context and any examples of script for the purposes of comparison make them especially difficult to attribute. Another related piece is a *Vorschrift*, which Joel Alderfer in his essay earlier in this volume attributes to David Kulp (see page 163, Fig. 112), and a copybook cover bearing the name of David Kulp (Fig. 230). All of these works contain extraordinarily similar bird motifs, some relating to a design drawn on a *Vorschrift* for Barbara Wismer that has been attributed to Eyer (see page 257, Fig. 216).[4] In addition, most share other common elements, including distinctive wreath or branch designs composed of evenly spaced, teardrop-shaped leaves. If indeed these fraktur pieces are the work of Kulp, they testify even more strongly to Eyer's influence on the former's work. If not by Kulp, or by Eyer himself, they suggest yet another highly skilled fraktur penman at work, perhaps in the period between Eyer's departure from Bucks County and Kulp's entrance into Bedminster and Hilltown classrooms.

In considering fraktur artists who fell under Eyer's spell, his own brother should also be mentioned. Johann Friedrich Eyer, fifteen years younger than his brother, is known to have taught in Chester and Berks County schools. Unfortunately, only a handful of fraktur works have been firmly attributed to Friedrich (Fig. 231), none of which seem to have originated in Bucks County.[5] Whether any of the Bucks County Eyer-school fraktur might be the early work of Friedrich is presently unknown.

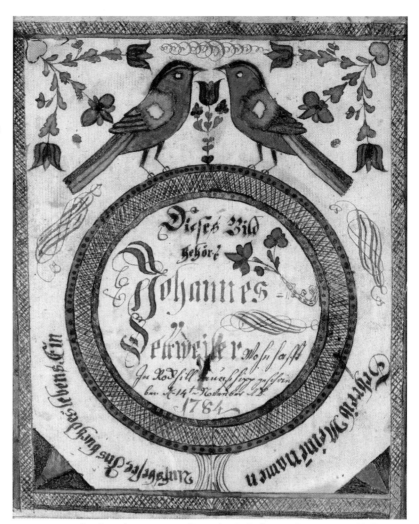

Fig. 226. **Drawing for Johannes Detweiler.** School of Johann Adam Eyer, Rockhill Township, Bucks County, 1784. Hand-drawn, lettered and colored on laid paper. 7¹/₂ x 6¹/₈ in. A Johannes Detweiler attended classes taught by Johann Adam Eyer at Deep Run in 1783–1784. (Private collection.)

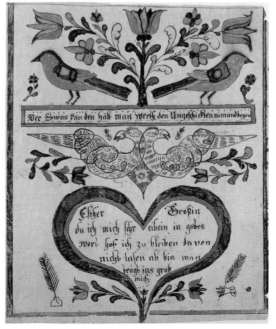

Fig. 227. **Drawing for Esther Gross.** School of Johann Adam Eyer (possibly Esther Gross), Bedminster Township, Bucks County, c. 1790. Hand-drawn, lettered and colored on laid paper. 8 x 6¹/₂ in. (Private collection.)

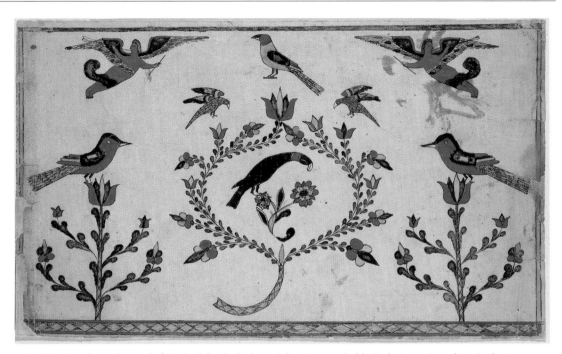

Fig. 228. **Drawing or Reward of Merit**. School of Johann Adam Eyer, probably Bedminster Township, Bucks County, c. 1790–1800. Hand-drawn and colored on laid paper. 7⁵/₈ x 12³/₄ in. An inscription on the reverse of this picture claims that it was presented to Abraham K. High by Abraham Kulp. Abraham Kulp was born in Tinicum and later moved to Deep Run, where he was a Mennonite minister. Abraham High (1833–1914) was his grandson and namesake. (Spruance Library/Bucks County Historical Society, SC-58. No. A-38.)

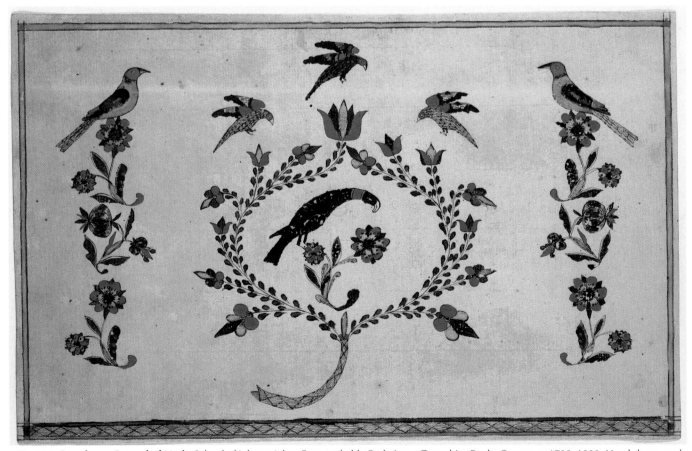

Fig. 229. **Drawing or Reward of Merit.** School of Johann Adam Eyer, probably Bedminster Township, Bucks County, c. 1790–1800. Hand-drawn and colored on laid paper. 7¹/₂ x 11⁵/₈ in. (Spruance Library/Bucks County Historical Society, SC-58. No. A-37.)

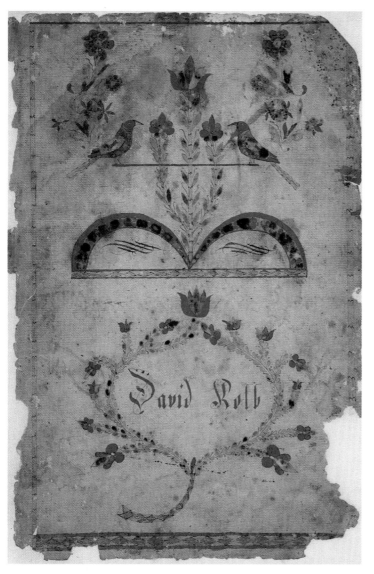

Fig. 230. **Copybook of David Kolb.** School of Johann Adam Eyer, probably Bedminster Township, Bucks County, c. 1790–1800. Hand-drawn, lettered and colored on laid paper. 12³/₈ x 8¹/₈ in. (Rare Book Department, The Free Library of Philadelphia, FLP 318.)

Notes

1. In addition to the tune book in Fig. 225, a similar booklet is in the collection of the Schwenkfelder Library and Heritage Center, Pennsburg. This tune book, from the "upper end of the branch," is in a private collection. See Bucks County Fraktur File, SL/BCHS.

2. This tune book is in a private collection. See Bucks County Fraktur File.

3. Frederick S. Weiser, "I A E S D: The Story of Johann Adam Eyer (1755–1837), Schoolmaster and Fraktur Artist with a Translation of His Roster Book, 1779–1787," in *Ebbes fer Alle-Ebber, Ebbes fer Dich/Something for Everyone—Something for You: Essays in Memoriam Albert Franklin Buffington*, in *Publications of the Pennsylvania German Society* 14 (1980): 494–495.

4. Ibid., 444.

5. For a listing and discussion of the fraktur of Johann Friedrich Eyer, see Russell D. Earnest and Corinne P. Earnest, *Papers for Birth Dayes: A Guide to the Fraktur Artists and Scriveners*, 2nd ed., 2 vols. (East Berlin, Pa.: Russell D. Earnest Associates, 1997), 1:261–262.

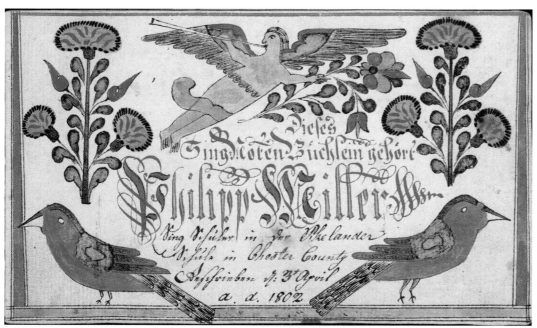

Fig. 231. **Manuscript Tune Book and Bookplate for Philipp Miller.** Attributed to Johann Friedrich Eyer, Pikeland School, Chester County, 1802. Hand-drawn, lettered and colored on laid paper. 3³/₄ x 6¹/₄ in. The slight bulges, or pouches, under the beaks of Friedrich Eyer's birds may be especially indicative of his work. (H. Richard Dietrich Jr., Philadelphia, Pa. Photo by Will Brown.)

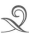
Samuel Meyer

(1767–1844)

Hilltown Township

After the American Revolution, some Bucks County Mennonite families moved north to Ontario, Canada. A few had been accused of sympathizing with the British during the war, and nearly all had refused to take up arms or voluntarily contribute to the American war effort because of their pacifist convictions. Canada offered a refuge for those who had at times suffered for their beliefs at the hands of colonial authorities. By 1800, more than twenty-four families had made the journey north, taking their fraktur bookplates, tune books, and pictures with them (Fig. 232).[1]

Among the migrants were cousins Samuel and Jacob Meyer (or Moyer). Precociously, at the age of sixteen, Samuel had begun teaching school in Hilltown, Bucks County.[2] After moving to the Niagara Peninsula, on the Ontario frontier, he continued instructing Mennonite youth at an institution known as the "Clinton School." According to a family genealogy,

> in early life he developed an aptitude for music and was appointed *"vorsinger"* in meeting, and also taught singing schools....He never attended an English school, yet acquired a very fair English education. His writing in English was excellent, in German elegant. He taught for many years the first school in the [Ontario] settlement, in a log building where now stands the Mennonite meetinghouse...[3]

In his seventeenth year, while still teaching in Hilltown, Samuel Meyer signed a rather crudely drawn religious text (Fig. 233). Given his age and inexperience, it is conceivable that this was an immature experiment. With practice, his fraktur

Fig. 232. **Manuscript Tune Book and Bookplate for Johannes Kratz.** Unidentified artist, possibly Samuel (1767–1844) or Jacob Meyer (1767–1833), Perkasie School, Hilltown Township, Bucks County, 1798. Hand-drawn, lettered and colored on laid paper. 3³/₄ x 6¹/₂ in. This tune book was carried to the Niagara Peninsula by a Bucks County Mennonite family. (Jordan Historical Museum, Jordan, Ontario.)

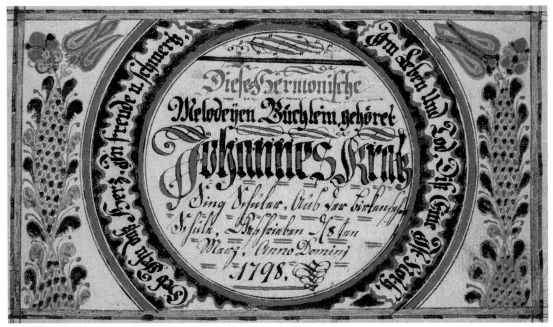

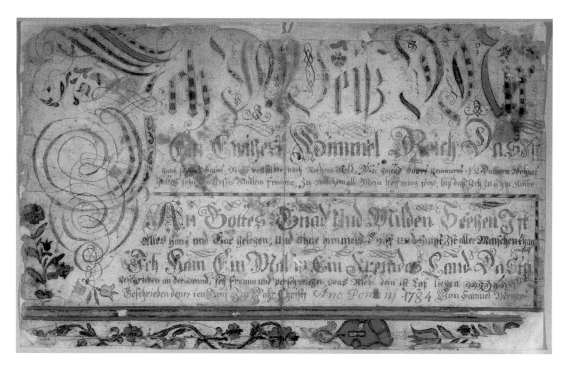

Fig. 231. **Religious Text.** Samuel Meyer, probably Hilltown Township, Bucks County, 1784. Hand-drawn, lettered and colored on laid paper. 8 x 13 in. The horizontally placed figure at the bottom of the composition is vaguely reminiscent of a female figure in a c. 1795 *Taufschein* by Eyer, drawn for the son of his younger brother Johannes (in a private collection). (Blooming Glen Mennonite Church.)

hand likely improved later in his career as a schoolmaster. In fact, it is claimed that as an adult he composed "numerous hymns and tunes which were as neatly penned as manuscripts by monks before the art of printing was invented."[4]

In his childhood, Meyer had been a student of Johann Adam Eyer at the school then known as *Birckenseh*, in the present-day community of Blooming Glen. In the "late winter quarter" of 1780, Eyer recorded young Samuel's name in his roll book.[5] The estate record of Samuel's father, dated 1783, also notes an overdue payment by his executors of £3, 10s and 3p to "Adam Eyer for Schooling the Deceased's Children."[6] Though sixteen-year-old Samuel was no longer attending Eyer's school by that date, his younger siblings had continued their education there.

In the early 1780s, Samuel Meyer's father subscribed to the construction of a new schoolhouse at *Birckenseh*. His debt to the construction fund at the time of his death amounted to £1, 3s and 2p.[7] Whether the senior Meyer had pledged this money for a new school yet to be built or had simply not completed his obligation under an earlier construction effort is unclear. But by 1800, Samuel Meyer was transferring eighty-four perches of his own land to the "Trustees of the Jerman School House in Hilltown." Though it is possible that a new school was again being planned, the deed noted that a building or buildings (the schoolhouse?) already stood on the property. In this document, Meyer is

referred to as "schoolmaster," suggesting that he had taught in the "Jerman" School for some time prior to his gift of the property to the trustees.[8]

Probably shortly after divesting himself of this property, Samuel Meyer left Bucks County for Canada. In 1866, the land and school were sold to the Township School District and then closed.[9] In the intervening years, however, the schoolhouse on Meyer's former land, "near Seiple's Mill," was the site of teaching by David Kulp and other school-master-fraktur artists.[10]

Samuel Meyer's cousin Jacob was a Mennonite minister who may also have kept school at times.[11] It was probably for this Jacob Meyer that school-master Johann Adam Eyer penned a reward of merit for fine singing in the *Birckenseh* school in 1780.[12] Michael Bird, in his book, *Ontario Fraktur*, writes

It is generally believed that Samuel Moyer, assisted by his cousin, Jacob Moyer, was the first teacher at the Clinton School. In view of the general expectations that Mennonite schoolmasters be teachers of calligraphy, as well as the tradition which attests to his own competence in writing and printing, there is good reason to believe that Samuel Moyer may have been the artist who executed the numerous decorated songbooks made for various students in the Clinton School during the first third of the nineteenth century.[13]

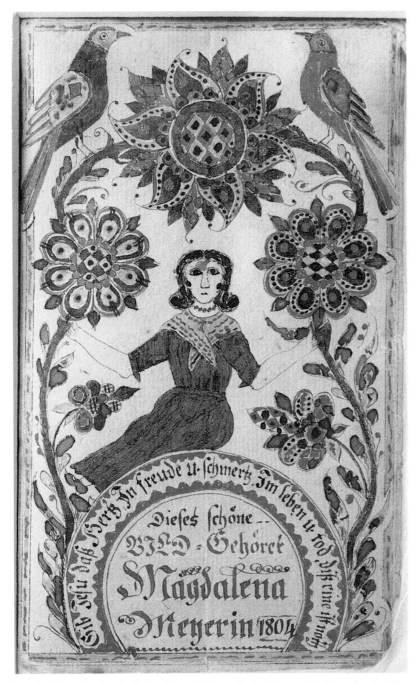

Fig. 234. **Drawing for Magdalena Meyer.** Unidentified artist, possibly Samuel or Jacob Meyer, probably Lincoln County, Ontario, Canada, 1804. Hand-drawn, lettered and colored on laid paper. 6½ x 3¾ in. This unusual picture featuring a female figure may be by the same hand as the Kratz *Notenbüchlein* (Fig. 230). Samuel and Jacob Meyer migrated to Ontario in the years 1799–1800. If indeed the picture was drawn by either of them, it probably originated in Canada. Samuel Meyer had a daughter Magdalena (1794–1834) and Jacob Meyer's wife was also named Magdalena, either of whom could have been the recipient of the fraktur. (Jordan Historical Museum, Jordan, Ontario.)

While the logic of this supposition is unassailable, evidence is still lacking to confirm it with certainty.[14] The supposition is also problematized by the uncertain nature of *Jacob* Meyer's role in the classroom. An early arithmetic textbook used in the Clinton School bears the inscriptions of both Samuel and Jacob Meyer. The latter reads "Jacob Moyer/his Assistant January/4th 1811."[15] Bird appears to interpret this passage as suggesting that Jacob Meyer assisted Samuel in the Clinton classroom. However, the term *Assistant* was often used in the period to describe a teaching aid, such as a textbook. In fact, the word was frequently incorporated into the title of the book itself.[16]

Curiously, despite recollections of Samuel Meyer's penmanship as elegant, a comparison of the two inscriptions in the arithmetic book shows Jacob Meyer's hand as much more refined. Perhaps Jacob Meyer did more than simply assist in the classroom. He seems to be another legitimate candidate for the identity of one of the unknown artists who produced bookplates and other teaching materials at the Clinton School[17] and other fraktur in the local Mennonite community (Fig. 234).

Regardless of who may have produced it, the fraktur of the Niagara Peninsula shows the close linkage between distant Mennonite communities, the lasting influence of artists such as Johann Adam Eyer and David Kulp, and the transmission of the fraktur tradition to a new setting (Fig. 235).

Notes

1. John L. Ruth, *Maintaining the Right Fellowship* (Scottdale, Pa.: Herald Press, 1984), 173.

2. Rev. A.J. Fretz, *A Genealogical Record of the Descendants of Christian and Hans Meyer* (Harleysville, Pa.: News Printing House, 1896), 100.

3. Ibid., 100, 102.

4. Ibid., 102.

5. Frederick S. Weiser, "I A E S D: The Story of Johann Adam Eyer (1755–1837), Schoolmaster and Fraktur Artist with a Translation of His Roster Book, 1779–1787," in *Ebbes fer Alle-Ebber, Ebbes fer Dich/Something for Everyone—Something for You: Essays in Memoriam Albert Franklin Buffington*, in *Publications of the Pennsylvania German Society* 14 (1980): 482.

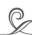

Fig. 235. **Manuscript Tune Book and Bookplate for Magdalena Meyer.** Unidentified artist, possibly Samuel or Jacob Meyer, Lincoln County, Ontario, Canada, 1804. Hand-drawn, lettered and colored on laid paper. 3⅝ x 6½ in. (Jordan Historical Museum, Jordan, Ontario.)

6. Estate of Jacob Mayer *(sic)*, Bucks County Orphans Court File No. 771, SL/BCHS. The author thanks Terry McNealy for locating this Orphans' Court record.

7. Ibid.

8. "Deed of Sale from Samuel Moyar, Schoolmaster, and wife to Abraham Hunsberrey, Sr., Samuel Moyar, Sr., Jacob Kolb, Sr., and George Sipel, Miller, Trustees of the Jerman School House in Hilltown," April 21, 1800, Deed Book 30, p. 475, SL/BCHS.

9. "Deed of Sale from Jacob Hunsicker, George A. Detweiler, Abraham H. Moyer and Christian Moyer, Trustees of the German School House in Hilltown Township near Sipel's Mill to the School District of Hilltown Township," February 24, 1866, Deed Book 132, p. 605, SL/BCHS.

10. Several bills for the teaching of poor children, including one from David Kulp and dated 1820, note that the location of the schoolhouse lay "near Seiple's Mill."

11. Michael Bird, *Ontario Fraktur* (Toronto: M. F. Feheley, 1977), 21, 44. For a brief biography of Jacob Meyer or Moyer, see Fretz, *A Genealogical Record,* 221–222.

12. Weiser, "Story of Johann Adam Eyer," 445.

13. Bird, *Ontario Fraktur,* 21.

14. Ibid., 56. Bird features a *Vorschrift* (illus. 40) which, according to traditions of the Albright family of Vineland, Ontario, may be by Samuel Meyer. Indeed, a comparison of certain fraktur letter formations between this and the 1784 religious text signed by Meyer seem to suggest a single hand at work. The absence of cursive script on the 1784 piece, however, makes a more thorough comparison, and hence a firm attribution, impossible. There are similar *Vorschriften* to the one Bird illustrates extant in Pennsylvania collections. An analysis of all of these pieces might be fruitful. Another piece of evidence, though it may be no more than hearsay, can be found in a copy of the Meyer family genealogy (n. 2) owned by Mr. Lawrence Moyer of Vineland, Ontario. On p. 100 a descendant of Samuel Meyer claims in a handwritten note that the latter was the artist behind the fraktur "pictures" remaining in the hands of various family members. Information from John L. Ruth, Harleysville, Pa.

15. Ibid., 44.

16. See, for example, Thomas Dilworth, *The Schoolmaster's Assistant: Being a Compendium of Arithmetic Both Practical and Theoretical* (Philadelphia: Joseph Crukshank, 1793); also *The American Tutor's Assistant or A Compendious System of Practical Arithmetic* (Philadelphia: Zachariah Poulson, 1800).

17. See article by Michael Bird in this volume.

David Kulp

(1777–1834, active c. 1801–1820)

Bedminster and Hilltown Townships

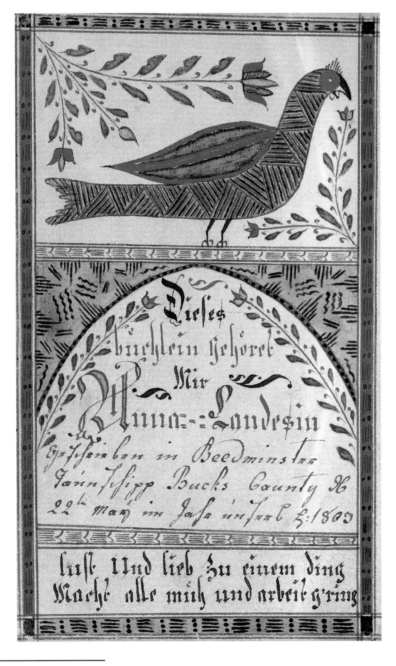

Given Joel Alderfer's thorough examination of David Kulp's career earlier in this volume, only a brief summary is necessary here. Once known as the Brown Leaf Artist, Kulp clearly followed the artistic and educational traditions of his teacher, Johann Adam Eyer.[1] Between about 1801 and 1820, Kulp kept school in the predominantly Mennonite communities of Deep Run and Blooming Glen (then referred to as *Birkenseh*, or Perkasie) where he drew bookplates, pictures, rewards of merit, and family registers for local families (Figs. 236–242). The obvious inspiration for a few of his bookplate designs is illustrated in Fig. 243. A decorated box, unusual for a fraktur artist, may also be by his hand (Fig. 244).

Despite the relatively recent identification of Kulp as a fraktur artist and the full documentation of his extant work, at least two earlier references to the Mennonite schoolmaster survive from Henry Mercer's time. In an entry in his 1897 *Tools of the Nation Maker* catalogue, Mercer referred to Kulp as a teacher at Deep Run, and as an early practitioner of fraktur.[2] Years later, at the fall 1914 meeting of the Bucks County Historical Society, an 1806 copybook belonging to David Kulp was placed on display along with various examples of fraktur.[3] Then owned by Eli Wismer of Bedminster, this copybook is apparently the same one now in the possession of the Mennonite Historians of Harleysville, Pennsylvania, and which has provided such important documentation of Kulp's career to contemporary scholars.

Fig. 236. **Bookplate for Anna Landes**. Attributed to David Kulp, Bedminster Township, Bucks County, 1803. Hand-drawn, lettered and colored on laid paper. 5³⁄₈ x 3¹⁄₈ in. (Rare Book Department, The Free Library of Philadelphia, FLP B-1022.)

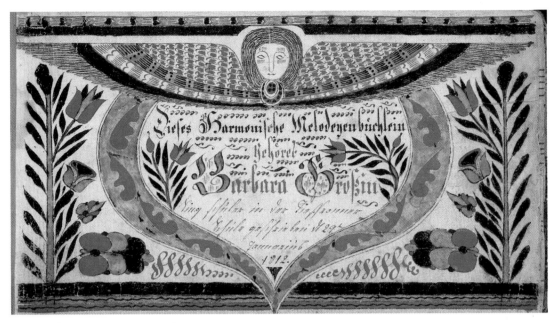

Fig. 237. **Manuscript Tune Book and Bookplate for Barbara Gross**. Attributed to David Kulp, Deep Run School, Bedminster Township, Bucks County, 1812. Hand-drawn, lettered and colored on laid paper. 4 x 6³/4 in. (Spruance Library/Bucks County Historical Society, SC-58. No. C-18.)

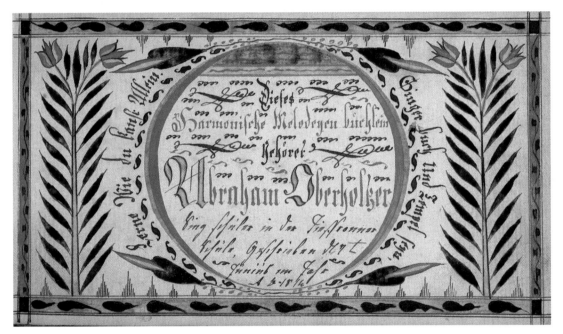

Fig. 238. **Manuscript Tune Bookplate for Abraham Oberholtzer**. Attributed to David Kulp, Deep Run School, Bedminster Township, Bucks County, 1814. Hand-drawn, lettered and colored on laid paper. 4 x 6³/4 in. (Spruance Library/Bucks County Historical Society, SC-58. No. C-01.)

Like his fellow schoolmasters, who were often the most literate members of their communities, David Kulp filled many roles. He served as Bedminster Township tax assessor and auditor, and as a scrivener helped local families with their correspondence and legal documents. In addition he instructed his students, thirty to forty at a time, in the reading and writing of English and German, in singing and in arithmetic. For his efforts, he received for each of his students anywhere from $0.04 a day to $1.50 per three-month term.[4]

In his own copybook, he recorded bits of rhyme and fragments of popular wisdom in both English and German. "Labour for learning before you get Old," he penned, "For learning is better than Silver and gold, Say's I David Kulp." Kulp apparently ended his teaching career about 1820, as no fraktur or school bills survive from his hand after that date. He died prematurely in 1834, three years before the passing of his mentor, Eyer.

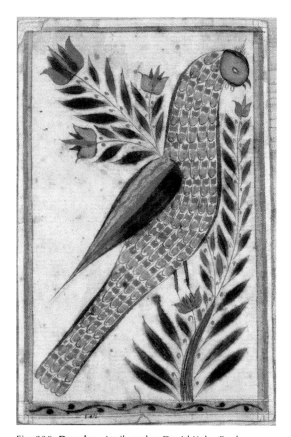

Fig. 239. **Drawing**. Attributed to David Kulp, Bucks County, c. 1810. Hand-drawn and colored on laid paper. 4⅞ x 3 in. (Spruance Library/Bucks County Historical Society, SC-58. No. A-03.)

Fig. 240. **Family Record of Johannes and Barbara Wissler**. Attributed to David Kulp, Bucks County, c. 1810. Hand-drawn, lettered and colored on laid paper. 12⅞ x 7⅞ in. (Private collection.)

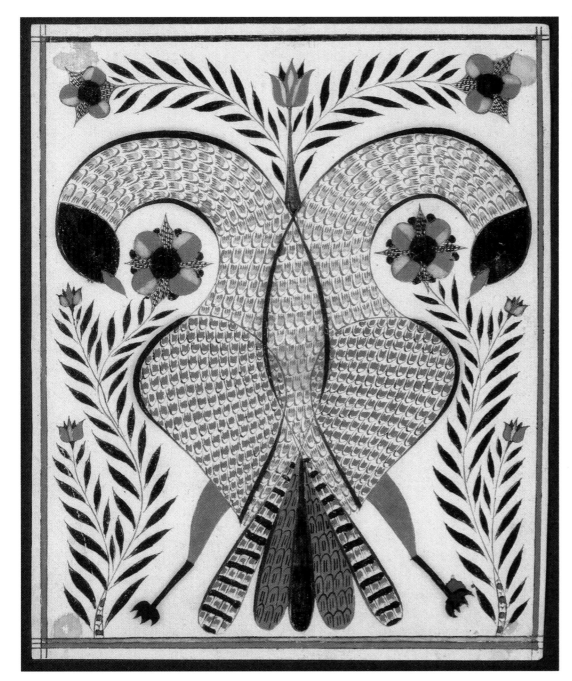

Fig. 241. **Drawing**. Attributed to David Kulp, Bucks County, c. 1810. Hand-drawn and colored on wove paper. 7⁷/₈ x 6¹/₂ in. (Courtesy, Christie's Images.)

Notes

1. Several German-language rhymes found in Kulp's work, including "*Lerne wie du kanst allein, Singer, buch und Tempel seyn*" [Learn how you alone can be Singer, Book and Temple], were derived from the fraktur of Eyer.

2. Henry C. Mercer, *The Tools of the Nation Maker* (Doylestown, Pa.: Bucks County Historical Society, 1897), 12. Mercer noted Kulp's role as a teacher in his description of a fraktur artist's paint box in the Historical Society's collection.

3. "Bedminster Township Meeting, October 24, 1914," in *A Collection of Papers Read Before the Bucks County Historical Society*, 4 (1917): 535.

4. David Kulp, "Bill for Schooling Catherine and Hannah Yost, March 22 through June 22, 1819, Hilltown Township," February 28, 1820, B.C. School Bills. See also the school bill recorded in the copybook of David Kulp, transcribed in Joel Alderfer's article in this volume. It should be noted that Kulp's rate of four cents a day was a penny higher than the customary three cents charged by most other teachers of the era.

Fig. 242. **Hymnal Bookplate for Catarina Staufer**. Attributed to David Kulp, Bucks County, 1807. Hand-drawn, lettered and colored on laid paper. 5½ x 3⅛ in. (Private collection.)

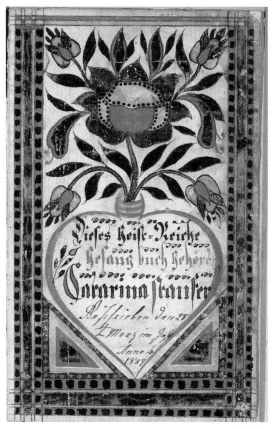

Fig. 243. **Reformed Church Hymnal with Decorated Cover**. Printed, bound, and colored in Frankfurt, Germany, but with imprint of Ernst Ludwig Baiche, Philadelphia, 1774. Laid paper with tooled and pigmented leather binding. The decorative binding on this and similar books printed in Germany and sold in Philadelphia served as the inspiration for some of Kulp's fraktur work. The bookplate for Catarina Staufer (Fig. 242) is derived from the heart and flower design on the leather covers, with slight artistic variation. (Spruance Library/ Bucks County Historical Society, SC-58, No. C-14.)

Fig. 244. **Decorated Box for Esther Kolb**. Probably David Kulp, Bedminster Township, Bucks County, 1810. Polychromed wood, iron, brass. 5½ x 11 x 7¾ in. This box, incorporating a design vocabulary and penmanship similar to those used by Kulp, may be rare evidence of a fraktur artist working in other media, and especially employing oil paints rather than watercolors. (Private collection.)

Rudolph Landes

(1789–1852, active c. 1814–1816)

Hilltown, Bedminster, and New Britain Townships

Although his style might at first glance be confused with that of Brown Leaf Artist David Kulp, schoolmaster Rudolph Landes was not nearly as prolific. Landes, the grandson of Deacon Rudolph Landes (1732–1802) of the Deep Run Mennonite Congregation, taught school in Hilltown and New Britain Townships between about 1813 and 1816.[1] The bills he forwarded to the county for teaching poor children, on which he wrote his name as "Ralph Landis," suggest that he taught in English-, as well as German-language, classrooms.[2] This, and his relatively short career, may help to explain the small number of fraktur that can be attributed to his hand.

While his penmanship is excellent, Landes's decorative style is a bit more open and less complex than that of his contemporary (and possibly his one-time teacher), David Kulp. A fraktur religious text that Landes drew and signed in 1814 (Fig. 245) features eight verses of a longer hymn composed originally, perhaps, by his grandfather Rudolph. The hymn was designed as an acrostic, with the first letter of each German verse spelling out the author's name.[3] On this piece Landes featured striped spherical ornaments that are quite unlike anything that sprang from David Kulp's pen and brush. The double-headed bird at the top of the page is also not as finely drawn as in Kulp's versions.

Landes apparently stopped making fraktur at about the same time that he abandoned the classroom. This was also the era of his marriage to Esther Overholt, which occurred in 1817.[4] Having moved to a farm in New Britain Township, Landes turned to raising both children and crops. He appears for the first time on township tax rolls in 1818, assessed only for a few livestock and having no occupation other than farming.[5]

He died in 1852, in possession of over $1,000 of personal property. Among his belongings were "Bibles and School Books," valued at $4.00.[6]

Fig. 245. **Hymn Text**. Rudolph Landes, probably Bedminster Township, 1814. Hand-drawn, lettered and colored on wove paper. 10 x 7⁷⁄₈ in. (Rare Book Department, The Free Library of Philadelphia, FLP 398.)

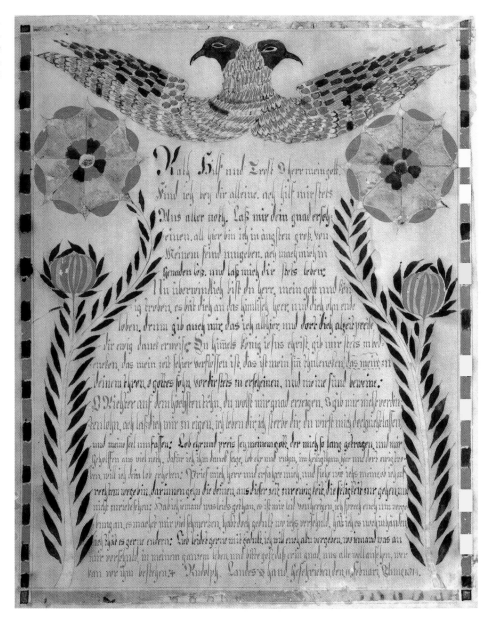

Notes

1. See, for example, "Bill for Schooling Barbara Christine, Hilltown Township," May 10, 1814; and "Bill for Schooling Night Bitting, New Britain Township," December 9, 1815, B.C. School Bills. Curiously, Landes's bills for teaching poor children contain two very different styles of penmanship. While it is possible that more than one Rudolph (or Ralph) Landes was working in the Bucks County schools during this period, it seems more plausible that someone other than the schoolmaster himself made out a few of the bills.

2. Ibid. The various school trustees who approved Landes's bills in Hilltown and New Britain Township were of both German and English ethnicity. Generally, where community members organized German-language schools, either separately or jointly with their English neighbors, they appointed men of their own ethnic group to supervise the institutions and approve the teachers.

3. According to Dr. Don Yoder, this technique is a survival of a European Anabaptist tradition used to conceal the identity of Mennonite authors during times of persecution.

4. Russell D. Earnest and Corinne P. Earnest, *Papers for Birth Dayes: Guide to the Fraktur Artists and Scriveners*, 2nd ed., 2 vols. (East Berlin, Pa.: Russell D. Earnest Associates, 1997), 2:493.

5. 1818 Tax List, New Britain Township, Bucks County, Pa., SL/BCHS.

6. Landes's obituary appears in *Der Morgenstern* (Doylestown, Pa.), March 17, 1852, p. 2. Estate of Rudolph Landes, File No. 9227, Register of Wills, Bucks County Courthouse, Doylestown, Pa.

Samuel Musselman

(active c. 1816–1820?)

Rockhill, Springfield, and Milford Townships?

The fraktur-decorated title page of a manuscript tune book, drawn with great precision by the artist, bears the name "Samuel Musselman" and the date 1819 (Fig. 246).[1] Because this bookplate makes no reference to being prepared for a particular student, it has been suggested that Musselman was not only the owner of the book but also its maker. Indeed, in that same year, a Samuel Musselman labored as a schoolmaster at the "Shool house at the manonist meeting house" in Rockhill Township, Bucks County.[2] The coincidence raises the question of what, if any, relationship existed between these two Samuels?

It seems likely that the teacher Samuel Musselman and the individual who owned and made the tune book were in some way related. Perhaps, they were the same person. This notion is suggested by evidence found in a teacher's practice book bearing the name of Samuel Musselman and containing page after page of designs for fraktur bookplates, pictures and religious texts, some of which relate stylistically to the tune book (Fig. 247). However, the decorative elements and penmanship appearing in the practice book are much more crudely rendered than in the 1819 bookplate. Either Musselman developed a more mature style between 1816 and 1819 (proving that practice does indeed make perfect), or more than one hand was involved.

Apart from the practice book featuring Samuel Musselman's name and signature, there is other evidence to point to a man by that name working as a fraktur artist. In 1915, antiques dealer A. H. Rice of Bethlehem noted in a letter to Henry Mercer that he had "bought a page of Illuminated Writing

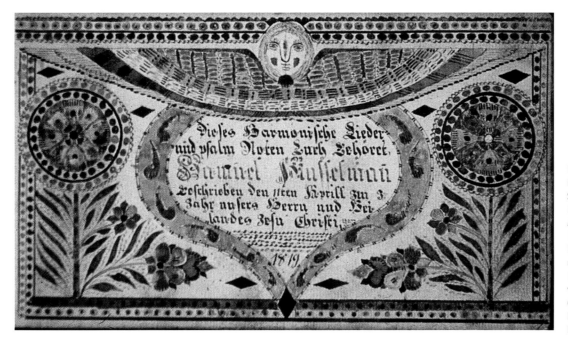

Fig. 246. **Manuscript Tune Book and Bookplate for Samuel Musselman.** Possibly Samuel Musselman, Bucks County, 1819. Hand-drawn, lettered and colored on unknown paper type. Dimensions and whereabouts unknown. (Photo courtesy of John L. Ruth and Mary Jane Hershey.)

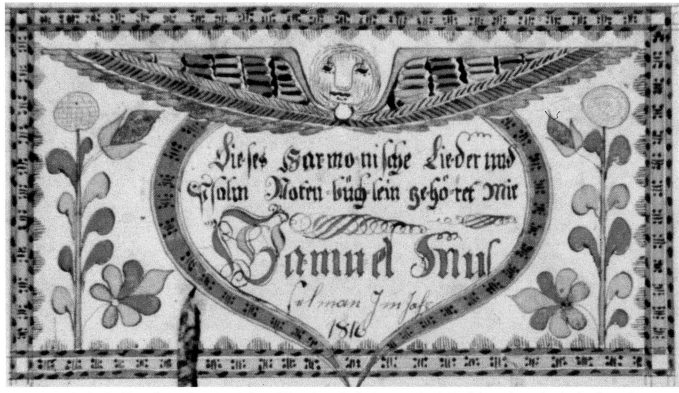

Fig. 247. **Practice Book of Samuel Musselman (page)**. Samuel Musselman, Bucks County, c. 1816. Hand-drawn, lettered and colored on unknown paper type. Dimensions and whereabouts unknown. (Photo courtesy of John L. Ruth and Mary Jane Hershey.)

[with] Tulip decorations and large German letters." The page bore the name of Samuel M. Musselman.[3]

There were several Samuel Musselmans living in northern Bucks County during the early 1800s. It has been proposed that the Samuel whose name appears in the tune book and practice book was the Mennonite preacher and bishop Samuel Musselman (c. 1759–1847) who resided in Milford Township.[4] It seems doubtful, however, that this Samuel would have begun a practice or sample book at the age of fifty-six if he had been an accomplished fraktur artist. It also seems improbable that he would have traveled to Rockhill to teach for two terms at the age of fifty-nine. More likely, the 1816–1819 fraktur artist and schoolmaster in Rockhill was a younger man, for whom teaching was an entry-level occupation. Among possible candidates are a Samuel Musselman (1797–1867), buried at the Saucon Mennonite cemetery in Coopersburg, Lehigh County, and another by the same name

(1802–1874), interred at the Line Lexington Mennonite graveyard in Bucks County.[5]

The most intriguing possibility, suggested especially by the middle initial mentioned in the Rice letter, is that the fraktur artist Samuel Musselman was the Samuel *M.* Musselman who later compiled a book of musical instruction entitled *Die Neue Choral Harmonie* [*The New Choral Harmony*]. This volume, published in Harrisburg in 1844, contained choral arrangements and texts for 190 songs, particularly religious melodies. Perhaps indicating the home turf and travels of its author, four of the tunes were titled "Milford," "Hilltown," "Upper Saucon," and "Franconia."[6] This Samuel is remembered as a gravestone cutter and teacher in Lower Salford Township, Montgomery County, though it is very likely that his origins lay with the Musselman families centered around Milford Township, Bucks County.[7]

Notes

1. The present whereabouts of this tune book, and a related practice book containing a variety of fraktur models, two bearing the date 1816, is unknown. As far as this writer is aware, they last appeared on the antiques market in 1976 (see n. 4). It is through the courtesy of John Ruth and Mary Jane Hershey (who copied the slide collection of scholar J. J. Stoudt) that color images of these fraktur were preserved and made available for study.

2. Samuel Musselman, "Bills for Schooling Christian Hottel, October 20, 1818 through March 20, 1819, and September 27, 1819 through February 7, 1820, Rockhill Township," March 16, 1819 and February 8, 1820, B.C. School Bills.

3. A. H. Rice to Henry C. Mercer, December 11, 1915, MSC 291, Series 1, Fol. 63, SL/BCHS. Unfortunately, the whereabouts of the piece of fraktur purchased by Rice is presently unknown.

4. *Ohio Antique Review* (June, 1976): 29. To the best of this author's knowledge, no proof has been offered for this assertion. This Samuel Musselman died in 1847 at the age of 88 according to his tombstone inscription in the West Swamp Mennonite Graveyard.

5. Tombstone Inscription File, SL/BCHS. For the Samuel buried at Saucon, whose wife Susanna lies beside him, see Clarence E. Beckel, comp., "Tombstone Inscriptions of Mennonite Burial Ground, near Centre Valley, Lehigh County, Pa.," Bethlehem, 1936 (typescript photocopy): 4. His family is more completely enumerated in Rev. A. J. Fretz, *A Genealogical Record of the Descendants of Christian and Hans Meyer, and Other Pioneers*, 2 vols. (Harleysville, Pa.: News Printing House, 1896), 2:599. Intriguingly, this Samuel married a Susanna Moyer (Meyer) whose sister Annie wedded a schoolteacher and marble cutter by the name of John Musselman, perhaps a relative. See Fretz, 2:598, and "Musselman Family," Musselman Family File, SL/ BCHS, p. 2. Also, *Der Friedens Bote* (Allentown, Pa.), 22 Jul 1813 for the marriage of John Musselman and Annie Moyer. The other Samuel (1802–1874), was the coverlet weaver Samuel B. Musselman, the son of Mennonite preacher Samuel Musselman Sr. (c. 1759–1847). It is not known whether Samuel the weaver may have taught school prior to embarking on his more notable career of coverlet making; however, his middle initial makes him an unlikely candidate for the fraktur artist if the Rice letter is to be believed. See "Musselman Family," p. 2; also Ron Walter, "Samuel B. Musselman, Coverlet Weaver in Milford and Hilltown Townships, Bucks County, Pa.," *Newsletter of the Mennonite Historians of Eastern Pennsylvania* 15 (January, 1988): 8–11.

6. Samuel M. Musselman, *Die Neue Choral Harmonie* (Harrisburg: Hickock and Cantine, 1844). See also John L. Ruth, *Maintaining the Right Fellowship* (Scottdale, Pa.: The Herald Press, 1984), 234. On the back cover of Musselman's choral book are testimonials from several individuals, including a church organist in Coopersburg, Lehigh County, and a noted Mennonite preacher and publisher (John Oberholtzer) in Milford. Clearly Samuel M. Musselman had connections in these communities.

7. Ruth, 234. In addition to Samuel, a John (n. 5) and a David Musselman are also recorded as schoolteachers in the Bucks County School Bills. All of these forenames occur among the Musselman families of Milford Township and vicinity. In addition, Henry Mercer in his "Survival of the Mediæval Art of Illuminative Writing Among Pennsylvania Germans," *Proceedings of the American Philosophical Society* 36 (September, 1897): 432n. notes that "a German school sustained by private subscription was taught by the Mennonite Samuel Musselman, in Swartley's schoolhouse, at the lower end of Hilltown...about 1866."

Jacob Oberholtzer

(1794–1880, active c. 1819–1828)

Milford, Springfield, Bedminster, and Hilltown Townships

After David Kulp's tenure ended at schools in Bedminster and Hilltown Townships, other teachers continued the local Mennonite fraktur tradition into the 1820s. Their bookplates and rewards of merit often mimic Kulp's fraktur, as well as the older traditions of Eyer and others. So closely did they copy the design vocabulary of these earlier teachers—and each other—that it is often difficult to discern whether we are looking at the work of one, two, or several artists.

Fortunately, through the survival of a copy of an important circular letter or advertisement, the hand of one of these later schoolmaster-artists can be positively identified (Figs. 248–250). Near the close

of 1822, a teacher by the name of Jacob Oberholtzer alerted the residents of Hilltown that he planned to begin a school and asked that their children might be sent to him for instruction. In his letter to the people of Hilltown he also outlined the curriculum:

I, Jacob Oberholtzer, announce to you Hilltown people that I intend to keep school in the Hunsperger school house, if you will provide for me 25 children, and every parent that sends a child must pay the daily tuition of two cents. And if there are no further hinderances, I intend to begin the school term on the 5th of January 1823, and for the following three months. And

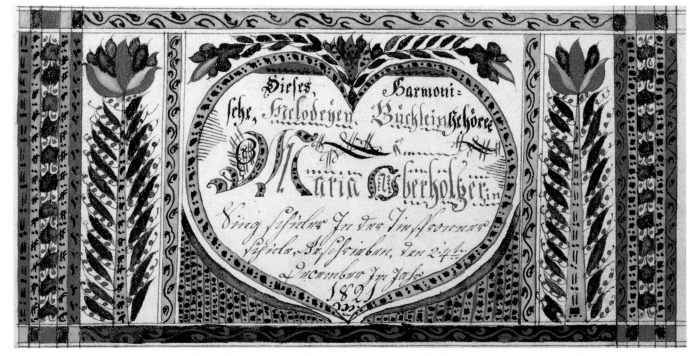

Fig. 248. **Manuscript Tune Book and Bookplate for Maria Oberholtzer**. Attributed to Jacob Oberholtzer, Deep Run School, Bedminster Township, Bucks County, 1821. Hand-drawn, lettered and colored on wove paper. 4 x 7⅝ in. The date on this tune book corresponds to the end of Oberholtzer's fall 1821 session at the Bedminster (Deep Run) Schoolhouse. (Private collection.)

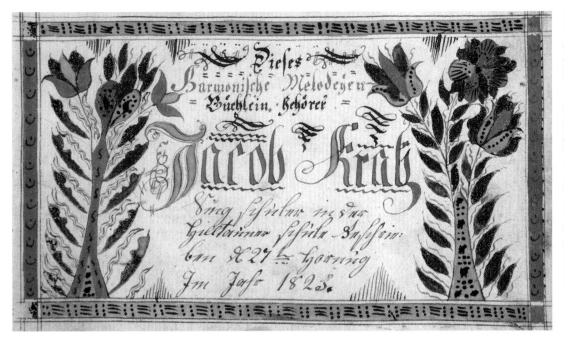

Fig. 249. **Manuscript Tune Book and Bookplate for Jacob Kratz**. Attributed to Jacob Oberholtzer, Hilltown School, Hilltown Township, Bucks County, 1823. Hand-drawn, lettered and colored on laid paper. 3³/₄ x 6¹/₄ in. Jacob Kratz' parents evidently answered Oberholtzer's call for students to attend the winter 1823 term at the Hilltown School House. Kratz was presented with this tune book on February 27, 1823. (Rare Book Department, The Free Library of Philadelphia, FLP B-19.)

all who will send children to this school house must provide the school house with sufficient wood to keep the school room warm. And I promise to teach the children in reading, writing, singing, praying, and spelling, as far as I am able. Jacob Oberholtzer, schoolteacher[1]

Oberholtzer evidently succeeded in attracting students. He later submitted a bill to the Bucks County Commissioners for teaching poor children at the Hilltown School House for the same three-month term, beginning January 6, 1823, and concluding on March 21. Curiously, he charged the county *three* cents a day per student rather than the two cents he advertised.[2]

Oberholtzer's 1823 bill to the county, like others that survive from his hand, shows that his English language skills were inferior to his German spelling and penmanship. Though clearly from the same pen, his circular letter to the people of Hilltown proves that he was much more accomplished with his German script than with the English he used in billing the county. It may also be that he felt he needed to impress Hilltown parents with his penmanship more so than the county officials who ultimately approved payments.

The school at which Oberholtzer taught, the Hilltown or Hunsberger School, was sited "aboute one mile From Dublin" according to the 1823 school bill.[3] Fortunately, the trustees' minute book from this school also survives, providing slightly more precise information about its location. It was

built on land provided by Abraham Hunsberger in 1816, "lying upon the road leading from the Bethlehem road to Dublin Village."[4]

Judging from the dates of his school bills, Oberholtzer continued to teach at Hilltown and Bedminster until at least 1828. Earlier in his career he had also presided over classes in Milford (the Lower Milford School House "about two Mile above Quakertown") and Springfield ("Near Christian Agenback's inn").[5] Some of his earliest fraktur survives from these locales (Figs. 251–252). On all of his school bills, the schoolmaster simplified, and anglicized, his name to Overholt.[6]

The repetition typical of Pennsylvania-German naming practices often frustrates attempts to distinguish one individual from several people having the same name. There are, for example, several Jacob Oberholtzers mentioned in public records as living in the Hilltown-Bedminster area during the early nineteenth century. In this instance, however, the recurrence of identical names works in favor of the researcher. Since even the tax assessor was confused by the number of Jacob Overholts in Bedminster Township, he conveniently distinguished them. One was listed with no special designation, one was "senior," one "junior," and one "schoolmaster." Tax records show that between 1831 and 1851, "schoolmaster" or "teacher" Jacob owned fifty-six acres of land in Bedminster.[7] To the tax man at least, Jacob apparently retained his scholarly title long after he had left the classroom.

281

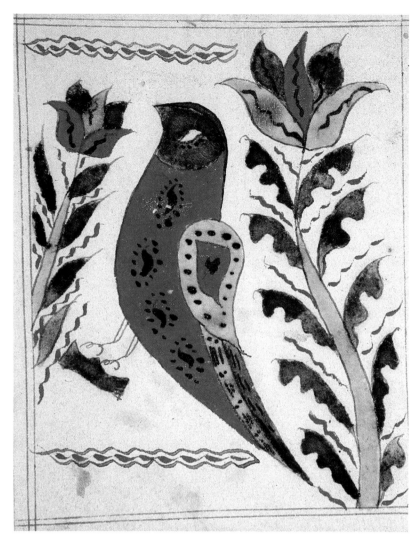

Fig. 250. **Drawing**. Probably Jacob Oberholtzer, Hilltown or Bedminster Township, Bucks County, c. 1825. Hand-drawn and colored on wove paper. 3⁷/₈ x 3 in. The flowers on this small presentation fraktur are identical to a tune book from Deep Run attributable to Oberholtzer, dated 1825, and in the collection of The Free Library of Philadelphia. (Private collection.)

The assessor's note, combined with other records, makes it possible to identify precisely the Jacob Oberholtzer who taught school in Bedminster, Hilltown, and elsewhere. He was the son of Rev. Abraham Oberholtzer, a Mennonite preacher at Deep Run, and his wife Margaret Wismer.[8] Jacob acquired his 56 acres in 1829 from the estate of his deceased father-in-law Isaac Gross. The acreage was still in his possession at the time of his own death in 1880, when the property was passed to Jacob's son-in-law David K. Landis.[9]

With land of his own to farm, it is likely that Jacob Oberholtzer ended his teaching career in 1829. The 1850 census lists him only as a farmer, living with his wife Barbara and twins (?), Maria and Jacob.[10] He died August 15, 1880—aged 85 years, 10 months, 28 days—and was buried at the Deep Run Meetinghouse.[11]

Fig. 251. **Manuscript Tune Book and Bookplate for Daniel Schelly**. Attributed to Jacob Oberholtzer, Milford School, Milford Township, Bucks County, 1820. Hand-drawn, lettered, and colored on laid paper. 4¹/₄ x 7¹/₂ in. (Schwenkfelder Library and Heritage Center.)

Raised in the Deep Run area, Oberholtzer probably learned his spelling, arithmetic, and singing in David Kulp's classroom. In fact, Kulp prepared a *Notenbüchlein* for a Jacob Oberholtzer in 1803, conceivably the same individual who would grow up to become a schoolmaster himself.[12]

In addition to compiling manuscript tune books, his primary fraktur form, Oberholtzer also produced rewards of merit and bookplates for Bibles and hymnals.

Fig. 252. **Manuscript Tune Book and Bookplate for Anna Schimmel**. Attributed to Jacob Oberholtzer, Springfield School, Springfield Township, Bucks County, 1821. Hand-drawn, lettered and colored on wove paper. 4¹/₈ x 7³/₄ in. Oberholtzer taught in Springfield until February 23, 1821—ten days after he prepared this *Notenbüchlein* for Anna Schimmel. (Private collection.)

Notes:

1. I am indebted to Ronald Trauger for bringing this document to the attention of the Mercer Museum and for its translation.

2. Jacob Overholt, "Bill for Schooling Christian Yeacle, January 6 through March 21, 1823, Hilltown Township," March 21, 1823, B.C. School Bills.

3. Ibid.

4. "German-English School, Hilltown Township, Bucks Co., 1816–1847," Historical Mss. L194, Mennonite Historians of Eastern Pennsylvania Archives, Harleysville, Pa. (typescript translation of original minute book), 1. It should be noted that this is a different school than the so-called "German School House In Hilltown" noted in another surviving manuscript. This latter institution, though located nearby "on the Bethlehem Road Near Sipel's Mill dam," was governed by different trustees than those appointed to the Hunsberger German-English School. For this other schoolhouse, see "Proceedings of the Trustees of the German School House In Hilltown," MSC 694, Fol. 1, SL/BCHS. It is not known if Jacob Oberholtzer also served this school; his hand cannot be positively recognized among the minutes.

5. Jacob Overholt, "Bill for Schooling Charles and John Strunk, November 9, 1819 through February 9, 1820, Milford Township," 1820; "Bill for Schooling George and David Heft, October 23, 1820 through February 23, 1821, Springfield Township," March 8, 1821, B.C. School Bills.

6. Another Jacob Oberholtzer, who signed his name as such on several school bills, apparently taught school between about 1818 and 1825 in Upper Milford Township, Lehigh County. The difference in penmanship on the school bills, coupled with his decision to write his name out in its Germanic form, makes it likely that this Jacob was a different individual from the teacher in Bucks County. See, for example, Jacob Oberholtzer, "Bill for Schooling Anna and Diana Caldoxy, et al, November 1, 1824 through March 24, 1825, Upper Milford Township," March 28, 1825, Lehigh County School Bills, Lehigh County Historical Society, Allentown, Pa.

7. 1831–1851 Tax Lists, Bedminster Township, Bucks County, SL/BCHS.

8. Barbara B. Ford, comp., *The Oberholtzer Book* (Overholser Family Association, 1995), p. 19.

9. "Deed of Sale from Barbara Overholt to David K. Landis," August 28, 1880, Deed Book 196, pp. 152–153, SL/BCHS.

10. U.S. Census of 1850, Bedminster Township, Bucks County, Pa., 261. For more genealogical data on this family see Elisha S. Loomis, *Some Account of Jacob Oberholtzer...And of some of his descendants in America*, (Cleveland: 1931), 97. This latter source only records a single offspring from the marriage of Jacob Oberholtzer and Barbara Gross: Maria Oberholtzer who married David K. Landis. If Maria had a twin brother, as the 1850 census suggests, he may have died prior to 1892 when Maria's mother wrote her will.

11. Hedwig H. Voltz, trans., *German Language Newspapers, Death and Obituary Notices, 1878–1886*, 3 vols. (Doylestown, Pa.: Bucks County Historical Society, 1997), 3:68.

12. Frederick S. Weiser and Howell J. Heaney, *The Pennsylvania German Fraktur of the Free Library of Philadelphia: An Illustrated Catalogue*, 2 vols. (Breinigsville, Pa.: The Pennsylvania German Society, 1976), 1:fig. 196.

The Plumstead Artists

(active c. 1820–1830)

Plumstead, Hilltown, and Bedminster Townships

Although Jacob Oberholtzer produced a number of manuscript tune books and bookplates during his teaching career, clearly he did not produce all of the extant fraktur that emerged from Bucks County's Mennonite schools during the 1820s. Some of this fraktur, including the examples now ascribed to Oberholtzer, had been previously attributed to an anonymous penman dubbed the Plumstead Artist. However, the teacher who inscribed a *Notenbüchlein* title page (Fig. 253) for Sarah Schattinger of Plumstead in 1822 (the apparent source of the *Plumstead* nickname) was only one of several individuals who drew bookplates contemporaneously at Deep Run, Hilltown, and Plumstead. A comparison of the penmanship on these various pieces shows multiple hands at work.

Several schoolmasters were active in the German schools during the 1820s. Among those associated with predominantly Mennonite institutions were Rudolph Landes (see his entry in this volume), Jacob Landes, and John N. Kepler.[1] The latter is the most likely individual to have composed the Schattinger bookplate. Kepler's school bills demonstrate that he taught at the Mennonite school in Plumstead from the spring of 1820 to November 1822.[2] Although he filed no bill for the specific term in which Sarah Schattinger was enrolled, it seems probable that he continued his tenure uninterrupted throughout this period. Although prepared in English, the slant and number formation seen in the cursive writing on Kepler's invoices is suggestive of the German script on the Schattinger bookplate (Fig. 254).

Fig. 253. **Manuscript Tune Book and Bookplate for Sarah Schattinger**. Unidentified artist, possibly John N. Kepler, Plumstead School, Plumstead Township, Bucks County, 1822. Hand-drawn, lettered and colored on wove paper. 4 x 6⁵/₈ in. (Private collection.)

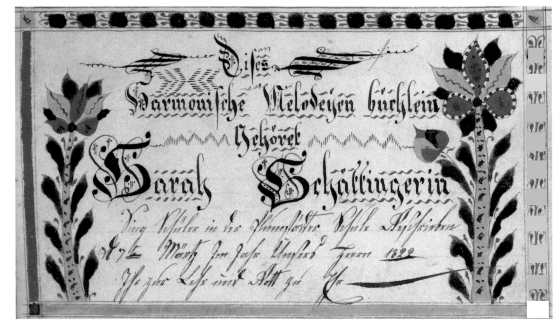

Kepler (1792–1883) was a twin brother of Bernard Kepler (1792–1890), both of whom seem to have lived out their lives as bachelors, residing on their farm with an Atkinson family near Gardenville, in Plumstead Township, until their deaths at very advanced ages.[3] Though John Kepler did teach briefly in Bedminster Township during the winter 1823–1824 term, by 1825 he had moved on to a position in Tinicum. There he instructed scholars for at least another five years.[4]

Other schoolteacher-artists were also active in Plumstead. Among them was an unidentified teacher who prepared a bookplate for Sarah Wismer in 1827 (Fig. 255). Drawn five years after the Schattinger bookplate and by a different penman, certain decorative elements—especially the red-tipped flower buds in the manner of Elisabeth Dieterly—still persist. One source has actually attributed this piece to the student, Sarah Wismer, though this seems doubtful.[5] Sarah later became the wife of Joseph M. Gross, to whom several fraktur bookplates have also been attributed. (For details, see the entry under the Swirl Artist later in this volume.)

Also teaching in Bedminster and Hilltown during these years was Jacob Landes. It is possible that he composed some of the tune booklets that survive from Deep Run and Hilltown, dating from the mid-late 1820s.[6] Until signed pieces of fraktur are found, however, or documented samples of Landes's and Kepler's German penmanship located, a firm attribution of these various works cannot be made.

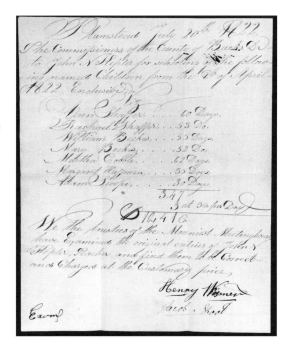

Fig. 254. **School Bill** John N. Kepler, "Monniest" [Mennonite] School, Plumstead Township, Bucks County, July 20, 1822. (Spruance Library/Bucks County Historical Society.)

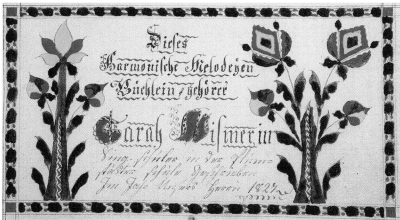

Fig. 255. **Manuscript Tune Book and Bookplate for Sarah Wismer**. Unidentified artist, Plumstead School, Plumstead Township, Bucks County, 1827. Hand-drawn, lettered and colored on wove paper. 4 x 7⅛ in. (Private collection.)

Notes

1. B.C. School Bills, Bedminster, Plumstead, Hilltown, and Rockhill Townships, 1820–1828.

2. See for example John N. Kepler, "Bill for Schooling Ann Shaffer, et al, April 8, 1822 through July 20, 1822, Plumstead Township," July 20, 1822, B.C. School Bills. Kepler is the only German schoolmaster who filed bills for teaching poor children in Plumstead during the years 1820–1822.

3. W.J. Kepler to Willis T. Kepler, July 8, 1929, Willis T. Kepler Collection, Kepler Family File, SL/BCHS. See also *Lower Tinicum Reformed Church and Cemeteries*, Part 3 (Doylestown, Pa.: Bucks County Historical Society, n.d.), 30; and Estate of Barnet Kepler, File No. 17965, Register of Wills, Bucks County Courthouse, Doylestown, Pa.

4. See for example John N. Kepler, "Bill for Schooling Ann Snyder, et al., May 3, 1825 through December 10, 1825, Tinicum Township," December 10, 1825, B.C. School Bills.

5. "Bedminster Township Meeting," in *A Collection of Papers Read Before the Bucks County Historical Society* 4 (Doylestown, Pa.: 1917): 535.

6. See for example Jacob Landes, "Bill for Schooling Elizabeth Eydam, et al, April 11 through August 30, 1826, Bedminster Township," September 11, 1826, B.C. School Bills. Most of Landes' school bills indicate only that he taught at the Bedminster School. This appears to have been a different institution (one possibly near the Tohickon Union Church) from the Deep Run School frequently named on surviving bookplates. It should be noted, however, that Mary Jane Hershey attributes one *Notenbüchlein* bookplate to Landes: the title page of a tune booklet for Johannes Gross at the Deep Run School, dated June 1, 1822.

Samuel Moyer

(active c. 1827–1828)

Bedminster Township

Another artist, whose work has been grouped previously with the "Plumstead" school, is Samuel Moyer, a Mennonite instructor at Deep Run in 1827 and 1828. Like Jacob Oberholtzer and others, Moyer flanked the text in his compositions with flowers perched atop either straight or curvaceous leafy stems. Based on the limited number of pieces that can be attributed to him, he also typically divided his bookplates into three panels: the center panel contained the dedicatory inscription, while the decorative elements were partitioned at left and right. Moyer's penmanship is dissimilar to that of Jacob Oberholtzer, Rudolph Landes, and other artists of the period, and helps us to recognize his distinctive hand.

It is possible to attribute works to Moyer through a bill he submitted to the county for teaching a poor child. Moyer instructed scholar Mathias Brown for a total of 89 days during two school terms at the "Bedminster Menonist Schoolhouse" (i.e. Deep Run) between April, 1827 and June, 1828.[1] In this same period, as surviving examples attest, he composed tunebooks and bookplates for Anna Letherman, Johannes Hoch, and Levi Meyer (Figs. 256, 257), all students at the Deep Run School.

There were, of course, numerous Samuel Moyers (or Meyers) among the inhabitants of north-central Bucks County during the 1820s. One, the husband of Mary Hagey Moyer and the father of three children, died in 1828 at a young age. Another, born in 1797 and raised on his parent's Hilltown farm, married an Elizabeth Hunsicker, also in 1828. This Samuel died in 1869. Still another, the son of Heinrich and Salome (Stover) Moyer, never married and died in 1832 at the age of 24.[2] Any of these individuals could have been Samuel Moyer, schoolmaster at Deep Run. Moyer the fraktur artist might well have taught school up to the time of his death, or marriage, in 1828. Or he could have been the young bachelor who began a teaching career at the age of 17 or 18, and died in 1832.

On the other hand, perhaps one of the tune books executed by schoolmaster Moyer offers a clue to his identity. The Levi Meyer for whom he drew a bookplate in 1828 is almost certainly the Levi S. Meyer, or Moyer, born in 1821 and buried at Deep Run. This Levi was the son of Samuel and Anna Shaddinger Moyer of Bedminster Township.[3] Perhaps Levi's own father was the schoolmaster who made the tunebook for him.

Whoever this Samuel Moyer may have been, he apparently taught for only a few years. Still, he sought to translate into his own idiom the penmanship skills and design vocabulary that he had inherited in a fraktur legacy stretching back to David Kulp and Johann Adam Eyer.

Notes

1. Samuel Moyer, "Bill for Schooling Mathias Brown, April 2, 1827 through October 26, 1827 and March 10, 1828 through June 6, 1828, Bedminster Township," September 8, 1828, B.C. School Bills.

2. A.J. Fretz, *A Genealogical Record of the Descendants of Christian and Hans Meyer and Other Pioneers*, 2 vols. (Harleysville, Pa.: News Printing House, 1896), 1:65, 143, 262.

3. Ibid., 1:199, 201.

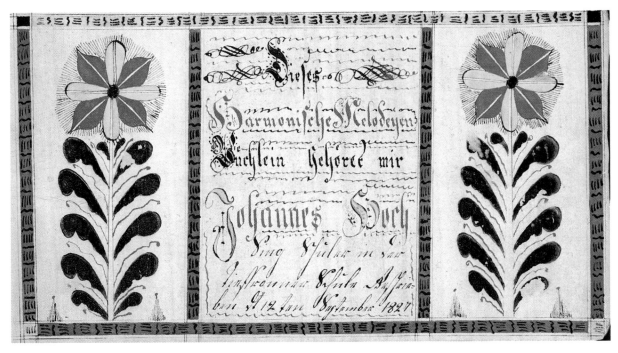

Fig. 256. **Manuscript Tune Book and Bookplate for Johannes Hoch**. Attributed to Samuel Moyer, Deep Run School, Bedminster Township, Bucks County, 1827. Hand-drawn, lettered and colored on wove paper. 4³/₈ x 7¹/₄ in. (Private collection.)

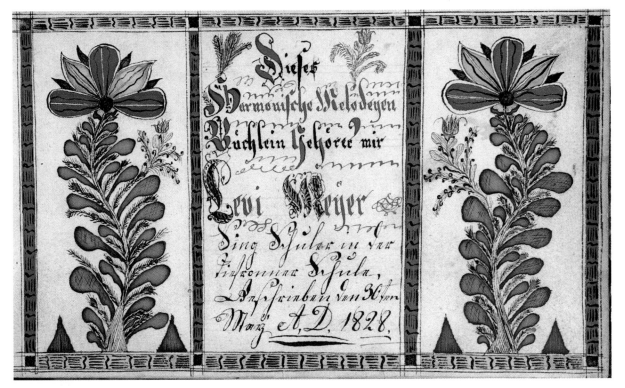

Fig. 257. **Manuscript Tune Book and Bookplate for Levi Meyer**. Attributed to Samuel Moyer, Deep Run School, Bedminster Township, Bucks County, 1828. Hand-drawn, lettered and colored on wove paper. 3⁷/₈ x 6¹/₄ in. (Mennonite Historical Library, Goshen College, Goshen, Indiana.)

Jacob Brecht

(c. 1784–1850, active c. 1810–1840?)

Springfield, Haycock, Richland, and Rockhill Townships

Jacob Brecht, a German Baptist (Brethren) schoolmaster,[1] taught in several schools in Bucks and Northampton Counties. Disappointingly, however, there is only one piece of fraktur that can be linked with certainty to his hand. In 1813, he produced and signed a double bookplate-birth record for Fronica Schimmel of Springfield Township, Bucks County (Fig. 258).

Brecht, whose name was frequently anglicized to *Bright* in census records and school bills, was a member of a Brethren congregation in Springfield Township.[2] At least as early as January 1811, he taught school in the neighboring township of Richland.[3] School bills and tax records for the following fifteen years of his life provide a nearly complete chronology of his teaching career. Between 1811 and 1816 he alternated between schools in Richland and Rockhill Townships.[4] Despite the location of these teaching assignments, Brecht was actually a resident of Haycock Township at the time.

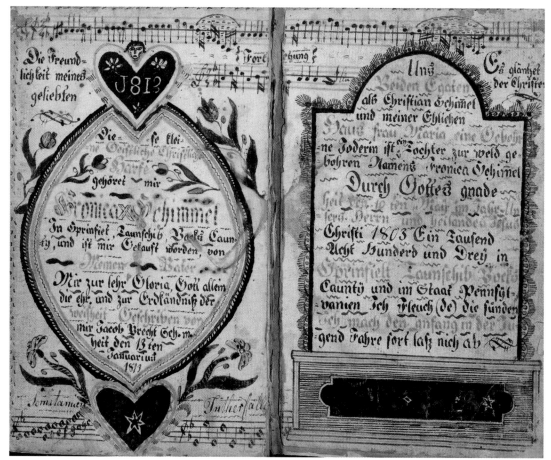

Fig. 258. **Hymnal Bookplate and Birth Record for Fronica Schimmel (b. 1803).** Jacob Brecht, Springfield Township, Bucks County, 1813. Hand-drawn, lettered and colored on laid paper. 6½ x 4 in. (each panel). (Private collection.)

288

In 1814, the Haycock tax assessor listed Brecht among the local taxables, noting his occupation as "schoolmaster."[5] At about the same time, Brecht was a buyer at two public sales in Haycock. At the sale of the effects of the late John Keller, Brecht purchased a bedstead and a "German law book," the latter for the substantial sum of $3.25.[6]

By 1817, Brecht may have found himself without a teaching position for he is listed as a "labourer" on the tax register. A separate list for the same year shows his name crossed out, suggesting that he had given up the few acres of land he owned and went off in search of a new appointment.[7] He soon found one in Lower Saucon Township, Northampton County, where by 1820 the tax assessor was listing the new "schoolmaster" on the rolls.[8]

Dropped from the Saucon lists three years later, Brecht next appears as a teacher in a Haycock Township school in 1824 and 1825. During those years he instructed at least eleven students, from seven different families, whose parents could not afford his daily tuition of three cents a day (Fig. 259).[9] On a small ten-acre plot of land in Haycock, with his family, a cow, and a dog (for which he was taxed extra), Brecht spent his next fifteen years.[10]

J. H. Battle's *History of Bucks County* (1887) offers a few sparse, but important, details of Brecht's life. Battle suggests that the Brecht family were early settlers of Haycock Township but moved on at an unspecified date. In fact,

Jacob was the only one of the family who stayed in Pennsylvania. He was a teacher until seven years before his death, which occurred when he was 65 years old. He stood high in the estimation of his neighbors, who often employed him to settle intricate business matters. He was three times married. His first wife had one child, who is deceased. His second wife left three children: Sophia, Lavina and Nancy.[11] The third wife, Catherine Tyson, had nine children: Samuel, Jacob, Josiah, George, Jackson, Edwin, Elizabeth, Lydia Ann and Englehart, who was born August 19, 1831.[12]

In Haycock, Brecht evidently continued to teach school for many years. The 1840 census found the family there, with the census taker noting that two members were engaged "in the learned professions."[13] It is possible that one of Brecht's sons or

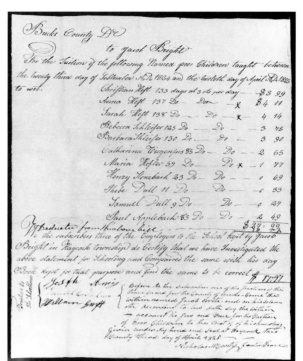

Fig. 259. **School Bill**. Jacob Bright [Brecht], Haycock Township, Bucks County, 1825. (Spruance Library/ Bucks County Historical Society.)

daughters had, by that date, followed their father into a teaching career.

Jacob Brecht returned to Springfield about 1841 where he acquired some thirty-five acres of land. Living nearby was the "widow Bright," John Bright, and Jacob D. Bright, all probably members of his immediate family or close relatives.[14] When Brecht died in 1850, the German newspapers *Der Morgenstern* and *Der Bauern Freund* both published his obituary, again noting his long-time occupation as a schoolteacher. His age was given as sixty-six, and his place of interment recorded as the "Springfield Meetinghouse."[15] When Brecht's wife Catherine was buried twenty-three years later, in 1873, she too was laid to rest in Springfield at the "Tunker Meetinghouse."[16]

Although only one piece of fraktur can be positively connected with Brecht, several other pieces bear a strong resemblance to his work. At least two other bookplate-birth records are known, each sharing very similar text and formats (Figs. 260, 261). Both originated in Haycock Township and are dated 1839.[17] Although the penmanship appears slightly different than on the 1813 fraktur signed by Brecht, it seems certain that their maker was at the very least influenced by Brecht's work. Perhaps another member of Jacob Brecht's family had picked up the pen and brush, turning to the older work of the schoolmaster as a copy model.

Fig. 260. Bible Bookplate and Birth Record for Aaron Landes (b. 1829). School of Jacob Brecht, Haycock Township, Bucks County, 1839. Hand-drawn, lettered and colored on wove paper. 6⅞ x 4 in. (each panel). Whether by Brecht's hand or that of an imitator, all of the fraktur illustrated here share very similar text. All note that the books were purchased for the child, for his or her "instruction." (Rare Book Department, The Free Library of Philadelphia, FLP B-163.)

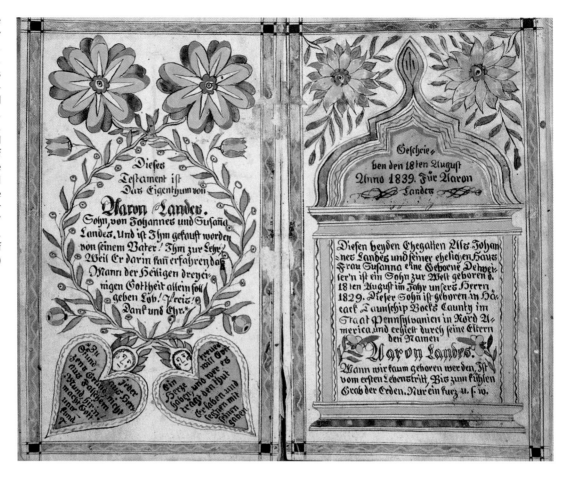

Notes

1. Isaac Clarence Kulp, folk historian and member of the Brethren congregation in Vernfield, Montgomery County, Pa., first brought Brecht's German Baptist background to my attention. The Brecht family traces its American origins to Michael Brecht (1706–1794) who emigrated from Schriesheim, Germany, and settled in Germantown, Pa., in 1726. See *The Brethren Encyclopedia*, 3 vols. (Philadelphia: The Brethren Encyclopedia Inc., 1983), 1:209.

2. The *Brethren Encyclopedia*, 2:1216, notes that the first German Baptist meetinghouse was built in Springfield in 1866, on a site about 2½ miles east of Coopersburg, Lehigh County. Prior to that date, the congregation met in local homes. This history, however, is a bit puzzling as Jacob Brecht was supposedly buried in 1850 at the Springfield Meetinghouse. See his obituary in *Der Morgenstern* (Doylestown, Pa.), May 8, 1850, 3.

3. Jacob Bright, "Bill for Schooling Samuel Crossley, January 7, 1811 through April 10, 1811, Richland Township," May 27, 1815, B.C. School Bills.

4. See, for example, Jacob Bright, "Bill for Schooling Sarah Charles, November 18, 1811 through April 17, 1812, Richland Township," May 27, 1815; "Bill for Schooling Isaac Troch, September 8, 1813 through October 29, 1814, Rockhill Township," January 28, 1814; "Bill for Schooling Hannah and Livy Green, October 31, 1814 through February 9, 1815, Richland Township," May

27, 1815; and "Bill for Schooling John Strome, et al, February 13, 1815 through January 16, 1816, Rockhill Township," May 25, 1816, B.C. School Bills. Curiously, seven of the nine bills extant from these years are in a very fine English script, evidently that of Brecht. However, two are in a much cruder hand. It seems unlikely that two different Jacob Brights were teaching in the same schools at the same time, but the inconsistent penmanship raises some questions.

5. 1814 Tax List, Haycock Township, Bucks County, SL/BCHS. Other tax lists note Brecht's presence in the Township as early as 1806.

6. "Vendue of John Keller, deceased," Haycock Township, July 1, 1813, Bucks County Vendue Lists, MSC 354, Fols. 7–8, SL/BCHS.

7. 1817 Tax List, Haycock Township.

8. 1820–1823 Tax Lists, Lower Saucon Township, Northampton County Archives, Easton, Pa.

9. Jacob Bright, "Bill for Schooling Christian Hest, et al, September 23, 1824 through April 12, 1825, Haycock Township," April 23, 1825, B.C. School Bills.

10. 1824–1841 Tax Lists, Haycock Township; U.S. Census of 1840, Haycock Township, Bucks County, Pa., 318.

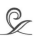

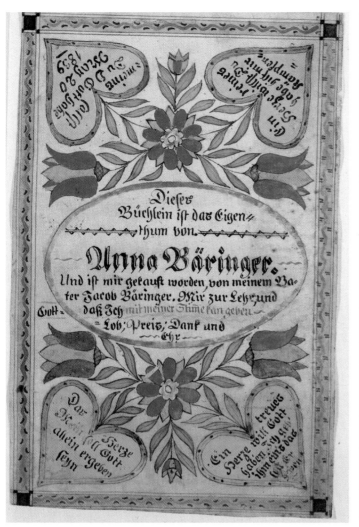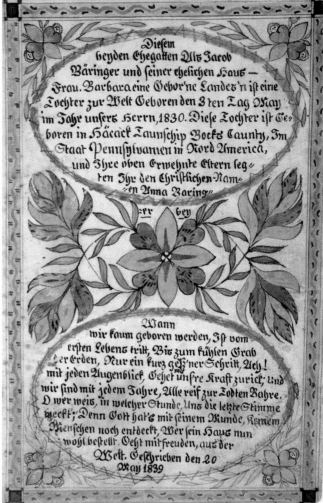

Fig. 261 a, b. **Bookplate and Birth Record for Anna Bäringer (b. 1830)**. School of Jacob Brecht, Haycock Township, Bucks County, 1839. Hand-drawn, lettered and colored on wove paper. 6³⁄₈ x 4¹⁄₈ in. (each panel). Both Mennonites and Brethren baptized only adult believers. The Brethrens' practice of completely immersing converts earned them the nickname "Dunkers." While the works attributed to Brecht and his copyists include children's birthdates, they actually postdate the births by about ten years. The lack of baptismal information suggests that all were made for Dunker or Mennonite children. (Private collection.)

11. The Lavina mentioned by Battle as a daughter of Brecht may be the "Livia Brecht" baptized in 1825 at St. John's Lutheran Church in Richlandtown, Bucks County. Though church records list Livia's parents as Jacob Brecht "and wife," no birthdate for the child is given. It is very likely that she was baptized as a young adult, in keeping with Brethren belief. See Frances Wise Waite, trans., *St. John's Evangelical Lutheran Church Register, Richlandtown, Bucks County, Pa., 1808–1837* (Doylestown, Pa.: Bucks County Historical Society, 1990), 15.

12. J. H. Battle, *History of Bucks County* (Spartanburg, S.C.: The Reprint Company, 1985), 1130.

13. 1840 Census, Haycock Township, 318.

14. 1841–1845 Tax Lists, Springfield Township. See also *Map of Bucks County, Pennsylvania* (Philadelphia: R. P. Smith, 1850) which shows the location of Brecht's home in Springfield.

15. *Der Morgenstern,* May 8, 1850, 3; *Der Bauern Freund* (Sumneytown, Montgomery County, Pa.), May 15, 1850. The reference to Brecht's burial at the Springfield Meetinghouse is perplexing. As previously noted (n. 2), the Brethren supposedly did not build a house of worship until 1866 in Springfield. Perhaps Brecht was actually interred at the Mennonite Meeting-house, not far from his home.

16. For Catherine Brecht's obituary, see *Der Reformer & Agricultural-ist* (Milford Square, Bucks County), September 4, 1873, 138.

17. In addition to these two combination bookplate-birth records, an 1839 single-page bookplate for Johannes Bäringer, probably by the same hand, is in the collection of the Free Library of Philadelphia (FLP B-79). See Frederick S. Weiser and Howell J. Heaney, *The Pennsylvania German Fraktur of the Free Library of Philadelphia: An Illustrated Catalogue,* 2 vols. (Breinigsville, Pa.: Pennsylvania German Society, 1976), 1:fig. 178. In vol. 2 of this same work, fig. 706 is a bookplate from Springfield Township for Hannah Appel, drawn in 1816, that could possibly be by Brecht himself (FLP B-1049).

Isaac Gross

(1807–1893)

Bedminster Township

In his 1897 essay, "The Survival of the Mediaeval Art of Illuminative Writing Among Pennsylvania Germans," Henry Mercer attributed several pieces of fraktur to Isaac Gross of Bedminster Township.[1] This Isaac was the father of Henry Kulp Gross (1851–1935), one of Mercer's key informants during his fraktur research.[2] In fact, many of the works Mercer attributed to Isaac Gross were, in 1897, still in the possession of Gross's son Henry.

In all, Mercer recorded four fraktur by Gross's hand. In addition to a religious text and a *Vorschrift* which he pictured (see pp. 8–9, Figs. 5 and 6), Mercer also catalogued a second *Vorschrift* and an extraordinary drawing of entwined tulips which he attributed to Gross (Figs. 262, 263). To confirm Mercer's attribution, this latter work bears the initials "I.G." in red ink.[3]

Yet another *Vorschrift* with similar decoration and an identical hymn text is in the collection of The

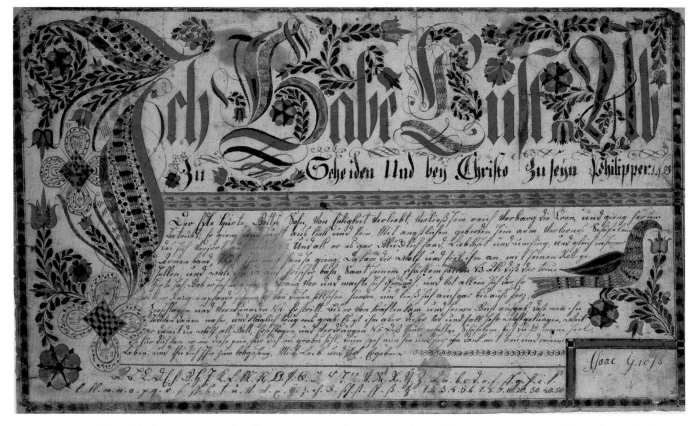

Fig. 262. **Penmanship Model of Isaac Gross**. Attributed to Isaac Gross, Bedminster Township, Bucks County, c. 1830. Hand-drawn, lettered and colored on wove paper. 8 x 13 ⅛ in. (Spruance Library/Bucks County Historical Society, SC-58. No. A-11.)

Free Library of Philadelphia (Fig. 264).[4] Finally, in the holdings of the Henry F. DuPont Winterthur Museum is an intriguing paper pocket that displays many of the same design elements (Fig. 265).[5] While there is a striking similarity in decoration among all of these pieces, there also appears to be some disparity in penmanship, especially in the bodies of the three hymn texts which are executed in cursive script. Perhaps more than one hand was at work in the production of some of these pieces.

Despite the early date of Mercer's study and his attributions, little is known about Isaac Gross's fraktur production. He labored as a tinsmith and farmer in Bedminster throughout most of his life and apparently confined his fraktur work to his early years.[6] Most of the fraktur that can be attributed to him, often typified decoratively by teardrop-shaped leaves and long-necked birds with striped bodies, date to about 1830.

In that year, Gross first appeared on Bedminster tax lists owning just ten acres of land.[7] He sold three of those acres in May 1830, and not long afterward left the area for a number of years.[8] He returned sometime before 1844 when he purchased forty-five acres from Jonas Fretz.[9] From that date until his death in 1893 he resided in Bedminster, an active member of the Mennonite congregation at Deep Run. His wife Mary died of cancer in 1886.[10] When Isaac followed her seven years later, the local newspaper called him simply "an aged and respected citizen of Bedminster."[11]

Fig. 263. **Drawing**. Isaac Gross, Bedminster Township, Bucks County, 1828. Hand-drawn, lettered and colored on wove paper. 7⁷/₈ x 6¹/₄ in. The artist recorded his initials, "I.G.," in red ink at the bottom center of his composition. (Spruance Library/Bucks County Historical Society, SC-58. No. A-02.)

Notes

1. Henry C. Mercer, "The Survival of the Mediaeval Art of Illuminative Writing Among Pennsylvania Germans," *Proceedings of the American Philosophical Society* 36 (September, 1897): 427, 429. It should be noted that while Mercer attributed several works to this Isaac Gross he misstated the latter's date of death. Gross died in 1893, not 1895 as Mercer reported.

2. Ibid. For documentation as to Henry K. Gross's parentage, see U.S. Census of 1880, Bedminster Township, Bucks County, Pa., 7; Frances Wise Waite, comp., *Bucks County Tombstone Inscriptions, Haycock and Bedminster Townships* (Doylestown, Pa.: Bucks County Genealogical Society, 1988), C38. For more information on this family also see Rev. I. John Letherman, *All Leatherman Kin History* (Nappanee, Ind.: E.V. Publishing House, 1940), 840; William W.H. Davis, *History of Bucks County, Pennsylvania*, 2nd ed., 3 vols. (Pipersville, Pa.: A. E. Lear, Inc., 1975), 3:316.

3. In addition to the four fraktur that Mercer attributed specifically to Isaac Gross, three other works were also, in 1897, in the possession of his son Henry K., any or all of which might have flowed from the elder Gross's hand. These included a picture of two trees (now in the Bucks County Historical Society collection and illustrated as Fig. 2 in this volume), a pelican, and a Bible bookplate.

4. Frederick S. Weiser and Howell J. Heaney, *The Pennsylvania German Fraktur of the Free Library of Philadelphia: An Illustrated Catalogue*, 2 vols. (Breinigsville, Pa.: The Pennsylvania German Society, 1976), 2:fig. 959.

5. This piece was brought to my attention by Betty Fiske and John Krill, paper conservators at Winterthur Museum, Winterthur, Delaware.

Fig. 265. **Decorated Wall Pocket**. Attributed to Isaac Gross, Bedminster Township, Bucks County, c. 1830. Hand-drawn, lettered and colored on paper, mounted to cardboard, with sewn edges. 8⅝ x 5⅞ x 2¾ in. (Courtesy, Winterthur Museum.)

6. See, for example, the U.S. Census of 1850, Bedminster Township, Bucks County, Pa., 253; and the U.S. Census of 1870, Bedminster Township, 7.

7. 1830 Tax List, Bedminster Township, Bucks County, SL/BCHS.

8. "Deed of Sale from Isaac Gross to David Hill," May 18, 1830 (recorded June 16, 1830), Deed Book 54, 699–700, SL/BCHS. 1832–1839 Tax Lists, Bedminster Township, Bucks County record Gross as a "non-resident" land owner.

9. "Deed of Sale from Jonas Fretz to Isaac Gross," April 5, 1844 (recorded May 12, 1845), Deed Book 72, 156–158.

10. Hedwig H. Voltz, trans., *German Language Newspapers, Death and Obituary Notices, 1878–1886*, 3 vols. (Doylestown, Pa.: Bucks County Historical Society, 1997), 3:213.

11. Gross' obituary appears in *The Bucks County Intelligencer* (Doylestown, Pa.) December 21, 1893, 2.

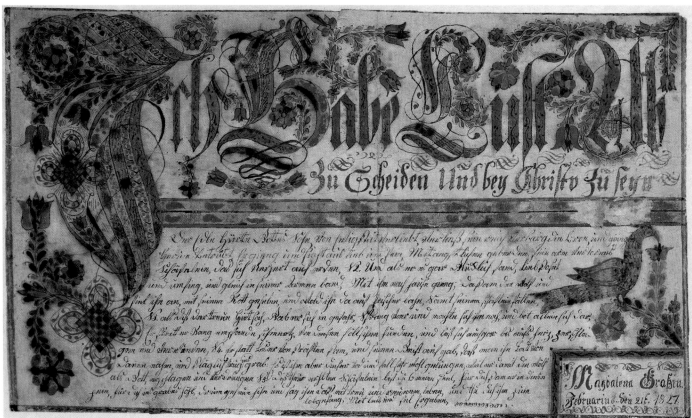

Fig. 264. **Penmanship Model for Magdalena Gross**. Decoration attributed to Isaac Gross, Bedminster Township, Bucks County, 1827. Hand-drawn, lettered and colored on wove paper. 7⅝ x 12⅞ in. (Rare Book Department, The Free Library of Philadelphia, FLP 335.)

<div style="background:gray">

George H. Gerhart

</div>

(1791–1846)

Rockhill and Milford Townships

George Gerhart, the third son of a Montgomery County farmer, was baptized September 11, 1791, at the Indian Creek Reformed Church in Franconia Township.[1] By 1815, he was teaching school just across the county line in Rockhill Township, Bucks County.[2] There, three years later, he prepared a penmanship model for an unnamed student, which he signed and dated. Earnestly concluding the text of this *Vorschrift*, Gerhart urged his pupil to "Heed this writing, for it has been made with great trouble" (Fig. 266).

Spurning the bachelor life of some schoolmasters, Gerhart married Susanna Stover Fried about 1811, with whom he had a family of ten children. All were baptized at the Indian Creek, Tohickon, and Great Swamp Reformed churches. In fact, the locations of the baptisms exactly parallel Gerhart's movements from Montgomery County, to Rockhill, and up-county to Great Swamp, northwest of Quakertown.[3]

By 1820, Gerhart had moved with his family to Upper Milford Township, Lehigh County.[4] During the next two decades he taught at schools near the

Fig. 266. **Penmanship Model**. George H. Gerhart, Rockhill Township, Bucks County, 1818. Hand-drawn, lettered and colored on wove paper. 7³/₄ x 12¹/₂ in. (Rare Book Department, The Free Library of Philadelphia, FLP 1224.)

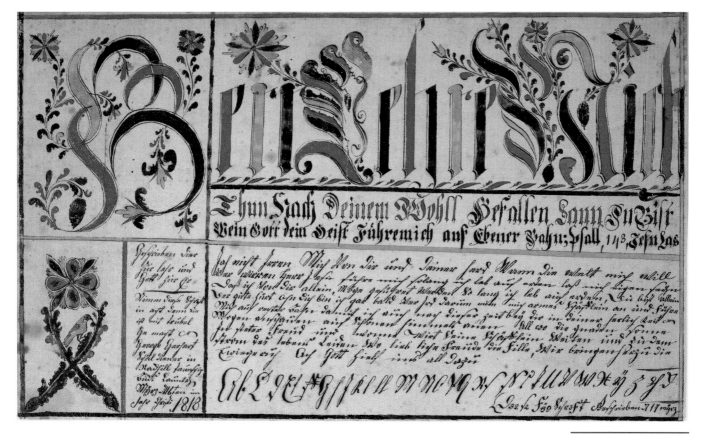

Fig. 267. **School Bill**. George H. Gerhart,
Upper Milford Township, Lehigh County,
1825. (Collections of the Lehigh County
Historical Society.)

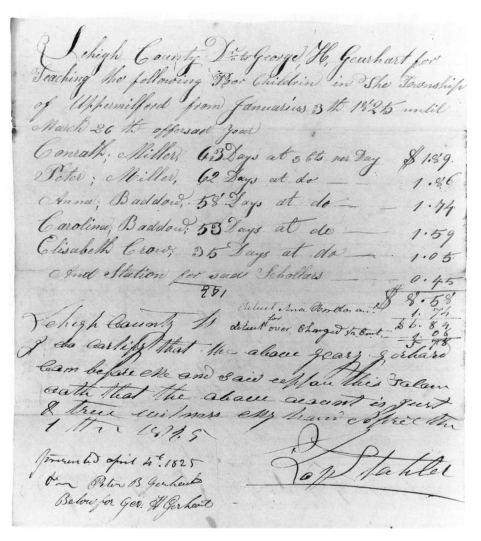

Bucks-Lehigh border, one or more of which were closely affiliated with the separated Lutheran and Reformed congregations in the Great Swamp region west and north of Spinnerstown (Fig. 267).[5] One of Gerhart's invoices for teaching poor children from this period specifically mentions the "Schoolhouse by the Swamp Church" in Upper Milford.[6] Returning to Montgomery County about 1838, Gerhart either purchased or inherited a farm of 133 acres in Upper Salford Township.[7] He likely retired from teaching at this time since no fraktur appears by his hand after 1837. He died in 1846 in Upper Salford and was buried at the Indian Creek graveyard. His death notice in *Der Bauern Freund*, a Montgomery County German newspaper, called Gerhart a "former teacher" and noted his age at death as fifty-five.[8] Unfortunately, nothing in his estate, except perhaps a "Lot of Boocks" valued at $5.00, remained to note his role as a teacher and one-time fraktur artist.[9]

Gerhart may have produced a great number of fraktur, or a lesser body of work. His decorative style, incorporating daisylike or pinwheel flowers, scalloped leaves and expressive birds with yellow, red, and black feathers, appears on numerous examples from Bucks and Lehigh Counties (Figs. 268–272). However, the penmanship on many of these extant pieces displays significant variation. It is likely that his students, as well as other teachers and artists, picked up Gerhart's decorative vocabulary and used it to produce their own bookplates, rewards and religious texts.[10] In any event, the places of origin of practically all of these manuscripts and drawings coincide closely with Gerhart's teaching positions in Bucks and Lehigh County schools. This coincidence suggests that if indeed he was not the maker of all of these works, his influence was very strongly felt.

Notes

1. Mildred C. Williams, "Gerhardt-Gerhart Family Notes," Genealogy File, Spruance Library, Bucks County Historical Society, 21; Charles H. Price, Jr., trans., "Parochial Register of the Indian Creek Reformed Church, 1753–1851," *Four Pennsylvania German Studies* (Breinigsville, Pa.: Pennsylvania German Society, 1970): 138.

2. George Gerhart, "Bill for Schooling John Leister's Children, November 27, 1815 through March 15, 1816, Rockhill Township," March 30, 1816, B.C. School Bills.

3. Williams, "Family Notes," 21.

4. U.S. Census of 1820, Upper Milford Township, Lehigh County, Pa., 182.

5. One of Gerhart's school bills from Lower Milford Township, Bucks County, bears the signatures of trustees Philip Mumbauer and David Schitz. See George H. Gerhart, "Bill for Schooling Reuben Reichenbach, et al, March 3, 1823 through May 8, 1823, Lower Milford Township," May 12, 1823, B.C. School Bills. Mumbauer was associated with the Reformed church just over the line in Lehigh County, above Spinnerstown, while the Schitz family was connected with the Lutheran church in Spinnerstown. This Philip Mumbauer, trustee, is very likely related to the Philip Mumbauer who was a schoolmaster and fraktur artist in Upper Milford (see Mumbauer entry in this volume). For evidence of Gerhart teaching Lehigh County pupils, see George H. Gerhart, "Bill for Schooling Conrath Miller, et al, January 3, 1825 through March 26, 1825, Upper Milford Township," April 4, 1825, Lehigh County School Bills, Lehigh County Historical Society, Allentown, Pa.

6. George H. Gerhart, "Bill for Schooling Elisabeth Miller, November 17, 1823 through March 27, 1824, Upper Milford Township," 7 May 1824, Lehigh County School Bills.

7. See 1838–1846 Tax Lists, Upper Salford Township, Montgomery County Archives, Norristown, Pa.; U.S. Census of 1840, Upper Salford Township, Montgomery County, Pa., 134.

8. *Der Bauern Freund* (Montgomery County, Pa.), April 8, 1846.

9. Estate of George Gerhart, File No. 10962, Montgomery County Archives, Norristown, Pa.

10. There were several men named Gerhart teaching school in Upper Milford and Upper Saucon Township along the Bucks-Lehigh County line during the 1820s. Among them were a Peter, Isaac and John Gerhart. Perhaps one or more of these schoolmasters was a relative of George Gerhart. See John Gerhart, "Bill for Schooling George Engel, et al, December 28, 1828 through April 3, 1829, Upper Milford Township," May 4, 1829; Peter B. Gerhart, "Bill for Schooling George Engel, et al, November 26, 1827 through February 28, 1828, Upper Milford Township," 1828; Isaac Gerhart, "Bill for Schooling Jacob and Maria Hoffman, and Joseph Diehl, May 2, 1827 through June 11, 1828, Upper Saucon Township," July 8, 1828, Lehigh County School Bills.

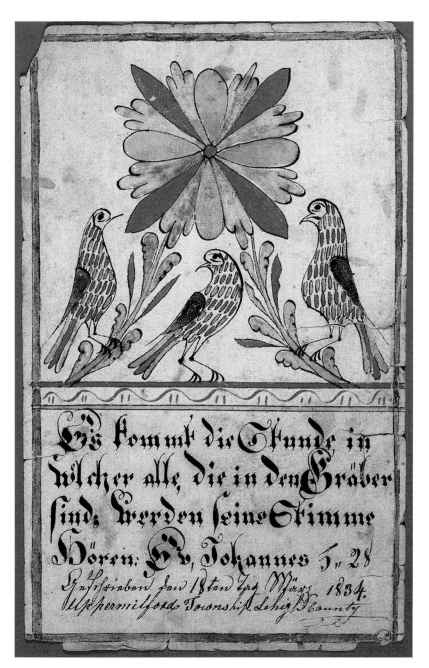

Fig. 268. **Religious Text**. Probably George H. Gerhart, Upper Milford Township, Lehigh County, 1834. Hand-drawn, lettered and colored on wove paper. 6¹/₂ x 4⁷/₈ in. (Private collection.)

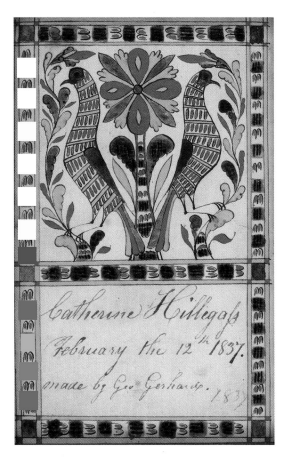

Fig. 269. **Drawing for Catherine Hillegass**. George H. Gerhart, probably Upper Milford Township, Lehigh County, 1837. Hand-drawn, lettered and colored on wove paper. 6½ x 4 in. (Private collection.)

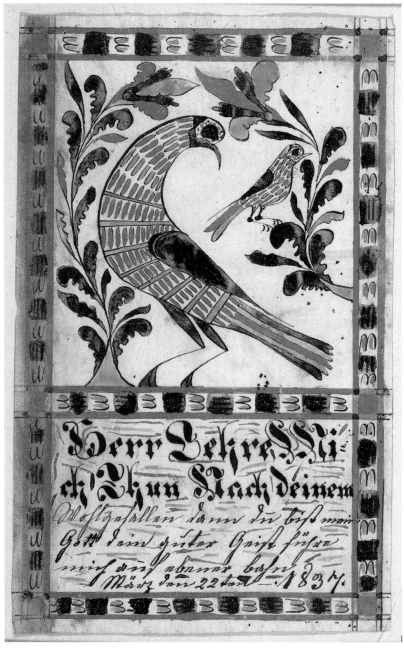

Fig. 270. **Religious Text**. Probably George H. Gerhart, Upper Milford Township, Lehigh County, 1837. Hand-drawn, lettered and colored on wove paper. 6⅝ x 4 in. (Private collection.)

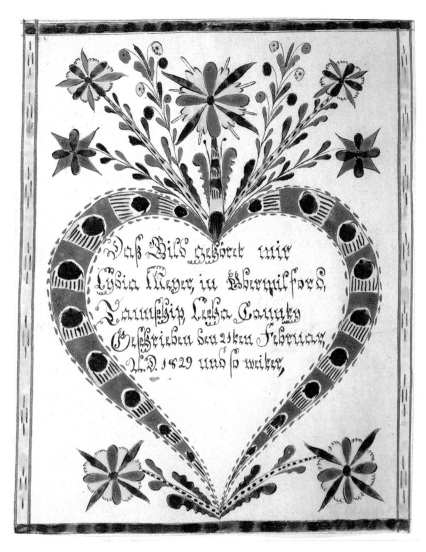

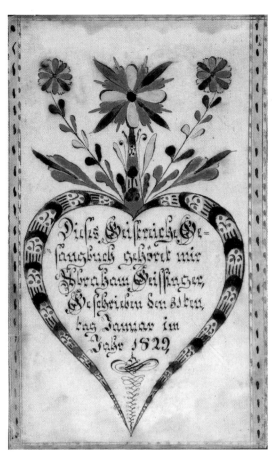

Fig. 271. **Drawing for Lydia Meyer**. School of George H. Gerhart, Upper Milford Township, Lehigh County, 1829. Hand-drawn, lettered and colored on wove paper. 7³/₄ x 6 in. (Mennonite Heritage Center, Harleysville Pa., 87.42.1.)

Fig. 272. **Hymnal Bookplate for Abraham Geissinger**. School of George H. Gerhart, Upper Milford Township, Lehigh County, 1829. Hand-drawn, lettered and colored on wove paper. Dimensions not available. The boy and girl for whom this picture and bookplate were made (Figs. 271, 272) later became husband and wife. Both were members of the Mennonite congregation in Upper Milford, Lehigh County. The two fraktur were probably produced by a student or imitator of George Gerhart. (Private collection.)

Enos Godshalk

(1801–1829, active c. 1820)

New Britain and Plumstead Townships

In the library of the Bucks County Historical Society is the neatly kept school record book of Enos Godshalk, a young teacher in New Britain's Union School.[1] The book, covering the years 1820 to 1824, details the names of students enrolled in his school, the number of days they attended classes, and the names of their parents (who paid Godshalk's daily tuition) (Fig. 273). Tucked inside this slim volume was an unfinished and uncolored *Vorschrift*, dated 1820, which begins "Rejoice thou Children's Order, Christ has become a

little child..." (Fig. 274). It seems probable that it is the work of the nineteen-year-old schoolmaster to whom the record book belonged.

Godshalk was born November 30, 1801, the son of John and Barbara (Kratz) Godshalk of New Britain Township.[2] Enos's father operated a sawmill in New Britain, and his family were members of the local Mennonite community. Enos, the oldest of the Godshalk children, began his teaching career about 1820, though it is unclear whether in a predominantly German- or English-language classroom. The

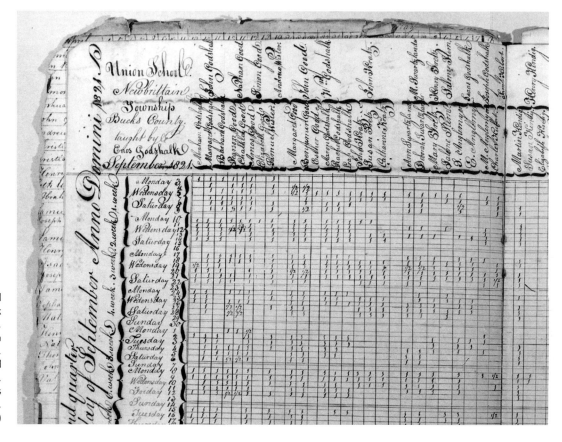

Fig. 273. **School Record Book of Enos Godshalk (detail)**. Enos Godshalk, Union School, New Britain Township, Bucks County, 1821. Hand-lettered and colored on wove paper. (Spruance Library/Bucks County Historical Society, MSC 185, Fol. 158.)

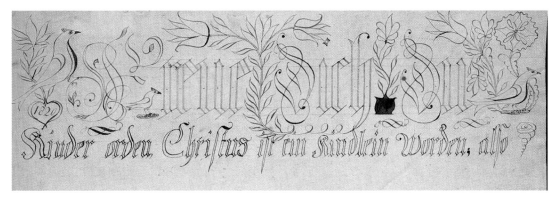

Fig. 274. **Penmanship Model (unfinished)**. Attributed to Enos Godshalk, New Britain Township, Bucks County, 1820. Hand-drawn and lettered on wove paper. 5³/₈ x 12¹/₂ in. (Spruance Library/Bucks County Historical Society, SC-58. No. A-22.)

majority of names in his roll book, however, are those of New Britain's Pennsylvania-German, and especially Mennonite, families.

Godshalk's record book reveals that he taught in the so-called quarter system, with the first quarter beginning in April and closing in early July, the second quarter running from September to December, and the third quarter from December to March. Each quarter actually lasted for about fourteen weeks. In addition to his students' names and those of their parents, Godshalk also recorded in his book the costs of school supplies for poor children who attended his school (expenses for which he would later bill the county, see Fig. 275), and numerous purchases of wood for the heating stove.

In 1824 and 1825, Godshalk taught at the Union School in Plumstead Township, though he continued to reside in New Britain. In the township tax rolls for those years, his occupation was valued at $100, and he paid $0.22 in annual taxes.[3] He was probably teaching in an English school in Plumstead, since he billed the county for "an English reader" for one of the poor children under his tutelage.[4] By 1827, he had returned to New Britain, where he presided over classes at the English-language Snodgrass School.[5] Just two years later, Godshalk died suddenly at the age of twenty-eight and was buried at the Doylestown Mennonite graveyard.

Apart from the single *Vorschrift* found in his rollbook, there is no evidence that Enos Godshalk made fraktur. Still, the fluidly drawn birds and flowers on that unfinished piece show that their maker possessed some talent. If indeed they are Godshalk's work, it is doubtful that he gave up the art form after one incomplete attempt.

Notes

1. "School Record Book of Enos Godshalk," MSC 185, Fol. 158, SL/BCHS.

2. Godshalk's date of birth is calculated from the inscription on his tombstone in the Doylestown Mennonite Meetinghouse graveyard. For his parentage, see A. J. Fretz, *A Brief History of John Valentine Kratz, and a Complete Genealogical Family Register*, (Elkhart, Ind.: Mennonite Publishing Company, 1892), 161.

3. 1824–1825 Tax Lists, New Britain Township, Bucks County, SL/BCHS.

4. Enos Godshalk, "Bill for Schooling Mary Ann Mackey, Charles Rowney and Benjamin Rowney, February 17, 1825 through March 24, 1825, Plumstead Township," May 5, 1825, B.C. School Bills.

5. Enos Godshalk, "Bill for Schooling Samuel Myers, et al, April 1, 1827 through October 1, 1827, New Britain Township," October 1, 1827, B.C. School Bills. For documentation on the Snodgrass School, see a copy of a deed from "James Snodgrass and wife Ann to John Todd, William Hynes and Philip Miller, Trustees of an English School to be known and distinguished by the name Snodgrass School," November 22, 1806, MSC 163, Fol. 1, SL/BCHS.

Fig. 275. **School Bill**. Enos Godshalk, Union School, New Britain Township, Bucks County, 1822. As this bill attests, Godshalk possessed beautiful English penmanship. (Spruance Library/Bucks County Historical Society.)

William Chamberlain

(b. c. 1771, active c. 1828–1832)

Doylestown and New Britain Townships

Bucks County's northern townships were a meeting ground for immigrants of different religious faiths and ethnicities. German Mennonites, for example, might settle near Scots-Irish Presbyterians, English Quakers, or Welsh Baptists. In this ethnic mixing bowl, a schoolmaster of English ancestry could easily find himself teaching the children of German parents, and vice versa.

William Chamberlain found himself in precisely this situation. Though a native Englishman, he accepted a position teaching the children of German Mennonite parents in New Britain and Doylestown Townships. Perhaps to meet the expectations of those parents, he made rewards and birth certificates for his pupils, mimicking his colleagues in German classrooms.

Born in the parish of Holbach, Lincolnshire, England, Chamberlain emigrated to America in 1817.[1] At the age of forty-six, "or thereabouts," he embarked from the port of Liverpool aboard the ship *Thomas*, arriving in Philadelphia on July 19. Shortly after his arrival he accepted a teaching position in Montgomery Square, and later one in Gwynedd, in Montgomery County. Staying only a few months in those communities, he next found work in classrooms in New Britain and Warwick Townships, Bucks County. He was residing in the latter community when he decided to apply for citizenship in 1823.[2]

Apart from these facts and his few extant drawings, little else remains to document Chamberlain's years in the classroom. A single school bill, dated December 5, 1828, confirms that

he returned to teach in New Britain following his naturalization.[3] At the Iron Hill School, just north of the Doylestown Township line, he instructed young Aaron and Elizabeth Bartles over a six-month period at a tuition of 2 cents a day. As is evident from his decorated rewards, he also taught at the Red Schoolhouse in Doylestown Township, on the Bristol Road. One of the students who attended this school, Oliver Shutt, remembered Chamberlain even in old age and preserved three rewards given to him by the schoolmaster between 1829 and 1830 (Figs. 276–278).[4]

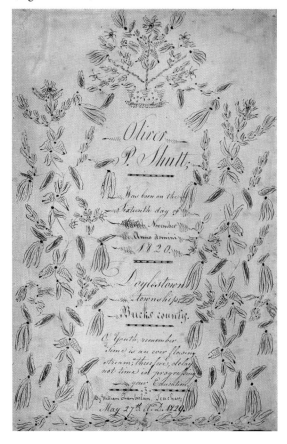

Fig. 276. **Birth Certificate and Reward of Merit for Oliver P. Shutt (b. 1820)**. William Chamberlain, Doylestown Township, Bucks County, 1829. Hand-drawn and lettered on wove paper. 13 x 8⅛ in. (Spruance Library/Bucks County Historical Society, SC-58. No. A-47.)

Chamberlain's fraktur, if it may be called that, is very different from that normally associated with the German schools. His colors are muted, and his designs more reminiscent of embroidery than of paint-decorated manuscripts (Fig. 279). But his decision to offer such pieces at all suggests the power of the fraktur tradition among Bucks County's German communities.

Notes

1. Chamberlain's petition for naturalization contains a very complete synopsis of his origins and teaching activities up to 1823. See "Declaration of Intention to become a Citizen by Wm. Chamberlain residing in Warwick," Bucks County Naturalization Records, Court of Common Pleas, File #00098, September 8, 1823, microfilm #1-G, SL/BCHS.

2. Ibid.

3. William Chamberlain, "Bill for Schooling Aaron and Elizabeth Bartles, April 14, 1828 to December, 1828, New Britain Township," December 5, 1828, B.C. School Bills.

4. "Historic Building 'Old Red School House' in Doylestown Township," MSC 26, Fol. 5, SL/BCHS. This printed reminiscence accompanied Oliver Shutt's gift of a drawing of the schoolhouse to the Bucks County Historical Society in 1901.

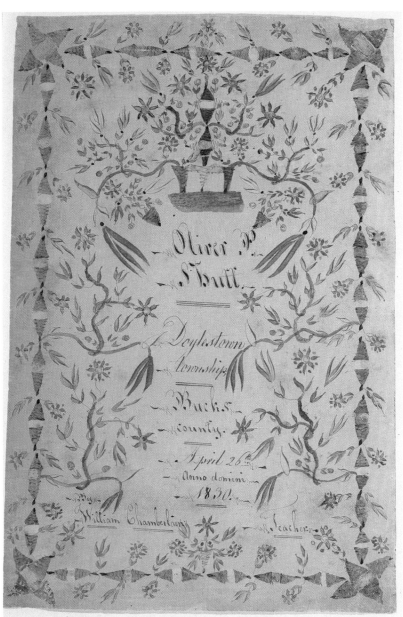

Fig. 277. **Reward of Merit for Oliver P. Shutt (b. 1820)**. William Chamberlain, Doylestown Township, Bucks County, 1830. Hand-drawn, lettered and colored on wove paper. 11½ x 7½ in. (Spruance Library/Bucks County Historical Society, SC-58. No. A-49.)

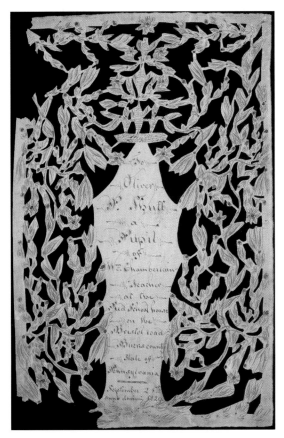

Fig. 278. **Reward of Merit for Oliver P. Shutt (b. 1820)**. William Chamberlain, Doylestown Township, Bucks County, 1829. Hand-drawn and lettered on wove and cut paper. 13 x 8⅛ in. (Spruance Library/Bucks County Historical Society, SC-58. No. A-48.)

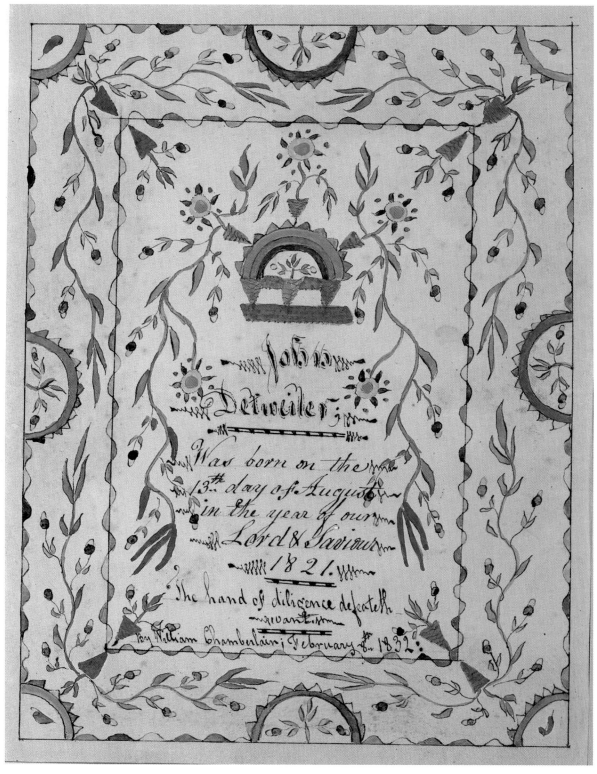

Fig. 279. Birth Certificate and Reward of Merit for John Detweiler (b. 1821). William Chamberlain, Bucks County, 1832. Hand-drawn, lettered and colored on wove paper. 10½ x 8⅜ in. (Spruance Library/Bucks County Historical Society, SC-58. No. A-46.)

Levi O. Kulp

(1813–1854, active c. 1835–1840)

Springfield Township

On the basis of his surname, one would expect Levi O. Kulp to be yet another Mennonite fraktur artist, perhaps even kin to Brown Leaf Artist David Kulp, or Isaac L. Kulp. But Levi Kulp was born and baptized into a German Reformed family, the son of Moses and Catherine Ott Kulp of Bedminster Township.[1] As an adult, he joined the congregation of the Trinity Reformed Church in Springfield Township where he was a frequent communicant between 1844 and 1853.[2]

At the time of his death in 1854, Kulp was serving as Bucks County prothonotary.[3] However, in earlier life, he taught school in Bucks and Northampton counties where he produced rewards of merit, and at least one manuscript tunebook, for his students.[4] On these he wrote in both German and English.

Kulp first appears on the tax lists of Springfield Township in 1838, assessed only for an unidentified occupation but owning no land.[5] The following year he purchased from Samuel Ruth, a Springfield carpenter, two small tracts of land amounting to twenty acres. In the deed, Kulp is identified as a

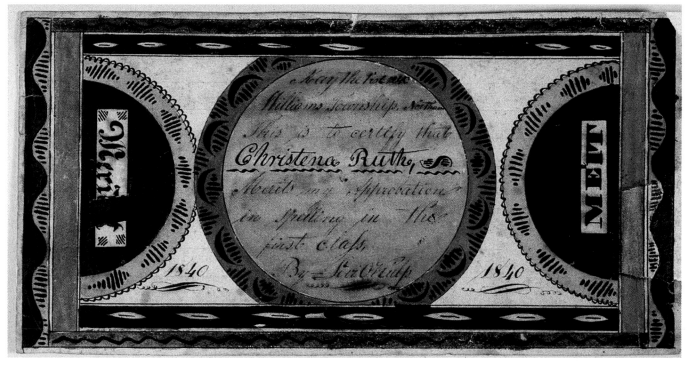

Fig. 280. **Reward of Merit for Christena Ruth**. Levi O. Kulp, Williams Township, Northampton County, 1840. Hand-drawn, lettered and colored on wove paper. 4⅛ x 7⅞ in. Although executed in English, this reward demonstrates that Kulp was equally proficient in both German and English lettering styles, as evidenced by his two different treatments of the word *Merit*. (Mennonite Heritage Center, Harleysville, Pa., gift of Hiram and Mary Jane Hershey, 99.10.11.)

"School Teacher."[6] Perhaps Samuel and his wife Christina were related to the "Christena Ruth" for whom Kulp drew a reward of merit in Northampton County in 1840 (Fig. 280).

Though owning little acreage, Kulp seems to have attained some degree of professional success and social status. By 1842, he had purchased a carriage and by tax time the following year had acquired the title of "Esquire."[7] Apparently in that year he began serving as a justice of the peace, an occupation later noted by the census taker in 1850.[8] A friend of education even after he left the class-room, in 1851 Kulp provided a lot for the Amity School in Springfield Township out of his holdings. In this school the first teacher, B. F. Apple, once had to flog his young charges for turning his top hat into a spittoon.[9] One wonders whether Kulp might have had to take similar disciplinary action in his classroom a decade earlier.

Levi Kulp served as prothonotary from 1851 until his death in 1854. By this time, he may have moved permanently or temporarily to Doylestown. His obituary noted that the disease from which he died was "of a very protracted nature," and that he left behind a wife and several children.[10]

Notes

1. William J. Hinke, trans./comp., *A History of the Tohickon Union Church, Bedminster Township, Bucks County, Pennsylvania* (Meadville, Pa.: Pennsylvania German Society, 1925), 190, 228.

2. Thomas G. Myers, comp., *Church Records of Trinity Reformed (UCC) Church, Springfield Twp., 1829–1957* (Doylestown, Pa.: Bucks County Historical Society, 1997), 52–70.

3. For Kulp's obituary, see *Der Bauern Freund* (Sumneytown, Pa.), January 25, 1854; also *The Doylestown Democrat* (Doylestown, Pa.), January 17, 1854, 3. Both newspapers record the place of his burial as the "Springfield Church," however his grave is actually at the Doylestown Cemetery (section E, row 1) according to Bucks County Tombstone Inscription Files, SL/BCHS. Kulp's parents Moses (1788–1880) and Catherine O. (1789–1876) are also buried at Doylestown.

4. In addition to the reward of merit illustrated here, a bookplate by Kulp from Springfield Township is illustrated in Frederick S. Weiser and Howell J. Heaney, *The Pennsylvania German Fraktur of the Free Library of Philadelphia: An Illustrated Catalogue*, 2 vols. (Breinigsville, Pa.: Pennsylvania German Society, 1976), 2:fig. 746.

5. 1838 Tax List, Springfield Township, Bucks County, SL/BCHS.

6. "Deed of Sale from Samuel and Christina Ruth to Levi O. Kulp," 30 March 1839 (recorded 26 April 1847), Deed Book 75, 139–140, SL/BCHS.

7. 1842–43 Tax Lists, Springfield Township.

8. U.S. Census of 1850, Springfield Township, Bucks County, 233.

9. William W.H. Davis, *History of Bucks County, Pennsylvania*, 2nd ed., 3 vols. (Pipersville, Pa.: A.E. Lear, Inc., 1975), 2:74–5.

10. *Doylestown Democrat*, January 17, 1854. Some additional information on Kulp and his wife Hannah Hess Huber may be found in Asher L. Hess, *Genealogical Record of the Descendants of Nicholas Hess, Pioneer Immigrant, Together with Historical and Biographical Sketches* (Philadelphia: by the author, 1912), 78.

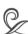

<div style="text-align: right; background: gray;">

The Rockhill Artist

</div>

(active c. 1830–1848)

Rockhill, Springfield, Hilltown, and Bedminster Townships

Probably a schoolmaster, this anonymous artist produced numerous bookplates and small pictures which were likely intended as gifts or rewards of merit.[1] He (or she) favored colorful bird-on-branch designs, often surrounding them with pinwheel or fan-shaped flowers (Figs. 281–285). Although labeled the "Rockhill Artist" by collectors, this watercolorist worked in several townships in north-central Bucks County, including Hilltown and Bedminster as well as Rockhill. Given the preponderance of Mennonite names that appear on his fraktur (Meyer, Kratz, Landes, and Rosenberger, for example), it is likely that he, too, belonged to a Mennonite congregation.

With his relatively large body of surviving work, the Rockhill Artist is one of the most important of Bucks County's frakturers still remaining to be identified. Efforts to attribute his hand to a specific teacher or scrivener, however, are frustrated by a lack of sources. No school bills survive after about 1829–1830 when works by this artist first begin to appear. Based solely on his fraktur, it appears that he worked in Rockhill about 1830, Springfield in 1832, Hilltown and/or Bedminster in the mid-late 1830s, and Rockhill again in 1839–1840. Thus, in attempting to identify the person behind the pen, we are probably looking for a teacher who moved between school appointments in a similar fashion.

The Rockhill Artist's work represents a conservative continuation of the art form at a relatively late date. By the 1830s, with a few significant excep-

tions, the finest watercolor work and traditional penmanship lay in the past. But despite the anachronistic character of his work, he found many customers among Bucks County's German, and especially Mennonite, inhabitants.

Fig. 281. **Drawing**. Attributed to the Rockhill Artist, Bucks County, c. 1835. Hand-drawn and colored on wove paper. 4⁵/₈ x 6¹/₄ in. (Private collection.)

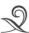

Notes

1. Of the extant bookplates, most are for New Testaments or Psalmbooks. Only one is for a manuscript tune book, a *Notenbüchlein* for Abraham Meyer, dated 1835. The absence of a school name on this bookplate or any reference to its owner as a "singing student" leads to speculation about the book's original intent. Could this fraktur have been executed by and for the artist himself, or for a family member, outside of a particular educational context? Perhaps it is only a coincidence, but an Abraham Meyer (1794–1877) did teach school in Bucks County in the early 19th century, and later resided in the Deep Run area. This same individual, rather late in life, composed a book of hymns that was published by John G. Stauffer of Milford Square, Bucks County in 1877. See Rev. A. J. Fretz, *A Genealogical Record of the Descendants of Christian and Hans Meyer* (Harleysville, Pa.: News Printing House, 1896), 593–4. Also Eleanor G. Raske, "German Mennonite Publications in Milford Township, Bucks County, Pennsylvania Between 1852 and 1881" (M.A. Thesis, Temple University, 1992), 193–194.

Fig. 282. **Bible Bookplate for Elisabeth Schneider**. Attributed to the Rockhill Artist, Hilltown Township, 1833. Hand-drawn, lettered and colored on wove paper. 6¹/₂ x 4 in. (Private collection.)

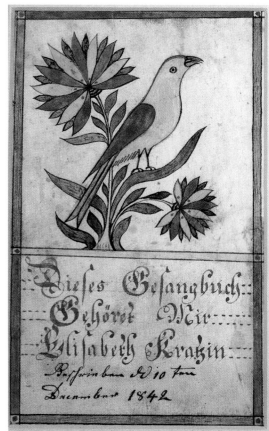

Fig. 283. **Hymnal Bookplate for Elisabeth Kratz.**
Attributed to the Rockhill Artist, Bucks County, 1842.
Hand-drawn, lettered and colored on wove paper.
6¹/₂ x 4 in. (Private collection.)

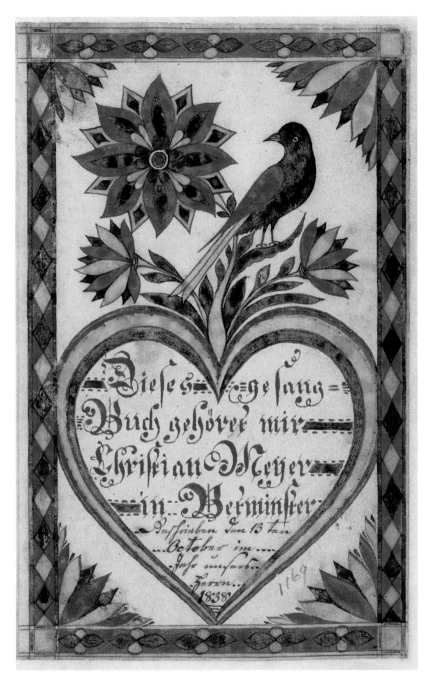

Fig. 284. **Hymnal Bookplate for Christian Meyer**. Attributed to the Rockhill Artist, Bedminster Township, 1838. Hand-drawn, lettered and colored on wove paper. 6¹⁄₂ x 4 in. (Schwenkfelder Library and Heritage Center.)

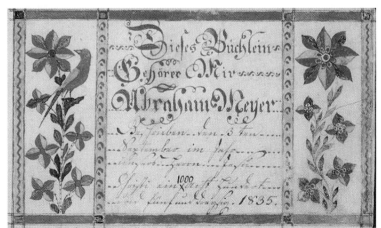

Fig. 285. **Manuscript Tune Book and Bookplate for Abraham Meyer**. Attributed to the Rockhill Artist, probably Hilltown or Bedminster Townships, 1835. 3⁵⁄₈ x 6 in. (Courtesy, Christie's Images.)

The Swirl Artist School

(active c. 1829–1871)

New Britain, Hilltown, and Bedminster Townships

Several Bucks County artists incorporated a distinctive spiral or swirl motif into their fraktur.[1] These same penmen also sometimes terminated the tops of their letters in a series of curls or flourishes running parallel to the lines of text (Figs. 286–292). The precise relationship of these various artists is still unclear—it is even possible that all extant examples were composed by the same hand—but judging from the diverse penmanship as many as six or seven separate individuals may have been at work over a very long time span.

The earliest known fraktur displaying the swirl design, a bookplate prepared for Henrich Letherman of the Deep Run School, is dated June 20, 1829 (see Fig. 93, p. 126). At the other end of the chronology, three pieces, all incorporating the same decorative feature, were drawn in 1871 (Figs. 293, 294).[2] Even as late as 1893, the spiral design appeared in a hymn text written out by Jacob Gross of New Britain Township (see the following entry). All of these pieces also display very similar fancy penmanship.

Given the number of Mennonite names that appear on this group of fraktur—Bishop, Gross, Gottschall, Rickert, Nesch, and Letherman to name a few—it seems certain that the artist or artists who produced them also belonged to a Mennonite congregation. Further, the schools named on the fraktur—Deep Run, Hilltown, and New Britain—all were centered in Mennonite communities.

All of the documented examples by these artists are bookplates, chiefly for hymnals and manuscript tune books, further suggesting a Mennonite

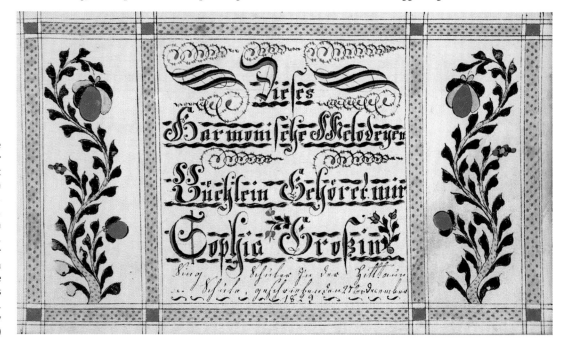

Fig. 286. **Manuscript Tune Book and Bookplate for Sophia Gross**. Swirl Artist School, Hilltown Township, Bucks County, 1829. Hand-drawn, lettered and colored on wove paper. 3⁷/₈ x 6³/₈ in. As suggested by a Wismer family history, this Sophia Gross was very likely the sister of the Joseph Gross mentioned in the text. (Schwenkfelder Library and Heritage Center.)

connection. The dominance of the rather similar calligraphic lettering on most of these works and the limited use of script makes even more challenging the task of distinguishing between different, but related, artists. In addition, school bills for these years, which might otherwise help to place certain schoolmaster-artists at the schools named on the fraktur, unfortunately do not exist.

Intriguingly, inside one of Henry Mercer's research notebooks can be found several small photographs, probably taken by Mercer or an associate, picturing various items of fraktur.[3] Among them is an image of a manuscript tune book bearing the swirl motif, now apparently lost to time, from the Hilltown School. The bookplate bears the name of Joseph Gross and the date April 20, 1830. This is undoubtedly the same tune book exhibited at a 1914 meeting of the Bucks County Historical Society held at the Deep Run Mennonite Meetinghouse in Bedminster Township. According to the meeting record, several tune books were displayed that were "made and owned by Joseph M. Gross in 1830."[4] While it is almost certain that the correspondent was in error in attributing the booklets to the hand of this Joseph Gross (he would have been only 14 and probably a student at the time[5]), the reference might yet provide a clue in eventually solving the puzzle of who produced some of these fraktur bookplates. Perhaps another member of the Gross family, several of whom are known to have been teachers, was at work on these pieces.

Notes

1. Not all of the works attributable to one of these hands display the spiral or swirl design. However, the motif appears frequently enough on fraktur from disparate locales to help unify the body of work. It should be noted, however, that other authorities have used different terms to group these fraktur. See, for example, Russell D. Earnest and Corinne P. Earnest, *Papers for Birth Dayes: Guide to the Fraktur Artists and Scriveners*, 2nd ed., 2 vols. (East Berlin, Pa.: Russell D. Earnest Associates, 1997), 1:394. The Earnests have clustered some of these fraktur under the heading of the *Hilltown Artist*. Since Mary Jane Hershey has used the nickname *Swirl Artist* in her essay on *Notenbüchlein*, I have chosen to employ that term here.

2. In addition to the two illustrated here, the third example, a hymnal bookplate for Elisabeth Rickert, is in a private Bucks County collection. Its text is identical to the bookplate for Isaiah Rickert, though instead of a sun motif it displays a winged angel in the astragal arch.

3. Henry Mercer Papers, MSC 291, series 16, fol. 8., SL/BCHS.

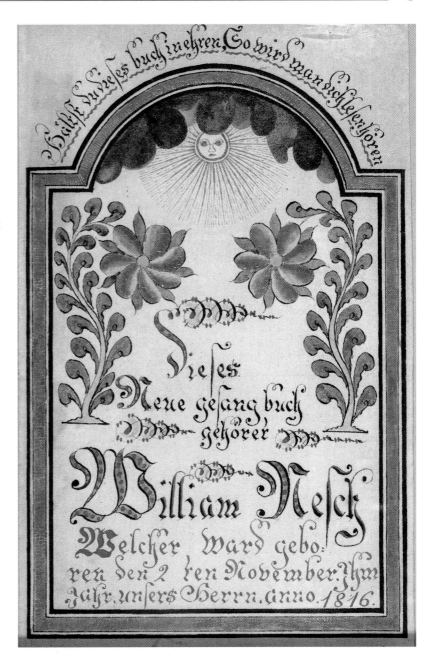

Fig. 287. **Bookplate and Birth Record for William Nesch [Nash] (1816–1851)**. Swirl Artist School, probably Bedminster Township, Bucks County, c. 1830. Hand-drawn, lettered and colored on wove paper. 6½ x 4 in. (Private collection.)

4. "Bedminster Township Meeting," in *A Collection of Papers Read Before the Bucks County Historical Society* 4 (Doylestown, Pa.: 1917): 535. This Joseph Gross's middle initial is clearly in error, however. He was Joseph *N.*, not Joseph *M.* Gross, the *N* probably standing for *Nash* (or *Nesch*), his mother's maiden name. See Rev. A. J. Fretz, *A Brief History of Jacob Wismer and a Complete Genealogical Family Register* (Elkhart, Ind.: Mennonite Publishing Company, 1893), 51.

5. Fretz, *A Brief History of Jacob Wismer*, 51.

Fig. 288. **Bookplate and Birth Record for Joseph Nesch [Nash] (1814–1851)**. Swirl Artist School, probably Bedminster Township, Bucks County, c. 1830. Hand-drawn, lettered and colored on wove paper. 6¹/₂ x 4 in. Both William and Joseph (Figs. 287, 288) were sons of Jacob and Elisabeth Nash of Tinicum Township. All four died in 1851 and were buried at the Deep Run Mennonite Cemetery. It is likely that the children attended the Deep Run school. Incidently, one of the brothers of Joseph and William, Tobias Nash of Wormansville, Bucks County, was an important early contributor to Henry Mercer's *Tools of the Nation Maker* collection, housed today in the Mercer Museum. (The Library Company of Philadelphia.)

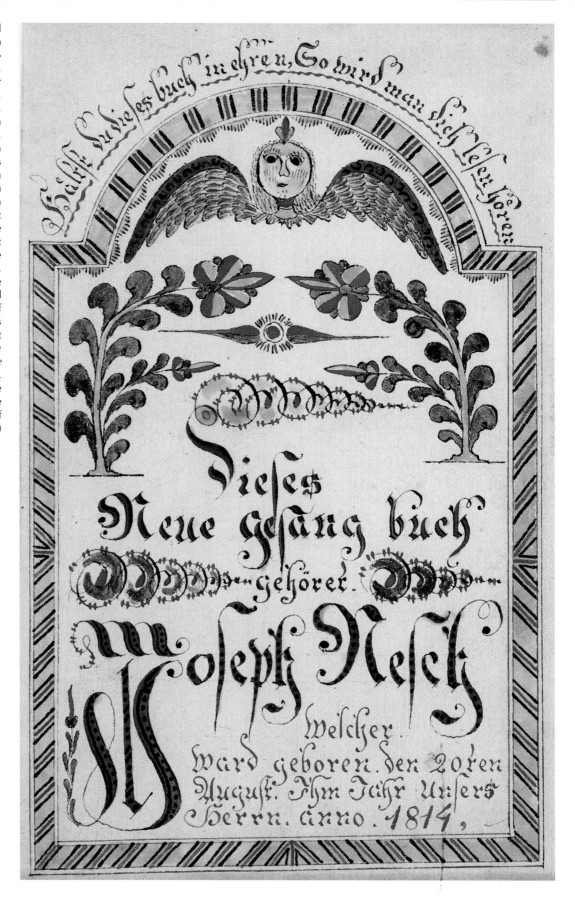

Fig. 289. **Manuscript Tune Book and Bookplate for Catharina Folmer**. Swirl Artist School, New Britain School, New Britain Township, Bucks County, 1833. Hand-drawn, lettered and colored on wove paper. 4 x 7 in. (Spruance Library/Bucks County Historical Society, SC-58. No. C-17.)

Fig. 290. **Manuscript Tune Bookplate for Rahel [Rachel] Bishop (b. 1822)**. Swirl Artist School, New Britain School, New Britain Township, Bucks County, 1835. Hand-drawn, lettered and colored on wove paper. 3⁷/₈ x 7 in. A Mennonite, Rachel was the daughter of Jacob Bishop (1787–1832) and Anna Fretz Bishop (1788–1865). After moving from Bedminster, her family settled on the Stewart Farm in southeastern New Britain Township. This was also the location of Stewart's School, an eight-square neighborhood schoolhouse on the north side of Ferry Road. It seems probable, then, that the New Britain School recorded on the bookplate was actually Stewart's Octagon School. (Private collection.)

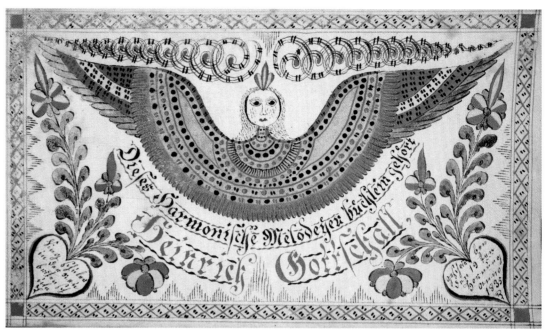

Fig. 291. **Manuscript Tune Book and Bookplate for Heinrich Gottschall**. Swirl Artist School, New Britain School, New Britain Township, Bucks County, 1835. Hand-drawn, lettered and colored on wove paper. 3⁷/₈ x 6¹/₄ in. (Dr. Donald A. Shelley Collection.)

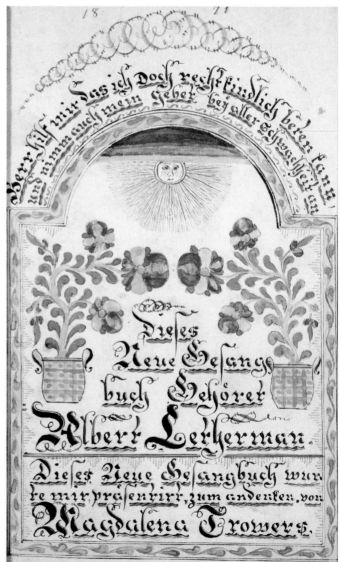

Fig. 293. **Hymnal Bookplate for Albert Letherman**. Swirl Artist School, probably Bedminster or Hilltown Townships, Bucks County, 1871. Hand-drawn, lettered and colored on wove paper. 6¹/₂ x 4 in. (Private collection.)

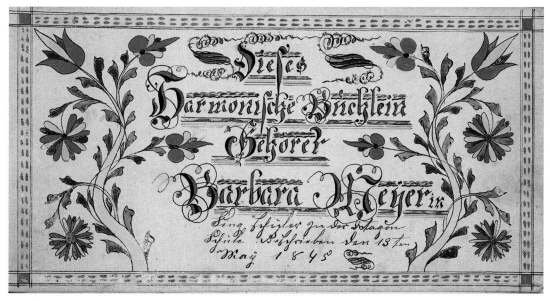

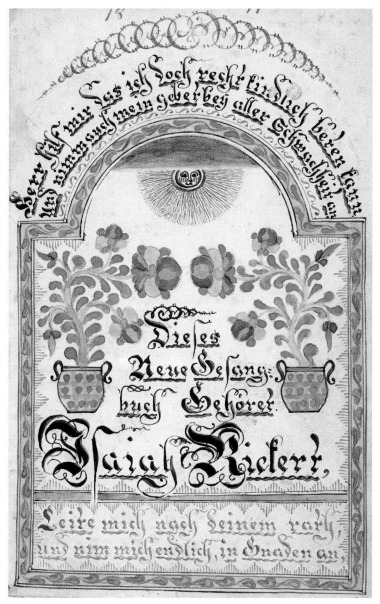

Fig. 292. **Manuscript Tune Book and Bookplate for Barbara Meyer**. Swirl Artist School, Octagon School, probably Hilltown or New Britain Townships, Bucks County, 1845. Hand-drawn, lettered and colored on wove paper. 4 x 7⁵⁄₈ in. This is an inexpert copy of the more sophisticated works produced by the Swirl Artists. There were eight-sided or "octagon" school buildings in Hilltown, New Britain, Plumstead, and several other townships in the 1840s. (Rare Book Department, The Free Library of Philadelphia, FLP B-2.)

Fig. 294. **Hymnal Bookplate for Isaiah Rickert**. Swirl Artist School, probably Bedminster or Hilltown Townships, Bucks County, 1871. Hand-drawn, lettered and colored on wove paper. 6¹⁄₂ x 4 in. (Rare Book Department, The Free Library of Philadelphia, FLP B-1007.)

Jacob Gross

(1807–1900)

New Britain Township

Toward the conclusion of his 1897 monograph on "illuminated manuscripts," Henry Mercer lamented the passing of the fraktur tradition in Bucks County. At the same time, he noted that "two aged masters of the craft still survive," one of whom was Jacob Gross of New Britain.[1] Unfortunately, in his essay Mercer recorded no examples by Gross's hand, nor did he reveal any other details of this "aged master's" life.

In 1923, however, Mercer again mentioned Gross in a paper entitled "The Zithers of the Pennsylvania Germans."[2] Mercer had acquired one of these stringed instruments from Gross for the Bucks County Historical Society collection. He wrote that it was given to him "in 1897 by Jacob Gross, formerly a Mennonite minister and schoolmaster, then living on King's road, New Britain township." Gross said that he had "made and played upon [the instrument] in his earlier days, probably about 1865."[3]

That Jacob Gross taught school and made fraktur is further evidenced in one additional source: a book of photographs assembled by members of the Bucks County Historical Society in the 1890s to document local history and material culture. In this album is a picture of Gross (Fig. 295), along with notes describing him as a schoolmaster and one of the "last surviving practitioners of Fraktur."[4]

Jacob Gross first appeared on New Britain tax lists in 1831, living on land owned by Daniel Gross.[5] Young Jacob, then about twenty-four years old, was assessed for an occupation but unfortunately the specifics of his trade or profession were not recorded. The following year Jacob purchased thirty-five acres of land from Daniel Gross, acquired a horse and three head of cattle, and apparently commenced farming.[6] At about the same time, he married and with his wife Mary began raising two sons, Christian and Isaac.[7]

Judging from the description of the property granted to Jacob Gross by the 1832 deed, his land adjoined the Thomas Stewart farm on Ferry Road. If Gross was still teaching school by this time, he might have done so at the old octagon schoolhouse on the Stewart property. This institution had been established as a German and English community school in 1816 in a wooded area at the northwest corner of the intersection of Ferry and Swamp Roads (present-day Fountainville).[8] Among the teachers at the school was supposedly a "David" Gross, who Bucks County architect Fred Martin described in his history of the Stewart Farm as "a fine old German, well educated in both English and German, and...from a family then as now prominent in the business and public affairs of the

Fig. 295. **Portrait of Jacob Gross**. Photograph by Mary F.C. Paschall, 1897. (Spruance Library/Bucks County Historical Society.)

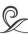

community."[9] As the given name *David* is rare among the Gross families of New Britain in the nineteenth century, one wonders whether the individual to whom Martin referred was actually Jacob Gross!

A handwritten hymn text recently given to the Bucks County Historical Society provides a glimpse at the decorative penmanship of this Jacob Gross (Fig. 296).[10] Written in his eighty-sixth year, the hymn is signed by Gross and dated the fifth of May 1893. Entitled "A Hymn for Reflection," the piece also displays a rather accomplished fraktur hand. In fact, the penmanship is very similar to that seen on fraktur originating from the Swirl Artist School decades earlier. This relationship is further strengthened by the concentric swirl motif with which Gross concluded his composition.

While the decorative penmanship in Gross's hymn text may fail to match *exactly* that seen on fraktur from the Swirl Artist School, the similarities are strong enough to suggest a connection. Did Gross, or perhaps a teacher or family member, compose some of the pieces displaying the distinctive motif and pen flourishes of the Swirl Artists?

Jacob Gross died on May 29, 1900, the victim of a fall that had caused internal injuries a few days previous. Despite his advanced age, "he was a man of remarkable vigor, and never suffered a severe illness until the accident that led to his death occurred."[11] One look at the lean, intense man who glares out of his 1897 photograph makes such a robust constitution entirely believable.

Notes

1. Henry Chapman Mercer, "The Survival of the Mediaeval Art of Illuminative Writing Among Pennsylvania Germans," *Proceedings of the American Philosophical Society* 36 (No. 156): 432.

2. Mercer, "The Zithers of the Pennsylvania Germans," Doylestown Meeting (1923), in *A Collection of Papers Read Before the Bucks County Historical Society* 5 (1926): 487.

3. Ibid.

4. Bucks County Historical Society Photograph Albums, 3 vols. (1897 to c. 1900), 3:133, SL/BCHS.

5. 1831 Tax List, New Britain Township, Bucks County, SL/BCHS.

6. "Deed of Sale from Daniel Gross and Wife to Jacob Gross," June 5, 1832 (recorded 1872), Deed Book 164, 98–99, SL/BCHS.

7. U.S. Census of 1850, New Britain Township, Bucks County, 303.

8. *Doylestown Democrat*, September 24, 1908, 2

9. Fred F. Martin, "The Highlands," n.d., (typewritten mss.), MSC 472, Fol. 5, SL/BCHS. Much of the information in this sketch is drawn from articles in the *Doylestown Democrat*, September 24 and October 1, 1908.

10. This hymn text was found with other materials, including a lease agreement with the signature of Jacob Gross, that make it clear that Gross resided in New Britain Township and is therefore likely the same individual referred to by Mercer. See Gross Family Collection, SL/BCHS.

11. *Daily Intelligencer* (Doylestown, Pa.), June 1, 1900, 3.

Fig. 296. **Hymn Text for Sarah Gross.** Jacob Gross, New Britain Township, Bucks County, 1893. Hand-lettered in purple ink on lined paper. 12 1/2 x 6 3/4 in. (Spruance Library/Bucks County Historical Society, 1998–11–25.)

Isaac L. Kulp

(1849–1915, active c. 1867–1871)

Bedminster and Plumstead Townships

A farmer and possibly a schoolteacher before his marriage, Kulp was born in Bedminster, Bucks County. About 1871, he married Catherine Bergey (1847–1906) and moved to a farm adjoining the property of his father-in-law, Jacob Bergey, in Plumstead Township.[1] In that same year, Kulp drew two bookplates for his wife's sisters, Esther and Mary Ann, who lived nearby (Figs. 297, 298). In 1906, Isaac and Catherine moved west to Colorado with their family, perhaps taking some fraktur with them.[2]

Isaac Kulp signed several of his works. An 1868 copybook is in the collection of the Mennonite Heritage Center in Harleysville Pennsylvania.[3] Two others are pictures, one with religious and the other with mostly secular text. On them he variously wrote his name as "Kulp" or "Kolp." Decorative elements on these and several other pieces by his hand consist of crudely drawn birds, flowers emerging from hearts (reminiscent of work by other Mennonite fraktur artists), and more unusual fruit motifs. On the two bookplates for the Bergey sisters, Kulp drew enormous red apples suspended from leafy branches.

Perhaps Kulp's fascination with fruit derived from his own agrarian surroundings. In 1870, his father reported $100 in income from the sale of orchard products, representing the high end of fruit production in Bedminster Township. By 1880, Isaac was tending his own orchards, producing fifty bushels of apples from forty-nine trees.[4]

Kulp perpetuated hand-drawn fraktur very late into the nineteenth century. However, his shaky penmanship and thin, amateurish decoration attest to the decline of the fraktur tradition (Fig. 299). No longer cultivated by the parochial school system, the folk art form had fallen into decay among Bucks County's Germans by the 1860s.

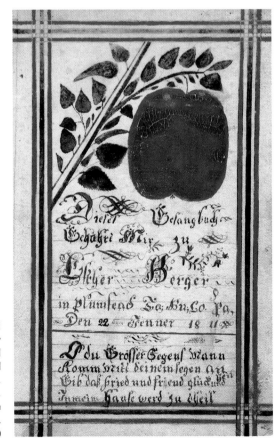

Fig. 297. **Hymnal Bookplate for Esther Berger [Bergey]**. Attributed to Isaac L. Kulp, Plumstead Township, Bucks County, 1871. Hand-drawn, lettered and colored on wove paper. 6½ x 4 in. (Private collection.)

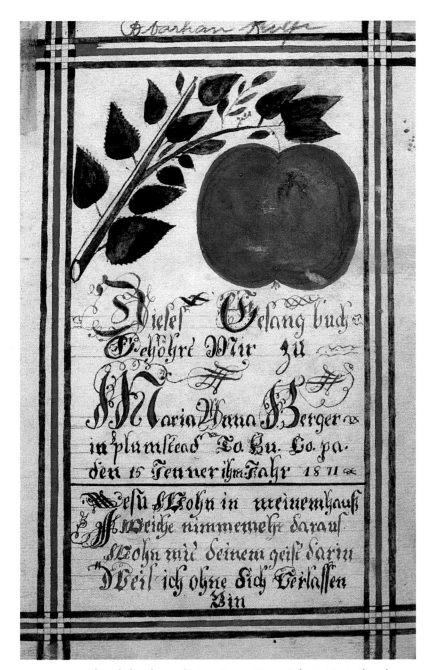

Fig. 299. **Bookplate and Birth Record for Heinrich Kolb (1813–1889).** Attributed to Isaac L. Kulp, probably Bedminster Township, Bucks County, 1868. Hand-drawn, lettered and colored on wove paper. 9¹/₈ x 6¹/₄ in. (Spruance Library/Bucks County Historical Society, SC-58 No. C-10.)

Fig. 298. **Hymnal Bookplate for Maria Anna Berger [Bergey] (b. 1845).** Attributed to Isaac L. Kulp, Plumstead Township, Bucks County, 1871. Hand-drawn, lettered and colored on wove paper. 6¹/₂ x 4¹/₈ in. (Menno Simons Historical Library, Eastern Mennonite University, Harrisonburg, Va.)

Notes

1. For genealogical and family data on Isaac L. Kulp, see David Hendricks Bergey, *Genealogy of the Bergey Family* (New York: Frederick H. Hitchcock, 1925), 102, 327. Also *Combined Atlases of Bucks County, Pennsylvania, 1876 and 1891* (Mt. Vernon, Ind.: Windmill Publications, 1992), 111 (1891); U.S. Census of 1870, Bedminster Township, Bucks County, 4; and U.S. Census of 1880, Plumstead Township, 52.

2. Russell D. Earnest and Corinne P. Earnest, *Papers for Birth Dayes: Guide to the Fraktur Artists and Scriveners*, 2nd ed., 2 vols. (East Berlin, Pa.: Russell D. Earnest Associates, 1997), 1:482.

3. *Mennonite Historians of Eastern Pennsylvania Newsletter* 18 (January 1991): 8.

4. U.S. Agricultural Census of 1870, Bedminster Township, Bucks County, 2; Agricultural Census of 1880, Plumstead Township, E.D. 159, 41.

The S. F. and Stover Artists

(active c. 1856–1857)

Bedminster and Haycock Townships

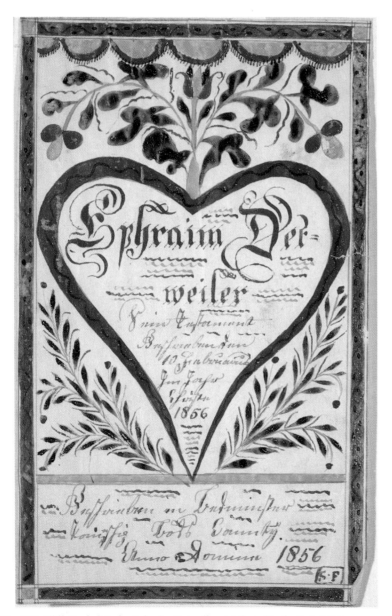

Fig. 300. **Bible Bookplate for Ephraim Detweiler**. Attributed to the S. F. Artist, Bedminster Township, Bucks County, 1856. Hand-drawn, lettered and colored on wove paper. 6⅝ x 4 in. (Rare Book Department, The Free Library of Philadelphia, FLP 441.)

Although the practice of fraktur decoration had declined considerably by the 1850s, some schoolteachers and independent scriveners continued the tradition. One individual who kept it alive was an artist who placed the initials "S. F." on a New Testament bookplate for Ephraim Detweiler in 1856 (Fig. 300).[1] Other bookplates by this same unidentified hand are known, two of which are illustrated here (Figs. 301, 302).

The existence of a closely related picture and penmanship specimen, written in English and prominently featuring the name "Abr: Stover," complicates the matter (Fig. 303). If not for the inexplicable *S. F.* initials on the Detweiler bookplate, this piece might seem to point to Stover as the maker of all of these works.[2] However, while there are clear similarities between this Stover fraktur and the works of the S. F. Artist, substantive differences in spelling and penmanship suggest two distinct hands at work. For example, an 1857 bookplate drawn for Catharina Weierbach, attributable stylistically to the S. F. Artist, is separated by only one day from the date on the "Abr: Stover" penmanship sample. Despite this close temporal proximity, the word *written* is spelled quite differently, and the execution of certain letters (especially the *m* and *r*) is inconsistent.

Whoever the mysterious S. F. Artist may have been, his or her profession was probably that of schoolmaster. The bookplate he or she drew for Catharina Weierbach is inserted into an English grammar book and the inscription refers to the volume as Weierbach's "Third Class Reader." More than likely, Abraham S. Stover was a student of S. F. and was sufficiently inspired by his teacher's drawing and pen work to produce fraktur of his own (Fig. 304).[3]

Notes

1. A similar bookplate, also inscribed to an Ephraim Detweiler but dated 1857, survives in the collection of The Free Library of Philadelphia. Clearly an inferior copy of the 1856 original, this plate bears two sets of initials, one of which ("M. M.") is placed in the same position (lower right corner of page) as the "S. F." in the original fraktur. Both pieces are in the Free Library collection, FLP 240 and FLP 441, respectively.

2. Another picture bearing the name "Abm. S. Stover" was sold at auction in 1985. See *Catalogue of the Collection of Paul R. Flack*, (Pennypacker Auction Center, May 13, 1985), lot 351. A similar fraktur inscribed to "H. C. Stover" is in a private collection and is illustrated as fig. 303. All three of these works are clearly by the same hand.

3. An Abraham S. Stover (1811 or 1814-1892) resided in Haycock Township in the 1850s; however, his age makes it unlikely that he would have been influenced by the penmanship of a local schoolmaster. For information on this individual see A. J. Fretz, *A Genealogical Record of the Descendants of Henry Stauffer and Other Stauffer Pioneers* (Harleysville, Pa.: The Harleysville News, 1899), 38; also Frances Wise Waite, comp., *Bucks County Tombstone Inscriptions, Bedminster and Haycock Townships* (Doylestown, Pa.: Bucks County Genealogical Society, 1988), K104.

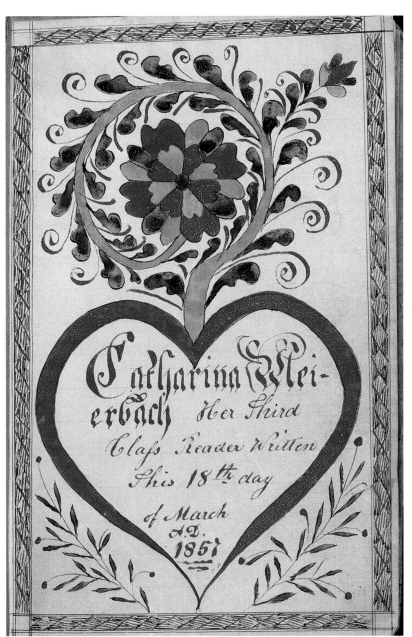

Fig. 301. **School Bookplate for Catharina Weierbach**. Attributed to the S. F. Artist, probably Bedminster or Haycock Township, Bucks County, 1857. Hand-drawn, lettered and colored on wove paper. 6⁷/₈ x 4¹/₄ in. (Collection of Ronald J. Trauger, Bucks County, Pa.)

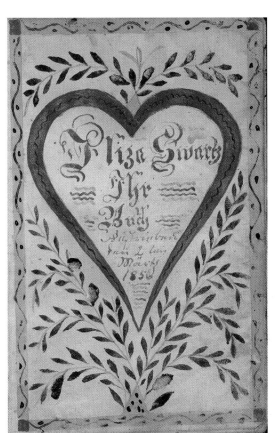

Fig. 302. **Bookplate for Eliza Swartz**. Attributed to the S. F. Artist, probably Bedminster or Haycock Township, Bucks County, 1856. Hand-drawn, lettered and colored on wove paper. 6¹/₄ x 4¹/₈ in. (Spruance Library/Bucks County Historical Society, SC-58. No. C-08.)

321

Fig. 303. **Picture and Penmanship Exercise of Abraham Stover**. Probably Abraham S. Stover, Haycock Township, Bucks County, 1857. Hand-drawn, lettered and colored on paper. 12¹/₂ x 15¹/₂ in. (Collection of Ronald J. Trauger, Bucks County, Pa.)

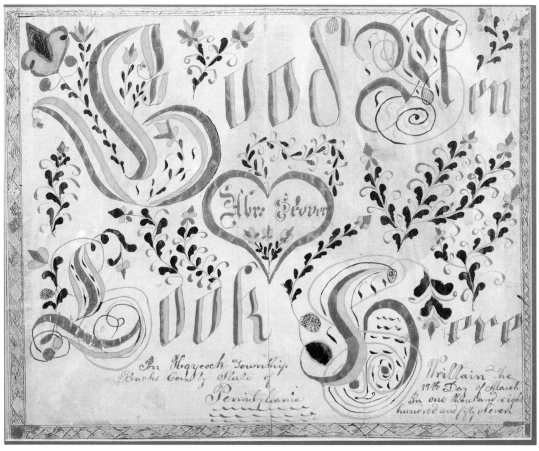

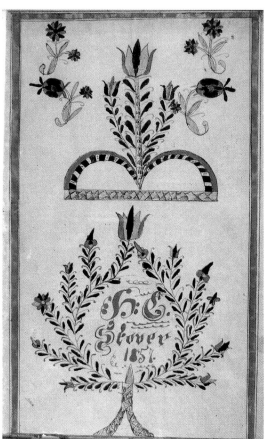

Fig. 304. **Picture for H. C. Stover**. Probably Abraham S. Stover, Haycock Township, Bucks County, 1857. Hand-drawn, lettered and colored on wove paper. 12¹/₂ x 7¹/₂ in. (Private collection.)

A Gallery of Unidentified Artists

Many fraktur artists who worked in Bucks County remain unidentified. This includes several who, based on surviving examples, produced relatively small bodies of work. Perhaps many of these individuals were teachers for only a brief period in their lives, and found little need or occasion to create fraktur after their time in the classroom ended. In addition, those who were able to purchase land and go into farming, or who became proficient at a more lucrative craft or trade, readily abandoned commercial fraktur production. Still, many of these individuals produced works of some significance, and deserve recognition.

Recording their work may also enable future researchers to match yet-to-be-discovered pieces with documented examples. For this reason, included here is a gallery of works by several of these "minor" artists and penmen about which little is known. As with the previous biographical entries, this concluding gallery recognizes the two distinct—though often converging—streams of fraktur production in Bucks County: the Lutheran/ Reformed (characterized primarily by the *Taufschein*), and the Mennonite/Brethren (in which the *Notenbüchlein* and *Bücherzeichen*, or bookplate, predominated).

Taufscheine Artists

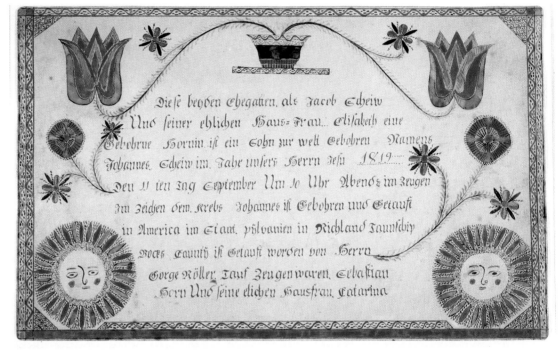

Fig. 305. **Birth and Baptismal Certificate for Johannes Schiew [Shive] (1819–1867)**. Unidentified artist, Richland Township, c. 1820. Hand-drawn, lettered and colored on laid paper. 8 x 12⅝ in. A certificate by the same hand for Johannes' brother is also in the Franklin and Marshall collection. (Permanent Collection, Rothman Gallery, Franklin and Marshall College.)

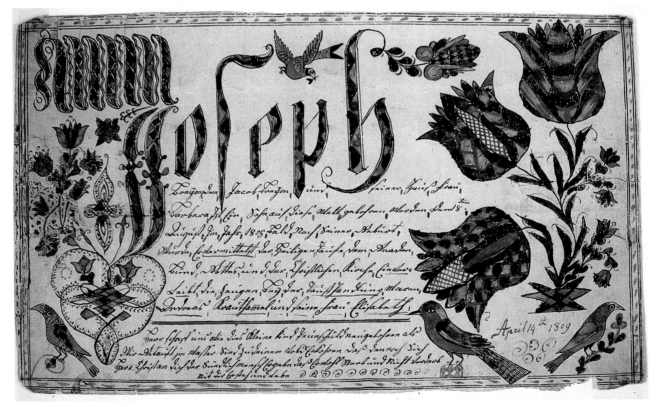

Fig. 306. **Birth and Baptismal Certificate for Joseph Bryan (b. 1805)**. Unidentified artist, probably Bedminster Township or vicinity, 1809. Hand-drawn, lettered and colored on laid paper. 7¾ x 13 in. Although no place of birth or baptism is noted on this *Taufschein*, extant church records show that the child was baptized at the Tohickon Union Church (Lutheran side) in Bedminster Township in October, 1805.[1] (Landis Valley Museum, Pennsylvania Historical and Museum Commission.)

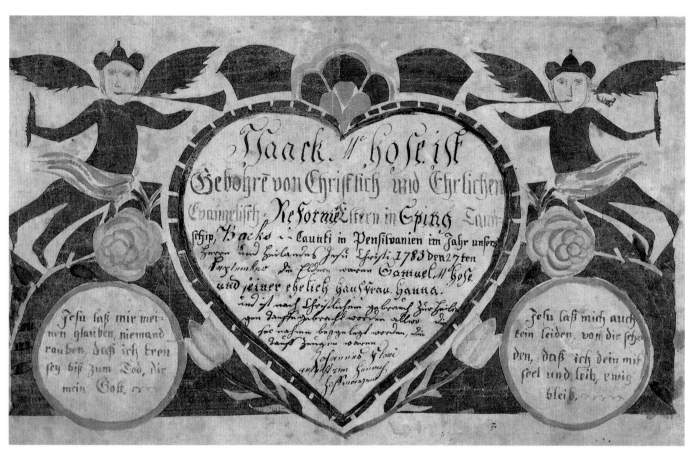

Fig. 307. **Birth and Baptismal Certificate for Isaack McHose (b. 1783).** Unidentified artist, Springfield Township or vicinity, c. 1800. Hand-drawn, lettered and colored on laid, cut paper, and backed with copper foil. 8 x 12³/₄ in. Although Isaack McHose was born in 1783, the baptizing minister recorded on this certificate did not arrive in the Springfield area until a decade later.[2] Thus, both the baptism and the making of this certificate took place many years after the child's birth. (Collections of the Lehigh County Historical Society.)

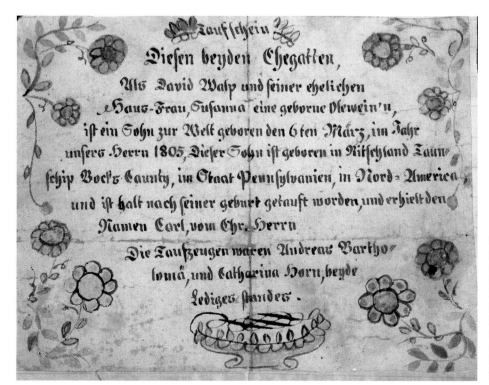

Fig. 308. **Birth and Baptismal Certificate for Carl Walp (b. 1805).** Unidentified artist, in the manner of Friedrich Krebs, Richland Township, c. 1805. Hand-drawn, lettered and colored on wove paper. 4¹/₂ x 5³/₄ in. Although the decoration is derived from the work of Krebs, the penmanship is not his. The diminutive size of this certificate, and simple form, may be indicative of the limitations on what the family could afford. (Private collection.)

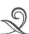
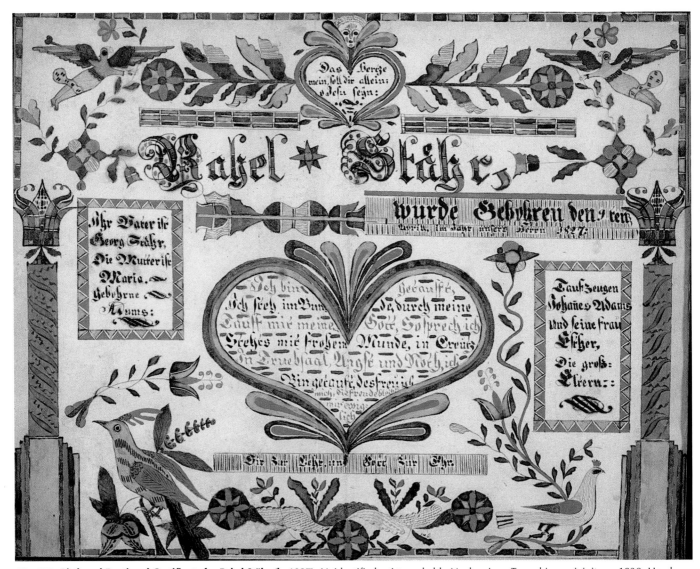

Fig. 309. **Birth and Baptismal Certificate for Rahel Stähr (b. 1827).** Unidentified artist, probably Nockamixon Township or vicinity, c. 1830. Hand-drawn, lettered and colored on wove paper. 13 x 15⅞ in. No location is reported on this *Taufschein*, however it is certainly from Bucks County. The child's parents, George and Mary (Adams) Stähr, had two other children baptized at St. Luke's Reformed Church in Nockamixon (in 1834 and 1836), Mary Adams herself was baptized at St. Luke's in 1804, and the child's grandparents, Johannes and Esther Atherholt Adams, are both buried in Durham Township.[3] The certificate is especially noteworthy as an amalgam of motifs favored by several different artists who worked in Bucks County, including the draped and trumpeting angels of the Eyers and the distinctive tulip (at bottom left) associated with Bernhard Misson and the Speckled Tulip Artist. It also resembles the work of Montgomery County artist Martin Gottschall. (Private collection.)

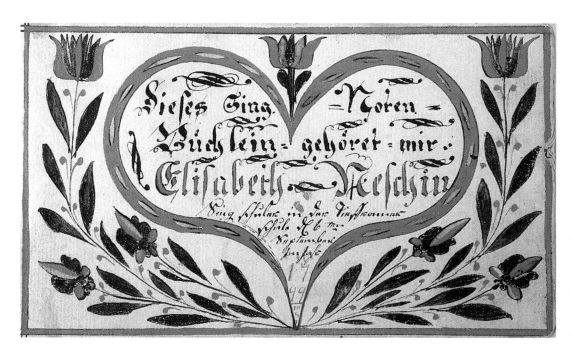

Fig. 310. **Manuscript Tune Book and Bookplate for Elisabeth Nesch [Nash] (1788–1823).** Unidentified artist, Deep Run School, Bedminster Township, 1799. Hand-drawn, lettered and colored on laid paper. 3³/₄ x 6³/₈ in. This tune book was recorded, though not pictured, by Henry Mercer in his 1897 monograph. On the same day that an unknown schoolmaster prepared the bookplate, he also drew a very different design for scholar Susanna Hackman at Deep Run.[4] (Private collection.)

Fig. 311. **Manuscript Tune Book and Bookplate for Samuel Detweiler.** "H.G.," Rockhill Township, 1805. Hand-drawn, lettered and colored on laid paper. 4 x 6 in. (Schwenkfelder Library and Heritage Center.)

327

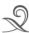

Fig. 312. **Manuscript Tune Book and Bookplate for Magdalena Gross**. Unidentified artist, Deep Run School, Bedminster Township, 1818. Hand-drawn, lettered and colored on wove paper. 4 x 6½ in. One day after he produced this bookplate, a schoolteacher created a nearly identical piece for another of his pupils, Sarah Kolb.[5] (Spruance Library/Bucks County Historical Society, SC-58. No. C-04.)

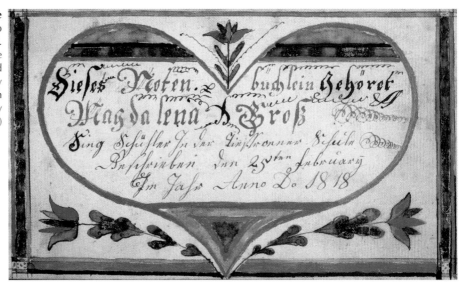

Fig. 313. **Manuscript Tune Book and Bookplate for Samuel Landes**. Unidentified artist, Bedminster School, 1816. Hand-drawn, lettered and colored on wove paper. 4⅛ x 7½ in. (Private collection.)

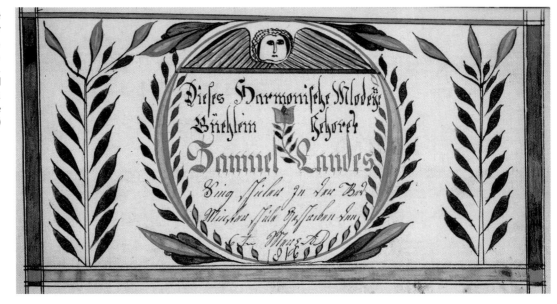

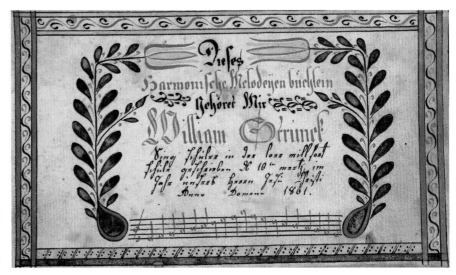

Fig. 314. **Manuscript Tune Book and Bookplate for William Strunck**. Unidentified artist, Lower Milford School, Milford Township, 1801. Hand-drawn, lettered and colored on laid paper. 3¾ x 6¼ in. (Private collection.)

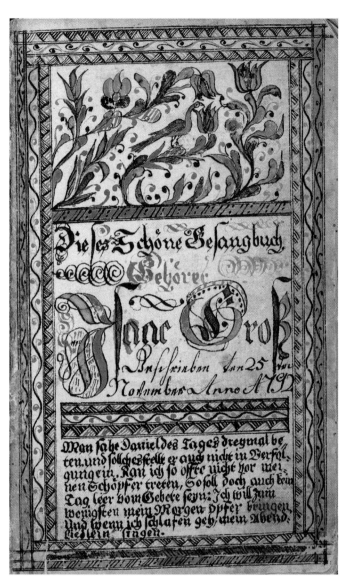

Fig. 315. **Hymnal Bookplate for Isaac Gross (1773–1815).** Unidentified artist, probably Bedminster Township, 1792. Hand-drawn, lettered and colored on wove paper. 5⅝ x 3½ in. (Mennonite Heritage Center, Harleysville, Pa., 94.18.1.)

Bücherzeichen Artists

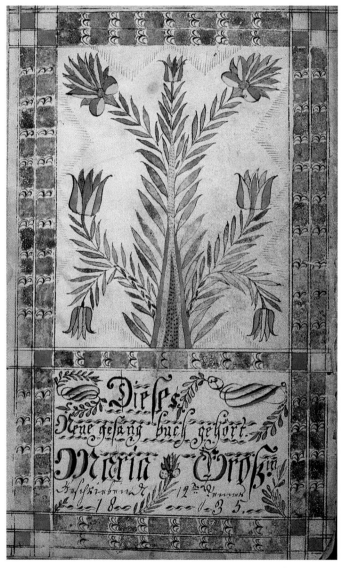

Fig. 316. **Hymnal Bookplate for Maria Gross.** Unidentified artist (School of David Kulp), probably Bedminster or Hilltown Township, 1835. Hand-drawn, lettered and colored on wove paper. 6½ x 3⅞ in. (Menno Simons Historical Library, Eastern Mennonite University, Harrisonburg, Va.)

Fig. 317. **Bible Bookplate for Joseph Laux**. Unidentified artist, Hilltown Township, 1859. Hand-drawn, lettered and colored on wove paper. 6³/₄ x 4¹/₄ in. At least one other bookplate by this same decorator is known, dated 1854 from Hilltown Township.⁶ (Private collection.)

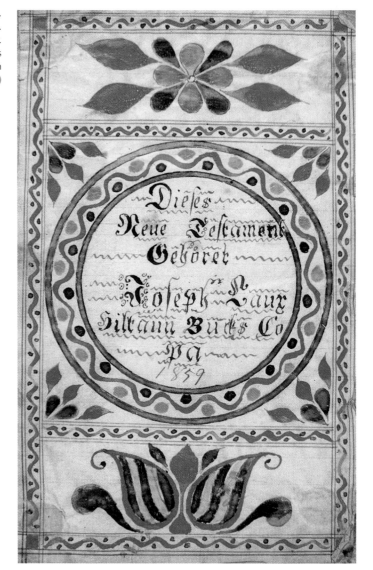

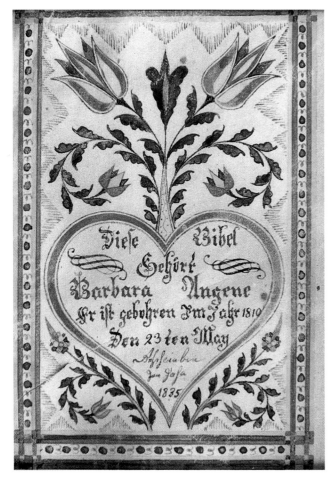

Fig. 318. **Bible Bookplate for Barbara Angene**. Unidentified artist, probably Hilltown or Bedminster Township, 1835. Hand-drawn, lettered and colored on wove paper. 6¹/₂ x 4³/₈ in. Many similar bookplates from Hilltown and Bedminster are extant, though differences in penmanship suggest that several artists may have produced them. (Private collection.)

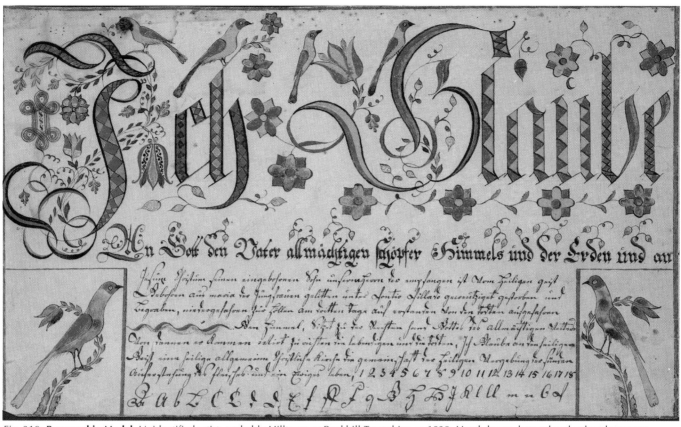

Fig. 319. **Penmanship Model**. Unidentified artist, probably Hilltown or Rockhill Townships, c. 1820. Hand-drawn, lettered and colored on wove paper. 8 x 13 in. As has been pointed out by one scholar, the incorporation of the Apostle's Creed into this *Vorschrift* would suggest a non-Mennonite origin.[7] A bookplate in a private collection for Catharina Aderholt, dated 1808, may be by the same hand.[8] (Courtesy, Christie's Images.)

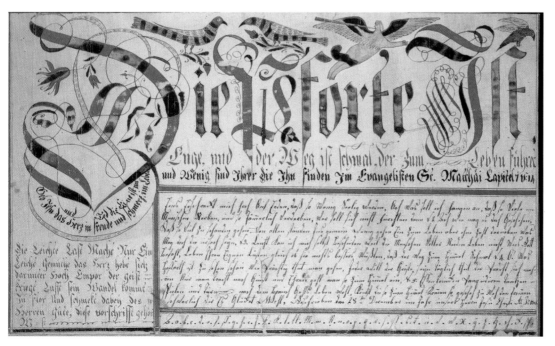

Fig. 320. **Penmanship Model for William Strunck (c. 1789–1853?)**. Unidentified artist, probably Milford Township, 1801. Hand-drawn, lettered and colored on laid paper. 7½ x 12½ in. The same schoolmaster who prepared the tune book illustrated in Fig. 314 probably drew this *Vorschrift* as well. The recipient, William Strunck, is likely the same person who died in Richland Township on May 23, 1853 at the age of 63.[9] He would have been about 11 years old when he received these gifts from his teacher. (Private collection.)

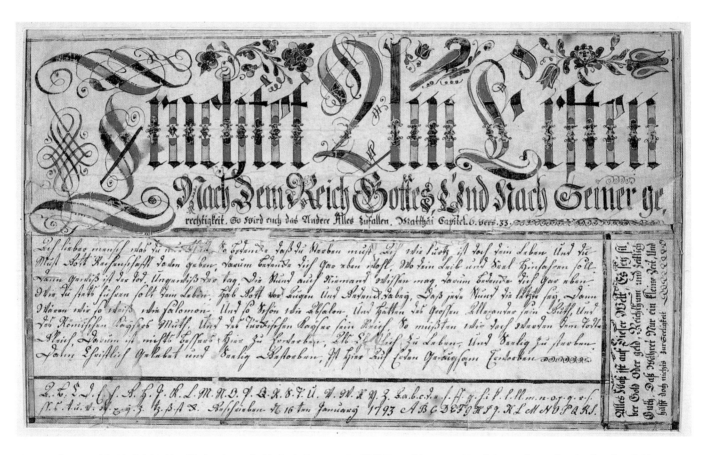

Fig. 321. **Penmanship Model**. Unidentified artist, probably Bedminster or Rockhill Township, 1793. Hand-drawn, lettered and colored on laid paper. 8 x 13 in. This fraktur was found with a group of birth and baptismal certificates prepared for several generations of the Scheib family of Bucks County. It may have been given to Peter Scheib (1778–1843) by his teacher at a school in Rockhill or Bedminster.[10] (The Aaron Family Collection.)

Fig. 322. **Drawing**. Unidentified artist, Bucks or Montgomery County, c. 1825. Hand-drawn, lettered and colored on wove paper. 4⁷/₈ x 3¹/₄ in. Several similar drawings[11] and at least one bookplate[12] are known by this decorator. Certain elements of his work—some letter formations and decorative motifs—bear similarities to the those of the Shive Family Artist (Fig. 304) above. The meaning of the number *27* at lower right is not known. (Schwenkfelder Library and Heritage Center.)

Fig. 323. **Drawing/Reward of Merit**. Unidentified artist, probably Deep Run School, Bedminster Township, c. 1840. Hand-drawn, lettered and colored on wove paper. 4¹/₄ x 6³/₈ in. Several small drawings of segmented flowers, often executed in pale, thin colors, can be attributed to this artist. Probably a schoolmaster, he or she seems to have intended these pictures as rewards of merit, as evidenced by one example associated with the Deep Run School.[13] (Private collection.)

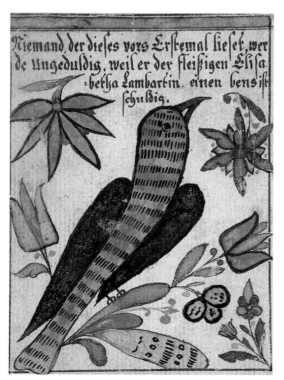

Fig. 324. **Reward of Merit**. Unidentified artist, probably Bedminster Township, c. 1795. Hand-drawn, lettered and colored on laid paper. 3⁷/₈ x 2⁷/₈ in. This little picture, drawn for the "diligent" Elisabetha Lambart, was found with a collection of tune books, rewards and copy books that descended in a Bucks County Mennonite family. Its recipient may have been the Elisabeth Lambart who was baptized at the Tohickon Union Church (Lutheran side) on June 22, 1788.[14] It is possible that this is the hand of schoolmaster Johannes Mayer, however the penmanship is somewhat different, and the design motifs have not been found elsewhere on his work. (Private collection.)

Notes

1. William J. Hinke, trans./comp., *A History of the Tohickon Union Church, Bedminster Township, Bucks County, Pennsylvania* (Meadville, Pa.: The Pennsylvania German Society, 1925), 409.

2. Charles H. Glatfelter, *Pastors and People: German Lutheran and Reformed Churches in the Pennsylvania Field, 1717–1793*, 2 vols. (Breinigsville, Pa.: The Pennsylvania German Society, 1980), 1:66.

3. See Charles R. Roberts, trans./comp., *St. Luke's Union Church, Ferndale, Nockamixon Township, Bucks County, Pennsylvania. Records of the Reformed Congregation* (Allentown, 1923), 38, 79, 81, 83. Also Nancy Seiner and Marjory Payne, comp., (Doylestown: Bucks County Historical Society, 1992), 3.

4. Frederick S. Weiser and Howell J. Heaney, *The Pennsylvania German Fraktur of the Free Library of Philadelphia: An Illustrated Catalogue*, 2 vols. (Breinigsville, Pa.: The Pennsylvania German Society, 1976), 2: 846. The 1799 Nesch tune book is also mentioned in a report on the Bucks County Historical Society's October 24, 1914 meeting in Bedminster Township. See "Bedminster Township Meeting," in *A Collection of Papers Read Before the Bucks County Historical Society* 4 (Doylestown, Pa.: 1917): 535. The correspondent actually attributes the making of the bookplate to the student Elizabeth Nesch, however this is unlikely. She was but eleven years old at the time. See Rev. A.J. Fretz, A Brief History of Jacob Wismer and a Complete Genealogical Family Register (Elkhart, Ind.: Mennonite Publishing Company, 1893), p. 51.

5. In the collection of the Mennonite Heritage Center, Harleysville, Pa.

6. Ibid.

7. Frederick S. Weiser, *The Gift is Small, The Love is Great: Pennsylvania-German Small Presentation Frakturs* (York, Pa.: York Graphic Services, 1994), 23.

8. See Bucks County Fraktur File, SL/BCHS.

9. His obituary is recorded in *Der Religioser Botschafter* (Milford Square, Pa.), 30 May and 13 June 1853.

10. See family data in the Bucks County Fraktur File.

11. See, for example, Weiser and Heaney, *Pennsylvania German Fraktur*, 1: 151. Also, the Schwenkfelder Library owns similar pieces. See Bucks County Fraktur File.

12. This bookplate for Anna Kiensie, in a private collection, is dated 1827. See Bucks County Fraktur File.

13. Weiser and Heaney, *Pennsylvania German Fraktur*, 2: figs. 575, 576. Another example is in the collection of the Mennonite Heritage Center.

14. Hinke, *History of the Tohickon Union Church*, p. 385.

Appendix: Translations

The following are translations, organized by essay, then by page and figure numbers, of the fraktur illustrated in this volume. Repetitive texts, such as the devotional verses found on many *Taufscheine*, have generally been omitted to conserve space. Likewise, examples of fraktur lacking significant text are not represented. Most translations are by Dr. Don Yoder, along with others prepared by John Ruth, Joel Alderfer, Hedwig Voltz, and Cory Amsler. A few have been adapted from published works. These have been credited to the original source. It is hoped that the translations will be of interest to genealogists and family historians, as well as to students of fraktur and Pennsylvania-German folk culture.

"The Survival of the Mediaeval Art of Illuminative Writing Among Pennsylvania Germans," *Henry C. Mercer*

Page 7, Fig. 4
Penmanship Model, c. 1800

There they crucified him with two others on either side, but with Jesus in the middle. Gospel of John 19:18.

Give Jesus thy heart in joy and pain,
In life and in death. This one thing is needful.

O joyful hours, O glorious time! Now in the struggle the
Duke [Christ] hath prevailed. The lion [Christ] hath battled,
the Lion hath triumphed, despite enemies, Devil,
Hell, and Death. We live set free of
affliction and peril.

With might the Warrior [Christ] put the world to flight, and
Satan tormented the wretched sinners by day and by night.
Hell none the less hath till now punished the Master,
And grimly aimed at conquering our souls.

There was here to be found no David the Bold,
[Who] could overcome the Giant's power,
Nor courageously in necessity slay Belial.
No Joshua could overcome the Mighty One,
And let him go without armor and weapons.

There was found no warrior but Jesus alone,
Who as Warrior and Victor rose from the grave.
To slay Satan he went joyously to Hell,
Where he himself unscrewed all the bars,
And forcefully robbed the most powerful robber.

O lovely hours! O joyous feast!
Now hath been found one who nevermore leaveth
The wretched souls in Belial's caves,
Who willingly hid his life for others,
Yet in the end the guarantor himself was put to death.

The Lord is a sign of victory, of honor,
A sign the like of which is no longer found.
Now he hath suffered, now he hath struggled,
Now in defiance of the enemy he hath conquered,
Which resulted in peace, to our advantage and protection.

[alphabet and numbers]

Oh, dear man, whatever thou dost,
Just remember that thou must die.
Yet, oh, how short is thy life!
And thou must give God a reckoning of it.
Therefore reflect on thyself quite plainly,
How thou shouldst continually lead thy life.
Hold God before thine eyes,
And consider quite well
Whither thy body and soul shall journey,
For death is certain, the day, the hour uncertain.

Page 8, Fig. 5
Penmanship Model, c. 1830–1840

I have a desire to depart, and be with Christ. Philippians 1:23.

[V1.] The noble Shepherd, Son of God,
Beloved from eternity,
Left his Kingdom, concealed his Crown,
And went about in sorrow.
He went and sought, from love and pain,
With anxious countenance,
His poor little lost sheep
That had lost its way on earth.

V2. And when happily he found it,
He caressed and embraced it,
And at once in his sling
Went home with it.
Then came the wolf and fell upon him
Attacking with his horde.

V3. When the faithful Shepherd saw this,
He put himself at risk,
Sprang forth and challenged him,
And offered himself alone.
He fought, he struggled, he felt pain,
From these treacherous dogs,
And let himself to his very heart
Be bruised and [sorely] wounded.

V4. He fought until he had lost his strength
And gave up his spirit,
So that when he was taken from there,

And, grieving, carried to his grave.
But this death of his enabled him to have success,
For with it he, as God, repressed and slew the wolves.

V5. This dearly preserved little sheep
Art thou, O my soul!
For thee he came into this pain,
For thee to his sepulchre.
So just go forth and tell him thanks,
With faithful and pure life,
And give thyself to him body and soul
As a Hymn of Praise.

Page 9, Fig. 6
Religious Text of Isaac Gross, 1830

Jesus shall remain my Jesus
 While I live, while I am.
Jesus' name I will write
 Even on my grave.
Jesus here and Jesus there,
Jesus is my very last word.

Isaac Gross, January 10th, 1830.

Page 11, Fig. 8
Birth and Baptismal Certificate for Samuel Röder (b. 1779)

Samuel Röder was born of Christian and lawfully wedded parents in Hereford Township in Berks County in Pennsylvania the 8th of May Anno 1779. The Christian name Samuel was conferred upon him by the Rev. Mr. Theobald Faber in the Christian Church in New Goschenhoppen. His baptismal sponsors were Conrad Nuss and his wedded wife Anna Margaretha. The child's father is Johannes Röhter [Röder], a son of Michael Röder Sr., the child's mother is Maria Catharina, nee Neukirch, a daughter of Heinrich Neukirch Sr....

All those who choose to live a godly life in Christ Jesus must suffer persecution. Everyone who is born of God overcometh the world. Faith is the victory, which overcometh the world.

God so loved the world, that he gave his only begotten son, that all who believe on him shall not perish but have everlasting life.

Blessed is the exalted one, who holdeth God before his eyes, applieth himself to his business, neither doth he desert it, then thou wilst support thyself by the work of thy hand. God will grant thee happiness.

Awake ye and be sober, for your Adversary the Devil goeth about like a roaring lion, seeking whom he may devour...[rest of text missing]

"The European Background of Pennsylvania's Fraktur Art," *Don Yoder*

Page 17, Fig. 12
Devotional Spiral

All wisdom is with God the Lord and is with him forever. For who hath considered beforehand how much sand there is in the sea, how many drops in the rain, and how many the days of the world shall be?

Who hath known how deep is the sea, how wide the earth, and how high the heavens should be? Who hath measured them and who can fathom the wisdom of God which existed before all things? Before all things there was wisdom and the understanding of its providence is from eternity. When is the origin of wisdom unsealed or who hath understood its thoughts? The sole creator of all things, the all high and mighty of all things, a powerful and mighty king before whom all mankind reasonably standeth in awe, who sitteth upon His throne, who alone is wise, who hath created wisdom. He hath seen it and made it and hath poured it out over all his works and over all flesh, according to his grace, and giveth it as well in abundance to all those who love him. Jesus Sirach, Chapter 1.

Page 18, Fig. 14
Wedding Contract of Philip Pfneissl and Catharina Rätz, 1731

Wedding Contract Concerning Philip Pfneissl and His Wedded Wife Catharina.

In the Name of the Most Holy Trinity, God Father and Son and Holy Ghost, amen!

I, Philip Pfneissl, my state that of a widower and community member in Haschendorff, acknowledge with the present wedding contract that, under the guidance of divine grace and having previously taken counsel with virtuous gentlemen and relatives, I have been properly wedded unto the virtuous virgin Catharina, legitimately begotten in the marriage bed of the late Stephanus Rätz, former community member in Haschendorff and his wife Susanna. I honorably betrothed and promised myself unto her for priestly marriage—and thereafter was joined in wedlock with her by the Right Reverend Mr. Johannes Rahrer, most learned servant of God, at the time indeed the meritorious pastor and spiritual advisor in the worthy market town of Markt Neckhenmarckh, in the Parish Church of the Holy Ghost.

In light of which, in behalf of my beloved virgin bride and future manager of my household, I the above-named bridegroom do herewith make the following marriage settlement:

Firstly, and foremost, it is our obligatory and bounden duty at all times, as Christian married folk, to grant each other every proof of conjugal love and faithfulness.

Secondly, 1/30th of the vineyard in the Pettersdorf highlands, adjoining Hanss Mayrhofer's property—one-half share as freehold and one-half share for life.

Thirdly, one-half share in an iron scales and an ox, for life, likewise six acres of barren grain land, with rights of inheritance. Now as far as my freehold portion is concerned, it hath with it this condition and warning—if at any time an accident might happen—which God forbid!—then shall I, the above-named bridegroom, have the freehold portion to enjoy for the rest of my life. But after my death it is to fall to her nearest relatives. However, what we have acquired or earned during the time of our life together shall by both parties be treated as and remain a joint property. But likewise what one or the other in the future transfers by testament or donation out of conjugal love, shall with its increase be reserved and held for the County of Forchtenstein.

As witnesses to this document, as a proper confirmation according to the truth have I, the bridegroom named at the beginning, on my side

requested the respected sirs and wedding attendants, namely Grägor Rudoff and Andterr Pfneissl, both community residents in Haschendorff; but on the part of my dear virgin bride there hath been requested the respected master Franz Schaur, a master miller. So let this wedding contract be prepared and ratified with their usual seals. Done and given forth the 12th of August in the year 1731. [three seals]

Page 21, Fig. 18
Apprenticeship Certificate of Johann Philipp Odenwalt, 1737

I, Ludwig Herbst, citizen and master butcher in the Electoral Palatine Capital and Residence City and Residence City of Heidelberg, do witness and acknowledge to and in the presence of everyone, and especially to all those who are attached to the honorable butcher trade, or to whomever this document may be duly presented or read, that the bearer of this, Johann Philipp Odenwalt, from Thüren [Dühren] near Sintzheim [Sinsheim], hath served with me as a butcher's servant, from Fastnacht of the year 1736 to Fastnacht of the year 1737, and hath now been with Mrs. Bormann one half year, namely, up to St. Bartholomew's Day [August 24]. During this time he hath proved himself to be pious, hardworking, faithful, and honest, also in buying and selling he hath proved himself faithful and honest, useful not only to me but to his neighbor.

Although he would have liked to remain longer in our service he hath decided to seek his fortune elsewhere. Thus he hath properly requested our permission to leave, which we by no means refuse him, but through this document we gladly and willingly grant unto him.

Hence, to each and every person, no matter what their status, condition, worth, or dignity may be, but especially those who are devoted to the honorable Butcher Trade, and to each person to whom this Attestation is presented, we make our respective collegial request and supplication, that the above-named Johann Philipp Odenwalt, in recognition of his praiseworthy reputation, may everywhere be requited and let pass as an honest butcher's servant. We also now attest that in similar occasions and situations we will willingly reciprocate the favor.

In witness whereof, we have suscribed this letter of dismissal in our own handwriting and confirmed it with our usual seals. Produced and executed in the Electoral Palatine Capital and Residence City of Heidelberg, this 24th day of the month of August according to the gracious birth of our only Savior and Redeemer Jesus Christ as is counted seven hundred thirty seven.

> Ludwig Herbst 1736
> Ana Barbara Bormann, widow

Page 23, Fig. 20a,b
Catholic Prayer Book Double Bookplates, 1691

[A] A Beautiful Little Prayer-Book, in which various devotional and very useful prayers drawn from other beautiful prayer-books have been compiled into this.

[B] To the Noble and Virtuous Miss Eva Catharina Sahervöckh, given as an Easter Present in the year 1691.

Page 24, Fig. 21
Writing Specimen of Anna Neff, 1779

Come ye here, let us rejoice in the Lord and shout for joy to the shield of our salvation. Let us come before his presence with thanksgiving and rejoice in him with psalms, for the Lord is a great God, and a great king above all gods. For in his hand is what the earth bringeth and the heights of the mountains are his also. For his is the sea, and he hath made it, and his hands have prepared the fallow ground. Let us worship and bow down and fall at the feet of the Lord, who hath made us. For he is our God.
[alphabet]

Written by me, Anna Neff, for the Easter Examination in Urnäschen in the year 1779.

Page 25, Fig. 22
Writing Specimen of Anna Cathrina Reutegger, 1794

My God, my God, why hast thou forsaken me? I cry, but my help is far away. My God, by day I call, yet thou answerest not, nor am I silent by night. But thou art holy, thou who dwelleth under the praise of Israel. Our fathers put their trust in thee, and when they did so thou didst give them aid. To thee they cried, and were delivered, they put their trust in thee, and were not dishonored. But I am a worm, and not a man, a mockery of the people and scorned by men.

[alphabet]

Written by me, Anna Cathrina Reutegger, at Easter 1794.

Page 26, Fig. 24
Palatine *Göttelbrief* for Nicolaus Meess, 1741

In the year 1741, reckoned from the birth of our only Savior and Redeemer, Jesus Christ, on the 24th of November, there was born into the light of the world a little son to my dear close relatives Johan Jörg Meess, citizen at Lachen, and his wedded wife Anna Maria, nee Dippel, our beloved relations. And on the 26th of November, in the rite of holy baptism the child was held by me, Johan Nicolaus Meess, legitimate son of the Honorable Jacob Meess, citizen and customs officer at Speyerdorf, at which time I bestowed upon him my Christian name [Johan Nicolaus].

Thus thou art, my dearest godchild,
Born on November 24th in the morning,
Born in sin, a child of wrath by nature,
But through Christ's Blood washed clean and pure.
Since thou hast now through God's Grace
Received Baptism, the Heavenly Bath,
Therefore may God the Highest watch over thee.
Accept from me this little gift,
Thy Savior give thee equally salvation, health and long life,
Until thou, through God's blessing, canst give thy
 Godfather and Godmother something better.
God bestow upon thee at last eternal bliss
So that thou mayest praise and glorify Him in Eternity.
Such is the wish for thee from thy faithful Godfather and excellent Godmother. God knoweth that this cometh from my heart.
 Joh. Nicolaus Meess, at Speyerdorf, the 26th of November 1741.

Page 27, Fig. 25
Alsatian *Göttelbrief* for Jacob ___, 1814

Today art thou, tender soul, through baptism
Led forth out of sin's den of iniquity,
To the ranks of the righteous.
So wilt thou receive the Crown of Life.

This is the cordial wish of thy faithful
Godmother, Magdalena Haas of Cleeburg.

Godchild, thou art born the 10th of September,
and baptized the 15th, 1814, and art thus named Jacob.

Page 28, Fig. 26
Alsatian *Göttelbrief*, 1830

God hath, dear child, conveyed thee into this world healthy and per-
fect on his angel wagon, and hath also this day received thee in grace
through thy Holy Baptism into the congregation of the righteous. This
is the heartfelt wish of thy faithful godmother, Salomea Kauffman from
Hunspach, the 2nd of August 1830.

Page 30, Fig. 27
Silesian *Geburtsbrief* for Anna Dorothea Rössel, 1793

We, the Mayors and Members of the Town Court of the Village of
Rentschen in the County of Schwiebusch in the Principality of Glogau,
witness and acknowledge by these presents to everyone in whatever
manner they appear in an ordinary court: The honorable and respected
gentlemen, namely, Mr. Carl Gottlob Willhelm Böckelmann from
Mühlbach, and George Fincke, farmer and magistrate as well as church
treasurer of the Protestant [Lutheran] Church at Mühlbach, from
Lancken, and Martin Pasler, farmer and magistrate from Rentschen,
through an effective oath, administered with bared heads, and lifting
the two forefingers of their right hand to God, testifying and establish-
ing by means of accredited certificates, that the bearer of this docu-
ment, Anna Dorothea Rössel, following God's order and the creed of
the Holy Christian Church, was born free, honorably, and in the good
old German manner, of a chaste, proper, and blameless marriage bed.
Her family roots were in the established princely village of Rentschen,
where she was born, and the above-named Mr. Carl Gottlob Willhelm
Böckelmann and George Fincke as well as Martin Pasler served as her
godfathers and sponsors in the holy rite of baptism.

[Her lineage is as follows:] Her natural father was the Honorable Mr.
Friedrich Rössel, hereditary tenant and chief magistrate in Rentschen,
and her natural mother the respected Mrs. Elisabeth Rössel, nee Rich-
ter, from Mühlbach. Her paternal grandfather is the Honorable Mr.
Gottfried Rössel, hereditary tenant and magistrate in Rentschen, and
her grandmother Hedwig [Rössel, nee] Gebauer, the youngest legiti-
mate daughter of the late Honorable Mr. George Gebauer, hereditary
tenant and magistrate in Rentschen. Her grandfather on the maternal
side is the Honorable and Industrious Christian Richter, farmer and
magistrate in Mühlbach, and her grandmother is the respected Anna
Fuhrmann, nee Friedrich, from Lancken. On both sides these were
legitimate and natural parents and grandparents.

Now when graciously requested, the bearer of this document is to be
accompanied with a true testimony of her legitimate birth. To each
and every person this document reacheth, of whatever class, merit, and
dignity they may be, we make our respective collegial request, that we
may be recognized as true witnesses of firm and undoubted faith. And
not only shall the birth of the above-named Anna Dorothea Rössel,
and her properly conducted life, well known unto us, be recognized as
honorable and irreproachable, admitting and accepting her into your
community, corporation, and society, but may she as well be allowed
fruitfully to enjoy every kindness, favor, and evidence of good will.
Such will she recognize with gratitude.

On our part, however, we are willing and prepared to reciprocate the
same treatment in suchlike and other cases. This attestation we have
deliberately prepared as a genuine official document under our court
seal and our signatures in our own handwriting.

Done in the high princely established village of Rentschen the 25th of
January in the year of Christ our Savior's birth one thousand seven
hundred and ninety three.

> Carl Willhelm Böckelmann [seal]
> George Fincke
> Martin Pastler as godparents

> Friedrich Rössel hereditary tenant and magistrate
> Gottfried Werner / George Krumm
> Christoph Hartman
> Martin Passler
> Sworn members of the Town Court here in Rentschen.

Page 31, Fig. 28
Alsatian *Göttelbrief*, 1748

Thou art, O dear child, baptized in Christ's death, who with his blood
hath redeemed thee from Hell. This for remembrance and constant
keepsake I have wanted to give thee after thy baptism. Grow up to
God's honor, and the joy of thy parents, to the benefit of thy neighbor,
and thy salvation, so that, when thou hast here on earth suffered with
God, thou mayest at last be also crowned with Him. This is the cordial
wish of thy faithful godmother, Caderina Hütz.

Baptized at [Sürss?]heim in the parish church the [16?] of June [1748].

Page 32, Fig. 29
Swiss *Taufzettel*, 1812

1. Lord, direct at all times this child's conduct here on earth, so that it
may through Grace, become fit for thy Salvation.
2. Grant that it may esteem itself lightly, and often bring its grievance
before thee, and that it exercise gentleness and love righteousness.
3. Just as the sun of an evening doth decline toward its setting, so soon
doth human life decline to its end.
4. Dear God, grant thee grace, and enrich thee now with blessings, to
live piously here on earth, so wilt thou live forever.

Remember, Lord, thy goodness, and guard this child from sin. Baptize
it in thy blood, grant it what will be good and useful, so that in tender
youth it may grow in precept and virtue. Urge it on constantly through
thy spirit, that it may lend obedience unto thee. Make it holy in time,
blessed in eternity.

This I wish thee, thy most faithful godfather, Peter Kupferschmid, the 9th day of August in the year 1812. Thou art baptized in the rite of Holy Baptism at Summiswald.

Page 33, Fig. 30
Baptismal Letter for Phillipp Lorentz, 1819

Jesus, inscribe this child into the Book of Life and let it through baptism be an heir of Heaven. Grant it in this world a thousand happinesses and blessings. Lead it according to thy spirit on pure paths of virtue. This is the cordial wish of thy faithful godfather Philipp Metz. Thou art baptized at Lemberg the 5th of February 1819 and art named Phillipp Lorentz.

"The Fraktur Texts and Pennsylvania German Spirituality," *Don Yoder*

Page 44, Fig. 31
Birth and Baptismal Certificate for Jesse Koder (b. 1816)

To this couple, namely Jacob Koder and his lawfully wedded wife Catharina, nee Tätesman, a son was born on the 7th day of July 1816 in Haycock Township, Bucks County, State of Pennsylvania. He was given the name of Jesse. He was baptized on the 1st day of September by Pastor Röller. The sponsors were August Schmitt and Elisabeth Tätesman. May the Lord stand by this child in its distress.

I am baptized. I stand in alliance with my Savior, Jesus Christ. I will be glad in the hour I am called home.

I was named Jesse. My life lies in God's hands. I am glad to be christened and will go to Heaven. I look forward to God's light and grace.

Page 45, Fig. 32
Birth and Baptismal Certificate for Johan Adam Knappenberger (b. 1769)

Johann Adam Knappenberger was born of Christian and lawfully wedded parents in Macungie Township, Northampton County in Pennsylvania, the 11th of July, 1769. The Christian name was conferred upon him by the Rev. Pastor Jacob Van Bosskirch [Buskirk] in the Christian Church in Macungie. His baptismal sponsors are Adam Tesch [Desch] and his wedded wife Gertraut. The child's father is Henrich Knappenberger, a son of Michael Knappenberger Sr., the child's mother is Anna Margarctha, nee Abel, a daughter of Jacob Abel Sr....
Place thy trust only in God, on human help thou shalt not rely. It is God alone who keepeth his faith, other than that there is nothing to be trusted anywhere in the world. 2. Preserve thine honor, guard thyself against disgrace, honor is verily thy highest security.

Verily I say unto thee that the sufferings of this age are not worth glory. Forget not to do good and to share, for such sacrifices are well pleasing unto God. It has been said unto thee, O man, what is good and the Lord will demand of thee, namely, keep God's Word, exercise love, and live humbly.

I know that my Redeemer liveth, and he will raise me from the dead, out of the earth, and I shall thereafter be clad in this body of mine, and I will see God in my flesh. The same will I behold and mine eyes shall look again upon him.

Jerusalem, Jerusalem! Thou that killeth the prophets and stonest those who are sent to thee. How often have I wanted to gather thy children, as a mother hen gathers her little flock under her wings, and thou hath refused it.

Page 46, Fig. 33
Birth and Baptismal Certificate for Samuel Röder (b. 1779)

(Previously translated, see. Fig. 8)

Page 47, Fig. 34
Penmanship Model for Barbara Wismer, 1788

O, that out of Zion help would come over Israel, and the Lord would redeem his captive people. Then would Jacob be joyful, and Israel rejoice. Psalm 14:7, also Psalm 53:7.

Give Jesus thy heart
in joy and pain,
in life and in death.
This one thing is needful.
Barb[ara] Wismer.

How do I become free? I am still like a prisoner.
Cry, sigh, and implore, then the Son maketh thee free.
How, where, and when shall I reach my rest?
How? as you believe. Where? only in Jesus' faithfulness.
When? if thou art at peace, then wilt thou be calm. Then shalt thou be released and free as a little bird.

After suffering followeth glory, triumph, triumph!
After a short struggle then the little flock singeth.
For soon the most faithful Shepherd will, with great power, redeem them from the annoyance of their burden.

Ye tender little sheep, go forth.
The Eternal Word calleth unto thee with the familiar voice.
Follow me on my narrow path, and seek my grace in humility.
I will shield thee from the fury.

The world that rageth all the way to its end,
and amasseth its sins a-plenty. Ah, just let it amass them!
Thou wilt soon see the high pomp brought low,
and made into nothing, through children who still stammer.

It revileth, it striketh, it sneereth, it wreaketh havoc,
Because your Father concealeth himself. But he will appear,
and root out the sharp thorns, also in righteous anger
dash against the rocks what Babel hath produced.
Ye children, just be of good cheer, for God, who does
great wonders, hath already arisen. I am the Lord Immanuel,
I go forth before Israel, and am awakened from sleep.

Arm yourselves with my understanding, take upon yourselves
my breath of life. Gird yourselves with strength. Your
limbs in the bond of love stand like the strong around
my bed, and do great works.

Faith breaketh through steel and stone, and holdeth omnipotence within itself. Who will overpower you? What is light straw to the fire? Satan is in flames with all opposing spirits.

Look in your innocence only to me, I lead my people miraculously, through my omnipotent hands. Their suffering and conflict indeed come to an end in the triumph of Glory, and take a glorious end.

Page 48, Fig. 35
Penmanship Model for Abraham Oberholtzer, 1782

I have a desire to depart, and to be with Christ. Philippians 1:23. 1782.

No brief hour passeth that I do not remember, wherever I am, that Death will put me in the final misery. O God, when everything else forsaketh me, then do thy best for me.

Here there is no sojourn. Death hath the power. He devoureth and wreaketh havoc on young and old. He teareth us out of our earthly condition and place. O God, when everything else forsaketh me, then do thy best for me.

No advice nor medicine, no howling or outcry, no brother can set me free. In all the world there is nothing that in the end can preserve me. O God, when everything else forsaketh me, then do thy best for me.

No riches, gold, nor possessions, no bold hero's courage availeth against Death's fury and rage. All praise for kindness and power for him is all in vain. O God, when everything else forsaketh me, then do thy best for me.

What pain, what fear and agony, O God, will envelop me, when death cometh smashing in? Who will then receive me with consolation? O God, when everything else forsaketh me, then do thy best for me.

When the book of my conscience, when the flood of the Law, when Sin and Satan overwhelm me as a trial, who is it that hath mercy upon me? O God, when everything else forsaketh me, then do thy best for me.

[alphabet and numbers]

Make thyself fit for death. Remember that on death's account all things will be removed. If I too should succeed, how could I go to the grave, and now stand before God?

This writing model belongs to Abraham Oberholtzer. [It was] written the 19th of November [1782].

Page 49, Fig. 36
Hymn Text for Jacob Oberholtzer, 1816

I have it in my mind to sing
But now I must mourn
To think who I am.

Oh, we poor creatures!
Made of dust and ashes,
Miserable by nature,

Oh, what help to me is my fine table
Decked with good food and drink,
When it is no longer of use to me?

Oh, what help to me is my raiment,
In which I do transport myself?
Pride bringeth grief.

Oh, what help to me is my fine house
In which are my joy and dwelling?
Death will take me out of it.

Alas, my poor wife and child
Who do weep so bitterly
Because I am so mortal.

Oh, Death! Oh, Death!
When thou callest,
I break out into a cold sweat.

The 25th of May, 1816. For: Jacob Oberholtzer

Page 50, Fig. 37
Penmanship Model for Christian Gross, c. 1785

Christian Groos [Gross].
Give Jesus thy heart,
in joy and pain,
in life and in death,
this one thing is needful.
Psalm 103, verses 8, 9, & 13.

Merciful and gracious is the Lord, patient and of great goodness. He will not always quarrel, nor hold his wrath forever. As a father showeth mercy to his children, so the Lord showeth mercy to those who fear him.

Happy the man who trusteth in God in all his affairs,
and leaveth everything to Him, who knoweth how to do all things well,
Happy the man whose head lyeth cradled on God's bosom alone,
where it will be entirely at rest, and free of many cares.

Happy the man who trusteth in God, to whom nothing is impossible.
His strong almighty arm can help without delay.
What we consider quite too difficult, is not at all difficult for him,
Because every difficulty of ours giveth way when he commandeth.

Happy the man who trusteth in God. If thou canst find no remedy,
and suppose thy need is not to be surmounted,
Then trust in the wise God, who hath every remedy.
With him is word and deed when thou art without counsel.

Happy the man who trusteth in God, for the proofs of his love
Every creature must praise with joyous tongue.
He giveth nourishment plentifully to every creature,
He even provideth for thee, because he heartily loveth thee.

Happy the man who trusteth in God, and not in the children of men.
They are quite often treacherous, seeking to hinder
What is useful to us, whether they indeed know and understand
What is of use to us, yet they are of no assistance.

Yet will I always trust in thee, my God,
I will look to thy paternal hand in my affliction.
O God, I come to thee, O provide thou for me.
O espouse my cause, and help me with thy grace.
Boldly I trust in God, it even pleaseth me now to go,
as it pleaseth my God. I stand steadfast in the faith
that God doth not forsake him who relieth firmly upon him,
for he will have delivered the man who trusteth in his God.

[alphabet and numbers]

Nothing, nothing that hath ever been created, shall separate me or snatch me away from God's love, for this love is grounded in the death and dying of Jesus. Him I implore full of faith, who neither will nor can desert me, his child and heir. Surely it is nothing but pure love that his true heart containeth, that everlastingly exalteth and sustaineth those who exert themselves in his service. Everything lasteth its time, God's love lasteth for eternity.

Page 51, Fig. 38
Copybook for Margaretha Wismer, 1781

This little copybook belongs to Margaretha Wismer, student of writing in the Perkasie School. Written for her the 4th of October, 1781.

O Lord, sigh forth thy Spirit on this Margreth, and lead her through the world, up to thy heavenly home, that she may follow after thee, also trust thee with her whole heart, and there [in Heaven] contemplate thy countenance into Eternity.

Whoever can do something is highly esteemed. There is no call for an unskilled person.
[remainder of text fragmented and missing]

Page 52, Fig. 39
Hymnal Bookplate for Jacob Kintzi, 1788

This hymnal belongs to me, Jacob Kintzi, in Rockhill Township, Bucks County, written the 29th of April Anno Domini 1788.

I myself cannot rest, nor do I wish to,
The great God's mighty deeds awaken all my senses.
I sing along when everyone sings, and let flow from my mouth
What resoundeth to the Highest.

Page 52, Fig. 40
Penmanship Model of Joel Cassell, 1841

Jesus, may thy holy wounds, thy torture and bitter death, console me every hour in times of bodily and spiritual need. When something evil falleth to my lot, let me think of thy pain, so that I ponder in my heart thy anxiety and sorrows.

My ruined flesh and blood want to delight in sensual pleasure. Let me consider that thy passion must quench the fires of Hell. If Satan presseth in to me, help me to hold before him. Thy wound marks and signs so that he must retreat from me.

When the world tryeth to lead me astray
Onto the broad way of sin,
Wilt thou therefore govern me that I may then behold
The heavy burden of thy agony
That thou hast endured.
So that I can remain in devotion [and] drive away every evil desire.

Joel Cassel's paper, May 12th 1841 Joel Cassel.

Page 53, Fig. 41
Religious Text of Christian Gottfried Weber, 1786

Mournful, Comforting, and Grateful Feelings on Contemplation of the Passion of Jesus, Inspired on Holy Palm Sunday, 1786. Piously glorified by Christian Gottfried Weber.

[Inside text, not illustrated:]

Look not toward Tabor's heights; Direct thine eyes, my soul, towards Golgotha. What the Apostles saw there, thou seest now, alas, not here. There God's Son was announced. Here God's Lamb is dishonored.

There the Father's voice resoundeth, this is my Beloved Son! Here, from wrath and rage, he striketh him with suffering, humiliation, and scorn. There he was seen in the light, here in dismal judgment.

God! How am I to understand this? Thou art holy and righteous! And yet I have to see him here, Jesus, the righteous servant, following the strictest sentence. I see him die, as if accursed.

Yet—he must put up with this, because he hath pledged himself for me. Yes, he now is put to death for sins not his own, that he hath taken upon himself. To absolve me from death, his heart must break in death.

Impress this, Jesus, upon my heart, quite vividly. Let it, in times of suffering and pain, be for me consolation and comfort. Let me praise thee gratefully, for the bloody proofs of thy faithfulness. Amen! Amen!

Page 54, Fig. 42
Religious Text, c. 1830

The love of children is special, as long as they remain in simplicity. Yet they strangely lose it as soon as they leave simplicity behind. They want to be grand everywhere, and thereby meet their downfall. Hence, ye little children dear, love humility and keep yourselves small. You will rejoice in eternity, but the opposite will bring you rue.

Page 55, Fig. 43
House Blessing, c. 1820

House Blessing.
In the name of God I go out.
O Lord, govern thou today this house.
The domestic servants and my children,
Let them be, O God, committed unto thee.
Hear my humble prayer, O Lord,
That it may redound to thy Glory.
Grant that I carry out my business well,
And return home rejoicing.
May each one keep absolute watch
That he neither curseth nor sweareth in my house,
Else God from Heaven could swiftly punish us all together.

Page 56, Fig. 44
Hymn Text of Rudolph Landes, 1814

O Lord my God, I find with thee alone counsel, help, and consolation. O help me continually in all my need, let Thy grace appear unto me. Here I am in great anxiety, surrounded by my foe. O set me free in grace, and let me live constantly unto thee.

Unconquerable art thou, Lord, my God and King above. The heavenly host doth worship thee and praise thee without end. Therefore grant that I too may here on earth and in heaven praise thee continually, and show thee eternal thanks.

Thou King of Heaven Jesus Christ, grant me constantly to consider that my time is almost spent, directing my mind to thy throne, O Son of God, to appear before thee continually and bewail my sins.

O Judge upon the highest throne, thou wilt show me grace. O grant me not the wages I have earned! O let thee be mine own! I live to thee, I die to thee, thou wilt not ever leave me, and will embrace my soul.

Praise, honor, and glory be to my God, who hath borne me so long, and helped me out of many emergencies, for which I say thanks unto him. Praise, honor, and glory, in the sanctuary here and for eternity there I will lift up my praise.

Test me, Lord, and watch my ways. Search my mind, whether I am on the right path, on which thine own are going out of time into eternity, going to salvation without looking back.

If I have injured anyone in any way, I am deeply sorry. I ask you all for forgiveness, it causes me much grief. Have patience where I am guilty; if I still had the ability, I would gladly alter it.

Love suffereth gladly in patience. I want to forgive you all, where anyone has been guilty toward me in my entire life, and pray God that he may look upon us all in grace. Who can stand before him?

Written by Rudolph Landes the 11th of February, 1814.

"The German Schools in Bucks County," *Terry McNealy and Cory M. Amsler*

Page 75, Fig. 55
Manuscript Tune Booklet for Catharina Wismer, 1828

This little harmonious melody book belongs to me, Catharina Wismer, singing student in the Deep Run School. Written the 7th of June, A.D. 1828.

Page 86, Fig. 59
Reward of Merit for Daniel Landes, 1781

Confirmed and select singer, Class No. 7.
For singing, praise, and honor, to thee, Lord, I am ready. Ever increase the devotion, until after this life I sing in Heaven's eternal joy.

Daniel Landes, who is in the ranks of singers at the school in Perkasie. Whoever readeth this, understand, he became the seventh singer.

"Skippack to Tohickon and Beyond: The Extended Community of Bucks County Mennonite Fraktur Artists," *John L. Ruth*

Page 99, Fig. 68
Penmanship Model for Gerhard Bechtel, 1747

Gerhard Bechtel.

To thee I present these instructions. They are useful even more to be and to others, constantly to be used to the glory of God.

Be pious, upright and faithful, patient and taciturn.
Flee sensual pleasure, idleness. Shun pride, strife and lying.
What hath been given thee on this earth from God's hand, let thyself be satisfied with that.
And since in this age the wolves in sheep's clothing are putting on a show of acceptability, take a good look at them.
Share with him who hath nothing, of the rest be sparing.
Beseech thy God for grace early and late, give gladly to the needy, part with many cares.
What thou canst still do today, put not off until tomorrow.
Take the advice of godly folk, and the warning of the faithful.
Do not forget the person who hath done thee good.
Value true friends, abandon false heretics.
Consider that we all must pass away with the years.
Above all, strive constantly, and that at every time, for what doth last forever, for what is good and true.

[alphabet and numbers]
Anno Domini Christi 1747

[in English:]
Honour and Dominion belongs unto the Omnipotent Jehovah.

Page 100, Fig. 69
Penmanship Model for Ludwig Benner, 1773

In this writing model, dear youth,
Thou wilt find described the beauties of virtue,
And from it how thou shouldst drill thyself
To love God and thy neighbor.
This testimony is for everyone—
It even concerns old folks.
Also to me and thee, and others besides,
This text doth give instruction fine
How thou shalt live the godly life.
God will grant his blessing on it.

[In English:]
Honour and Dominion belongs unto the Omnipotent Jehovah.
Anno Domini 1773, the Second of October.

Page 101, Fig. 70
Fretz Family Record, 1782

Birth Register. Mine and my wife's, also with our children whom we have produced in our marriage to each other. Firstly, I, Johannes Fretz was born A.D. 1730, in the month of March. In the 25th year of my age I was united in holy matrimony with Maria, nee Kolb, who was

born in the year 1730, the 10th of September.

Children:

The first son, Manasse, was born in the year Anno Domini 1755, the 22nd of March.

2nd, a daughter, born in the year of our Lord 1756, the 22nd of May. We named her Barbara.

3rd, a little son, born the 3rd of February, 1758, named Abraham.

4th, a little son, born the 18th of August, 1760, to whom the name Ephraim was given.

5th, a daughter was born in the year of our Lord 1761, the 25th of October, and she was given the name Judith.

6th, a son was born in the year of our Lord 1763, the 23rd of December, and given the name Moses.

7th, a little daughter, born in the year 1765, named Anna.

8th, a daughter was born in the year of our Lord 1768, the 30th of May, and she was given the name Dina.

9th, a daughter was born in the year Ao. Do. 1771, the 26th of December, and she was given the name Sara.

10th, again a daughter, born in the year of our Lord 1774, the 13th of October, and we named her Elisabeth.

Written the 16th of July in the year of Christ 1782 by John Moyer.

Page 102, Fig. 71
Bible Bookplate for Madteis Schnebelli, 1708

This Bible belongs to Matthias Schnebelli at the Ibersheimerhof, and it is in love so written in the year of Christ, 1708.

Page 103, Fig. 72
Manuscript Tune Book and Bookplate for Henrich Honsperger, 1780

Little harmonious melody book of the best known hymns in the Marburg hymnal, prepared for Henrich Honsperger, singing student in the Perkasie School. Written the 12th of April in the year of our Lord A.D. 1780.

Learn how thou alone canst be Singer, Book, and Temple.
Whoever can do something is highly esteemed. There is no call for an unskilled person.

Page 104, Fig. 73
Marriage Greeting for Christian Meyer and Maria Landes, 1784

C.M. & M.L. have consented together in Holy Matrimony on the 11th of May, 1784.

Dear peace nourisheth. Base jealousy dreameth. Therefore may God himself tie the band of love in your estate.

Commit thy way unto the Lord, trust in him, he will act. Ps. 37, v. 5. Remain decent and upright, for it will go well for such at last. Ps. 37, v. 37.

Christian Meyer and Maria Landes
Love moveth me to give this to thee as a constant reminder and remembrance.
Receive it also in love, observe it, write it into your heart, do not scorn it.

Be true to God in your estate, in which he hath established you. If he holdeth you in his hand, there is nothing that can harm thee. Who

hath his grace hath a breastplate, him can no devil harm. If God hath thee under his keep, thou remainest well off. Be true to God, his dear Word constantly confess, stand firmly on it in all places, do not depart from it. Everything which this world hath in its arms must pass away. His dear Word abideth eternally, standing without any wavering. Be true to God, as one who letteth thee find him true and gracious. Do battle under him nobly. Do not let sins bridle thee against duty. Should they cause a fall, be prepared through timely repentance to rise up again. Be true to God unto death and let nothing distract thee. In all thy need he will and can send thee true support and should the kingdom of hell press with all might upon thee at once, believe then that thou art not oppressed by it. If thou remainest true to God, he will show thee that he is thy dear Father, as he hath also promised to place a crown upon thee in heaven as the fruit of grace. There thou wilt have thy fill of his faithfulness in his kingdom.

This is wished to thee, bridegroom, and also to thee, bride, and also to everyone who is well intended and trusts God heartily by a good and also true [friend]. His name is and he is called H[ans] Adam Eÿer, a school teacher.

[Above translation adapted from Frederick S. Weiser and Howell J. Heaney, *The Pennsylvania German Fraktur of The Free Library of Philadelphia: An Illustrated Catalogue*, 2 vols. (Breinigsville, Pa.: Pennsylvania German Society, 1976), 1:fig. 193.]

Page 105, Fig. 74
Marriage Greeting for Abraham Kolb and Anna Meyer, 1784

AK and AM, together have given themselves into Holy Matrimony, the 30th day of Novem[ber] in the year of Christ, anno, 17[8]4. Loving peace nourisheth, naked jealousy devoureth. Therefore may God himself tie the band of love, in your state [of matrimony].

Bridegroom:
Commit unto the Lord thy ways and hope in him and he will bring it to pass.

Bride:
Remain godly and keep thyself, for with such it will go well in the end.

A.K. and A.M.
Love compels me to give this gift to you as a souvenir and constant reminder, too.
Receive it now in love, consider what I advise; write in your [heart], do not the words despise.

Be true to God, in the state in which he now sets thee,
If he still holdeth thee in his hand, there's nothing that can molest thee,
Who hath the breastplate of his grace, is safe from the devil's conniving.
If the power of God keeps watch over thee, then thee will still be thriving,
Be true to God, to his dear word, confession steadfast making,
In every place, stand fast thereon, let not the bond be breaking.
That which this world embraceth here, will some day cease existing,
His eternal word, will firm remain, without a quake, persisting.
Be true to God, as to one who faithful still is proving,
Fight under him, most valiantly, let not sin, o'er you moving,
Against your duty, place on you its seal and its infection,
Thyself prepare, through repentance share in his resurrection,

Be true to God, till death doth come, in nothing from him tending,
He can and will, in every trial, faithful help be sending,
If hell's empire, upon thee fire, in dread array, alarm thee,
By faith stand fast, be not downcast, his power cannot harm thee.

If thee to God will faithful be,
He will reveal himself unto thee,
And thy beloved Father be,
As he hath promised to thee,
A crown he'll place, recompense of grace,
In heaven, upon thy forehead,
And then thou will, in his kingdom still,
With pleasure be rewarded.

This wish to thee, dear Bridegroom, and also Bride, and all well-meaning folk who in God's trust abide, comes from the heart of a friend, so dearly loved, whose name is known and called, Andreas Kolb.

[Above translation adapted from Mary Jane Lederach Hershey, "Andreas Kolb (1749–1811): Mennonite Schoolmaster and Fraktur Artist," *The Mennonite Quarterly Review* 61 (April 1987): 182–183.]

Page 106, Fig. 75
Penmanship Model for Phillip Markley Jr., 1787

By this shall everyone recognize that ye are my disciples, if ye love one another. Simon Peter sayeth to him, Lord, whither goest thou? Jesus answered...Gospel of John, Chapter 13, verses 35–36.

If anyone sayeth, I love God,
And yet hateth his brethren,
He maketh a mockery of God's Truth,
And demolisheth it completely.
God is Love, and he wanteth me
To love my neighbor just as I love myself.

Whoever hath property on this earth,
And seeth his brethren suffer,
And doth not feed the hungry,
Doth not clothe the naked,
He is the enemy of the first, the first commandment,
And hath not the love of God.

Whoever revileth his neighbor's honor,
And gladly heareth him reviled,
Rejoiceth when his enemy perisheth,
And teacheth nothing for the best,
Doth not contradict the slanderer,
He also loveth not his neighbor.

But whoever with counsel and comfort and protection
Supporteth his neighbor,
Yet only out of pride and self-interest,
Out of weakness and not out of obedience or duty,
He also loveth not his neighbor.

Whoever waiteth
A needy person
Hasteneth not to stand by the pious
He...[incomplete stanza]

[alphabet and numbers]

Written the 17th of January 1787 on the Skippack

Writing model for Philip Märkel Jr.

But now remaineth Faith, Hope, Love,
These three, but the greatest amongst them is Love.

Be as cunning as serpents,
and as innocent as doves.

Page 107, Fig. 76
Hymnal Bookplate for Samuel Gottschall, 1834

The New Hymnal. 1834. This hymnal belongs to me, Samuel Gottschall, written in the year 1834.

Page 107, Fig. 77
Hymnal Bookplate for David Hoch, 1809

This spiritually rich hymnal belongs to David Hoch in the year 1809.

Page 108, Fig. 78
Manuscript Tune Book and Bookplate for Maria Gross, 1788

This little singing note book belongs to Maria Gross, singing student in the Deep Run School. Written the 12th of November, A.D. 1788.

Give Jesus thy heart, in joy and pain, in life and in death. This one thing is needful.

Page 109, Fig. 79
Page from Copybook of Catharina Rohr, 1784–6

[1.] I feel like singing [repeat]
 But would much rather weep
 When I think who I am

2. A weak creature, [repeat]
 Made from dust and earth
 Toilsome by nature.

3. What is man's concern? [repeat]
 What is man's life?
 It is a debilitating illness.

4. It is full of anguish and misery, [repeat]
 Much grief and much mourning,
 That lasteth unto death.

5. Death is an end to the torment, [repeat]
 And through it God leadeth us
 Out of this vale of tears.

6. Death is universal. [repeat]
 It cannot be otherwise.
 We have to die.

 [No verse no. 7]

8. Death cometh from sin. [repeat]
 If many a man could avoid it,
 He would give his property and wealth.

9. Not I! I am a Christian, [repeat]
 And know that for me
 Death is a gateway unto life.

10. O Lord, I am very pleased [repeat]
 That I shall leave this earth
 And come to rest.

11. It bringeth its grievance to the flesh. [repeat]
 But I shall trust in God, who shall indeed
 Be my sole consolation.

12. The godless person feareth death. [repeat]
 He cannot avoid it,
 It bringeth him anguish and misery.

13. O man, pay no attention to insults, [repeat]
 Lest thou easily go astray and never find
 What is eternal.

14. O man, prepare thyself for death. [repeat]
 Pray to God that he will release thee
 From all anguish and misery.

15. Mark well the difference! [repeat]
 The one doth depart with joy,
 The other with deep sorrow.

16. It resteth in God's grace. [repeat]
 Therefore guard thyself from sin,
 Whether it be early or late.

17. Reflect upon thy death at all times. [repeat]
 In faith commend thy soul
 Into God's hand.

18. Death cometh to the door....[unfinished]

Page 110, Fig. 80
Memorial Record of Anna H. and Samuel K. Meyer, c. 1860

Here rests the body of Anna H. Meyer, daughter of John and Maria Meyer, born December the 17th, 1829. Married with Mr. Jacob Cassel, in the year of our Lord Jesus Christ 1857. Died, April the 9th, 1858. Age, 28 years, 3 months, and 22 days.

Samuel K. Meyer, son of John and Maria Meyer, born February the 18th, 1827. Died, December the 8th, 1855. Age, 28 years, 9 months, and 21 days.

Rest in peace—quietly sheltered,
You who early have fulfilled your pilgrimage,
For you there waits a beautiful morning,
When there you awake in glory.

"The *Notenbüchlein* Tradition in Eastern Pennsylvania Mennonite Community Schools, in an Area Known as the Franconia Conference, 1780 to 1845," *Mary Jane Hershey*

Page 115, Fig. 81
Manuscript Tune Book and Bookplate for Henrich Honsperger, 1780

(Previously translated, see Fig. 72.)

Page 116, Fig. 82
Bernese Manuscript Tune Book, 1701

I have always resigned myself
That I shall not live eternally
Thus I hope that my memory will remain
As long as what I write here lasts. 1701.

Page 120, Fig. 85
Bookplate for Maria Alderfer, 1788

Little harmonious melody book of the best known hymns in the Marburg Hymnal, prepared for Maria Alltörffer [Alderfer], singing student in Lower Salford Township, in Montgomery County. Written the 4th of August 1785.

Page 121, Fig. 86
Manuscript Tune Book and Bookplate for Elisabetha Kolb, 1787

This little book of notes belongs to Elisabetha Kolb, singing student in the Perkasie School. Written the 20th of June, 1787.

Page 122, Fig. 87
Manuscript Tune Book and Bookplate for Anna Haldemann, 1791

The little book of notes belongs to Anna Haldemann, diligent singing student in the Pikeland School in Chester County. Written the 8th of April, A.D. 1791. J.Fr.E.

Page 123, Fig. 88
Manuscript Tune Book and Bookplate for Maria Bächtel, 1788

Little harmonious melody book of the best known hymns in the Marburg Hymnal, prepared for Maria Bächtel, singing student in the Swamp School. Written the 27th of October 1788.

Page 124, Fig. 89
Manuscript Tune Book and Bookplate for Johannes Herley, 1802

This little melody book belongs to me, Johannes Herley, in Lower Salford. [Rest in English:] Dated June the 4th in the year of our Lord 1802.

Page 125, Fig. 90
Manuscript Tune Book and Bookplate for Anna Lädtermann, 1812

This little harmonious melody book belongs to Anna Lädtermann, singing student in the Deep Run School. Written the 12th of January, 1812.

Page 125, Fig. 91
Manuscript Tune Book and Bookplate for Jacob Laux, 1822

This little book of notes belongs to Jacob Laux, singing student in the Deep Run School. Written the 2nd day of May, A.D. 1822.

Page 126, Fig. 92
Manuscript Tune Book and Bookplate for Anna Letherman, 1827

This little harmonious melody book belongs to me, Anna Letherman, singing student in the Deep Run School. Written the 15th of September, 1827.

Page 126, Fig. 93
Bookplate for Henrich Letherman, 1829

This little harmonious melody book belongs to me, Henrich Letherman, singing student in the Deep Run School. Written the 20th of June, 1829.

Page 128, Fig. 94
Manuscript Tune Book and Bookplate for Susanna Kassel, 1792

This little book of notes belongs to Susanna Kassel, a [??] singer in the Skippack School. Written the 16th of September 1792. 17 and 92.

"'David Kulp, His Hand and Pen, Beet it if You Can:' The Bucks County Brown Leaf Artist Identified," *Joel D. Alderfer*

Page 152, Fig. 96
Manuscript Tune Book and Bookplate for Sarah Oberholtzer, 1815

As a little flower soon fadeth, so our life is seen.

This little harmonious melody book belongs to Sarah Oberholtzer, singing student in the Deep Run School. Written the 5th of February in the year 1815.

Page 153, Fig. 98
Hymnal Bookplate for David Kolb, 1783

This beautiful hymnal belongs to David Kolb on the Deep Run. Written the 8th of May 1783. I have a mind to sing.

Page 154, Fig. 99
Manuscript Tune Book and Bookplate for Maria Kolb, 1801

This little book of notes belongs to Maria Kolb, singing student in the Deep Run School. Written the 22nd of May in the year A.D. 1801. Learn how thou alone canst be Singer, Book, and Temple.

Page 157, Fig. 102
Manuscript Tune Book and Bookplate for Ulrich Hackman, 1802

As a little flower soon fadeth, so our life is seen.
Learn how thou alone canst be Singer, Book, and Temple.

This little harmonious melody book belongs to Ulrich Hackman, singing student in the Deep Run School. Written the 15th of August in the year of our Lord Jesus Christ 1802.

Page 158, Fig. 103
Bookplate for Maria Gross, 1812

This little harmonious melody book belongs to Maria Gross, singing student in the Deep Run School. Written the 27th of January 1812.

Page 160, Fig. 106
Bible Bookplate for Anna Landes, 1807

This New Testament belongs to me, Anna Landes. Written the 19th of March in the year of our Lord, 1807.

Page 160, Fig. 107
Hymnal Bookplate for Elisabetha Kolb, 1809

This spiritually rich hymnal belongs to Elisabetha Kolb in the year 1809.

Page 161, Fig. 108
Bookplate for William Heacock, 1812

[written in English:] William Heacock, his book. Dated the 25 day of January in the year 1812.

Page 162, Fig. 109
Bible Bookplate and Birth Record for Barbara Fretz, c. 1815

This Bible belongs to Barbara Fretz and is a present from my grandmother Stauffer. And I, Barbara Fretz, was born on December 26, in the year of our Lord, 1796. The human being born of a woman liveth a short time and is full of restlessness. Riseth like a flower and decayeth, fleeth like a shadow and remaineth not. Job Chapter 14, verses 1–2.

Page 162, Fig. 110
Hymnal Bookplate for Jacob Kolb, 1814

This spiritually rich hymnal belongs to Jacob Kolb. Written the 7th of February in the year 1814.

Page 163, Fig. 111
Henrich Lädtermann Family Record, c. 1815

I, named Henrich Lädtermann, was born the 4th of September in the year Anno 1770. And my wife Elisabeth was born the 20th of June in the year Anno 1776. The 5th of September in the year Anno 1797 we were with each other joined in holy wedlock and brought forth the following children:
First, the 13th of September in the year Anno 1798 a son was born and to him was given the name Abraham.
Second, the 11th of October in the year Anno 1800 a son was born, and to him was given the name Johannes.
Third, the 15th of June in the year Anno 1803 a son was born, and to him was given the name Jacob.
Fourth, the 17th of June in the year Anno 1806 a son was born, and to him was given the name Henrich.
Fifth, the 7th of May in the year Anno 1811 a daughter was born, and to her was given the name Catharina.

Sixth, the 1st of May in the year Anno 1815 a son was born, and to him was given the name Samuel.

Henrich Lädtermann, the father of these children, died the 18th of April in the year Anno 1815 at the age of 44 years, 7 months and two weeks.

Elisabeth Lädtermann, the mother of these children, died the 7th of September in the year Anno 1847, at the age of 71 years, 2 months and 17 days.

Page 163, Fig. 112
Penmanship Model, c. 1800

God is a Spirit and they who worship him, must worship him in Spirit and in truth. E[vangel of] J[ohn], C[hapter] 4, V[erse] 24.

On, on to heaven. Why wilt thou delay here? Thou must hurry on to Zion; there is true rest. On, on to heaven, what type of harps are these which make thee so ardent? A smoke which soon appeareth, and then again disappeareth. The flowering young years come onto the bier. Who knoweth whether today the flower will break to pieces?

There is true rest in Christ; gifts for thee to refresh heart and mind. Therefore onward to heaven. There is true rest. Think only on the love which drove thee, in such tender impulses in the heart of Christ, and moved him for thee that he gave up his faithful life to death for thee and every man. O soul, think on that.

It goes to Canaan. This shall become my own. Therefore flee from earth and hasten from the earth. It goes to Canaan. If thou dost find the way too narrow and come to be oppressed, do not be afraid, since Christ himself speaketh. He wanteth to travel with thee, himself show thee the way; He goeth and showeth the path, therefore go and follow.

Thy Savior still liveth. He speaketh not in vain. He is the basis of life. He sayeth, "Why art thou concerned?" The Savior still liveth and hath thy soul in this small space. Hearken surely to him, so it is rightly done. For that reason whoever looketh upon him, and trusteth in further help, he may not lie without help in all pain. He is the best counsel.

[alphabet]

O dear man, whatever thou dost, just remember that thou must die, and thou must give God account thereof. Therefore remember well how thou shalt constantly lead thy life. Keep God before thine eyes and in thy thoughts, thyself, very well where thy body and soul may go, for sure is death, unsure the day of it.

[Above translation adapted from Frederick S. Weiser and Howell J. Heaney, *The Pennsylvania German Fraktur of the Free Library of Philadelphia: An Illustrated Catalogue*, 2 vols. (Breinigsville, Pa.: Pennsylvania German Society, 1976), 2:fig. 964.]

Page 164, Fig. 113
Penmanship Model, c. 1800

One thing is needful; Mary hath chosen the better part, that shall not be taken from her. Luke 10:42.

[V.1]. The noble shepherd, Son of God, beloved from eternity, left his kingdom, hid the crown,

And went forth distressed. He went and sought, out of love and pain, with anxious care, his poor lost lamb that was chased over the earth.

[V.]2. And as he joyfully found it, kissed and embraced it, and went home with it in his arms' embrace, came the wolf, with his horde of fellows, and wanted afresh to fall on him along with the little sheep.

[V.]3. When the good shepherd saw this, he gave himself into danger, springing close to place himself there alone. He suffered long with pain received from these hellhounds, and let himself be torn and wounded to the heart.

[V.]4. He strove until his strength was gone and then gave up the ghost, till he was taken from the tree and sadly to the grave. But this sad death and fall to him became success triumphant, since he thereby, as God, the wolf left beaten and defeated.

[V.]5. Thou art this little cherished lamb loved dearly, O my soul,
For thee he came into such pain within the grave of hell.
Go then thy way and say him thanks, with true and spotless living,
With body and with soul together songs of praises giving.

[alphabet]

Blessed is he who striveth believing,
Keeping up the fight of faith,
And suppresseth sin within him.
Blessed he who scorneth the world,
Carrying Christ's cross of shame,
One who pursueth the path of peace.
He who heaven would inherit,
Firstly must with Christ be dying.

Shun what God to thee forbideth,
Travel on thy Jesus's pathway,
Choose salvation's pilgrimage,
Strive to reach [that] blessedness,
Shun what God to you forbideth.

"*Dieses Bild gehöret mir*: Transforming Bucks County Fraktur in Canada," *Michael S. Bird*

Page 169, Fig. 114
Manuscript Tune Book and Bookplate for Anna Hoch, 1825

This little harmonious melody book belongs to Anna Hoch, singing student in the Clinton School. Written the 11th of March 1825.

Page 170, Fig. 115
Picture for Catarina Meyer, 1829

This picture belongs to me, Catarina Meyer. Received the 4th of November 1829.

Page 170, Fig. 116
Picture for Catharina Hoch, 1830

This picture belongs to Catharina Hoch. Written the 18th of April in the year 1830.

Page 171, Fig. 117
Religious Text for Catharina Meyer, 1830

O blessed shall he be
Who can go along into the Kingdom of Joys.
Justly shalt thou act here upon earth,
For ever and ever, and prepare thyself well [for Heaven].

Catharina Meyer
Written the 9th of March
in the year 1830.

Page 171, Fig. 118
Picture for Rebecca Moyer, 1833

This picture belongs to Rebecca Moyer, 1833.

Page 172, Fig. 119
Manuscript Tune Book and Bookplate for Magdalena Albrecht, 1834

This little harmonious melody book belongs to Magdalena Albrecht, singing student in the Clinton School. Written the 28th of March 1834.

Page 173, Fig. 120
Bible Bookplate and Birth Record for Barbara Fretz, c. 1815

(Previously translated, see Fig. 109.)

Page 175, Fig. 122
Copybook for Barbara Gross, 1785

Desire and love are the only things that make all trouble and labor easy.

This little copybook belongs to Barbara Gross, writing student in the Deep Run School. Written the 4th of October, A.D. 1785.

"Ausfullers und Dindamen: The Fraktur Scriveners of Bucks County,"
Russell and Corinne Earnest

Page 180, Fig. 124
Birth and Baptismal Certificate of Heinrich Roth, c. 1836

Birth and Baptismal Certificate.
To this married couple, namely Alexander Roth and his lawful wife Maria, nee Hillegass [?], Heinrich Roth was born into the world the 17th day of June in the year of our Lord [and] baptized. This [blank] was born in Marlborough Township, [Montgomery] County, in the State of Pennsylvania, North America, and was baptized and received the name Heinrich Roth. The sponsors were...[illegible]

We are scarcely born into the world when we take the first step of our life toward the cool grave of the earth. Only a short measured step—O, with that moment our strength begins to wane. And with every year that passeth we are all too ready for the funeral bier. And who knoweth in what hour the last voice will waken us. For God with his tongue hath never yet revealed this to anyone. Whoever now putteth his house in order, goeth with joy out of the world. But here eternal dying can promote assurance.

Printed and to be had...from E. Benner, Sumneytown, Pa.

Page 181, Fig. 125
Birth and Baptismal Certificate for Abraham Krämer (b. 1776)

On the 13th of April in the year of our Lord and Savior Jesus Christ 1800 I was joined in Holy Matrimony with Maria Catharina Nes[s].

Abraham Krämer died the 5th of June 1829; his age was 63 years; [funeral text:] Genesis 28:21.

To this married couple, namely Master Lorenz Krämer and his lawful wife Sophia Catharina, nee Jost, a son was born into the world, namely Abraham Krämer. He was born into the world in the year of our Lord Jesus 1776, the 12th day of January at [blank] o'clock, in the sign of [blank].

God grant grace, power, and strength, so that this Abraham may grow up in the fear of the Lord, to his praise and glory, and may increase greatly in his desire to seek for the substantial pure milk of the original salvation, and making his confession of faith and laying aside his sin through true contrition and atonement before the Christian Church, be assisted to spiritual rebirth through Holy Baptism. Following Christ's command, Matthew 28:19, he was baptized by Mr. Conrad Röller, preacher and servant of the Word, and incorporated into God's Covenant of Grace. This Abraham, as St. Paul teacheth in Titus 3:5–7, through the bath of the New Birth and Renewal of the Holy Spirit, was admitted and received into the Lutheran Religion, as a member into the Communion of Saints. The baptism took place the 31st day of March, 1776, and through true faith in our Redeemer Jesus Christ, he was installed as heir of those dearly won merits, the Joys of Heaven and of Eternal Salvation.

Therefore forget not how the Apostle Paul hath described thy duty in Colossians 1:12,14. Give thanks to the Father, who hath made us so excellently, for the inheritance of the Saints in the light, etc.

The baptismal sponsors were Abraham Jost and Elisabetha Krämer. This Abraham was born and baptized in America, in the State of Pennsylvania, in Bucks County in Rockhill Township. [He] was confirmed by Mr. Conrad Röller in the year 1792.

Scarcely are we born
When from the first step we take in life
Till we reach earth's cool grave,
Is just a short measured pace.

O, with every moment
Our strength recedeth,
And with every year
We are all too ripe for the funeral bier.

And who knoweth in which hour
The last voice will awaken us?
For God hath with his mouth
Revealed it to no mortal.

Whoever putteth his house in order well,
Goeth out of the world with joy,
But be sure that the contrary
Can cause eternal death.

Good night, my dears!
What God...that is true.

Reading:
Printed by Barten and Jungmann
in the year 1793.

I am baptized! I am in the Covenant
Through my baptism with my God,
This I declare always with joyful tongue,
In cross and affliction, anxiety and need:
I am baptized, in this I rejoice.
The joy of Jesus endureth forever.

I am baptized! Whether I die at once,
What harm can the cold grave do me?
I know my fatherland and portion
That I have with God in Heaven.
After my death there is prepared for me
The joy of Heaven, eternal salvation.

Page 182, Fig. 126
Birth and Baptismal Certificate for Samuel Laux (b. 1813)

Birth and Baptismal Certificate.
To this married couple, namely Andreas Laux and his lawful wife Maria, nee Hartman, a son was born into the world the 31st day of March in the year of our Lord 1813. This Samuel was born in Bedminster Township, Bucks County, in the State of Pennsylvania in North America, and was baptized and received the name Samuel Laux the [blank] day of [blank] in the year of our Lord 1813 by Pastor Sent. The sponsors were the parents themselves.

We are scarcely born into the world...
I am baptized, I am in the Covenant...
I am baptized, whether I die at once...
I am baptized in thy name...

Allentown. Printed and to be had from H. Ebner and Company.

Page 183, Fig. 127
Birth and Baptismal Certificate for Lidÿ Flück (b. 1831)

Birth and Baptismal Certificate.
We are scarcely born into the world...

To this married couple, namely Christian Flück and his lawful wife Maria, nee Stehr, a daughter was born into the world the 26th day of November in the year of our Lord 1831. This daughter was born in Haycock Township, Bucks County, in the State of Pennsylvania in North America, and was baptized and received the name Lidÿ Ana Funck [sic] the 18th of March in the year of our Lord 1832 by Mr. Strassberger. The sponsors were Abraham Flück and his wife Lidya.

I am baptized! I am in the Covenant...
I am baptized in thy name...
I am baptized! Whether I die at once...

Page 184, Fig. 128
Birth and Baptismal Certificate for Noah Ott (b. 1865)

Birth and Baptismal Certificate.
To this married couple, namely Daniel J. Ott and his lawful wife

Car[o]lina, nee Heller, a son was born into the world the 2nd day of July in the year of our Lord 1865. This son was born in Bedminster Township, Bucks County, in the State of Pennsylvania, in North America, and he received through holy baptism the name Noah, the 5th day of November in the year 1865 from Mr. P.S. Fischer. The sponsors were the parents.

We are scarcely born into the world...
I am baptized! I am in the Covenant...
I am baptized! Whether I die at once...
I am baptized in thy name...

Reading, Pa. Printed and to be had from Ritter and Co.

Page 184, Fig. 129
Birth and Baptismal Certificate for Aelles Sahre [Alice Sarah] Hoffman (b. 1868)

Birth and Baptismal Certificate.
To the married couple David Hoffman and his wife Catharina, nee Scherer, a daughter was born into the world the 25th day of January in the year of our Lord 1868. This daughter was born in Perry Township, Berks County, in the State of Pennsylvania, in North America, and was baptized on the 26th of April in the year of our Lord 1868 by Pastor T. Jäger and received the name Aelles Sahre. The sponsors were David Scherer and his wife Sarah, the grandparents.

We are scarcely born into the world...
I am baptized! I am in the Covenant...
I am baptized in thy name...
I am baptized! Whether I die at once...

Martin Wetzler.
Printed and to be had from E.C. Leisenring & Co., Allentown, Pa.

Page 185, Fig. 130
Family Record of the Shelly Family, 1887

Marriage:
Henry L. Shelley with Elisabeth S. Shlifer by Rev. John H. Oberholtzer in Milford Township, Bucks County, Pa. the 6th of January 1856.
Births:
Henry L. Shelley was born the 20th of May 1831 in Milford Township, Bucks County, Pa.
Elisabeth S. Shelley was born the 24th of September 1830 in Richland Township, Bucks County, Pa.
Melinda S[helley] was born the 16th of February 1858 in Milford Township, Bucks County, Pa.
John S[helley] was born the 4th of May 1865 in Milford Township, Bucks County, Pa.

Deaths:
Elisabeth S. Shelley died the 11th of May 1909 in Philadelphia, Pa. Aged 78 years, 7 months and 17 days.
Henry L. Shelley died the 30th of March 1913 in Philadelphia, Pa. Aged 81 years 10 months and 10 days.

Page 185, Fig. 131
Marriage Record of Nelson Leatherman and Lizzie Fretz, 1882

[written in English:] Marriages. Nelson K. Leatherman with Lizzie Fretz by Rev. Silas M. Andrews; at Doylestown, Pa. on the 19th day of March 1874. August Baumann, on the 16th day of August 1882.

Page 186, Fig. 132
Birth and Baptismal Certificate for Nora Jane Smith (b. 1880)

[written in English:]
Birth and Baptism.
"Permit them to approach," he cries...

To these parents, Jonathan A. Smith and his wife Mary Ann Jane, a daughter of Jesse and Barbara Hiensheimer [Hirsheimer?], was born a daughter on the 1st day of November in the year of our Lord 1800. This child was born in Worcester Township, County of Montgomery, State of Pennsylvania in North America, and was baptized on the 30th day of January in the year of our Lord 1881 by Rev. Oscar F. Waage and received the name Nora Jane. Witness Present: the parents themselves.

When life's tempestuous storms are o'er...

Page 186, Fig. 133
Memorial Record of Jennie Minnola Keeley, 1881

[written in English:]
In Memory of Our Beloved Daughter Jennie Minnola. Dedicated by her parents Josiah and Margaret Keeley. Gone but not forgotten. Asleep in Jesus.

Date of Birth
March 29, A.D. 1876
East Coventry, Chester County

Date of Death
April 10, A.D. 1881
Age 5 years and 12 days.

We cannot grow used to the silence,
 We listen all the day,
For the voice that made such music,
 For the voice that's far away.
For the merry foot on the stairway,
 For the voice like a silver bell,
And thou knowest, O our Father!
 How hard to say, it is well!
But our hearts are lifted higher,
 In the holy hour of prayer;
And our heaven has drawn the nigher,
 And grown exceeding fair.
Now here little feet are waiting,
 Up above the golden stair;
The Prophet's words are sounding,
 A little child shall lead them there.

A beautiful story is told of a father who desired to cross the river on a dark night. He could not see but his child standing on the opposite shore and calling out, "Father, steer this way." He was led directly and safely across the river. Just so our little children taken by the Lord reach the other side and often in silence we hear their call in our own soul.

Pastor Barrows preached an impressive and appropriate sermon from the text Isaiah Chapter 11 Verse 6. "And a little child shall lead them."

Page 187, Fig. 134
Birth and Baptismal Certificate of Walter Rottman (b. 1840)

Birth and Baptismal Certificate.
We are scarcely born into the world...

To this married couple, Walter Rottman and his wife Maria, nee Musick, a son was born into the world the 21st day of August in the year of our Lord 1840. This [child] was born in Allen Township, Northampton County, in the State of Pennsylvania in North America, was baptized and received the name Walter the 6th day of September in the year of our Lord 1840 by Pastor Mensing. The sponsors were the child's parents themselves.

Allentown, Pa. Printed and to be had from Blumer, Busch and Co. 1849.
I am baptized! I am in the Covenant...
I am baptized in thy name...
I am baptized! Whether I die at once...

Page 188, Fig. 135
Birth and Baptismal Certificate for Louis Ott (b. 1880)

We are scarcely born into the world...

Birth and Baptismal Certificate. To this married couple, Daniel J. Ott and his wife Carolina, nee Heller a son was born into the world the 23rd day of July in the year of our Lord 1880. This son was born in Bedminster Township in Bucks County, in the State of Pennsylvania in North America; and was baptized on the 21st day of November in the year of our Lord by Pastor Jacob Kehm [Rehm?], and received the name Louis. The sponsors were the parents themselves.

I am baptized! I am in the Covenant...
I am baptized! Whether I die at once...
Wm. Gross

I am baptized in thy name...
Printed and to be had at the Eagle Bookstore, 542 Penn Street, Reading, Pa.

Page 188, Fig. 136
Birth and Baptismal Certificate for Horace Sylvester Swope (b. 1863)

[written in English:]
Behold what condescending love
 Jesus on earth displays!...

Record of Birth and Baptism.
To These Two Parents: As Mr. George W. Swope and his wife Lydia, a daughter of Samuel Mauer, was born a son on the 21 day of May in the year of our Lord 1863. This child was born in Tinicum Township in Bucks County, in the state of Pennsylvania in North America; was bap-

tized by the Rev'd. Mr. David Rothrock and received the name of Horace Sylvester on the 27 day of January A.D. 1864. Witnesses: The parents themselves. John H. Heins.

When life's tempestuous storms are o'er...

Kindly receive this tender branch,
 and form his soul for God...

Printed and for sale by Theo. F. Scheffer—Harrisburg, Penna.

Page 189, Fig. 137
Birth and Baptismal Certificate for Johann Christein (b. 1860)

Birth and Baptismal Certificate.
We are scarcely born into the world...

To this married couple, namely Ruben Christein and his lawful wife Magdalena, nee Kichlein, a son was born into the world the 31st day of May in the year of Christ 1860. This son was born in Durham Township, Bucks County, in the State of Pennsylvania in North America, and was baptized the 15th day of September A.D. 1860 by Mr. D. Rothrock and received the name Johann. The sponsors were the parents themselves. John H. Heins.

I am baptized and inscribed, the Book of Life includes me...
Christ's Baptism in the [River] Jordan...

[written in English:] Printed and sold by J.S. Dreisbach, Bath Pa., 1861.

Page 190, Fig. 138
Birth and Baptismal Certificate for Sarah Seip (b. 1833)

Birth and Baptismal Certificate.
We are scarcely born into the world...

To this married couple, namely Wilhelm Seip and his lawful wife Anna Maria, nee Raub, a daughter was born into the world the 10th of January in the year of our Lord 1833. This daughter was born in Durham Township, Bucks County, in the State of Pennsylvania in North America, and was baptized and received the name Sarah the 3rd day of February in the year of our Lord 1833 by Mr. H.S. Miller. The sponsors were Johannes Roessler and his wife Anna Beth.

I am baptized! I am in the Covenant...
I am baptized! Whether I die at once...
I am baptized in thy name...

Sarah Seip Dide [*sic*] the December 24th 1853
Allentown. Printed and to be had from H. Ebner and Company.

Page 190, Fig. 139
Birth and Baptismal Certificate for Lorentz Freiling (b. 1818)

Birth and Baptismal Certificate! To this married couple, namely Master Jacob Freiling and his lawful wife Magdalena, nee Francke[n]fil, a son was born into the world the 11th day of September in the year of our Lord 1818. This son was born in Nockamixon Township in Bucks County in the State of Pennsylvania, in North America, and was baptized and received the name Lorentz the [blank] day of [blank] in the year of our Lord 1818 by Pastor Mensch. Sponsors were Lorentz Franckenfil and his lawful wife Catharina.

Page 191, Fig. 140
Birth and Baptismal Certificate for Jacob Kohl (b. 1810)

Birth and Baptismal Certificate. To this married couple, namely Conrad Kohl and his lawful wife Sarah, nee Sassemann, a son was born into the world by the name of Jacob Kohl in the year of our Lord 1810, the 21st day of January at [blank] o'clock in the sign of the [blank]. This Jacob Kohl was born and baptized in America, in the State of Pennsylvania, in Bucks County, in Nockamixon Township. The above-named son was baptized the 18th day of February 1810 by Pastor Mensch. Sponsors were Jacob Wolfinger and his wife Elisabeth.
We are scarcely born into the world....
Printed by H. and W. Hütter, Easton.

I am baptized! Whether I die at once...
I am baptized! I am in the Covenant...

Page 191, Fig. 141
Birth and Baptismal Certificate for Anna Mumbauer (b. 1821), 1822

Praise the Lord, O my soul, and all that is within me, [praise] His holy name.

Baptismal Certificate. Anna Mumbauer was born of Christian parents the 23rd of October in the year of our Lord 1821 in the sign of the [blank] in Haycock Township, Bucks County, Pennsylvania. Her father was Nicholas Mumbauer, her mother Rachel. The above-named A.M. received holy baptism the [blank] of [blank] at the hand of Mr. Samuel Stähr, according to Christ's commandments. The sponsors were Henry Kressler and his lawful wife Catharina.

Hear Israel, the Lord thy God is an only God.
Holy, Holy, Holy is our God, the Lord of hosts.
I am baptized! Whether I die at once...
May the 17th 1822.

"Bucks County Fraktur: A Catalogue and Guide to the Artists," *Cory M. Amsler*

Page 198, Fig. 142
Detail of Copybook for Abraham Landes, 1779

...Then spake the Lord, how can I conceal [from] Abraham what I do?
Since he shall become a great and mighty people!
and all peoples upon earth will be blessed in him.
For I know, he will command his children,
and his house after him, that they hold to the Lord's ways,
and do what is right and good.
Thereupon the Lord let come to Abraham,
what he had promised to him.
And the Lord spake: There is an outcry in Sodom and Gomorrah!
That is great, and their sins are already serious.
Therefore I want to go down and see,
Whether they have done everything according to the outcry,
that came before me. Or whether it hath not been so!
That I know it in the Second Book of Moses [i.e., Exodus], 18:17

Abraham, I write my name? By honor and virtue will I remain.
How then can this virtue be accomplished?
Then I can laugh the false world to scorn.

By Johannes Mayer, Schoolmaster on the Tohickon. Anno Domini 1779.

Page 198, Fig. 143
Family Record of Henry Jungken (b. 1717)

Henrich Jungkin was born the 31st of January in year 1717. His wife Catharina was born in the year of Christ 1736. They married in 1753 and had the following children:

1. Johannes, born the 28th of November, 1756.
2. Dorothea, the 17th of October, 1758. X [deceased]
3. Jacob, born the 13th of July in the year of our Lord 1761.
4. Frederick, born the 15th of October in the year 1763.
5. Rudolph, born the 7th of July in the year of Christ 1766.
6. Anna Elisabeth, born the 10th of April, 1769. Died. X [deceased]
7. Anna Elisabeth, born the 3rd of September 1770.
8. Henrich, born the 9th of October, 1773.
9. Catharina, born the 30th of March, 1776.

Page 199, Fig. 144
Birth and Baptismal Certificate for Johann Adam Laux (b. 1771)

John Adam Laux John Adam Laux

John Adam Laux was born in the year Anno 1771. His father is the Honorable Peter Laux, the mother Cathrina. The baptismal sponsors are the Honorable Friederich Sallade and his Christian wife Barbara. Written the 3rd of September, Anno 1773.

My time standeth in thy hands, saith David in the 31st Psalm [v. 15], and again in Psalm 39. See, my days are a handbreadth with thee. Verse 7:[15?].

Page 199, Fig. 145
Bookplate for Philipp Strauss, 1806

This beautiful book belongs to Philipp Strauss, Nockamixon, the 22nd of November 1806.

Page 199, Fig. 146
Drawing: *Frederick III, the King of Prussia*

Year of Our Lord 1769. Frederick [the] III, King of Prussia. Written [by?] Johannes May[er], schoolmaster, [at?] his school in...[rest of line is missing]

Page 200, Fig. 147
Drawing: *Frederick II, the King of Prussia*

[Written in English:]
Frederick II, the King of Prussia.

Abraham Landes, his picture [on reverse]

Page 200, Fig. 148
Drawing, 1798

[Roman numerals/clock face]

O man, from the depths of thy heart atone
atone at every hour.

In the year 1798.

Page 201, Fig. 149
Drawing with Verse, c. 1800

It is all vanity.

Page 201, Fig. 150
Drawing, 1800

While here [on earth], always remember thy goal,
and Christ's Cross and death. Bury thyself in His wounds,
so shalt thou proceed out of the misery of pain and
evil times, into long-hoped for bliss.

In the year 1800.

Page 202, Fig. 151
Penmanship Model, 1769

From the prophet Isaiah, the 40th Chapter [verse] 8.

Little red flower, little white flower,
I love the little flowers with all my diligence.

Just as a bird sweetly singeth in the field and green woods,
singing out and echoing in all the woodlands,
So, too, my spirit thanketh thee, O God, in the morning,
for thy goodness and recognizeth thy great faithfulness,
which is every morning altogether new.

The hay dryeth, the flower withereth, but
the Word of God remaineth forever.

O dear man, whatever thou dost,
Remember that thou must die.
O, how short indeed is thy life,
And thou must give God an accounting of it.
Therefore consider well
Where thy body and soul are heading.
For death is certain, the day uncertain,
The hour, too, no one may know.
Therefore consider quite exactly
How thou shalt always conduct thy life.
Hold God before thine eyes, and remember along with it
That each hour may be the last.

Deep Run, Bedminster Township, Bucks County. Written the 8th day of March, 1769.

Page 202, Fig. 152
Bible Bookplate for Jacob Fretz, 1785

This Testament belongs to Jacob Fretz, Anno Domini 1785.

Page 203, Fig. 153
Reward of Merit for Elisabeth Stein, 1812

For Elisabeth Stein! 1812

Page 205, Fig. 154
Birth and Baptismal Certificate for Anna Margretha Schick (b. 1772)

Anna Margretha, a daughter of Jacob Schick and Maria Catharina his lawful wife, was born in Nockamixon Township, Bucks County, in Pennsylvania the 2nd of September in the year of the gracious birth of our Lord and Savior Jesus Christ 1772. This Margretha was baptized immediately after her birth. The baptismal sponsors were Michael Schick and his wife Margreta. J. Nicholas Andre.

Page 206, Fig. 155
Church Register Bookplate, 1787

Church Book of the Christian Reformed Congregation in Nockamixon in the year of Christ 1787. Those who stand with Mr. Pastor Friedrich Willhelm Von der Sloot are now:

Johannes Klincker
Michael Worman
Johannes Nicolaus Hoffmann
Jacob Sumstein
and Johannes Kohl

Page 207, Fig. 156
Debit and Credit Book of Michael Dech, 1796

[Written in English:]
Debit and Credit Book for Michael Degh [Dech] of Forks Township in Northampton County.

Page 207, Fig. 157
Birth and Baptismal Certificate for Michael Fackenthal (b. 1795)

My heart I give to Jesus,
In Jesus I constantly live,
And Jesus is my refuge,
Jesus my last word.
Jesus is mine, my Savior.

This Certificate of Baptism testifieth that Michael Fackenthal was born the 13th day of May in the year of our Lord Jesus Christ 1795, in Durham Township in Bucks County in the State of Pennsylvania. His father was Michael Fackenthal and the mother Christina. After his birth his dear parents, following the command of Jesus Christ, had him acknowledged in Holy Baptism, and baptized by Pastor Mann, and incorporated into the Holy Covenant of Grace of Jesus Christ. On this occasion Michael Rath and his wife were godparents, and gave him his Christian name.

I am baptized! I am in the Covenant
Through my baptism with my God,
This I declare always with joyful tongue,
In cross and affliction, anxiety and need:
I am baptized, in this I rejoice.
The joy of Jesus endureth forever.

I am baptized! I have received
The garment of glory fairest of all,
In which I can be resplendent at all times
Here and in glory.
I am bought with Jesus' blood,
And I am also baptized in it.

I am baptized and inscribed,
The Book of Life includeth me.
My Father will love me forever
And be gracious to his child:
My name is known unto God,
My name resteth in his hand.

I am baptized! Whether I die at once,
What harm can the cold grave do me?
I know my fatherland and portion
That I have with God in Heaven.
After my death there is prepared for me
The joy of Heaven, eternal salvation.

God grant happiness and rich blessing
And soundness of health at all times.
Jesus will be the best protection
And Jesus alone will be his consolation.

Believe on the Lord Jesus Christ,
so wilt thou and thy entire house be saved.

Commend thy ways unto the Lord and put thy hopes in him, he will make it right for thee.

Page 208, Fig. 158
Birth and Baptismal Certificate for Michael Koplin (b. 1782)

Sing to and praise God, the Lord, with all your heart.

This Certificate of Baptism testifieth that Michael Koplin was born the 14th day of February in the year of our Lord Jesus Christ 1782 in Colebrookdale Township, Northampton [corrected to "Berks"] County in the State of Pennsylvania. His father was Johannes Koplin and his mother Anna Maria. Soon after his birth his dear parents, following the command of Jesus Christ, had him confirmed in Holy Baptism and baptized in the Christian manner by Pastor Vogt and incorporated into the Holy Covenant of Baptism of Jesus Christ, at which the Honorable Michael Krumrein and Maria Schweinhart gave him the above Christian name and were his sponsors.

I am baptized! I am in the Covenant...
I am baptized! Whether I die at once...

Page 209, Fig. 159
Birth and Baptismal Certificate for Johannes Sehms, c. 1809

Johannes Sehms was by Christian and lawful parents created and born the 9th of October 1_ [rest of date blank], in Pennsylvania, Bucks County, in Haycock Township. The father was Johann Conrad Sehms and the mother Elisabetha, nee Neisler. And he was baptized by Mr. Anthony Hecht. Sponsors were Stephi Neisler and his wife Catharina. He was joined in marriage the 23rd of April, 1809 with Catharina Schmell.

Page 210, Fig. 160
Birth and Baptismal Certificate for Christina Klein (b. 1803)

To this married couple, namely Johannes Klein and his lawful wife Frony, a daughter was born into the world named Christina the 4th of September 1803, and was baptized by Mr. Johann Faber, preacher, in the year 1803, in the State of Pennsylvania in America, Bucks County, Lower Milford Township. The sponsors were Johannes Klein and his lawful wife Maria, namely the grandfather and grandmother.

I am baptized! I am in the Covenant...

Page 211, Fig. 161
Birth and Baptismal Certificate for Anna Catharina Krämer (b. 1802)

Birth and Baptismal Certificate. To this married couple, namely Michael Krämer and his lawful wife Barbara, nee Eckert, a daughter was born into the world, named Anna Catharina, in the year of our Lord Jesus 1802, the 3rd day of November at 11 o'clock in the evening in the sign of the [blank]. This Anna Catharina was born and baptized in America, in the State of Pennsylvania, in Bucks County, Rockhill Township. The above-named Anna Catharina was baptized the 3rd of April 1803 by Mr. Georg Röller. The sponsor was the grandmother, Anna Sophia Catharina Krämer, widow. [Beneath the artist's text is another hand noting the death of Anna C. Krämer in 1844 at the age of 41 years, 4 months, 16 days.]

We are scarcely born into the world...
I am baptized! I am in the Covenant...
I am baptized! Whether I die at once...

Page 212, Fig. 162
Birth and Baptismal Certificate for Johannes Schmid (b. 1786)

[Written in English:]
Good ware makes quik [sic] market.

[Written in German:]
Johannes Schmid. Born in Pennsylvania in Bucks County, in Springfield Township, in the year after Christ's birth 1786, the 4th of July. His parents were Johan Jost Schmid and his wife Anna Margareta. He was brought to holy baptism by Pastor Friederici, preacher. Sponsors were Johannes Schmid and Sibilla Horn.

Page 213, Fig. 163
Birth and Baptismal Certificate for Johannes Reichert (b. 1796)

Honor Father and Mother. Johannes Reichert was born in Pennsylvania, Bucks County, Springfield Township, in the year after Christ's birth 1796, the 8th of February. Parents were Michael Reichert and his wife Elisabeth, and he was brought to holy baptism by Mr. Pastor Schmid. Sponsors were Johannes Knecht and his wife Margaretha.

Page 213, Fig. 164
Birth and Baptismal Certificate for Jacob Fasberner (b. 1812)

[Written in English:]
Certificate of Birth and Baptism. Jacob Fasberner, a son of John Fasberner and Wife Mary, was born on the 2nd day of February in the year of our Lord, 1812 in the Township of Betminster in the County of Bucks in the State of Pennsylvania in North America, and was baptized on the [blank] day of [blank] in the year of our Lord [blank] by the Revd. Sent. His sponsors were John Sine and his wife Mary.

[at bottom in a later hand:] Died October 29th 1870.

Page 213, Fig. 165
Birth and Baptismal Certificate for Maria Meyer (b. 1819)

Birth and Baptismal Certificate. To this married couple, namely Jacob Meyer and his lawful wife Susanna, nee Beitler, a daughter was born into the world, the 8th day of September in the year of our Lord 1819. This daughter was born in Springfield Township, Bucks County, in the State of Pennsylvania in North America, and was baptized and received the name Maria...[rest of text not completed]

Page 217, Fig. 166
Birth and Baptismal Certificate for Susanna Hess (b. 1811)

To this married couple, namely Joseph Hess and his lawful wife Cathrina, nee Weber, a daughter was born into the world by the name of Susanna in the year of our Lord 1811, the 15th of March at 6 o'clock in the afternoon in the sign of [blank]. This Susanna was born and baptized in the State of Pennsylvania, Bucks County, Springfield Township. The above-named Susanna was baptized by Pastor William Degham, Reformed preacher. Sponsors, Michael Wisch and Susanna Hess, single people.

Page 218, Fig. 167
Birth and Baptismal Certificate for Elisabeth Yost (1793–1857?)

Baptismal Certificate. To this married couple, namely Conrad Yost and his lawful wife Catharina, nee Tolfer, a daughter was born into the world by the name of Elisabeth in year of our Lord Jesus 1793, the 30 day of November at 7 o'clock [?] in the sign [blank]. This Elisabeth was born and baptized in Pennsylvania, Bucks County, Bedminster Township. The above-named Elisabeth was baptized by Pastor Hecht, Lutheran preacher. Sponsors, George Tolfer and his wife Sofina.

Page 219, Fig. 168
Birth and Baptismal Certificate for Daniel Afflerbach (1781–1856)

Birth and Baptismal Certificate. To this married couple, namely Ludwig Afflerbach and his lawful wife Anna, nee Schleier, a son was born into the world the 24th day of March in the year of our Lord [missing]. This little son was born in Springfield Township, Bucks County, State of Pennsylvania in North America, and was baptized and received the name Daniel Afflerbach, the 8th day of May, in the year of our Lord Jesus Christ, 1781 by the Rev. Mr. Piethahn, Pastor. The baptismal sponsors were Daniel Afflerbach and his wife Dorothea.

Page 220, Fig. 169
Birth and Baptismal Certificate for Maria Magdalena Oberbeck (b. 1816)

Birth and Baptismal Certificate. To this married couple, namely Conrad Oberbeck and his lawful wife Christina, nee Klein, a daughter was born into the world in the year of our Lord 1816 on the 6th day of March at 10:30 in the evening in the sign of Taurus. This daughter was born in Nockamixon Township, Bucks County, in the State of Pennsylvania in North America, and was baptized by the Rev. Pastor Nicholas Mensch, and received the name Maria Magdalena in the year of our Lord 1816 on the 2nd day of June. The baptismal sponsor was Maria Magdalena Oberbeck, widow.

Son, exercise faithfulness and sincerity, up to the cool grave, and do not step one finger's width off God's way. Then thou mayest may go through this pilgrim life on green meadows. Then thou mayest...fear and dread...stand against death. Then thy grandsons will seek thy grave and weep over it, and summer flowers, full of scent, will bloom out of the tears.

[Above translation adapted from Beatrice B. Garvan, *The Pennsylvania German Collection* (Philadelphia Museum of Art, 1982), 341]

Page 221, Fig. 170
Birth and Baptismal Certificate for Daniel Trumbauer (1800–1894)

Daniel Trumbauer was born in the State of Pennsylvania, Bucks County, Lower Milford Township, the 25th of January in the year of our Lord 1800 at [blank] o'clock in the sign of [blank]. His father was Johannes Trumbauer, the mother Elisabeth, nee Baum. This D. T. was baptized according to Christ's commandment in Matthew 28:19 by Mr. Röller. The baptismal sponsors were Nicholas Trumbauer and his lawful wife, the grandparents. He is of the Evangelical [Lutheran] religion, confirmed by Pastor Röller.

Glory to God. 1809. Peace on Earth. BM.

Page 222, Fig. 171
Birth and Baptismal Certificate for Jacob Benner (b. 1805)

Jacob Benner was born in the State of Pennsylvania, Bucks County, Rockhill Township, in the year of our Lord 1805 the 28th of February, at [blank] o'clock in the sign of the [blank]. His father was Johannes Benner, the mother Elisabeth, nee Ziegenfuss. This J B was baptized according to Christ's teachings in Matthew 28:19 by Pastor Röller. The sponsors were Johan Jacob Luez and his lawful wife Maria. He is of the Evangelical [Lutheran] religion, confirmed by [blank].

Bucks County. BM. March the 23rd 1809. BM.

Page 223, Fig. 172
Birth and Baptismal Certificate for Margaret Heller (b. 1818)
Margareth Heller was born of Christian parents the 12th of February in the year of our Lord 1818 in Bedminster Township, Bucks County, in the State of Pennsylvania. Her father was Bernhart Heller, the mother Eva. The above-named M. Heller was baptized according to Christ's teachings by Pastor Röller, Evangelical Lutheran teacher and preacher of the Word of God. The sponsors were Carl Schellenberger and his lawful wife Margaret.

Hear, Israel, the Lord thy God is an only God. October the 6th, 1820. Holy, Holy, Holy is our God, the Lord of Hosts. Bucks County, Haycock Township.
Bucks County, October the 12th, 1820.

Page 223, Fig. 173
Birth and Baptismal Certificate for Heinrich Borger (b. 1820)

Baptismal Certificate. Heinrich Borger was born the 6th of January in the year of our Lord 1820 in Haycock Township, Bucks County, in the State of Pennsylvania. His father was Heinrich Borger, the mother Magdalena, nee Zöllner. The above-named H. B. was baptized by Pastor Mensch, Evangelical Lutheran minister. The sponsors were Johannes Dieder and his wife Maria.

Hear, Israel, the Lord thy God is an only God.
Holy, holy, holy, is our God, the Lord of Hosts.

Page 224, Fig. 175
Birth and Baptismal Certificate for Hannah Hefler (b. 1815), 1823

Baptismal Certificate. Hannah Hefler was born of Christian parents the 17th of October in the year of our Lord 1815 in the sign of the ram in Haycock Township, Bucks County, in the State of Pennsylvania, North America. The named H.H. received holy baptism by Mr. Röller, Evangelical Lutheran teacher [i.e., minister]. The above-mentioned [Hannah's] father was Jacob Hefler, the mother Sarah. The Christian sponsors were Johannes Schmitt and his lawful wife Maria.

My Jesus I will not leave
Because he gave himself for me.
So my duty clearly demandeth
That I cleave unto him.
He is the light of my life,
My Jesus I will not leave.

Jesus I shall never desert
While I am to live on earth.
I have devoted to him my full trust
What I have and what I am.
Everything is directed to him,
My Jesus I shall not desert.

Bucks County. March the 21st 1823.

Page 224, Fig. 176
Drawing, 1823

Out of many, one.
Freedom is the life of the world and coercion is death.
Durham, Bucks County. April the 9th, 1823.

Page 225, Fig. 177
Birth and Baptismal Certificate for Isaac Weaver (b. 1819)

Isaac Weaver was born the 27th of September in the year of our Lord 1819 at 8 o'clock in the evening. He was born in Tinicum Township in Bucks County in Pennsylvania in North America. He was baptized the 9th of April in the year 1820 by Mr. Nicholas Mensch. The baptismal sponsors were Peter Trollinger and his wife Mary.

Hold fast to God's word. It is thy happiness on earth, and, as surely as God exists, will be thy happiness in heaven.

Page 226, Fig. 178
Birth and Baptismal Certificate for Daniel Friedrich (b. 1826)

Daniel Friedrich was born the 14th day of August in the year 1826 in Rockhill Township, Bucks County, State of Pennsylvania. His father was Joseph Friedrich, the mother Maria, nee Scheim. This Daniel was baptized the 14th day of November in the year 1826 by Mr. J.A. Strassberger. The baptismal sponsors were Daniel Althouse and his lawful wife Elisabeth.

Page 227, Fig. 179
Birth and Baptismal Certificate for Hannah Hunsperger (b. 1822)

Hannah Hunsperger was born the 11th day of February in the year 1822 in North America, State of Pennsylvania, in Rockhill Township, Bucks County. Her father was Isaac Hunsperger and the mother Elisabeth, nee Deis. This Hannah was baptized by Mr. Strassberger, preacher and teacher of the word. Baptismal sponsors were [Jacob?] Hunsperger and Susanna Benner.

Page 227, Fig. 180
Birth and Baptismal Certificate for Elias Scheib (b. 1823)

Baptismal Certificate. Elias Scheib was born the 12th of February in the year 1823 in Richland Township, Bucks County, Pennsylvania. His father was Martin Scheib and the mother Eva, nee Horn. This Elias was baptized the 25th of May in the year 1823 by Mr. Johan Wagen, preacher. The sponsors were Jacob Scheib and his lawful wife.

I am baptized! I am in the Covenant...
I am baptized! Whether I die at once...

Page 228, Fig. 181
Birth and Baptismal Certificate for Anna C. Ziegler (b. 1820)

Anna C. Ziegler was born on the 17th of January in the year 1820, her father was Carl Ziegler, the mother Hanna, nee Magel. This Anna Christina was baptized on the 23rd of April in the year 1820 by Andreas Strassberger, preacher and servant of our Lord and Savior Jesus Christ. The sponsors were Daniel Magel and his wife.

Because the man was God's true Son who let himself be baptized at the Jordan as a sinner, which he was not, and yet himself alone atoneth for all sin, for that the heavens opened up and the Holy Spirit came down. The father sayeth to us all that in Christ we should please him. Because of that we receive baptism and are taken up so that we can be with God the Father, Son and Holy Spirit throughout eternity. This hath happened for our sake. God did not appear for his own sake.

[Above translation adapted from *Fraktur: A Selective Guide to the Franklin and Marshall* Fraktur *Collection* (Lancaster: Franklin and Marshall College, 1987), 21–22. Translated by Curtis C. Bentzel.]

Page 229, Fig. 182
Birth and Baptismal Certificate for Johann Andreas Hartzel (b. 1841)

Johann Andreas Hartzel was born on the 19th of December 1841 in Hilltown Township, Bucks County, Pennsylvania. His father is William Hartzel and his mother Magdalena, nee Wambold. He was baptized by Mr. J.A. Strassberger. The sponsors were: Tobias Fluck and Anna his wife.

Page 229, Fig. 183
Birth and Baptismal Certificate for Elisabeth Koffel (1838–1922)

Elisabeth Koffel was born on the 14th of January 1838 at 4 o'clock in the morning in Rockhill Township, Bucks County, Pennsylvania. Her father is Peter Koffel and her mother Sarah, nee Ried. She was baptized by Mr. Georg Röller and the sponsors were: Johannes Friedrich and his wife.

Page 231, Fig. 184
Birth and Baptismal Certificate for David Ku[h]ns (b. 1794)

In the year of our Lord 1794, the 25th of July, David Kuns was born and subsequently baptized. The sponsors were Nicholas Trumbauer and his wife Magdalena, and he was baptized by Mr. Friederich Geissenheimer [Geissenhainer], preacher. The parents were the late Philip Kuns and his wife, nee Achabach. Whoever trusteth God hath built well and is worthy of heaven. Whoever submitteth himself to Jesus Christ will also become blessed. P.M. Schoolteacher, May 5, 1814.

[Above translation adapted from Frederick S. Weiser and Howell J. Heaney, *The Pennsylvania German Fraktur of the Free Library of Philadelphia: An Illustrated Catalogue*, 2 vols. (Breinigsville, Pa.: Pennsylvania German Society, 1976), 2:fig. 393]

Page 232, Fig. 185
Birth and Baptismal Certificate for Christian Vogely (b. 1770)

Birth and Baptismal Certificate. To this married couple, namely Master Christian Vogely and his lawful wife Maria, nee Drescher, a son was born into the world the 23rd day of October in the year of our Lord 1770. This son was born in Long Swamp Township in Berks County, in the State of Pennsylvania in North America, and was baptized and received through Holy Baptism the name Christian the 7th day of March in the year of our Lord 1771 by the Rev. Mr. Busskirch, Pastor...Michel [?] The sponsors were Johannes Mertz and his lawful wife Catharina. Confirmed the 23rd of April 1786 by Pastor Busskirch. [indecipherable characters, perhaps numerals, appear at lower left]

Page 233, Fig. 186
Birth and Baptismal Certificate for Margretha Wolfinger (b. 1803)

Birth and Baptismal Certificate. To this married couple, namely master Johannes Wolfinger and his lawful wife Margretha, nee Schick, a daughter was born into the world the 25th day of April in the year of our Lord 1803. This daughter was born in Nockamixon Township, Bucks County, Pennsylvania, in North America, and was baptized and received the name Margretha the 26th day of September in the year of our Lord 1803, by Pastor H. Hoffmeyer. The sponsor was Margretha Schick, widow.

Page 233, Fig. 187
Birth and Baptismal Certificate for Catharina Mast (b. 1811)

Birth and Baptismal Certificate. To this married couple, namely Master George Mast and his lawful wife Maria Magdalena, nee Stein, a daughter was born into the world the 24th day of February in the year of our Lord, 1811. This daughter was born in Tinicum Township, Bucks County, Pennsylvania, in North America, and was baptized and received the name Catharina Mast the [blank] day of [blank] in the year 1811 by Pastor Mensch. The sponsors were the parents themselves. 78.

Page 235, Fig. 190 a, b
Decorated Poems: *The Rooster Speaks to the Hen* and *The Hen Speaks*

The Rooster speaks to the Hen:
> When I see you on a manure pile
> Consorting with strange roosters,
> then I will cut off your beak,
> and for me you must shun strange roosters.

The Hen speaks:
> Ah yes, my Rooster, who would not laugh
> Over such curious matters
> If these things are bound to happen
> Then many women will be going about without noses.

Page 236, Fig. 191
Birth and Baptismal Certificate for Daniel Ott (b. 1830)

Birth and Baptismal Certificate. 28_. To this married couple, namely Master George Ott and his lawful wife Magdalena, nee Jacoby, a son was born into the world the 11th day of April in the year of our Lord 1830. This son was born in Bedminster Township, Bucks County, in the State of Pennsylvania, in North America, and was baptized and received the name Daniel Ott the 27th day of June in the year of our Lord 1830 by Pastor S. Stöhr [Stähr]. The sponsors were the child's own parents.

We are scarcely born into the world...
I am baptized! I am in the Covenant...
I am baptized! Whether I die at once...
I am baptized in thy name...
Printed and to be had from H. Ebner and Comp.

Page 237, Fig. 192
Birth and Baptismal Certificate for Catharina Textor (b. 1820)

Catharina Textor was born in the year of the world of our Lord 1820, the 27th of January, in Haycock Township, Bucks County, and soon thereafter was brought to Holy Baptism. The baptismal sponsors were Johannes Ahlum and his wife Catharina. I am baptized! I am in the Covenant...

Page 238, Fig. 193
Birth and Baptismal Certificate for Johannes Seib (b. 1794)

To this married couple, namely Johannes Seib and his lawful wife Elisabeth, nee Steininger, a son was born and named Johannes in the year of Christ 1794, the 20th of May. He was baptized by Mr. Helffrich, preacher of the word of God, in the year 1797, the 2nd of June. The baptismal sponsors were Georg Müller and Eva Grat. This Johannes Seib is born in America, in Pennsylvania, Northampton Township, Weisenberg Township.

Page 238, Fig. 194
Reward of Merit/Religious Text, 1814

This heart of mine shall be devoted to thee alone. Haycock Township, Bucks County, the 10th of March, 1814.

Page 239, Fig. 195
Bookplate for Jacob Stöhr, 1817

Tame my mouth that it doth not curse.
This Testament belongs to me Jacob Stöhr, Salisbury Township, Lehigh County, the 4th of January 1817.
Pray and Work.
Herrmann Diederich Bremer.

[Above translation adapted from Frederick S. Weiser and Howell J. Heaney, *The Pennsylvania German Fraktur of the Free Library of Philadelphia: An Illustrated Catalogue*, 2 vols. (Breinigsville, Pa: Pennsylvania German Society, 1976), 2:fig. 717]

Page 242, Fig. 197
Birth and Baptismal Certificate for Johannes Hüffendraer (b. 1806)

Baptismal and Birth Certificate. To this married couple, namely Daniel Hüffendraer and his lawful wife Catharina, nee Manggold, a son was born into the world in the year of our Lord Jesus 1806, the 21st of October, and is baptized in the year 1806, the 31st of October by Pastor G. Räller [Röller], preacher and teacher of the Word of God according to Christ's commandment in Matthew, 28 c[hapter], v[erse] 19. He was given the name Johannes. The sponsors were Christophorus Sachs and Magdalena Sachs. This son was born and baptized in Lower Milford Township in Bucks County in North America.

Page 243, Fig. 198

Birth and Baptismal Certificate for Elias Hetterich (b. 1815)

Baptismal and Birth Certificate. To this wedded couple, namely Christian Hetterich and his lawful wife Catharina, nee Schütz, a son was born into the world by the name of Elias in the year 1815, the 10th of December, at 10 o'clock in the morning. This son was born and baptized in America, in the State of Pennsylvania, in Bucks County, in Lower Milford Township. The above-mentioned Elias was baptized by Mr. Reller [Röller]. Witnesses at the baptism were Adam Nes and his wife Reul [Rachel?] Biber.

Scarcely are we born
When from the first step we take in life
Till we reach earth's cool grave,
It is just a short measured pace.

Alas! with every moment
Our energy is depleted,
And we are with every year
All too ready for the funeral bier.

Oh, who knoweth at what hour
The last voice will waken us,
Which God hath with his lips
Never yet revealed to any man?

Whoever putteth his house in order
Goeth with joy out of the world.
But certainly the opposite
Can cause eternal death.

Written the 4th of March 1818 by me Anton Rehm.

...and was confirmed 1832 in the Reformed Church by Johann Andreas Strassberger.
...and entered the state of matrimony with Feiette Leister on the 14th of February, 1841, [married] by Johann Andreas Strassberger, Reformed preacher.
Written on the 30th of July 1857 by Martin Wetzler.

I am baptized! I am in the Covenant...
I am baptized! Whether I die at once...

Page 244, Fig. 199

Birth and Baptismal Certificate for Caroline Matilda Transu (b. 1821)

Birth and Baptismal Certificate. To this married couple, namely John Transu and his lawful wife Susanna, nee Strauss, a daughter was born into the world the 22nd day of July in the year of our Lord 1821 in Nockamixon Township, Bucks County, and was baptized by Mr. Mensch. The sponsors were Philip Hoffman and his wife Sarah, and she received the name Caroline Matilda.

I am baptized! I am in the Covenant...
I am baptized in thy name...

Page 245, Fig. 201

Birth and Baptismal Certificate for Aaron Wismer (b. 1824)

Birth and Baptismal Certificate. To this married couple, namely David Wismer and his lawful wife Maria, nee Stauffer, a son was born into the world on the 15th day of February in the year of our Lord 1824. He was baptized by Mr. Miller. The baptismal sponsors were John Stauffer and his lawful wife Anna, and he received the name Aaron.

I am baptized! I am in the Covenant...
I am baptized in thy name...

June the 12th 1824. Nockamixon Township, Bucks County.

Page 246, Fig. 202

Birth and Baptismal Certificate for Elias Nicholas (b. 1823)

Birth and Baptismal Certificate. To this married couple, namely Mr. Johannes Nicolas and his lawful wife Maria, nee Lang, a son was born into the world by the name of Elias, in the year of our Lord Jesus 1823, the 18th day of August at [blank] o'clock in the sign of the [blank]. This Elias was born and baptized in America, in the State of Pennsylvania, in Bucks County, in Haycock Township. The above-named Elias was baptized on [blank] by Mr. Henrich Miller. The sponsors were Peter Lang and his wife Catharina. [In a different, later hand:] He was confirmed and accepted into the Lutheran congregation by L. Welton in the year of our Lord 1839.

We are scarcely born into the world...

Printed by H. and W. Hütter, Easton.
Completed by Elizabeth Dieterly, 1827.
I am baptized! Whether I die at once...
I am baptized! I am in the Covenant...

Page 247, Fig. 203

Birth and Baptismal Certificate for Elisabeth Schitz (b. 1825)

Birth and Baptismal Certificate. To this married couple, namely George Schitz and his lawful wife Esther, nee Fluck, a daughter was born into the world by the name of Elisabeth in the year our Lord Jesus 1825, the 25th day of January at four o'clock in the evening in the sign of Aries. This Elisabeth was born and baptized in America, in the State of Pennsylvania in Bucks County, in Bedminster Township. The above-named Elisabeth was baptized the 6th of March by Pastor Miller. The sponsors were Samuel Ott and his wife Elisabeth Ott.

We are scarcely born into the world...

Printed by H. and W. Hütter, Easton.
Completed by Elizabeth Dieterly, A.D. 1825.

I am baptized! Whether I die at once...
I am baptized! I am in the Covenant...

Page 248, Fig. 204

Birth and Baptismal Certificate for Elisabeth Dieterly (b. 1798)

Birth and Baptismal Certificate. To this wedded couple, namely Michael Dieterly and his lawful wife Barbara, nee Borneman, a daughter was born into the world, named Elisabeth Dieterly, in the year of our Lord

Jesus 1798, the 13th day of December at [blank] o'clock in the sign of [blank]. This Elisabeth Dieterly was born and baptized in America, in the State of Pennsylvania, in Bucks County, in Bedminster Township. The above-named Elisabeth was baptized by Mr. Nicolaus Mensch. The sponsors were the parents themselves...

We are scarcely born into the world...

Printed by H. and W. Hütter, Easton

72 yrs., 7 mos., 17 days.

Page 249, Fig. 206
Drawing for Anna Ruuh, 1831

This picture belongs to me, Anna Ruuh, November in the year 1831.

Page 251, Fig. 209
Birth and Baptismal Certificate for Antrias [Andreas] Althaus (b. 1824)

Antrias Althaus was born in the state of Pennsylvania in North America, in Rockhill Township, Bucks County, in the year 1824, the 12th of October. His father was Friederich Althaus, the mother Susanna, nee Schlicter. This Antrias was baptized by Mr. Strassberger according to Christ's command [in] Matthew, chapter 10, verse 14. The sponsors were his own parents. Holy, holy is our God.

Page 252, Fig. 210
Birth and Baptismal Certificate for Maria Schmiedt (b. 1795)

Birth and Baptismal Certificate. To this married couple, namely Henrich Schmiedt and his wife Margaretha, nee Schneider, a daughter was born into the world the 12th day of July in the year of our Lord 1795. This daughter was born in Springfield Township, Bucks County, in the State of Pennsylvania, in North America, and was baptized and received the name Maria Schmidt the 20th day of August in the year of our Lord 1795 by Mr. Mann. The sponsors were Peter Grub and his wife Margaretha.

We are scarcely born into the world...
I am baptized! I am in the Covenant...
I am baptized! Whether I die at once...
I am baptized in thy name...

Allentown. Printed and to be had from Henrich Ebner. 1818.

Page 253, Fig. 211
Birth and Baptismal Certificate for Franklin Meyer (b. 1830)

To this married couple, namely Henry Meyer and his lawful wife Catharina, nee Kruger, a son was born into the world the 7th day of April, in the year of our Lord 1830. This son was born in Haycock T[ownship], Bucks County, in the State of Pennsylvania, in North America; and was baptized and received the name Franklin the 9th day of June in the year of our Lord 1830, by Mr. Miller. The sponsors were Elias Kruger and his lawful wife Margretha, the grandparents.

I am baptized! I am in the Covenant...

Page 254, Fig. 212
Birth and Baptismal Certificate for Elias Strauss (b. 1828)

To this married couple, namely Jacob Strauss and his lawful wife Catharina, nee Herweck, a son was born into the world the 29th day of August in the year of our Lord 1828. This son was born in Tinicum Township, Bucks County, in the State of Pennsylvania, in North America, and was baptized and received the name Elias, the 5th day of April in the year of our Lord 1829 by Mr. Stähr. The sponsors were Heinrich Strauss and his wife Maria Magdalena, the grandparents.

Page 254, Fig. 213
Birth and Baptismal Certificate for Catharina Anna Sara Stähr (b. 1826)

To this married couple, namely Samuel Stähr and his lawful wife Anna Catharina, nee Wolfinger, a daughter was born into the world the 6th day of June in the year of our Lord 1826. This daughter was born in Nockamixon Township in Bucks County, in the State of Pennsylvania, in North America; and she was baptized and received the name Catharina Anna Sara the 10th day of July in the year A.D. 1826 by the father himself. Sponsors were Johannes Stähr and his wife Sara.

Page 256, Fig. 214
Reward of Merit for Catarina Ruhl, 1785

I have firmly made up my mind,
Although often my rest is disturbed,
In learning I want to be perfect,
O God, give me grace to accomplish it.

This heart of mine belongeth to Jesus alone.
New Year's Day, 1785.
To Catarina Ruhl, a diligent student.

Page 257, Fig. 215
Reward of Merit for Jacob Meyer, 1780

To God alone the glory. Prospect for first foresinger in the Perkasie School.

Wonderful King, Ruler of us all,
Let our praise please Thee.
Thy father's goodness, hast thou cast aside,
Although we ran away from Thee,
Help us yet, surely strengthen us,
Let the tongue sing,
Let the voice ring!

Jacob Meyer, 1780.

Page 257, Fig. 216
Penmanship Model for Barbara Wismer, 1788

O, that out of Zion help would come over Israel, and the Lord would redeem his captive people. Then would Jacob be joyful, and Israel rejoice. Psalm 14:7, also Psalm 53:7.

Give Jesus thy heart
in joy and pain,

in life and in death.
This one thing is needful.
Barb[ara] Wismer.

How do I become free? I am still like a prisoner.
Cry, sigh, and implore, then doth the Son makes thee free.
How, where, and when shall I reach my rest?
How? as you believe. Where? only in Jesus' faithfulness.
When? if thou art at peace, then wilt thou be calm. Then
shalt thou be released and free as a little bird.

After suffering followeth glory, triumph, triumph.
After a short struggle then the little flock singeth.
For soon the most faithful Shepherd will, with great
power, redeem them from the annoyance of their burden.

Ye tender little sheep, go forth. The Eternal Word
calleth unto you, with the familiar voice. Follow me on
my narrow path, and seek my grace in humility. I will
shield you from the fury.

The world that rageth all the way to its end, and
amasseth its sins a-plenty. Oh, just let it gather them!
Ye will soon see the high pomp brought low, and
made into nothing, through children who still stammer.

It revileth, it striketh, it sneereth, it wreaketh havoc,
Because your Father concealeth himself. But he will appear,
and root out the sharp thorns, also in righteous anger
dash against the rocks what Babel hath produced.

Ye children, just be of good cheer, for God, who produceth
great wonders, hath already arisen. I am the Lord Immanuel,
I go forth before Israel, and am awakened from sleep.

Arm thyselves with my understanding, take upon yourselves
my breath of life. Gird thyselves with strength. Thy
limbs in the bond of love stand like the strong around
my bed, and do great works.

Faith breaketh through steel and stone, and holdeth omnipotence
within itself. Who will overpower thee? What is light
straw to the fire? Satan is in flames with all
opposing spirits.

Look in thy innocence only to me, I lead my people
miraculously, through my omnipotent hands. Their
suffering and conflict indeed come to an end in the
triumph of Glory, and take a glorious end. 1788.

[alphabet and numbers]

Page 258, Fig. 217
Manuscript Tune Book and Bookplate for Esther Gross, 1789

Give Jesus thy heart in joy and pain, in life and in death. This one
thing is needful.

This little singing note book belongs to Esther Gross, singing student
in the Perkasie School, in Hilltown Township, Bucks County. Written
the 4th of December A.D. 1789.

Page 258, Fig. 218
Copybook for Jacob Beitler, 1784

How fleeting is Man's time.

Desire and love are the only things
That make all trouble and labor easy.
This little writing book belongs to Jacob Beitler, writing student in the
Deep Run School, written the 16th of June, A.D. 1784.

Page 259, Fig. 219
Religious Text (Spiritual Maze), c. 1783

Let us praise the Lord,
and increase his glory.
Strike up the sweet tunes,
Ye that belong to him.
His mercy lasteth forever,
Forever will he embrace us
With the sweet hold of love,
Remembering not our guilt,
Praise his name forever.
Ye who are Abraham's seed,
Praise his works forever.
Give him honor, praise, and strength.
Before a human being was even born
He already knew us,
And as chosen in Christ
Applied his grace unto us.
Even Heaven and Earth
must serve our purposes,
Since through his dearest Child,
We have become his children.
Such grace lasteth forever,
Which he hath granted us in Christ,
Eternally shall we strive
To love him above all.

This heart of mine shall be
wholly devoted to Jesus.

Page 260, Fig. 220
Birth and Baptismal Certificate for John Philip Hilgert (b. 1785)

John Philip Hilgert, son of Peter Hilgert and his lawful wife Elisabeth,
was born into this world the 14th of December 1785. On the follow-
ing 8th of January, 1786, he was baptized. The baptismal sponsors
were Philip Emmerich and Eva Guth.

This sheet, my dear child, shall be a memorial unto thee,
That the Savior hath taken thee into his Covenant.
O, press this deeply into thy memory,
As soon as with time, thou arrivest at years of discretion.
The benefit, dear child, is incomparably great
That thy Savior hath rendered unto thee in thy baptism
Full of grace, he took thee to his beloved bosom,
And let his precious blood flow upon thy stains.
Thou camest as a child of wrath into the world.
Death, curse, and sin were thine inward inheritance.

But thy Jesus represented thee gloriously,
and colored thy stained spirit with his blood.
He covereth thy guilt with his innocence,
He adorneth and crowneth thee with a thousand gifts of grace.
He granteth thy spirit salvation, life, peace, and rest.
The riches which he hath shalt thou have forever.
Such great grace and salvation and inward favor
Have truly been done to thee in thy baptism.
For Jesus's sake must thou neither early nor late,
No, nevermore, must thou consort with Satan.
When thou wert baptized, then the question was put to thee,
Dost thou renounce the Devil and all his works?
Thy sponsors said to that a distinct "Yes" —
So shalt thou then mark this word in thy whole life.
Always remain true to thy Jesus according to thy duty,
Because he heartily loveth thee, thou must love him in return.
He willeth that thy heart be unto him a pure temple,
Hence must no member in thee exercise itself in sin.
May the Savior guard thee from all offences.
May he let thee bloom unstained like a lily,
So both God and men will have to love thee.

Page 260, Fig. 221
Copybook for Abraham Hackman, 1786

Whoever can do something is highly esteemed. There is no call for an unskilled person.

This little writing book belongs to Abraham Hackman, writing student in the Deep Run School, written the 22nd of April, 1786.

Page 261, Fig. 222
Copybook for Abraham Oberholtzer, 1782

Learn to write beautifully, then thou canst also pass thy time beautifully.

This little writing book belongs to Abraham Oberholtzer, writing student in the Deep Run School. Written out for him to copy the 6th of March, 1782.

The ink is my seed, with which I write my name.

Page 261, Fig. 223
Bookplate for Maria Gross, 1791

This beautiful little book belongs to Maria Gross, in Bedminster Township, Bucks County. Written the 8th of September in the year Anno Domini 1791.

The secret of the Lord is amongst those who fear him and he showeth them his Covenant. Psalm 25:14.

Page 261, Fig. 224
Copybook for Maria Eichlin, 1796

This little writing book belongs to Maria Eichlin, writing student in the Durham School, in Bucks County, written out the 24th of March 1796.

Page 262, Fig. 225
Manuscript Tune Book and Bookplate for Susanna Kraud, 1792

This little singing note book belongs to Susanna Kraud, singing student in the Deep Run School, Bedminster Township, Bucks County. Written the 13th of June, 1792.

Page 263, Fig. 226
Drawing for Johannes Detweiler, 1784

This picture belongs to Johannes Detweiler, living in Rockhill Township. Written the 14th of November, 1784.

Page 263, Fig. 227
Drawing for Esther Gross, c. 1800

Whoever can do something is highly esteemed.
There is no call for an unskilled person.

Esther Gross, I write my name.
In God's word I hope to remain
[and] not desist therefrom
until I am carried to my grave.

Page 265, Fig. 231
Manuscript Tune Book and Bookplate for Philipp Miller, 1802

This little singing note book belongs to Philipp Miller, singing student in the Pikeland School in Chester County. Written the 3rd of April, A.D. 1802.

Page 266, Fig. 232
Manuscript Tune Book and Bookplate for Johannes Kratz, 1798

This little harmonious melody book belongs to Johannes Kratz, singing student in the Perkasie School. Written the 8th of March, Anno Domini, 1798.

Give Jesus thy heart,
In joy and pain,
In life and in death,
This one thing is needful.

Page 267, Fig. 233
Religious Text, 1784

I know an eternal Kingdom of Heaven
built all beautiful for me,
Not of silver nor of red gold,
[But] walled with God's Word.

There dwelleth God's Son,
The goodly little Jesus Child,
To whom all my hope doth point,
Until I come to him.

With God's grace and gentle blessing
All things are totally proper,
And lacking Heaven's help and favor,
All human actions are in vain.

I once came into a foreign land
Where written on the wall [it said]:
Be upright and discreet,
What is not thine, let lie.

Written the 17th of June in the year of Christ
Anno Domini 1784. By Samuel Meyer.

Page 268, Fig. 234
Picture for Magdalena Meyer, 1804

Give Jesus thy heart,
In joy and pain,
In life and in death,
This one thing is needful.

This beautiful picture belongs
to Magdalena Meyer 1804.

Page 269, Fig. 235
Manuscript Tune Book and Bookplate for Magdalena Meyer, 1804

This little harmonious melody book belongs to Magdalena Meyer, singing student in the Clinton School. Written the 4th of March in the year of Christ Anno Domini 1804.

Page 270, Fig. 236
Bookplate for Anna Landes, 1803

This little book belongs to me, Anna Landes, written in Bedminster Township, Bucks County, May 22 in the year of our Lord 1803. Desire and love are the only things that make all trouble and labor easy.

Page 271, Fig. 237
Manuscript Tune Book and Bookplate for Barbara Gross, 1812

This little harmonious melody book belongs to Barbara Gross, singing student in the Deep Run School. Written the 29th of January, 1812.

Page 271, Fig. 238
Manuscript Tune Book for Abraham Oberholtzer, 1814

Learn how thou alone canst be Singer, Book, and Temple.

This little harmonious melody book belongs to Abraham Oberholtzer, singing student in the Deep Run School. Written the 7th of June in the year 1814.

Page 272, Fig. 240
Family Record of Johannes and Barbara Wissler, c. 1807

I, Johannes Wissler, by name, was born in the year 1764, the 21st day of April. His wife Barbara was born in the year 1766, the 16th day of January. In the year 1792, the 27th day of March, he entered into holy matrimony with the praiseworthy Barbara Meyer, and in this married state they produced the following children:

1st. In the year 1792, the 25th of December, a son was born to us and given the name Samuel.

2nd. In the year 1795, the 28th of January, a daughter was born to us and given the name Elisabeth.

3rd. In the year 1797, the 7th of December, a son was born to us and given the name Joseph.

4th. In the year 1799, the 6th of May, a daughter was born to us and given the name Maria. But she was soon recalled from this life into the Heavenly Paradise, having reached the age of only 4 months, 11 days.

5th. In the year 1801, the 25th of July, a daughter was born to us and given the name Barbara. She too brought her earthly life only to 2 months, less one day.

6th. In the year 1804, the 19th of July 19, a daughter was born to us and given the name Anna.

7th. In the year 1807, the 19th of May, a son was born to us and given the name Johannes. Because it pleased the Lord to take him back, his earthly life lasted only 5 months and three weeks.

In the year 1828, the 22nd of December, Johannes Wissler died, and was buried on the 24th of December. Daniel Landes delivered his funeral sermon, taking for his text Mark 13:37. Age: 64 years, 8 months, 1 day.

In the year 1830, the 13th of April, Barbara Wissler died and was buried the 15th of April. Henrich Hunsperger delivered her funeral sermon, taking for his text [omitted]. Age: 64 years, 2 months, 3 weeks, 4 days.

Page 274, Fig. 242
Hymnal Bookplate for Catharine Stauffer, 1807

This spiritually rich hymnal belongs to Catharine Stauf[f]er. Written the 28th of March in the year of our Lord 1807.

Page 274, Fig. 244
Decorated Box for Esther Kolb, 1810

Esther Kolb. Written the 10th of March, A.D. 1810.

Page 276, Fig. 245
Hymn Text, 1814

(Previously translated, see Fig. 44.)

Page 277, Fig. 246
Manuscript Tune Book and Bookplate for Samuel Musselman, 1819

This harmonious hymn and psalm note book belongs to Samuel Musselmann. Written the 11th of April in the year of our Lord and Savior Jesus Christ 1819.

Page 278, Fig. 247
Sample Bookplate from Practice Book of Samuel Musselman, 1816

This little harmonious hymn and psalm note book belongs to me, Samuel Musselman in the year 1816.

Ye servants of the Lord, all together, praise the Lord
in the Kingdom of Heaven,
Where by right in God's house
as his wards and flock,

Ye lift up your hands in the Sanctuary.
Give praise, honor, and glory to the Lord,
Give thanks to him from the bottom of your heart.

Page 280, Fig. 248
Manuscript Tune Bookplate for Maria Oberholtzer, 1821

This little harmonious melody book belongs to Maria Oberholtzer, singing student in the Deep Run School. Written the 24th of December in the year 1821.

Page 281, Fig. 249
Manuscript Tune Book and Bookplate for Jacob Kratz, 1823

This little harmonious melody book belongs to Jacob Kratz, singing student in the Hilltown School. Written the 27th of February, 1823.

Page 282, Fig. 251
Manuscript Tune Book and Bookplate for Daniel Schelly, 1820

Learn how thou alone canst be Singer, Book, and Temple. This little harmonious melody book belongs to Daniel Schelly, singing student in the Lower Milford School. Written the 3rd day of March in the year of our Lord Jesus Christ, A.D. 1820.

Page 283, Fig. 252
Manuscript Tune Book and Bookplate for Anna Schimmel, 1821

Learn how thou alone canst be Singer, Book, and Temple. This little harmonious melody book belongs to Anna Schimmel, singing student in the Springfield School. Written the 13th of February in the year of our Lord, A.D. 1821.

Page 284, Fig. 253
Manuscript Tune Book and Bookplate for Sarah Schattinger, 1822

This little harmonious melody book belongs to Sarah Schattinger, singing student in the Plumstead School. Written the 7th of March in the year of our Lord 1822. For thine instruction and to honor God.

Page 285, Fig. 255
Manuscript Tune Book and Bookplate for Sarah Wismer, 1827

This little harmonious melody book belongs to Sarah Wismer, singing student in the Plumstead School. Written in the year of our Lord 1827.

Page 287, Fig. 256
Manuscript Tune Book and Bookplate for Johannes Hoch, 1827

This little harmonious melody book belongs to Johannes Hoch, singing student in the Deep Run School. Written the 12th of September, 1827.

Page 287, Fig. 257
Manuscript Tune Book and Bookplate for Levi Meyer, 1828

This little harmonious melody book belongs to me, Levi Meyer, singing student in the Deep Run School. Written the 30th of May A.D. 1828.

Page 288, Fig. 258
Hymnal Bookplate and Birth Certificate for Fronica Schimmel, 1813

The kindness of my beloved...
1813
The inner life of the Christians shines forth...

This little Spiritual Christian Harp belongs to me, Fronica Schimmel, in Springfield Township, Bucks County, and was bought for me by my father, for my instruction. Glory [to] God, to him alone the glory, and for the knowledge of the Truth. Written by me, Jacob Brecht, schoolmaster, the 13th of January 1813.

To us as a wedded couple, namely Christian Schimmel and my wife Maria, nee Joder, a daughter was born into the world by the name of Fronica Schimmel, through God's grace today, on the tenth of May in the year of our Lord and Savior Jesus Christ 1803, one thousand eight hundred and three, in Springfield Township, Bucks County, and in the State of Pennsylvania. I flee the sins, I make the beginning in my youth, I make haste in beginning the years of my youth. Proceed, desist not from it.

Page 290, Fig. 260
Bible Bookplate and Birth Certificate for Aaron Landes, 1839

This testament is the property of Aaron Landes, son of Johannes and Susanna Landes, and was bought for him by his father, for his instruction, because in it he can experience that to the holy triune Godhead alone is to be given glory, praise, gratitude, and honor.

In every hour, out of the foundation of the heart, not from a false mouth, God in this book makes himself known.

God wanteth [everyone] to have a true heart, and whoever hath it, him will God comfort and bless with his gifts.

Written the 18th of August Anno 1839. For Aaron Landes.

To this married couple, namely Johannes Landes and his lawful wife Susanna, nee Detweiler, a son was born into the world the 18th of August in the year of our Lord 1829. This son was born in Haycock Township, Bucks County, in the State of Pennsylvania in North America, and received from his parents the name Aaron Landes.

Once we are born, and learn to walk, it is only a short measured step to earth's cool grave.

Page 291, Fig. 261 a,b
Bookplate and Birth Certificate for Anna Bäringer, 1839

This little book is the property of Anna Bäringer, and was bought for me by my father Jacob Bäringer, for my instruction, and that with my voice I can give God glory, praise, gratitude, and honor.

This heart of mine shall be devoted to God alone.
A true heart is what God wanteth. I give him one that shall be his.
A pure heart wilt thou have? Help me to fight the battle!
My [heart], O God, shalt thou have. May 20, 1839.

To this married couple, namely Jacob Bäringer and his lawful wife Barbara, nee Landes, a daughter was born into the world the 3rd day of May in the year of our Lord 1830. This daughter was born in Haycock

Township, Bucks County, in the State of Pennsylvania in North America, and her above-mentioned parents conferred on her the Christian name of Anna Bäringer.

Scarcely are we born
When from the first step we take in life
Till we reach earth's cool grave,
It is just a short measured pace.

Oh, with every moment
Our strength recedeth,
And with every year
We are all too ripe for the funeral bier.

And who knoweth in which hour
The last voice will awaken us?
For God hath with His mouth
Revealed it to no mortal.

Whoever putteth his house in order well,
Goeth out of the world with joy.
 Written the 20th of May 1839.

Page 292, Fig. 262
Penmanship Model, c. 1830

I have a desire to depart, and be with Christ. Philippians 1:23.

The noble Shepherd, Son of God,
Beloved from eternity,
Left his Kingdom, concealed his Crown,
And went about in sorrow.
He went and sought, from love and pain,
With anxious countenance,
His poor little lost sheep
That had lost its way on earth.

And when happily he found it,
He caressed and embraced it,
And at once in his sling
Went home with it.
Then came the wolf and fell upon him
Attacking with his horde.

When this the faithful Shepherd saw,
He put himself at risk,
Sprang forth and challenged him,
And offered himself alone.
He fought, he struggled, he felt pain,
From these treacherous dogs,
And let himself to his very heart
Be bruised and [sorely] wounded.

He fought until he had lost his strength
And gave up his spirit,
So that when he was taken from there,
And, grieving, carried to his grave,
This death of his enabled him to have success,
For with it he, as God, repressed and slew the wolves.

This dearly preserved little sheep

Art thou, O my soul!
For thee he came into this pain,
For thee to his sepulchre.
So go thou now and tell him thanks,
With faithful and pure living,
And give thyself to him, body and soul,
As a Hymn of Praise.

Page 293, Fig. 263
Drawing, 1828

1828. I G.

Page 294, Fig. 264
Penmanship Model for Magdalena Gross, 1827

I have a desire to depart and be with Christ...[same hymn text as Fig. 262 above]...Magdalena Gross, February 21, 1827.

Page 294, Fig. 265
Decorated Wall Pocket, c. 1830

This belongs to Anna Junkin, written the...[rest illegible]

Page 295, Fig. 266
Penmanship Model, 1818

Lord teach me to act according to thy pleasure because thou art my God, thy spirit lead me on pleasant paths. Psalm 143.

Jesus, let me not stray from thee and thy flock. When the world wanteth to confuse me, Lord Jesus, lead me as long as I live upon earth. Let me be thine own, that I may be led by thee alone, as long as I live upon earth. Thou alone art the Good Shepherd. Without thee I am soon gone astray. So take me up, poor little sheep, and lead me on the right path, so that after this life I may be with thee in thy salvation, may look upon Heaven's lovely meadows, where the Son of Grace, in constant joy and bliss, will pasture his little sheep and lead them to the Stream of Life, where there will be delightful pastures in abundance. We come forth toward Eternal Rest, O God, preserve us all for that.
[alphabet] This copy model was written the 17th of March.

Written to instruct thee and to honor God. Heed this writing, for it has been made with care by George Gerhart, schoolmaster, in Rockhill Township, Bucks County, March the 16th, in the year of Christ 1818.

Page 297, Fig. 268
Religious Text, 1834

There cometh the hour in which all those who are in their graves, will hear His voice. Gospel of John 5:28. Written the 18th day of March, 1834, Upper Milford Township, Lehigh County.

Page 298, Fig. 269
Reward of Merit for Catherine Hillegass, 1837

Catherine Hillegass. February the 12th, 1837. Made by George Gerhard.

Page 298, Fig. 270
Religious Text, 1837

Lord, teach me to do according to thy pleasure, for thou art my God. Thy good Spirit lead me on pleasant paths. March the 22nd, 1837.

Page 299, Fig. 271
Drawing for Lydia Meyer, 1829

This picture belongs to me Lydia Meyer in Upper Milford Township, Lehigh County. Written the 21st of February, 1829, and so on...

Page 299, Fig. 272
Hymnal Bookplate for Abraham Geissinger, 1829

This spiritually-rich hymnal belongs to me, Abraham Geissinger. Written the 31st day of January in the year 1829.

Page 301, Fig. 274
Penmanship Model (unfinished), 1820

1820. Rejoice, thou Children's Order, Christ hath become a little child, therefore...

Page 302, Fig. 276
Birth Certificate and Reward of Merit for Oliver P. Shutt, 1829

[written in English:] Oliver P. Shutt was born on the Sixteenth day of November Anno Domini 1820. Doylestown township, Bucks County.

O! Youth, remember Time is an ever flowing stream; therefore, delay not time in progressing your Education. By William Chamberlain, Teacher May 27th A.D. 1829.

Page 303, Fig. 277
Reward of Merit for Oliver P. Shutt, 1830

[written in English:] Oliver P. Shutt. Doylestown township, Bucks county. April 26th Anno domini 1830. By William Chamberlain, Teacher.

Page 303, Fig. 278
Reward of Merit for Oliver P. Shutt, 1829

[written in English:] To Oliver P. Shutt a Pupil of Wm. Chamberlain Teacher at the Red Schoolhouse on the Bristol road Bucks County State of Pennsylvania, September 25th anno domini 1829.

Page 304, Fig. 279
Birth Certificate and Reward of Merit for John Detweiler, 1832

[written in English:] John Detweiler was born on the 13th day of August in the year of our Lord & Saviour 1821. The hand of diligence defeateth want. By William Chamberlain. February 8th, 1832.

Page 305, Fig. 280
Reward of Merit for Christena Ruth, 1840

May the 1st 1840 Williams Township, Northam[pton County]
This is to certify that Christena Ruth merits my Approbation in spelling in the first class.
By Levi O. Kulp
1840 1840 MERIT MERIT

Page 308, Fig. 282
Bible Bookplate for Elisabeth Schneider, 1833

This New Testament belongs to me Elisabeth Schneider, living in Hilltown Township Bucks County. Written in the year 1833.

Page 308, Fig. 283
Hymnal Bookplate for Elisabeth Kratz, 1842

This hymnal belongs to me Elisabeth Kratz, written the 10th of December 1842.

Page 309, Fig. 284
Hymnal Bookplate for Christian Meyer, 1838

This hymnal belongs to me Christian Meyer in Bedminster. Written the 13th of October in the year of our Lord 1838.

Page 309, Fig. 285
Manuscript Tune Book and Bookplate for Abraham Meyer, 1835

This little book belongs to me, Abraham Meyer. Written the 3rd of September in the year of our Lord Jesus Christ one [thousand] eight hundred and thirty five. 1835.

Page 310, Fig. 286
Manuscript Tune Book and Bookplate for Sophia Gross, 1829

This little harmonious melody book belongs to me, Sophia Gross, singing student in the Hilltown School. Written the 27th of December, 1829.

Page 311, Fig. 287
Bookplate and Birth Record for William Nesch [Nash], c. 1830

If thou holdest this book in honor, then thou wilt be heard reading [from it].

This new hymnal belongs to William Nesch who was born the 2nd of November in the year of our Lord anno 1816.

Page 312, Fig. 288
Bookplate and Birth Record for Joseph Nesch [Nash], c. 1830

If thou holdest this book in honor, then thou wilt be heard reading [from it].

This new hymnal belongs to Joseph Nesch who was born the 20th of August in the year of our Lord 1814.

Page 313, Fig. 289

Manuscript Tune Book and Bookplate for Catherine Folmer, 1833

This little harmonious melody book belongs to me, Catherine Folmer, singing student in the New Britain School. Written the 7th of January in the year of our Lord 1833.

Page 313, Fig. 290

Manuscript Tune Bookplate for Rachel Bishop, 1835

This little harmonious melody book belongs to me, Rachel Bishop, singing student in the New Britain School. Written the 8th day of March in the year of our Lord 1835.

Page 314, Fig. 291

Manuscript Tune Book and Bookplate for Heinrich Gottschall, 1835

This little harmonious melody book belongs to Heinrich Gottschall, singing student in the New Britain School. Written the 19th of February in the year 1835.

Page 315, Fig. 292

Manuscript Tune Book and Bookplate for Barbara Meyer, 1845

This little harmony book belongs to Barbara Meyer, singing student in the Octagon School. Written the 13th of May, 1845.

Page 314, Fig. 293

Hymnal Bookplate for Albert Letherman, 1871

1871.
Lord, help me, so that I may pray like a child. Receive my prayer in all its weakness.

This new hymnal belongs to Albert Letherman.
This new hymnal was presented to me, as a memento, by Magdalena Trowers.

Page 315, Fig. 294

Hymnal Bookplate for Isaiah Rickert, 1871

1871.
Lord, help me, so that I may pray like a child. Receive my prayer in all its weakness.

This new hymnal belongs to Isaiah Rickert.
Direct me according to thy counsel and receive me at last in grace.

[Above translation adapted from Fredrick S. Weiser and Howell J. Heaney, *The Pennsylvania German Fraktur of the Free Library of Philadelphia: An Illustrated Catalogue*, 2 vols. (Breinigsville, Pa.: Pennsylvania German Society, 1976), 2:fig. 703.]

Page 317, Fig. 296

Hymn Text for Sarah Gross, 1893

<u>A Hymn for Reflection</u>

No. 1. Quite sad at heart
I was impelled to sing
When I remember
How things are going in the world.
Trombones and trumpets
Are blowing all too loud.
They will awaken
The dead from their coffins.

No. 2. Awake, awake, ye dead!
Ye dead, wake up!
Ye must give an account
of the course of your life.
How dark the moon doth shine,
The sun doth shine so clear.
What is kept secret on the earth
Becometh manifest before God.

No. 3. Up yonder in Heaven
Is full of every joy
And he who cometh there
Liveth well forever.
But down there in Hell
Is nothing but pain and woe
And he who cometh there
Will never come out anymore!

Written the 5th of May, 1893,
for Sarah Gross, by Jacob Gross (in his 86th year).

Page 318, Fig. 297

Hymnal Bookplate for Esther Berger [Bergey], 1871

This hymnal belongs to me, Esther Berger, in Plumstead To[wnship], Bu[cks] Co[unty], Pa. the 22nd of January 1871.

O thou great Man of Blessing,
Come to me with thy blessing.
Grant that peace and joy, happiness and salvation,
May dwell in my house.

Page 319, Fig. 298

Hymnal Bookplate for Maria Anna Berger [Bergey], 1871

This hymnal belongs to me, Maria Anna Berger, in Plumstead To[wnship], Bu[cks] Co[unty], Pa. the 15th of January in the year 1871.

Jesus, dwell thou in my house,
Nevermore depart from it,
Dwell therein with thy Spirit
For without thee I am forsaken.

Page 319, Fig. 299
Bookplate and Birth Record for Heinrich Kolb (1813–1889), 1868

Heinrich Kolb was born the 17th of July 1813. He[inrich] Kolb, his book, written the 25th of January 1868.

Page 320, Fig. 300
Bible Bookplate for Ephraim Detweiler, 1856

Ephraim Detweiler, his Testament. Written the 10th of February in the year of Christ, 1856. Written in Bedminster Township, Bucks County, Anno Domini, 1856. S.F.

Page 321, Fig. 301
School Bookplate for Catharina Weierbach, 1857

[written in English:] Catharina Weierbach. Her third class reader. Written this 18th day of March A.D. 1857.

Page 321, Fig. 302
Book and Bookplate for Eliza Swartz, 1856

Eliza Swartz, her book. Written the 2nd of March, 1856.

Page 322, Fig. 303
Penmanship Model of Abraham Stover, 1857

[written in English:]
Good Pen Look Here
Abr: Stover
In Haycock Township Bucks County, State of Pennsylvania
Writtain [sic] the 19th day of March in one thousand eight hundred and fifty seven.

Page 322, Fig. 304
Drawing for H. C. Stover, 1857

H.C. Stover. 1857.

Page 324, Fig. 305
Birth and Baptismal Certificate for Johannes Scheiw [Shive] (b. 1819)

To this married couple, namely Jacob Scheiw and his lawful wife Elisabeth, nee Horn, a son was born into the world named Johannes Scheiw in the year of our Lord Jesus 1819, the 11th day of September, at 10 o'clock in the evening in the sign of the crab. Johannes was born and baptized in America in the state of Pennsylvania in Richland Township, Bucks County, baptized by Mr. George Röller. The sponsors were Sebastian Horn and his lawful wife Catarina.

Page 324, Fig. 306
Birth and Baptismal Certificate for Joseph Breyon [Bryan] (b. 1805)

Joseph Breyon [Bryan]. To Jacob Breyon and his wife Barbara a son was born into the world the 8th of August in the year 1805. Soon after his birth, he was through Holy Baptism incorporated into God's Covenant of Grace and the Christian Church. The sponsors at the baptismal act were Andreas Krauthammel and his wife Elisabeth.

Lord, make us like this little child,
Born anew in innocence,
As we are baptized in water,
Chosen for thy people.
That sinful man shall yet yield himself
Unto thee, Lord Christ,
That though he die he will not be lost
But rise and live with thee.

April 14th 1809.

Page 325, Fig. 307
Birth and Baptismal Certificate for Isaack McHose (b. 1783)

Isaack McHose was born of Christian and honorable Evangelical Reformed parents in Sping [Springfield] Township, Bucks County in Pennsylvania in the year of our Lord and Savior Jesus Christ 1783, the 27th of September. The parents were Samuel McHose and his lawful wife Hanna, and he was, according to scriptural custom, brought to Holy Baptism, where this name was given him. The sponsor was Johannes Flori. He was baptized by Heinrich Hoffmeier.

Jesus, let no one rob me of my faith, so that I remain faithful to thee, my God, until death.
Jesus, let no sorrow make me part from thee, so that I may dwell with thee in body and soul eternally.

Page 325, Fig. 308
Birth and Baptismal Certificate for Carl Walp (b. 1805)

Baptismal Certificate. To this married couple, namely David Walp and his lawfully wedded wife Susanna, nee Olewein, a son was born into the world the 6th of March in the year of our Lord 1805. This son was born in Richland Township, Bucks County, in the State of Pennsylvania, in North America, and following his birth was baptized, and received the name Carl from Mr. [blank]. The sponsors were Andreas Bartholomä, and Catharina Horn, both single.

Page 326, Fig. 309
Birth and Baptismal Certificate for Rachel Stähr (b. 1827)

This heart of mine belongs to thee alone, O Jesus.
Rachel Stähr was born the 9th of April in the year of our Lord 1827. Her father is George Stähr, the mother Maria, nee Adams. Baptismal sponsors: the grandparents, Johannes Adams and his wife Esther.

I am baptized! I am in the Covenant...
To thee as an example, and to God an honor.

Page 327, Fig. 310
Manuscript Tune Book and Bookplate for Elisabeth Nesch [Nash], 1799

This little singing note book belongs to me, Elisabeth Nesch, singing student in the Deep Run School, the 6th of September in the year 1799.

Page 327, Fig. 311
Manuscript Tune Book and Bookplate for Samuel Detweiler, 1805

This musical tune book belongs to Samuel Detweiler, living in Rockhill Township, Bucks County. Written the 20th of April, A.D. 1805. H.G.

Page 328, Fig. 312
Manuscript Tune Book and Bookplate for Magdalena Gross, 1818

This little book of notes belongs to Magdalena Gross, singing student in the Deep Run School. Written the 25th of February, Anno Domini 1818.

Page 328, Fig. 313
Manuscript Tune Book and Bookplate for Samuel Landes, 1816

This little harmonious melody book belongs to Samuel Landes, singing student in the Bedminster School. Written the 6th of March A.D. 1816.

Page 328, Fig. 314
Manuscript Tune Book and Bookplate for William Strunck, 1801

This little harmonious melody book belongs to me, William Strunck, singing student in the Lower Milford School. Written the 10th of March in the year of our Lord Jesus Christ, Anno Domini 1801.

Page 329, Fig. 315
Hymnal Bookplate for Isaac Gross, 1792

This beautiful hymnal belongs to Isaac Gross. Written the 25th of November, Anno 1792. Daniel was seen praying three times a day and he did not discontinue this practice when under persecution.

If I cannot so often come before my Creator,
Then at least no single day shall be devoid of prayer:
I wish to bring at least my morning offering
And when I go to sleep, to sing my little evening song.

Page 329, Fig. 316
Hymnal Bookplate for Maria Gross, 1835

This new hymnal belongs to Maria Gross. Written the 12th of January, 1835.

Page 330, Fig. 317
Bible Bookplate for Joseph Laux, 1859

This New Testament belongs to Joseph Laux, Hilltown, Bucks County, Pa. 1859.

Page 330, Fig. 318
Bible Bookplate for Barbara Angene, 1835

This Bible belongs to Barbara Angene. She was born in the year 1810, the 23rd of May. Written in the year 1835.

Page 331, Fig. 319
Penmanship Model, c. 1820

I believe in God, the Father almighty, creator of heaven and earth, and in Jesus Christ, His only son, our Lord. He was conceived by the power of the Holy Spirit and born of the virgin Mary. He suffered under Pontius Pilate, was crucified, died, and was buried. On the third day he rose again. He ascended into heaven, and is seated at the right hand of the Father. He will come again to judge the living and the dead. I believe in the Holy Spirit, the holy Christian Church, the communion of saints, the forgiveness of sins, the resurrection of the body, and the life everlasting. [numbers and alphabet]

[Above translation adapted from Frederick S. Weiser, *The Gift Is Small, the Love is Great: Pennsylvania German Small Presentation Frakturs* (York, Pa: York Graphic Services, 1994), 23.]

Page 331, Fig. 320
Penmanship Model for William Strunck, 1801

The gate is narrow, the way is small, that leadeth unto life, and few there be that find it. In the Evangelist St. Matthew 7:14.

[V1.] One thing frighteneth me deeply on earth,
That so few achieve salvation.
Oh, what shall I do,
That so many humans die,
And go to ruin so miserably?
Who then would not be afraid?

V2. Oh, how indeed can this happen,
That so many go to disgrace?
From all classes in common,
Few enter into life,
But many without number [choose perdition],
What indeed can the reason be?

V3. I can easily limit my desires
Because mankind, full of envies,
Doth not live as God commanded.
Many live for their own pleasures,
Just as if they knew no better,
That the way to Heaven is narrow.

V4. Oh, what pride there is to be seen.
See how gorgeously they go!
Each one wanteth to be the highest,
Daily doth the pomp increase.
One striveth only for favor and honor,
Can one get to heaven that way?

V5. Eating, drinking, banqueting,
Dancing, gambling, and contending,
According to custom life goeth well.
Couldst thou come to Heaven so?
So it is done to the woe of the pious,
hardly to thee it turneth out well.

Written the 28th of December in the year of our Lord Jesus Christ A.D. 1801.

[alphabet]

Give Jesus thy heart,
in joy and pain,
in life and in death,
this one thing is needful.

The easy burden maketh just a light heart.
Under a light burden the heart reacheth sublime heights.
The spirit catcheth its breath,
Its conduct cometh into a flourishing state,
And in it all tasteth the goodness of the Lord.

This *Vorschrift* belongs to W=St [William Strunck]

Page 332, Fig. 321
Penmanship Model, 1793

Strive first of all for God's Kingdom and His Righteousness, then all the other things will fall to your lot. Matthew 6:33.
O dear mortal, whatever thou dost,
Just remember that thou must die.
O how very short is thy life,
And thou must give God an account of it.
Therefore consider well
Where thy body and soul are headed.
For Death is certain, the day uncertain,
Nor may anyone know the hour.
Therefore consider well

How constantly thou shouldst conduct thy life.
Keep Good before thine eyes and bear in mind with it
That each hour can be the last.
For if we were as wise as Solomon,
And as beautiful as Absalom,
And had the possessions of the great Alexander,
And the courage of the Roman Emperor,
And the Turkish Sultan's Empire,
All the same we are destined for death.
Therefore nothing is better to be gained here on earth
Than to live a Christian life and to die saved.
For living as a Christian and dying in salvation
Is enough to have gained here on earth.

[alphabets]

Written the 16th of January 1793.

Everything that existeth on this world,
Be it silver, gold, or money,
Riches and temporal property,
That lasteth only for a short time,
And doth not help at all for salvation.

Page 333, Fig. 324
Reward of Merit for Elisabetha Lambart, c. 1790

Let no one who readeth this for the first time become impatient, because he oweth one pence to the diligent [student] Elisabeth Lambart.

Notes on Contributors

Joel Alderfer (b. 1961) is a native and ninth generation resident of Lower Salford Township in Montgomery County, Pennsylvania. He graduated from Christopher Dock Mennonite High School in 1979 and studied history and English at Ursinus College. Since 1988, he has served the Mennonite Heritage Center in Souderton and Harleysville, Pennsylvania as librarian/curator/archivist. The Center, operated by the Mennonite Historians of Eastern Pennsylvania (MHEP), maintains an extensive collection of Pennsylvania-German Mennonite fraktur, folk art, and decorative arts. Mr. Alderfer has also served as contributing editor to the *MHEP Newsletter* and the *MHEP Quarterly*, where he has published numerous articles on local Mennonite history, material culture and genealogy. He is the author of *Peace Be Unto This House: A History of the Salford Mennonite Congregation, 1717–1988*, published by the Salford Mennonite Church.

Over the past twenty years, Mr. Alderfer has done extensive free-lance genealogical and local history research in Bucks and Montgomery Counties. In the last ten years he has also done considerable research in documenting the material culture (including fraktur, furniture, textiles, manuscripts, rare books, etc.) of local Mennonite communities. He has been able to identify, often by coincidence, a couple of Mennonite schoolmaster-fraktur artists, as well as reveal the identities of a few local Pennsylvania-German Mennonite furniture makers. As curator, his research is still on-going.

He is married to Cindy Jenkins, lives near Harleysville, Lower Salford Township, and is the father of three young sons. He is also involved in a number of church, community, and educational programs.

Cory Amsler is Curator of Collections at the Mercer Museum of the Bucks County Historical Society in Doylestown, Pennsylvania, a position he has held for ten years. Having come to the Mercer as an intern in 1988, he was promoted to Assistant Curator in 1989, and to his present position in 1990. Between 1978 and 1983 he attended the University of South Florida, where he received degrees in Social Science Education and History. In 1988 he received an M.A. Degree from the Cooperstown (New York) Graduate Program in History Museum Studies.

At the Mercer Museum Mr. Amsler is responsible for the overall care, management, documentation and exhibition of the museum's extensive collection of artifacts related to the everyday lives of the middling and mechanic classes in pre-industrial America. He has curated numerous exhibitions, including 1997's *From Heart to Hand: Discovering Bucks County Fraktur*, which marked the centennial of Henry Mercer's pioneering 1897 study of these Pennsylvania-German decorated manuscripts. He also coordinated the Bucks County Fraktur symposium on which the current volume is based.

Mr. Amsler lectures extensively on the history and collections of the Mercer Museum. He resides in Doylestown, Pennsylvania with his wife and colleague, Eileen Shapiro.

Michael Bird is a Professor in the Faculty of Arts at the University of Waterloo in Waterloo, Ontario, where he teaches in the departments of religious studies and fine arts. His teaching and research interests include religion and art, religion and folk art, and religion and cinema, and the subject of sacred places. He is author of numerous books and articles on religion, art, and architecture, with contributions specifically on the subject of fraktur and folk art, beginning with *Ontario Fraktur: A Pennsylvania German Folk Art Tradition in Early Canada* (M.F. Feheley Publishers). Other books include: *Canadian Folk Art: Old Ways in a New Land* (Oxford University Press), *Canadian Country Furniture* (Stoddart), *Religion in Film* (University of Tennessee Press), *Art and Interreligious Dialogue* (University Press of America) and others. Dr. Bird has organized many exhibitions of folk art in Canada, the United States, Great Britain and Germany. Most recently he has served as guest curator for an exhibition on religious aspects of fraktur at the Heritage Center Museum of Lancaster County in Lancaster.

Russell D. Earnest, a native of San Diego, California, joined the U.S. Navy submarine service after high school. Following the military, he completed his undergraduate and graduate work at Oregon State University. Following retirement from the U.S. Department of Interior, he joined his wife, Corinne, in a writing/publishing business she established in 1982. The Earnests publish on the subjects of fraktur and genealogy. They have studied fraktur for thirty years, and have recorded genealogical information from more than 20,000 examples.

Corinne Earnest, a native of Amarillo, Texas, earned her undergraduate and graduate degrees in secondary education and modern languages. She became a freelance writer in 1982. In 1992, she became the winner of the first William M. Hiester Manuscript Award, given annually by the Historical Society of Berks County in Reading, Pennsylvania. She currently serves as President of the Mid-Atlantic Germanic Society.

Russell and Corinne are authors of numerous books and articles on Fraktur, the latest being *Fraktur: Folk Art and Family* (1999), and the second edition of *Papers for Birth Dayes: Guide to the Fraktur Artists and Scriveners.* This latter book was released in conjunction with the 1997 exhibit, "The Prints and the Penmen," guest-curated by the Earnests at the Heritage Center Museum in Lancaster, Pennsylvania. In 1999, the Earnests were given an Award of Merit by the Pennsylvania German Society for their research on Fraktur.

Mary Jane Lederach Hershey, a resident of Harleysville, Pennsylvania, is a graduate of Goshen College (B.A., 1952) and Drexel University (M.A., 1957). She was a founding member of the Mennonite Historians of Eastern Pennsylvania and the first director of MHEP's Mennonite Heritage Center. Recently she completed two terms as President of the organization. She continues to contribute as a member of the Library and Collections Committee and as Trustee Emeritus.

Ms. Hershey is the author of several articles, including "A Study of the Dress of the (Old) Mennonites of the Franconia Conference, 1700–1953" (*Pennsylvania Folklife,* Summer, 1958), and "Andreas Kolb (1749-1811): Mennonite Schoolmaster and Fraktur Artist" (*Mennonite Quarterly Review,* April, 1987). For twenty years she has researched Fraktur made by or for Mennonites of the Franconia Conference.

At present, Ms. Hershey is a real estate broker in the Harleysville area and an active member of the Salford Mennonite congregation.

Terry A. McNealy, a native of Doylestown and lifelong resident of Bucks County, served from 1971 to 1993 as Librarian of the Spruance Library of the Bucks County Historical Society. During that time he was responsible for acquiring, preserving and cataloguing a wide variety of source materials useful both for Bucks County research and the documentation of the Historical Society's diverse collections. He has written extensively on local historical and genealogical subjects.

Since his retirement from the position of Librarian, Mr. McNealy has continued to research and write about local history. He has also served as an adjunct researcher and cataloguer on various projects at the Historical Society, including the fraktur exhibition. Currently he is at work on an illustrated, popular history of Bucks County, due to be published in 2001.

John Landis Ruth (b. 1930) has paternal roots on a farm in New Britain Township, Bucks County, and lives on the eight-generation (maternal) homestead where he was born in Lower Salford, Montgomery County. Residents of this house brought home fraktur by schoolmasters Andreas Kolb, Jacob Hummel and Isaac Hunsicker. A graduate of Eastern College and Harvard University (Ph.D., English and American Literature, 1968), Dr. Ruth has taught (1962–76) at Eastern College and the University of Hamburg, Germany. In 1975, at the invitation of local Mennonites, he turned to film/video and history projects related to Pennsylvania Mennonite heritage. For two decades he served as Associate Minister of the Salford Mennonite congregation near Harleysville, in whose earlier meetinghouse frakturist Christopher Dock taught school, (1738–1771). Among Dr. Ruth's productions are films on the Amish and Hutterites, while his books include *'Twas Seeding Time: A Mennonite View of the American Revolution* (1976); *Maintaining the Right Fellowship: A Narrative Account of the Oldest Mennonite Community in North America* (1984); and *The Earth is the Lord's: A Narrative History of the Lancaster Mennonite Conference* (forthcoming).

Having retired from the ministry in 1993, Dr. Ruth continues on the Board of the Mennonite Historians of Eastern Pennsylvania, while preparing a multi-volume narrative interpretation of Mennonite life in the Lower Salford/Franconia region. He is the husband of Roma Jacobs Ruth, who has taught and practiced the art of fraktur since 1974.

Don Yoder is a native Pennsylvanian and Professor Emeritus at the University of Pennsylvania. He received his B.A. from Franklin and Marshall College and his Ph.D. from the University of Chicago. Since 1956 he has been associated with the University of Pennsylvania where he has presented courses in the Departments of Folklore and Folklife, Religious Studies, and American Civilization. Since 1962 he has directed over sixty Ph.D. dissertations, and has also served as both Chairman and Co-Chairman of the Graduate Program in Folklore and Folklife.

Dr. Yoder was a co-founder in 1949 of the Pennsylvania Folklife Society, and served as editor of the Society's quarterly journal, *Pennsylvania Folklife,* between 1961 and 1978. As a member of the American Folklore Society, he chaired its Material Culture Committee and served as the organization's President. More recently, Dr. Yoder served as editor for the Pennsylvania German Society, both authoring and editing numerous publications for that organization. On the subject of fraktur, he has written several books and articles, including *Pennsylvania German Fraktur and Color Drawings* (1969), "Fraktur in Mennonite Culture" in *The Mennonite Quarterly Review* (1971), and *The Picture Bible of Ludwig Denig* (1989). Dr. Yoder resides in Devon, Pennsylvania.

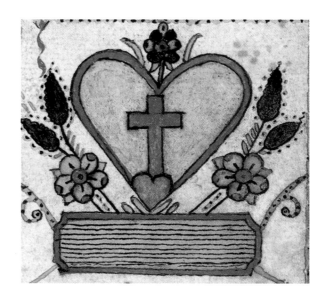

Subject Index

Name Index